"Carla Kaplan offers a joint biography of six large_y _._g_____ ____
ured in the Harlem Renaissance of the 1920s and 1930s as patrons, muses, and editors and in assorted other roles that Kaplan captivatingly illuminates and places in overdue perspective."

—*New York Times*

"Kaplan always writes from inside her characters, and with a novelist's sense of scope—and compassion."

—Hilton Als, NewYorker.com

"[Kaplan's] extensive research has given life to a critical period in black American history—and given credit to the white women who, for various reasons, helped the Harlem Renaissance flourish."

—NPR.org

"An empathetic and skillful writer, Kaplan . . . shares the previously untold story of a group of notable white women who embraced black culture—and life—in Harlem in the 1920s and '30s. . . . Captivating."

—*Publishers Weekly* (starred review)

"Each biography is shaped by Kaplan's vivid scene-setting, historical perspective, psychological sensitivity, narrative panache, and frank analysis of the virulent sexism and racism of 1920s America and the confluence in Harlem of grim social conundrums and a spectacular creative flowering. . . . Kaplan's meticulously documented and intrepid history of Miss Anne encompasses a unique vantage on the complexities of race and gender and a dramatic study in paradox."

—*Booklist* (starred review)

"In this utterly fascinating and deeply insightful account, Carla Kaplan reveals the disparate women who together became 'Miss Anne' in the Harlem Renaissance. From the reticent Annie Nathan Meyer through the manipulative Charlotte Osgood Mason to the flamboyant Nancy Cunard, they could see themselves as better Negroes than actual black people and despise other whites in the black milieu. Yet they challenged the meanings of race and gender in ways that still deserve attention. This fine book takes the Misses Anne seriously and goes further, to reveal the workings of interracial networks in one of the most important cultural phenomena in American history."

—Nell Irvin Painter, author of *The History of White People*

"The fact that white women played a pivotal role in creating the Harlem Renaissance was a secret hiding in plain sight, but it took Carla Kaplan's keen eye, rigorous research, and crystal-clear prose to reveal it. *Miss Anne in Harlem* is a surprising, delightful book that will soon be essential reading for anyone interested in the Harlem Renaissance and the brave, bold women of the Jazz Age."
—Debby Applegate, author of *The Most Famous Man in America*

"Carla Kaplan has taken on a dauntingly liminal topic and by force of scholarly rigor and narrative compassion rendered it central to our understanding of an era. Lush, original, and vigorously argued, *Miss Anne in Harlem* does justice to the difficult richness not only of these exceptional women's lives but of life itself."
—Diane McWhorter, author of *Carry Me Home*

"Endlessly fascinating, *Miss Anne in Harlem* reveals a whole new perspective on the Harlem Renaissance, and Carla Kaplan delivers an essential and absorbing portrait of race and sex in twentieth-century America."
—Gilbert King, author of *Devil in the Grove*

"With superb, exhaustive research and finely dramatic writing, Carla Kaplan's brilliant *Miss Anne in Harlem* fills an aching void in our knowledge of the Harlem Renaissance. It also significantly deepens our understanding of American culture in the 1920s and American feminism in general."
—Arnold Rampersad, author of *The Life of Langston Hughes*

"A work of meticulous and far-ranging scholarship, Carla Kaplan's *Miss Anne in Harlem* matches its characters' shocking and subversive lives with explosive revelations and subtle insights. Kaplan has assembled an unforgettable ensemble cast of race-rebels, 'traitors to whiteness,' who gave their full resources—talent, compassion, money, ingenuity—to the cause of black cultural liberation a half-century before America discovered that 'black is beautiful.' A story of Harlem Renaissance insiders who would always be outsiders, Kaplan's haunting narrative forces a rethinking of race and gender."
—Megan Marshall, author of *Margaret Fuller: A New American Life* and *The Peabody Sisters: Three Women Who Ignited American Romanticism*

"In her clear-sighted, empathetic assessment of a half-dozen of these women, Carla Kaplan casts a fresh eye over people and relationships too often reduced to stereotypes."
—*Daily Beast*

"Carla Kaplan has given us and history a great gift." —*New York Journal of Books*

Miss Anne in Harlem

Miss Anne in Harlem

➤➤ ◄◄

THE WHITE WOMEN OF THE BLACK RENAISSANCE

Carla Kaplan

HARPER ⬤ PERENNIAL

NEW YORK • LONDON • TORONTO • SYDNEY • NEW DELHI • AUCKLAND

HARPER ● PERENNIAL

A hardcover edition of this book was published in 2013 by HarperCollins Publishers.

MISS ANNE IN HARLEM. Copyright © 2013 by Carla Kaplan. All rights reserved. Printed in the United States of America. No part of this book may be used or reproduced in any manner whatsoever without written permission except in the case of brief quotations embodied in critical articles and reviews. For information address HarperCollins Publishers, 195 Broadway, New York, NY 10007.

HarperCollins books may be purchased for educational, business, or sales promotional use. For information please e-mail the Special Markets Department at SPsales@harpercollins.com.

An extension of this copyright page appears on page 351.

Frontispiece: Etta Duryea, circa 1910. Photographed by Elmer Chickering. Courtesy of the Boston Public Library, Print Division.

First Harper Perennial edition published 2014.

Designed by Leah Carlson-Stanisic

Library of Congress Cataloging-in-Publication Data has been applied for.

ISBN 978-0-06-088237-2 (pbk.)

14 15 16 17 18 OV/RRD 10 9 8 7 6 5 4 3 2 1

For Steve

MISS ANNE: "A White Woman."

—Zora Neale Hurston, "Glossary of Harlem Slang"

ANN; MISS ANN: Coded term for any white female. [e.g.] "His mama washes clothes on Wednesday for Miss Ann."

—Clarence Major, *From Juba to Jive:
A Dictionary of African-American Slang*

ANN: (1) A derisive term for a white woman. . . . Also "Miss Ann."

—Geneva Smitherman, *Black Talk*

MISS ANN and MISTER EDDIE: Emancipated bluebloods.

—Taylor Gordon, *Born to Be*

Contents

Contents

A Note to the Reader

It is conventional for biographers to use either first or last names for their subjects, depending on whether the focus is on a subject's private or public life. Not surprisingly, women are more often referred to by their first names in biographies than are men. In this book, I have tended to use last names when referring to those aspects of my subjects' lives that were public—such as their writing careers—and their first names when I am writing about their personal lives. However, some of the women I write about, such as Charlotte Osgood Mason, maintained such strong public fronts in all aspects of their lives that I have found it impossible to refer to them by their first names. Conversely, some of the women in this book, such as Nancy Cunard, were so adamant about erasing the line between public and private that I have found it impossible to treat them with the distance that last names confer.

This biography relies on a great deal of original archival material in the form of letters, journals, diaries, and notebooks. In all cases, I have left original wording intact and refrained from any corrections of spelling, grammar, or accuracy in these women's papers. The indicator [*sic*] is used as sparingly as possible and only when not to do so would create significant confusion.

Illustrations

Illustrations

THE POET'S PAGE

To a Pickaninny
By EDNA HARRIET BARRETT

HOW broad you smile at people pass-
 ing by,
There in your carriage, swathed in vivid
 pink,
Before the ten-cent store. Your great
 eyes blink
At street cars, roll in ecstasy, and try
To follow every rambling dog or boy
Until he's out of sight. Your heart is
 gay
And, gleefully, you reach for the display
Of window trinkets—gurgling for sheer
 joy.

You do not know that bits of glass like
 this
Once lured your dusky race to slavery,
Nor that these persons passing on the
 street
Will banish you from their white-peo-
 pled bliss.
Poor trusting babe, you will awake to
 see
These phantom fetters dragging at your
 feet.

The Lost Heart
By BILLIE B. COOPER

ONE day,
 When I was playing in the sand,
I found a bottle that the tide
Had washed ashore.
I filled it with bright pebbles,
And to me
Each pebble was a promise and a dream.
And then at last
Because it was not full,
I put my heart on top
And flung it far.
As it splashed beneath a wave,
Child-like, I blew
A kiss to the early evening star.
I meant it all in play
And little knew
The years to follow
Would bring one like you,
Who would be tired and very sad today
To know the sea had washed my heart
 away
Long years before.

1930
By NANCY CUNARD

NOT yet satisfied,
 But I'll be satisfied
With the days I've slaved for hopes,
Now I'm cuttin all the ropes—
Gettin in my due of dough
From Ofays that'll miss me so—
 Go—ing . . . Go—ing . . .
Where the arrow points due South.

I dont mean your redneck-farms,
I dont mean your jim-crow trains,
I mean Gaboon—

I dont mean your cotton-lands,
Old-stuff coons in Dixie bands,
I've said Gaboon—
This aint no white man's nigger
Nor was—but I've grown bigger
The further away from you
(Further, longer away from you)
 My Cracker moon.

Doin my own stuff now,
Equator, Pole and Pole—
Fixin to board the prow
And let the Ocean roll and roll
And roll me over, even,
To where the Congo waters roll.

Wont take from the old lands
But twelve bottles of gin—
Wont leave on the old lands
But my cheque cashed in—
Then make clear to the Black Folks
They can't but win.

Last advice to the Crackers:
Bake *your own* white meat—
Last advice to the lynchers:
Hang *your brother* by the feet.
One sitting-pretty Black Man
Is a million-strong on heat.

Goin to beat up Fear on the octaves,
Tear the Crackers limb from limb—
Goin to take on each-every vengeance,
Drum one blood-blasting hymn—
And laugh laugh laugh in the shadows
Louder'n Death—I'll be watching him.

Pedestal

NO . . . do not place me here
 Within this shrine

*But you are beauty
And I would worship you!*

'Tis cold . . .

*No . . . for you are a shaft
Of silver fire against the sky*

Take me down . . . Let me be
A crimson flame against your heart . . .

*I am afraid . . . you might crumble
At my touch . . .*

Ah! Better to know the touch.
I will be far more lovely
In your embrace . . . even tho' I be
 dust . . .!

*Your love is a shrine
And I the Priest who guards
Its stainless beauty.*

But my love would be more beautiful
Were it bruised between our lips
Like the fallen rose . . .

*Such rapture I could not endure
I would die . . .*

Better to die of rapture
Than wither with age . . .
But . . . as you will.
There are others . . .
Never . . .!! Come . . . Let me die

The Church of the Green Pastures
By JEANNE COLLINS

THE Green Pastures is my Church
 here God walks and God talks
just off Broadway.
Services are held every evening
including Sabbath and Wednesday Mat-
 inee.
The Scriptural Text is from the Five
Books of Moses.
The Hymns and Spirituals
are sung by God's Chosen Race.
"Go Down Moses"
burns into the hearts of mankind.
In the sight of the Lord,
the Mansfield Theatre transformed
into the Church of the Green Pastures.
God be praised,
Brother Richard Harrison and his holy
 flock
be praised.
Brother Roark Bradford be praised
Brother Lawrence Rivers be praised
and last but not least Brother Marc
 Connelly
be praised for endowing the Modern
 Babylon
with the Church of The Green Pastures.

A White Girl's Prayer
By EDNA MARGARET JOHNSON

I WRITHE in self-contempt, O God—
 My Nordic flesh is but a curse:
The Black girl loaths to clasp my hand;
She doubts my love, because I'm white.
An Oriental shrinks from me,
While flashing Hindu eyes disdain
My pallid cheek, my Saxon hair,
And Jewess lips rebuke my smile.
Shy "senorita" apprehends
The sneering crowd, were she my guest.
Old Indian squaws perplexed will stare,
When I but praise their basketry.

O, bitter age. I'm ostracized
By my own proud Caucasian clan,
Since I, among my friends would have
The youths of every race and caste.

O God of Life, remove this curse—
The cords of shame are strangling me.
Remorse is mine. I would atone
For white superiority—
Sheer carnal pride of my own race.

Tonight on bended knees I pray:
Free me from my despised flesh
And make me yellow . . . bronze . . .
 or black.

A White Girl's Prayer

By EDNA MARGARET JOHNSON

I WRITHE in self-contempt, O God—
　My Nordic flesh is but a curse:
The Black girl loaths to clasp my hand;
She doubts my love, because I'm white.
An Oriental shrinks from me,
While flashing Hindu eyes disdain
My pallid cheek, my Saxon hair,
And Jewess lips rebuke my smile.
Shy "senorita" apprehends
The sneering crowd, were she my guest.
Old Indian squaws perplexed will stare,
When I but praise their basketry.

O, bitter age. I'm ostracized
By my own proud Caucasian clan,
Since I, among my friends would have
The youths of every race and caste.

O God of Life, remove this curse—
The cords of shame are strangling me.
Remorse is mine. I would atone
For white superiority—
Sheer carnal pride of my own race.

Tonight on bended knees I pray:
Free me from my despised flesh
And make me yellow . . . bronze . . .
　or black.

THE CRISIS

Toward the end of the 1920s, the NAACP journal, The Crisis, *began to transform its "Poet's Page" into a forum for white views of race, ranging from verses in the minstrel tradition to radical antiracist odes, often printed on the same page and without editorial comment. Although extreme, "A White Girl's Prayer" spoke for many who longed for the exotic utopia they imagined Harlem could offer, just as Nancy Cunard's "1930" voiced the belief of some white women that they could speak for, or as, blacks.*

Introduction:
In Search of Miss Anne

There were many white faces at the 1925 Opportunity awards dinner.
So far they have been merely walk-ons in the story of the New Negro,
but they became instrumental forces in the Harlem Renaissance.
 —Steven Watson, *The Harlem Renaissance*

You know it won't be easy to explain the white girl's attitude, that is,
so that her actions will seem credible.
 —Carl Van Vechten, *Nigger Heaven*

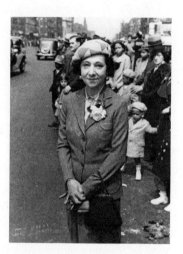

Fania Marinoff in Harlem.

I did not set out to write this book. Some years back, in the course of writing *Zora Neale Hurston: A Life in Letters*, I needed, but could not find, information on the many white women Hurston knew and

befriended in Harlem: hostesses, editors, activists, philanthropists, patrons, writers, and others. There was ample material about her black Harlem Renaissance contemporaries: "midwife" Alain Locke; leading intellectual W. E. B. Du Bois; educator Mary McLeod Bethune; activists Walter White and Charles S. Johnson; actors Paul Robeson, Charles Gilpin, and Rose McClendon; and the array of Harlem Renaissance writers and artists from the cohort with whom she edited the radical journal *Fire!!*—Wallace Thurman, Langston Hughes, Gwendolyn Bennett, Richard Bruce Nugent, Aaron Douglas, and John Davis—as well as satirist George Schuyler, novelists Jessie Fauset and Nella Larsen, and poets Claude McKay and Countée Cullen, among others. The white *men* associated with the Harlem Renaissance—writer and honorary insider Carl Van Vechten; writers Sherwood Anderson and Waldo Frank; playwrights Eugene O'Neill, Paul Green, and Marc Connelly; editor/satirist H. L. Mencken; activist Max Eastman; folklorists Roark Bradford and John Lomax; German artist Winold Reiss; anthropologists Franz Boas and Melville Herskovits; philanthropists Arthur and Joel Spingarn and Edwin Embree—also proved easy to research. But the white women were a problem. It seemed that there was virtually no information available about some of them. Many, such as Charlotte Osgood Mason, a wealthy patron known as the "dragon lady" of Harlem, were described with the same few sentences in every source on the Harlem Renaissance, sentences that I eventually learned were wrong (although not before I too had committed some of them to print).

We have documented every other imaginable form of female identity in the Jazz Age—the New Woman, the spinster, the flapper, the Gibson Girl, the bachelor girl, the bohemian, the twenties "mannish" lesbian, the suffragist, the invert, and so on. But until now, the full story of the white women of black Harlem, the women collectively referred to as "Miss Anne," has never been told. White women who wrote impassioned pleas such as "A White Girl's Prayer" (see frontispiece) about their longings to escape the "curse" of whiteness have rarely been regarded seriously.

Some believed they should not be. The press sexualized and sen-

sationalized Miss Anne, often portraying her as either monstrous or insane. To blacks she was unpredictable, as likely to sentimentalize a "gleeful," "trusting," eye-rolling "pickaninny," as Edna Barrett did on "The Poet's Page," or to claim that she could speak for black desires to murder "Crackers," as Nancy Cunard did there also (see frontispiece), as she was to question or criticize her own status. And so, blacks did not necessarily welcome her presence either, although they often sidestepped saying so publicly or in print. Miss Anne crops up in Harlem Renaissance literature as a minor character—a befuddled dilettante or overbearing patron whose presence in cabarets or political meetings spawns outbreaks of racial violence. Occasionally, she is caricatured in black newspapers, as in this cartoon image of white women flocking to throw

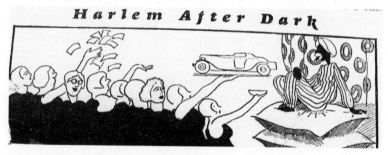

A bevy of sex-starved white women showering riches on one lone "sheik" (Harlem slang for a hip black man).

gold, jewels, and cars at one sexy young black man, known in those days as a "sheik." Relying on these stock characters, we might believe that she was found only in cabarets, drinking and "jig-chasing" (pursuing black lovers), or enthroned on New York's Upper East Side, bankrolling black writers. Historians and critics such as Kevin Mumford, Susan Gubar, and Ann Douglas dismiss these women as "slummers" guilty of "sinister . . . vampirism" and pronounce their incursions into Harlem undeserving of serious inquiry. Even Baz Dreisinger's recent *Near Black: White-to-Black Passing in American Culture*, the only book of its kind on this subject, mentions just one woman, the journalist Grace Halsell.

There are a few individual biographies of these women. These biographies typically dispense with their time in Harlem in a few pages, although it was often the most important and exciting period of their lives.

Some still believe that Miss Anne's story should remain untold. Often dismissed as a sexual adventurer or a lunatic, Miss Anne may be one of the most reviled but least explored figures in American culture. *Miss Anne in Harlem* aims to see what can be understood now about this figure's unlikely, often misunderstood, choices. What can we resurrect about her lived experience of "identity politics," and how might that be relevant today? What context gave her choices meaning? Why have so few questions been asked about her actions? Could we reconstruct her own view of what she was doing in Harlem without first imposing judgment? One problem with dismissing these women out of hand is that so many of the principal engineers of the Harlem Renaissance sincerely loved them, even if their efforts to become "voluntary Negroes" and speak for blacks also made them nervous.

Sometimes it seems as if Miss Anne engineered her own erasure from the historical record. Some of the most influential white women in Harlem—such as NAACP founder Mary White Ovington, Harlem librarian Ernestine Rose, and philanthropist Amy Spingarn—believed that they were most effective when they drew the least attention to themselves. Some of Harlem's white women destroyed their own papers. Laboring still under the dictum that a lady's name should appear in public only upon her birth, marriage, and death and that all other notice of her was unseemly, many of them went to great lengths not to be mentioned. Some of their papers were destroyed by disapproving family members. Some were thrown in with those of their husbands or the famous men with whom they worked. Some of their records remain unprocessed to this day. This lack of materials reflects both the history of gender and the gendered history of Harlem.

It was one thing for white men to go "slumming" in Harlem, where they could enjoy a few hours of "exotic" dancers and "hot" jazz, then grab a cab downtown. But it was another thing altogether for white *women* to embrace life on West 125th Street. Epitomizing everything

that was unrespectable at a time when social respectability meant a great deal more than it does now, a white woman who embraced Harlem risked extraordinary disapproval, even ostracism. In the 1920s, short of becoming a prostitute, there was no surer way for a white woman to invite derision than to eschew her whiteness or be intimate with a black man. The ease with which Miss Anne's embrace of black Harlem has been dismissed as either degeneracy or lunacy, rather than explored as a pioneering gesture worthy of attention, indicates how fundamentally she challenged her era's cherished axioms of racial identity, axioms often held on both sides of the color line, and still valued in many circles today.

The "race spirit" of the Harlem Renaissance was militant rebellion, born from the galvanizing return of Harlem's triumphant 369th Regiment of the American Expeditionary Forces (also known as the "Harlem Hellfighters"), at the end of World War I. Du Bois's best-known essay, "Returning Soldiers," calls on other "New Negroes" to "return from fighting" and "return fighting" the enemy at home. It echoed Claude McKay's often-reprinted poem "If We Must Die," admonishing "far outnumbered" black men that however "pressed to the wall" they might be, they should die "fighting back." That spirit was also echoed in such essays as W. A. Domingo's "If We Must Die," published in *The Messenger* in 1919, which noted that "The New Negro has arrived with stiffened back bone, dauntless manhood, defiant eye, steady hand and a will of iron." This fighting spirit buttressed the "race pride" that Alain Locke called "the mainspring of Negro life." And it largely precluded the white Negrotarians flooding Harlem. To some extent, white male philanthropists could fight their way in—if insider status was their goal—by modeling themselves after white abolitionist militants such as John Brown and William Lloyd Garrison. But with the rare exception of a few antilynching activists, white women could do no such thing. While it seemed to some Harlemites that "Negrotarians . . . came in almost infinite variety," many of the most devoted white female activists found themselves at sea.

Caught between a militancy they could not model and a desire not to seem like primitivist interlopers, white women philanthropists had

to tread carefully to get their bearings in Harlem. The most effective among them, especially in the early years of the New Negro movement, tended to build on such foremothers as the female abolitionists or the New England schoolteachers in southern freedmen's schools. For the most part, though, Miss Anne was a singular figure who kept other white women at bay and struggled to make a place for herself in Harlem alone.

Often, they went to remarkable lengths to draw attention away from themselves. Amy Spingarn, daughter of a wealthy manufacturer, always allowed her husband, Joel, and his brother, Arthur, to take credit for her civil rights work, though it was her money that paid for all the prizes and philanthropy given in their names.

Amy Spingarn.

Sometimes Miss Anne was asked what she was doing. "I have found since I have become known in radical Negro work," Mary White Ovington wrote, "that colored people, under their pleasant greetings, are thinking, 'Why did you take up the Negro cause?' . . . I try to answer, but it takes a long time to explain."

Taking that time is the work of this book.

Many of the women in this book were once famous. One was America's highest-grossing writer (now largely unread). Two were the subject of lengthy *New Yorker* profiles. Another was the target of endless society stories and Movietone newsreels. Others appeared frequently in newspaper accounts. One was so infamous in Harlem that her name was hardly uttered, because she strictly forbade it. But trying to capture these women can be like looking at images drawn in invisible ink. Sometimes Miss Anne seems to vanish the moment she is spotted. One of these women, Lillian Wood, has been miscategorized as black for almost a hundred years. A white identity seemed so unthinkable, given her choices, that her blackness has always been assumed. She looked toward Harlem from the South, where she had all but disappeared into a small black college.

Almost all histories of the Harlem Renaissance begin with two of the first literary celebrations to bring together Harlem intellectuals and white publishers, editors, and philanthropists: the Civic Club and *Opportunity* awards dinners of 1924 and 1925 sponsored by *Opportunity* magazine, the National Urban League's journal. I thought I would begin my search for Miss Anne there. I was sure I would see these women in photos of those important inaugural interracial galas, and I hoped that photo captions would help me identify them and the roles they played there as judges, patrons, writers, hostesses, and friends. But no photos of the dinners survive. And in the myriad written descriptions of the events, two of the most celebrated in New York's social history, white women are mentioned fleetingly at best, though they did attend in large numbers.

The Civic Club dinner on March 21, 1924, connected the cream of New York's literati to the Harlem Renaissance's advance guard, creating interracial networks the movement would depend on for years to come. As *Opportunity* reported, it was a chance "for many of the contestants to meet in person many of those who were making American literature." The evening was a fantastic success, providing whites with a wealth of

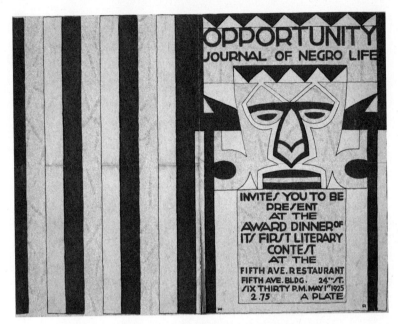

Journals such as Opportunity *often used African arts.*

cultural material and blacks with needed social resources. In fact, the Civic Club dinner became so legendary that it soon proved necessary to host a second, larger dinner, on May 1, 1925. Taking place downtown in the Fifth Avenue Restaurant, this was the premier interracial cultural event of the year. It was "a novel sight," according to the *New York Herald Tribune*, with "white critics whom everybody knows, Negro writers whom nobody knew—meeting on common ground." "Novel" it may have been. But in almost every other way, the *Herald*'s reporter missed the mark. The gathering in those white, gold, and mirrored rooms was not Old New York's hidebound version of *Who's Who*. This was a new social order, one in which the "Negro writers" were well known indeed. They were the reason Greenwich Village, Midtown publishing, and uptown university types were there. Harlem was already "hot."

"Common ground" was not equal ground, however. Of the nearly two dozen contest judges, eighteen were white, as were all the section heads for each competing literary genre. The dinner was free for most

of the white attendees, who were designated as "honorary" invitees. But black attendees, or "supporting" guests, as they were called, were charged handsomely for their chicken, mashed potatoes, and peas. One black award winner, Brenda Ray Moryck (a granddaughter of the editor of *The Colored American*, the most important antebellum weekly in the nation), reflected on the "paradox" of treating whites as experts on black culture when "colored people always have known [more about whites] and always will . . . than they will ever know about the black race." Men and women were not in the same position either that night. Most of the white women who went to Harlem did so with limited cultural capital. Their funds were rarely their own, siphoned, sometimes surreptitiously, from their fathers or husbands. For every well-connected white publisher, editor, or producer—such as Carl Van Vechten, editor John Farrar, or literary critic Van Wyck Brooks—seated comfortably at one of the room's round white tables and keen to acquire protégés, new authors, or clients, there was an equally keen white woman with fewer resources at her disposal.

Admittedly, what Miss Anne wanted was often hard to pin down. The dozens of white women who attended that night were as divergent a lot as those who published their pieces on "The Poet's Page." Some were primitivists, such as Edna Barrett and the writer and translator Edna Worthley Underwood, who thought black people were "a new race differently endowed" that could help restore white culture and art "because joy—its mainspring—is dying so rapidly in the Great Caucasian Race." Others were activists squirming in their high-backed chairs whenever such things were said. Some came looking for friends or collaborators. Others sought the thrill of being rebels. Many came to escape the social conventions that awaited them at home: lectures, calling cards, concerts, and whist. Most wanted to be members of something meaningful, to be part of a group. Some may have shared the hopes of a white woman named Sarah N. Gelhorn, who wrote in to the radical black weekly *Chicago Defender*, "I have sometimes dreamed of a band of justice-loving white women." When journalists bothered to mention the white women of Harlem, which was not often, they tended to lump them together,

assuming that all of them were motivated by prurient sexual or primitivist sentiments. That created friction between the women that often led them to avoid one another.

But surely they did not eat their dinners in silence. Whom did they talk to, and what did they say to one another that night? We do know, even if they could never have predicted it, that they had a profound impact on the "New Negro Movement," as it was most often then called, and on its understandings of race. Whether as hostesses, patrons, comrades, lovers, writers, or—most intriguingly—as white women passing for black, these women went to Harlem to participate in its renaissance, often with the pioneering notion that they could *volunteer* for blackness. By making themselves socially unintelligible and courting ostracism, they confounded available categories and introduced many of our own critical ideas about the flexibility or "play" of social identity, often with unhappy outcomes. A period's most peculiar and confounding figures often offer the greatest cultural insights. Miss Anne was one of the culture's most confounding. We now understand identity as relative, constructed in response to what it is not. Miss Anne's mere presence in Harlem helped make that relativity visible. Hence, by simply showing up, she helped construct what blackness and whiteness both meant at an especially volatile moment in the country's racial history. Miss Anne complicated her culture's notions of identity, in other words, whether she set out to do so or not.

These women were struggling with some of the most vexing problems of their day. Each was there upsetting the apple cart for her own reasons. But together they gave expression to many of the social ideas most salient now: the understanding that race is a social construction and not an essential aspect of our being; the notion that identity is malleable and contingent; the theory of whiteness as social privilege; and the awareness that blackness and whiteness, as social categories, are not constructed identically or even symmetrically but demand different analyses. Whatever their intentions, these women were precursors of some of our most cherished nostrums. All of them used race to expand the cultural roles available to them as women. As an NAACP official, Mary White Ovington,

born in 1865, could travel, and she spent a great deal of time in the rural South, staying in black people's homes and speaking at black churches. Among her close friends she counted both W. E. B. Du Bois and James Weldon Johnson, two of the most intriguing and expansive intellectuals of the century. She could write. She was the author of two plays, a major sociological study of race, two autobiographies, three children's books, a group biography of black America, and an important, innovative novel about passing called *The Shadow*. She could also give public speeches. In Harlem, Ovington noted, "I did what I wanted to." Today, we have a term for Ovington's linking of gender and race: it is "intersectional." Miss Anne pioneered "intersectionality." "Performativity"—the subversion of social roles through exaggerated performances that reveal their social codes—Miss Anne also pioneered. Her experience of identity politics was often a kind of tragic performativity that exposed the codes of whiteness even as it also revealed that getting outside our identities may not always be a desirable sort of social freedom.

I am not claiming that these women were trying to be precursors. They were just trying to get by where (they were told) they did not belong. This means that their missteps are as important as their conscious efforts to dismantle racial thinking—maybe even more so. Miss Anne was as much a product of her time as she was sometimes way ahead of it. For her, the line between Negrophobia and Negrophilia was always shifting. Her desires were chaotic and contradictory. And that is the point of reconstructing them. Miss Anne pushed the idea that identity is affiliation, allegiance, and desire—rather than biology or blood—farther than almost anyone else in her day, sometimes even farther than she meant to. She was a disconcerting figure who sometimes made both herself and others miserable. Reconstructing her life enables us to watch her tumble into important insights, which, more often than not, is the way insight occurs. Miss Anne's situation was so unique that it would have been almost impossible for her not to develop original ideas, such as her simultaneous rejection of racial essentialism and "color-blindness." Her insistence that race is a constructed idea, but one we cannot afford to ignore, is an important double insight, one that we could stand more of today.

This is a book informed by theory and cultural studies. It could not have been written without the provocative insights of critical race theory, identity theory, whiteness studies, and contemporary feminism. But it is not a work of theory. It is, rather, chiefly a set of untold stories, biographies that sometimes reveal the salience of our theories about who we are and sometimes take those ideas in other, unexpected, directions. My interest is, finally, more in the questions these stories allow us to ask than the judgments they encourage us to draw. It is a central tenet of critical race theory that "racism is ordinary," occurring across myriad social moments we might take as neutral or unrelated to race. Part of what Miss Anne's stories can teach us is that *anti*racism can also be ordinary, found in some of the most unexpected places and made manifest, however imperfectly, by some of the most unlikely social actors.

I am not interested in claiming heroic status for these women. Nor do I see them all the same way. Their motives and their contributions cover the gamut from dreadful to honorable, with much in between. Nor do I say that they were more important than the black intellectuals and artists who led the Harlem Renaissance. But that story has already been told.

Without knowing Miss Anne's story, it is hard to spot her legacy. Yet that legacy is all around us today. When Tom Hayden and Jane Fonda, for example, recently remarked to the writer Hilton Als that they were "especially happy" that their son's marriage to a black woman would contribute to "the peaceful, nonviolent disappearance of the white race," they were channeling one of Miss Anne's signature ideas—that interracial intimacy could end race categories.

In myriad ways we still struggle with Miss Anne's questions. Can we alter our identities at will, and, if so, how? What, if anything, do we owe those with whom we are categorized? Does freedom mean escaping our social categories or instead being able to inhabit those that don't seem to belong to us? The white women of Harlem lived those questions every day, with varying degrees of awareness and varying degrees of success.

Miss Anne's story also redraws maps and time lines of the 1920s. Scholars such as George Hutchinson have made a strong case for seeing the Harlem Renaissance as interracial. Until we write Miss Anne back

into that interracial history, however, its true texture cannot be clear. The Renaissance has long been understood to have ended when the Harlem "vogue" became economically unfeasible after the stock market crash. However, many of the white women of Harlem found their way into their cultural and political work only when the prominent white men abandoned that field. Seen through their eyes, the Harlem Renaissance extended well into the 1930s. So with the map of bohemian New York: Miss Anne might have gone to Paris's Left Bank or New York's Greenwich Village; she chose Harlem instead. Her forays into Harlem connected those regions to one another with filaments that are otherwise unseen.

By the time I finished my search for Miss Anne in Harlem, I had more than five dozen names. While the first two chapters of this book provide brief profiles of a number of these women, I focus thereafter on the half dozen figures who best exemplify the range of ideas white women brought to Harlem (or, in Lillian Wood's case, to black communities) and the range of strategies they used to make themselves a place there. In part, I chose women who left enough of an archive to make such a reconstruction possible. Three of the women proved especially exemplary of the continuum that stretches from primitivism to antiracism as well as the ways in which white women tried to fit into Harlem. Their stories I tell at greatest length to try to answer the question of what took them to Harlem in the first place and where their unusual idea that they could volunteer for blackness might have come from. Of those three, Charlotte Osgood Mason was widely understood to be a malignant force in Harlem yet was beloved by many Harlemites; Nancy Cunard was dismissed as a bed-hopping Communist and rarely treated seriously, yet she was enormously effective; and Josephine Cogdell Schuyler some historians consider "boring," though to me she seems anything but. All three dreamed—quite literally—of Africa, at a time when people paid much more attention to their dreams. And all three followed their African dreams into black New York. Some of the white women of Harlem were most important for one specific thing they contributed—usually a book that had a big impact. Between the longer stories of Mason, Cunard, and Schuyler are shorter chapters on three

of those game-changing contributions: *Let My People Go* by Lillian E. Wood, *Black Souls* by Annie Nathan Meyer, and *Imitation of Life* by Fannie Hurst, all of which were written within a few years of one another, with an eye toward making a statement on race and making an unusual reputation for their writers. Three of the women in this book were young in their Harlem years. Three were old enough to have been those young women's mothers. Thus, they comprise two generations of rebellion and experimentation.

All six of these women had influence and impact. Wood and Meyer wrote works that, while forgotten today, were watersheds in their day. Schuyler married one of the most important figures of the Harlem Renaissance and became a Harlem voice in her own right through her writing. Mason was Harlem's most influential patron. Cunard edited the most comprehensive anthology of the era. And Hurst remains famous today largely because of her one novel about blacks, *Imitation of Life*.

To highlight some of the key themes that bring these women together and that animated their own interests in Harlem, I have grouped them into three parts: "Choosing Blackness: Sex, Love, and Passing"; "Repudiating Whiteness: Politics, Patronage, and Primitivism"; and "Rewards and Costs: Publishing, Performance, and Modern Rebellion." These headings are by no means exclusive. To one degree or another, Miss Anne was always choosing blackness, repudiating whiteness, and experiencing the rewards and costs of those choices. So the headings bleed into one another, proving relevant, at different times, to each of the six women whose story this book tells.

It is important, I believe, to try to let Miss Anne speak for herself, to reconstruct her reasons for being in Harlem and her ideas about race, rather than simply passing judgment on her for crossing lines she was told to stay behind. This book's six biographies are an effort to hear what Miss Anne had to say.

It is also important to understand the context in which Miss Anne's social experiment became meaningful. "Miss Anne's World" sketches two related axes of that context: the official view of race and the unofficial view that many lived and breathed. Many who were deeply commit-

ted to the position that race was a social construction were nevertheless also deeply attached to the very notions of blood and essential being that, in public, they decried. This racial erotics—simply put, this love of blackness—nourished the cultural explosion that made Harlem America's black "Mecca." Miss Anne's love of blackness, however, was like a too-large spigot into that nourishing wellspring, bringing to the surface challenging desires for belonging and threatening, some feared, to drain Harlem dry. "Miss Anne's World" aims to provide a sense of the tensions that the women in this book experienced and to suggest how their efforts were viewed in their day. It provides the context in which their isolation and loneliness—as well as their longing to belong—took shape and took on meaning. It allows us, I hope, to understand what we are hearing when we listen to Miss Anne.

Miss Anne's World

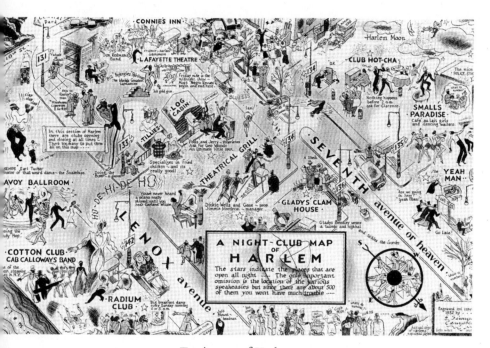

Tourist map of Harlem.

Chapter 1

Black and White Identity Politics

The black-white relationship has been symbiotic; blacks have been essential to white identity (and whites to blacks). . . . Black Harlem could not be left alone, for in a sense it was as much a white creation as it was black.

—Nathan Huggins, *The Harlem Renaissance*

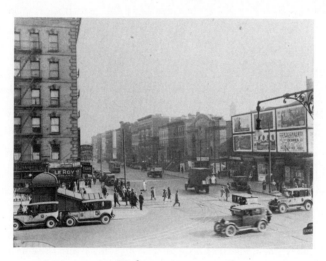

Harlem street scene.

Taxonomic Fever: Identity Frenzy in the 1920s

The 1920s were both a propitious and a peculiar time to undertake race-crossing and experiment with what we now call the "free play" of identity. When it came to race, the Jazz Age was a bitter, brittle

time, one of the most conservative in our history. On either side of "the color line," being seen as a "race traitor" was perilous.

The newspapers made that peril clear. If you were in your kitchen on an autumn day in 1925, drinking coffee and leafing through *The New York Times*, you'd see images of a high-spirited America proud of its prosperity and pleased with the status quo. Advertisements for clothes, bath products, appliances, homes, and cars depicted well-heeled executives hopping out of gleaming roadsters to join beaming families on their substantial, maple-shaded front porches: a Main Street of solid middle-class houses right out of Sinclair Lewis's *Babbitt*. Advertisers painted a world in which consumers were white; young women were wives; and young wives were "General Purchasing Agents"—pearl-stranded domestic executives streamlining their family's communications and purchasing, hygiene, education, and leisure. Seen from this glowing perspective of growing postwar consumerism, the twenties look strangely complacent, rather than rebellious.

Most of us have been taught that the 1920s were when Americans suddenly broke free of taboos and conventions, flinging the old order aside to drink and dance their way to tomorrow in one great "roar." But race was not like the artistic, sexual, civil, and stylistic norms Americans were then challenging. Racial norms were a line that even most radicals dared not defy.

One case in particular made the costs of such crossings clear. Everyone in Harlem was mesmerized by it. So were many other readers in New York and across the nation. In 1924, Leonard Kip Rhinelander, the heir to the Rhinelander fortune, shocked his family, and the country, by marrying Alice Beatrice Jones, a young woman who did laundry and domestic service. Within weeks, however, he gave in to family pressure and allowed his father to file for annulment on the grounds that Alice had deceived him into believing she was white when she was, in fact, a "Negro" under the law. Called "the scandal of the decade," the ensuing trial was one of the most sensational, and closely watched, in U.S. history.

Leonard was the descendant of America's economic elite. His fa-

ther, Philip Rhinelander, was an important figure in New York's real estate world and the arts. Alice Jones was a working-class woman, one of three daughters of George and Elizabeth Jones, British domestics. Elizabeth was white. But George was a "colored" man, or "mulatto." Alice worked as a domestic, living in or traveling from her parents' small wood-framed home off an alley in New Rochelle, New York.

Jones and Rhinelander met in 1921 when Leonard was out driving with his friend Carl, an electrician, and they met Alice's sister Grace on the street. Leonard was initially interested in Grace, but he quickly transferred his affections—and a ring—to Alice. They dated for the next three years. They went to movies. They petted in Leonard's car. They spent time with Alice's family in New Rochelle. They also spent a week in the Marie Antoinette, a New York hotel, having sex.

Philip Rhinelander may not have known about the sex, but various sources reported the relationship to him. He tried desperately to separate his son from Alice. First he sent Leonard abroad. Then he installed him on a dude ranch in Arizona. Leonard and Alice exchanged hundreds of love letters, some of them pornographic by the standards of the day—a fact that would come back to haunt Alice later. Through the mail, they became engaged. When Leonard turned twenty-one in 1924, he came into his trust fund, a combination of cash, securities, real estate, and jewelry worth over $4 million in today's dollars. He returned and married Alice in a quiet civil ceremony in the New Rochelle courthouse on October 13, 1924. Within a month, news of their marriage hit the newspapers and a tempest erupted when the papers reported that a Rhinelander had married a "colored" woman. "Blueblood Weds Colored Girl." "Social Registerites Stunned at Mixed Marriage." Philip Rhinelander sought an annulment of his son's marriage claiming that Leonard had been deceived about Alice's race.

After a lengthy set of trials, the court denied the annulment on the grounds that Leonard must have known that his bride was not white. The most extraordinary moment in an extraordinary trial came on November 23 when Alice—at that moment one of the richest women in America—was forced to disrobe to the waist so that the judge, lawyers,

and all-male, all-white jury could determine, from their own examination of her naked body and breasts, if Leonard might have been deceived about Alice's race. The black community immediately responded to the forced disrobing, which put Alice "into a long line of women of color who have had their bodies, literally and figuratively, put on trial," and which reasserted the one-drop rule of blackness and the notion of racial "telltales." Among others, Du Bois expressed his outrage in *The Crisis* that the courts would so "persecute, ridicule and strip naked, soul and body, this defenseless girl." The press coverage was relentless. *The New York Times* alone published more than eighty articles on the case. On some days, the spectators struggling "to get into the court had become a small riot."

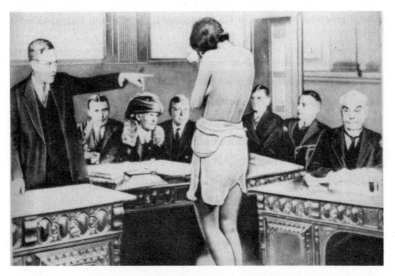

Alice Jones Rhinelander's forced disrobing in court was an unthinkable humiliation for a woman; the New York Evening Graphic's *composographic image depicting this incident was the first faked photograph in journalism.*

To bolster its claim that Leonard had been seduced and sexually "enslaved" by Alice, the prosecution read the couple's love letters in court, including letters that detailed practices, such as cunnilingus, considered "unnatural." The prosecuting attorney, Isaac Mills, went on to depict

the marriage as "unnatural" in every way. "There is not a mother among your wives," he commented to the white men of the jury, "who would not rather see her daughter with her white hands crossed in her shroud than see her locked in the embrace of a mulatto husband."

Alice won the case and prevailed over an appeals process that dragged out for the next two years. The court did not accept that Leonard had been "deceived" into marrying her. It was clear that he had known of her "taint" all along. Leonard disappeared and tried to file for divorce in Nevada. The court had to force the Rhinelander family to pay Alice her settlement money: a lump sum of $31,500 plus $3,600 a year (equivalent to roughly $380,000 and $45,000 a year today). A key provision of the settlement was that Alice promise to leave Leonard alone and never use the Rhinelander name for any purpose.

Alice's victory was pyrrhic. She had lost her marriage. She had lost her claim to whiteness; she was now known as that "colored" girl who married a Rhinelander. And she could no longer be considered a decent woman; she was remembered as the half-naked woman examined by a panel of men. Even the sex lives of prostitutes were less exposed than Alice's brief time with Leonard. The Ku Klux Klan went after her with all the vehemence it reserved for those it considered passers, those who tried to sneak into whiteness. Alongside some supportive letters from blacks, Alice received huge quantities of hate mail, much of it violent and threatening. She never remarried and mostly lived with her parents for the rest of their lives, using part of her settlement money to help them buy their small home.

Leonard died of pneumonia in 1936 at the age of thirty-four. Alice had to return to court to again force the Rhinelanders to honor her legal settlement. She died in 1989 and is buried with her family in New Rochelle. Her headstone, in defiance, reads "Alice J. Rhinelander."

Newspaper readers in 1925 would have had no trouble drawing the obvious conclusion: that this was how black women—or even women *suspected* of being black—should expect to be treated if they crossed race lines. The citizenry was warned to be exactly what they were and not try to become—or pass as—anything else.

That was the dark side of the decade: a violently enforced insistence that people were only one thing and nothing else and ugly anxieties about racial differences that were always present, even—sometimes especially—when they were unseen. Part of what was jazzing up the famously frenetic twenties was that taxonomic fever, a nearly obsessive mania for putting people into categories and demanding loyalty to them. The Rhinelander case was just the tip of an enormous, nasty iceberg.

Fueled by the astounding growth of the Ku Klux Klan, racial violence exploded in the aftermath of World War I. From riots in Washington, D.C., Tulsa, Rosewood, East St. Louis, Chicago, and elsewhere to lynchings (fifty-one in 1922; seventeen in 1925) to police harassment of interracial couples to the firebombing of dozens of black homes in white neighborhoods, violence enforced the racial status quo. As an "instrument of social discipline," lynchings in that period "became increasingly sadistic and spectacularized," with images of racial violence disseminated widely on picture postcards and in newspapers. Nativist anti-immigration sentiment was strengthened by this climate, and groups such as the American Legion proclaimed the ideal of an all-white, nonimmigrant nation. "We want and need every One Hundred Per Cent American. And to hell with the rest of them," trumpeted American Legion Commander Frederic Galbraith. Countless social sectors—journalism, academia, radio, politics, and "Americanization" organizations—seemed equally hell-bent on extending segregation's legal and economic reach by portraying any movement across racial lines as unnatural. While other sexual and social taboos were falling by the wayside in that legendarily rebellious time, rigid racial lines were being drawn more sharply than at almost any other period in American history. Never before or since has the color line been treated with quite such Janus-faced hysteria. White women who crossed race lines must have expected to be singled out as bad social examples.

Most Americans in the 1920s remembered Etta Duryea, black prizefighter Jack Johnson's first wife. Duryea was a well-off, white Brooklyn socialite when she met Johnson at a racetrack and fell in love with him. In 1912, only a couple of years into their marriage, she killed herself

above the nightclub they co-owned. Newspapers treated her life as a lesson in the "inevitable" fate awaiting race-crossers. The *New York World* insisted that an early death was "preordained" for any "girl of gentle breeding" who cast her lot with blacks. Suicide was the logical outcome for a "woman without a race," the paper editorialized. Several reporters remarked that Duryea's death proved that white women did not belong in the black community. Duryea had already said as much. " 'Even the Negroes don't respect me,' she had complained; 'They hate me.' " Her mother insisted that Etta had been insane to marry Johnson. Killing herself was an act "not of temporary madness, but of ultra-lucidness," Etta's only sane act since crossing the color line, her mother stated.

 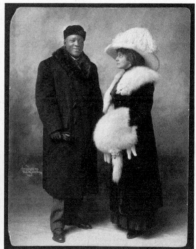

Jack Johnson's marriage to Etta Duryea caused a scandal.
Many people were shocked when Johnson (right) married another
white woman only weeks after Duryea's suicide.

Rigidity, however, always encourages escape. Racial passing increased dramatically in the twenties. Some papers claimed that five thousand people a year were "crossing the color line" to join the "white fold." Others estimated twenty thousand. One put the number as unrealistically high as seventy-five thousand people a day in Philadelphia

alone. Sociologist Charles S. Johnson, the founding editor of *Opportunity* and later president of Fisk College, calculated that 355,000 blacks had passed between 1900 and 1920 and that blacks were leaving the race at the rate of ten thousand a year. Those reports fueled the fear that economic inequality was pushing blacks across "the color line." Such crossing, many whites worried, was becoming increasingly difficult to detect. The matter of knowing "when . . . a Caucasian [is] not a Caucasian" was becoming "a conundrum which is no joke," one agitated reporter wrote. Failure to enforce "the color line," Americans were warned, would lead to social chaos and worse: unknown relatives lynched, "pure white" wives revealed as "colored," white women birthing black babies. Editorials suggested how to stop passers. Various tricks were offered to tell "authentic" whites from fake whites and rout out passers. The so-called "telltales"—"fingernails, palms of hands, shapes of ears, teeth, and other equally silly rot"—are hard to take seriously now. But they were deadly serious then, as Alice Jones found out.

The novel of passing—which traces a character's journey across the color line—became especially important in the years leading up to the Harlem Renaissance, partly as a way to respond to those strict ideas of absolute racial identity. It was a not a new form. In the hands of white writers, such as Mark Twain, the genre had provided decades of dire warnings about the catastrophic social consequences attendant on the unethical behavior of racial passers, characters who selfishly pretended to be what they were not. But in the hands of black writers, beginning with Charles Chesnutt in 1900, the story of passing took a very different direction, indicting a society that denies privileges to blacks by celebrating the successful black passer as a folk hero and at the same time depicting the white world as one not worth the trouble of trying to get into. In black novels of passing, racial detection proves nearly impossible because race is merely a set of social behaviors and ideas, not a fixed essence to be ferreted out by telltales. Hence, the black novel of passing battled both racial hierarchies and the pseudoscience of "hypodescent," the "one-drop rule," which held that any amount of so-called black blood, "any known African ancestry," made a person black.

The "one-drop rule" treated blackness as "a contaminant that overwhelms white ancestry" if not contained, a contagion that could threaten, even darken, whites who came too close. It created a profound asymmetry in understandings of whiteness and blackness. Blacks could no longer whiten over time. But the merest proximity to blackness threatened to "blacken" whites, white women especially. The 1930 U.S. census reinforced the "one-drop rule" by dropping the category "mulatto." That forced every American to choose either black or white but not both. Since greater numbers of people without so-called black visual markers were now classified as black, the increasingly stringent classification schemes actually increased the ease of passing as white, an irony that black novels of passing were quick to parody.

Ideas of absolute racial identity were especially challenging to Harlem's leaders, who, understandably, advocated racial loyalty. Harlem's leaders wanted to debunk the various "blood" myths upon which racial taxonomies were based, but they also wanted to celebrate the unique aspects of black culture that were most worth preserving and encourage racial allegiance.

Harlem's dynamic "race pride"—so central to its art and its politics— was built on revaluing, not repudiating, race differences. Alain Locke, the editor of the most important anthology of the period and an influential force throughout the Harlem Renaissance, maintained that "race pride" and "racial solidarity" were prerequisite to any improvement in national race relations. So did W. E. B. Du Bois, Langston Hughes, Claude McKay, and many others. But it was not always clear what constituted loyalty. Some Harlem leaders believed strongly in essential, immutable differences between black and white. Marcus Garvey, the charismatic, bombastic, self-educated Jamaican leader of the Black Nationalist "back-to-Africa" Universal Negro Improvement Association (UNIA), even made common cause with white segregationist organizations such as the Ku Klux Klan, based on their shared "opposition to race mixture" and commitment to the idea of distinct, "pure" races. Garvey's insistence on "the racial purity of both the Negro and white races" led him to label the NAACP a "miscegenation organization" and

put him sharply at odds with Du Bois, who discouraged interracial marriages but also considered Garvey a "traitor" for allying with groups such as the Klan. Even those who considered ideas of pure race to be mere "superstitions" also acknowledged that for "men and women who lived race as a daily identity, the notion that race was nothing more than an illusion was personally disconcerting; it was also politically perilous because . . . 'it called into question the very basis of black unity.' "

It was not uncommon, therefore, to both argue against fundamental differences between races and, at the same time, advocate for tolerance of the profound, innate differences between them. Many in Harlem found both views equally appealing. Yet racial "loyalty" remained as prized as its meaning proved elusive. Even those who most vociferously opposed notions of blood-based or biological racial essence also accepted the proposition that race was an ethics, that they owed something to other blacks. Those who refused to be classed with "their" people—such as the biracial writer Jean Toomer, who asked not to be included in any anthologies of "Negro" literature—were sharply denounced. On the other hand, anyone who might have passed but did not—such as the blue-eyed, blond NAACP leader Walter White—was lionized as an example of admirable racial behavior. "*Voluntary* Negroes," they were called. Only the most radical race thinkers eschewed racial loyalty altogether. Zora Neale Hurston and George Schuyler built their reputations on provoking the line between racial loyalty and "treason," sometimes suggesting that the best—even the only—way to be loyal to "the race" was to blast its pretensions and make it self-critical. But among Harlem's intellectuals, few were as effusive about their love of blackness—and black people—as Hurston and Schuyler. Straddling this tension between Harlem's official identity politics and personal feelings of racial belonging was the norm throughout the twenties.

This was not, then, an altogether auspicious time or an opportune set of circumstances for white women to cross race lines. Whether they wanted to socialize interracially, support or organize black communities, represent blacks in literature and the arts, be intimate with black men or raise black children, or pass as black, there was little social sup-

port for their straying. Their behavior cut to the heart of what Walter White called the "great peal of implacable Negrophobia" by challenging the categorizations on which it was based. But it also threatened to expose cultural contradictions in Harlem. For many, what I call Harlem's erotics of race—feelings of identity and belonging at odds with the critique of essential identity—was a guilty pleasure, a retreat into feelings that there were good reasons not to broadcast or admit too freely. When white women expressed their own longings for color and an escape from whiteness—"make me yellow . . . bronze . . . or black," as Edna Margaret Johnson prayed in her "White Girl's Prayer"— they deepened what was already a troubling set of contradictions. By the antiessentialist logic favored in Harlem's intellectual circles, there was no logical reason to deny such whites entry. Indeed, their affiliation would have to be seen positively, as an act of solidarity. But by all the cultural and emotional values that most blacks held dear, white women's "crossover" claims to blackness were awkward and largely unwelcome. The status of "*voluntary* Negro" had never been meant for them. And the powerful desire for blackness that so many of them felt—Miss Anne's own particular erotics of race—always threatened to expose a contradiction in racial thinking that very few Harlemites wanted to see aired.

On both sides of the color line, then, Miss Anne was a nuisance. Whenever possible, the white press tried to ignore the white women of Harlem. When it could not do so, it sexualized and sensationalized them. If that did not work, they were characterized as monstrous or insane, socially and culturally unintelligible. Because their mere presence in Harlem put pressure on some of Harlem's most vexed contradictions, Harlem's response to these women was not always that different from mainstream white America's.

"What Is Africa to Me?":
The Question of Ancestral Heritage

I was only an American Negro—who had loved the surface of Africa and the rhythms of Africa—but I was not Africa.

—Langston Hughes

I Was African.

—Nancy Cunard

As Harlem's leaders looked for a reasonable foundation for shared identity, the question of whether or not Africa was a "usable past" for contemporary African Americans loomed especially large. It was also a vexed question. On the one hand, Africa represented cultural wealth from which blacks had been violently estranged and that they then decided to reclaim. But many found the idea that Africa was a heritage for American blacks questionable at best. Hughes criticized the notion, but he also traveled to Africa to explore it, and he expressed it in poems that bathed their speakers in the Congo and Mississippi rivers, poems where the low beating of African "tom-toms / stirs" the blood of modern black cosmopolitans and poems that might posit that "So far away / Is Africa / Not even memories alive," even as they insist that crucial vestiges persist—"yet / Through some vast mist of race / There comes this song." Alain Locke also tried to have it both ways, releasing American blacks from any obligatory ties to Africa while preserving a claim to its rich cultural legacy. "There is little evidence of any direct connection of the American Negro with his ancestral arts," he admitted, even as he insisted that they *were* "his" ancestral arts, part of *his* "emotional inheritance." George Schuyler, less ambivalent, declared the notion "hokum" and maintained that "your American Negro is just plain American."

In 1923, Gwendolyn Bennett's poem "Heritage," published in *Opportunity*, made clear how emotional this "emotional inheritance" could be.

Every stanza of her poem, which imagines African palm trees, roads, ruins, flowers, rivers, and villages, begins with the refrain "I want." "I want to see," "I want to hear," the speaker laments. She wants to feel that under "a minstrel smile" is an authentic blackness to which she can lay claim with an authority grounded in ancestral legacy. All the repeated "wanting," however, makes clear how unsure she is.

Countée Cullen's "Heritage" probably expressed those mixed sentiments best. It spoke to the central problem: did "race" exist, and, if so, what grounded it? If not blood or biological essence, might race inhere in a shared, even if also distant, history? In Cullen's poem, a modern urban speaker returns almost obsessively to an imaginary Africa in the hope that it might contain a meaningful link to his present. He feels skeptical. "What is last year's snow to me / Last year's anything?" he asks.

> *What is Africa to me:*
> *Copper sun or scarlet sea,*
> *Jungle star or jungle track,*
> *Strong bronzed men, or regal black*
> *Women from whose loins I sprang*
> *When the birds of Eden sang?*
> One three centuries removed
> From the scenes his fathers loved
> Spicy grove, cinnamon tree,
> What is Africa to me?

The speaker feels a strong connection to Africa but criticizes himself for what he also sees as a flight of imagination. Again and again, the poem repeats the word "lie" to suggest both passivity and falsehood.

> *. . . So I lie, who always hear,*
> *Though I cram against my ear*
> *Both my thumbs and keep them there,*
> *Great drums throbbing through the air.*

Africa seems like a story.

> *Africa? A book one thumbs*
> *Listlessly till slumber comes . . .*

But it is a story, or fiction, that haunts and disturbs him, one he cannot set aside by a simple act of will.

> *So I lie, who find no peace*
> *Night or day, no slight release*
> *From the unremittant beat*
> *Made by cruel padded feet*
> *Walking through my body's street.*
> *Up and down they go, and back,*
> *Treading out a jungle track.*

So Africa was a problematic resource, at best. The Great Migration from the southern states to the northern had, over two decades, brought a population to Harlem that, as Alain Locke described it in *The New Negro*, was not "merely the largest Negro community in the world" but also the most diverse. "It has attracted the African, the West Indian, the Negro American . . . the Negro of the North and the Negro of the South; the man from the city and the man from the town and village; the peasant, the student, the business man, the professional man, artist, poet, musician, adventurer and worker, preacher and criminal, exploiter and social outcast. Each group has come with its own separate motives." Did such a diverse people really share a "heritage"?

And how to avoid sounding like the primitivists? Wouldn't they just thrill to "wild barbaric birds . . . massive jungle herds . . . jungle boys and girls in love"? What Harlemite could afford to be so dreamy and reductionist? Cullen's speaker is unsure if Africa is a resource. Indeed, the poem stresses the repeated word "lie" to suggest how delusional such fantasies might be. Modern primitivists were all *too* sure of Africa. In the minds of primitivists such as Charlotte Osgood Mason, modern Har-

lemites unquestionably were vessels for a jungle sensibility that might—that she hoped *would*—erupt at any moment into America's "flaming pathway" out of modernity's failures.

At the same time, with such a potentially rich resource to draw on and such a paucity of other American resources, what Harlemite could afford *not* to look to Africa? Doing so was crucial to the work of "revaluation by white and black alike of the Negro in terms of his artistic endowments." The nation's folklore craze—anthropologist Margaret Mead later called it a "search-and-rescue" mission to preserve the roots of American culture—made the advantage of a reclaimed African "heritage" too rich to ignore. If African Americans could successfully seize that terrain, they would have an ironclad claim for recognition of their cultural patrimony at a time when cultural achievements were especially highly valued.

One of the problems of turning to Africa, however, was how many whites had fallen in love with an African ideal. Primitivism, a mostly white and highly idealized view of blacks, was an especially knotty collection of ideas in this context. Primitivists often carried on a tradition of romantic racialism that saw blackness as an antidote to atomistic, joyless modern life, based on ideas of blacks as a more childlike and natural people. Their influence could be felt throughout American culture from advertising to high art, making the primitivist welter of celebration and condescension unavoidable for blacks forced to contend with it. Some black leaders found it useful to be celebrated by Pablo Picasso or Gertrude Stein, who at least reversed the negative values usually assigned to blackness. Black-loving whites, such as Edna Margaret Johnson, on "bended knee" to a black "God of Life," often bought into the idea that "Nordic" culture was "pallid" but black culture was vibrant, exciting, even healing for whites. But primitivists generally did not challenge the idea that such racial characterizations could be made in the first place. Hence, many white "friends of the Negro" who promoted such ideas were unpredictable political allies, at best.

Cullen's speaker keeps asking whether a Negro identity can be grounded in African origins, deeply aware of the emotional charge that

possibility carries for an alienated modern urbanite. Rather than take for granted that Africa will help fix his woes, he repeats the refrain "What is Africa to me?" again and again. The poem refuses to resolve Harlem's debate over whether race is an essence, a social construction, or, alternatively, an ethics—a moral and ethical obligation to one's "own" people. Unable to decide, he struggles for personal "peace" and wonders if playing a "double part" might serve just as well as anything else. In doing so, he winks at his own project. Grounding his identity, apparently, means inventing it.

That was Harlem's Pandora's box in the 1920s and 1930s. If origins were invented, then what did "authenticity" mean? Why couldn't a white writer create as authentic a portrait of black life as a black writer? What separated Fannie Hurst's view of passing from Walter White's or Nella Larsen's? What distinguished the ideas of blackness of white southern writers such as Julia Peterkin and Marjorie Kinnan Rawlings from those of writers such as Langston Hughes? Like so much of Harlem at this time, Cullen's speaker alternates between being tortured by those questions and being tired of them.

"Grabbing Our Stuff and Ruining It": Whites Writing Black

The white people are pushing themselves among the colored.
—Chandler Owen, "The Black and Tan Cabaret"

At a time when literature was *the* social currency of public debate, playing a role now shared by radio, television, cinema, and the Internet, literature and the arts were at the heart of the Harlem Renaissance. Believing that accurate representations of blacks would turn the tide of American racism, black artists and intellectuals of the Harlem Renaissance "promoted poetry, prose, painting and music as if their lives depended on it." In the words of diplomat, writer, editor, and activist James Weldon Johnson, "the final measure of the greatness of all

peoples is the amount and standard of the literature and art they have produced. . . . 'Through his artistic efforts the Negro is smashing the race barriers faster than he has ever done through any other method.'" Given those stakes, it should not be surprising that Harlem's black writers watched with dismay as white writers including Gertrude Stein, Sherwood Anderson, Waldo Frank, Carl Van Vechten, Paul Green, Eugene O'Neill, DuBose and Dorothy Heyward, and Fannie Hurst became more successful for depicting black life than they were.

No book ignited as much of a firestorm in Harlem as Van Vechten's 1926 novel, *Nigger Heaven*. Having lauded the "wealth of novel, erotic, picturesque material" available to the artist who tackles "the squalor of Negro life, the vice of Negro life," Van Vechten evidently decided to exploit the material himself. *Nigger Heaven* is a fairly predictable story of a troubled romance between a black Harlem librarian and her would-be writer lover as they battle racism in New York against a violent and sometimes sensationalized backdrop of Harlem's nightlife. Most of the novel is sympathetic to middle-class blacks and a serious treatment of such important Harlem Renaissance themes as interracial marriage, passing, racial solidarity, patronage, the idea of Harlem as "a sort of Mecca," the "one-drop rule," race discrimination, primitivism, and black arts. But the opening pages in particular are peopled with enough sensational Harlem figures—"jigchasers," "high yellows," "Bolito" players, "ofays," "dicties," "pink-chasers," "bulldikers," "arnchies," "creepers," and "Miss Annies"—to necessitate a "Glossary of Negro Words and Phrases" for white readers. Van Vechten's black people have "a primitive birthright . . . that all civilized races were struggling to get back to . . . this love of drums, of exciting rhythms, this naïve delight in glowing colour . . . this warm sexual emotion."

Some black friends supported the book—Nella Larsen, George Schuyler, and James Weldon Johnson among them. "To say that Carl Van Vechten has harmed Negro creative activities is sheer poppycock," Hughes insisted. But some were outraged at Van Vechten's assumption of black racial privileges. The novel's title, meant as an ironic metaphor for social segregation (a "nigger heaven" being a segregated balcony in

a theater or orchestra hall), occasioned such outrage that many of Van Vechten's harshest critics never, in fact, read the book. Du Bois spoke for many of Van Vechten's detractors (and not a few of his black friends as well) when he complained that Van Vechten had displayed "exceptionally bad manners" in using "cheap melodrama" to portray Harlem as just the "wildly, barbaric drunken orgy" white revelers imagined. For Du Bois, the title was not an act of solidarity or irony but an "affront" and a "blow in the face." To Van Vechten's delight (he loved being scandalous), the novel was banned in Boston. He was also banned from the Harlem nightclub Small's Paradise, about which he was not delighted at all. And *The Pittsburgh Courier*, the most important black newspaper in the country, pulled its advertisements for the book.

Even before controversy erupted over *Nigger Heaven*, writers such as Eugene O'Neill and Julia Peterkin were staking their fortunes on representing blacks. Peterkin, for example, whose "rich" life on a former slave plantation had given her "plenty of material," spoke for numerous white writers when she declared that "Negro" culture just made for better literature than white society:

> I have lived among the Negroes. I like them. They are my friends. . . . These black friends of mine live more in one Saturday night than I do in five years. I envy them, and I guess as I cannot be them, I seek satisfaction in trying to record them. . . . I shall never write of white people. Their lives are not so colorful.

Peterkin's depictions of Gullah blacks, rather than resulting in her being banned from Harlem nightclubs, actually earned her a special status in Harlem, where she was invited to review work by black writers such as Langston Hughes, feted by NAACP officials Amy and Joel Spingarn, and praised by black critic and folklorist Sterling Brown, who applauded her "uncanny insight into the ways of our folks" and declared that there could be "few better mentors" for black writers. When Peterkin's *Scarlet Sister Mary*, a romantic postslavery vision of black cotton pickers—"the

long rows, laughing, talking . . . musical voices . . . the picking is easy. . . . Every work-day is a holiday"—won the Pulitzer Prize in 1929, many in Harlem felt compelled to read the book, and it became one of the two most popular books at Ernestine Rose's Harlem branch library. New Negro stalwart Alain Locke ranked it as every bit as successful in getting to the "bone and marrow of [black] life" as works by black writers.

To many, nevertheless, the overwhelming success of white writers felt like a return to the days of minstrelsy, when, to represent themselves, they had had to "black up" into an exaggerated, white-defined version of themselves. In a letter to Jamaican writer Claude McKay, Harold Jackman, a young black Harlemite and Countée Cullen's intimate, wrote, "Tell me, frankly, do you think colored people feel as primitive as many writers describe them as feeling when they hear jazz? . . . There is so much hokum and myth about the Negro these days (since the Negro Renaissance, as it is called) that if a thinking person doesn't watch himself, he is liable to believe it." For white writers, though, it was a great opportunity. "Damn it, man," Sherwood Anderson wrote to H. L. Mencken, "if I could really get inside the niggers and write about them with some intelligence, I'd be willing to be hanged later and perhaps would be." White editors and publishers were offering enormous advances for "authentic" depictions of black Harlem. And they determined what qualified as black.

Theater seemed to be one of the first arts in which blacks could break significant ground. Many felt that the black composers Noble Sissle and Eubie Blake's successful 1921 musical *Shuffle Along*, which featured an all-black cast, was especially important in expanding the cultural space available to black people. Black performers such as Charles Gilpin, Rose McClendon (who would later star in Annie Nathan Meyer's play *Black Souls*), Paul Robeson, Florence Mills, Bill "Bojangles" Robinson, Frank Wilson, Ethel Waters, and Eubie Blake starred in a range of successful plays about black life: Eugene O'Neill's *The Emperor Jones* in 1920 and *All God's Chillun Got Wings* in 1924, Paul Green's *In Abraham's Bosom* in 1926, DuBose and Dorothy Heyward's *Porgy* in 1927, Lew Leslie's *Blackbirds* in 1928, and Annie Nathan Meyer's *Black Souls* in 1932. The

problem was that all these playwrights were white. Black dramatist Montgomery Gregory, a foundational figure in the development of a national black theater, argued that "Negro theater . . . must come from the Negro himself, as he alone can truly express the soul of his people." But for some black critics and theater people, the "Negro plays" by white authors offered advantages. For them, any drama that stepped away from what Du Bois called the "silly songs and leg shows" of min-strelsy had value as an authentic "Negro drama," regardless of its au-thor's race. Often "held out as inspiration and challenge," such white plays were frequently "acclaimed by critics as 'Negro drama.' " Black critic Esther Fulks Scott called the plays "an ideal means of foster-ing racial co-operation." And black actress Eulalie Spence wrote that "these writers have been a great inspiration. . . . They have pointed the way and heralded a new dawn." Even those who were most skeptical usually found something to praise. Du Bois maintained that a "Negro theatre" should be "About us . . . By us . . . For us" and called O'Neill's black characters "white theatrical, psychological, and commercial stereotypes." But he also called O'Neill a "genius" who "dignified" Negro drama. Alain Locke agreed. This is not to say that everyone in Harlem accepted the category of the white-authored "Negro play." Theophilus Lewis, one of the most important black drama critics of his day, was insistent that "Negro drama" mean "plays written by Negro authors."

The question of black representation in the arts was the basis of a symposium entitled "The Negro in Art: How Shall He Be Portrayed?" which ran monthly in *The Crisis* for most of 1926. It not only invited whites to weigh in on how blacks should be portrayed; it also invited Van Vechten—easily the most controversial white man in Harlem—to pen most of the questions. (For example, "Are artists or publishers un-der any obligations to depict people at their best?" "What is the best response to negative stereotypes?" "Is there a danger in the fascination with lower-class Negro life?") Dominating the symposium were whites such as H. L. Mencken, DuBose Heyward, Joel Spingarn, Mary White Ovington, publisher Alfred A. Knopf, poet Vachel Lindsay, John Farrar

(founder of Farrar, Straus and Giroux), Sinclair Lewis, Sherwood Anderson, Julia Peterkin, and others.

In her response, Julia Peterkin maintained that "the crying need among Negroes is a development in them of racial pride." "The Negro is racially different in many essential particulars from his fellow mortals of another color," she went on, and his art needed to reflect that difference. She then detailed the black "type" most "worthy of admiration and honor," the type on which she felt black writers should focus. The "Mammy," she maintained, is a "credit" to the race and "a man who is not proud that he belongs to a race that has produced the Negro Mammy of the South is not and can never be either an educated man or a gentleman." At the end of her response, she offered to answer the question of why she wrote about black people and found them so fascinating: "I write about Negroes because they represent human nature obscured by so little veneer; human nature groping among its instinctive impulses and in an environment which is tragically primitive and often unutterably pathetic."

Resentment over the ubiquity of such attitudes was keen. But bad feeling also had to be handled with care. Hurston, for example, freely told her best friend, Langston Hughes, "It makes me sick to see how these cheap white folks are grabbing our stuff and ruining it. I am almost sick—my one consolation being that they never do it right and so there is still a chance for us." But when she repeated those sentiments to her benefactor Charlotte Osgood Mason, writing to Mason that white people "take all the life and soul out of everything," Mason took offense. Hurston had to backpedal or give up Mason's help. Indeed, Hurston's anger, though shared by almost every other black Harlemite, was usually not made public. Most black artists in Harlem were surrounded by influential or moneyed whites whose feelings needed to be taken into account.

For white women the enticements of black literary impersonation were particularly strong and the rewards especially rich. White women writers in the 1920s were still fighting Nathaniel Hawthorne's description of them as "scribblers" and gossipers. So the vogue for novels about

black life opened an important literary door for them. In addition to those already mentioned, Dorothy Fields, Dorothy Parker, Rebecca West, Pearl Buck, Helen Worden Erskine, Marjorie Kinnan Rawlings, Florine Stettheimer, Anne Pennington, Muriel Draper, Mabel Dodge Luhan, Hallie Flanagan, Edna St. Vincent Millay, Ethel Barrymore, and Libby Holman all took advantage of "the vogue."

Miss Anne's view of blacks was not always appreciated by those she wrote about. But because "Negroes are practically never rude to white people," as Langston Hughes noted, the record of such responses is scant. Many black women, especially, chose to respond to Miss Anne's portrayals of them with either silence or exaggerated, ironic flattery in place of a more direct critique. There were occasional political cartoons of white women, but not as many as one might expect, and most of them, such as those included here, were both relatively benign and printed anonymously.

One way to deal with Miss Anne and her portrayals of blacks was to respond to her in kind, embedding depictions of white women into black literature. In contrast to the histories of the period, in which Miss Anne hardly appears, and black writings, including correspondence, in which she's hardly mentioned, the fiction of the Harlem Renaissance is riddled with depictions of Miss Anne. Almost always, she appears either as a fool or as a monster. Those depictions were a powerful part of the Harlem world that Miss Anne entered.

Rudolph Fisher's Agatha Cramp, for example, is based on Charlotte Osgood Mason, and as a caricature, it pulls no punches. Miss Cramp is "the homeliest woman in the world," with a "large store of wealth" and a "small store of imagination." Miss Cramp decides that there's "a great work" for her to do in Harlem, notwithstanding the fact that she knows nothing about black culture and has met no black people other than "porters, waiters, and house-servants of acquaintances." But enamored of her own "vision" of blacks, she sees an "alien, primitive people" who need her, she believes. Wallace Thurman also created a recognizable caricature in Barbara Nitsky, who appears in his 1932 novel *Infants of the Spring*. Nitsky seems an exotic and appealing woman, but as it turns

out, she is just another "Jewish girl who had been born in the Bronx, sophisticated in Greenwich Village . . . and then migrated to Harlem, broke and discouraged, to discover that among Negro men she could be enthroned and honored like a queen of the realm." Nitsky (or Countess Bedbug) is a very thinly disguised Fania Marinoff, Carl Van Vechten's wife, also a Jewish girl from the Bronx, originally named Fanny.

A certain amount of friendly ribbing was part of interracial life in Harlem. Making one's way in those circles as a white woman meant making allowances for such playfulness. Often, however, Miss Anne is depicted as an oblivious fool, ridiculously unself-conscious about how out of place she is. In *Infants of the Spring*, Thurman includes "the ex-wife of a noted American playwright . . . doing the Black Bottom with a famed Negro singer of spirituals. 'Ain't I good?' she demanded of her audience; . . . [and] she insinuated her scrawny white body." Such portrayals were not always playful.

Part of Miss Anne's pathos in those depictions is her earnestness and sincerity—she is almost always well-meaning. In Langston Hughes's

Miss Anne was often depicted as perplexed and out of place; here Fania Marinoff stands in for bewildered white women.

short story "Slave on the Block," Anne and Michael Carraway are very well-meaning whites. They are "people who went in for Negroes," even "raved" over them. Unhappily, however, "much as they loved Negroes, Negroes didn't seem to love Michael and Anne" (or "Miss Anne"). Being earnest is not such a virtue, it turns out. As a fool, Miss Anne's mere presence can lead to murder and tragedy. In James Weldon Johnson's *Autobiography of an Ex–Colored Man*, there is a white woman, known only as "the widow," to whom the black narrator is drawn against his better judgment. One night, when the "widow" is unaccompanied by her usual black boyfriend, a "surly, black despot," she beckons the black narrator with a come-hither look. "Knowing that I was committing worse than folly," the narrator, says, he goes to her. The widow's enraged black lover enters, pulls out a pistol, and shoots her dead.

Sometimes Miss Anne is tragic. In Jean Toomer's *Cane*, she appears as Becky, a "God-forsaken, insane white shameless wench" with sunken eyes, a stringy neck, and fallen breasts who has mothered two black sons and been abandoned to die, forsaken by both whites and blacks. Sometimes Miss Anne is simply a monster. In "Portrait in Georgia," Toomer forswears pity for women such as Becky to, instead, depict the seeming seduction of white women as death-dealing delusion. A white woman's beauty, he insists, is a grotesque mask of lyncher's tools, and she feeds not on honeysuckles and love songs but, ghoulishly, on the blood and bodies of black men:

> *Hair—braided chestnut,*
> * coiled like a lyncher's rope,*
> *Eyes—fagots,*
> *Lips—old scars, or the first red blisters,*
> *Breath—the last sweet scent of cane,*
> *And her slim body, white as the ash*
> * of black flesh after flame.*

For the most part, the more well-meaning or well-intentioned such women are, the more dangerous they become. Richard Wright's doomed

white girl in *Native Son*, the well-meaning liberal Mary Dalton, is nothing if not sincere: "We know so *little* about each other. I just want to *see*. I want to *know* these people. Never in my life have I been inside of a Negro home. . . . I want to work among Negroes. That's where people are needed. It seems as though they've been pushed out of everything." Such sincerity is hardly a saving grace when white women's mere presence, *as* white women, can endanger black men. Not realizing that is the most treacherous racial misunderstanding possible. Ovington's acceptance into the inner circles of black middle-class society may have come, in part, from her constant vigilance on these grounds. "That the sincerity of my [interracial] friendship has never been doubted has been my greatest joy," she wrote.

White women "oughta stay outa Harlem," one of Thurman's characters concluded. The harder they tried, the more damage, heartbreak, and destruction they were likely to leave in their wake. Given those depictions, it is surprising that so many white women did try to gain acceptance in Harlem. Clearly, whatever they were seeking was a stronger pull for them than the uncertain welcome they were likely to face.

An Erotics of Race

Harlem seemed a cultural enclave that had magically survived the psychic fetters of Puritanism. Negroes were that essential self one somehow lost on the way to civility, ghosts of one's primal nature. . . . The creation of Harlem as a place of exotic culture was as much a service to white need as it was to black.

—Nathan Huggins, *The Harlem Renaissance*

"A Little Paradise":
Harlem as "America's Racial Laboratory"

What a crowd! All classes and colors met face to face, ultra aristocrats, Bourgeois, Communists, Park Avenuers galore, bookers, publishers, Broadway celebs, and Harlemites, giving each other the once over. The social revolution was on.

—Geraldyn Dismond, *The Interstate Tattler*

There were always two Harlems in the 1920s—the one that whites flocked to for pleasure and the one that (mostly) blacks lived and worked in. Guidebooks written for white readers presented Harlem as a "real kick," "New York's Playground," a "place of exotic gaiety . . . the home-town of Jazz . . . a completely exotic world" where "Negroes . . . remind one of the great apes of Equatorial Africa." Primitivists of many different stripes, from antiracists to racists and everything in between, held that white culture was dull, depleted, restricted, cold, without vibrancy or creativity, and that all the passion, purity, and pleasure it lacked was hidden away in black communities. That conviction was the

Libby Holman with jazz guitarist Gerald Cook.

foundation of what Langston Hughes called the "Negro vogue," making Harlem, in James Weldon Johnson's words, "the great Mecca for the sight-seer, the pleasure-seeker, the curious, the adventurous" and drawing whites to shows at interracial cabarets or to clubs that catered to their patronage. Gay and straight, male and female, white would-be revelers descended on Harlem from taxis and subway stations, in spring weather and in snowstorms, individually and by guided tour, in hopes of an evening's dose of the life-giving force they believed in and that popular culture reinforced. Harlem, *Variety* promised, "surpasses Broadway. . . . From midnight until after dawn it is a seething cauldron of Nubian mirth and hilarity. . . . The dancing is plenty hot. . . . The [Negro] folks up there . . . live all for today and know no tomorrow. . . . Downtown *Likes* Harlem's Joints." One travel writer gushed, "Here is the Montmartre of Manhattan . . . a great place, a real place, an honest place, and a place that no visitor should even think of missing. But visit Harlem at night; it sleeps by day!"

Harlem did not, of course, sleep by day. White revelry was not its rai-

Harlem street scene.

son d'être. African Americans came to Harlem from all over the world, paying inflated rents and tolerating overcrowding, to experience a richly faceted black world. As Adam Clayton Powell, Sr., the pastor of the Abyssinian Baptist Church, put it, Harlem in the 1920s was "the symbol of liberty and the Promised Land to Negroes everywhere." There were magazines, newspapers, and literary journals, and cultural institutions rich with community programs, such as the 135th Street Library (now called the Schomburg Center for Research in Black Culture, after the collector Arthur A. Schomburg). There were patrons who wanted to support black artists. There were foundations such as the Guggenheim, Rosenwald, Garland, and Viking that were actively seeking African-American talent. The NAACP and the Urban League supported competitions, as did the *Opportunity* and *Crisis* awards, the Spingarn Medal, the Harmon Award, the Boni & Liveright award, and others. And there were literary salons and parties—writer Georgia Douglas Johnson's, Walter White's, the famous "Dark Tower" salon of hairdressing fortune heir A'Lelia Walker, and Carl Van Vechten and Fania Marinoff's apartment—all providing space for black and white artists, intellec-

tuals, musicians, and political leaders to mix and share ideas. It was a heady time, "a rare and intriguing moment," in the words of Nathan Irvin Huggins, "when a people decide that they are the instruments of history-making and race-building."

If there was anyplace in the nation where race lines could be undone, that place seemed to be Harlem. Its interracial nightlife was legendary. Society columnists in the same papers that warned against race mixing thrilled to stories of Harlem's "black-and-tan" parties and cabarets. Harlem was the country's symbol of interracial relations, "a large scale laboratory experiment in the race problem," as writer, NAACP leader, and professor James Weldon Johnson described it. The "Negro renaissance," wrote Wallace Thurman, was a place "to do openly what they [whites] only dared to do clandestinely before."

Goaded by that possibility, Langston Hughes wrote, "white people began to come to Harlem in droves." They felt entitled to Harlem's vaunted exotic sensuality and the escape it promised from urban capitalism's alienation. As British heiress, activist, and Harlem aficionado Nancy Cunard put it, "It is the zest that the Negroes put in, and the enjoyment they get out of, things that causes . . . envy in the ofay [white person]. Notice how many of the whites are unreal in America; they are *dim*. But the Negro is very real; he is *there*. And the ofays know it. That's why they come to Harlem." White visitors flooded nightclubs and elbowed their way into literary events. "White America has for a long time been annexing and appropriating Negro territory, and is prone to think of every part of the domain it now controls as originally—and aboriginally—its own," James Weldon Johnson commented. Those with money took up black writers and artists. Those with political aspirations threw themselves into Harlem politics. A visit to Harlem's fabled cabarets was de rigueur for out-of-town tourists, who all wanted to go back home to Cincinnati, Seattle, or Dallas and shock their friends with stories of interracial drinking and dancing in New York's celebrated black metropolis. The cabarets capitalized on white America's desire for black exoticism, and they presented themselves, as Huggins puts it, as a "cheap trip . . . a taxi ride . . . thrill without danger."

But there were upsides as well as downsides to being, as Langston Hughes put it, "in vogue":

At almost every Harlem upper-crust dance or party, one would be introduced to various distinguished white celebrities there as guests. It was a period when almost any Harlem Negro of any social importance at all would be likely to say casually: "As I was remarking the other day to Heywood___," meaning Heywood Broun. Or: "As I said to George___," referring to George Gershwin. It was a period when local and visiting royalty were not at all uncommon in Harlem. And when the parties of A'Lelia Walker, the Negro heiress, were filled with guests whose names would turn any Nordic social climber green with envy. It was a period when Harold Jackman, a handsome young Harlem school teacher of modest means, calmly announced one day that he was sailing for the Riviera for a fortnight, to attend Princess Murat's yachting party. It was a period when Charleston preachers opened up shouting churches as sideshows for white tourists. It was a period when at least one charming colored chorus girl, amber enough to pass for a Latin American, was living in a pent house, with all her bills paid by a gentleman whose name was banker's magic on Wall Street. It was a period when every season there was at least one hit play on Broadway acted by a Negro cast. And when books by Negro authors were being published with much greater frequency and much more publicity than ever before or since in history. It was a period when white writers wrote about Negroes more successfully (commercially speaking) than Negroes did about themselves. It was the period (God help us!) when Ethel Barrymore appeared in blackface in *Scarlet Sister Mary*! [by white writer Julia Peterkin]. It was the period when the Negro was in vogue.

White women could get their names in the paper simply for showing up. Joan Crawford, Gertrude Vanderbilt Whitney, Helena Rubenstein, Fannie Hurst, and Zelda Fitzgerald all found that useful. Torch singer Libby Holman made Connie's Inn, the Clam House, and Small's Paradise into second homes for herself and her bisexual posse of friends: Tallulah Bankhead, Jeanne Eagles, Beatrice Lillie, Louisa Jenney, and others, who liked to go to Harlem "dressed in identical men's dark suits with bowler hats." When Small's Paradise moved, it advertised its new location in *Variety* by describing itself as a place where the (white) "high hats" who mingled with the (black) "native stepper[s]" came to dance.

There is an often-repeated apocryphal anecdote that recounts a black porter conversing with Mrs. Astor. "Good morning, Mrs. Astor," the porter says, picking up her luggage. "Do we know one another, young man?" she asks, incredulously. "Why, ma'am," he replies, "we met last week at Carl Van Vechten's." It didn't matter that the story was not true. It nevertheless conveyed the idea that Harlem's social world, to a degree unprecedented elsewhere in the nation, leveled social distinctions. No Harlem Renaissance novel, black or white, was complete without its requisite party or cabaret scene. Wallace Thurman's *Infants of the Spring* vividly describes a rent party

> crowded with people. Black people, white people, and all the in-between shades. . . . Everyone drinking gin or punch. . . . The ex-wife of a noted American playwright . . . confused middle-westerners, A'Lelia Bundles, Alain Locke . . . four Negro actors from a current Broadway dramatic hit . . . [a] stalwart singer of Negro spirituals . . . a bootblack with a perfect body, a . . . drunken English actor . . . a group of Negro school teachers . . . Harlem intellectuals . . . college boys, the lawyers, the dentists, the social service workers . . . [all] unable to recover from being so intimately surrounded by whites.

Real parties were even more extravagant. A'Lelia Walker Bundles, the daughter of Harlem's first millionaire, hairdressing entrepreneur Madam C. J. Walker, was Harlem's "great party giver," and her elegant limestone town house at 108–110 West 136th Street was something to see. It had French doors, English tapestries, Louis XVI furniture, Persian rugs, a grand piano, and crystal chandeliers. "Negro poets and Negro number bankers mingled with downtown poets and seat-on-the-stock exchange racketeers. Countee Cullen would be there and Witter Bynner, Muriel Draper and Nora Holt, Andy Razaf and Taylor Gordon. And a good time was had by all. . . . Unless you went there early there was no possible way of getting in. Her parties were as crowded as the New York subway at the rush hour—entrance, lobby, steps, hallway, and apartment a milling crush of guests, with everybody seeming to enjoy the crowding."

Harlem Renaissance physician and writer Rudolph Fisher captured the interracial excitement of these gatherings in his essay "The Caucasian Storms Harlem":

> It may be a season's whim, then, this sudden, contagious interest in everything Negro. . . . But suppose it is a fad—to say that explains nothing. How came the fad? What occasions the focusing of attention on this particular thing. . . . Is this interest akin to that of the Virginians on the veranda of a plantation's big-house—sitting genuinely spellbound as they hear the lugubrious strains floating up from the Negro quarters? Is it akin to that of the African explorer, Stanley, leaving a village far behind, but halting in spite of himself to catch the boom of its distant drum? Is it significant of basic human responses, the effect of which, once admitted, will extend far beyond cabarets? . . . Time was when white people went to Negro cabarets to see how Negroes acted; now Negroes go to these same cabarets to see how white people act.

All the sudden popularity could be offensive. The idea that blacks should provide a social safety valve for stifled white passions was especially insulting, as was the pressure to perform a version of blackness that satisfied whites' expectations. "Ordinary Negroes," Langston Hughes maintained, did not "like the growing influx of whites toward Harlem after sundown, flooding the little cabarets and bars where formerly only colored people laughed and sang, and where now the strangers were given the best ringside tables to sit and stare at the Negro customers— like amusing animals in a zoo." One black newspaper called the influx of whites into Harlem "a most disgusting thing to see." A 1926 article in the *New York Age* noted that "the majority of Harlem Negroes take exception to the emphasis laid upon the cabarets and night clubs as being representative of the real everyday life of that section. . . . All this has but little to do with the progress of the new Negro." Wallace Thurman, usually known for irreverence, was uncharacteristically sober in objecting to the fact that "few white people ever see the whole of Harlem. . . . White people will assure you that they have seen and are authorities on Harlem and things Harlemese. When pressed for amplification they go into ecstasies over the husky-voiced blues singers, the dancing waiters, and Negro frequenters of cabarets who might well have stepped out of a caricature by Covarrubias."

Others, however, while agreeing that the "vogue" was suspect and sure to be short-lived, advocated taking advantage of the sudden surge of interest as long as it lasted. Black novelist Nella Larsen urged her friends to "write some poetry, or something" quickly, before the fad ended. Zora Neale Hurston took white friends to hear jazz and see black church services. It never occurred to her to charge for doing this. Enterprising black tour guides, on the other hand, charged $5 a person for "slumming" parties of the Harlem cabarets. One "slumming hostess" mailed prospective white clients an invitation that read:

> Here in the world's greatest city it would both amuse and also interest you to see the real inside of the New Negro Race of Harlem. You have heard it discussed, but there are

very few who really know. Because the new Negro will be looked upon as a novelty, I am in a position to carry you through Harlem as you would go slumming through Chinatown. My guides are honest and have been instructed to give the best of service, and I can give the best of references of being both capable and honest so as to give you a night or day of pleasure. Your season is not completed with thrills until you have visited Harlem through Miss _____'s representatives.

Yet there were those who agreed with the black gossip columnist Geraldyn Dismond that the Harlem "vogue" represented an important cultural moment and was a form of "social revolution," in spite of its limitations. For example, Chandler Owen, one of the editors and founders of the black radical journal *The Messenger*, believed that the racially integrated Harlem cabaret was "America's most democratic institution . . . a little paradise *within*." He argued that Harlem's nightlife provided an education in interracial understanding unavailable elsewhere in the nation and was, hence, invaluable:

Here white and colored men and women still drank, ate, sang and danced together. Smiling faces, light hearts, undulating couples in poetry of motion conspired with syncopated music to convert the hell and death from *without* to a little paradise *within*. . . . These black and tan cabarets establish the desire of the races to mix and to mingle. They show that there is lurking ever a prurient longing for the prohibited association between the races which should be a matter of personal choice. . . . They prove that the white race is taking the initiative in seeking out the Negro; that in the social equality equation the Negro is the sought, rather than the seeking factor. . . . Fundamentally the cabaret is a place where people abandon their cant and hypocrisy just as they do in going on a hike, a picnic, or a hunting trip.

Harlem's parties could be seen in a similar light. Carl Van Vechten and his wife, Fania Marinoff, threw spectacular parties in their apartment on West 55th Street (sometimes referred to as the "Midtown office of the N.A.A.C.P."). According to Langston Hughes, they were parties "*so* Negro that they were reported as a matter of course in the colored society columns, just as though they occurred in Harlem." Careers could be created from the networking opportunities such parties provided. Van Vechten's daily notebooks detail that. Nella Larsen, who was trained as a nurse, married to a chemist, and working as a librarian—partly as an assistant to white librarian Ernestine Rose of the Harlem branch library—wanted to write her way into the "vogue" in 1927 but had no background as a writer. She wrote a short, intense novella about the myriad obstacles to a young black woman's fulfillment. Without Harlem's social whirl, it would have stalled.

Parties were her opportunity. On March 16, 1927, she went to a party at the Van Vechten–Marinoffs' at which she mingled with Nickolas Muray, the era's most important photographer; Louise Bryant, a New Woman activist and the wife of John Reed; Harlem celebrity James Weldon Johnson; William Rose Benét, the publisher of *The Saturday Review of Literature*; his wife, writer Elinor Wylie; and editor and publisher Blanche Knopf. Four nights later, she joined Van Vechten and Marinoff for another party, that time at the home of actress Rita Romilly, where she spent the evening with Harry Block, a senior editor at Knopf; T. R. Smith, the senior editor at Boni & Liveright (then the second most important publisher of black literature); and Blanche Knopf again. Nine days later, she joined some of the same group at a party that also included Zelda and F. Scott Fitzgerald, Walter White, Rebecca West, French writer Paul Morand, and others.

White editors such as Blanche Knopf were anxious for black manuscripts but also insecure about their ability to judge black literature. They leaned heavily on the advice of a few white advisers and favored black writers recommended by them, especially those they had come to know socially.

That month, Knopf accepted Larsen's first novel, *Quicksand*. While

it was being edited at Knopf, Larsen attended another party, on April 6, that included A'Lelia Walker; Paul Robeson; Walter White; Geraldyn Dismond; and the editor of the *Chicago Defender*, one of the most important black newspapers in the country. A few nights after that, she attended another small party with Van Vechten and Marinoff, Langston Hughes, and Dorothy Peterson, a poet and writer. Over the next few nights she attended parties given by Dorothy Peterson and by Eddie Wasserman, the heir to the Seligman banking fortune; these parties included such guests as Harlem Renaissance writer and gadfly Richard Bruce Nugent, poet Georgia Douglas Johnson, writer Alice Dunbar-Nelson, writer and editor Arna Bontemps, salonista and writer Muriel Draper, and, again, editor Blanche Knopf. In March 1928, Larsen won second place in the coveted Harmon Award for literature. In the fall of 1929, her second novel, *Passing*, was accepted by Knopf. She received a

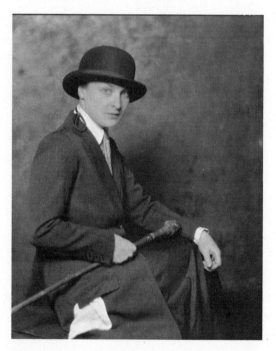

There were many forms of modern rebellion; Blanche Knopf in drag.

Guggenheim Fellowship. *Passing* was feted with a "tea" (cocktail party) at Blanche Knopf's on the day of its publication, ensuring that it received widespread critical attention and good initial sales.

In spite of her extraordinary talent, without the social opportunities Van Vechten and Marinoff's parties provided, such success might not have occurred. Those parties were Harlem's Rotary Club or Chamber of Commerce. Once Larsen dropped out of that social world in the early 1930s, she never published again.

Most of the parties were hosted by women, principally the white women of Harlem. Indeed, Carl Van Vechten's parties, as they are always known, were mostly the work of his wife, Fania Marinoff. She ordered the food, checked on invitations, and kept conversations from getting out of hand. Though often dismissed as inconsequential, hostessing was a way for white women to turn the roles available to them toward more professional goals. Dismissing these events as merely frivolous—in comparison with the serious work of culture building through journalism and organizing—has buried some of white women's most earnest, if also sometimes awkward, attempts to take part in the "New Negro" movement. But given the world that Miss Anne entered and the unique place she occupied within it, sometimes awkward gestures were also deemed effective.

"An Interracial Extravaganza": Libby Holman and the NAACP

On December 8, 1929, black and white New York came together to raise money for the NAACP on the occasion of its twentieth anniversary. In spite of the stock market crash, the benefit, sponsored by the Women's Auxiliary of the NAACP and produced by Walter White (in his new role as acting secretary) was completely sold out. White rented the four-year-old Forrest Theatre on West 49th Street (now known as the Eugene O'Neill Theatre) for the princely sum of $500 (just under $10,000 in today's currency). The NAACP had already sponsored

a midnight showing of the wildly successful all-black musical *Shuffle Along*, which White now intended to top with his own "extravaganza," the "biggest benefit that Broadway has ever known," he promised. He engaged more than two dozen of the most popular black and white performers of the day. Thanks to his aggressive lobbying, the lineup ranged from Duke Ellington with his Cotton Club Orchestra to blues singer Clara Smith to Jimmy Durante (already a jazz and vaudeville star). There were performers from the London production of *Show Boat*, the Jubilee Singers, and even a female impersonator. The entertainer White wanted most is unknown now, but she was one of the most sought-after performers of the 1920s, and White faced stiff competition to secure her for the benefit. She was a white actress and torch singer named Libby Holman. Holman performed in a wildly popular sultry blackface number called "Moanin' Low" as a Harlem prostitute.

Hollywood head shot of Libby Holman.

Today it is hard to imagine blackface and the NAACP together. The "crippling" black image that blackface presented to whites— "childlike . . . comic . . . pathetic . . . foolish . . . vulgar . . . lazy . . . unrestrained . . . and insatiable"—reinforced "deep emotional needs" at the core of white racism. But blackface did not die with the Civil War or even with Reconstruction. Nor was it merely a southern form. Although black newspapers urged its demise, the form was still popular throughout the nation in the 1920s, "standard material for stage comedy." The Harlem nightclubs that catered to whites regularly featured blackface comedians as well as mulatto chorines. The man or woman in blackface was a "surrogate" for the guilty pleasures of his white creators, licensing a range of behaviors that the "Protestant ethic" prohibited. Blackface could still be found from vaudeville stages to the Metropolitan Opera House, and it was performed for black audiences as well as white. There were renowned blackface performers of both races. In a nightclub description in James Weldon Johnson's *Autobiography of an Ex–Colored Man*, black blackface minstrel performers, great black prizefighters, and Frederick Douglass are all accorded equal status as emblems of black achievement.

Libby Holman's blackface "Moanin' Low" had been the runaway hit of New York City's 1929 season, and White had been especially determined to secure it for his benefit. "We would want by all means to have you sing 'Moanin' Low,' " he wrote to her.

New York's literati turned out in force. Harlem novelist Nella Larsen rhapsodized about the "fantastic motley of ugliness and beauty" that made up the audience's "moving mosaic" that night: "sooty black, shiny black, taupe, mahogany, bronze, copper, gold, orange, yellow, peach, ivory, white." Carl Van Vechten, one of White's advisers, was there with Fania Marinoff. Amy and Arthur Spingarn, benefactors and NAACP officials, had one of the six boxes available that night. So did Mary White Ovington, who was honored with a quarter-page photograph as the "mother" of the NAACP and whose family paid for a full-page ad for their department store. Alfred and Blanche Knopf also had a box, as did A'Lelia Walker. James Weldon Johnson and his wife, activist Grace

Nail, attended. Artist Miguel Covarrubias, Harold Jackman, performer Taylor Gordon, and Geraldyn Dismond were all present. Most of the white women in this book were there. Nancy Cunard was in Europe in 1929, and Lillian Wood rarely left Tennessee. But Annie Nathan Meyer, Josephine Cogdell Schuyler, Charlotte Osgood Mason, and Fannie Hurst were all checked off, on internal NAACP memorandums, as responding favorably to requests to be patrons.

The show was a "huge success" financially and, in the eyes of the NAACP, an even bigger symbolic victory as a model of integration. Blacks and whites mingled freely throughout the $4 orchestra, $2 balcony, and $5 box seats of the Forrest Theatre. Such an intimate mingling, music historian Todd Decker has pointed out, was highly unusual in the still segregated 1920s. Even black celebrities such as Paul Robeson were "afraid to purchase orchestra seats for fear of insult" at most Broadway shows. The evening's interracialism would have been "extremely difficult, if not impossible" outside the auspices of the NAACP.

Such a display was indeed cause for self-congratulation in the Jim Crow world of 1929. But it also entailed complications. Just a few months before the benefit, James Weldon Johnson had tagged those complications the special "dilemma" of the Negro artist. "The Aframerican," he wrote,

> faces a special problem which the plain American author knows nothing about—the problem of the double audience. It is more than a double audience; it is a divided audience, an audience made up of two elements with differing and often opposite and antagonistic points of view. . . . This division of audience takes the solid ground from under the feet of the Negro . . . and leaves him suspended.

Given the Forrest Theatre's mixed audience, White's choice to headline Holman's "Moanin' Low" seems peculiar indeed. Raw, undignified, and titillating, "Moanin' Low" evoked an imaginary black "low life"

steeped in sexuality, primitive emotions, and violence. Those were the very stereotypes the NAACP worked to contest as not "representative of the real everyday life" of blacks. Hence this performance of a mulatta prostitute begging her black pimp not to leave her—"My sweet man is gonna go / When he goes, Oh Lordee! / Gonna die / My sweet man should pass me by"—seemed destined to offend its black audience and pander to the worst misconceptions of its white one. Why, then, did Walter White pursue that particular piece so avidly? And why did black newspapers, usually quick to point out stereotypes, note only that the mixed audience had been "well pleased" by "Moanin' Low"? Why was Holman not seen—as she surely would be seen today—as insulting her hosts and promoters—trespassing upon, rather than just impersonating, blackness?

Those who study whiteness would call such impersonation "onerous ownership," the arrogant assumption of defining blackness. But not only were intellectuals such as White not offended; they welcomed an extraordinary range of responses to what Judith Butler calls "ready-mades," or conventional ideas of identity. Many Harlemites felt that *Nigger Heaven* had focused too bright a light on Harlem's cabarets and nightclubs and portrayed its citizens as possessing "a birthright that all civilized races were struggling to get back to . . . this love of drums, of exciting rhythms, this naïve delight in glowing colour . . . this warm, sexual emotion," when they needed to be seen, by whites, as lawyers, doctors, professors, and politicians. Nevertheless, White's souvenir brochure for the benefit included an essay by Van Vechten that encouraged blacks to "keep inchin' along," advice usually anathema to the militant spirit of the New Negro movement. It was not White's only risky gambit that night.

The printed program, which sold for 50 cents as a souvenir brochure, with autographed copies auctioned off for much more, was designed especially for the evening by Harlem's favorite artist, Aaron Douglas. Its cover image of a white man and a black woman, their facial silhouettes touching evocatively, bathed in the light of a radiating sun labeled "NAACP," depicted one of the most taboo issues in race politics. Was

NAACP benefit program, close-up.

White using his vaunted status as "voluntary Negro," someone who had chosen the "struggle of the black people of the United States," to make a point about interracial affiliation? If so, his program and his inclusion of Libby Holman both made space for Miss Anne in Harlem, suggesting that choosing—even impersonating—blackness over whiteness could be a meaningful act of solidarity. As someone who looked entirely white and who had to insist on his blackness daily, was Walter White suggesting that passing for black, performing as black, and identifying with blacks should be encouraged, not discouraged, throughout Harlem?

The space given to Holman by the NAACP would most likely have encouraged both Edna Margaret Johnson's bid for acceptance and Nancy Cunard's assumption, printed on the same page as Johnson's "Prayer," that she could speak as—and for—a black man bent on destroying racist "crackers." With so much discussion in American culture of blacks crossing the "color line" and passing as white, it would have been inevitable that some white women—including Johnson and Cunard—would imagine a reverse crossing that passed from white to black.

"Strange Longing":
Interracial Love, Passing, and Voluntary Blackness

I am possessed by a strange longing.
—James Weldon Johnson, *The Autobiography of an Ex–Colored Man*

Published anonymously in 1912 and reissued under his own name in 1927, James Weldon Johnson's novel *The Autobiography of an Ex–Colored Man* was one of the most widely read books of the Harlem Renaissance. A novel of passing in the guise of a confession, this short work tells the story of an unnamed narrator who is pushed across the color line by the horrific sight of a lynching, described in gruesome detail. The narrator determines that he is "not going to be a Negro" henceforth and resolves to go to New York, where, because he looks white, it will not be "necessary for me to go about with a label of inferiority pasted across my forehead." He goes to school, becomes a successful real estate developer, moves up in society, and finds that in almost all particulars, except the economic, the white and black worlds are nearly identical; it is class and culture, not race, that account for real differences between people. After some time in the white world he falls in love with a white woman, who agrees, after much torment, to marry him and keep his racial secret. They are a "supremely happy" couple. But she dies in childbirth with their second child. He continues to pass for his children's sake: "there is nothing I would not suffer to keep the brand from being placed upon them." At the end of the novel, the narrator ruminates on his life, remembering his mother (from whom he received his "coloured" blood). He wonders if he has been "a coward, a deserter" and if he has committed an unforgivable moral breach.

Before he can answer that question, however, he finds himself "possessed by a strange longing for my mother's people." His longing is strange because in learning that there is no real difference between the races, there should be nothing, in particular, for him to miss. His long-

ing is also "strange" because the sudden desire to be among "his people" is so forceful, threatening to upend his carefully considered choices.

The power of this "strange" longing for blackness turns up everywhere in the black literature of the Harlem Renaissance. It is a disruptive force in both of Nella Larsen's novels. Helga Crane, in Nella Larsen's *Quicksand*, visits a "subterranean" Harlem cabaret, and finds it

> gay, grotesque, and a little weird. . . . A blare of jazz split her ears. . . . They danced, ambling lazily to a crooning melody . . . or shaking themselves ecstatically to a thumping of unseen tomtoms. . . . She was drugged, lifted, sustained by the joyous, wild, murky orchestra. The essence of life seemed bodily motion. And when suddenly the music died, she dragged herself back to the present with a conscious effort; and a shameful certainty that not only had she been in the jungle, but that she had enjoyed it, began to taunt her.

She finds herself overcome, after this, with longing to be amid the "brown laughing" faces of "her" people and experience those "joyous," essential feelings. She is "homesick . . . [for] her" people. And in *Passing*, Clare Kendry has crossed over into white society and finds that she cannot stay there because she too is overcome by her "longing" for blackness. That longing grows in her as a "wild desire . . . an ache a pain that never ceases." Warned that this "wild desire" may destroy her marriage to a white man who does not know her secret, Clare responds, "You don't know, you can't realize how I want to see Negroes, to be with them again, to talk with them, to hear them laugh."

This sudden longing is an important turning point in black authors' novels of passing. Racial longing reinforces a racial ethic—the idea that "a refusal to pass is commendably courageous"—and vice versa. The longing to "come back" is an affirmation of race pride, a testament to the fact that there is nothing enviable in white culture. "A good many colored folks that try to be white find that it isn't as pleasant as they imagined it would be," Booker T. Washington is reported to have re-

marked. "White folks don't really have a good time, from the Negro point of view. They lack the laughing, boisterous sociability which the Negro enjoys." Turning one's back on blackness is portrayed not only as betrayal but also as undesirable. This makes a coercive stricture into attractive preference. "Voluntary Negroes" are not only better people, in other words, but happier. What might otherwise have been a guilty pleasure, since an emotional preference for one race over another always smacks of essentialism, is reaffirmed as a proper ethical stance.

But a "strange longing" for blackness meant something quite different when expressed by white women. White women who believed in essential, or fixed and immutable, notions of racial identity often aligned themselves with primitivism's conviction that blacks embodied a set of qualities and characteristics not found elsewhere. To them, attacks on biological difference seemed to fly in the face of their efforts to appreciate blackness as something very different from—and in some ways even better than—whiteness. Nor did they take to what was then a pragmatic position that eluded the question of what race was by insisting that whatever race was, it was an ethics, a mandate that blacks be loyal to their "own" people in the face of discrimination and oppression. White women animated by an erotics of race did not want to be loyal to "their" own race—that was the whole point. They wanted to qualify as "voluntary Negroes" instead (in spite of the fact the honorific was meant only for blacks who might have passed but chose not to). Simply put, some of the white women who were most taken with black Harlem also had a powerful personal—if unacknowledged—stake in some of the very ideas of racial difference that so vexed and frustrated the political/cultural movement. Their "strange longing," as many would have called it, put pressure on the very thing most Harlemites wanted least to admit—that ideas of essential and immutable racial difference persisted, even among blacks and even though they were widely challenged.

Some of the most subtle literature of the Harlem Renaissance dramatizes this paradoxical persistence. For example, black novelist and *Crisis* literary editor Jessie Fauset, the stepdaughter of an early interracial marriage, demonstrates who can and cannot volunteer for blackness in

her 1920 short story "The Sleeper Wakes." Here, a blond, blue-eyed child named Amy is left with a middle-class black family when she is five years old, a family that is unable to tell her with certainty whether she is white or "colored." Amy joins the white world but finds it sterile, cold, insolent, and acquisitive. "She wanted to be colored, she hoped she was colored." Finally, she gives in to the "stifled hidden longing" for blackness. Because Amy *might* have black blood, *might* therefore *be* black, those longings are validated. Indeed, Amy's longings are validations, in and of themselves, of black pride.

Miss Anne sometimes saw her exclusion from "voluntary blackness" as Harlem's version of America's "one-drop rule." She protested against it by claiming also to have, as Charlotte Osgood Mason put it, the "creative impulse throbbing in the African race." Seeing black poets proclaim "I am Africa," she sometimes concluded, as Nancy Cunard did, that that she too could "speak as if I were a Negro myself." On the one hand, Miss Anne had a point. What prevented such a claim, if not blood and biology? On the other hand, of course, such a claim was audacious, even outrageous. By suggesting that she could volunteer for blackness and that only an essential ideology could logically exclude her, Miss Anne managed at one and the same time to both validate black culture and challenge its racial edicts in almost equal measure. Hence, her mere presence seemed to undermine "rooted identity . . . that most precious commodity."

Sexualizing Edna Margaret Johnson's prayer for color made all the complexities of Miss Anne's "strange longing" easier to dismiss. The white press, especially, went to extraordinary lengths to sexualize any longing white women expressed for blackness over whiteness. Civil rights activist and NAACP founder Mary White Ovington was a remarkable example of this phenomenon.

Like Nancy Cunard, Ovington was a socialist from a well-heeled family. And, like Cunard, she was a stubborn woman who strained her family's tolerance as she doggedly transformed herself from dilettante to fighter. She rejected the mannered, 1880s Brooklyn Heights society in which she was raised: its balls, card games, fox hunts in the country,

and long, chaperoned Sunday walks with suitors. Like Nancy Cunard, she resolved never to marry. "To live on in an eternal round of home duties without any outside fun or outside work even would just about kill me." She moved from settlement work to NAACP leadership. Her parents were at a loss to understand her. "Do stand by me if you can," she begged her increasingly distant mother.

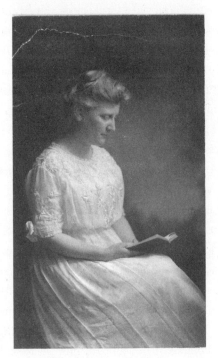

Mary White Ovington.

Ovington was a very serious, even severe person. She was not at all a "New Woman," demonstrating her feminism and independence through rebellious style. Born in 1865, she was in her late fifties during the Harlem Renaissance and the product of the very Victorian society that New Women like Cunard set out to affront. She disapproved strongly of their flamboyance and especially their provocative behavior with black men, which she felt drew the wrong kind of attention to integration. Hyperconscious of the "need for caution about appearances," she saw "the

nasty propaganda potential of any event with white women and black men." Although Ovington used femininity to escape the constraints of womanhood that faced her, she did not believe in openly flouting sexual conventions. Adopting a personal style marked by decorous behavior and old-fashioned pastel suits helped her draw attention away from herself. She also deflected notice by working without a salary for forty years and being very careful about contradicting the NAACP's black male leadership in public. So successful were her self-effacing strategies that to this day people are often unaware that she founded the organization.

Yet the white press attacked this mild-mannered, middle-aged woman just as viciously as it attacked Cunard. Ovington was called a sexual hydra. She was accused of working for black rights only to insinuate herself sexually into the company of black men. Seizing on an interracial dinner she sponsored in 1908, long before such occasions were in "vogue," front-page stories from *The New York Times* to the *Chattanooga Times* to the *St. Louis Post-Dispatch* exploded with "public disgust and indignation" over such a "disgraceful" social gathering. The press worked itself into a froth over the "forces of evil" represented by social interracialism and especially excoriated the "unbalanced" white women it insisted went to Peck's Restaurant to seduce black men. Ovington was singled out for particularly ugly charges that she had ulterior motives for organizing the "Miscegenation Banquet," as the press dubbed the dinner. If she wasn't seeking black men for herself, then she was attempting to lure young white women into sex with black men, they insisted. "High priestess, Miss Ovington, whose father is rich and who affiliates five days in every week with Negro men and dines with them at her home in Brooklyn," declared one southern newspaper, was determined to "take young white girls into that den." A flood of threatening and "nauseatingly obscene" letters arrived at Ovington's home, remarkably like the letters Cunard would receive nearly thirty years later during her own stay in Harlem. Ovington tried—as always—to put a brave face on things, declaring that "one is complimented to feel that one may have endangered one's life for a cause." But she was concerned enough to retreat to her sister's home.

The papers did not always have to stretch to sexualize white women in Harlem. Certain white women, such as Cunard and Schuyler, were open about their sexual desire for black men. In those cases, the press had only to render such desire as monstrous, insane, unnatural, and unhealthy. Given the taxonomic fever of the twenties, that was not hard to do.

In the winter and spring of 1927, there was a string of mysterious and brutal attacks on Hollywood starlets. One of them occurred on April 12, 1927, when Helen Lee Worthing—a Ziegfeld Follies girl (named "one of the five most beautiful women in the world") and screen star who had played opposite John Barrymore in *Don Juan*—was badly beaten by an intruder who broke her nose, knocked out a tooth, and left without attempting to take anything from her bungalow. Soon after her recovery, she vanished.

As it turned out, Worthing had eloped with her doctor, a black man, marrying in Mexico to evade California's antimiscegenation laws. Fearing scandal in the press, she withdrew from her film and stage career after her marriage. "We didn't intend for the story to get out," her husband told reporters. The story did get out, however, and Worthing rushed to defend her love for the light-skinned black doctor. (Her defense was not the most thoughtful, conflating Negrophilia and Negrophobia: "We

Helen Lee Worthing with her husband, Dr. Nelson.

all have the blood of the chimpanzee in our veins," she averred. "Why should I object to a faint trace of dark blood in my husband?") Worthing and Nelson challenged Hollywood to accept and defend them, making it known that if they could not win support from those in film, they'd go to Harlem "and accept all that her status as his wife implies." Their gambit failed. Trying to win over her friends was a "losing game." She encountered "no recognition or friendliness" when she appeared in her former social circles. "I might have been an utter stranger." Other whites treated her as if she were "not quite human."

Worthing began to receive the same kinds of hate mail Ovington had received—an antagonism that may have been the cause of the attacks on her. Those "venomous, coarse, and vindictive notes" called Worthing "a disgrace to the white race," a "sex-crazed degenerate," and worse. "They were cruel, dirty, anonymous letters." She felt afraid to go out. Her studio work dried up overnight, and "every one of my old friends had deserted me." She "gradually withdrew from society," isolating herself both from her Hollywood friends and from her husband's friends in their black Los Angeles neighborhood and beginning to abuse drugs and alcohol. Two years into the marriage and desperately lonely, she collapsed. By November 1932, she was confined, against her will, in Los Angeles Hospital, pending a formal charge of insanity. A few years later she reappeared as a bathroom matron in a defense plant and then as a sewing machine operator in an apparel shop, working her way up from piecework to shop forewoman, still considered newsworthy by the tabloids. In 1948, she killed herself with an overdose of sleeping pills. "Worthing's decline and her banishment from Hollywood served as a warning for many other stars who followed. Interracial relationships were clearly taboo." A death like Worthing's gratified those who thought "it was a sign of insanity to have a black lover and advertise the fact." It proved that "white women who voluntarily married black men were . . . depraved, insane, or prostitutes" and sure to come to a bad end.

It is probably impossible, nearly a hundred years later, to recapture the social force of the term "Nigger lover." The term was used to indict

those who had transgressed whiteness in ways that now made them ineligible for it: whites who refused to discriminate, were intimate with blacks, or socialized with blacks. Women who were "Nigger lovers" were traitors to whiteness; they were guilty of acts of symbolic treason, and they forfeited whatever class privileges they had acquired. Having given up the only superiority available to them, they could be understood, in the terms of their day, only as self-hating.

Not everyone believed that interracial relations were doomed. Joel A. Rogers, for example, a friend of George Schuyler and the author, among other works, of *This Mongrel World: A Study of Negro-Caucasian Mixing Throughout the Ages, and in All Countries* (1927), argued that interracial sex had a "'cosmic' significance" and that white women who feared rape were expressing "an ungratified desire for intimacy with Negroes." Schuyler applauded Rogers's position and agreed with him, as did his white wife, Josephine. But they were in a distinct minority. Citing "incompatible personalities, irreconcilable ideals, and different grades of culture," even Du Bois and the NAACP discouraged interracial marriage. According to Claude McKay, "the white wives of Harlem have had such a rough time from the Negro matrons that recently there was organized an association of White Wives of Negro Men to promote friendly social intercourse among themselves."

Black activist and antilynching crusader Ida B. Wells called such women "white Delilahs" and resented having to defend them. But on balance, a woman such as Helen Lee Worthing may have been less troubling—at least she was predictable—than Edna Margaret Johnson with her "White Girl's Prayer," her "self-contempt," and her glorification of all things black. When white women went to Harlem full of "strange longing" to escape from themselves into blackness, there was no telling what they might do.

Indeed, white women were often, for black communities, both unpredictable and dangerous. A second trial brackets the time period covered in this book, and it was every bit as influential in its day as the Rhinelander case was. It reinforced, for many, just how dangerous white women could be. And it reinforced, as well, how frightened white

women might be of being perceived as choosing blacks over whites. The Scottsboro case began in the troubled Depression era, on March 25, 1931, when a fight erupted between black and white boys riding the rails in search of work in Alabama. Some of the white boys were thrown off the train and quickly ran to seek help from local farmers. In Paint Rock, Alabama, the train was stopped by a mob, which dragged the black boys off the train, along with two white women dressed in men's overalls. The two women, Ruby Bates and Victoria Price, initially did not press charges or mention rape. But local officials quickly made it clear that "riding the rails, dressed in men's overalls, consorting with rowdy white men, they could have been charged with vagrancy or worse." Were they "nigger lovers"? the authorities demanded to know. Both women already had prostitution records. Neither had money or family to fall back on. "Bates and Price must have quickly recognized their stark choices. They could either go to jail or claim to be victims. They cried rape."

No physical evidence supported the claim. At no time did either woman act as if she were recovering from a savage attack. No witness confirmed their stories. Yet in trial after trial, the Scottsboro Boys, as the defendants were called, were found guilty and sentenced to death. The case rose to prominence among progressives partly because such unfounded accusations had become so commonplace in the country. As Dan Carter, one of the historians of the case, puts it, Scottsboro "was a mirror which reflected the three hundred years of mistreatment they [blacks] had suffered at the hands of white America."

"By the spring of 1932," historian Glenda Gilmore wrote, "the Scottsboro case had traveled around the world and back again." As whites began to grasp the workings of southern racism, the case created "tectonic shifts" in racial attitudes. Artists and writers came out strongly in defense of "the boys." The case became a referendum on the nation's racial future not only as a test of racism's blind injustice but also as a referendum on political strategy, with militancy and caution at odds. Spearheaded in part by Mary White Ovington, the NAACP reluctantly took up the case. The Communist Party, in a campaign in which Nancy Cunard played an important role from Britain, did so as

well, aiming to show up the NAACP as timid. Wrangling between the NAACP and the Communist Party continued for years. The case revealed to the nation what many in Harlem had long known: blacks were at risk of death at any time, for any infraction, real or imaginary. And white women played a very particular role in that threat; it was a role that was so deeply ingrained in history that saying no to their complicity in racist violence seemed nearly impossible. Some white women antilynching activists distanced themselves from the case when it became known that both Bates and Price had not only worked as prostitutes but also accepted black clients. "The women of the ASWPL [Association of Southern Women for the Prevention of Lynching, founded in 1930] were at a loss for how to address consensual interracial sex, something they had never considered possible before. . . . Consensual sex could not be officially imagined." In this, as in myriad other ways, race and desire were conflated and collapsed.

Choosing Blackness:
Sex, Love, and Passing

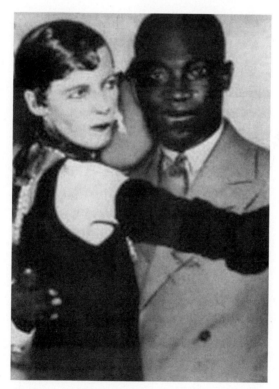

Nancy Cunard dancing with an unidentified man.

Let My People Go:
Lillian E. Wood Passes for Black

The crusade of the New England schoolma'am . . . yet to be written . . .
[is] the tale of a mission . . . more quixotic than the quest of St. Louis.
. . . Rich and poor they were, serious and curious . . . women who
dared. . . . They did their work well.
　　　　　　　　　　—W. E. B. Du Bois, *The Souls of Black Folk*

Nothing at all could be found.
　　　　　　—Bibliographer Ann Allen Schockley on Lillian E. Wood

Lillian Wood and the Morristown College faculty, 1925.
Wood is in the front row, fourth from the right.

ecause Harlem was an "imagined community," as well as a geographic center, it attracted emotional and intellectual adherents from across the country and, indeed, from around the world. Writers in the 1920s, both black and white, wrote with an eye toward Harlem and a hope of attracting its attention, just as international modernists wrote about the Left Bank. Those who succeeded, like Julia Peterkin, writing from a South Carolina plantation, might be part of the movement no matter who they were or where they lived. The myriad submissions to "The Poet's Page" (originally "Poet's Corner") from Los Angeles and Kansas City, St. Louis and Denver, Hoboken and Detroit, all reflected the hopes of whites who wanted in on the new black movement. One white woman writer, Lillian E. Wood of Pleasant, Ohio, succeeded so well in that endeavor that she erased all traces of her effort.

In 1925, at the height of the Harlem Renaissance, Wood published a novel that attempted to tell the full history of black people after slavery up to the Harlem Renaissance. Stopping just short of it was an important, deliberate omission. Wood lived in Morristown, Tennessee, a small Appalachian community, to which she moved in 1907 and where she stayed until 1954. Her novel, *Let My People Go,* was written, in part, to convince southern blacks—Wood's students of more than four decades—that they need not rush up to New York to make a difference in the world. It was also written to prove that a white woman could understand and serve the black community, and without moving to New York City to do so. Wood always said that her novel was written *as* a friendship gift for her black students but *for* an intended audience of other whites. As a novel about the sexual abuse of black women and the lynching of black men, *Let My People Go* was inspired by Wood's perception that white women were failing to act responsibly to end lynching and racial violence. It was designed to encourage other white women to put social responsibility ahead of their fear of being labeled "Nigger lovers" and losing social status. In that sense, it was also written to and for Miss Anne, in the hope that she'd recognize a kindred sister tucked away in the South. As a friendship offering to southern blacks, her book

succeeded admirably. But as either a lesson for inactive white women or as a smoke signal to Miss Anne in Harlem, the book failed spectacularly, and for reasons Lillian E. Wood could never have predicted.

Until now, *Let My People Go* has been listed in all the standard reference works of early African-American fiction and Lillian E. Wood has been thought to have been a black woman. Hers is a case of passive, not active, passing. Wood never claimed to be black, as far as I can tell. But feeling flattered, perhaps, she did nothing to correct the error. And for almost a hundred years, in spite of a general feeling that "a more in-depth study of this obscure author seems warranted," the prevailing assumption has been that "nothing at all" could be found out about "African-American novelist" Lillian E. Wood, as the Fisk librarian and eminent bibliographer Ann Allen Shockley maintains. Wood's biography appears in anthologies as a blank: a double question mark inside a parenthesis where her birth and death dates should be: "(??–??)."

This racial misattribution and the ability to hide in plain sight are part of Miss Anne's history. Even to black bibliographers, it seemed unimaginable that a white woman would declare blacks "my people" in the way that *Let My People Go* does. Such are the expectations of Miss Anne's racial choices. And such, as well, are the assumptions of what Miss Anne would and would not dare. Wood's disappearance from the historical record is part of the long history of Miss Anne's obstacles to finding a place for herself.

The white women of the Harlem Renaissance were not the first to try to make a place for themselves in black communities, to bring to that experiment their own biases and desires, or to discover that their experiences of race-crossing changed them in deep, unexpected ways. That history begins with white women such as Nell Butler, who married a black slave in 1681; Ann Wall, who became a slave after marrying one in 1702; Dorothea Bourne, who took a black slave lover in Virginia in 1824; and suffragist Helen Pitts, who married Frederick Douglass in 1884 and found herself denounced by both blacks and whites. It includes female abolitionists such as the Grimké sisters, Sarah and Angelina; and Susan B. Anthony. And it continues with Miss Anne's immediate

predecessors, the Yankee schoolmarms, white women who went south, largely from New England, to teach in the Freedmen's Bureau schools immediately after the Civil War.

Those forebears cast an especially long shadow over the Harlem Renaissance. On the one hand, intellectuals such as Du Bois saw them as pioneering heroines to be emulated by other white women. He was especially moved that those "few" whites had "dared to know and help and love black folk" and that, against terrific odds, they had created some "brave and splendid" interracial friendships. Those white women, he insisted, were "the finest thing in American history." But derisive stereotypes also dogged the New England spinster teachers, making any woman who followed in their footsteps easy to dismiss and minimizing the importance of the interracial friendships they forged. Heroic and bumbling, determined and terrified, thoughtful and thoughtless, these schoolteachers haunted Miss Anne. And because they did, the story of Miss Anne in Harlem rightly begins with the Yankee schoolmarm in the freedmen's schools and historically black colleges of the South.

During a brief few years, from 1861 to 1871, thousands of white single women, mostly from New England, went south to teach in the hastily founded new black schools. While there was some support from church mission societies and somewhat less support from the Freedmen's Bureau (which existed more on paper than anywhere else), these women were largely untrained, poorly equipped, and ill prepared for what they'd find. They traveled alone into territories where they were "shut out" by a still bitter, defeated population. "Ostracized by white society," they were also intimidated by groups such as the Klan, which threatened to whip, shoot, poison, or burn them out of their schoolhouses. Locals blamed them for leading "their" black people astray. "Schoolmarms, not native blacks, were the primary targets of resentment" in much of the South. These teachers faced "bitter opposition." Damned as zealots and meddlers, they were relentlessly mocked and caricatured. Teaching in a black school was considered "disgraceful, shameful. . . . Among some groups, teaching blacks was a treasonous act."

They were often all too easy to caricature. Many of the women who

went south were out of their league. Few had traveled extensively before making the difficult trip. Most had never seen large numbers of black people; they were unfamiliar with southern habits, untrained as teachers, and woefully unprepared for the climate. Some reported shamelessly that they could not tell black people apart: "All the men looked just alike, and so did all the women and girls." Many had strong racial prejudices and were "condescending toward African Americans and oppressively maternalistic." One white Methodist from Wisconsin remembered "'a positive antagonism to the idea of working with the Negroes.'" Her fellow missionaries, she said, and most of the whites she met in church missionary and educational work, did not see "'the Negro as a *person* with feelings.'" Many went south full of good intentions, only to depart as quickly as they could, once their sub-spartan conditions became clear and their harassment from local whites commenced.

Many also stayed, braving ostracism and assault, demonstrating a "striking" willingness to rethink their own "preconceived opinions" and often developing "deep affection" for their black students. Their very insistence that blacks were educable and deserving of education served to challenge racist claims of innate black inferiority. Yet, historians have been hard on those women. "By the 1940s and 1950s, it was commonplace for white historians to mock these missionaries." Those who stayed were generally either more stubborn and more deeply committed to an interracial life than the rest or else they were the ones who had nowhere else to go. In black schools such as Morristown, negative stereotypes of spinster teachers did not prevail. There, the Yankee schoolmarm commanded respect and admiration, was still regarded as virtuous and brave. And though they were isolated within their colleges, such teachers could also maintain independent households, a rare privilege for women at the turn of the last century. White women were not, by and large, allowed into men's colleges and were denied a classical education. Teaching at a black college, with a classical curriculum, was also a route to self-education for some of the women who stayed. Their isolation in black colleges proved lonely, but it also provided an escape from the strictures of femininity they were raised with. These school-

teachers could go from being socially limited to being women in charge by traveling to the South.

One of those women was stubborn Almira H. Stearns, Lillian Wood's immediate predecessor and role model at Morristown College. A New Jersey Civil War widow born April 12, 1823, in Vermont, Stearns went south in 1868 to replace a departing Mrs. Hanford from Ithaca, New York. In an inadequate frame building that had served variously as a church, a slave market, and a hospital for both Confederate and Union soldiers during the war, Hanford taught every imaginable grade and level, attempting to instruct nearly a hundred black students of all ages (including one 110-year-old man) in basic literacy and grammar. Hanford hated it.

Stearns and her twelve-year-old daughter boarded a train in New Jersey for the difficult two-day trip, traveling through a postwar landscape of "graves and graves." A fellow passenger pointed to the "woman on her way south to teach the 'niggers,'" and mother and daughter were shunned for the trip. When they eventually alighted at the small brick station in Morristown, Hanford, who had survived an arson attempt and appealed to the governor of Tennessee for protection, wasted little time getting out of town. She departed as Stearns was unloading her bags.

At first, Stearns fared little better than Hanford. She was taken with the wide views of the Appalachian Mountains and the Nolichucky and Holston rivers across the valley from her hilltop school. And the students welcomed her warmly. But the hardscrabble white community was often hostile and "occasionally violent." They had no universal education for their own children, so why should black students get special teachers from the North? The school was set on fire numerous times, and Stearns lost the few things she had brought with her on the train: "a gold watch, gold glasses and various pieces of bric-a-brac." Students were fired upon. Homes were burglarized. Stearns faced "verbal abuse and ostracism." Locals pressed "their faces to the windows with all sorts of hideous contortions of countenance and with howling and cries; getting under the house and beating on the floor with sticks and such other doings." They spat on her daughter and followed her whenever she ven-

tured off school grounds. Stearns was unable to shop in town. Forgoing "white society to minister to the needs of another race" and preferring black company to white was intolerable to the local whites, and they made sure Stearns knew it. For a recently widowed middle-aged white woman, alone in the South, with a twelve-year-old daughter to protect, the situation must have been terrifying. She could not appeal to the local whites for forbearance. To them, she was a "race traitor" and as "alien" as if she had "come from another planet." Nor could she expect much protection from her students. In that part of eastern Tennessee, blacks totaled only 3 percent of the population. They could not afford confrontations on her behalf. Stearns later described the constant threats from the white community as "earthquake-like shocks." She never "entirely recovered" from their "mental and nervous strain," she said.

A few photographs of Stearns survive. All were taken after she had spent many years in Morristown. In them she looks every bit the Yankee schoolmarm stereotype: grim, thin, sharp-featured, determined, and steely, with tightly pressed lips and closely coiled braids. Was that her look when she alighted from the train in Morristown? On the day she married her late husband? Did the New England schoolteachers arrive looking unhappy and severe, or did they acquire that pinched look after years in the field?

"One of the most persistently stereotyped Americans of the age," the Yankee schoolmarm was depicted, even by northerners, as "horsefaced, bespectacled, and spare of frame . . . a dangerous do-gooder who had rejected Victorian norms of behavior for women . . . at best a comic character, at worst a dangerous fool, playing with explosive forces which she did not understand." Once a cultural icon of moral rectitude, the spinster teacher lost social status steadily over the first decades of the twentieth century, in white communities, until, by the 1920s, she had become an object of considerable ridicule from other whites. She was already maligned as "meddlesome" at best and tyrannical at worst, and popularized Freudian notions of what was sexually normal made her unmarried state—often mandated by district regulations—seem increasingly "queer." To a resentful South, still bitter over northern missions aiding

blacks rather than whites, any opportunity to paint the teachers as social outliers was irresistible. The more unnatural the schoolteacher could be made to seem, the more she could be punished for her racial choices with the loss of white femininity, her chief social capital.

Characters of comedy to some, race traitors to others, but potential heroines to their black students, women like Stearns led unpredicted lives. Those who stayed put when the waves of missionary teachers returned north experienced interracial socialization unprecedented elsewhere. Pushed out by white locals, such women often became honorary members of black communities. At a time when women of their race and class were especially constrained and immobilized by expectations, they moved aggressively into new worlds. "New understandings are arrived at and misconceptions brushed away," many of them found. They "came to help and were helped." In the Great Migration many of their students went north to cities such as Chicago and Washington, D.C., and to Harlem. They took with them memories of those Yankee teachers. Sometimes they measured other white women by that yardstick. According to historian Edward Blum, "positive memories of these schoolteachers and their influence could be found far and wide . . . examples of mercy in a world of madness . . . as if something transcendent happened during black-white encounters."

At one point in *Let My People Go*, a white man speaks admiringly of blacks and the challenges they face. He wishes, he says, that he were black: "It's a hard thing to be a Negro, but I'd give a million dollars for the chance! . . . Your people are looked down upon—spurned from the sidewalks in some parts of the world. They are appointed and confessed servants of the whites. Every man's hand is against them. You have a tough job—a hard job. . . . I'd just like to tackle a job like yours." That was Lillian Wood's thinly veiled confession. Like Edna Margaret Johnson, she looked to blacks to infuse her life with purpose. And like the missionary teachers for whom Reconstruction's "call to moral arms" had offered the "great thing" of "something better to live for," Lillian set out to find herself by leaving all she knew behind.

Lillian did not intend to be a radical. In fact, she could hardly have

had a more usual background. Lillian, whose legal name was Elizabeth, was born to Courtney and Rebecca Wood in 1868 and raised in Pleasant, Ohio, with two older sisters, Florence and Alma; and an older brother, William. The Woods were hardworking, conservative Methodists who did not do well financially. Courtney Wood was a miller, an important job in a grain-producing state such as Ohio but not one likely to generate wealth. He and William took a chance and opened a shoe store in the nearby town of London in the late 1870s or early 1880s. The family lost all its money. Lillian wanted to be a writer, an artist, or a missionary, perhaps in China, but her mother forbade it, and she began teaching in her teens. She did manage a year at Ohio Wesleyan, then was called back to elementary and Sunday school teaching to supplement the family income.

Life was rough for the Wood sisters, as it was for many single women of lower-middle-class homes. None of the sisters married, though Lillian loved a local farmer who chose a woman with more money. Things were especially difficult after William married and left home. The sisters' parents died. They could not afford the mortgage on the family property and were forced to sell it. Florence's health turned delicate. Alma proved unreliable. Though she was the youngest, Lillian assumed the role of caretaker and took Florence to Chicago to recuperate and study millinery, one of the most acceptable professions for women in the late 1800s (also one of the few in which earning a decent wage was possible). Chicago was an immensely exciting city in the late 1800s, with thirty-three different train lines bringing workers into the stockyards, steel mills, shops, and neighborhoods to help the city rebuild after the Great Fire of 1871. Lillian wanted to stay and study art. But she was called back to Ohio almost immediately to care for an ailing aunt. Before long she found herself back in London, an unwelcome guest in the home of her brother and his "not agreeable" wife.

Florence took up her millinery work in Toledo, so Lillian packed up the family furniture and went to join her. She found work teaching and advanced to principal of a small school. Then "disaster again overtook us." Florence lost her health, her money, and her ability to work. Alma,

"always a problem because, especially, she could stick to nothing," descended upon them, to be looked after as well. In short order, trying to juggle too many different responsibilities, Lillian lost her job and was penniless. It was 1907, and the country's finances, depleted by a long recession, teetered on collapse.

At that point, Lillian received what she later described as her great "calling" and arranged to move to Morristown, Tennessee, a part of the country she had never seen. "I'll go to the colored people," she declared. In 1907, she set up Florence and Alma in nearby Knoxville and took up residence in one of the college dormitories, beginning a stint as dormitory matron. At that time it was highly unusual, anywhere in the South, for black and white teachers to live together. Lillian believed that she'd been foreordained from childhood to live among blacks. Even as an infant, she declared, she had shown a marked preference for "colored" babies over white ones, proving that "God then designed *me* to go to the Colored People." But Lillian was also canny. By giving herself in "service" to "the coloured people" of Morristown, she made herself unavailable to most of her family's demands. Her sisters were nearby but no longer able to lean so heavily on her. The wishes and needs of her Ohio relatives necessarily faded. She had a steady income, a welcoming community, a challenging occupation, and the possibility—if only she could squeeze out enough time—of pursuing her artistic and literary ambitions.

She could hardly have picked a more difficult time to go south, at the tail end of a "steep decline in the commitment of the North to blacks in the South." Not only had northern support turned away from higher education for blacks in favor of either vocational training or elementary schools, but decades of backlash to Reconstruction gains had deepened racial divides. Southerners' tendencies to see blackness as a contagion threatening whiteness had intensified. Segregation hardened. As historian Joel Williamson explains, "By about 1900 it was possible in the South for one who was biologically pure white to become black by behavior. . . . White people could easily descend into blackness." That may have been fine with Lillian.

Arriving at Morristown College in 1907, Lillian was not altogether pleased. Morristown College was founded at the same time as Hampton Institute, a vocational and industrial school for blacks with an emphasis on the so-called dignity of labor, which meant menial work. Hampton's white founder, General Samuel Chapman Armstrong, called on blacks to "refrain from participating in southern political life because they were culturally and morally deficient and therefore unfit to vote and hold office in a 'civilized' society." Morristown College was struggling. "Southern white opposition [to blacks] was very largely aimed at black education of any kind" but was especially fierce about schools, such as Morristown, that emphasized the liberal arts. Since donors favored Hampton's model, Morristown attempted to straddle it and a classical liberal arts education both. In addition to theology and religious instruction, the early curriculum offered courses in Latin, algebra, Greek history, English, Roman history, medieval history, geometry, geology, physics, psychology, modern history, and composition, as well as carpentry, woodworking, blacksmithing, machining, steam fitting, printing, upholstery, broom and brush making, foundry, domestic science, and sewing. It was a demanding program, with an insufficient faculty, and everyone at Morristown worked extraordinarily long hours.

Morristown was without any public hospital for blacks in 1907 when Lillian Wood arrived. President Hill thought the school should attempt to serve as a hospital, in addition to schooling blacks of all ages in every possible discipline. The pay was low, even by the standards of such schools (Lillian earned $20 a week, only a few dollars more than the weekly pay of work-study students). Classes were crowded, standing room only at times. Church attendance was mandatory. Most students worked at least five to six hours a day, in addition to their classes. Not surprisingly, they were often too exhausted to study. Lillian had been hired "to care for the boys and girls in her care much as a mother would in a home." When she was found to be an able teacher, she was quickly assigned to teach history, grammar, zoology, and English classics—no doubt daunting for a woman trained in none of those subjects.

Relations with local whites were not much better than they'd been

in Stearns's day. The white president, Judson Hill, who came in 1881, found that he and his wife, Laura Yard Hill, were "shunned." "Taunts and threats were part of their daily lives." Called "Nigger Hill" by local whites, Judson was pushed and shoved on the streets. Eggs were thrown at him, and he was nearly tarred and feathered. "Our friends among the white people could be counted on the fingers of both hands. . . . Myself and family were completely ostracized. We scarcely dared to walk on the streets of town," he noted.

Lillian had left Ohio for Tennessee expecting white opposition but also imagining interracial harmony in her new job. She did not know that the majority of white teachers "did not necessarily think their living students were yet their equals. Some thought they never would be." The attitudes of her white colleagues disappointed Lillian most. Most of her fellow teachers looked down on blacks and refused to socialize with them or give them important responsibilities. In spite of working with blacks, they did not want to be charged with "nigger-loving." "I found to my surprise . . . that there was a difference between a 'missionary' and a 'friend.' Some teachers were one thing and some were the other." Lillian, determined to be a "friend," attached herself to the one teacher there, Eugenie Hepler, who refused to kowtow to whites or condescend to blacks. Hepler "lived in [the] New Jersey Home [a girls' dormitory] with the girls and showed at no time that she wasn't a woman of color. She entered into the social life of the students and went to church at the colored Methodist church." "Miss Eugenie Hepler," Lillian wrote admiringly, "was a 'friend' of the colored people. She took me under her care, God bless her memory." Through Hepler, Lillian learned to ignore being charged with "nigger loving," a challenge most of her white colleagues failed.

At Morristown, Lillian attempted to teach black history courses. Even Alain Locke, the leading black philosopher of his generation, could not succeed in getting a single such course approved at Washington, D.C.'s Howard University, the nation's premier black educational institution. She also initiated a student exchange program called "Friends of Africa" that brought African students (mostly from the Congo) to study

in Morristown. The program succeeded. But it raised eyebrows. She was rumored, according to former Morristown students, to have fallen in love with one of her older African students. What Barack Obama's mother, Stanley Ann Dunham, attempted in 1961 was nearly unthinkable in 1907.

Lillian crossed other lines as well. Most white and black faculty members did not socialize. She did. She grew especially close to her elegant black colleague Andrew F. Fulton, who taught English (basic academic skills) from 1889 to 1927. Fulton was a former slave, sold for $1,666 from the same building where Almira Stearns had first taught. In her later years, especially, Lillian also took black students, both female and male, to live with her in a cottage behind the president's house: an A-frame wooden house with a porch and three bedrooms but heat only in the living and dining rooms. The students spent winter evenings huddled together in the living room, reading or talking, sitting on Lillian's overstuffed red and black horsehair furniture, "the ugliest furniture I'd ever seen," one of them remembered. To Lillian, those students were always her "good friends" and her "best friends."

Her novel was intended as a gift to them, and she wrote her friendships into the book. *Let My People Go* is in many ways a classic sentimental/didactic novel, of the type generally considered heavy-handed. But as a writer, Wood incorporated a number of surprises into the novel's more predictable plotlines, testaments to how far she was willing to go and how unlike other white women she had come to consider herself.

On the face of it, *Let My People Go* seems remarkable only in the breadth of its historical reach and its attempt to condense all of black history into the life story of one Bob McComb, a black boy of origins so humble they are almost Dickensian. The novel weaves its way, via a classic sentimental love story between Bob and his beloved, Helen, through Reconstruction, lynching, disenfranchisement, early black education, the "Red Summer" race riots of 1919, officers' training camps, World War I, the New Negro, the Great Migration, and the development of the NAACP: "nearly all the race's ordeals," as Shockley noted. Lillian was obviously reading the northern newspapers in which her small

black college, Morristown Normal and Industrial, was placing weekly ads. She knew that the students and faculty at the college—a two-year industrial and teacher-training school founded in 1881—worried about their place in the "New Negro" world. Wood's fictional protagonist, Bob McComb, was modeled on her own hardworking students. *Let My People Go* proposes that such a young man, acting with reason and intelligence, could solve the problems that leaders such as Du Bois, Locke, and others found insurmountable. By implication, his teachers—women such as Lillian E. Wood—had a place in the future as well.

Just as Lillian Wood hoped to draw positive attention to Yankee schoolmarms like herself and her predecessors, so too did she aim to strike a blow against lynching. She wanted to enter the growing national conversation through her novel. With the explosive growth of the black press that occurred during the 1920s, readers in Harlem could track the persistence of lynching and the heartbreaking failure of attempts to pass federal antilynching laws.

From Alabama to New York State, blacks were murdered for being more successful than neighboring whites, "sassing" a white person who took umbrage, looking like someone else in a lineup, passing a white driver on the road, or being in the wrong place at the wrong time. They would be accused of theft or dishonesty because they spoke their minds, stood up for themselves, talked to or merely smiled at a white woman, or even let a white woman smile at them. And the "Big Lie"—that black men threatened white women—held sway in many places, although, as activist Ida B. Wells put it in her controversial pamphlet *A Red Record, 1892–1894*, no one in Harlem or other black communities "believes the old threadbare lie that Negro men rape white women." The fact that white women sometimes seduced black men was the far more dangerous truth. As Wells bravely noted, some southern communities would go to almost any length to hide that. "If Southern white men are not careful," she warned, with guarded circumspection, "they will overreach themselves and public sentiment will have a reaction; a conclusion will then be reached which will be very damaging to the moral reputation of their women." Wells's carefully worded warning nearly cost her her life. "'Tie

the wretch who utters such calumnies to a stake,'" a white newspaper responded, "'at the intersection of Main and Madison Streets, brand him in the forehead with a hot iron and perform upon him a surgical operation with a pair of tailor's shears.'"

The threat of lynching was a factor in the Great Migration of blacks moving north to cities such as Chicago and New York, and it helped create the population boom in Harlem. But northern cities were not altogether free of racial terror. In nearby Port Jervis, New York, in 1892, a black man named Robert Lewis was seized by more than a thousand whites who dragged him across almost half a mile of ground before hanging him from a maple tree. "Hundreds" of white locals "hurried to the lynching to see his body. Afterward, men women and children hacked apart the lynching tree and cut up the rope for distribution among the crowd. Port Jervisites proudly displayed their morbid relics in the following days." Wood used the lynching in *Let My People Go*.

The heart of the "New Negro" ideal was refusal to tolerate such violence: "If we must die; oh let us nobly die / dying but fighting back," as McKay put it. Too narrow a focus on Harlem's nightclubs and novels overlooked the pall that lynching cast over black communities and how central the antilynching fight was to the Harlem Renaissance, even—sometimes especially—when it was not mentioned. Frustration over lynching and the tepid national responses to it was as formative of the Harlem Renaissance—and as determining of the possibilities and limits of interracial friendship—as was enthusiasm for the arts. White women were so often the excuse for racial violence that Miss Anne had an important role to play in this struggle—if she was brave enough to take it.

Far too often, the nation proved indifferent to people of color. By the early 1920s, hundreds of antilynching bills had been launched, but none had managed to pass. National organizations such as the NAACP and, later, the Association of Southern Women for the Prevention of Lynching threw their weight—and much of their operating budgets—into lengthy, committed campaigns to pass meaningful laws. The most hopeful moment in the long antilynching struggle seemed to occur in 1921, when Representative Leonidas Dyer's antilynching bill was ap-

proved by the House of Representatives. But Dyer's bill was defeated, that same year, by a Democratic filibuster in the Senate. In response, there were stepped-up efforts by activists and a range of cultural appeals in poems, novels, and plays—giving rise to an entire genre of antilynching theater—but no federal legislation passed, then or ever. To some blacks, it seemed that white women cared more about the vote than they did about lynching.

National apathy was a devastating blow to blacks' hopes for white support. As scholar Jacqueline Goldsby writes, "The nation's callous disregard for the mortal danger under which African Americans lived was indeed widespread." Northern Methodist churches did not condemn the practice until 1900, only seven years before Lillian Wood went south, and southern Methodist churches stayed silent. Photographs of lynchings remained so popular—appearing commonly on postcards—that as late as 1908, one year after Lillian went south, the U.S. Post Office was forced to ban their circulation through the mails. "White Americans' apathy allowed lynching to thrive as much as did white southerners' much-studied antipathy." In August 1927, W. E. B. Du Bois expressed his outrage and bewilderment that "the recent horrible lynchings in the United States, even the almost incredible burning of human beings alive, have raised not a ripple of interest, not a single word from the pulpit, and not a syllable of horror or suggestion from the Defenders of the Republic, the 100% Americans, or the propagandists of the army and navy."

National indifference made the need for white allies more urgent. Southern black women writers reached out to white women: "The Negro women of the South lay everything that happens to the members of her race at the door of the Southern white woman. . . . We all feel that you control your men . . . that so far as lynching is concerned . . . if the white women would take hold of the situation that lynching would be stopped. [As for the excuse that lynching is necessary to protect] the chastity of our white women . . . I want to say to you, when you read in the paper where a colored man has insulted a white woman, just multiply that by one thousand and you have some idea of the number of colored women insulted by white men." "There must be good people of

the white South," one despairing black leader wrote. "If only they would give some sign, protest in some form, it would have telling effect." It was not enough to *tsk-tsk* and lament. Being a "true friend of the Negro" as Lillian Wood put it, now meant more than letting go of the long-standing white image of blacks as "childlike, affectionate, docile, and patient." It meant castigating other whites and, if necessary, renouncing them. It meant rethinking staid ideas about race and desire.

For the most part, white women came weakly and late to the cause. The Association of Southern Women for the Prevention of Lynching did not form until 1930. And it did not generally support full enfranchisement for blacks or endorse a black militant response to racial violence, advocating instead "a slow process of cultural change" through the influence of white women. Black activists such as Mary B. Talbert pleaded with white activists such as Mary White Ovington: "The hour has come. . . . I am firmly convinced that your help and co-operation is needed at this time." But little changed. It is no wonder, then, that a woman like Lillian Wood, looking around her and lacking political skills, decided to act on her own and no accident that she turned to literature.

Let My People Go is a wish-fulfillment novel. It imagines resolving this intractable issue of lynching, the most pressing one facing black communities in the 1920s. And it imagined white women playing an important role, refusing to be the excuse for the violence perpetrated against black men. Historian Glenda Gilmore noted that "most white women simply could not overcome the racial contexts in which they lived, even if they had thought to try." As much as her move to a black community, Wood's novel was an attempt to both confront and overcome her race. Bob McComb advances from a college modeled on Morristown to the U.S. Congress, where his demand that "Lynch law and Mob rule be abolished" is met with unanimous enthusiasm. He is able to speak back to the highest levels of national power, insisting "that the President be instructed to enforce this measure" (at a time when enforcement of existing laws was virtually nonexistent in some parts of the nation). And his congressional acts inaugurate a new day for black America, a "morning light" for "our people."

Bob's national triumph comes at the end of many tribulations. He is orphaned at fourteen, escapes three lynchings, avoids jail after being wrongly accused of a theft, acquires a white patron, goes to school, meets and courts his wife, joins the service, fights valiantly, is wounded and recovers, chooses to live in Tennessee over New York or Chicago, and prospers as a "race man." One dramatic incident sets everything he does in motion. He is "called" into service to his race when he witnesses a young black woman's anguish after being raped by her white employer. Feeling for "his sisters suffering wrongs such as that," Bob determines that he will do "somethin' to help the girls."

Lillian knew firsthand of such incidents in the lives of her female students. At Morristown, she vigorously defended a black female student who had been living off campus with a local minister and his wife. When the student became pregnant by the minister and the school moved to expel her for indecency, Lillian took her into her home and made sure she was able to pass her examinations and graduate with her classmates. "I remember Beulah with pleasure," she later reflected. "I was and am sorry that I displeased some of the faculty, but it seems I had to try to save my girl." A few women, former students at Morristown, remember how risky the defense of Beulah Tucker was. "She took a chance," one said. "She was brave to do that," said another. The centrality of black female honor in Wood's novel indicated to many that its author must be a black woman. Shockley praised how well the novel "summed up the new black woman." Other bibliographers have similarly assumed that this portrait of the "emerging black woman" displays the inside understanding of a black woman writing about her own people.

Lillian's white colleagues did not like her book. "It was not well received by some white members of the faculty," she wrote in her unpublished memoirs, "and was refused by some book sellers. They thought it was too radical and pushed the Negro forward too much." Financially and critically, the novel fared poorly. It had a modest print run of five hundred copies, was not reviewed, and appears not to have been advertised. She gave away as many copies as she sold.

But among her former students at Morristown, the novel did well. Her

"best friends" (her students) all spoke "well of it," she reported happily. I was able to meet a few of those former students, including some who had lived with Lillian Wood toward the end of her life. They confirm Wood's remembrance. *Let My People Go*, they told me, was important because it demonstrated that an older white woman from a very different northern background could "get it"—could empathize with the issues dearest to young black men and women and, especially, with ideas about black female sexuality. She had a "tremendous impact" on them, they told me. "She was very sincere." She proved that in spite of race, people are "just people." The forthrightness of the book belied schoolmarm stereotypes. "What she believed in, she would let you know," her students noted admiringly.

The Franklin sisters, Odessa, Violet, and Lady Bee Coleman, former students of Lillian Wood who lived with her at Morristown College; their copy of Let My People Go *is carefully preserved.*

Her portrayal of the teacher-student relationship between Bob McComb and the white Miss Ranier, "a small white woman with beautiful graying-brown hair," stands out. Wood used it to model interracial

intimacy. Why is it, Bob asks, that some white teachers just don't "like Negroes," for all of their "talk? . . . Miss Ranier . . . looked at Bob, and his eyes met hers with a look Bob always remembered. It seemed that they looked into each other's souls and found out that they were the dearest of kin. From that time forward their friendship was firm and true. She held him to her soul, and he was her own." Miss Ranier was Bob's "best friend."

Wood contrasted Miss Ranier with false "friend[s] of the Negro" who oppose "social equality." But Wood went considerably farther. Doing what even black radical antilynching activist Ida B. Wells would not have dared, Wood depicted white women as absolute fiends. She painted a scene of an Illinois lynching in which the most brutal participants are the white women:

> A crowd of white women, with wildly flying hair and garments, rushed by just as a shot struck the [black] preacher's wife. Two women took the body and threw it back into the burning house; then they rushed on. One of them stumbled and fell over [the little child] Teddy who had fallen near the burning cottage. She arose with a curse, grasped Teddy by the arm, and dragged him to an open space in the throng. Then these savage women stripped the clothing from his little body and in [a] frenzy of hatred they stoned him until they had finished the earthly life of their victim. They then threw the body into the flames.

This is the most condemnatory portrait of white women I have encountered, and one of the very few portraits of lynching to also include white women. It all but declares war on white womanhood. In it the author advocates "fighting back" against her "own" people and represents white women, not blacks, as beyond the social "pale."

Her support of black militancy was probably especially discomforting to her white colleagues. The Morristown College teachers were instructed never to strike back at their harassers. Indeed, they were

instructed never to look at them. Students and faculty were counseled in forbearance. *Let My People Go* gave lip service to that ideal, but it emphasized, instead, the New Negro manhood and the right of blacks to fight for "the rights of men, the respect due to men, and the chance of men."

Wood published her novel through the African Methodist Church's Book Concern, a highly unusual move for a white Methodist. Its foreword, moreover, was written by Robert E. Jones, the first black bishop of the Methodist Church. In African-American literature there is a long tradition of white prefaces preceding black autobiographies, part of the "authenticating machinery" designed to reassure white readers that the story is true and its author trustworthy. There is no corresponding tradition of white literature depending on black "authenticating machinery" to establish its legitimacy. Even Mary White Ovington did not turn to W. E. B. Du Bois to introduce her memoir of founding the NAACP. In giving Bishop Jones the first word, Wood pointedly reversed hundreds of years of custom.

Of course, since she had been taken for black for so long, much of this went unnoticed, except locally. In Morristown, Lillian remained visible, living at the college during the school year and with her sisters in Knoxville in the summer, and taking creative writing courses at the University of Tennessee. Morristown College kept faith with Lillian Wood. When it was accredited and the state required all teachers to have college degrees, Lillian E. Wood, who never earned an advanced degree, was made college librarian. When her sister Alma died, the school permitted her other sister, Florence (also uncredentialed), to move in with Lillian on campus and give the students piano lessons. When Florence died, the black college president accompanied Lillian to Ohio for the funeral (one can only imagine what her Ohio relatives thought of that). As Morristown transitioned from a mostly white faculty to an all-black faculty, Lillian Wood remained, living in campus housing and receiving a small salary.

Nonetheless, vestiges of old racial attitudes are visible in her novel. Occasionally, in *Let My People Go*, blacks roll their eyes. Sometimes they exhibit the "usual optimism" of their race and "laugh, sing, and

feast," thinking "as little as possible of the morrow," as do Harriet Beecher Stowe's characters, Mark Twain's, and Joel Chandler Harris's. Lillian Wood was not perfect. She was one of a band of what Almira Stearns called "remarkable women," women who, while ordinary in many ways, nevertheless did extraordinary things.

When Wood wrote *Let My People Go*, black colleges such as Morristown were well into a historic shift away from all-white faculties. Morristown, in 1925, was roughly fifty-fifty. By the time Lillian Wood died of a heart attack at Morristown in 1955, she was the only white faculty member left standing in the yearly faculty photograph, a striking presence with her large bun of white hair and her heavy suits and dresses. She was ninety years old and had spent forty-eight of those years at Morristown, more than half of her life. She failed in her effort to attract the notice of white women of the Harlem Renaissance, but she clearly watched them from afar and was influenced by their writings. I suspect she would have been very glad to know some of the women in this book, such as Mary White Ovington, Annie Nathan Meyer, Fannie Hurst, and even Josephine Cogdell Schuyler. Charlotte Mason, no doubt, would have put her off and alienated her. And she probably would have been shocked by Nancy Cunard. No doubt she would have been especially glad to know Amy Spingarn, who mounted an extraordinary antilynching exhibit in 1935. Spingarn's show, "An Art Commentary on Lynching," like Wood's novel, was unusually graphic. Some called it "grisly" and "heartbreaking."

Integration was not kind to Morristown College. Like many historically black colleges, it struggled to attract students. Finally, in 1989, it was acquired by Knoxville College, also a struggling historically black college. Knoxville hoped to use the fifty-two-acre campus, with its beautiful historic buildings, many of them on the National Register, as a satellite campus. But Knoxville lost its own accreditation and had to give up its Morristown plans. The school stood abandoned from 1994 to 1996, vandalized and decaying. A few of its records and archives were transferred to Knoxville, but most were left behind in the empty buildings. The Morristown campus was purchased in 2006 by a local developer for $776,000. He

wanted to convert it into condominiums. But he soon declared bankruptcy and then died, leaving the school grounds abandoned again. A series of arson fires then picked off the campus's most striking historic buildings: the cafeteria, the gymnasium, dorms, and science buildings. In 2010, another arson fire reduced the college's crown jewel, its Laura Yard Hill Administration Building, to a pile of smoking bricks, each of which had once been made, on campus, by Morristown College students.

During the years of neglect, local alumnae did what they could to salvage the college's records and movable artifacts. Often in their sixties, seventies, and even eighties, they braved unsafe flooring, dug through Dumpsters, challenged homeless squatters and drug addicts, looked around crumbling corners, and carted what they could into their cars. Some records were taken to a Head Start Center, where the Progressive Business Association then met around long folding tables to discuss its hopes for black Morristown. There they stored college records and photographs, catalogs and artifacts, archives and newsletters as best they could in a wall of dented tan file cabinets.

Among the many artifacts stored at the Progressive Business Association was a life-size bronze bust of a white woman, which sat on the edge of a black folding table.

Bust, depicting either Almira Stearns or Lillian Wood, maintained by Morristown's Progressive Business Association (now defunct).

She has a roundish face, a large bun, and a determined, kindly face. She was identified to me as Almira Stearns, but she looks more like Lillian E. Wood. When I asked for clarification, no one was quite sure which of those two teachers the bust represented. They were certain, however, that she needed to be preserved somewhere people could see her, along with the rest of the college history, which, they knew all too well, was vanishing.

The once eminent black school Morristown College, for sale.

Josephine Cogdell Schuyler:
"The Fall of a Fair Confederate"

Most of America is crazy on the race question.

—Josephine Cogdell Schuyler

My purpose? To break down race prejudice that my children may not suffer as my husband and my friends in Harlem . . . and that families like the one in which I was born may cease to exist.

—Josephine Cogdell Schuyler

Sad Are Beautiful Revenges.

—Josephine Cogdell Schuyler

The Schuylers at home.

It almost did not happen. But late on a cloudy, unseasonably warm Friday in early January 1928, a petite, graceful white Texas beauty named Josephine Cogdell slipped into the New York City marriage license bureau with her black lover, George Schuyler, Harlem's most biting satirist and a widely published journalist: a short, dark, elegant man with excellent manners, an arch wit, and a sardonic smile. They were exceptionally well dressed, dignified, and mature—both in their early thirties—but they were being treated like children, conducted from one corner of the municipal building to another by scowling officials, then rushed through the steps of their civil ceremony without explanation or congratulation. A graying justice of the peace, anxious to clear his desk and get home, read from a perfunctory script without looking up. George barely had time to peck Josephine's cheek before they were hustled outside again, where they found themselves standing on the stone steps, left alone to adjust to their new status under the muted colors of a winter sunset slanting through lower Manhattan's administrative buildings. Josephine looked up from under her new green hat, swayed, and steadied herself with a gloved hand on George's arm.

She had succumbed in a daze to the disappointing ceremony. Now she imagined that she "was being abducted by a dark prince who would take me to his castle in an exotic new land." The weight of racial intolerance was bearing down on her, demanding that she sacrifice "everything I knew" and bid an "emotional farewell" to the white world. She feared that she would never again return to what she knew or be known for who she was. It felt like dying. "I have dropped completely out of sight. No one in the white world . . . knows my whereabouts or will ever know."

Josephine was admittedly "dramatic." And she would have acknowledged being theatrical about having to "cast my lot henceforth with the Negro." But for all of her hyperbole, she was not understating the vertigo-inducing stakes of marrying George that day. The taboo against interracial intimacy, or miscegenation as it was still then called, was fundamental to maintaining myths of racial difference and purity. In 1928, blacks and whites lived in such different worlds that white women who

married black men did undergo a kind of social death, often expelled from family, home, and community. As they attempted to enter a black world in which their presence was an unwelcome reminder of inequality and oppression, they often found themselves without kin, church, or familiar social networks. Many crossed over without knowing much about black cultural expectations or black history. Some knew only a few black people. Most were ill equipped to face the hostile reaction they engendered or to fit into the new world they had chosen.

The newspapers, meanwhile, were thick with warnings to race-crossers. An assistant professor at a medical college in Virginia had recently been fired for remarking, hypothetically, that she'd prefer to "marry an intellectual and highly cultured 'Negro' than an inferior type of 'white man.'" In Poughkeepsie, New York, a black man was charged with "second degree criminal assault" for the "crime" of living with his white wife—in a state that had no laws prohibiting intermarriage. Only one state over, in Connecticut, Beatrice Taylor, a *Mayflower* descendant, could not find a single minister willing to marry her to her fiancé, Clarence, "who looks white, but isn't." In Washington Heights in New York City, white Helen Croute was beaten by white neighbors who resented her marriage to a black man. Marriages that were routine in every way but race, such as that between Edith Sproul and Jerome Peterson, two young medical students at Columbia University, were described in full-page spreads. The Jack Johnson case lived on in an angry white imagination of the "growing evil" of intermarriage. And the Rhinelander case, with its painful reminders that even where interracial marriage was legal, it was still considered immoral, and that those who crossed race lines might be subject to untold and unimaginable humiliation, was still headline matter in 1928.

Intolerance of interracial intimacy was not confined only to southerners. Nor only to whites: the black press, albeit less hysterical, was hardly more supportive. With "social sensibilities [against intermarriage] . . . intensifying on both sides of the [color] line" throughout the twenties, many black editors were quick to pronounce interracial unions "unwise" and insist that *their* papers had "never argued for racial intermarriage."

Some claimed that most blacks were not "overeager to marry into the white race" and felt, as a race, "neither eagerness nor expectation of intermarriage or amalgamation." An "uncharitable attitude" toward blacks who married whites was sometimes justified in the black press with reference to the long history of the trouble that white women had visited upon black people. Almost as many blacks as whites had objected to the "miscegenation theme" of Eugene O'Neill's *All God's Chillun Got Wings* in 1924. And more than ten years after Johnson walked away from prison, black readers were still writing letters to editors lamenting that the fighter had not married "some worthy black woman" rather than the two white wives who had brought the black community such bad press.

Marriages between black men and white women, as George and Josephine well knew, were especially stigmatized. It was fashionable to cross race lines in cities such as New York and Paris if one crossed them just so: dancing at nightclubs, watching black revues on Broadway, visiting black churches, sponsoring black literature and arts, and attending interracial parties. But marrying black men, even where such marriages were legal, was not part of the accepted Harlem "vogue." Josephine noted a "difference in attitude among Aframericans [George's word] toward the Alice and Kip Rhinelander affair and the two marriages of Jack Johnson." She knew that "love between a white woman and a black man was sensational even in the *tumulte noir* of the 1920s."

Josephine and George were newspaper buffs. To keep up with his competition, in fact, George sometimes read as many as a dozen papers a day. Josephine had been reading black papers since the early 1920s, when she had departed Texas for San Francisco. (In fact, they had met through *The Messenger*, which he edited and to which she subscribed.) Both were keenly aware that they were making themselves "outcasts." Their chief worry that day was keeping their marriage a secret from Josephine's family. "My family is incapable of ever understanding my marriage as anything but insane and disgraceful," Josephine believed.

Racial norms are maintained, for the most part, in the breach. Those who crossed race lines in the 1920s and 1930s could expect "crazy"

retaliation—not only beatings, murder, or ostracism but also the loss of social identity that the court's assault on Alice Jones Rhinelander's womanhood demonstrated. The tabloids would have been thrilled to obtain a photo of the Texas heiress and the smirking black writer. As it happened, the Schuylers married on a day when the nation's attention was riveted on Charles Lindbergh's successful landing in Nicaragua. Taking advantage of that, marrying late in the day, informing no one of their plans, and deploying every subterfuge they could devise, the couple successfully evaded the very press attention that, a few years later, when their daughter was born, they would begin to actively court.

During the Depression, George and Josephine became Harlem's most vocal proponents of intermarriage, advocating interracial intimacy as "the permanent solution," Josephine called it, to America's race problem. With Josephine's help, George became "the most recognizable name in black journalism . . . a star." Their daughter, Philippa, born in 1931, turned out to be a genius, and they proudly showed her off as an example of the benefits of "miscegenation." Josephine had very set— and unusual—views about child rearing that Philippa's musical talent helped her disseminate. Prominent publications such as *Life*, *Time*, *The New York Times*, and *The New Yorker*, as well as *Ebony*, *The Pittsburgh Courier*, and many other national black magazines, profiled the Schuyler family. Josephine and George became "the first interracial celebrity marriage in Harlem since the [marriages of] boxer Jack Johnson."

For the next two decades, the Schuylers straddled contradictions. They were a national news item—"America's Strangest Family," as one magazine put it. Amazingly enough, given the mainstream coverage, they were also kept a secret from the Texas Cogdells. Every Christmas, D. C. Cogdell sent his daughter in New York a big box of pecans harvested from the family's trees. He never imagined that in their apartment in Harlem's tony "Sugar Hill," a black son-in-law would eat the nuts while reading *Opportunity* and writing about the absurdities of the "pork-skins," while a "mulatta" granddaughter, in her room down the hall, ate the pecans while practicing her piano. Josephine's sisters

came to see her in New York, even visited her Harlem apartment, yet remained somehow unaware of both husband and daughter. Family mail was addressed to Miss Josephine Cogdell or to her pen name, Heba Jannath. Every year, Josephine went home to Texas alone. No one asked questions. George found the studied silence remarkable. He tested it by writing about it in *Modern Quarterly*, a well-known socialist journal with a mostly white, national readership. "It is incredible," he remarked, "how long a mixed couple can be married, their marriage be well known throughout Aframerica, and yet be unknown in the white world. . . . Nothing more forcibly reveals the social chasm dividing the two races." In a world where blacks and whites led separate lives, whites could afford not to know what they could not accept. Women like Josephine could hide not only in plain sight but under klieg lights.

In addition to straddling the nation's contradictions over privacy and publicity, the Schuylers embodied all of their era's contradictory ideas about race itself. They became Harlem's most strident anti-essentialists, arguing that the "general terms 'Negro' and 'Caucasian,' 'black' and 'white' are convenient propaganda devices" and that "race is a superstition [*sic*]." Yet they also constructed a marriage based on the erotic appeal of the very difference they decried. Sometimes they advocated all manner of passing and race-crossing, believing that none of us have "our own" people, distinct from others. At other times, they talked about "we" or "us" in ways that were inescapably racialized.

Today, when we are surrounded by interracial images, it may be hard to grasp how brave George and Josephine were in their time. The lines they crossed did not begin to break down until recently. The first interracial kiss, for example, did not take place on television until the late 1960s. In the 1920s and 1930s, these were not lines that most people were willing to cross in the open. But Josephine and George founded their marriage on their shared willingness to brave censure, violence, and isolation for what they thought was right. As they often put it, they spent their lives trying to "break down race prejudice" so that the challenges they faced would fade in future generations.

To that task they brought their own myriad contradictions about

race. Throughout their lives, the two principals of Harlem's "interracial celebrity marriage" oscillated among all of the available positions on the race debates of their day (debates that remain central in ours): Is "race blindness" a goal or another form of racism? Can one attack racial essentialism and still celebrate race difference? What, if anything, do we owe our "own" race? Can we switch races, opting for an identity based on affiliation rather than blood? Sometimes the oscillation brought them closer together. Sometimes it drove a wedge between them. In that, too, they mirrored the texture of political and emotional ties in Harlem. Those were the questions creating mixed reactions to blond, blue-eyed NAACP leader Walter White's decision to declare himself black and use his light skin to go undercover among lynchers. These questions created the divided view that Zora Neale Hurston was both too race-proud and too white-focused. They generated controversy about white Annie Nathan Meyer's *Black Souls*, held up as a model for black theater. They fueled an uproar over white writer Carl Van Vechten's 1926 novel *Nigger Heaven*.

Carl Van Vechten was one of the Schuylers' best friends and a walking set of contradictions all by himself. He paid a telling tribute to his friend Josephine. In addition to being Harlem's most famous "honorary Negro," Van Vechten was also an incurable pack rat and kept every scrap of paper that ever came his way (much to the horror of his wife, Fania, who had to move his teetering piles in order to sit down anywhere in their huge Central Park West apartment). Van Vechten loved letters. He wrote thousands of them, was unusually well connected, and was one of the best correspondents of the century. His correspondence registry reads like a *Who's Who* of the epoch: Mabel Dodge Luhan, Muriel Draper, Theodore Dreiser, Waldo Frank, Lillian Gish, Fannie Hurst, Alfred and Blanche Knopf, Sinclair Lewis, H. L. Mencken, Gertrude Stein, Ethel Waters, Langston Hughes, Claude McKay, James Weldon Johnson, Walter White, W. E. B. Du Bois, Dorothy Peterson, Chester Himes, Richard Wright, Jean Toomer, Arna Bontemps, Countée Cullen, Zora Neale Hurston, Wallace Thurman, and others. When it came time to turn that vast archive of letters over to the Beinecke Rare Book

and Manuscript Library at Yale University as the core of the collection Van Vechten created and named for his friend James Weldon Johnson, he faced a difficult decision: should he retain or discard the filing system that he had used at home and that had been so important to him for decades? In Van Vechten's careful system, every letter he kept (which means every letter he ever received) was meticulously categorized under either "Letters from Blacks" or "Letters from Whites." This system was not merely a clerical convenience; over the years it became one of the nation's best resources for determining the race of less-known members of modern America's literary and artistic circles. Van Vechten built his reputation as an "honorary Negro" partly on his ability to detect anyone's race. He prided himself on being the one who could always "tell the sheep from the goats," as Nella Larsen put it in a famous caricature of him. His racial radar, as we would now say, proved his bicultural bona fides. There is only one exception in this vast racial schema: all of Josephine's letters he placed under "B: Letters from Blacks."

Why? In part it was an inside joke between fellow race-crossers. In just the same playful spirit, Josephine sometimes referred to them all—Carl, Fania, George, and herself (all white, except for George)—as "Us Darkies."

But Van Vechten's sly miscategorization was also his homage to Josephine's effort. He put his friend where she did her best to fit in, detractors and naysayers be damned. This tribute recognized that once she had married George and given birth to Philippa, she did not "belong" anywhere and ceased, in an important sense, to be white. As a married bisexual and "honorary Negro" hated by many whites, Van Vechten had a keen sense of the costs, and the joys, of not fitting in. As he knew well, freedom *from* constraints is a taxing kind of freedom. It is different from the freedom that comes from privilege and standing: freedom *to*—to represent oneself, express oneself, pursue happiness, and so on, all the freedoms we pursue within our socially recognized identities rather than by escaping them. We do not have to look far, Van Vechten was keenly aware, to find unhappy stories of those who free themselves from social categories only to find that they have nowhere to go.

On January 6, 1928, as she stood on the steps of the municipal building, all of those challenges and questions were still in her future. Josephine's objective that darkening Friday winter afternoon was simpler. She was trying not to faint.

"My White Fortress"

The white woman was almost as much a serf in Dixie as the black man.

—Josephine Cogdell

I beat the walls for wild release.

—Josephine Cogdell

Josephine Cogdell was born on June 23, 1897, in Granbury, Texas, a pioneer town rich in both natural resources and legendary townspeople (Jesse James, Davy Crockett, and John Wilkes Booth among them). Residents were—and are—proud of its Confederate past and the Confederate general for whom the town was named; when the general's remains were brought back to Granbury for reinterment, the Hood County mourners stretched from one end of town to another, miles of mute testimony to the principle of never forgiving or forgetting their losses. Bloody battles with the Comanche and the Apache and the war with Mexico paved the way for Josephine's ancestors: men who bought up towns, administered by force, and laid down the law. The Granbury "lynching tree" was just off the main road and visible in all directions, towering over a dusty clearing. Every Granbury resident knew that tree and what it was for. Granbury residents often referred to the town's "colorful" past. Josephine called it "savage." Nearly a hundred years later, residents remain testy about Granbury's violent racial history. A few well-meaning older white residents of Granbury still exhibit the condescension and love-hate attitude toward blacks that Jody, as she was called then, was taught as a norm. Describing the "colony" or "nigger

colony" where blacks then lived and that has now been flooded over to form the town's lake, one local historian told me that blacks had been self-segregating by choice. Everyone was happy with the way things were, she believes. "It was understood that they [blacks] kept their place and there [were] so few black people here, and we all knew each other; we were all friends." Another local historian, describing Jody's cook, told me, "Her name was Nigger Phoebe, and she liked to be called that."

When Jody was growing up, Granbury was still a thriving county seat with five cotton gins, wooden sidewalks, three jewelers, two milliners, three newspapers, three hotels, seven doctors, four law firms, five saloons, six grocery stores, a hardware store, an ice cream parlor, a saddle shop, and "little or no middle class." While most residents scrambled in farming or ranching, the Cogdells presided over Granbury like royalty. Jody was raised to view herself as better than everyone else in town.

Her father, Daniel Calhoun (known as D.C.) Cogdell, had accumulated his wealth through banking, racehorses, and mills. With only a third-grade education, he had worked himself up to founding president of the First National Bank of Granbury in 1887, a position he held for forty-eight years. By the time Jody was born, the youngest by many years of the Cogdells' eight children, D.C. owned "around a million acres of land scattered throughout the state, and always kept thousands of head of cattle." He had the clout to bring the Fort Worth railroad right into the middle of his property, creating, just a mile or two from the town's main depot, a personal station for transporting his cattle. D.C. was brutal, but he could also be generous. He doted on Jody. She had tutors, trips to Fort Worth, ballet, theater, concerts. She basked in his largesse. She admired her father's "super-energy," his "great deeds," his "penetrating intellect." D.C. was, she noted, "an excellent type of the Feudal Ruler."

Whereas most of the town's well-to-do families lived clustered around the town square and courthouse, D.C. installed his family on a lavish estate planted with live oaks and pecan trees. The Cogdells disdained their neighbors. But the house was designed for socializing and show,

with a wide front porch, a full-length balcony on the second floor, large rooms, extra-wide hallways, and butler's bells, all built to impress. D.C. didn't care much about being liked. He required envy. "We lived on a scale people just don't live on now," said Jody's brother Buster. "We had one of the finest collections of cut glass and sterling silver in the state of Texas. . . . We always had three, four, or five servants and clothes made by a dressmaker in Louisville, Kentucky." D.C. spent money on things Granbury had never heard of: bird's-eye maple floors, master cabinetry, leaded-glass doors and windows, a central heating system, a music room, and a library, even though "writers weren't held in high esteem," as one family member told me. He had a custom-made soaking tub more than six feet long which guests were exhorted to admire. Behind the house were quarters for the servants and stables for his prize racehorses. Every Cogdell was an excellent rider. It was a beautiful home. And Jody hated it. "How I loathe it all," she wrote. "The house that smothered me and imprisoned my youth."

In that world, Josephine wrote in an unpublished novel, feminism was dismissed as a "silly notion" held by women who should have been making do, not making a fuss. "Mama was a lady," she wrote of her

The Cogdell family home, built by Josephine's father. The house burned down when Josephine was in her late teens and was replaced by another on the same foundation.

mother, Lucy Duke Cogdell, born on a Louisiana sugar plantation to a gentleman farmer and his French bride. "The defeat of the South hit them hard." D.C. proposed to Lucy and married her when she was only fourteen to spite Lucy's mother, an attractive thirty-four-year-old widow who had spurned him. It was a marriage foreordained to fail. Lucy exacted her own revenge. One family member described her as "savagely selfish." Josephine said she was "determined, dogged, and overbearing." Jody appreciated her mother's stubborn efforts to "always put her best foot forward." But she resented her dullness and neglect. "Her thoughts were all borrowed thoughts. . . . When you talked with her she showed not the slightest attention." The mismatch of her parents' marriage—a "pigmy and a giant, a hare and a lion, an oak and a vine"— always upset Jody. As a child, she set herself against marriage in her determination not to "be a bit like" her mother, nor "any man's slave." Even as an older woman, exposed to a first-wave feminist understanding of domesticity, Josephine never showed any sympathy for her mother. Though she fought with her father, physically and once quite violently, she always took his side. After Jody was out of the house, Lucy Duke Cogdell hit her head on the top of a car as it went over a bump and broke her neck. She remained partially paralyzed for the rest of her life. Jody still refused to "sacrifice" her life to her mother's conventional notions.

The Cogdells wrote their own rules in Granbury. "They were fiery, temperamental, uncompromising, ruthless, rapacious, arrogant, and strong-willed. They had a craving for danger and a desire for power." They were a "'godless family . . . they worshipped one thing and one thing only: money.'" Her older brother, a stunningly handsome alcoholic, was rumored to have killed a man. At home, he wandered about stark naked. Jody knew that many of the strategies by which her father, and later her brothers, acquired the family's wealth were morally dubious at best, "superbly unmoral" at worst. With all the high moral standards of idealistic youth, she deplored their tricks, such as paying the taxes of wounded soldiers in exchange for their lands. But appalled as she was, she still thrilled to a sense of difference that came from knowing that the Cogdells were all "absolutely unfitted by temperament and

intellect [for] . . . Domesticity!" They had all, she felt, succumbed to the family "tragedy" or "wasted" themselves by trying to fit in. She was bent on avoiding their fate.

A true Cogdell, she was headstrong, adventurous, stubborn, and egotistical. Although she painted, read, wrote poetry, and embroidered— all traditional occupations for a young girl—she had unusual tastes, preferring astronomy, botany, and biology to the more typical drawing room pastimes. Allowed to take her pony out of the stables alone, she would ride him for miles through the scrubby Texas countryside. For her thirteenth birthday she asked her brother Buster for a penknife. Snakes did not faze her. Classical music bored her.

Although she had everything money could buy, "she was not happy," a niece remembered. As much as she admired the Cogdell spirit, Cogdell behavior horrified her. Too many of the Cogdell men "murdered, quarreled, raped, and used their money recklessly in order to achieve their goals." She could be most like them, she intuited, by putting distance between them and her. "'She tried to have some kind of world view, something other than a parochial or provincial viewpoint. . . . She was groping. She had a fine mind,'" a nephew remembered. Brief stints at boarding schools did not work out. Jody made friends and was exposed to new ideas—she read Elinor Glyn's scandalous novel of an adulterous affair, *Three Weeks* (one of Nancy Cunard's favorites), with particular delight. But she could not conform to the discipline such schools demanded.

Jody had no siblings near her age and was not allowed to play with other children. She was forced to draw either on a family she could not fit into or on the servants whose intimacy she was denied. It made her an unusual and mercurial child, "'liable to do most anything. She was histrionic and artistic, and prone to great mood swings. Always dancing, dressing up, horseback riding, memorizing poems and plays or writing in her diary, she was continually in motion as if warding off something terrifying yet unknown.'"

Without her family's knowledge, Jody took her pony to visit "all the iconoclasts, who became my veteran cronies, black and white, ex-

rangers, gamblers, one-legged cowboys, rheumatic washerwomen, and country philosophers." Her favorite companions were the Cogdell family servants, Aniky, Rhoda, Joe, Mandy, Ivory, Linky (the cook), Bup (the houseboy), and Big Jim (the groom), who, oddly enough, also served as Jody's nurse. He took her riding daily and taught her "how to shoot, skin a possum, ride a bronco, and rope a cow." Her friendship with Big Jim probably "doomed" her to a sexual preference for black men, she later felt. She wrote that when she was a child,

> the activities of the Negroes fascinated me. The were always doing something interesting—branding and dipping cattle, slaughtering hogs and sheep, shooting wild game or chasing coyotes out of the pastures, gathering pecans from the towering trees along the creeks. . . . Good-naturedly, they let us white children follow them as they went about their work. On social occasions they provided music for dancing and entertained our guests with cakewalks and songs. [Elsewhere, she wrote:] I preferred sitting in our large, airy kitchen with the honeysuckle and wisteria vines poking into the windows, amid pleasant odors of baking and frying, listening to the sardonic comments on life which were flung out in a running repartee between Jim, Linky the cook, and Bup our long-legged black houseboy, to hearing the musty platitudes soberly pronounced by my mother and her friends in our marble and mahogany parlor. I particularly liked Monday, which was wash day, for then Linky would help Rhoda, who was washing under the big live oak in the back yard. The clean scent of the lye-soap boiling in the pot, the acrid odor of burning twigs under [it], the bed and table linen flapping on the line, dazzlingly white in the sunshine, and the two robust Negresses standing over their tubs of hot suds in the cool shade. [And she noted:] My mother, watching us hang around the half-dozen colored laundresses when they gathered under the big oak trees in the back yard to

do the weekly washing, would sigh, "You are just like your father. He never knew what class or color he was."

Jody trailed after the servants into the "colony," where all of Granbury's black people were forced to reside. She could never understand such segregation. But as a child she accepted it.

Josephine and the family cook.

Like many of the southerners around her, she both loved black people and saw herself as superior to them. In her own words, she was a "thoroughgoing Negrophobe, a believer in the superiority of my white skin, in the preciousness of my white womanhood, in the gallantry of Southern white men, and the mental and spiritual inferiority of all people with dark skins. Sentiments eminently befitting the daughter of a cotton and cattle baron." Believing in white superiority did not detract from feeling comforted "among these black people . . . soothed as in a dark swan's nest." Such ambivalence was part of her Cogdell (and southern) legacy.

Her father was a member of the local Ku Klux Klan. "Any mention of the Negro, save in a servile role, infuriated" him. Yet, Jody noted, he drew "no color line in his love life." He had a black mistress for more than forty years and subjected his wife to what one family member called "countless humiliations." Josephine's brother Gaston also had black mistresses and a biracial daughter. "Interracial love was not unknown in my environment." But such hypocrisy was revolting to the young Josephine. She wanted to be proud of her family's success. She was eager to offer unconditional love.

Once she left home, and for the rest of her life, Josephine thought about her father and brothers, wrote about them, traced their complex genealogies, longed for them, and—with the exception of her brother Buster—refused to speak with them. They haunted her nonetheless. For her daughter's fourth birthday, for example, Josephine's cake was an elaborate reconstruction of the Cogdell family home, complete with chimney, roof, a well, and footsteps made of coconut and cinnamon. Growing up in thrall to their exploits, indulged by them, petted by them, but enraged by them made her choice to give them up both inevitable and heartbreaking. It left her with a bottomless resentment toward any kind of duplicity. Her fierce determination to forge a life free of sex stereotypes and racial hypocrisy became, in its way, a private dialogue with them, a way to keep them in her life, to cherish a memory of "a romantic era."

"From Texas to Harlem with Love"

I was a thoroughgoing Negrophobe.

—Josephine Cogdell Schuyler

I became a Negrophile.

—Josephine Cogdell Schuyler

Josephine always considered her exodus from Texas and her eventual arrival in Harlem an adventure story worth telling. She wrote it up as "From Texas to Harlem with Love," a novel that she shopped around, without success, for decades, until all known copies of it eventually vanished. She was especially proud of going from Negrophobe to Negrophile. It proved that self-education and clear thinking could triumph over convention.

A historian who was Josephine's contemporary wrote that "it is possible for the Southern girl now to an extent never permitted before to . . . become a person and not just another woman." Josephine could not become a person under the Cogdell roof, so she chose a time-honored, even clichéd, maneuver: she eloped. At sixteen years old, after what must have been a lightning-quick courtship, she married Jack Lewis, a traveling salesman she met through the boy she was then dating. She hardly knew Lewis when she married him. The Cogdells did not consider him a proper suitor for their daughter, and he courted her in secret. Josephine married him in spite of feeling that he had seduced and taken advantage of her. Lewis was an alcoholic and a womanizer. He had swaggering self-confidence and "flaming joviality," but to Josephine he was "crude." The marriage failed quickly, as they found themselves incompatible in every way but sexually. Lewis's work as a "drummer"—a company representative for Purity breakfast cereals— made cheating all too easy, and she found keepsakes from other women in his suit pockets during his returns from sales trips. In response, she tried to "humiliate wifehood" with affairs of her own, playing out sex-

ual scenarios she'd read about in novels. Quickly becoming pregnant, she had a clandestine—and dangerous—abortion. According to one guarded reference in her diaries, Lewis was killed not long after his return from military service, in something she described cryptically as a "very strange affair." Josephine never referred to herself as a widow and all but erased the marriage. Her reference to Jack's death may have been angry wish fulfillment on her part. Though they separated not long after marrying, they seem to have divorced only once Jack was drafted into the army and went to war as a soldier with the American Expeditionary Forces in Siberia. Whatever Jack's fate, Josephine kept the Lewis name in reserve, in case she ever needed an alternative identity.

Determined to "be a rebel," in 1920, Josephine did what many young women from small towns did to escape "Domesticity!" She moved to California, starting first in Los Angeles, where she hoped to parlay her good looks and excellent figure into a film career. Josephine liked Los Angeles well enough, but the movie industry, she thought, was run by idiots. "Taking orders from people [I] knew to be [my] inferior" proved intolerable. Her "temperment rebelled." She fled Los Angeles.

She then went north to San Francisco, which had been known as early as the 1850s as a kind of "second Paris." By 1920, when Josephine arrived, it had been a hotbed of rebellion for years. "More open than Eastern cities because it had no established old families, no longstanding mercantile houses, no dominant banks," San Francisco had countercultural traditions that were well ingrained. Guidebooks to San Francisco promised the "brave bohemian" a "place where one could be done with conventionality for good," a way to "dynamite the baked and hardened earth" of conventions and traditions in art, sex, family life, business, politics, food, and friendship. Imbued with the Cogdell confidence and raised on Texas's "baked earth," Josephine was more than ready to blow things up.

Bohemia was a mix of the exotic and the familiar. As one guidebook put it, bohemia could offer "solace for your wounded heart." The San Francisco bohemians, like "scores of other young radicals and intellectuals," sought escape in the arts, in nature, in childlike states of

exploration, and in communion with Gypsies, Native Americans, and Eastern philosophies. Following Harold Stearns's then-famous call in the modern magazine *The Freeman* to "Get out!" they turned away from mainstream America's Babbittry, prohibition, and consumerism. If they could not achieve Malcolm Cowley's "salvation by exile" abroad, they could create an internal exile on American soil. Popular myths and movies about America's bohemias portray democratic worlds of free love and equal relations. In reality, however, gender stereotypes prevailed. In bohemia, mainstream traditions of "male authority and female subservience" were the norm. San Francisco's bohemian world was by and large the product of white men. Its pleasures were their pleasures. And so were its prerogatives. The San Francisco Bohemian Club, which built an international reputation for radicalism, for example, was closed to women.

So Josephine faced a quandary. Granbury was behind her. The kinds of social reform and social work that many first-generation New Women and feminists had pursued to escape their stultifying choices—activists such as Mary White Ovington and Eleanor Roosevelt; settlement workers such as Florence Kelley, Lillian Wald, Jane Addams, and Dorothy Day—interested her not one whit. She wanted the arts, not social service. "San Francisco supported a milieu of writers and painters attuned to the glorious light-washed landscape." It seemed to offer a meaningful artist's life, albeit inside a male-defined world. Josephine took up painting, working in a highly colorful style that crossed impressionism and realism. She took acting and dance classes with a number of teachers, including Ruth St. Denis, who as one of the founders of modern dance would work with Zora Neale Hurston and her folklore troupes in the coming decades and who was introducing San Franciscans to the ideas and dances of east India. Josephine also began to write, trying her hand at fiction, essays, and poetry simultaneously. She studied literature and politics, attended lectures on capitalism and human nature, read Charles Darwin and Karl Marx, studied Emma Goldman and James Joyce, immersed herself in novels by George Sand and Anzia Yezierska, and looked for paying work.

The easiest route would have been to attach herself to a man again. But Josephine was intrigued by the independent women she met in San Francisco, even if she did not become intimate with any of them. The New Woman seemed to be taking over the streets of San Francisco: "She could be seen on the streets, walking alone, or on the omnibuses on her way to work, marked by a graceful, athletic bearing and the lack of a wedding ring." Josephine had at least one love affair, with an Indian man named Bhogwan, with whom she stayed friendly for many years. It was not a serious relationship. She was testing the waters, like many New Women, exploring her sexuality and discovering her pleasures, experimenting with a form of interracial intimacy that would raise few eyebrows in San Francisco but would have been scandalous in Granbury. The fact of having had relationships meant more to her than the relationships she was having. They were her rite of passage. She was moved by a vision of artists and intellectuals "helping to shape a more humane social and economic system" through art, love, and pleasure. She was especially drawn to the individualism that both New Women and bohemians espoused: "We intend simply to be ourselves . . . our whole big human selves."

Josephine was petite, with an hourglass figure, a heart-shaped face, twinkling eyes, athletic self-confidence, thick brown hair, and Cupid's-bow lips. She believed that she was not a natural beauty. Most people disagreed. She had the excellent bearing of a superior horsewoman. She wore her long brown hair loose down her back to the tops of her thighs, giving her the melancholy look of a Dante Gabriel Rossetti painting. In California, she cut it into a becoming modern bob. To supplement the small allowance her father was sending from Granbury, she found work as a nude artist's model and posed for Mack Sennett's "bathing beauty" pinup cards, distributed nationally through tobacconists. Tame by our standards, they were then considered very racy. In one, she is wearing a black bathing suit, with her white arms crossed across her bare white legs and her calves laced into tight leather boots; her sexy smile challenged both national and familial norms. She kept meticulous scrapbooks of her cards and modeling assignments. When she went home to Granbury

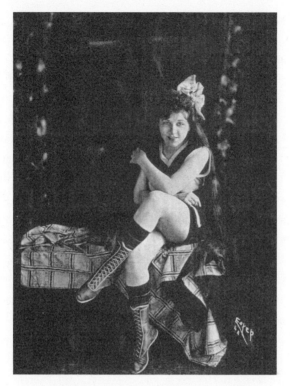

Josephine as a Mack Sennett pinup girl;
she took pains to ensure that her family saw the photos,
considered quite scandalous in their day.

to visit the family, she carried her heavy scrapbooks with her and laid them out on the large oak dining table. As both a model and a pinup girl, she was successful beyond any of her expectations; it was her first taste of sexual and economic power. She could create a persona, a different Josephine. They'd buy it. "I know I'm not beautiful," she wrote. "And it always surprises and amuses me for people to be trapped into thinking so by my carriage and toilette."

In California, Josephine was taken with the idea that cooking destroyed nutrients and released carcinogens. She began a lifelong advocacy of raw food. The diet appealed to her health consciousness, her affinity for rules, and her delight in shocking others. Whereas most raw

foodists became vegetarians, Josephine continued to eat meat. She took a special pleasure in delicately slicing up raw organ meats ordered at restaurants. "All cooked food is dead food" and all cooked-meat eaters are "carrion-eaters" like "the buzzard, the jackal and the fly," she'd serenely tell her dinner companions just before they tucked into their grilled steaks. She linked diet to the ills of modernity. The one thing that "most distinguishes and characterizes civilization," she wrote, "is disease." "To be healthy . . . we must return to a wild animal diet." Being a New Woman bohemian artist who ate a "wild animal diet" was also a good way to distinguish herself from the Texas Cogdells.

She was ever alert to hypocrisy (hypervigilant about it, in fact), and the contradictions she saw in her bohemian circles, which preached individual liberty but expected women to follow men, led her into politics. Socialism and civil rights especially appealed to her, and she identified more strongly with the wrongs done to workers and blacks than she did with women's oppression. "California was flaming with 'Red' activities," all of them fascinating to her. Unlike Max Eastman and others, who had begun to see a conflict between socialism and individualism that began to make the former seem "an insular, irrelevant, hole-in-the-corner thing," Josephine felt that anarchism and socialism could both nurture individualism. "Socialism has always drawn to itself the leading artists & creative thinkers . . . realizing that Individualism is the product of opportunity." She studied Marxism, sang the left-wing anthem "The Internationale," and subscribed to magazines such as *The Messenger*, *The Liberator*, and *The Crisis*. She gave away as much of D. C. Cogdell's money as she could spare to causes such as Irish freedom, labor, and Chinese and Hindu revolutionary support struggles. She gave money to women's suffrage but did not record joining its marches or demonstrations.

Increasingly, her growing political awareness was focused on race. "Like all intelligent Southerners, the Negro problem distressed me," she wrote. She was torn between an attraction to blacks and her southern instincts. She advocated racial justice. But she did not want to sit next to blacks. "A colored woman seated herself beside me on the street car. I . . .

rose and marched indignantly to another seat. And the first time I went to the theatre and perceived a colored man in the audience I was so irritated that I could not look at the performance." As she read about the atrocities of lynching and especially the role that white women had played in it, however, she was increasingly tormented by feelings of "shame and guilt." She had terrible nightmares about white "barbarism": "white chickens pecking black ones to death; large dogs devouring small ones; buffaloes torn and stampeded by cattle. . . . I suppose this was some kind of inner chastisement." She knew that there was something very wrong with her "exalted opinion of my superiority." She'd had a spotty formal education, focused as much on poise and good manners as anything else. To understand how race had threaded its way through her life, she set out to read everything written on the subject (just as her fellow autodidacts Nancy Cunard and Charlotte Osgood Mason were doing at the same moment). She listened to black spirituals, danced the Charleston, collected Negro art and poetry, and "began a novel in which the hero was a Negro boy and the villain was the Ku Klux Klan." Before long she was making "a point of sitting beside those whom the nice passengers avoid" and seeking out "educated Negroes in classes and studios."

Since some black newspapers and magazines were actively seeking antiracist writings by whites and featuring works such as Edna Margaret Johnson's "A White Girl's Prayer," Josephine sent them her work. She was pleasantly surprised to find encouragement for her writing. *The Messenger*, founded by the socialist labor activists Chandler Owen and A. Philip Randolph (who would later head the Brotherhood of Sleeping Car Porters), was particularly welcoming. It published her somewhat garbled but passionate overview of American art in 1923, as well as three not very distinguished but heartfelt poems in 1924 and an essay on how Jews and blacks have taken turns as America's scapegoats in 1925. Josephine knew next to nothing about blacks or Jews, but she was now dead set on becoming a writer. Publishing in one of Harlem's most important journals fueled her determination. "A swift metamorphosis from Negrophobe to Negrophile is possible," she decided. "I became a Negrophile."

In spite of her interest in individualism, Josephine was uncomfortable alone. In spite of her newfound feminism, she found romance irresistible. Her transition to Negrophile was watched—but not joined—by her lover, the painter John Garth, whom she met in 1921 on a streetcar. John Garth, originally named Wallace Hogarth Pettyjohn, was tall but not traditionally handsome. He was overweight and a poor dresser, with thinning hair and an unpredictable manner—sometimes charming, sometimes dismissive, often narcissistic. But he was talented, romantic, nonjudgmental, and a great storyteller. His effect on women was magnetic. "Everyone was madly in love with him." He was the son of a well-regarded doctor, who gave him access to dissecting rooms to study anatomy. And he had the sophistication born of his travels in Europe and New York, and his training at the Art Institute of Chicago and in Istanbul and Venice on fellowships. When Josephine met him, he had dropped his original name, reinvented himself as John Garth, had a few successful one-man shows, and was operating the successful John Garth School of Art in San Francisco.

John Garth, self-portrait.

Before long, Josephine was modeling for Garth, then living with him. With her allowance from her father, she was able to pay their rent, buy Garth paints and canvases, and help him rent a studio, shared with another painter. She was devoted to Garth, whom she called "Belovedest." He called her "Baber." Both were avid journal keepers, and they opened their diaries to each other, committed to confiding all. Although they fought constantly, Garth also encouraged Josephine's writing and believed she had talent. The stress of their relationship left her with a "melancholy [that] had almost made an epileptic out of me," but she also felt "devoted, consecrated to him to the point of madness."

Life with Garth was difficult. Josephine sometimes had to pawn her jewelry to keep them in supplies. Garth kept long hours at his studio, leaving her feeling "monastic" at times, neglected and abandoned.

Josephine Cogdell posing for John Garth in his studio.

They collaborated on a book. But Garth could also be condescending. He never truly listened, she felt. Josephine was emotional. Garth was contained. She wanted to get married. He was "married" to his work. She had a strong sexual appetite. He believed that men had a finite amount of sexual energy; too much intercourse would sap his strength.

"Nonsense," Josephine called it. They quarreled constantly. "I am not happy," she wrote in her diary.

By1927, they decided to take a break. She would go to New York and try to find publishers for her book about the Negro boy and the Ku Klux Klan. "I know it's good enough to win [publication] if I can only get the publishers to read it. . . . If it doesn't get a publisher I shall kill myself." She would also look for a publisher for the book they had cowritten, described by a family relative as a *Gone with the Wind*–type romance. She was leaving with the new literary name she'd given herself—Heba Jannath—and a small brown notebook that contained the street addresses of some of the most progressive new modernist and black journals: *The Smart Set*, *The Dial*, *The Messenger*, and others. She had packed her manuscripts, her best clothes, and some of her sister's best clothing as well, including a Spanish shawl on which her sister had lavished $400.

On a late spring day in 1927, Josephine lifted the edge of her skirt to board the train that would take her to New York. She expected to feel relieved at the prospect of time off from Garth. Instead she panicked. Throwing her luggage down on the seat, she raced backward through the compartments, jostling other boarding passengers as she went, hoping to get Garth's attention from the observation car. Spying him on the platform, she gripped the railing with one hand, waving frantically with the other. Garth never looked up. Slowly at first, then picking up speed, Josephine's train pulled out of the San Francisco station.

Josephine went from San Francisco to Texas, where she spent two months with her family. "I find everything the same but worse," she remarked. From there, in early July, she took the train to New York, stopping off in Kansas City to meet Emanuel Haldeman-Julius, the entrepreneurial publisher of the "Little Blue Book" series, which had ushered in the then-sensational phenomenon of paperback books. Haldeman-Julius had placed an essay of hers in his monthly magazine, and she had very high hopes that he'd turn his New York publishing connections in her direction. As she did when she was anxious, she wrote compulsively in her journal, filling more than sixty pages with details of her stopover.

Mostly she focused on what a terrible disappointment Haldeman-Julius had turned out to be. The hotel he'd recommended was seedy. They had gone out to dinner and stopped at a roadside cabaret to hear a black woman blues singer. He didn't understand jazz and had gawked embarrassingly at the black patrons. Worse, he kept pulling his car off the road to grope her. Josephine told him that his drooling kisses were repulsive, pressed herself into the passenger door, and put her hands flat into his chest to push him away. It had only aroused him further. Locking herself into her grim little room later, she felt a huge relief, then rage. No sooner had she succeeded in composing herself in the morning for breakfast than he appeared in the dining room again, ready to give it another go. By the time she escaped the second time, to board the train to New York, Manhattan seemed less intimidating.

The rest of her train trip was uneventful, if tiring, and she arrived with a large black suitcase, many of her manuscripts (some were in a Fort Worth safe), an enormous album of family photographs and memorabilia from Texas, and letters of recommendation from her family, all addressed to people she did not want to meet. It was late July, stiflingly hot and sticky. Josephine was weary and overwhelmed. She needed to lie down somewhere cool. The only hotel name she had was from her sister Lena: the Shelton. Directing her cabdriver there, Josephine had no idea that it was one of Manhattan's toniest destinations. The Shelton's steep nightly rate came to nearly half the cash she had in her purse. But having braved her way through the lobby and up to the registration desk, luggage in hand, she felt too humiliated to admit that she could not afford it. She booked a room for one night. She might have looked out her hotel window at one of the most famous views in the United States: New York City as seen by Alfred Stieglitz and Georgia O'Keeffe, who lived at the swanky hotel. But she would not have cared. She was thinking about how little cash she had left and how useless her family was proving to be in her new life. She had never felt so alone. First thing the next morning, she hauled herself downtown to Greenwich Village to rent a studio. She was done with advice from the Cogdells and furious at herself for not knowing better.

She had heard that housing in the Village was good and as cheap as $8 a month for a room, and she was eager to surround herself with the Village's vaunted tearooms, cheap restaurants, free lectures, small theaters, little magazine offices, colorful bars, and literary salons. She wanted to go to the places she'd heard about, like Mabel Dodge's, and meet "Socialists, Trade Unionists, Anarchists, Suffragists, Poets, Relations, Lawyers, Murderers, 'Old Friends,' Psychoanalysts, IWW's, Single Taxers, Birth Controlists, Newspapermen, Artists, Modern Artists, Clubwomen," and more. She liked the Village's stress on personal freedom, sexual freedom, and freedom from strict gender norms and class hierarchies. In Greenwich Village, "if anywhere," it seemed, "I must find what I wanted." First, though, she'd need a place to sleep.

Like so many other young hopefuls arriving in New York, she spent a hot, exhausting day looking for an apartment. The editor Freeman Hubbard, in whose *Art and Story Lovers' Magazine* she had published poems alongside John Garth's photographs of her, escorted her through the Village. It was a frustrating day of fearing (needlessly, she was relieved to find out) a replay of the Haldeman-Julius disaster and walking in tight shoes with paper-thin soles, traipsing into and out of cramped Village apartments that looked onto brick walls, smelled of mold and old cigars, were cockroach- or bedbug-infested, and lacked a full bathroom or a kitchen or worse.

She finally found a furnished studio on West 19th Street for a steep $70 a month that she could sublet until October. It was almost ten times the amount she'd expected to pay, but fortunately, she still had her father's allowance to fall back on. It was moldy, dusty, and greasy besides. But it also had a "large airy room with a marble mantle and a hardwood floor" and a good view, and she discovered that she could write easily there. She started another novel. Within days she could report that she had "slept, eaten, and dreamed book," was doing something "unique and superior to myself," and felt "full of content that I am a creator."

She took full advantage of her new freedom, managing a few brief affairs, including one with a Jewish diamond dealer named Fred Finkelstein, and in spite of feeling that there was hardly a "real man . . .

among the Literati" of Greenwich Village. She made casual friends in the neighborhood with writers and artists who also believed in "free love." "The Committee of the hole," she called them. One of "the Committee" tried to rape her one night after a party, but, as many hippie women would do four decades later, she made light of it, chalking it up to the "rude" manners that seemed to her pervasive among the "Village Yankees." If she didn't complain, she learned, fitting in was easy.

By then, some felt that the great era of Village bohemia was already over. But Josephine was full of enthusiasm. New York's bohemia seemed to take women more seriously than had San Francisco's, and "participation in suffrage was pretty much de rigueur for male intellectuals on the bohemian left" just prior to her arrival. New York's women artists, journalists, writers, actresses, and activists seemed, as the newspapers said, "half-way through the door into To-morrow." Not that life was easy for bohemian women like Josephine. The bohemian men who romanticized "living by one's wits" often had intact family ties and family money, networks of support, and an array of occupations open to them, all typically closed to bohemian women. "Female Bohemians had to be twice as clever to live by *their* wits." Josephine had faith in herself. According to one account, by 1900 there were already as many as four thousand women journalists in New York City. She thought she'd join their ranks.

In the end, Greenwich Village did not have what she wanted after all. The artists she met seemed silly to her, "intellectually sterile" and disconnected from reality. Just as Nancy Cunard would experience across the ocean with the surrealists and *their* double standards, many of the issues dearest to Josephine were not on the table. Within days of her arrival in the Village, she was already looking for something else. The Village seemed "childish."

She began listening to jazz seriously. Then she began going to Harlem, which seemed to her, and to some black intellectuals as well, an even better bohemia than the Village. James Weldon Johnson, as early as 1912, wrote that "Black Bohemia" was a "new world . . . [of] primitive joy in life and living . . . an alluring world, a tempting world, a world of greatly lessened restraints, a world of fascinating perils, but, above all, a

world of tremendous artistic potentialities." Josephine Cogdell couldn't have agreed more. "In Harlem," she wrote from her Greenwich Village studio, "life expresses itself because it expresses itself fully." In Harlem, if anywhere, she thought, she would find what she wanted.

"The Fall of a Fair Confederate"

The fact that he was dark and I fair gave an added fillip to our association.

—Josephine Cogdell Schuyler

There is a certain affinity between individuals of opposite colors. The fascination of the unknown is so alluring that mutual stimulation is inevitable.

—George Schuyler

The year 1927 might not have been the best time to arrive in Greenwich Village, but it was a good year to venture uptown into Harlem, especially with extra spending money and an adventurous spirit. Any tourist with taxi fare could stroll across 125th Street, taking in soapbox speeches about housing, self-improvement, workers' rights, colonialism, birth control, and social policy or admire the fashion parade: men in wide-legged, cuffed pants and sporty two-tone shoes, women in gathered tunics with belted hips, and strapped shoes, sashaying under felt hats with brims like bird wings or folded, just so, over perfect pin curls. Duke Ellington was playing at the whites-only Cotton Club. At the newly opened Savoy Ballroom, blacks and whites were dancing to the "hot jazz" of Fess Williams and his Royal Flush Orchestra. A little insider knowledge and the price of admission (a steep 15 cents just to check your hat) earned admission to A'Lelia Walker's "Dark Tower" club in her town house on West 136th Street.

Some of that "Mecca" was closed to casual tourists: Harlem's storied rent parties; its most important political meetings; its many social clubs, fraternities, and sororities. Its salons were private, and its jam

sessions were by invitation only, as were many of the awards ceremonies, strategy sessions, and drag balls. Many Harlemites resented white "slummers" as fiercely as Greenwich Village bohemians did their own tourist throngs. "Only Negroes *belong* in Harlem . . . it is a place they can call home," stated Paul Robeson's wife, Eslanda. Those who let in whites were often resented. The Dark Tower, for example, "was a place for A'Lelia to show off her blackness to whites," some gibed. Some whites, such as Charlotte Osgood Mason, who went to Harlem as a tourist in 1927, couldn't stand being shut out. For them, Harlem's private face was a personal affront and an individual challenge. Mason responded by refusing to go uptown and creating a Harlem of her own right down on Park Avenue. In her private mini-Harlem, peopled with a handpicked group that she hoped to control through money and psychic energy, she was always welcome, always a queen. Josephine was not looking to reign. She just wanted to drink it in, glad to have her foot in the door. She loved Harlem "at once."

> Everything about Harlem thrilled me. . . . The octoroon choruses at the Lafayette, the black sheiks at Small's, the expert amateur dancing to be seen at the Savoy, the Curb Market along the 8th Avenue "L," with its strange West Indian roots and flare of tropical fruits . . . the displays of chitterlings and pigsnouts in the restaurant windows; Strivers Row where the colored aristocracy lived in stately houses behind stately trees . . . the dirty tenements of 142nd Street with their shrieking swarms of black, brown, and pale ivory children; and the foreign Negroes speaking French, Spanish, and Dutch . . . the rural Southern Negroes so entirely different from the urban Southern Negro and yet more like him than like their Northern rural cousins.

She was delighted with how much was open to her. There were concerts to go to—by black singers such as tenor Roland Hayes or baritone Jules Bledsoe, Paul Robeson, or the Hall Johnson Choir. If she did not

want to join the white and black crowds swarming downtown at Dorothy and DuBose Heyward's *Porgy*, there were many little theaters nurturing more "authentic" plays, including white writer Annie Nathan Meyer's promiscegenation *Black Souls*, hailed as superior "Negro drama." At the 135th Street branch of the New York Public Library, "the intellectual pulse of Harlem throbbed," thanks in part to the efforts of Ernestine Rose, whom many people, including George Schuyler, praised as a model. Like everyone else, Josephine had read Carl Van Vechten's notorious novel *Nigger Heaven*. Nothing she saw around her seemed true to what she'd read: "The popular idea of Harlem as a Nigger Heaven, half-garish, half-primitive, where everybody drinks gin, does the Black-bottom and cuts up a 'high yallah' on Saturday night, is a Harlem which so far I have been unable to discover." "Intense political debates raged everywhere," and Josephine gobbled them up after her disappointment with Greenwich Village. "I found the group of intellectual Negroes I met in Harlem more interesting than my Southern friends and relatives who made a midtown hotel their rendezvous. . . . I found them intellectually sterile."

For Josephine, the political would always be personal. Her determination to transform herself had to go beyond adopting new ideas. On July 27, an especially steamy Wednesday, she put on her stockings, heavy undergarments, best blue crepe suit, and heels and decided to drop into the offices of *The Messenger*, which had already published some of her writing and to which she'd been subscribing for years. She planned to introduce herself to its controversial editor, George Schuyler, whom she and John Garth had long considered "terribly clever." She had been in New York only a few weeks but was determined to waste no more of her time there.

In 1927, George was on his way to becoming the best-known and most widely published black journalist in the nation, famous for his willingness, in the words of black civil rights activist Ella Baker, to "raise questions that weren't being raised" by anyone else. He was "a notorious naysayer." In addition to editing the socialist-identified, prolabor periodical *The Messenger*, he was associate editor of *The Pittsburgh Courier*, perhaps the most influential black newspaper in the nation, for which

he wrote a syndicated weekly editorial. The year before, he had made a splash in *The Nation* with an essay called "The Negro-Art Hokum," which attacked the idea of "'fundamental, eternal, and inescapable differences' between white and black Americans" with the provocative claim that the so-called "Negro artist" was nothing more than a "lamp-blacked Anglo-Saxon." It prompted an angry rejoinder from Langston Hughes called "The Negro Artist and the Racial Mountain," which charged Schuyler with lacking "race pride," perhaps the worst insult one black person could offer to another. Alongside Carl Van Vechten's scandalous *Nigger Heaven*, the Schuyler-Hughes exchange helped set the terms for Harlem's debates over the nature of race, the meaning of racial "loyalty," and whether there was any way to both contest racialist thinking and, at the same time, be "true" to "one's own" people.

In a radical departure from most Harlem intellectuals, Schuyler took aim at the very idea that there was a black *anything*, asking "Why are most of us bellowing for NEGRO art, NEGRO literature, NEGRO music, NEGRO dancing, etc!" He sometimes invoked the very sense of collective racial identity to which he was objecting: "*We* are not," he insisted, "a separate group, a different group." But that inconsistency did not keep him from insisting that all forms of racialism were backward-thinking racism. Most Harlemites were profoundly torn about what race was—an essence to be celebrated or a myth to be debunked? But most also felt strongly that blacks owed something to other blacks and that race, whatever it was, entailed some kind of ethics: loyalty, allegiance, identification. Schuyler took the much less common position that if race did not exist, no one could "owe" it anything. That rejection of racial allegiance brought to light contradictions at the core of much of Harlem's progressive race politics. It questioned whether a race could belong to anyone, whether anyone had his or her "own" people, and suggested that there could be no designated gatekeepers for racial belonging or race loyalty, since there was nothing to protect or be loyal to. Schuyler was becoming one of Harlem's most controversial thinkers. And he relished the role of finger pointer.

Josephine was preparing to take her racial reeducation into her own

hands. Early in the afternoon, she took a taxi to *The Messenger*'s offices, uptown on Seventh Avenue. In ninety-degree weather, she climbed three flights of stairs, wiping away sweat. Opening the wooden door into George's office, she saw a "stunning" black man with skin "like satinwood" whose "long and graceful hands" were resting on a pile of paperwork. George was flabbergasted. "My whole life changed" the day she walked in, he later wrote. "She was something very special," he continued: "beautiful, vivacious, fashionably dressed, sharp, witty, and well-read."

George was also canny. He might have complimented Josephine's good looks, which he noted instantly. Instead, he praised her writing, telling her that even though he prided himself on being "something of an expert in the detection of racial identity," he "could not tell her race from the articles she had submitted to the magazine." It was the best thing he could have said. They sat for hours in George's dusty office, chatting amiably about literature, politics, writing, travel, and art. Their rapport was intense. At 6 p.m., exhausted by talk, they headed over to 140th and Lenox for dinner at the Grill Room at Tabb's, famous for its chicken and ragtime music. After dinner they went dancing at the Savoy. As soon as George took Josephine into his arms to dance, her "flesh burned under his touch." They were among the last couples on the dance floor when the Savoy finally closed, just before dawn:

> How bawdy the music had been at the Savoy. How Fess Williams had waved his magic baton over the dancers, converting them into gaily gliding pans and shepherdesses. So like Pan did Williams look with his dark African face . . . he and George might almost be brothers.

Thinking over the evening later in her Village studio, Josephine added into her diary: "The glance and touch of X [George] thrilled me as no other man's ever had."

Josephine had found, quite literally, the man of her dreams. Like many other post-Victorian women, she was fascinated by what dreams

could tell about individual desires and social mores. Like them, she believed "the dream is the Superself instructing the active self." She kept dream journals; studied dreams and the available literature about them, including Freud; and advocated acting on the wishes dreams express. Dreams exist "to help you to make changes in your life," she felt.

A few years before meeting George, while visiting her family in Texas, she had had a series of dreams that she described as "one of the few absolutely rapturous experiences of my life." They were signs, she believed, of what should come. The dreams unraveled the "weaknesses" in the race "propaganda" she'd been raised with. They were filled with erotic scenarios of kissing and dancing with dark black men, both irresistible and threatening. She dreamed of taking responsibility for the weight of white racism. In her dream, taking that responsibility liberated her into a state of erotic and emotional bliss. She wrote:

Altho I trembled with fear I said to myself "now I will pay that long due debt which the white race owes the black Race for the centuries of cruel assault which its women have undergone at the hands of male whites"—and the realization that I would pay this debt even to death thrilled me exquisitely—I waited but nothing terrible occurred and instead a great burden seemed to have been lifted from life and the black youth and I clasped hands and joyfully began to dance. Wildly, ecstatically we danced whirling and leaping together with joined hands and arms. And as we each simultaneously lifted one foot high into the air kicking with pointed toe I beheld with one inexpressible sensation the magnificent contrast of my Ivory-white limb to his of gleaming ebon and the sign sent my soul soaring in ineffable heights of bliss—this sensation was not merely sexual in the accepted sense but athletic and philosophical as well. . . . In this dream I rose to heights of the purest most divine joy possible for a human being to experience.

Josephine believed that suppressing what such a dream expressed would lead, inevitably, to "neurotic disease."

George was the ideal candidate to fulfill Josephine's fantasies. He was very dark, very sexual, and highly intelligent. Importantly, he was as attracted to whiteness as she was to blackness and as likely as anyone to agree with Josephine that individual actions—race-crossing especially—had world-historical significance. As much a Yankee as she was a southerner and as instantly attracted to her as she was to him, George seemed the perfect dream-lover to help Josephine complete her personal transformation. His studied disengagement and signature skepticism only contributed to his allure, posing the challenge that Josephine, who'd recently found it too easy to get male attention, now needed. George was far more conventional than Josephine. But his irreverence and his race made him seem the most exotic man she'd ever met. Caught up in the drama of breaking the nation's most cherished taboo, she would take years to notice how ill suited they were. By then she was out of options.

George Schuyler was born February 25, 1895, in Providence, Rhode Island, and raised in a decidedly middle-class household. His highly literate parents took pride in being able to trace their heritage "as far back as any of them could or wanted to remember." The family set "a good table," with Haviland china and silver. In their household, "order and discipline prevailed." Feelings were not indulged. George was an only child, the center of attention. His parents told George that he was as good as—or better than—anyone else. They encouraged him to take no guff. "I was always to fight back when called names." Almost all their neighbors were white.

George joined the army in 1912. Although he stood only five feet, five inches tall, his success as a drill instructor bolstered his masculinity. He felt at home with military discipline and might have made a place for himself had it not been for the army's ingrained racism. He collected stories from the other blacks he met in the military about the strategies they used to defeat racist whites. One of his favorites came from a young southern black man in his company with the surname "Wright." Know-

ing that their child would be called "Boy," or worse, the Wrights had given their son the first name "Mister." "What's your name, boy?" he'd be asked. "Mister," he'd reply. "Don't get smart with me, Nigger! What's your first name?" "Mister." George Schuyler couldn't get enough of that story. "Mister (W)right." Schuyler cracked up every time he told it. He was learning about using humor to subvert and provoke. But racism was rarely amusing. His refusal to accept the status quo was beginning to land him in trouble.

Eventually it landed him in jail. Strolling in his lieutenant's uniform one day, George was refused service by a Greek shoe-shine man who refused to polish a "nigger's" shoes. In a rage, George went AWOL. He subsequently spent nine months in a military prison. After his release he found little employment that matched his skills. He worked as a porter, handyman, messenger, dishwasher, hod carrier, taxi driver, clerk, and laborer and briefly owned a housecleaning business. Those jobs exposed him to labor issues and in 1919 he joined the Socialist Party.

Moving to Harlem shortly thereafter deepened his political aware-ness. George took an apartment near Fifth and 131st with his girlfriend, Myrtle, a young "quadroon" with "wavy hair" and a "full bosom"— "Men turned to admire her," he wrote, "and that always makes a fellow feel pretty good." After Myrtle fell short of his expectations, being nei-ther a good housekeeper nor a good conversationalist, he landed at the Phyllis Wheatley Hotel, on 136th Street, which was operated by Mar-cus Garvey's black nationalist UNIA. That stay, though brief, proved fateful. The UNIA was in its ascendancy then, and Marcus Garvey, its militant, charismatic Jamaican leader, was ubiquitous throughout Har-lem; sporting a self-designed, highly decorated uniform, he preached an ideology of race pride and self-help that drew thousands of support-ers to his "back-to-Africa" cause. George admired Garvey's organizing skills almost as much as he hated Garvey's endless calls to "race pride," his bombast, and his willingness to cooperate with organizations such as the Ku Klux Klan. George saw that willingness as a natural, maybe inevitable, consequence of racialist thinking, the weakness at the core of the "race pride" idea. "Race pride," George discerned from watching

Garvey in action, had almost limitless power for either good or ill. Race pride hence became the core of his thinking and the constant butt of his increasingly scathing satire (skin whitening and hair straightening were particular targets). There was no such thing as this "so-called race," in his view, and therefore nothing to be proud of or swear allegiance to. "The words 'Negro,' 'white,' 'Caucasian,' 'Nordic' and 'Aryan' . . . [should be] permanently taken out of circulation," he wrote. The belief in "fundamental, eternal, and inescapable differences" between people of different races was just the "last stand" of the "Negrophobists," just another form of racism. "At best, race is a superstitution," he asserted, combining "superstition" and "institution."

The day George met Josephine, he was pondering those problems, searching for a way both to be proud of blackness and to debunk it as a dangerous myth. He was also in search of effective ways to fight back. And, along with almost everyone else in Harlem, he was looking only to masculine models of militancy, not necessarily thinking that Garvey could be replaced with something entirely different. When Josephine opened the door to his office, did he see someone who might be able to help him think that through? Perhaps.

Over the next few weeks, George and Josephine saw each other often. He went downtown to the Village to see her once or twice a week. More often, Josephine went uptown to accompany him to the Savoy Ballroom, Lafayette, Small's Paradise, the Curb Market, or Strivers' Row. George was "the *only* gentleman I've met in New York," she said. He was also a fine dancer and an excellent kisser. "His lips are softer and more sensuous than white lips," she rhapsodized. When they went dancing, as they often did, Josephine's vaguely sadomasochistic erotic tendencies were gratified: his hands "gave me a sense of much fear and pleasure as if a black whip were playing coyly across my limbs."

She was attracted but also bewildered. His mix of racial ideas was puzzling. He was the blackest man she'd met. But he professed no interest in race. It seemed, in fact, that she was more interested in blackness than he was. George's ideas, Josephine wrote, "disappointed me, for I wanted to believe that the Negro was essentially different." She was

concerned that her own love of blackness, her fascination with Harlem, would brand her in George's eyes as just another "slumming" bohemian. She felt that blacks had a "unique side" and were "more realistic and natural" than whites—forced to be so by society, perhaps, yet "different all the same." But she also knew that George wanted a white woman who "was liberal on the race question without being mawkish and mushy." Caution seemed to be called for. "Everything about Harlem thrilled me, but I concealed my enthusiasms." She probably also concealed the fact that she was "darkening her complexion," by using a "brunette" face powder. George wanted her to emphasize her whiteness, even to bleach her hair blond. Josephine hated what she called "the moldy cheese look [of] white skin" and often waxed rhapsodic about the beauty of a "glistening" black complexion.

She needn't have worried. George was only too happy to undertake Josephine's racial education. Her views tickled rather than annoyed him. "My sentimental views of the Negro greatly amused him," she was pleased to discover, "and he undertook to emancipate me from my first emancipation," she reported in her essay "The Fall of a Fair Confederate," her first published account of becoming a "Negrophile." Although George opposed race-based ideologies and organizations, she saw that he promoted race pride, black history, greater attention to black achievement, and the importance of blacks being "loyal to OURSELVES." He wanted to see more biographies of "great men and women in Negro history" and more monuments "commemorating the achievements, sacrifices and tribulations" of great African Americans from history. Josephine's love of blackness delighted him, especially coming from a white woman. As one of his biographers rightly pointed out, George "would have been hard pressed to find anyone, white or black, who could have loved his blackness like Josephine." Once Josephine understood that consistency was not a requirement of the ideology George espoused, she quickly adopted his views of race as her own, vacillating, along with much of the rest of Harlem, between celebrations of racial differences and adamant denials that there was any difference at all.

She also learned, to her relief, that George was neither as aloof from or as uninterested in "pork-skinned" people as he claimed. As with most people who cultivate a cool exterior, when he did give way to sentiment, he was very sentimental indeed. His love letters to Josephine were resplendent with purple prose and with "disgust and violent dislike" for everything but her. You are my "oasis" and "ideal," "superior to everybody," and the world's "finest expression of womanhood," he wrote. "I want to prostrate myself at your feet; to slave for you, and if need be, to die for you," Harlem's most renowned antiromantic added.

Josephine did not laugh off such hyperbole. She was also sexually satisfied, for perhaps the first time in her life. The couple had sex on April 17, a Wednesday morning, a little over two weeks after they met, in George's "spotless and orderly" Harlem room. Josephine carefully recorded in her diary that George was "a marvelous lover and possesses the most gigantic anatomy." Sitting in her studio in Greenwich Village, she mused over feeling "ennobled" and at peace after her first intimacy with a black man. As she would continue to do throughout her life, she immediately connected her individual situation to its larger social context, feeling that in taking a black lover she had struck a moral blow against racism and what we would now call "white privilege." As one critic incisively put it, "Sex across the color line always represents more than just sex." "Something marvelous has happened" that "ennobles" me, she wrote. It was "unlike all other embraces . . . like a benediction, a purification." The combination of taboo defiance and "super-sexual" intercourse was intoxicating. "It draws me, undoes me, makes me long to sacrifice for it. . . . I want to say 'Devour me, Negro, Devour me.' Aloud I say, 'I should like you to kill me, Schuyler.' I feel like a white rabbit caught in the coils of a glistening black snake. . . . I know that I love him. Oh God, how I love him as I've never loved before." George was the first man who'd been willing to play "diabolically" with Josephine and who possessed the "mischievous smile" she needed.

At this time, Josephine was also constructing her own racial ideology—without the benefit of a social movement or a cohort, with none of the analytical tools associated with the academic field now known

Josephine checking her reflection.

as whiteness studies, which exposes how whiteness is constructed as an "invisible norm." She was working out how racism damages whites as well as blacks: "Even worse than what they [prejudices] do to the Negro is the effect they have upon the whites who mouth them. They create in the white a bloated egotism which is both dangerous and disgusting and which has no place in this age." She saw the personal as political. She also went farther—much farther than most other whites—to see her identity itself as political, something other than a mere accident of birth. In thinking through the ways, as she put it, that "most of America is crazy on the race question" as a problem for whites as much as blacks, she was way ahead of her time.

Josephine was enjoying herself immensely. Harlem was a revelation. And through George she could experience it as insiders did. She was no longer a "slummer" from the Village but his lover. She was now an honorary Harlemite. So distanced did she now feel from the slumming

whites, entranced with the black "vogue"—precisely what had drawn her just weeks before—that in the August *Messenger* she published a poem, credited to "an Anonymous White Woman," poking fun at other white women who came to Harlem to dance with black men:

Temptation

I couldn't forget
the banjo's whang
And the piano's bang
As we strutted the do-do-do's
in Harlem!

That pansy sea!
A-tossing me
All loose and free
In muscled arms
of Ebony!

I couldn't forget
That black boy's eyes
That black boy's shake
That black boy's size
I couldn't forget
O, snow white me!

She was learning the pleasures—and techniques—of satire as well.

Still, she never considered a future with George: "With George there would never be any question of a lasting relationship." Taking the affair any farther would be too drastic a risk. "I felt that what was good enough for my forefathers was good enough for me. But marriage was a very different matter."

Then, unexpectedly, in September, John Garth appeared at her door. He had dreamed that someone had come between them. So he had sold an expensive painting and come across the country to "surprise" her. She took him to hear the blues sung by Ethel Waters at the Palace; to Central Park, Hester Street, and Chinatown; and to see many of New York's out-of-the-way neighborhoods. She insisted that he accompany her to Harlem and meet George. He insisted, in turn, that she not sleep with George as long as he was visiting. She agreed but also refused to have sex with Garth, who grumblingly slept on the sofa in her tiny studio. She pressured both men into double dating. "You must be out of your mind, sister," George said. But he went along with it anyway, bringing Mary Jane Jones, a light-skinned dental student, along to the Sugar Cane Inn. (Josephine later noted in her journal that her own artificially darkened complexion was two shades darker than Mary Jane's.) Garth, in turn, pressured Josephine and George to pose for him so that he could paint them as a nymph and satyr, with Josephine naked and George stripped to the waist. George took Josephine aside. What had she ever seen in Garth? he wanted to know: "He's deplorably middle class . . . like a Rotarian." Josephine couldn't disagree. In reality, Garth was no more conventional than George. But in Harlem he seemed to her "offensively harmless," and that was about the worse thing a man could be in her eyes.

At that moment, comparisons were not working in Garth's favor. George had prodigious energy; he could make love two to three times a night, work all day, and dance till dawn. Garth was tired, overweight, anxious, and much more moderate sexually. And Garth had foolishly been fighting with Josephine about race, telling her that she "ought to be hobnobbing with the most prominent people in New York" and that she was a "fool" to be "living with a nigger!" Disapproval always steeled Josephine's determination. But Garth was beyond strategy and erring in all directions. While he was visiting, Josephine's novel was rejected by the George H. Doran Company, and Garth handled her disappointment badly. He was also unaware that Josephine was now terrified

that she might be pregnant. "I hope you are pregnant and have a black baby!" Garth yelled during one of their arguments. "I hope I do, too!" Josephine answered. "You'll probably end by committing suicide!" Garth retorted. "Undoubtedly," she agreed.

Until his arrival in New York, she had always expected to return to Garth when her Harlem holiday ended. Seeing him now and comparing him with George, however, she felt that she was "done" with Garth. They parted angrily. But as soon as he was gone, she was once again beset with doubt. "Now that it is too late, I long to be his again," she wrote of Garth in her journal. She lay down on her bed in despair, feeling resentful of New York, Garth, George—everything. She resolved that she would never see George again and that she was through with men. Then she decided to rededicate herself to Garth. Moments later she was anxiously watching the clock, impatiently waiting for George to phone.

Josephine had another surprise, immediately after Garth's departure. Her sister Lena and Lena's husband showed up in New York, sent by D. C. Cogdell. Josephine went briefly with Lena to Park Avenue, where Lena tried to force "the 'Best' People" down her throat: "flabby bankers and brokers and the callow sons of the rich . . . like old boys playing at life. . . . The atmosphere of their parties seemed cheap." Lena aired her own "violently anti-Negro" feelings. She was "flaunting her prejudice . . . churning out Southernisms . . . an ugly, loud-mouthed shrew." "Niggers can't marry white people," Lena's husband added. It was a "fearful example of what I might become," Josephine wrote. "I decided that I must learn to be humble or I was lost. . . . I had seen all my family corroded by egotism into miserable and arrogant fools. I decided to marry X [George] if he would have me." Through George, she felt, she could put behind her not only Garth but whiteness itself. She could step, with George, into blackness. "I decided to . . . become a member of a race which we daily forced to be humble."

Josephine was scheduled to go back to Granbury and see her family for the Christmas holidays. She and George planned to marry when she returned. Evidently, the pregnancy scare was a false alarm, as her journals ceased to mention it. She recorded an uneventful time with her fam-

ily and wired George from Texas that she'd meet him in Philadelphia, to marry him there on New Year's Eve. She boarded a train to Philadelphia that had been cleaned by black Pullman porters and onto which black Pullman porters loaded her luggage; the porters also served her food and coffee and offered to post her letters and telegrams. She may have thought about Schuyler's stepfather, who had worked as a cook on those trains. Perhaps she watched the porters' hands, comparing them with George's elegant, tapered fingers. She may have stared at the porters' faces longer than a white woman should, perhaps noting their resemblance to her husband-to-be. She may have paused over every small luxury that being a white woman afforded her on the train, aware that she would never again be able to claim them. On December 30, she lay down on the narrow bed of her sleeping compartment, looked out at the dark plains rolling past her window, and felt sure that she was spending the "last pure white night" of her life.

When she disembarked in Philadelphia, George was not there. In a pattern that would become frequent after their marriage—and that would include places as far-flung as Cuba and Haiti—Josephine found herself alone and unable to reach him. Furious and feeling both abandoned and humiliated, she took the next train to New York. There she learned that George had never received her telegram about Philadelphia and was wondering when she was due to arrive. They arranged to meet at Penn Station.

Seeing him again in a soft gray suit and hat, after her time in Texas, she found his appearance thrilling, but she also recoiled from him, feeling "strange and self-conscious to be kissing his dark face and heavy lips" in the public waiting room. She was torn between her desire to marry him and her feeling that it was an impossible course for "the daughter of one of the first families of Texas, a full white whose grandparents had been slave-holders." They took a taxi up to George's Harlem apartment, a newer and bigger apartment thanks to his increasing success as a journalist, where they celebrated the New Year. Then they lived through a week of Josephine's agonizing indecision. At one point, with George out of the apartment on an errand, she ran down to the phone booth on

the corner and called every man in her address book, looking for rescue. As it happened, no one picked up the phone. "Experimenting with a Negro lover," she realized, "was a vastly different matter than coming to his house in Harlem to live. . . . Dixie had filled me with cowardice. . . . I shall not marry him." George was getting ready for a business trip that would keep him away for weeks. Josephine faced a lonely time in his absence. On January 5, he once again urged her to marry him. "Yes, Schuyler," she said, crying. "Tomorrow."

"When Black Weds White"

Josephine on her Harlem rooftop.

I have gained the peace of humility and a purpose in life.
　　　　　　　　　　　　　　—Josephine Cogdell Schuyler

The violent American complex against racial intermarriage seems very puzzling.
　　　　　　　　　　　　　　　　　　—George Schuyler

Looking back on her marriage in the mid-1940s, Josephine avowed that "there was never a happier bride" than she was on her wedding day. It was a nice sentiment but not at all true. Josephine's wedding day was tortured. "The race barrier, so to speak, is America's last frontier and it requires all the courage and determination of a pioneer to enter into an interracial marriage," she later wrote. As she approached her wedding day, she found that she lacked that courage. In the final twenty-four hours, her resolve evaporated.

The night before her wedding, alone in Harlem (George stayed elsewhere for the night), Josephine poured out her doubts in her journal to try to dispel them:

> I know up North here the Negro women will all hate me and feel I have taken unfair advantage of them and used my pale color to turn Schuyler. Now it all recurs to me—how I have felt him alone of all the men I've known to be my mental and spiritual & sexual [added in margin] equal. Now, I suddenly remember why I am marrying S. I want him to brow beat me. I want him to destroy my superiority complex. I want him to laugh at my white affectations and rationalize my fears. To my mind, the white race, the Anglo Saxon especially, is spiritually depleted. America must mate with the Negro to save herself. Our obnoxious self esteem will utterly destroy us unless we do. We need "shaking down" humanizing as Bhogvan Shing so often said. I need Schuyler. Without him I shall quit growing and solidify. If I am to be saved, S. will save me . . . my last pure white night I shall

take calmly serenely, as befitting the future wife of a XXX [illegible] realist of uncompromising courage and color.

Recently, in "Our Greatest Gift to America," George had argued that the gift of blacks was allowing whites to revel in an unearned sense of superiority, to be "buoyed up" by blacks operating as "the mudsill upon which all white people alike can stand and reach towards the stars." Josephine did not want a life lived on those terms. She wanted to eschew the baggage of unequal advantages. She was familiar with a 1928 article, published in *The Messenger* by the black historian Asa H. Gordon, arguing that there were terrible disadvantages to being white. The average white man, he wrote, is an "intellectual Slave" whose immersion in unearned privilege makes it "impossible to be scientific and objective about race," think straight, or make friends who could help him. His knowledge is "limited," and his soul is "shriveled." He lives in fear that his undeserved advantages will be snatched away from him. Josephine, who would soon write convincing poems and essays herself on exactly that theme, had long felt like something of an outcast from white culture. Becoming a critic of whiteness gave her a new perspective.

But on the evening of January 5, 1928, just hours from her own marriage to a black man, she was not thinking about abstract arguments. She was painfully aware that this was a step, once taken, which she could never take back. There was no one, including her husband, with whom she could share her doubts. So she wrote in her journal until an exhausted, restless sleep overtook her.

When she awoke the next morning, the day of her wedding, she found that she could not get out of bed. Neither had she come to a decision. Lying under the covers while George paced in the living room, she fashioned some of her doubts into an imaginary dialogue with John Garth. "Never once did *you* ask me to marry you," she scolded her imaginary interlocutor. She worried (presciently, as it turned out) that once the novelty wore off, George might find monogamy too constraining. She was also concerned (rightly again) that for all his professions of feminism George was a domestic traditionalist and that, as a wife, she might stop writing. "I

can live with you but I can't marry you," she had told George. "I've got to wait and see if I can write again. . . . I can't be the orthodox wife." Her greatest anxiety, however, had to do with race. Because it loomed so large, it swept her other concerns aside. If she could just resolve the racial question, she determined, she'd marry George, faithfulness and professional ambition be damned. The boldness of their racial move, as a couple, made everything they did, or might do, seem radical.

Her imaginary conversation with John Garth continued. "What about the others," she had him ask her, "the suave and rich men of your sister's influential circle? They'd put you on easy street." "But they'd bore me to extinction" was her reply:

> I don't want to play at life in a living room. The Cogdells were all miserable with their legal mates, their good women and men. . . . Yes, I *will* marry Schuyler. He is the only straight, honest-to-god real man I've ever met.

"Leave me alone now," she finally told the Garth she had conjured.

By the time she had made up her mind, it was midafternoon. She got up slowly, showered, and began to dress. George had been circumnavigating the living room for hours, by the time Josephine emerged from the bedroom at three o'clock. She was wearing the colors of spring renewal: a green-and-brown silk dress, green-and-brown suede gloves, a green snakeskin handbag, and a dark green felt hat, decorated with tiny green and gray violets. She had on her pearls and her best perfume. It was too late for a taxi. They'd have to take the subway. Josephine blamed George for the ride's discomfort and and the passengers' stares. "The crackers are worried," George whispered. He promised that it would not always be that way. "You and I are going to get some money some way, sweetheart," he promised her. We will "live like we should!"

They got off the subway and arrived at the marriage license bureau on Broadway just before its 4 p.m. closing time. A gray-haired clerk showed them the papers that would be filled out by his registrar. Josephine felt light-headed. "I lost all sense of sound. People and

things seemed to float weightlessly. . . . Events crowded each other swiftly like tumbling cards." George filled out his side of the paperwork calmly, putting down his age as thirty-two; his occupation as editor; his birthplace as Providence, Rhode Island; and this as his first marriage. When he pushed the papers over to her, Josephine swayed. Caught up in her own indecision, she'd not considered what kinds of questions might be asked.

"What shall I write?" she mouthed to George, pointing to the blank that asked for her name, horrified to imagine the Cogdells discovering her marriage. What if her brothers lynched George? "Use your married name as your maiden name. They'll never know," George advised. Shakily, she wrote "Lewis" in place of "Cogdell." Underneath that, where the "Bride's Residence" was requested, Josephine gave her old San Francisco address: 847 Diamond Street. She wrote twenty-seven for her age, collecting herself just long enough to lop the customary three years off her age.

The next problem was worse. The forms needed her "color." Dozens of states at that time had laws prohibiting racial intermarriage in 1928, but New York was not one of them. Josephine understood, nevertheless, that what she and George were doing was criminal, in a larger social sense. States such as New York, which had enacted no intermarriage laws, were not necessarily supporting, or even tolerating, such unions. On the contrary, they typically operated from the position that "interracial marriage was considered so disgusting by whites that it was unlikely to occur on a wide scale."

Josephine did not want to admit her race. "There's some colored blood in my family," she averred, alluding to her father's and brother's black mistresses. "Does that make me colored?" she asked the clerk. "Oh, yes, yes!" he replied, clearly delighted that she was not the white woman he'd assumed. Josephine wrote in "Colored." No one questioned her claim to blackness. As an article in *The Negro Digest* noted, "This is by far the easiest of all forms of passing, even if the woman happens to be a golden blonde. Few whites, or Negroes either, for that matter, can imagine her saying she is a Negro if she isn't." It was not the only way she passed that day. She wrote "Single" for marital sta-

tus, rather than "Divorced," and checked the space indicating that this marriage was her first. She changed her birthplace from Granbury to Dallas and changed her father's name to Jack, her ex-husband's name. But for some reason, perhaps because her mother had already died, she left her mother's name unaltered on the form, writing it down in full: Lucy Norfleet Duke Cogdell.

When the clerk asked them to swear that all the information in their applications was correct, they swore. The required witness signed after their names. With their completed application thrust into their hands, they were hustled out the door and told to hurry upstairs to the justice of the peace. There they waited in line while the "hard-boiled Irish Judge" rushed the couple ahead of them through a perfunctory, unpleasant service. Josephine stared at the judge's "greasy bald head" and "irritable impatient expression," feeling ever sorrier for herself. Then it was their turn. A judge with an "amicable though skeptical face" waved them up to the bench. Josephine felt "ridiculous," she wrote in her diary, "standing up before so many desks and officials, like a child petitioning permission" to do something that no one seemed to have the slightest interest in either granting or withholding. How could marriage—the end for which all women were raised—be such a nonevent? She had feared condemnation. But this disregard was worse. She and George were doing something noble and bold, even heroic, "a progressive deed." No one seemed to notice. "Their indifference was degrading."

"Clasp hands," the judge told them. Then everything unfolded in "a daze": "I heard Schuyler saying, 'I do.' . . . Next . . . the official uttered an appalling catechism of my future intentions toward the man beside me. . . . I grew very sober and perhaps terrified. . . . I answered 'Yes.' The question had to be repeated." Josephine made herself heard. Then George planted a "stiff kiss" on her lips. It was over. They were married. Josephine Cogdell was now Mrs. George Schuyler.

They walked down the wide white marble steps of the Municipal Building. The sky was darkening. George was thinking of the wedding scene in *All God's Chillun Got Wings*, where the interracial couple come out of the church "and the people are gathered on either side with the

hands out pointing at them." Josephine was even farther away, back in Granbury, Texas, talking to the Cogdell family servants (as she later recorded it in her diary):

> As I stepped down, I thot—"Aniky," you won. And in the shadows Big Jim strode beside us with his death wound in his black back and now he looked content as if his debt had been repaid, and Ronda nodded, and her mother who had said, "'Niggahs'll never have no justice in this earth. No, lil missy, nevah!'" nodded also and the distraught look on her gnarled chocolate face smoothed away, and she smiled. Gaston's mulatto daughter said, "our blood is yours." Jo shook hands with me and Mandy took me against her soft yellow bosom, 'Baby,' she said "you done right.' And all the cotton pickers and mill hands stood smiling at me, and all of them shouted—joyously—'Things is changed!—de ole man's baby has married a Niggah.' It's a good thing S. doesn't know how sentimental I am, I thot, full of embarresment at these hallucinations. Nothing can justify the pain his race has suffered at our hands, it is silly to harbor such illusions, in fact the Negroes at home would probably disapprove of my action on commonsense grounds—yet, I believe that all these things have somehow influenced me and bound me indissolubly to the Negro.

Josephine needed to convince herself that what she'd done was right, logical, and even fated. With her family background, she reasoned, what else could anyone have expected?

> You papa, you initiated me so. How about Aniky! and you Gaston, your first love and your only child, my niece. It's in our blood, the love of Black people. We are savages too. all strong people are savages which means we are too proud to be unreal. we have no place in the pale conventional modern

world[.] our kind is with people who frankly, lustily, fight
and love and break the soil and sing. . . . Twice I evaded
respectability did you think you'd catch me this time! . . .
Before this I've worn not calico perhaps but torn silk and
been happy. . . . How is it I hesitate now that I've met my
equal! Because he is black. I've always loved the night better
than the day for the night is primal still and can never be
tamed like the day. And I love his blackness. Because I'll
be in exile. From what? Boredome! O, S. no other man can
dance, or love or talk or drink like you. From the start I've
been rushing toward you.

For both George and Josephine, the marriage was what Freud called
"overdetermined": wrought of overlapping and interlinking, even op-
posed, forces and causes. As much as they were in love, both were also
fiercely committed to ideas that the marriage seemed to embody. Both
believed that intermarriage could end racism as the black race lightened
and the white race darkened. It was, they reasoned, the only natural
and permanent solution. "The future war between the white and colored
races . . . may be averted" through interracial sex and marriage, Josephine
wrote. George tied the first wave of feminism and the New Woman
movement directly to a transracial future. Freedom for women, he felt,
would translate into increased interracial relations. "New Women," he
argued, would not "stand" for being deprived of black men. Given the
ability to choose sexual partners freely, "they will in increasing numbers
cross the color line in search of lovers and husbands."

On their way home from the Municipal Building, they stopped at a
Greek market for wine and raw oysters to make a celebration dinner.
In their apartment, Josephine set an elegant table with linen and silver,
green candles, crystal candleholders, and romantic lighting. "My mother
left me her choicest silver and linen, little knowing that it would star in
our wedding supper," she told George. "Poetic justice," he replied.

Josephine planned to nap while George finished a writing assign-

ment that was due the next morning before he left on another business trip. But they ended up in bed. By the time they got up, it was late, and George's writing was still undone. Together they went to the desk and worked collaboratively until dawn, when the piece was finally finished. While he went to the office to deliver the essay, Josephine went to the train station for his ticket, came home and packed his clothes, and made him a lunch to eat on the train. "We stand absolutely alone," he told her, praising her teamwork. "We can't count on anybody. The whole world is against us. The Negroes against the whites."

After he left, an exhausted Josephine cleaned the apartment, then wrote up their wedding day and night in her journal. Those detailed entries constitute the last time, as far as we know, that Josephine ever wrote about herself, in her journals. From a "spoiled" child and a self-centered young woman, Josephine transformed herself into a thoroughly committed wife and devoted mother. Later diaries contain no references to her own feelings or ideas; they detail—with incredible minuteness—the progress of her daughter, Philippa.

The pattern the Schuylers set on their wedding night would continue—unnoticed by critics and never credited by George—for the rest of their lives: working together, both writing and editing when and as necessary, to meet George's deadlines. Her job, Josephine decided, was to see that George was "cherished and inflated . . . certain of his superiority." He would see that she was "pruned" of whiteness. It would be years before Josephine would notice the way in which traditional gender conventions undergirded the Schuylers' bold racial experiment and how the price of all that courage would be paid by her alone.

Both George and Josephine idealized and sentimentalized their marriage. They liked to claim that defying the racial taboo had made them stronger as a couple. Writing under a pseudonym in *The Crisis*, Josephine published this poem in "The Poet's Corner":

Taboo

He never rails nor threatens
Nor boasts nor tells a lie
But often he will harden
His moon-full lips go wry
With proud and mocking laughter
For those who pass him by,
And then he softly mutters
In sadness without gall:
"Because we didn't falter
Because we didn't fall
For an infamous taboo
We're two against them All."
When I lose my temper
Or talk a bit too free
He will call me to him
And quietly lecture me:
"If we act like others
And ever stoop to brawl
They will say Mixed Marriage
Is what has caused it all."

In fact, Josephine and George were somewhat mismatched. They had to work carefully at getting along. "My husband is a Yankee," Josephine summed it up, "and in many respects, I remain a Southerner. George is orderly, objective, disciplined, cautious; I am emotional, reckless, genial, careless, generous, and talkative. I improvise and he works by method." In spite of feminist protestations, and promising Josephine that "I do not want you to be less of an individual because you have married me," George was seeking an iconoclastic career but a conventional home. There was not room in his vision of his own ambition, and its demands, for a partnership of equals. "You are entering a new life, Josephine," he told her. "You must forget your freedom!"

Henceforth they *would* be a team, but their goal would be to build a better George Schuyler, ever more productive, quick to take on all comers, and fierce in the defense of the principles they would now share. "I have dropped completely out of sight," the last page of Josephine's diary reads. "No one in the white world but Mr. H [Freeman Hubbard] knows my whereabouts or will ever know." The young woman who had come to New York determined to make her way as a writer learned to channel her ambitions in ways that rendered her almost invisible. Her marriage freed her from the constraints she so badly wanted to escape and opened up a range of experiences otherwise unthinkable for a young white heiress from Texas. It also foreclosed any likelihood that she would make a mark, in her own name, on history.

"Changing All the Time"

Anything that's alive is changing all the time.
— Josephine Cogdell Schuyler

Except as Mrs. George S. Schuyler, Josephine was mostly out of the public eye in 1928. Her time was spent furnishing and decorating their three-room apartment on St. Nicholas Avenue, creating a family refuge. She did not throw herself into political causes or groups, as she'd done in San Francisco or earlier in New York. Suffrage and feminism seemed not to interest her anymore. Nor did she take to the forms of activist antiracism where she might have found other white women like herself: the antilynching movement, the Communist Party, or labor politics. She developed friendships with white women such as Fania Marinoff and black women such as Ella Baker, women who shared her commitments and interests, but those were personal connections, not political partnerships. In the days and months immediately after her wedding, Josephine appeared to ground herself exclusively in the very "Domesticity!" she'd run from.

George, on the other hand, was very much in the public eye. His es-

say "Our White Folks," which had appeared just days before their marriage in H. L. Mencken's influential magazine, *The American Mercury*, attracted national attention. Written while George and Josephine were dating, certainly discussed by them, and very likely edited by her, the essay argues that trust or love between whites and blacks is impossible. "Our White Folks" makes its case for interracial impossibility so sardonically and unapologetically—especially in its treatment of "the average peckerwood" (or white person)—that nothing like it had ever been seen before.

The "fervent scribbling" and "alarmist gabble" by whites about blacks, Schuyler wrote, creates a situation in which the "real feelings" blacks have about "the cracker" can only be distrust and dislike:

> There are Negroes, of course, who publicly claim to love the white folks, but privately the great majority of them sing another tune. Even the most liberal blacks are always suspicious, and have to be on the alert not to do or say anything that will offend the superior race. Such an atmosphere is not conducive to great affection, except perhaps on the part of halfwits.

Forced to live under white rule, the average black person cannot escape having the ugly "inside information on the cracker":

> Knowing him so intimately, the black brother has no illusions about either his intelligence, his industry, his efficiency, his honor, or his morals. . . . The Negroes know the Nordics intimately. Practically every member of the Negro aristocracy of physicians, dentists, lawyers, undertakers and insurance men has worked at one time or another for white folks as a domestic, and observed with cynical detachment their orgies, obsessions and imbecilities, while contact with the white proletariat has acquainted him thoroughly with their gross stupidity and often very evident inferiority. . . .

The efforts of the Nordics to be carefree are grotesque; the so-called emancipated whites being the worst of the lot. . . . Look, for example, at their antics in Greenwich Village. It is not without reason that those white folks who want to enjoy themselves while in New York hustle for Harlem.

What he called "the moony scions of Southern slaveholders" with their "sloppy sentimentalities" about blacks (inescapably a reference to his wife, if only by implied contrast between her first and her later forays into Harlem), come in for special derision. These "pork-skinned friends of Southern derivation," he wrote, smother blacks with a love that is as racist and self-serving—and as demeaning—as hate would be. In short, the essay concluded, "the Negro is a sort of black Gulliver chained by white Lilliputians. . . . The fact is that in America conditions have made the average Negro more alert, more resourceful, more intelligent, and hence more interesting than the average Nordic." Everyone who knew the Schuylers, and quite a few who'd only heard about them, knew that Josephine was a southerner who'd made her way to Harlem from Greenwich Village. Was she in on the attack, or was she its target?

Josephine left no record of feeling offended by "Our White Folks." That in itself is suggestive. It appears that as the coproducer of the literary persona known as George S. Schuyler, she could take it for granted that when whites were attacked, it was "present company excepted." In fact, in an act of psychological distancing from other whites, Josephine joined in such attacks. She was not, in other words, the pathetic, abject, apologetic, and self-hating Edna Margaret Johnson of "A White Girl's Prayer" but instead part of the critique. Not taking offense could be a mechanism of racial reidentification. In a culture where racism saturates every feature of social life and is just as ubiquitously denied, Schuyler's inclusion of whites like his wife, and Josephine's apparent refusal to be offended by that inclusion, carried symbolic weight. Thus they demonstrated their exceptional commitment to political principle. And thus Josephine also passed, yet again, this time as something other than the white woman her husband was vilifying across the nation.

"Our White Folks" generated such a sense of racial victory that it was honored with its own testimonial dinner a few weeks after George and Josephine married. Hosted by the well-known society editor and publicist Geraldyn Dismond, the dinner, at the Venetian Tea Room on 135th Street, was attended by more than seventy guests, including such Harlem notables as the scholar William Pickens, A. Philip Randolph, Charles S. Johnson, and others. "Copious praise" was heaped on Schuyler. It was a major turning point. George's autobiography devotes considerably more space to recollecting that dinner than to describing his marriage. "Our White Folks" helped make George "the most recognizable name in black journalism." It also made him much in demand as a speaker. Just days after his return from his January 7 trip, he embarked on what became the first of an extensive annual lecture tour. That one took him to Los Angeles, Oakland, Seattle, Pasadena, San Diego, Pittsburgh, and Philadelphia. Josephine stayed home.

Harlem did not warm to Josephine right away. She was lonely. While there were mixed marriage clubs across the nation, the Schuylers appear not to have joined one. She was also convinced that the black women of Harlem hated her for marrying George and competing with them for "their" man. According to a story that Josephine's father told her and that she believed, some of the early Klan activity in the South was the product of black women wanting to break up liaisons between white women and black men. That charge infuriated Nancy Cunard, who wrote an angry rejoinder about the "particular kind of lie the white Southern gentlemen put out" when she published Josephine's essay about "the color line." But Josephine was not *entirely* wrong. While black women rarely aired their views about white women in Harlem, one angry article, published in the same newspaper George was then editing, contended that white women in Harlem were not merely "brazen," but worse. "There is no creature more abandoned, depraved" than the white woman who takes a black mate, the article argued. The weaknesses of white men leave the white woman "sex starved" and she flees them to black men, from whom she will "always stand more abuse than her darker sister." No wonder, then, that Josephine felt put off not only by other white women

but also by many of George's friends. She had "dignified, friendly" relationships with her neighbors. She was "cordially received by my husband's literary associates." But she was not treated as an insider. Ella Baker recalled that "the wives of many of Schuyler's black colleagues disapproved of his interracial marriage, which was quite uncommon in those days, and did not welcome Josephine into their social circle." Josephine looked down on most other white women in Harlem, seeing them as slummers, exploiters, or uncommitted adventurers. She associated with almost none of them. In March, the *New York News* printed an article called "Schuyler Marriage Shocks Elite," which criticized what it called George's "irretrievable fall to a lighter hue" as a rejection of black women. Black society was disappointed with him, the article noted, "to the point of frigidity." Such articles did little to encourage Josephine to put herself forward more forcefully.

Josephine was reconstructing herself in Harlem on the basis of both the New Woman and the radical race ideas of her husband. George always pointed to breaking the taboo on interracial sex as the boldest and most important gesture an antiracist activist could make. He praised—especially in private letters to her—his wife's willingness to endure public scrutiny for doing so. But in his autobiography, the two white women he singled out for praise—Ernestine Rose for fomenting "intellectual ferment" and Annie Nathan Meyer for being "a militant feminist, a fine writer, and an outspoken Negrophile"—were both women who respected gender norms, avoided scandal, and were rarely in the limelight, certainly never because of sex.

In July, *The Messenger* folded. George was in New York, giving another lecture, that Robert Vann, *The Pittsburgh Courier*'s editor, happened to attend. Vann offered George the editorship of a weekly newspaper insert to be published out of Chicago for national distribution to the nation's black papers. The circulation would be 250,000, the largest platform any black writer had achieved in America. The editorial offices of the weekly, however, were in Chicago. George accepted Vann's offer on the spot. "Leaving Josephine to send the new furnishings we had in our three room apartment on

St. Nicholas Avenue, I departed for Chicago and a new adventure."

Josephine followed him to Chicago and set up housekeeping in the fall in "a very nice four room apartment in a South Side neighborhood which had just been infiltrated by blacks." George worked long days, nights, and weekends. Josephine, he noted, was "delighted" with their "lovely nest . . . and with furnishing it and decorating it" and hosting dinner parties for new friends who came to eat and listen to jazz on the phonograph. But the new venture, which demanded long hours and had difficult finances, took its toll on George; in early winter he gave notice to Vann. "Leaving Josephine behind to pack up in Chicago," he wrote, "I returned to New York City and rented a three room apartment in a brand new [apartment] house on Edgecombe Avenue on what was facetiously called Sugar Hill because so many high-income Negroes lived up there." Josephine followed and took up the task of setting up,

Miss Anne was often raised to be a proper lady;
Ernestine Rose in her youth.

furnishing, and decorating their third home in a year. If she minded the responsibility, she did not say so.

Sugar Hill afforded exciting opportunities. It was renowned as Harlem's most elegant area, with doorman buildings and well-tended parks. A Sugar Hill address was a mark of arrival—and 321 Edgecombe, next door to the buildings where W. E. B. Du Bois, Paul Robeson, Count Basie, and Aaron Douglas lived, was a very good address indeed. The Schuylers' neighbors at 321 included Marvel Jackson Cooke, Du Bois's secretary; the journalist Ted Poston; and both Walter White and Roy Wilkins of the NAACP. Perched on a high hill, 321 Edgecombe was a six-story elevator building overlooking Colonial Park, with panoramic views of Manhattan. Its apartments had parquet floors, wood paneling, large rooms, modern kitchens, intercoms, and laundry facilities. The Schuylers' third-floor apartment had good light, comfortable furniture, African art, many paintings—including quite a few canvases by Garth—and hundreds of books and phonograph records. Josephine painted the walls (and later Philippa's piano) a cheerful apple green; the chairs were green and orange, upholstered in bright Hawaiian fabrics; and the bookcases were multicolored. Everything about the apartment suggested both culture and good cheer.

Without diaries or letters—Josephine now had no one to write to—we must rely on the descriptions of others for a sense of the Schuylers' home in the early days of their marriage. Ella Baker, who worked with George on the creation of the Young Negroes' Cooperative League and spent a lot of time with the family in those years, remembered their home as a lively center for "animated discourse that helped define African American public life," with a salon atmosphere that welcomed artists, writers, intellectuals and politicians: "stimulating company, provocative conversations, and elegant hospitality"—everything that Josephine had come to New York to find.

Being public models of progressive, interracial relations came easily to Josephine and George. Both contributed enthusiastically to the myth-making that goes into being a celebrity couple. They continued to keep

The Schuylers at home, reading.

their marriage a secret from the Cogdells. But they "fed off their importance to others." Each eventually took advantage of the podium their marriage provided to publish essays about interracial marriage. Their celebrity status translated into invitations for George to speak on topics as far-ranging as feminism and psychoanalysis. There were interviews and, most enjoyably, the occasional published homage, such as the following bit of doggerel published in the *Cincinnati Union* by its editor, their friend W. P. Dabney:

> *George and Josie jogged along*
> *The path of domestic life;*
> *The world for them seemed one glad song,*
> *So free was it from strife*
> *But thus it had not always been,*
> *The past had taught them well,*

So when they met they did begin
To make paradise out of Hell.

Letters between Josephine and George, especially in the first years of their marriage, reveal that they remained passionate about each other. Josephine expressed her gratification in having both a lover and a friend and praised George's character, work, and looks. George, in turn, though traveling almost constantly, wrote romantic paeans to Josephine's bravery and her faith in him—telling her that the strength she'd given him had made her into his "God."

If so, his form of "worship" strained the marriage almost from the start. Josephine was no sexual puritan. But she was convinced that "love must be monogamous." George held no such view. Some of his friends were hard pressed to keep up with the stories he wanted them to tell his wife to cover his tracks. In addition to his infidelity, there was the strain of constant separation. George was on the road more often than he was home, and Josephine was left in Harlem to take care of business. All of George's articles were sent to her before they went to their editors. There was no reason for George, pressed by deadlines and time pressures, to send his articles to Josephine first, unless she was also editing, fact checking, finishing, and making copies, just as she had done on their wedding night.

Less than two years into their marriage, the financial markets fell. Josephine and George watched with alarm as one after another of the restaurants, nightclubs, and periodicals that made up their cultural world closed down. They read in their daily newspapers about food that Americans could not afford rotting in the fields; war veterans marching in Washington; and riots breaking out in Seattle, Boston, Detroit, Chicago, and New York. Almost daily they passed evicted families with their belongings on the street or Harlem's "slave markets," where increasing numbers of black women—many of them former clerical workers or educators—waited for day work as maids to white women. By the early 1930s, almost a fourth of Harlem residents were jobless and scores of homeless families were sleeping in nearby St. Nicholas Park, alongside

City College. The Harlem Hospital, already notoriously understaffed, fired almost all of its black doctors. Many of their friends, including Zora Neale Hurston, accepted positions with the Works Progress Administration and the Federal Writers Project at a small fraction of what whites were receiving. Harlem YWCA staff member Anna Arnold Hedgeman remembered, "Women and children searched in garbage cans for food, foraging with dogs and cats. Many families had been reduced to living below street level . . . in cellars and basements that had been converted into makeshift flats. Packed in damp, rat-ridden dungeons, they existed in squalor."

The Schuylers were in no danger of eviction. Josephine was certainly not going to find herself cleaning other white women's bathrooms. But George's position was precarious. *The Pittsburgh Courier*, now his financial mainstay, reduced his salary by 40 percent. He knew that, as a black journalist, he was vulnerable to "last hired, first fired" standards. In the winter of 1930, just as the Depression was deepening in Harlem, George was offered the opportunity to investigate claims of modern slavery in Liberia for the *New-York Evening Post*. The trip would mean months away from home with scant means of communicating with Josephine, who was pregnant. But he was in no position to turn down the assignment, although he was already overcommitted to other writing and in the middle of his organizing effort to form black consumer cooperatives with Ella Baker. Departing from the practices of other Harlem organizations, the Young Negroes' Cooperative League was radically democratic, intent on putting power into the hands of its members. It was an exciting vision but, like so many of George's activities, not one that included a significant role for Josephine. While George was in Liberia, Josephine found evidence of his affair with another woman. She cabled that she was going to leave him. George's pleading telegrams, probably combined with Josephine's knowledge of how few places would welcome a single woman bearing a biracial child, kept the marriage going, if not altogether intact.

Philippa was born on a steamy Sunday morning, August 2, 1931, at home (the Harlem Hospital had a death rate twice that of other hospitals

in New York, earning it the nickname "Butcher Shop," and Josephine refused to go there). George had come home but was gone before nightfall on another trip. Ella Baker and other women friends stayed with Josephine for her first few stressful days, then left her alone with her newborn daughter.

"Gargoyles of Color"

Whites sometimes . . . pass for Negroes.
—Josephine Cogdell Schuyler

George traveled so constantly during the early years of their marriage, and wrote for so many different venues at once, under so many various names and pseudonyms, that scholars have always been at a loss to explain his productivity. He is credited with as many as seventy stories in the early 1930s, in addition to his journalistic and editorial work, some pieces under his name, some anonymous, and some under a plethora of other men's and women's names, including Samuel I. Brooks, Rachel Call, Edgecomb Wright, William Stockton, Verne Caldwell, Rachel Love, John Kitchen, and D. Johnson. Many of the pieces use a mix of styles and voices. All of George's biographers have noted how "extraordinarily productive" he was in the immediate aftermath of his marriage to Josephine, his period of greatest, even "inexplicable," output. Many have noted a change in his style during that time, some saying that his work seemed to "mature" overnight. None have noticed how much some of these writings sound like Josephine. From his long travels in Liberia, especially, many unanswered questions remain about the authorship of articles that appeared weekly under George's byline. Often he was in areas so remote—"not a hundred miles of road in the country" and with no airports, let alone telephones or telegraph offices—that Josephine sometimes did not know, for weeks at a time, if he was living or dead. Yet the pace of his publication hardly slackened. In spite of their collaborations, their shared use of pseudonyms, and the near impossi-

bility that George was working without help, no critic or biographer has ever suggested that the explanation for George's "inexplicable" output was probably the active participation of his wife. It is another instance in which Josephine seems to have gotten away with hiding in plain sight.

George certainly would not have showcased his wife's collaboration. His reputation increasingly rested on both his willingness to attack anyone and his renown as the hardest-working writer in Harlem. If some of the writings long credited to him were Josephine's work, it would not have been to George's advantage to draw attention to that.

Indeed, it might not have been entirely to Josephine's advantage to reveal such a practice either. She was fascinated with the phenomenon of "passing" and had played at fooling others with her various personae going back to her early childhood. George had thrilled her in their very first meeting by confessing that he'd been unable to detect her race definitely from her writing. She was particularly entranced with the idea that one need not be stuck in the racial (or gender) identity into which he or she had been born. Her idea of freedom was the freedom to be whoever she wanted and to change identities at will.

As Heba Jannath, the pen name she used most often, Josephine published in Nancy Cunard's *Negro* "America's Changing Color Line," a long article on passing, intermarriage, and race. The essay is wistful, even envious, of those who move from one race to another: "I know or have heard of dozens of people who have passed successfully. . . . The octoroons who 'pass' are usually past masters at detecting the slightest change in the thoughts and emotions of the people around. They obtain a view of both races denied most of us, and, full of ambition as they usually are, they emulate the best points of both groups."

"America's Changing Color Line" considers passing's ability to prove contradictory things. It shows that someone can cross from one race to another because race is merely learned behavior. But it also suggests that there are different racialized states to pass *between*, that one is crossing from something to something else. Blacks can pass for white, she wrote, because whiteness is a cultural creation that can be mimicked. But whites can never truly pass for black. Although "whites sometimes

find it convenient to pass for Negroes . . . Negroes, being shrewder in such matters, are not easily taken in." Passing works only from black to white, because whiteness and blackness are fundamentally different things: one a construction and the other a property. In its conclusion, the essay took a position that goes something like this: white identity is nothing, a negative, and open to all; black identity might actually be something, but whites can't have it. If Josephine was right that whiteness was emptiness and blackness had substance, it's no wonder that some white women, such as Edna Margaret Johnson, pined for a blackness that seemed more authentic than the whiteness to which they'd been born.

From girlhood on, Josephine had played with personae. Whenever she was with someone who seemed ill at ease, she'd invent shocking stories about herself, "bits of scandal." It was "entertaining" for everyone, she found, to play with different identities. And even as she wrote about passing and its limits, she was continuing to both pass and test identity. She had been experimenting with being Heba Jannath for years, well before she met George (he probably learned the pleasures of pen names and pseudonyms from her). Whereas Josephine was cautious, Heba Jannath was fearless: a guilt-free New Woman, a confident authority on everything from modernism to race to nutrition. She was more radical than Josephine and far less sentimental. Heba did things other women only dreamed of. As Heba Jannath, Josephine not only wrote essays and a small mountain of unpublished novels—including *The Last Born, or Rebel Lady, Southwest, Husbands and Lovers*, and others—she also wrote movie scripts, including one called *The King of Africa*. And although Josephine did not consider herself especially musical, Heba was a jazz artist. In 1930, she wrote a song called "The Penalty of Love," which was featured first in the revue *Hot Chocolates* at Connie's Inn and then at the Times Square Theatre in the play *Hot Rhythm*, which starred Dewey "Pigmeat" Markham, a former black minstrel performer who had become one of Harlem's biggest—and raunchiest—stars. The well-known singer Edith Wilson performed the song—"The penalty of love is closing your eyes/Hiding your sighs, feelings and the lies"—which

was recorded that year by Bubber Miley and His Mileage Makers for Victor Records. As Heba Jannath, Josephine also published a long verse story about the dark side of the South called "Deep Dixie," which turns attention away from the "moonlight" and "honeysuckles" of the South to focus attention on a "rotten" land. There, oppressed white workers, frustrated in competition with blacks, are bought off with the myth of "pure white womanhood," blacks are lynched for the sins of white men, and a white woman who crosses the color line by so much as an inch is doomed. William Pickens, evidently unaware of who Heba Jannath was, wrote her a fan letter to say that "Deep Dixie" was a *"Damned Good Story. It is the best thing of the kind I have read in many a moon. . . . You are Southern & Human,"* he added.

Another of Josephine's more interesting personae was Laura Tanne (or tan allure), whose view of interraciality was much darker than either Josephine's or Heba's. Whereas Josephine saw interraciality as a solution to the race problem, Laura Tanne was not convinced. As Tanne, Josephine published "To a Dark Poem," a very grim rendition of interracial love in which the white female speaker binds her black lover in a "white fortress" (a phrase Josephine had used to describe her family home in Granbury), refusing him freedom and offering, instead, just the "pallid loom of my breasts." This needy, pallid, monstrous woman would show up as the death-dealing widow of James Weldon Johnson's *Autobiography of an Ex–Colored Man.* She is the terrible ashen specter of Jean Toomer's "Portrait in Georgia" and the hideously well-meaning but lethal Mary Dalton of Richard Wright's chilling novel *Native Son.* As Laura Tanne, Josephine joined with Lillian Wood to create a white woman character who represented the most devastating critiques blacks made of whites, critiques far bleaker than anything ever published by her husband. As Laura Tanne, Josephine could also out-Schuyler Schuyler by ridiculing the racism of her white friends. In 1930, Tanne's "Now I Know the Truth" exposed "gross" whites, who sexualize all interracial relations and find blacks "strange and fascinating."

Writing under different personalities allowed Josephine to experience social positions otherwise unavailable to her and to write in ways

that were otherwise foreclosed, including satire, usually a masculine form. Through her pseudonyms, she could articulate a range of views—from the most sentimental kinds of primitivism to a radical version of antiessentialism—without worrying about reconciling their contradictions. Issues that caused problems in her home life were given free rein on the page. She could depict interracial love as a playful erotics of difference, then turn around and present it as doomed precisely because people insist on a difference that does not exist.

Publishing under various names also allowed her to publish much more than she would have otherwise. In the April 1928 issue of *The Messenger*, she published at least four separate pieces: a long article on diet and nutrition as Heba Jannath and three different poems as Laura Tanne. In the next issue she published at least three pieces: two as Heba Jannath and one as Laura Tanne. George could not afford evidence that the editor's wife was filling out issues of his magazine. By publishing under different names and at times anonymously, Josephine was able to create the appearance that there were many more white women circumstanced as she was and writing about it. In that way, she was able to create an imaginary community of like-minded white women that she needed but did not have. Her strategy worked, almost too well. Hence, anyone paying attention to a long-running series such as "The Poet's Page" would have assumed, wrongly, that there were many more progressive white women writing antiracist poetry than ever, in fact, existed. Until now, most of Josephine's writings have been unknown, unremarked, and never traced back to her authorship. And if her marriage had made her uncomfortable writing about herself in her own voice—as the cessation of her diaries suggests—her pseudonymous publications allowed her to keep writing, regardless.

As Mrs. George Schuyler, Josephine must have keenly missed the company of other women. Her family had been contentious but also intimate, and, as the youngest Cogdell child, she'd been especially doted on by servants and siblings. For the first three years of her marriage, until her daughter Philippa was born, she was largely alone in Harlem. None of the other white women she met—not Fania Marinoff, Mary White

Ovington, Annie Nathan Meyer, or Nancy Cunard—shared her goal of trying to assimilate into the black middle class. Her most interesting, and peculiar, persona was Julia Jerome, Harlem's black Ann Landers. As Julia Jerome, black advice columnist, Josephine could experience the intimacy with women she was, in fact, often without. Julia Jerome's calling card was girl talk. As the leading black female advice columnist in *The Pittsburgh Courier*, the nation's most widely circulated black paper (200,000 to 250,000 copies were distributed at its peak), Josephine had the ear of (other) black women. Speaking to them, advising them, communicating with them about the most intimate and vexing parts of their personal lives helped her go from having almost no one to speak with to presiding over a huge and public conversation about private, domestic life.

"Julia Jerome" was an ardent feminist and a more consistent defender of modern women than Josephine ever was. She cautioned lovelorn women that love is "always changing," not something they can expect to be the same year after year or even day after day. "Believe me, I know a thing or two about this love game," she told her readers. She advised her black women readers not to accept their first chance at marriage but to assume that they would have multiple opportunities. Since "money is necessary," she warned, be very shrewd in choosing a husband who is both a good provider and a competent lover, a man with both "love-making and home-making qualities." Do not to be afraid to teach a man how to give sensual and sexual pleasure. Think of marriage as a partnership, an "ideal" that is also a "deal." Understand virtue not as sexual abstinence, but as self-development and improvement. Appreciate that "your first duty is to yourself and your own happiness." Remember that the world is full of men and that "there will be others just as good" if one does not pan out. Women "for thousands of years have been literally bought and sold" and now need a "square deal," she advised male readers. A "mercenary" and "calculating" framework is good for women until such time as "the state provides for the support of every prospective mother" and also "takes the ban off of contraceptive knowledge," she added. "Couples should be pals," she wrote to her male readers;

"treat [your] wives as comrades." In her combination of New Woman ideology and New Negro militancy, Julia Jerome was a fantastical—and fantastic—creation, unique in the Harlem Renaissance.

The Pittsburgh Courier's marketing of Julia Jerome was odd. Accompanying the columns was a Victorian-style silhouette of a stereotypically bushy-haired and large-lipped female profile. Long out of fashion by the 1930s, replaced by the camera and too closely associated with whites, such a silhouette was an unusual marketing choice. It created a hall of mirrors effect of masks upon masks for those who knew—as the paper's editors *must* have known—that black Julia Jerome was white Josephine Cogdell Schuyler. It verified Jerome's pretended blackness with antiquated, even offensive, racial markers.

In both her life and her writing, Josephine sought "emancipation" through remaking herself over and over again. But making yourself invisible is a tricky business. Even when it works—or especially when it works—there is an irony to escape by self-erasure. Or, as Josephine put it once in her diary, "sad are beautiful revenges."

"An Adventure in Bitterness"

Generally speaking, my life in Harlem has been most satisfactory.
—Josephine Cogdell Schuyler

Motherhood is an adventure in bitterness.
—Josephine Cogdell Schuyler

Philippa's birth in 1931 changed everything for Josephine. Once it became clear that Philippa was a genius and a piano prodigy skilled enough to achieve international renown, Josephine became ambitious for her daughter, not for herself. She continued to call herself a writer until Philippa was four years old, and then, despite the fact that she had never stopped writing, began referring to herself as a housewife.

Josephine documented every detail of Philippa's development:

weight, size, first crawl, first unassisted sit, first stomach pat, first head
rub, first stand, first steps, first laugh, first words ("Mama," followed by
"Daddy," "God damn," and "How do"). Nothing was too minor for Jo-
sephine's attention: what Philippa thought of dried leaves, what her fa-
vorite sounds were, how she looked at the cat. By the time Philippa was
an adolescent, there were more than a dozen heavy, oversize scrapbooks
filled with notes, photos, and clippings about her. There were photos
of Philippa on the roof with her mother, Philippa playing with dolls,
Philippa in the park, Philippa playing dominoes, and Philippa compos-
ing music—and, of course, many photographs of Philippa playing the
piano, since she sometimes rehearsed for eight hours a day. The scrap-
books were also filled with newspaper clippings. Reporters were mag-
netized by the toddler who played Mozart, could spell the longest word
in English, was a mathematical wizard, ate raw food, spoke in complex
sentences, and called her parents by their first names. Kept to be read

Josephine's scrapbook, with a message for her daughter:
"Your 'illustrious father and mother' during the critical period"
(that is, of Josephine's pregnancy with Philippa).

by Philippa as soon as she was old enough to do so, the scrapbooks also contained early history, from George's side of the family, to encourage Philippa's pride in her black ancestors. The first scrapbook opened with a picture of Colonel Schuyler, George's ancestor, and a map of New Amsterdam, so that Philippa would see "the city, the forts, and the defenses" that blacks had helped to build.

Philippa was the Schuylers' project. She could read at the age of two, play music at four, compose and give concerts at five. Those extraordinary accomplishments, combined with uncanny poise and maturity, would allow her, both parents believed, to "topple America's race barriers." Both wanted Philippa's story to defeat the old tragic mulatto narratives—stories of mixed-race people who cannot find their place in the world and die unhappily. Philippa could upend racism by demonstrating the superior benefits of "hybrid vigor." "What glory she will reflect upon us. . . . We must do everything to preserve her, like a hothouse flower," George wrote to Josephine when Philippa was four years old. To some people, "Jody's desire to prove the success of her marriage, through her daughter" seemed excessive, even "an obsession." But Josephine had never given up her determination that life should be lived toward greatness, not mediocrity. "As I look back, I see how I longed to be important, to be taken seriously, to be given a way of life, pointed a road that was interesting. Instead, I was given money, social position and treated like a baby. I loathed it." She believed that Philippa could be a "great personality in the world."

Philippa was exposed to literature and music, invited to listen to the debates of her parents' friends, taken to movies, and taught the values of discipline, hard work, and self-control. Both parents were followers of the child-rearing techniques of John Broadus Watson, "the Dr. Spock of his time," who recommended treating children as young adults. Watson was a proponent of spanking, and Philippa was spanked. (Hard, sometimes.) She was fed Josephine's raw-food diet with no processed food or sugar, lots of fruits and vegetables, raw meat, cod liver oil, large amounts of Vitamin C, wheat germ, lots of milk and dairy products, and as much fresh air and sunshine as Josephine could devise for her—often on the roof of their

apartment building. Special treats included homemade ice cream made from fresh fruit, unpasteurized cream, ice, and honey; and cakes made of ground dates, nuts, and raisins.

George was absent for so much of Philippa's childhood that Josephine referred to herself and her daughter as "widows." In one letter to Josephine, George acknowledged that he'd done "somewhat less" than his best. When he was home, though, he played with his daughter, read to her, and made up little poems for her, sometimes about her background and biraciality:

> *Ride a horse to Granbury town*
> *One foot is white, the other is brown.*
> *Go in the morning, come back at night.*
> *One foot is brown, the other is white.*

But in a marriage where most of the successes were put onto George's ledger, Philippa was Josephine's success. George always gave his wife credit for being a brilliant, responsible mother. "Jody was Philippa's whole world, and vice versa." Whatever ambitions she had once had for herself, Josephine now focused instead on her daughter's future.

Managing Philippa's development and professional career—which commenced before she was ten—became Josephine's full-time job. Some have criticized her for being a classic "stage mother" with an "obsessive need to control her daughter." But for others, Philippa's problems—she was clingy, depressed, dependent, often suicidal (beginning as early as nine or ten years old), and emotionally immature—left Josephine little choice. Josephine was "ruled by Philippa," not the other way around, one of Josephine's relatives said. Josephine never denied that she and her daughter had an unusual, possibly dangerous, symbiosis. In a letter to George, Josephine expressed her worry that "she has no other influence but me; and if my influence fails her, she fails: like a certain kind of bird that lives just in one kind of tree and if that tree is chopped down, it flies and flies until it dies of exhaustion because there is no other tree."

George's life changed very little after the birth of his daughter. In

fact, the novel that many consider his "greatest literary effort" and for which he remains known to this day, *Black No More*, came out in January 1931, just months before Philippa's birth. It launched another major chapter in George's literary career. Devastatingly funny, *Black No More* is the best thing George ever wrote. And it is probably the last piece of his writing on which Josephine collaborated or to which she contributed substantially (it bears her unmistakable editorial stamp). *Black No More* was also a turning point: the novel expresses—*and reverses*—the values the couple had always held most dear.

The plot of this Swiftian satire turns on Dr. Junius Crookman, who discovers a chemical process to turn blacks white. The wildly popular process results in "crazy" race behavior on both sides of the color line, with blacks rushing to undergo "chromatic perfection" and become white and whites increasingly hysterical about how to tell passers from "true" whites. As it turns out, Crookman's process makes *new* whites even lighter in color than "true" whites. Before long, all color values are reversed, with "true," or original, whites scrambling for skin-darkening solutions and tanning parlors to darken their complexions and thereby prove their claim to essential whiteness. The novel's protagonist— and the character closest to Schuyler—is black Max Disher, a Harlem dandy who becomes white Matthew Fisher, marries the white daughter of a leading Klan official, and becomes the Grand Exalted Giraw of the Knights of Nordica. By the end of the novel, Max/Matthew is financially comfortable and socially secure but longs for the black world he's left behind. He finds himself increasingly unhappy with Helen, his shapely, white southern wife. Along the way, the novel manages to lampoon every major figure of the Harlem Renaissance, from Du Bois (Dr. Shakespeare Agamemnon Beard) to Madam C. J. Walker (Mme. Blandish) to Marcus Garvey (Santop Licorice) and others.

Given Schuyler's staunch antiessentialist conviction that race is a superstition, all the passing in the novel *should* prove the absurdity of claims to racial difference. We should learn, from all the "crazy" race-crossing in the novel, that there is no reason to cross from one side

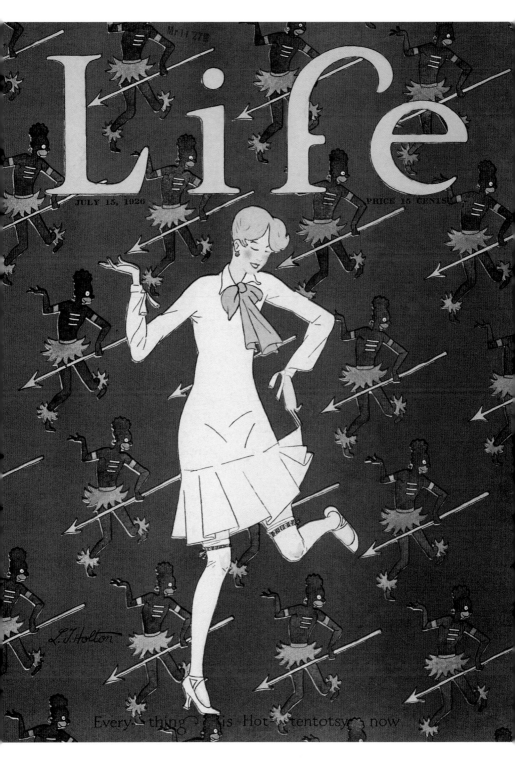

"Hot-tentotsy," 1920s primitivism.

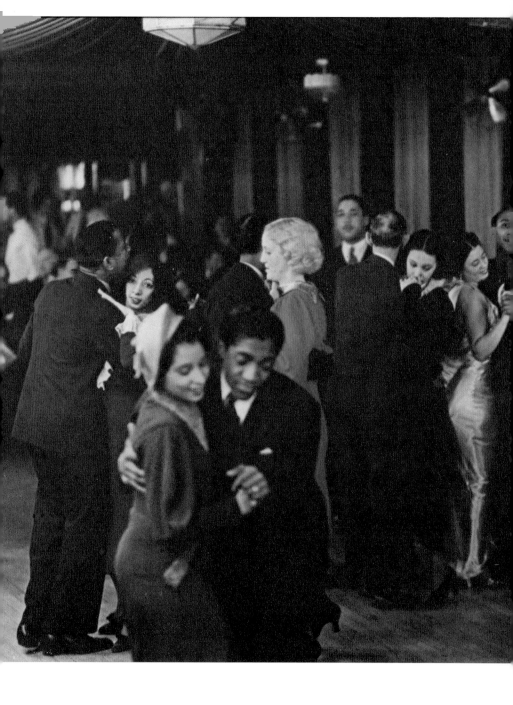

Harlem nightclub.

Walter White.

Carl Van Vechten.

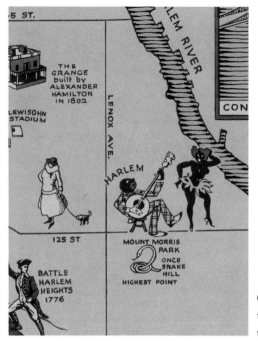

Close-up of Harlem
tourist map encouraging
stereotypes.

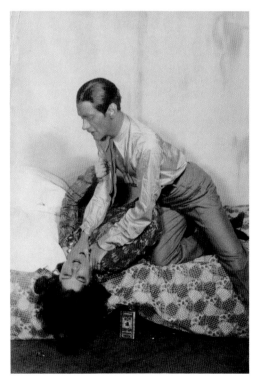

Libby Holman in blackface as a
prostitute, with Clifton Webb,
in "Moanin' Low."

Clockwise from above:

Langston Hughes.

Zora Neale Hurston.

Alain Locke.

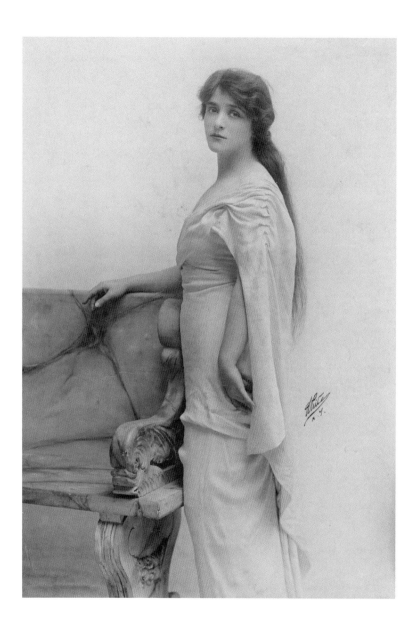

Studio portrait of Josephine Cogdell
as a young woman.

Josephine Cogdell's painting of her father in Texas.

John Garth's painting of Adam and Eve,
possibly using Josephine and George Schuyler as models.

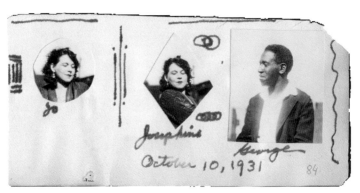

Scrapbook images of Josephine and George Schuyler, 1931.

to another (since the two sides are identical) and nothing to protect or hold on to, nothing to feel "pride" in, on either side of the color line.

But that is not what happens. It turns out that blacks can become white only on the outside. They remain, in some fundamental way, different. The race-crossings in the novel are absurd not so much because they are from nothing to nothing but instead because no one can leave behind his or her "true" self. Even more surprisingly, the novel makes use of a trope that I call the "moment of regret." The "moment of regret" anchors almost every black passing novel, from emancipation through the Harlem Renaissance, around a highly charged moment when the passing character second-guesses his or her decision to pass. Finding white society lacking—in some fundamental decency, ability to love, appreciation of music and dance, or capacity for humor—the passer longs for the black world he or she has left. At this moment the passer realizes that whiteness is empty, a bad bargain, in spite of the material gain it can offer: it is what James Weldon Johnson's passing narrator calls a "mess of pottage." Max's "moment of regret" is standard issue: "There was something lacking [in the white world.] . . . The joy and abandon here was obviously forced. . . . The Negroes were much gayer, enjoyed themselves more deeply and yet they were more restrained, actually more refined."

Black No More was very successful, (even in a depressed publishing market) and Schuyler received lavish praise from a diverse cross section of the Harlem intelligentsia, including journalist Eugene Gordon, Georgia Douglas Johnson, Mary Church Terrell, J. A. Rogers, Mary White Ovington, and Carl Van Vechten. Even Du Bois gave *Black No More* a thumbs-up as "significant" and brave and signed the review "Agememnon Shakespeare Beard," all of which Josephine especially appreciated. "You are indeed a sporting gentleman," she wrote to him gratefully. When white writer Dorothy Van Doren gave the novel a negative review in *The Nation*, calling it "white literature," Josephine rushed to its defense, arguing that there is no such thing as "racial" literature (Schuyler's argument in "The Negro-Art Hokum" and elsewhere) and that it

is foolish to expect a racial aesthetic from blacks. But George's novel was "racial" literature of a type unexpected for him: a black defense of essential blackness as different from and superior to whiteness, a novel which only *seemed* to argue that race was constructed.

However much she defended the novel—and regardless of what her own contributions to it may have been—*Black No More* must have been hurtful to Josephine. It was not only that Helen, the white wife, is tiresome, dull, an intellectual lightweight, and sexually uninspiring. But the novel's perverse racial logic must have affected her. She had staked everything on the idea that race differences could be breached. An intensely emotional woman, she had "consecrated" her life to a spiritual union with her husband that would prove that what everyone said about identity was wrong. If race, finally, was a fissure that could never be closed, perhaps she'd been wrong all along. Perhaps her greatest experiment was a failure.

By the time Philippa was born, only a few months after the novel appeared, the couple were beginning not only to live in separate bedrooms—which they maintained until the end of their lives—but also to keep their writing lives, as well as their personal lives, increasingly separate. Many strains were stretching their marriage to the breaking point.

One of those strains was George's changing politics. Soon after *Black No More* appeared in the early 1930s, he began an inexorable political slide from left-wing socialist to far-right conservative, "further right than Barry Goldwater," one of his friends later said. He came out against the 1932 Scottsboro case as a "Communist plot." When Angelo Herndon, a black Communist Party organizer, was arrested on political charges in Atlanta and found guilty by an all-white jury, Schuyler attacked him, instigating a vitriolic public exchange with Nancy Cunard's friend Eugene Gordon. Over the next two decades George opposed black boycotts; attacked black nationalism; argued for self-help rather than protest; championed American progress; supported Joseph McCarthy; eventually opposed the civil rights movement, attacking both Martin Luther King, Jr., and Malcolm X; supported Barry Goldwater; and finally joined the John Birch Society and be-

came a journalist for the notoriously reactionary Manchester *Union Leader*. Much of Harlem was disgusted with George. Twenty-four people, including Langston Hughes, signed a petition to the staff of *The Pittsburgh Courier* asking that he be fired. Schuyler lost many friends (though, oddly, not Nancy Cunard). It is very unlikely that Josephine shared his politics. Though she also became an anti-Communist (as did many Harlemites; the Party did not behave admirably in Harlem), she left no record of agreeing with any of George's other conservative views. Josephine was nothing if not loyal. She never disagreed in print with any of his increasingly alarming views. What must it have been like for her, who had married one of Harlem's most sparkling and radical thinkers, to now be saddled with a figure she had come to see as emotionally withholding, constantly absent, and shunned by most of their former friends, notorious where he had once been famous, and increasingly a laughingstock in the Harlem intellectual circles she had long respected and tried so hard to enter?

Josephine suffered from increasingly severe bouts of depression and feelings of abandonment. She did not address the widening political rift. Instead she pleaded with George to be more loving:

> I felt you had long ago stopped loving me. That you had long ago become very hard boiled and callous and did not care about anything much . . . that you did not love us or understand us at all . . . that you lived a life away from us and only wanted to be away from us and that we were doomed. That it was only a question of time when we would have to die by suicide. . . . First me, then Philippa, for she will imitate anything I do. . . . I cannot live without you—and you fail me when you leave me and meet others. That I can't accept . . . though I try to I can't. It kills me.

Throughout those years, Philippa's professional success continued to grow, especially outside the United States. Increasingly, she lived and

worked abroad, far from Josephine and George. She was emotionally unstable and involved in a string of unhappy romances, and Josephine worried about her.

In addition to performing and composing, Philippa followed her father's lead as a journalist, imitating his conservatism. In 1967, she was on tour in Vietnam, performing and also reporting for the Manchester *Union Leader.* Josephine felt she was unsafe and begged her to come home. On May 9, the Schuylers received a phone call from a journalist friend. Philippa had been helping to evacuate orphans from Hue, and her helicopter had crashed into Da Nang Bay. Some of the passengers had been able to swim to safety. But Philippa's lifeless body had been pulled from the water.

Philippa's death was covered by every major television channel as well as all the national newspapers, and within hours there were dozens of tasks to perform: reporters' questions to answer; letters, telegrams, phone calls, and cables to respond to; her funeral to plan. The international outpouring of sympathy was overwhelming. Ella Fitzgerald cabled. So did Henry Cabot Lodge and Sammy Davis, Jr. George could not get up from his chair, and Josephine took care of everything. The funeral, on May 17, 1967, rivaled anything Harlem had ever seen, including the gala funeral for A'Lelia Walker. Philippa's silver casket was borne through the streets from Harlem to St. Patrick's cathedral, with hundreds of mourners lining the processional route and another two thousand packing into the church.

In the following months there were many activities to distract Josephine. There was a memorial foundation to create. There was a memorial book to write, *Philippa: The Beautiful American*, Josephine's poetic tribute to her daughter's life from birth to death. There were hundreds of letters to write. There were tribute concerts around the world. Philippa had left unfinished manuscripts of all kinds. It was exhausting. But it was also something to which Josephine could fix her formidable determination, something to live for.

But as the two-year anniversary of Philippa's death approached, most of those tasks had been completed and the active work of grieving,

mourning, and memorializing was coming to an end. Josephine was entering what might have been the hardest phase of all: moving on with her own life.

She collapsed. Her depression overwhelmed her, and she stopped going out, stopped talking to friends, stopped reading the papers, and turned away from the world. By May 2, 1969, even George was worried. Josephine had not eaten or slept for days. She seemed distant and quiet. George found her, at one point, standing aimlessly in her bedroom, staring vacantly toward, but not out of, the window. He went back to the living room. Three hours later, he went back down the hall to Josephine's bedroom. While he had been reading in the living room, Josephine hanged herself with her bedroom drapes.

She left a suicide note, carefully written out on her personalized stationery. "Everything I have goes to George Schuyler, my husband," she wrote.

> The cats must go to the ASPCA with pension. They must [not?] be put to sleep. Call them and they will come. P.S. You had better marry Carolyn. The gold piano should go to Ivy Anderson—not Betty, but you can get the phone [number] from Betty Gumby in the book. The little typewriter to Hugh Gregory Jr. The music and instruments (violin and horn) in closet to Armenta Adams.

She also appended a note "to the press":

> I am killing myself rather than go to a New York hospital which today are crowded, dirty, with incompetent nurses, indifferent mercenary doctors & attendants looking like the cutthroats from a chain gang.

Like her daughter, Josephine was cremated. George was left alone in the quiet three-bedroom apartment on Convent Avenue, surrounded by his manuscripts, his wife's manuscripts and paintings, his daughter's

manuscripts and compositions. Urns containing both women's ashes sat on the mantelpiece in the living room.

In 1970, George made efforts to have Josephine's novel *From Texas to Harlem with Love* published. He contacted an agent, who expressed great interest in placing the book. Nothing ever came of it. Josephine would have been happy to see that book published. But she would not have wanted to be judged on the basis of it or any one project. "We have

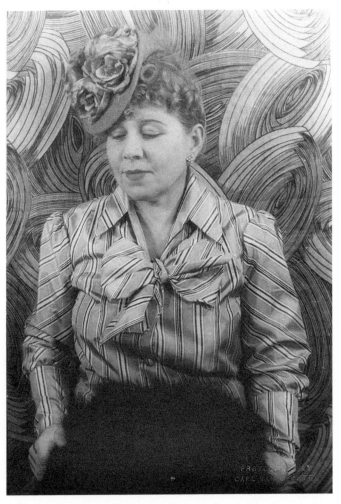

Josephine photographed by Carl Van Vechten.

refused to be conventional," she once noted in her scrapbook. "We . . . are a challenge to the set notions of America on race." Her whole life, in that sense, was her project. Though it may not have been happy, it is not clear that she would have declared it a failure either. Refusing to be conventional, as Josephine well knew, is a very risky business. And unconventional lives, by definition, are the most difficult ones to live— and to judge.

Part Three

➤ ◄

Repudiating Whiteness:
Politics, Patronage,
and Primitivism

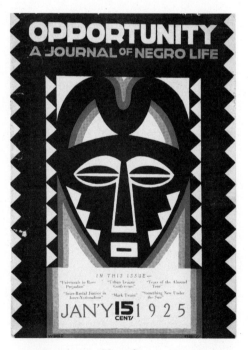

*Images inspired by African art appeared
often on* Opportunity's *covers.*

Chapter 5

Black Souls:
Annie Nathan Meyer Writes Black

Black Souls *is accusing them on their own ground. They can't tolerate that.*

> —Josephine Cogdell Schuyler to Annie Nathan Meyer

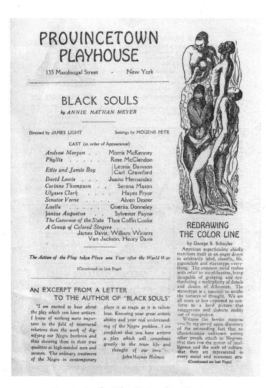

Program for Black Souls, *close-up.*

Deep in the basement of Columbia University's Adele Lehman Hall, the linoleum floors dip suddenly and the hallways undulate as if a drunken builder had laid them out underwater. There, under suspended banks of fluorescent lights, are the Barnard College archives. In one of five cardboard boxes of unsorted material from Barnard's founder Annie Nathan Meyer is a sepia studio portrait of her at fifteen or sixteen years old. A caption made of mismatched letters cut from newspapers is pasted onto the heavily matted old photo. Although she later grew into a solid, squarely built woman, she is slender in that photo, formally dressed in a heavy tucked suit cinched with a wide leather belt. She stands erect, her long neck rising out of a white collar and her hair smoothed neatly back. With her hands folded lightly in front of her, she avoids the camera, fixing the middle distance with a cool, direct gaze. Everything about the photo seems to assent to 1880s conventions: a familiar portrait of a carefully prepared young woman of means about to take her proper place in an ordered society. Everything but the caption. Presumably placed there by Meyer herself, its large cutout letters read, "Listen, honestly, Get Out."

Meyer does not conform to the images we have of rebels. She did not support some of the most important feminist causes of her day. She founded a college for women but eschewed suffrage. She was a doctor's wife and a writer prone to crafting melodramas out of step with modernist avant-garde aesthetics. But Annie Nathan Meyer kept faith with that young girl who wanted to "get out" of the life that was expected for her. One way she did so was to write a play called *Black Souls*, which was entirely unlike anything ever written before.

By 1924, Meyer was already the author of eight successful plays, numerous novels, many essays, and hundreds of editorials. Not entirely satisfied with any of them, she began drafting what she considered her most daring and important work: a short play called *Black Souls*. She wrote during a time when many successful "Negro plays" were by white authors. But she disdained the work of other white writers as not "authentic" and was determined to make her mark by doing something "bigger."

Annie Nathan Meyer around the time she wrote Black Souls.

Nothing she had ever written had been quite so difficult for her, not even a turn-of-the-nineteenth-century novel about artificial insemination. *Black Souls* told the story of a white southern woman's desire for a black man. It did not pretend that she had been seduced. It did not suggest that she had been deceived. It did not moralize against her desire. The appeal of her intended was treated as a given. This, in Meyer's day, was unheard of. As a white woman, Meyer "felt utterly unworthy" to accomplish such a "great theme." "Never approached a theme with such humility," she noted. So she took her drafts to her friends Mary White Ovington and James Weldon Johnson.

> Miss Ovington heard me read it before I went—thinks climax builds superbly but thinks [first?] scenes drag. . . . I must reread it carefully trying to have less talk & less pro-

paganda. . . . A few sentences are academic rather than from the heart. . . . Miss Ovington tho't play immensely improved since she had heard it a month before. Last night I read it to James Weldon Johnson colored poet, orator & organizer & his charming wife. They were much moved. . . . All thot it true—one breathed a sigh when I finished & cried out "Dynamite!"

She asked Johnson to edit and authenticate the work, but she also felt she needed the input of a black woman writer. The perfect opportunity presented itself at the 1925 *Opportunity* awards, where she met Zora Neale Hurston and found her enormously engaging. Within a week she had sent Hurston money, recommended her to a friend who was a *Vanity Fair* editor, and helped arrange for Hurston to work with Fannie Hurst. She used her pull to persuade Barnard to accept Hurston on a scholarship, though no black student had ever been admitted before. Your interest "keys me up wonderfully," Hurston told her.

They approached each other as fellow writers, sharing story ideas, outlines, and drafts. But Meyer also became Hurston's most important "Negrotarian." "*I must not let you* be disappointed in me," Hurston wrote to her on May 12. Hurston's early letters to Meyer adopt a mock-servile pose: "Your grateful and obedient servant"; "Your little pickaninny"; "Yours most humbly & gratefully"; and so on, all designed to give Meyer honorary status as a Harlem insider with whom one could joke about race.

Meyer first shared *Black Souls* with Hurston as early as the fall of 1925 or winter of 1926. Hurston wrote back that *Black Souls* was "immensely moving . . . accurate . . . [and] brave, very brave without bathos." At first Hurston hoped that she would act in the play, in the role of Phyllis. "I want to be the principal's wife so badly." She became the play's advocate, talking to "every one of the literary people" and "scouting around" for singers, "trying to pick them up off of Lenox Ave." Meyer soon became convinced that Hurston should rewrite

Black Souls as a novel. On January 21, 1927, as Hurston was head-
ing south on her first folklore-collecting mission as Charlotte Mason's
"agent," Meyer offered terms: "[If] the book is published, I shall make
full acknowledgement. . . . Also I shall give you one half (½) of all
royalty received by me. . . . I shall give them to you also if a Movie
is made from the novel, but not if a play is produced, because I have
already done the play. . . . I do hope you will enjoy making it into
a real novel." By March, in spite of crisscrossing Florida, collecting
folklore, starting a novel, and getting herself engaged, Hurston was
able to reassure Meyer that she had already completed the first thirty
pages of a rewrite. "I hope you will like what I have done on the story,"
she wrote. By fall she had finished the first draft. But now she felt that
the crucial interracial love story "would strike a terribly false note" in
the South, especially. I could "go over it with you page by page," she
offered. Meyer was committed to that scene, and rather than drop it
from the play, she let their collaboration fade.

As it turned out, the scene that Hurston thought should be removed
was in fact too controversial. Despite the approval of many of Meyer's
friends and collaborators, no producer would touch the play. Annie Na-
than Meyer had the persistence of a tugboat. The resistance to her play
convinced her of its merit, and she labored on it doggedly for the next
eight years.

Finally, in 1932, the Provincetown Playhouse on MacDougal Street
in Greenwich Village decided to stage *Black Souls*. Featuring some of
Harlem's most celebrated actors, including Rose McClendon in a star-
ring role, and involving the design and directing talents of many of the
best artists in Greenwich Village, *Black Souls* opened to great fanfare,
mixed reviews, and one of the most heated controversies in the history
of modern American theater.

All of Annie Nathan Meyer's friends had advised her that she would
never find "any manager bold enough to produce" the love scene be-
tween white Luella and black David. But for Meyer, that love scene was
the heart and soul of the play:

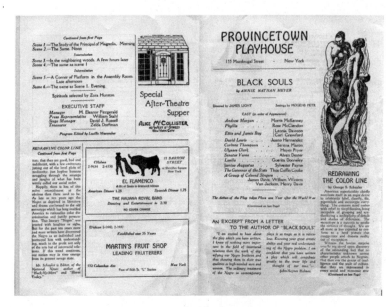

Program for Black Souls.

To me the most original note in my play had been the hither-to untouched accusation that beneath the lynching of the Negro, beneath the Southern white man's determination at all costs to protect his women, was the dread that some of them responded to the call of the strong black man. It was easy enough to cry "Rape," but it was not so easy to feel satisfied in one's heart that it was entirely a question of force.

Josephine Cogdell Schuyler told her that the scene was

absolutely true to life . . . to have a Southern girl of the upper classes who has seen her father keep black mistresses fall in love with a Negro is not nearly so unusual as people like to think. In fact I did exactly that myself and for this reason your play rings exceedingly true.

Important political events influenced the Provincetown Playhouse's decision to stage the play. On March 24, 1932, the Alabama supreme court voted to uphold the death sentences of the Scottsboro Boys, in spite of a dearth of evidence and the recantation of Ruby Bates. There had been, Bates now admitted, no rape. "Those policeman made me tell a lie," she wrote to her boyfriend, Earl Streetman. "I wish those Negroes are not Burnt on account of me it is these white boys fault." Wild enthusiasm initially greeted Ruby's recantation. The Scottsboro Boys' supporters were sure that it would lead quickly to justice. For white women, especially, the Scottsboro case represented an opportunity to take a stand against what Nancy Cunard called "the abomination of racial injustice" carried out "in the name of white American womanhood." The American Left, still reeling from the executions of the anarchists Nicola Sacco and Bartolomeo Vanzetti in 1927 and the feeling, as John Dos Passos put it, that "we are two nations," was determined to see no more wrongful executions. Both blacks and whites believed that the national outcry over the case could reverse the tide. To their horror, the recantation made no difference. Bates's testimony had put the Scottsboro Boys in jail, but her recantation could not free them. Once she became part of what Nancy Cunard later called "the lynch machinery," facts no longer mattered. Ruby Bates's inability to stop the wheels that she herself had set into motion became a crucial aspect of Scottsboro's symbolic meaning.

On March 24, 1932, the Alabama supreme court upheld almost all the nine convictions. On March 30, 1932, *Black Souls* opened at the Provincetown Playhouse. The play's advance publicity did not mention Scottsboro or Bates's flailing attempt to change her story. It didn't have to. The Bates/Luella parallel was clear. The 220-seat house was packed. The program for the play's opening night included an essay by George Schuyler under a drawing of intertwined black and white bodies. Schuyler was known for his sardonic tone. But with atypical earnestness, his program notes extolled *Black Souls* for helping "our nation . . . emerge from its present savage state" and "redrawing the color line."

When the Provincetown Playhouse finally staged *Black Souls*, the

country was also in a deep economic depression that hit the arts and Harlem especially hard. Since "Negro plays" were now considered too risky and producers wanted private backers to finance productions, (as Charlotte Mason had done with Hurston's *The Great Day* two months earlier), Meyer agreed to finance *Black Souls* herself. She had been born with a surfeit of self-confidence and a prodigious capacity for work. She was capable, opinionated, and stubborn. She had grown up, like Mary White Ovington, in thrall to stories about William Lloyd Garrison, and she wanted to be someone, like him, who "stands up & dares" and who "cannot be juggled with." She was also easy to underestimate. Even as a young girl she had a decidedly matronly look, which she adopted as a kind of disarming armor: old-fashioned pince-nez, high tight collars, and a severely upswept hairdo. She used conservatism to stand out from her more liberal relatives. And she used her money to stand out from other whites.

Meyer was born on February 19, 1867, into a relatively opulent but also circumscribed world at odds with her own ambitions. The Nathans' world was a tight-knit Jewish version of Edith Wharton's Old New York: a private-clubbed, grand-pianoed, silver-serviced world of Sephardim from the South, Manhattan, and Rittenhouse Square. It was "narrow, provincial, smug, self-satisfied," her sister, the prominent suffragist Maud Nathan, called it. This was a world of libraries and music rooms downstairs and made-to-order furniture and drawing rooms upstairs. The household staff included Irish maids, a waitress, two nurses, a governess, three servants, and a yardman. Seamstresses were brought in to hand-make the family's clothing, mattress covers, sheets, pillowcases, and bath linens. Unlike some households, which reserved their best things for company, "we used our solid silver every day," Meyer remembered. The Nathans were one of New York's first families, and their genealogy included presidents of stock exchanges, renowned rabbis, Columbia University trustees, Supreme Court Justice Benjamin Cardozo, and Emma Lazarus, whose poem "The New Colossus" was engraved on a tablet within the pedestal on which the Statue of Liberty stands. They were "imbued . . . with the spirit of New York's social direc-

tory." Annie Nathan Meyer was raised with the understanding that her family was "the nobility of Jewry" and "the nearest approach to royalty in the United States." Nathan men were expected to accomplish great things. But Nathan women were expected to hang back. Her mother, the southern-bred Augusta Anne Florance, who had grown up "well-to-do and surrounded by slaves," had "very decided" views about her two daughters. The girls were told to have no "pursuits" of their own, sent to dancing school, and taught "to cook and to sew . . . [and] to embroider." Despite all their privileges, Meyer and her sister grew up, she later wrote (sounding strikingly like both Josephine Cogdell and Nancy Cunard), "heart-hungry, brain-famished." Meyer was a brilliant child, but her father discouraged her studies. "Men hate intelligent wives," he warned her sometime before he abandoned his family altogether.

Meyer was a born contrarian, and she chafed against those standards. She also craved attention and wanted to "stand out." She and Maud were known as "the fighting Nathan sisters." When Maud Nathan became a social activist and a suffragist, Meyer became staunchly, infamously, antisuffrage. "She did it mostly to spite Maud," one family member maintained. In her autobiography, Meyer wrote proudly of how her indignant essays "attracted a great deal of attention all through the country" and kept her in the public eye as "the most forceful of the Antis." Being taken seriously meant moving into realms that were not already inundated with women like her, and it ruled out both suffrage (her sister's world) and settlement work.

In 1885, she attended Columbia University's Collegiate Course for Women but nearly failed her examinations because they were based on lectures that women weren't allowed to attend. She fought the examining committee and won her certificate. But the experience was humiliating. So she organized a petition drive, wrote fiery articles for *The Nation*, went door to door collecting endorsements, and, with the support of her new husband, rented a building to house a new college for women, New York's first.

Difficult as it was to found a college, getting the credit she craved for doing so proved even harder. From the day Barnard opened to the day

that she died, Meyer waged a furious battle to be acknowledged not as *a* founder or *one of* Barnard's founders but as *the* founder. She attributed Barnard's resistance to acknowledging her to entrenched anti-Semitism. "During the entire forty-six and a half years since the College opened," she wrote, "there has never been given any public official recognition of the part I played." In her journal, she described being "heart-sick—wounded in the house of my friends."

Meyer never got over the Barnard slight: "grudging, grudging . . . the worst hurt I ever received." She stopped pouring her energies into her "own" community and her "own" people. For Jewish women like Meyer, there may have been particular temptations associated with activist work in Harlem. Jewish activists might become "white" people in Harlem, when many had never before experienced themselves as "whites" in the larger American culture. For them, being white in Harlem but Jewish (and hence not fully white) elsewhere provided special insights into the relative nature of all social identities, as well as a status otherwise unobtainable. "God! I'd like to be recognized," she wrote in 1924, hard at work on *Black Souls*. Whereas Barnard had swept her name under the rug, *Black Souls*, in 1932, finally seemed poised to garner her the notice that she wanted.

To cover the play's costs, she withdrew money from her savings accounts and sold her Liberty Bonds. To cover additional opening-night costs, she paid for special tickets, a manager's assistant, costumes, Actors' Equity dues for many cast members (including the two stars), props, an opening-night party (for which she felt her manager spent far too much money), telephones, ushers, a doorman, flashlights, and a treasurer. With such an outlay, it seemed to her that she could not fail.

Opening night looked promising. The theater was standing room only. Ticket sales were a healthy $286 for the evening. But white critics savaged the play's opening night. By the second day, the number of tickets sold dropped from 220 to only 24. By the end of the fourth night, the play had lost $452.93. Subsequent performances fared no better. On Tuesday, April 5, the Provincetown Playhouse sponsored a special "Barnard Night" with speeches on *Black Souls* by Meyer, Hurston,

and Fannie Hurst. Unfortunately, with 154 of the 220 seats for the special performance left unsold, the show netted only $21.50. *Black Souls* limped into the next weekend, netting a nearly $4,000 loss before closing on April 10.

Josephine Cogdell Schuyler was furious. She had seen the play on opening night with George and felt sure it would be a hit. *Black Souls* was infinitely superior, she believed, to popular plays about blacks such as Marc Connelly's Pulitzer Prize–winning *The Green Pastures*—with its retelling of biblical stories through simple-minded, happy-go-lucky black characters, "happy Negroes at a fish fry"—or plays by Eugene O'Neill. She very much looked forward to meeting Annie Nathan Meyer, who seemed a kindred spirit, in spite of being many years her senior and a northerner from an upper-class, highly educated, professional Jewish background: a far cry from Granbury, Texas. "As you know," she wrote to Meyer, "many of our noted liberals like to patronize the Negro and when they find one as independent as Mr. Schuyler . . . they are slightly shocked. . . . It is for the same reason that Black Souls made them feel uncomfortable. Green Pastures permits them to feel superior but a Black Souls is accusing them on their own ground. They can't tolerate that. . . . We simply must meet," she added

Set on the campus of Magnolia, a striving southern black industrial college with liberal arts aspirations (a college strikingly similar to Lillian E. Wood's Morristown), *Black Souls* tells the story of five people: the college founder and president, Andrew Morgan; his pretty black wife, Phyllis; her brother, David, a poet who has just returned from France with the 369th Regiment (the highly decorated unit credited with helping launch the Harlem Renaissance); a reprehensible white southern senator who raped Phyllis when she was only sixteen, a history that her brother, David, suspects but her husband, Andrew, does not know; and, Luella, Senator Verne's pretty white daughter, who met David, our returning soldier, in Paris and tried to make love to him there.

When David and Luella meet again on Andrew's campus, which depends heavily on Senator Verne's political and financial support, Magnolia College is getting ready for distinguished white northern visitors

who might become donors. David insists that Luella respect the South's color lines, and he resists her persistent advances. But Luella chases him down and then, in the play's third scene, follows him into the dark woods and leads him inside an abandoned cabin. " 'Miss Verne, I begged you not to come here,' " David pleads. " 'Really, you must go back at once. I had no right to weaken. You don't understand what you're doing.' " Luella, however, is hungry for life, adventure, and passion—all of which she identifies with David's blackness. "I don't want to be safe," she insists. "No. I want to know everything. To feel everything, to experience everything! I'm not afraid of life. I want life—I want it—bubbling over the brim. . . . I'm not a child! . . . I am a woman—with the feelings of a woman." She throws herself into David's arms. He sees a "white face peering in the window," and realizes that unless he acts quickly, Luella's reputation will be ruined. "Swiftly he makes up his mind to do what he can to save her," the stage directions read. "He would rather be killed for the usual cause than have her encounter the scorn and possible violence that would be aimed against her if white men suspected her of actually inviting him to bring her to this lonely place in the woods." The scene ends with the door flung open by incensed white men and Luella's ineffective plea: "Stop, stop, I say." David, predictably, is lynched. His death not only terminates his career as one of Harlem's most promising poets; it also brings his brother-in-law's college crashing down. Phyllis, the ending suggests, will once again fall prey to the vile Senator Verne, whose lascivious crimes the now-weakened Andrew cannot avenge without starting "the biggest race riot the South has had yet . . . hundreds—thousands" of lynchings.

The final scenes are remarkable in insisting that freedom for blacks must include sexual freedom. A few black intellectuals, including George Schuyler and J. A. Rogers, were advocating for a full range of black sexual freedoms, but they were in a distinct minority. Most black writers avoided the subject assiduously. The final scenes also insist that we treat Luella's desire for David as completely natural; the play's dramatic realism never pathologizes her passion. Such insistence on white

women's cross-racial desire was unusual. Hurston refused to believe it. "I am absolutely certain," she wrote to Meyer, "that the daughter of a *southern senator* would never follow any Negro man to the woods however handsome he might be, or brilliant."

The play's final scene, like Wood's depiction of lynching (which Wood was composing at almost the same moment), implicated white women in racial violence to a degree almost unheard of on the American stage. Luella is paralyzed and useless. Desiring David, she forfeits any claim to either whiteness or womanhood, as defined by the culture of the American South at the time. Her ineffectual attempt to stop the violence carried out in her name—her pathetic "Stop, stop, I say"—shows that she cannot escape her own complicity with the barbarities of whiteness. Many historians of the period argue that white women were "reluctant to adopt" an understanding of lynching that took full responsibility for their role "in maintaining the system of racial oppression." Meyer's play sets itself apart by its eagerness to dramatize that understanding.

Most of the white "Negro" plays by Paul Green, Eugene O'Neill, Julia Peterkin, and Fannie Hurst were as sympathetic to their white characters as to their black ones, if not more so. In spite of their efforts to write black, that sympathy often gave those white writers away. Luella is attractive and intelligent, even admirably rebellious. But she is wholly unsympathetic. More than unsympathetic, she is a version of the well-intentioned, monstrous white woman found throughout Harlem Renaissance literature. Luella embodies Angelina Weld Grimké's (and other black women's) view of white women as "about the worst enemies with which the colored race has to contend." That figure appears in McKay's and Toomer's chilling poems, and she prefigures Richard Wright's Mary Dalton, whose every good intention only further seals Bigger's doom. "I didn't mean to—I didn't know—honestly I didn't!" Luella laments. Good intentions cannot get Luella off the hook. In fact, the worst acts of barbarism, as *Black Souls* demonstrates, may spring from good intentions. That was hardly a message well-intentioned "Negrotarians" would welcome. By insisting upon it, Meyer risked alienating

other whites. Blacks, surprised to see it come from a white woman, were thrilled. The play underscored how sharply divided the black and white worlds were. So did its divided reception.

Walter White, the executive secretary of the NAACP, believed *Black Souls* to be "a remarkably courageous and straightforward [play] free from the usual sensationalism." It "cannot help but be convincing to those who have hearts and brains to recognize the truth," he said. James Weldon Johnson overcame his earlier objections to call it "one of the most powerful and penetrating plays yet written on the race question." Black folklorist and activist Arthur Huff Fauset (the son of a black man and a white Jewish mother and the half brother of novelist Jessie Fauset) appreciated its "unvarnished truths about the situation [interracial sex] which has so many lies and half-truths to its credit." He called it "a landmark." Black critic Vere Johns, in the widely distributed black newspaper *New York Age*, wrote that "Black Souls . . . gives a true picture of the cultured and educated Negro. . . . Mrs. Annie Nathan Meyer has written a play of frankness, of understanding, of sympathy." Hurston offered the highest possible praise: "The author has such an understanding of this inter-racial thing. . . . Never before have I read anything by a white person dealing with 'inside' colored life that did not have a sprinkling of false notes." Meyer also received fan letters congratulating her on her "compelling," "wonderful, eye-opening" play. Some fans wondered why she was closing *Black Souls* early. Like Nancy Cunard and Josephine Cogdell Schuyler, she carefully pasted the letters into her scrapbooks.

The white press, on the other hand, liked almost nothing about the play. In spite of being widely reviewed in the white press, it was also roundly dismissed as "crude," "almost hopeless," "uneven," "untheatrical," "unfortunately inept," "written clumsily," "crudely written," "muddled," "windy," and "meandering"—"rhetorical propaganda." The *New-York Evening Post* said the play was "a great deal of earnest talk, giving the impression of a series of stump speeches demanding justice for colored folk." And the *New York Herald Tribune* faulted it even as propaganda: "The play fails to become either an exciting bit of theater

or a convincing treatise." Worse yet, Walter Prichard Eaton, a Harvard-educated Yale professor and drama critic, claimed that *Black Souls* "has no authentic tang."

Meyer's Harlem friends tried to be comforting. "What a pity it is that newspapers must, perforce, dispatch mere 'dramatic critics' to report plays like this one," Arthur Huff Fauset wrote. "What does your casual 'critic' know about Negroes or Negro-white relations?" Josephine Cogdell Schuyler rushed to Meyer's defense. Under her pen name Heba Jannath, she wrote that *Black Souls* was "in advance of the popular conception of the Negro" and therefore too advanced for Eaton's understanding. "I always felt," Meyer agreed, that white critics "were afraid of it."

Meyer was right. If there was one thing most of white America was unprepared for in the 1920s and early 1930s, it was sexual equality between races on the dramatic stage. Much milder, by any standard, than *Black Souls*, Eugene O'Neill's play *All God's Chillun Got Wings* had led to a "press storm" and "more publicity before production than any play in the history of the American theatre, possibly of the world" over much less. Its depiction of a white woman married to a black man and a scene in which he—played by Paul Robeson—kissed her hand was O'Neill's only breach. But it was enough. "A romantic scene between an interracial couple was perceived [even] by the black community as self-destructive, beyond sensible discussion." O'Neill treated interracial love as a "doomed passion." He reinforced long-standing notions about blackness as evil and whiteness as purity—"I've got to prove I'm the whitest of the white," says O'Neill's black Jim. Luella's passion, treated unapologetically, is of another order altogether.

That difference made *Black Souls* a cause célèbre in Harlem. What Fauset called the play's "tragically brief run" became a symbol of the sorry state of American race relations. *Black Souls* emerged as a testing ground for insider or "honorary" status in Harlem. Those whites who liked *Black Souls* were viewed as reliable members of what Fauset called the "ever narrowing band of fearless ones on this earth." They could be trusted. Those who disliked it were outsiders. They could not be trusted

politically. Socially, they were seen as hopeless. George Schuyler spoke for many in Harlem when he called Meyer "brilliant and peppery" and noted how unusual it was for "an elderly Jewish lady, wife of the distinguished Dr. Albert Meyer," to be such a "militant feminist, a fine writer and an outspoken Negrophile."

Meyer took happily to being a "landmark" and attempted to pay homage to her predecessors such as Lillian Wood. She encouraged Columbia University president Nicholas Murray Butler to recognize "some white educator of colored people." Butler declined.

The play's reception by blacks became her special source of pleasure, compensating for the decadelong effort she had put into what had turned out to be a ten-day run. "When persons didn't know who I was," she declared proudly, "they always assumed it was written by a Negro. . . . One and all the Negroes have thought well of it." "It is the biggest piece of work I have ever done," she stated. She took increasing comfort in Josephine Cogdell Schuyler's idea that *Black Souls* had succeeded *by* failing and had been forced to close only because its message had been too radical for other whites to tolerate. As Nancy Cunard would also do in the years following the publication of *Negro: An Anthology*, Meyer reread her "wonderful letters of appreciation" over and over to relieve (and perhaps relive) her anger.

Although she had questioned the interracial love affair, Hurston remained a staunch supporter of *Black Souls*. When the play closed early, she argued that "the Negroes should raise the money for its subscription." Meyer never forgot that. Decades later, she was still telling people that "Zora Hurston said I really penetrated to the real soul of black folks."

Black Souls set itself apart by depicting female desire at all, let alone white female desire for a black man, and also by eschewing dialect, concentrating on the middle class, and using none of the folk elements— singing, dancing, storytelling, and sermonizing—that were selling so well in white authors' Broadway revues about black life. Even Zora Neale Hurston had included those elements in *The Great Day*, which had opened just two months before *Black Souls*.

Black Souls: *Annie Nathan Meyer Writes Black*

By the time she began writing *Black Souls*, Meyer was a mature playwright with many Broadway productions to her credit (*The Advertising of Kate* was first produced in 1911). In addition to her longtime literary agent, Margaret Christie, she was represented by both Samuel French and Elisabeth Marbury, the two most important theatrical agents of her day. She might not have come to Harlem with the resources of a Van Vechten, a Spingarn, or a Knopf, but her professional theater background was cultural capital. She resolved to create something other than the derisive, romantic, predictable reviews of dancers, cakewalkers, "Mammies, faithful servants," and comics then popular onstage. She did not want to produce another "happy-go-lucky, singing, shuffling, banjo-picking being."

Like most white playwrights, she had begun with no background in African-American culture. But like Nancy Cunard, Charlotte Osgood Mason, Lillian Wood, Mary White Ovington, and Josephine Cogdell Schuyler, she went about her self-education in blackness with an autodidact's dedication, reading everything she could get her hands on. "I studied and read for years to write it." As part of her self-education she boarded a train to learn about southern conditions firsthand, reversing the direction of the many thousands who were making the "Great Migration" North. Her trip included a stop in Atlanta, where she met with black Morehouse College's first black president, John Hope, and his wife, Lugenia. They made a lasting impression on her. Hope was the biracial son of a white Scottish father and a free black mother who had been forbidden marriage under Georgia's antimiscegenation statutes. He leaned toward Du Bois's militant views of black education in the debates that divided followers of Du Bois from followers of the vocationally oriented Booker T. Washington over the controversial "Hampton model." His relations with white liberals were hence often strained. But he and Meyer got on well. "Your visit with my wife and me is quite pleasantly remembered by both of us," he wrote her. "Your good cheer, your insight into both races, and your great sympathy with the best that is in colored people." Inspired by her visit, Meyer "returned from Atlanta Ga. more than ever feeling that Black Souls is worthwhile." Hope was

her model for Andrew, the college president in the play. She also took her success in breaking through Hope's usual reserve with whites as a model for gaining acceptance in Harlem.

In addition to African-American history and literature, Meyer studied white authors' plays about black life. On the whole, she felt that they failed to move beyond minstrelsy. She was particularly disdainful of the self-satisfied sincerity of Paul Green and Eugene O'Neill. To her they were fatuous. "I was not writing as Paul Green did. And that was that." Unlike them or Carl Van Vechten, she would depict the middle-class, educated sectors of black life. "This [Black Souls] was a play that, for the first time, pictured ladies and gentlemen, college professors," she remarked. Her black characters would not mispronounce their words, use the wrong fork, dance, or roll their eyes. None of what Hurston called "margarine Negroes" for her. This is "the first play of Negro life that doesn't take the Negro as a naïve child or make fun of him or show him incompetent or second rate," she wrote to Grace Nail Johnson.

In late July 1924, as part of her self-education, Meyer made the long trek from Woods Hole, where she summered, to O'Neill's "deserted lighthouse . . . a wild and dreary spot," in Provincetown. Riding in a horse-drawn carriage from town, she shared a bumpy, broken seat with a dripping oil can and rode over the dunes—"sand, sand, sand"—to tell the distracted O'Neill, "still in his swimming trunks," why it was that "the Negroes had not cared for his play." "What do you think you know of Negroes anyway?" she asked a surprised O'Neill. "You make your Negro hero flunk his examinations for becoming a physician time after time. . . . And you expect Negroes to like and enjoy your play!"

Rather than model her play on anything whites were writing, Meyer made the unusual decision to mimic the black antilynching theater tradition, the least professionalized form of American drama then existing, almost always "presented in societies, schools," colleges, churches and amateur theatres. A "distinct genre of American drama," the antilynching tradition had begun in 1916 with Angelina Grimké's *Rachel*, a play addressed to white women in the hope that they could sympathize

with a black mother so agonized over the lynchings of blacks that she wonders if it wouldn't be "more merciful to strangle the little things at birth." Mary White Ovington published an unusual antilynching play in 1923 to which *Black Souls* clearly responded. *The Awakening* depicts young members of a northern black social club who come to a growing awareness of lynching as they harbor a young southern fugitive falsely accused of raping a white woman and succeed in securing his safety. In the process they grasp the importance of the NAACP's fight against lynching and join the cause by turning their social club into a local NAACP chapter. Very few antilynching plays end that happily. The black plays in this tradition are mostly tragedies in which lives are "blighted" and "accursed" by racism, by lynching, and especially by the complicity of white women in those wrongs. In small but significant ways, Meyer signaled her desire to be thought of as one of those black playwrights. Like their plays, hers used black music, poetry, prayers and sermons, speeches, and other kinds of dialogue within the body of the play, including a quartet of "colored singers" identified as "Zora Hurston's Choral Group." Most white authors' antilynching plays, however, such as *The Forfeit* and Ann Seymour's *Lawd Does You Undastahn,* used dialect.

Black Souls was also collaborative. In the early stages of the play, particularly, Meyer was experimenting with the idea of a multiracial dramatic voice. She was particularly taken by the idea of black-white literary collaboration between women, which was extremely rare, if not unheard of, in the Harlem Renaissance and which she had attempted with Hurston.

Black Souls makes its central problem white women's responsibility for racial violence. What Cunard called "the lynch machinery" was for Meyer a moral dilemma every white woman needed to face.

Hence she refused to give up. She turned her bitter disappointment about the unexpected closing of *Black Souls* into a massive advertising campaign, printing a brochure that invited the public to "find out for yourself why the dramatic critics, with significant unanimity, distorted its message and ignored its path-breaking originality, pretending that it

was only the same old black and white stuff. The truth is, never before has a playwright dared to utter certain truths." Using the interest her campaign helped create, she tried again to get a publisher for the play. None was interested. She appealed to H. L. Mencken; Eugene O'Neill's German translator, Rita Matthias; Edward Goodman of the Washington Square Players; the publishing houses Boni & Liveright, Macmillan, Harcourt Brace & Company, and Brentano's; Carl Van Vechten; black composer Flournoy Miller; the agency Brandt & Brandt; and renowned black actor Charles Gilpin. Nothing. "I have great faith that my play will stir people greatly once I can only get some one with courage to put it on," she lamented.

She decided to get her play back before the public by publishing it herself, although she and her husband were feeling the Depression's pinch. By mid-July she had signed a contract with Reynolds Printing, which specialized in the new field of direct-mail advertising, to bring out 250 paperback copies and 200 clothbound copies and hold an additional 550 copies in flat sheets for instructions. Meyer was sure she would need them once the book caught on. She gave William Rossi of Reynolds an initial payment of more than $400, with author's revisions to cost extra, the equivalent of many thousands of dollars today. What she did next must have rocked her genteel upper-class marriage. So determined was she to disseminate *Black Souls* that she took out expensive ads in magazines and newspapers, printing her home address (1225 Park Avenue) and selling copies (75 cents for paper, $1.25 for cloth) from her home— something almost unthinkable for a member of her social class and probably unheard of in their upscale town house neighborhood.

Eschewing her milieu's edict to avoid publicity at all costs, she next entered into a massive letter-writing campaign. In a world without computers or photocopiers and without a secretary or assistant, she mass-marketed to black colleges, movie producers, churches, political and civic organizations, philanthropic foundations, influential individuals, university presidents, literary and dramatic agents, newspapers, reading clubs and literary societies, actors, producers, and theater managers. Every letter was a personal appeal. She drew on her name and

family connections. She "guilt-tripped" shamelessly. At the same time, she angled for a movie version of her play and, simultaneously, a Broadway version. There was brief interest from the WPA, which "rehearsed devotedly for fully six weeks" and then got cold feet. Nothing came of it.

Her Reynolds Press version of the play did garner many reviews, some of them excellent. As she had from day one, Mary White Ovington applauded Meyer's bravery for sticking with such a "daring" story. Ovington remarked on how different it was from other plays of the day. "Here is realism, not folk lore, not slap-stick humor," she wrote. George Schuyler, with whom Meyer was growing increasingly close, reviewed the book twice for *The Pittsburgh Courier*. He wrote: "*Black Souls* is so unusual as to be breath-taking. . . . Few white people would have had the nerve or honesty to write a play like that. . . . It should come as a welcome relief . . . [from] the Emperor Jones—Florian Slappey—Green Pastures bunk." *Opportunity* also reviewed it twice. In his yearly retrospective for 1932, Alain Locke discussed no other play, risking Charlotte Mason's ire by not even mentioning *The Great Day*.

Meyer even tried to work with Gloss Edwards, an aspiring theater producer who proposed turning *Black Souls* into a musical with a happy ending. I am "immensely interested," she wrote Edwards. "I don't mind changes," she continued, trying to hold both his interest and her ground simultaneously,

> but frankly, I cannot see how the tragedy can mean anything if it has a happy ending. It seems to me the whole basic idea of the play would simply disappear. . . . Yet please don't think that I shall be difficult with changes. I pride myself on being the reverse. As to musical comedy (or tragedy) Personally I hate it. . . . *Nevertheless* I am interested. . . . I should rejoice with all my heart to see my play on, but wouldn't care a bit about it being put to music. . . . However I won't stand in the way if people who know really think Black souls would make a good Musical Show. Do I make myself clear?

She ended her letter with an invitation to Edwards to motor up to Maine for more discussion and promised to provide him with all of his meals. Nothing came of that either.

For a woman of Meyer's background and personality, the fact that many of the most interesting avenues of work were open only to men must have been galling. What she needed to be "happy," she wrote to her friend and agent Margaret Christie, was the ability "to plunge into work" of significance. In fact, she was able to parlay the notoriety of *Black Souls* into a place of honor in the black community, though not nearly as extensively as her friend Fannie Hurst was able to do, for writing that was not nearly so bold. In May 1933, advertised prominently as the author of *Black Souls*, Meyer appeared in *Opportunity* as a featured reporter on black life, providing a firsthand account, with analysis, of "Negro student" attitudes toward American communism. She used her platform similarly throughout the 1930s and 1940s, giving addresses on a range of race-related issues at churches, black schools and colleges, and institutions from the Urban League to the historian Carter Woodson's highly regarded black research organization, the Association for the Study of Negro Life and History. Excepting her good friend Mary White Ovington, no white woman (except Hurst)—at least none whom Meyer knew—could boast as long or as distinguished a New York career as an expert on race. When possible, she combined her standing as a Nathan with her status as a racial expert. In 1935, for example, she started a campaign in *Opinion*, a Jewish intellectual journal, to expose the notorious racist Madison Grant and oust him from his positions with the Zoological Society and the Museum of Natural History. She was especially delighted when she could use her new social power to help her Harlem friends. In the mid-1930s she helped underwrite a yearly salary for George Schuyler so that the NAACP could hire him to press for passage of the Costigan-Wagner Anti-Lynching Bill.

Unlike most other white women in Harlem, Meyer liked the company of other "broad-minded white women who are working for the

Negroes . . . charming women." *Black Souls* helped her build a network of such women. "The more I think of it the more I believe in it," she said. Being well liked in the black community was also deeply gratifying. Achieving that goal gave her a sense of freedom, as well as a sense of accomplishment and the first experience of comfortable community she'd attained. Meyer found it nearly impossible to be a feminist among women or a Jew among Jews. But advocating for black civil rights allowed her to give expression to both identities. Ill at ease and often bitter among those designated as her "own" people, she was able to do her best work when she was among those whose expectations weighed least heavily on her. In Harlem, she was free to be as contrary as she liked. That worked to her advantage. But it also helped ensure her obscurity.

Like many of the women whose stories this book tells, Meyer's involvement in Harlem was once extraordinary enough to earn her coverage in such prestigious venues as *The New Yorker*, which ran a two-part profile on her and her husband. (She hated the fourteen-page illustrated profile, which caricatured her to the point of cartoonishness, painting her as a crabby, self-congratulatory eccentric who careened from crusade to crusade and was lucky not to have ended up a spinster.) Yet, like those other once-famous women, she vanished from Harlem Renaissance histories almost without a trace. If she is remembered at all, it is for founding Barnard College. As one Barnard historian put it, "Annie's names, married and maiden, have been dropped entirely" from history. Meyer died in 1951, still fighting for the recognition she felt was her due.

Black Souls did help Annie Nathan Meyer "get out." It gave her meaningful work that combined her two passions. It opened an alternative world for her; helped her to set herself apart from her family; and gave her the recognition she had long craved, a sense of community, and the special freedom that comes from being an outsider on the inside of a social movement. It deepened her relationships with other white women, such as Mary White Ovington and Fannie Hurst. And it made possible intimate interracial friendships with James Weldon Johnson, George

and Josephine Schuyler, and Zora Neale Hurston. At one point she even developed a most unlikely friendship with one Clifford C. Mitchell, a syndicated columnist, reviewer, and admirer of *Black Souls*, who also happened to be inmate no. 30667 of the Michigan State Prison in Jackson, Michigan. She often described *Black Souls* as the most important thing that had ever happened to her. Sometimes she said that the play, and the ways it had changed her life, had given her something "worth living for." "I was always more of a pioneer than people realize," she peevishly remarked once to an interviewer. "It is of no more use to be ahead of your time than behind it," she added.

Chapter 6

Charlotte Osgood Mason:
"Mother of the Primitives"

<hr />

I am eternally black.

—Charlotte Osgood Mason

I am a Black God.

—Charlotte Osgood Mason

Mrs. Mason . . . is one of the mysteries of the Harlem Renaissance.
—Robert Hemenway

B y late September 1927, it was clear to Harlem that something was up. Alain Locke typically played things close to the vest, but word had spread about hushed consultations with an unnamed East Side individual to launch an extravagant new Harlem museum of African art. Instead of being fidgety, defensive, and self-conscious, he seemed calm and self-assured. Langston Hughes was sporting a handsome leather briefcase and elegant new clothes, and was spotted squiring an impeccable, lace-collared, white-haired elderly white lady to concerts, plays, and lectures, showing her the sights of Harlem, and traveling in a large chauffeur-driven car. "I saw Langston," Harold Jackman wrote to Countée Cullen, "escorting a dowager (white) of ninety-eight. She must have been that or at least an octogenarian—no kidding, she was really

Charlotte Osgood Mason looking grandmotherly.

very old. Langston was all properly 'tuxed' and the old lady handed him the carriage check and the last I saw of him he was getting into the automobile." Suddenly Hughes had seemingly limitless spending money and was able to pick up the tab for friends who'd come to take his charming freeloading for granted.

Zora Neale Hurston was even more notorious for being broke. Many Harlemites winked at her strategies for making ends meet. There was her failed stint as Fannie Hurst's secretary and personal assistant (Hurston could not type and was allergic to organization) quickly followed by her determination to "set up as a chicken specialist . . . fried chicken at a moment's notice to the carriage trade" to bring in extra cash. But now she was paying her own way and also flaunting new clothes, even giving some away. She claimed to have access to expensive equipment, such as tape recorders and movie cameras, and there was talk here and there that she might have a car. Tongues wagged when other formerly penniless black writers, artists, and musicians suddenly appeared flush as well.

This evidence of money—from somewhere—was especially notice-able given that the Harlem "vogue," as Hughes drily called it, had not translated into much cash for black artists. "Harlem is an all-white picnic ground and with no apparent gain to the blacks. . . . The saloons were run by the Irish, the restaurants by the Greeks, the ice and fruit stands by the Italians, the grocery and haberdashery stores by the Jews. The only Negro business, excepting barber shops," Claude McKay complained, "were the churches and cabarets." Many black Harlemites found them-selves receiving welcome attention but "no dollars."

Of course, Harlem's writers welcomed the notice of publishers. Com-ing after long years of neglect, the interest of the Knopfs, Horace Liver-ight, and Albert Boni felt like vindication. "I never expect to have a greater thrill," Hurston declared after being published for the first time. "You know the feeling when you found your first pubic hair. Greater than that." But, as with every aspect of the Harlem "vogue," there was a catch: white publishers depended heavily on white intermediaries to tell them which black writers to pursue. The most powerful publishers of black literature, Alfred and Blanche Knopf, never took a step in a black direction without first consulting Carl Van Vechten, who also acted as their white tour guide to what they still, in 1924, called Harlem's "Nigger joints" (i.e., its nightclubs). Van Vechten recommended only writers he knew personally. Attendance at the drinking parties at his 55th Street apartment—a riot of color with walls painted in "bright pink, pale pur-ple, and bright turquoise"—thus became a necessary rite of passage for Harlem's black writers. So many of Harlem's writers were vetted there that Walter White dubbed it "the midtown branch of the NAACP."

Van Vechten was a prodigious reader and a dogged tastemaker. If a book moved him, he was inconsolable until he badgered all those around him into liking it as well. After reading Nella Larsen's manuscript—an "extraordinary story, extraordinarily told"—in one sitting, for example, he marched straight to the Knopf office. "I stir Blanche & Alfred up about Nella Larsen's *Passing*, making quite a scene," he admitted. At the Knopfs' anniversary party he promoted the book relentlessly. By the next day, Nella Larsen had a contract and a marketing plan. "Alfred

Knopf tells me they are instituting a selling campaign for [Larsen's] book," he noted happily. Publishing then was hardly the corporate enterprise it has now become; personal influence could make or break a career.

In that context, Van Vechten's "Negrophilia" was a form of social currency. It was a time when *Life* could portray a caricature of a dancing African as wallpaper for the modern flapper. Many of New York's theaters and restaurants still segregated blacks; some denied them admission outright. Interracial socializing was still considered scandalous. Van Vechten's "passion for blackness" and his many interracial friendships were important in elbowing aside certain racial givens, especially the idea that blackness, as Patricia Williams put it, is "not worth knowing." By making white interest in blackness more familiar, Van Vechten paved the way for other like-minded whites.

But his flamboyance and love of attention also threatened to set the terms for such interest. Van Vechten loved the limelight. He reveled in the scandal his *Nigger Heaven* produced. "Every porter in the country seems to know the author of *Nigger Heaven*," he remarked delightedly; "Harlem . . . is seething in controversy." He thrilled to being so personally identified with the Caucasian "storm" that descended on Harlem that a popular song by the author of "Ain't Misbehavin,'" called "Go Harlem," encouraged its listeners, "Like Van Vechten," to "go inspectin.'" Refusal to compromise was both his strength and his weakness. Although blacks were anxious not to be seen as entertainers, for example, he pressed his black friends to perform at his interracial parties by singing, dancing, or reading aloud from their manuscripts and drafts. Most felt it necessary to oblige. Van Vechten did not handle disagreement well. In 1929, when Essie Robeson refused to take his advice to "do some more work" on her biography of her husband, Paul, Van Vechten was so upset that he became physically ill. "This puts me in a frightful anger," he noted in his daybook; it gave him a "sudden sore throat" and forced him to take to his bed.

The situation was ripe for a white patron of a different temperament. And in 1927, following a lecture by Locke on African art, Charlotte

Osgood Mason, a wealthy widow with a long-standing interest in blacks and Native Americans, found her opportunity. Subdued where Carl Van Vechten was excessive, calm where he was overexcitable, private where he was attention-grabbing, Charlotte Mason struck many of her new protégés as an antidote. She seemed to be just the "Godmother" she asked to be called.

Her gracious twelve-room home at 399 Park Avenue could not have been more different from the chaos of the Van Vechtens' apartment. Park Avenue, by the time Mason took up residence there, had supplanted Fifth Avenue as "America's street of dreams" and "the end of the American ladder of success." Writer Edna Ferber described it as a haven of "sedate gentility where . . . space . . . silence . . . [and a] sense of peace and privacy" prevailed. Mason's address, just north of Grand Central Terminal between 53rd and 54th streets, was a particularly good one, since her building (now replaced by the Citigroup towers) was on one of the earliest-developed sections of the avenue. Her apartment would have also been one of the largest on the street, topped only by some of the eighteen-room penthouses just then coming into fashion (rooftops previously having been the preserve of staff and laundresses). Apartments such as Mason's, with high ceilings, large rooms, fireplaces, wood paneling, staff quarters, and bedroom suites with private baths, would have rented for $1,500 a month prior to the stock market crash, roughly $20,000 a month in today's currency, making them inaccessible to any but Manhattan's storied 1 percent.

Her drawing room, a well-designed mix of European antiques and first-rate African art, was a refuge of hushed tones, Irish servants, and actual afternoon tea in place of cocktails. Finger sandwiches, lemonade, and cookies were served on bone china and fine crystal. On delicately turned side tables current issues of *Opportunity*, *The Crisis*, and *Survey Graphic*'s special issue on "The New Negro," edited by Locke, were elegantly fanned. Mason's debilitating arthritis meant that others fluttered about her, seeing to her every need. It made her seem downright girlish. She sat in her damask armchair, wrapped in a shawl, and invited her new protégés to share their dreams. White people in the 1920s rarely asked

black people what they thought, much less what they dreamed. But she offered unstinting encouragement, pronouncing everything she heard brilliant and original.

Mason was not socially positioned to broker the sorts of deals that Carl Van Vechten could arrange; the old New York society a doctor's wife such as herself or Meyer could command was a very different world from his. What she had, however, was a great deal of wealth and no one on whom she wanted to lavish it. She also had a fiercely competitive spirit and was determined not to be outdone by someone like Van Vechten. She dispensed her money with unprecedented liberality, writing large monthly checks to each of her protégés and also encouraging them to round up others she could help. In return for that largesse, she requested only intimacy and the shared emotional bond that comes from working together. It seemed little enough to ask, and in the main, Harlemites gave it eagerly. To Locke she was an instant mother figure, "one of the two dearest and best creative forces in my life." Zora Neale Hurston called her "the true conceptual mother." "It was all very wonderful," Langston Hughes said. "I loved her." Indeed, the whole arrangement seemed too good to be true.

It was. In the few photographs of her that survive, Charlotte Mason looks like a kindly grandmother or a sister to Lillian E. Wood, with a round face and features, a white bun, pearls, and a thick shawl. She appears kind and gentle, as she seemed at first to all of her protégés. Such pictures, however, do not tell the whole story. They do not capture Mason's unwavering stare, the press of her thin lips, the intensity of her sharp blue eyes, or the pull of her steely will. Over time, the intense intimacy she demanded became more and more disturbing. Her relationships with her protégés became so peculiar that historians of the era have thrown up their hands. They regard Charlotte Mason as "a shadowy figure," . . . "shrouded in mysteries"; a delusional, suffocating dowager; and a "regal husk" who turned her protégés into "courtiers" in "bondage" to her and her cash. "The purse strings she controlled were like tentacles," one wrote. There is no accounting, they claim, for why so many Harlemites—almost every major figure of the Renaissance, in

Charlotte Osgood Mason looking fierce.

fact—tolerated her interference. "So little is known today about Mrs. R. Osgood Mason . . . that she almost seems a . . . fiction."

Much fiction has been created about Mason. But she was, like so many of the white women of Harlem, hiding in plain sight. Neither fictional nor a mystery, she made sense within the confines of her era's race and gender ideologies, and her attempts at interracial collaboration also reveal a great deal about how people of different races and backgrounds, seeking to come together in the 1920s and 1930s, actually experienced those efforts. Born during slavery, reared in the Civil War, and raised to assume a leisured life as a doctor's wife, Charlotte Mason is less an impossible puzzle than she is a key to understanding the origins of some of our own stubborn ideas of difference and race.

A New Jersey Girlhood, a Spiritualist Husband, and a Mission

Charlotte Osgood Mason, originally named Charlotte Louise Van der Veer Quick, was born on May 18, 1854, the same year that Josephine Cogdell Schuyler's mother, Lucy, was born and the year the poem "The Angel in the House" prescribed woman's role as domesticity alone. Her parents, Peter and Phoebe Quick, were farmers in Franklin Township, New Jersey. There was railroad and industrial wealth in the family, on the side of her relatives the Van der Veers, that would find its way to Charlotte decades later. In her childhood, none of it was in her parents' hands, however. Her father's side of the family could be traced back to Dutch settlers and farmers arriving in New York as early as 1640. Her mother's side of the family revealed a direct line to the first white child born on colonial American soil. But pedigree did not always translate into assets. As was common, the Quicks had divided up their estate among their surviving sons, and Peter Quick had inherited one-seventh of his father's large farm in Somerset County, originally worked by as many as ten slaves. Charlotte was fascinated by her early family history. Her great-great-grandfather had owned dozens of slaves and freed them before the American Revolution in 1775; as an adult she shared that fact frequently.

Known as "Lottie" as a child, Charlotte was born under what Julia Ward Howe called the "old doctrine that women should be worked for, and should not work, that their influence should be felt, but not recognized, that they should hear and see, but neither appear nor speak." Her upbringing reveals little about the sources of her later belief that she should influence world events. Describing the society of Charlotte's childhood, Annie Nathan Meyer wrote that woman's work outside marriage was still subject to the "absolute scorn" of opponents. "More dangerous," she added, "because instead of employing the weapons of disdain, they use those of homage; instead of goading with scorn, they disarm with the incense of a false and hollow sentimentality."

Within a few years of Charlotte's birth, her mother died, and Charlotte became the only girl in a hardworking household of men. She had an older brother, Peter; and a younger brother, John. Before long, her father remarried; his new wife was named Catherine Jane Pumyea, and they had two children, Charles and Aletta. Aletta died in childhood, leaving Charlotte once again the only girl in the family. It was not uncommon in those postbellum times for some children to be raised by relatives who were better off financially. Charlotte's half brother Charles was sent to live with his aunt and uncle on his mother's side; he was listed as their servant in the 1880 census. Motherless girls were often raised by relatives. In spite of having a stepmother, young Charlotte was sent to live with her maternal grandmother, Joanna Van der Veer, and her aunt Amelia in Princeton, then a town of roughly six hundred families. She may have felt banished or abandoned. But had she stayed on the farm, her world would have been far more circumscribed.

Lottie turned eleven in 1865, the year of Lincoln's assassination. She spent the last years of the Civil War, an especially tense time in Princeton, with her grandmother and aunt. They lived in a neighborhood dominated by ministers, professors, and students and the various servants—mostly Irish and a few African Americans—who attended them, as well as a few cobblers, carpenters, blacksmiths, and a lawyer. The vast majority of young Charlotte's neighbors were students at the College of New Jersey (renamed Princeton University at the end of the century). During Charlotte's girlhood, fully half of those students were southern, sent north to acquire the genteel education requisite for legislators and plantation owners. The college worked hard to build up a reputation as "a suitable school for the Southern gentry who were loath to expose their sons to the abolitionism and radicalism at Harvard or Yale." It succeeded in becoming the most southern of all the northeastern schools.

At her grandmother and aunt's home, the impressionable young Charlotte experienced the pleasures of being an only child in an all-female household (except when her younger brother John came to stay). She also experienced the suffocating constraints of gender. Her

young male neighbors, not many years older than she was, were being trained as national leaders, spokesmen for their communities, models, and exemplars. It would have been impossible for her not to compare her own intelligence—which was formidable even in her adolescence—with theirs and not to notice how much narrower her options were.

Race was a central social issue in the Princeton of Charlotte's childhood. The town had a free black community with proud traditions. The college had been especially affected by the Civil War. Princeton's southern students vanished almost entirely once the war began, returning home to either fight for the Confederacy or care for family plantations. "Indeed, as many Princetonians died fighting for the South and for slavery as for the Union during the Civil War." That cast an especially mournful—and ambivalent—pall over the town. Charlotte briefly went to secondary school in Princeton. But a young girl's education did not typically include much discussion of current political events, let alone the complexities of race and gender. She was left mostly on her own to ponder both the community's debates and the possibilities for her own future.

The Van der Veers were neither activists nor recluses. Charlotte's father's relatives recruited volunteers for the Union Army. And during the Civil War, many Princeton women gave their time to aid societies: making uniforms, assembling care packages, raising funds for the Union Army through recitals and lectures, and working as army hospital volunteers. Charlotte's mother, Phoebe, as well as her grandmothers Johanna Garretson (on her mother's side) and Lucretia Voorhees (on her father's side), may have been involved in such activities. In Princeton, during the war, debates over slavery and race were unavoidable. But Charlotte's family took no public stands on those issues and left no records of their views.

As an adult, Mason would replicate the female-centered household of her grandmother by informally adopting young women she could mentor: ethnomusicologist Natalie Curtis, followed by the artistically inclined Chapin sisters, Cornelia and Katherine. Rather than enter the public sphere directly, she entered through protégés she expected to act

as her eyes, ears, and hands. And she thought of her role in a uniquely female way, calling herself "Godmother" and insisting that anyone she aided do likewise. Members of the Chapin family remark that the nickname "Godmother" was used without irony or humor. Mason evidently did not joke about her "mission" or her efforts to make a place for herself in the world. The Chapins also point to a story that influenced her ideas about how women could make a difference.

There was, from the time of Charlotte's birth, a much-discussed Princeton legend about a slave, James C. Johnson, and his white benefactress, Theodoric Provost. Johnson escaped from slavery in 1843. Landing in Princeton, he started selling candy and fruit out of a pushcart to Princeton University students, who developed a great affection for him. One day, at the height of tense student body divisions over the war, a southern student recognized Johnson as a former slave, informed his former owner, and effected the escaped slave's arrest. Johnson's trial attracted enormous crowds. His popularity, the black community's outrage, and the determination of both factions to take advantage of an opportunity for opposing points about states' rights, made a terrible riot seem imminent. Violence—and the ignominy of shameful national attention—was averted only when Provost stepped forward and paid the price needed to free Johnson out of her own pocket money. Johnson paid Provost back in less than five years. That was the kind of single-handed, heroic impact for which Mason strove. To have such an impact, however, she would need cause, sphere, and means.

According to one family member, Charlotte Quick met her future husband, Dr. Rufus Osgood Mason, twenty-four years her senior and already widowed, when her parents called him to Princeton to help her break a morphine addiction that had left her bedridden. Such addictions were fairly common during a time when morphine and opium, in the form of laudanum, were widely used to treat everything from diarrhea to coughs, sleeplessness, and rheumatism. Dr. Mason had a New York City practice. He specialized in "supernormal" psychological phenomena such as telepathy, multiple personality, clairvoyance, and automatism, and he used hypnosis to cure an array of ailments, including drug

and alcohol addiction. In New York, he was the darling of wealthy city dwellers anxious to host séances and other means of communicating with departed loved ones, many of whom were Civil War dead. Besides a shared New Jersey birthplace, Dr. Mason and Charlotte Quick had little in common. Charlotte was thirty-two, quite old then for a bride, and Mason was fifty-six, a Dartmouth graduate, Civil War veteran, and fellow of the New York Academy of Medicine. He was firmly established in his profession and, by the standards of the day, already an old man. But his New York circles were more interesting than anything Princeton had to offer, including strong ties to the New York Philharmonic through his former father-in-law, and the growing field of psychical research, in which he was fast becoming a celebrity. Many of the patients for whom he acted as physician and psychic, as well as occasional séance host, were New York's wealthiest and most influential citizens. Charlotte felt an immediate affinity for the world of paranormal ideas. From Dr. Mason she learned that she was a "born sensitive" to whom grand "visions" came easily and who could discern the meanings of the "divine energy permeating the universe . . . a special class of persons." She had long believed that she was one of the elect, put on the earth to lead, save, and get things done. Most of the people she met struck her as dull-witted, ineffective, disorganized, and lacking in determination. She expected little of them. But she was always on the lookout for other sensitives, born leaders, and role models, even before Dr. Mason gave her words for them and anointed them both as exemplars.

For his part, Rufus Osgood Mason had been saddled, after the recent death of his wife, with a demanding practice and a young daughter in need of a mother. Charlotte was clever, maybe even brilliant. She was also willful and determined, as well as attractive, well off, and adoring. They married in New York City on April 27, 1886.

Dr. Mason could now devote more time to his specialty of mind over matter: trances, hypnosis, divination, telepathy, clairvoyance, thought transference, somnambulism, automatic writing and drawing, and multiple personality. Hidden in each individual was a "subliminal self," he believed. Hypnosis could release that self to cure myriad ailments. As

a highly regarded physician, Mason added the weight of his medical training to the popular but not always highly respected field of paranormal investigation, lending it credibility while also increasing his own fame. Among the cases he claimed to have cured by hypnosis were a forty-one-year-old female melancholic, an eighteen-year-old woman debilitated by her fear of thunder and lightning, a German woman in her twenties plagued by "obstinate constipation," a forty-two-year-old woman "afflicted with inordinate and excessive blushing," a new mother whose breast milk would not come in, a bad case of measles, an infected hand wound, an alcoholic actor, and a practicing homosexual. An important part of his hypnosis therapy involved release from the "ego." If the "ego," which blocked the "divine within himself" of every human mind, could be freed of its "intense self-consciousness and self-considering carefulness," humans could return to their purer selves. The parapsychologist-physician's ability to effect that release, Mason believed, was "the most important work now being done in the world—by far the most important." Mason considered himself a "pioneer." In a series of newspaper stories, he described parapsychology as the nation's greatest new frontier and researchers such as himself as "scouts" and "explorers," comparable to Columbus, Darwin, and Shackleton in revealing the "laws of nature."

Dr. Mason was also a primitivist. "Our western civilization," he had written in 1896, "is materialistic, hard, mechanical; it values nothing, it believes in nothing that cannot be weighed, measured, analyzed, labeled and appraised." The seemingly odd ideas of "primitive, undeveloped and ignorant people," he suggested, were clues, cultural "vibrations" that could release the superior "subliminal" or "secondary" self stuck behind the anxious, grasping, uncreative, and overly acquisitive modern self. Proper channeling of spiritual phenomena, he argued, was the cure for a "materialistic, hard, mechanical" civilization. As early as 1900, he had been inculcating in his wife an idealized picture of Native Americans, even insisting to her that some native peoples could make their crops grow psychically just by "standing apart and singing."

His wife agreed with all his ideas (though many other people did

not). In the only written work she ever published, she compared her husband's ability to "heal the sick" through "the message of the spirit" to that of Jesus Christ. He had taught her that a divinely inspired "great genius soul" would lead the way out of "this jungle of stupidity," as she called the modern world. Such genius, she often pointed out, was not to be expected from "every little mingapoop crawling on the Earth." She was no "mingapoop," she knew. But as long as he was alive, that "genius soul" was her husband. She apprenticed herself to him wholeheartedly.

In fact, her thinking had been strikingly similar to his even before they met. In 1885, a year before her marriage, she'd had her first "mystical vision" of how to save America from itself. She had had dreams about Africa as a "flaming pathway" to America's "cure." Believing in the truth of her dreams and convinced that African or Indian native cultures could restore modern citizens to a lost spiritual health, she became determined to infuse America with an African ideal. If she mediated between the traditional and modern worlds, she believed, "the creative impulse throbbing in the African race," could save a world destroying itself through commercialization and industry (ironically, the sources of her own wealth). A "magic bridge" from Africa to America was needed to wake up the country and infuse it with earthy authenticity. "As the fire burned in me," she wrote, "I had the mystical vision of a great bridge reaching from Harlem to the heart of Africa, across which the Negro world, that our white United States had done everything to annihilate, should see the flaming pathway . . . and recover the treasure their people had had in the beginning of African life on the earth." As her husband's acolyte, she may have expected Dr. Mason to realize her vision.

But matter unexpectedly got the best of Dr. Mason on May 11, 1903, when, at seventy-three years of age and at the height of his professional career, he suffered a burst gallbladder. He died at home on West 58th Street, of septicemia. His death was a tragedy for Charlotte, who was not yet fifty. But with willfulness and plenty of money, it was also a kind of freedom. She could now be the "genius soul" she had looked for by channeling her dead husband's spirit. As the new century ushered in more progressive ideas about women's roles, she could experience some

of the new freedoms while also, as Dr. Mason's dedicated disciple, staying true to her Victorian ideas about gender. She could now assume leadership of that "most important" task of releasing the nation's "subliminal self" and, at the same time, realize her 1885 "vision." Like her contemporary Annie Nathan Meyer, she cannily combined a doctor's wife's conventional privileges with a modern desire to make a name for herself, adopting the prerogatives of modern feminism without espousing its ideology.

To channel Dr. Mason, she added to his blend of spiritualism and psychology her own version of primitivism, founded on a collective—or racial—"subliminal self." Thus she combined two of her husband's chief ideas into a new philosophy. If an individual could release a subliminal self to approach divinity, she reasoned, the subliminal self of the human race could similarly be freed for planetary healing. She resolved to effect that planetary health, making herself, in her own eyes, the earth's psychical physician. Her mission was now clear: under her direction, a select army of Mason "godchildren" would heal the world.

"The Primitive Element"

Like many others who watched modernity roll in with anxiety and apprehension—fearful of the alienating effects of industrialization, mechanization, urbanization, commercialization, and capitalism— Charlotte Mason felt that modern society was hell-bent on annihilating everything that mattered. She was part of an explosion of solutions for modern woes that was as characteristic of the 1920s as was its taxonomic fever. Social healers offered orientalism and psychoanalysis; religious revivalism and folklore; medical cure-alls such as raw-food diets, cornflakes, and radium-laced drinking water; suntanning; and surgically implanted goat testicles—all promising to restore vim and vigor.

Mason's first serious attempt to forge her planetary cure occurred when she went to the Southwest soon after her husband's death in 1903. Many Americans looked to Native Americans in the early twentieth

century to lead them to a purer and more holistic way of living, especially romanticizing the Pueblo cultures of the Southwest as guardians of a spirituality absent from mechanized, modern cities. In what she viewed as a "simple people," Mason saw "the primitive element still flaming [that] opposing whites, in order to live at all, will yet *have* to receive." She wanted to bring that flame back to white society and took Natalie Curtis west with her to help her collect it.

Curtis (no relation to the famous photographer) was born on April 26, 1876, into a well-to-do Washington Square family, in what Henry James called "the most delectable" of New York's neighborhoods, educated at Brearley, and reared in a liberal family with ties to Transcendentalism and abolitionism. Her father was a New York physician active in various medical societies and social clubs, and most likely the women met through those. Natalie's family was close-knit. According to her biographer, she was especially influenced by her father's older brother, her uncle George William Curtis; and her aunt Anna Shaw Curtis. George Curtis was an early supporter of abolition and black civil rights, with a "sincere, intense aversion to racial prejudice and discrimination of any kind." His wife, Anna Shaw Curtis, was the sister of Robert Gould Shaw, celebrated as a martyr for his role as the commander of the all-black 54th Regiment from Massachusetts. Anna's sister, Josephine, who had lost her husband, Charles Russell Lowell, in the Civil War, spent her adult life in a variety of progressive causes, including work with the Freedmen's Society to build the kinds of schools to which Lillian Wood dedicated her life. George Curtis took advantage of his public platform to promote suffrage for women as well. "The sphere of the family is not the sole sphere either of men or women . . . they are also members of the State," he argued.

Separate-sphere ideology dominated U.S. society. Natalie admired her uncle's "moral courage," but, as a woman, she could not very well imitate his activities. Women such as Natalie, "whose sex forbade them to offer their lives," had to approach political issues gingerly, mindful that public advocacy was not considered feminine. She cannily discerned, as did Harlem's white women, that the farther she moved from

white, upper-class society, the greater freedom of movement she could have. Being a white woman in nonwhite society afforded special freedoms.

Though raised to be a composer and pianist, Natalie turned from performing music to collecting it, feeling that her performing skills did not match her ambitions. "I want to have a kind of profession just as a man would, so that I could be perfectly independent," she wrote to her best friend. "Don't you think that it would be awful to feel as some girls do that they *must* marry? Just as though they were as many cows!" She taught herself ethnology, folklore, and ethnomusicology, attracting support from financier George Foster Peabody and Franz Boas. She was a New England New Woman, described as bright, optimistic, and sympathetic. Like most New Women, she sought out female role models. She met Mason in the 1880s and considered her a woman with a "warm interest in human problems and . . . charity of heart."

The Southwest at the time was particularly attractive to "restless and rebellious women seeking freedom from their stays and from the drawing room domesticity of Boston and New York." Curtis and Mason went there to make their mark by documenting the art of " 'living ruins' from the childhood of civilization." They traveled throughout the Southwest to gather material, sitting in on interviews, listening to songs, and meeting with subjects to capture their perceptions of the "sunset hour" of a romantic world. Both believed they could honor the authenticity of what they collected (although they spoke none of the languages in which the songs were sung), by capturing "the direct utterance of the Indians themselves" to reveal "the inner life of . . . the child-race of a by-gone age." They faced competition from Columbia-trained students of Franz Boas, such as Elsie Clews Parsons, Ruth Benedict, Gladys Reichard, and Ruth Underhill, who were strongly encouraged to do fieldwork in the Southwest, a radical idea for women ethnographers especially. Like most autodidacts, Natalie Curtis disliked academics. "I resented," she wrote, "the notion that only New England with Harvard College as its 'hub' can be 'American.'" She took the view that "the Southwest was quite literally overrun with anthropologists." Mason was even more resentful.

They also faced competition from commercial interests, such as the Harvey House enterprise, which had created a national fascination for Indians through the "staged authenticity" of "human showcases" appearing across the nation along the Santa Fe Railway line. Observers were invited to witness the daily behavior of an "exotic" people in a "natural habitat." Along its railroad routes and restaurants, the Fred Harvey formula used those staged "artist-demonstrators" to sell trinkets, souvenirs, and an image of the Southwest designed to lure tourists to the region.

Mason and Curtis disdained "stage Indians" and "sentimental conventions about the 'Noble Savage,'" although they were sentimental as well. Documenting songs, they felt, rather than collecting things, set them apart. Unlike other whites, whom they saw as less sensitive, they believed that, as mediums, they were merely channeling the Indians they interviewed and recorded. Hence the book that came out of their collecting, the 1907 volume *The Indians' Book: Songs and Legends of the American Indians*, carried the subtitle "An Offering by the American Indians of Indian Lore, Musical and Narrative, to Form a Record of the Songs and Legends of Their Race." Curtis and Mason also used their connections to bring exemplary Native Americans before the national government. They moved to Washington, D.C., in 1905 to lobby "chosen people here and there in conversation" about government policy and to encourage more native singing in the notorious Indian schools. President Theodore Roosevelt was an old family friend of the Curtises, and he invited Natalie to sing Indian songs at luncheon one day. But he did not take her—or her friend Mason—seriously.

Nonetheless, Mason felt that *The Indians' Book* was a great triumph. She and Curtis alone, she believed, had recorded what was authentic, precious, and "True." The Southwestern Indian, she maintained proudly, "has been ready to give me everything he had of his people, and then closed completely that door to the [other] white man." Winning such approval meant the world to Mason. "The Indians say that the book speaks with the straight tongue," she told her readers.

How did Curtis and Mason square their conviction that they were channeling cultural salvation from a morally superior people with their

condescending belief that all native music was, as Curtis put it in 1903, "monotonous barbaric chanting" and that the Indians were "a race of savage people" stuck in a "primitive grade of development"? To say that primitivism, as one critic has written, was "a new way of packaging racism" is only part of the story. Romantic racialism was built on contradictions and fueled by reverence and disrespect, emulation and condescension. It allowed white women such as Mason and Curtis, to take up the mantle of pioneer explorers otherwise foreclosed to them by both gender and class. Romantic racialism let them conquer—and claim—new worlds. Sometimes Curtis and Mason represented that privilege as a conflict, sometimes as a blessing. "What a problem," Curtis complained in 1916, "to have a primeval soul and one's home in New York!" Strange as it may seem to us today, none of those contradictions was particularly striking to their contemporaries. Contradictory ideas about race and identity were a matter of course.

Mason's intellectual contributions to Curtis's work were substantial. Her ideas of interracial friendship, especially, are stamped across *The Indians' Book* like a shadow text drawn from "Genius and Primitive Man," Mason's unpublished manifesto. The book's epilogue quotes her essay at length (without ever mentioning her name):

> Do we tend to become a people continually busy with the world's affairs, let us remember that the sources of spiritual truth have arisen oftenest among the contemplative peoples of the Orient, and let us then turn to the contemplative dark-skinned natives of our own land. If not in the hope and expectancy that are born of friendship, at least with tolerance and without skepticism let us stop long enough to hear the broken fragments of a message which they might have brought in its entirety to all their brethren in the world.

Mason may have felt that *The Indians' Book* was a triumph aesthetically, but it did not sell particularly well. She took that disappointment keenly.

She began nurturing additional protégés, Katherine and Cornelia Chapin, clearly determined, as she would be for the rest of her life, not to put all her eggs into one basket. She moved into the Chapin family's Upper West Side home in 1908, six months before the wedding of her stepdaughter, Ethel, her husband's child from his first marriage. She immediately, and with the apparent approval of their parents, assumed responsibility for the moral and intellectual education of the sisters, with whom she then lived on and off for the next three decades. Both sisters were descendants, like Mason, of some of New York's earliest Dutch settlers. And, like her, they also descended from American railroad fortunes. They had been raised in the same elegant and rarefied atmosphere Natalie Curtis had enjoyed, trained in music, acting, literature, the arts, and philosophy. Mason helped ensure that they had the best teachers available, even hiring the leading intellectual Max Eastman as Katherine's private tutor. Mason was almost old enough to be the girls' grandmother, but the influence that she exerted over them was intense. Katherine arranged all of her relationships so that they could include her "Godmother," now nicknamed "Precious." She insisted that all of her friends bow to Mason's advice. And she hated to be separated from "Precious" even for a night. They often shared a bed, lying awake for hours to talk, read, and plan Katherine's life, down to the last detail of the linen she would order and how it would be stored. When Katherine married a man of Mason's choosing, Mason accompanied her and her new husband, Francis Biddle (later to become the attorney general of the United States under FDR) on their honeymoon. A matching third ring—identical to their wedding bands—was made for "Precious." Dozens of letters about Mason from Katherine to Francis Biddle survive. "Godmother" is always "all-seeing," "Precious," "Darling," "adorable," "absolutely selfless," "perfectly glorious," a "blessing," and "Divine." Indeed, "there is never quite paper enough to take all the love I want to send her," Katherine wrote to her skeptical husband. Katherine's descendants have told me that they remain baffled about the influence Mason was able to exert over the young women. But such power was not

unusual for her—Mason had a genius for showering her "godchildren" with equal measures of devotion and control.

From her new base of operations with the Chapins, Mason helped Curtis cofound the Society for the Preservation of the American Indian in 1911 "to keep extant the Indian type, racially." They also founded a short-lived Music School Settlement for Colored People, which they put under the direction of the composer J. Rosamond Johnson, a brother of James Weldon Johnson and the author of "Lift Every Voice and Sing" (also known as the "Negro National Anthem"), among many other works. None of the New York projects succeeded. Faced with multiple failures, they made a final effort to secure their vision in 1919. On a stifling hot day in August, they brought a Mojave Apache chief named Pelia to Manhattan. At Mason's Park Avenue apartment, he was "well soaped and combed." Mason and Curtis took him to Washington to meet with Roosevelt, a meeting that Curtis claimed was a great success in rescuing "the country's promise to the Native Americans." The reported success of the meeting is inexplicable, since apparently nothing at all came of it.

By 1920, competition from other Native Americanists and primitivists was fierce. Mason and Curtis withdrew. Curtis gravitated away from Native Americans altogether and developed an interest in African-American and African music. She completed two volumes of black ethnomusicology, *Negro Folk-Songs* and *Songs and Tales from the Dark Continent*, based on work at Hampton Institute, one of the few black schools to also train Native Americans.

In moving toward Hampton and studying blacks, Curtis was not distancing herself from her patron, whose long-standing interest in Africa deepened at that time as well. But in deciding, very late in her life (Natalie was then over forty) to pursue the "Great Happiness" of romantic love, she did effect a decisive break. In New Mexico in 1915, she had met the modernist painter Paul Burlin, who had begun incorporating native designs into his art. Burlin was Jewish, ten years Natalie's junior, and, as she readily admitted, decidedly "not in the Social Register." They married in Santa Fe on July 25, 1917. Mason was an anti-

Semite, and Natalie's marriage to a Jew must have stung. "Don't, in your interest in Paul's work, forget your own," she wrote plaintively, as her own influence over Natalie waned.

Natalie intended to persuade her new husband to "put the American Negro into American art." They purchased a small house in Santa Fe and began to settle in. Paul now took Mason's place as Natalie's companion on her visits to native reservations. But increasingly, like many other modernists, they felt the pressure to expatriate to Europe. In May 1921, they sailed to England; they then went on to Paris, where Natalie composed and Paul painted. On October 23, in Paris, however, Natalie was struck by a car and killed.

Mason was devastated. Her interest in collecting African art became obsessive, fueled by the determination she had shared with Natalie to explore the roots of American folk culture and help transport new spiritual resources to America. Enshrining the memory of her time with Curtis as a model of ideal collaboration, she turned *The Indians' Book* into "a kind of bible, preaching the superiority of primitive spirituality." The book became her solace, and she later presented a copy of it to each of her Harlem protégés, enjoining the recipients to consecrate it as a sacred text. In the wake of Curtis's death, Mason froze her ideas about primitive culture, fixing them exactly where they'd been during her Southwest travels. While the rest of the world put primitivism under an increasingly intense microscope, Mason paid homage to her dead husband and Natalie Curtis by refusing to change. Rather than lose Natalie to Paul Burlin, Mason immortalized her as an icon. Neither Natalie Curtis nor Dr. Mason could now disappoint her.

"Africa's Flaming Pathway"

According to most sources, Mason became interested in the Harlem Renaissance as a consequence of wandering into Alain Locke's lecture on African art in early February 1927. By then, however, she was already a serious collector of African art. She owned fetish totem masks

from the Ivory Coast and a Bundu secret society mask and headdress from Africa's west coast, as well as weapons, cups, and ivory masks. An African spear and other pieces were on display in her Park Avenue drawing room. Her oversize bank safe-deposit box held other excellent examples of African art. "I want," she wrote in 1927, "to see the same thing done by the Negroes as I did with the Indians." As she saw it, Negroes with true "vision" (hers) now had the "privilege . . . to build a bridge of light . . . between two continents—between the past and the future—building a vital hope." For that she needed a contact and partner from inside the Harlem Renaissance. She picked Alain Locke. Probably no one but Charlotte Mason, with her complete inability to see herself through others' eyes, would have had the nerve to choose, as her second, none other than the "father" of the cultural movement she sought to influence. With Locke as her foot soldier, "the presentation of African Art," she felt, could be "so positive that never again do certain horrors vibrate in Harlem."

Locke's lecture, on February 6, part of the opening celebrations for the African Art Exhibit at the New Art Circle gallery, took place during a time of especially heated debates in Harlem over African art. Although Hughes had gone to Africa in 1923, most Harlem Renaissance leaders had not been there. But Locke had. His answer to Cullen's question— "What is Africa to me?"—was clear: Africa was a vital resource, possibly the best resource, black Americans had available in their struggle to be recognized. "Nothing is more galvanizing than the sense of a cultural past," he argued. Locke's role was crucial in influencing the direction others in Harlem would take.

In *The New Negro*, Locke published photographs of African masks and sculptures from the Barnes Collection, as well as pieces from the Tervuren, Berlin Ethnological, and Frankfurt museums. *The New Negro* included Aaron Douglas's reverential painting *The Spirit of Africa*, as well as bibliophile Arthur A. Schomburg's essay insisting that "the American Negro must remake his past in order to make his future," Cullen's "Heritage," and collector Barnes's "Negro Art and America," which claimed that black art was "great art" because of its proximity

to Africa and its "primitive nature." Locke's own essay on African art in *The New Negro*, "The Legacy of Ancestral Arts," advocated a broad view of "the resources of racial art," richly detailed with images of African masks. In his declaration that "we must believe that there still slumbers in the blood something," Mason thought she heard echoes of her own beliefs.

The New Art Circle's show followed a major exhibition at the Brooklyn Museum in 1923. The centerpiece of that show was the Blondiau-Theatre Arts Collection, which Locke had assessed the previous year in Europe. The Blondiau Collection was assembled by a wealthy Belgian and purchased by a committee of wealthy New Yorkers, including Mason. It totaled more than four hundred high-quality pieces from the Belgian Congo and elsewhere. Mason, who was nearly deaf by then, usually avoided what she considered the "shame" of being unable to hear in public. But she went to the New Art Circle exhibition at least four times, taking Cornelia Chapin with her once and Katherine Garrison Chapin Biddle twice. (After one visit, she purchased a "little man figure" for Katherine's sons, Edmund Randolph and Garrison Chapin.)

Fascination with Africa had been the backbone of modernist innovation in art and literature for years. African imagery was highly visible in the work of Paul Cézanne, Henri Matisse, Georges Braque, Pablo Picasso, Paul Gauguin, Constantin Brancusi, Amedeo Modigliani, T. S. Eliot, Gertrude Stein, Vachel Lindsay, Joseph Conrad, and many others who saw in it a "natural, primitive, life-affirming" presence. When black artists tried to embrace the tradition as a resource, they encountered a territory on which the white modernists had already planted their flags. As one of the chief architects of the Harlem Renaissance, Alain Locke, whose conviction was that "African art held a key to Afro-American artistic expression," was invaluable to Mason. She believed she'd found a precious foot soldier. For his part, Locke saw in her a wealthy and powerful partner. Mason had determination and deep pockets, as well.

Patronage remains one of the most vexed issues in the history of the Harlem Renaissance. Some contend that it was a sincere attempt at in-

terracial collaboration. Others believe that white patronage curtailed and ultimately destroyed black creative expression. Many place it somewhere in the middle, as a kind of necessary evil, support that the movement could not have done without but that it accepted at great cost. What few of those judgments ask, however, is how the relationships *felt* at the time. Through stories such as Mason's we can see that for all the difficulties such relationships entailed, a giddy delight—not unlike falling in love—was a frequent feature of their beginning stages. Patrons and protégés both relished feeling recognized across race lines. In a world that cautioned against intimate interracial relations, interracial pioneers—patrons and protégés included—were proud of their own bravery and felt exhilarated by it.

Those feelings blossomed when Alain Locke and Charlotte Mason were introduced at the African Art Exhibit on February 6, 1927. They had, Mason noted in her journals, an instantaneous "tremendous rapport." Within days, Locke was at Mason's Park Avenue home, where he was met with "open arms and a brush of the spirit" and presented with a $500 check to begin work toward an African art museum in Harlem. That project was the beginning of "a relationship in which all their private thoughts and ideas were constantly and freely shared," a relationship that deepened and endured—against all odds—"for almost two decades." From that day forward, whether together or separate they would both celebrate February 6, the anniversary of their meeting, as a momentous personal holiday.

Mason served as vice chair of the planning committee they formed for their new Harlem Museum of African Art, and Locke served as secretary. Both owned important pieces of African art, some of which they lent to the traveling collection. After the New Art Circle show, the collection was temporarily housed at the 135th Street Branch of the New York Public Library, certainly with the assistance and support of librarian Ernestine Rose, before traveling to a number of locations, including Chicago, Buffalo, and Rochester, with a catalog written by Locke. Meanwhile, Locke and Mason conferred with others about how to realize their dream of a permanent museum of African art in Harlem.

Mason, like both Josephine Cogdell Schuyler and Nancy Cunard, had been dreaming of Africa since she was a young child. "I used to dream as a child that I would go to Africa and bring back the things in the upstairs of Slave Ships." Now she saw the possibility of realizing "the dreams I had 47 years before in regard to the creative impulse throbbing in the African race." She was "happy in her heart," she told Locke, when she went to the Harlem library and saw the African pieces on exhibit there, where "the little Negro children with wide eyes could look at their ancestral monuments and absorb without any fear from the white people." She was ready to fund more such exhibits and more African travel for Locke. But she worried about how to ensure that the African art they'd brought over would be safe. Were the cases locked? Was the exhibit safe from fire? What if "undeveloped Negroes" went "wild" and destroyed the art?

In their plan for a Harlem museum of African art, Mason believed, she'd found her solution to "weakening white civilization . . . whose spiritual life is choked by the love of material possessions and material power." The quality of life that "we have trampled . . . to dust" could be restored by African Americans *if* they would avoid becoming "white Negroes" and look instead to Africa, as their "flaming pathway" back to the "Truth." Mason believed that her Harlem mission was threatened by the shallow pleasure seeking that brought New York tourists north on Saturday nights. Whites such as Carl Van Vechten "horrified" her. She had only "perfect contempt" for them and considered them enemies. With Locke's assistance, she'd take control of how outsiders saw American blackness.

She'd chosen a complex person to be her champion and lieutenant. Born in 1886, and carefully drilled in old-school manners and propriety, Locke was considerably better-educated than Mason and the first black recipient of a Rhodes Scholarship. He studied in England and Berlin and traveled widely in Europe and Africa but also suffered discrimination in Cambridge, which refused to accept his thesis. He began teaching at Howard University—the Harvard of black America—in 1912, also

traveling to Harvard for a PhD in philosophy, writing a dissertation on the problem of categories in human thinking, a cornerstone of cultural pluralism. Locke was often at odds with the Howard administration. He struggled for years, in vain, to teach courses on race there. In spite of those difficulties, he chaired the Department of Philosophy from 1918 to 1953, while also ushering in the Harlem Renaissance. A closeted homosexual, Locke was formal and reserved. Mason's nearly instant intimacy with him was unusual, and many have explained it by the recent loss of his mother, Mary, with whom Locke had been especially close.

Mason and Locke met often in the winter of 1927, conferring about the museum, having tea, attending concerts, seeing the exhibit together again, and dining at Mason's home. Almost immediately, Mason began to offer Locke detailed advice about public speaking (which she had never done), heart exercises (Locke suffered from a weak heart due to rheumatic fever in childhood), handling university responsibilities (which she had never assumed), medicine (she sent him red marrowbone and bran bread, among other things), where and when to travel, eating and elimination, breathing exercises, and more. Locke was now her "precious Brown Boy." "You know I believe deeply," she wrote to him, "that you are the only one on the horizon now, who can be trusted to accomplish for his people." He, in turn, told her of his ambitions and difficulties; introduced her to Langston Hughes, Zora Neale Hurston, and others; and depended on her almost exclusively "for a large measure of emotional comfort." Together they contrived to attack those blacks he considered "traitors" to their cause of revivifying interest in Africa. In spite of myriad connections to every important black intellectual in America, including Du Bois, James Weldon Johnson, Charles S. Johnson, Walter White, and others, it was to the white-haired white widow that Locke turned for advice on how to best occupy his position as the "godfather" of the New Negro movement. She helped him strategize how to "slough off this weight of white culture" and realize his full "Brown potential." It was Mason, above all others, who he believed recognized and sympathized with him, understood his daily trials, and

shared his grander visions. He trusted her. "I believe we can transfigure all things Alain," she wrote to him. "A Primitive light moves before you my Boy," she added approvingly.

As maternal as Mason could be with Locke, however, she could also be bitingly critical. Only months into their relationship, Mason was upbraiding him regularly for excess "egotism" and susceptibility to "compliments" from others. She took him to task for failing to give her "crucial" information she needed to nourish him "mentally spiritually physically" (a detailed report of his days) and for sometimes saying the wrong thing. One letter expressing concern for her health got him into particularly hot water. Mason was then seventy-three years old and suffering from an array of ailments. "I do pray that you are already strong in your mind again," Locke had written. "This is unbelievable that you could be so plain stupid," she shot back. "Nothing the matter with my mind only that psychically I have to jump boulders. . . . Of course physically I have hardly any life. It's only [because of] the strength of my flaming spirit and my mind that I can pursue life at all." Many found it odd that a "sophisticated intellectual like Alain Locke could become deferential in her presence." But Locke was more than deferential. Though generally imperious and bossy, he was simultaneously reverent and cowed with Mason. And he remained so for decades.

Mason and Locke maintained their unlikely intimacy by glossing over their differences. They focused on their shared passion for Africa. And for each other. But they never saw eye to eye on race. Mason believed that races were fundamentally distinct and the "primitive" ones artistically and spiritually superior. Locke, on the other hand, like the Schuylers, believed that race was an "ethnic fiction" to be contested rather than celebrated. He saw "little evidence of any direct connection of the American Negro with his ancestral arts." So any bridge he could build between Africa and America could only have fallen terribly short of Mason's "vision." Her thoroughgoing antipathy toward white Western civilization demanded a firm ideological essentialism. If blacks were no different from whites, how could they effect the cure she intended to bring about?

At the time she met Locke, Mason was already feeling pressed for time and distressed about anyone who would not follow her direction. "They are absolutely no use, don't count. Put them in a hole & let them die," she wrote to Locke of those who disappointed her.

Mason's imperiousness was married to a fierce and often compelling curiosity. She was deeply interested in other people, and once she took them into her inner circle, she captivated them by never forgetting the minutiae of their daily lives and by interesting herself fully in every detail of their struggles. That interest, combined with her lack of self-doubt, contributed to the power she was able to wield over others. It certainly contributed to Locke's admiration for her and to the bond he felt. Deep pockets were nowhere near as enchanting as these deeper emotional ties.

"Godmother" and "Psychologist"

Alain Locke brought Mason his ambitions and anxieties, plans and ideas, finances and department hassles, health records and test results. He also managed to introduce Mason to almost everyone who mattered in Harlem: Langston Hughes, Aaron Douglas, composer Hall Johnson, Arthur Fauset, Claude McKay, and Miguel Covarrubias, among others. Some Harlem artists, such as Paul Robeson, Roland Hayes, Jean Toomer, and Countée Cullen, resisted Mason's overtures— Louise Thompson declared her monstrous—but in a matter of months, Locke helped put Mason in the middle of Harlem's key aesthetic and po-litical debates. She could attend major cultural events—such as Wallace Thurman's play *Harlem*—on Hughes's arm, pass judgment on events with Locke, and visit storefront churches with Hurston. Happily en-sconced in the comfort of her Park Avenue home, she was surrounded by the most luminous minds of the most interesting cultural movement of her day.

Estimates of the amount of money Mason gave to the Harlem Renais-sance vary widely, from a few hundred thousand dollars to well over a million dollars in today's currency. But even the most modest estimates

make her, by a very competitive margin, the largest white supporter of the movement, rivaled only possibly by Amy Spingarn, who quietly funded both the *Crisis* literary awards and many individual writers. The $150 to $200 a month that Mason regularly gave her protégés didn't include her expensive gifts of clothing, luggage, writing supplies, and paid secretarial services; in all, her stipends were equivalent to a Guggenheim or MacArthur fellowship today and every bit as coveted. Mason was not going to repeat the errors she'd made with Natalie Curtis, however. As close as she was to Locke, whom she could at least trust not to marry, she engaged multiple other protégés as well, telling each that he or she was her most special "godchild."

If Locke was her designated lieutenant, Langston Hughes was Mason's first true black love. She considered him flawless. He was, Mason told him, "the salvation of your people." He returned her feelings. "I had loved very much that gentle woman who had been my patron," he wrote. Hughes was Mason's "flaming pathway," a "shining messenger of hope for his people" embodying all her ideals of creative genius. "You are a golden star in the firmament of Primitive Peoples," she told him. From the time of their first meeting, at Carnegie Hall on February 16, 1927, to sometime in the spring of 1930, Hughes and Mason's bond defied expectations about ties a wealthy white widow in her seventies could forge with a nearly penniless young homosexual black poet. Building an impossible bridge across differences of gender, race, and class was the charm of their connection. "We don't bore one another," Hughes marveled. "She is so entirely wonderful." Their relationship surpassed even her intimacy with Locke. Mason and Hughes shared opinions about plays, music, and books and collaborated on every aspect of Hughes's writing and career. Nothing was omitted from their correspondence: his mother, his Lincoln University classes, his younger brother's welfare, and—especially—his novel *Not Without Laughter*, which Mason reviewed in draft. She supplied Hughes with a twenty-eight-page chapter-by-chapter critique for which he expressed warm appreciation and to which he paid the closest possible editorial attention. Paying him her highest compliment, Mason called

Hughes her "silent Indian chief" and christened him "Alamari" (African war drum).

Hughes's writing from that time bears Mason's unmistakable stamp—eerily so at times: "In the primitive world where people live closer to the earth and much nearer to the stars, every inner and outer act combines to form the single harmony, life. . . . The earth is right under their feet. The stars are never far away. The strength of the surest dream is the strength of the primitive world." Even the syntax is hers.

Through Hughes, Mason met Hurston in September 1927. Mason recognized Hurston's energy and brilliance straightaway, though some of Hurston's behavior initially gave her pause. Hurston also described a powerful psychic bond between them. "We got on famously," she noted. She believed that Mason's patronage fulfilled a dream she had had many years ago:

> Laugh if you will, but there was and is a psychic bond between us. . . . She could read my mind, not only when I was in her presence, but thousands of miles away. . . . I was her only Godchild who could read her thoughts at a distance. . . . She was just as pagan as I. . . . She was extremely human. There she was sitting up there at the table over capon, caviar and gleaming silver, eager to hear every word on every phase of life on a saw-mill "job." I must tell the tales, sing the songs, do the dances, and repeat the raucous sayings and doings of the Negro farthest down. She is altogether in sympathy with them, because she says truthfully they are utterly sincere in living.

At that point Hurston had spent more than a decade estranged from her family. She had found romantic intimacy nearly impossible, since all the men she became involved with had balked at her ambitions. She was still grieving the early loss of her mother and was deeply spiritual. Mason's intense nurturing and spiritual beliefs seemed like a godsend.

For Locke, Hughes, and Hurston, forging an intense friendship with

such an unlikely woman—different in age, class, race, background, and style—seemed utopian. It promised that anything was possible: all social barriers could be breached. Hurston called Mason her "light" and "True one." "Darling, My Godmother," her letters began. "Far-seeing one," "God-flower," "the world's blossom," she wrote. "How many you have dragged from everlasting unseeing to heaven. . . . I am one of the rescued. . . . I light a candle in your name." Sometimes Hurston called Mason her "true conceptual mother—not a biological accident." She signed her letters "Love and Love and Love." For Mason's birthday, Hurston wrote poems exalting her as "the Spring and Summer of my existence"; "Out of the Wise One I am made to be/From her breath I am born." We might think all of that would strike Mason as suspiciously hyperbolic. It never did.

Mason had been mastering four techniques to intensify the interdependency of her patronage relationships since "adopting" the Chapin sisters in 1908: triangulation, keeping secrets, promoting her own exceptionalism, and carefully used criticism. Just as she had triangulated her relationships with Natalie, Katherine, and Cornelia, she now created a triangle of Locke, Hurston, and Hughes, playing them off against one another and encouraging them to jockey for primacy with her. Competition between them would keep her as their center. Or so, at least, she hoped.

Although she never worked outside the home, Mason called herself a "Psychologist." That was not entirely inaccurate. She had a remarkable command over those she supported. She could be generous, even sweet sometimes, some said, but she was a formidable personality whose powerful "laws," as she called them, were broken at one's own peril. One of her laws was silence, "the law of creation," a way to conserve creativity so "that later when you are ready to use it the flame of it can burn. Only she—with her gift for divining planetary "vibrations"—would know, however, when that right moment had come.

Mason was also fanatical about secrecy. Over a philanthropic career spanning three decades, she allowed her name to be made public only twice. "Flaming results came out of my Indian work because of the pro-

found silence and complete fooling of anyone who wanted to know what I saw in the West," she believed. She had learned a great deal about how secrecy could work to control others in the years preceding Katherine Chapin's marriage to Francis Biddle in 1918. The marriage had been Mason's idea. Katherine and Francis were already in their twenties, unattached, and had compatible interests: reading, lively conversation, a love of the outdoors (Cape Cod especially), a keen interest in politics, closeness to family. But they felt no passion for each other. Mason encouraged a clandestine engagement. "Our engagement was to be a secret, and she [Mason] was determined that we live up to this idea," Katherine later wrote. Secrecy impassioned them and also tied them both to Mason in a triangle that Katherine described as "delicious" in the "tenderness and warmth" through which "we three move together through it all." "My greatest happiness," Katherine wrote in her diary of the engagement, "was always in talking over with Godmother everything we had said and done together . . . and everything I felt. . . . It was pure joy to go over it all with her." Katherine's "Secret Diary" records how "very happy we three [were] together":

> Never for one instant did Francis and I feel that we wanted to be alone, away from her—that she was there meant an added halo to our love—sometimes when we were talking intimately or he was kissing me goodnight Grandmother, standing right with us, as she might happen to be, would "go off"—actually her spirit would go far, so as not to intrude, that though she stood there smiling, sometimes we would call her three or four times before she would even hear us and come back with a start and a smile that blest us like sunshine. It was a rare miracle, and a great happiness to us both.

Francis's feelings are not recorded.

All of Mason's protégés understood her rules about secrecy. But Hurston was especially uncomfortable with them. Whenever she told the other godchildren what she was doing, whether writing a book or

buying a car, she begged them not to let Mason know. Hurston was a first-rate secret keeper, able to lop ten years off of her age without anyone knowing, keep a marriage from every one of her friends and acquaintances, and reveal so little about her teens and twenties that they remain known, to this day, as the "lost years." Hurston was also building a scholarly reputation as the nation's premier chronicler of the strategies African Americans use to avoid letting outsiders in:

> The Negro, in spite of his open-faced laughter, his seeming acquiescence, is particularly evasive. . . . The Indian resists curiosity by a stony silence. The Negro offers a feather-bed resistance. That is, we let the probe enter, but it never comes out. It gets smothered under a lot of laughter and pleasantries. The theory behind our tactics: "The white man is always trying to know into somebody else's business. All right, I'll set something outside the door of my mind for him to play with and handle. He can read my writing but he sho' can't read my mind. I'll put this play toy in his hand, and he will seize it and go away. Then I'll say my say and sing my song."

Hurston's gift for "feather-bed resistance" was a source of tension between her and Mason. It also conflicted with another of Mason's "laws." One pillar of Mason's carefully constructed edifice was her exceptional status as a white woman who derided whites and whiteness. She especially enjoyed joining with Hurston to mock any black intellectual who "goes to Whiteland to learn his trade! Ha!" Being able to make fun of other whites was one of the privileges avidly sought by Harlem's white insiders. Such derision-rights are part of the thrill of leaving behind one social group and taking up with another. It can produce a seductive sense of superiority, leading easily to the kind of excess Van Vechten displayed in stubbornly insisting on *Nigger Heaven* as his title. Langston Hughes encouraged both Van Vechten and Charlotte Mason to enjoy the pleasures of honorary membership. He joined with them,

for example, in collecting racist postcards, a large archive of which survives in his papers. The postcards could hardly be more insulting. There are big-eyed pickaninnies stealing Master's chickens, kerchief-headed mammies caring tenderly for white charges, a "Darkey's Prayer" for "deliberance" from alligators who chomp on his exaggerated rear end, and so on. Coming across such cards, some scholars have too readily assumed that they've discovered evidence of venal racism. But such collecting was meant to demonstrate the opposite: the collectors' distance from what the collection documents. One of Mason's gifts was offering people just what they had given up hoping for. Hurston and Hughes had both written insightfully on what Hurston called the "pet Negro" syndrome: the aspect of bigotry that singles out for exceptional devotion one—and only one—representative of an otherwise denigrated group. Locke, Hurston, and Hughes wanted to believe that a less patronizing white love for blacks was possible. They never saw themselves as pets. They were hence particularly susceptible to the idea that Mason *was* that truly exceptional white person whose racial love broke the racist mold, the one with whom there need be no bar, no distance, no safe cautions.

Mason's oddest psychological strategy was relentless criticism. She conveyed the sense that only she truly understood her protégés' flaws and hence only she could help them reach their true potential. When that strategy worked—as it did with the Chapin sisters—it engendered profound dependence. Mason turned criticism into a system. Each protégé, or "godchild," was classified by the character flaw Mason considered paramount. Each was instructed to keep track of that flaw in a journal, note it down, confront it, and report everything about its daily doings. Mason would then battle the flaw into remission. Hurston's flaw, Mason believed, was lack of discipline. Locke presented Mason with so many failings that she was hard pressed to choose just one. She noted his "dry & long winded writing"; "his great ignorance of his own people"; his "playing with truth," which tended to "choke off every vibration I try to start"; his "lack [of] Vision"; his lack of a "philosophy of Living"; his "egotism"; and his "mania for wanting to do my kind of work . . . when you haven't any spiritual instrument to do it with." She often chided him

for being an incorrigible blabbermouth. "Things do not live within your being silently, to be well born," she wrote him. "Such a pity your tongue could not be hung front to back so you could preach to yourself and not to the world," she put it more sharply another time. As one protégé remarked, there was "sometimes a whip in her voice." Only Hughes was exempt from such criticism.

What worked with the Chapin sisters and Locke did not work with Hurston. Mason felt that Hurston's genius could succeed only if she regulated it. And although she hoped that Hurston's anthropological work—especially her investigations of hoodoo in New Orleans—would strike gold and bring back vivid examples of the survival of "flaming" African ways throughout the southern black community, she increasingly let Hurston see her lack of trust. Rather than loosen her hold, she tightened the reins. Hurston *seemed* to accept Mason's views. "I see all my terrible weakness and failures, my stark stupidity and lack of vision and I am amazed that your love and confidence has carried over," she wrote to Mason. Privately, however, the criticisms chafed.

On December 8, 1927, Mason had Hurston sign a contract that made Hurston Mason's legal "agent" in the collection of "music, folk-lore, poetry, hoodoo, conjure, manifestations of art, and kindred matters existing among the 'American negroes.'" The contract stated that an agent was needed because Mason was "unable because of the pressure of other matters to undertake the collecting of this information in person." In return for $200 a month, a camera, and a car, Hurston was to "faithfully perform her task, return . . . and lay before said first party [Charlotte Mason] all of said information, data, transcriptions of music, etc., which she shall have obtained." Mason maintained a special safe-deposit box for Hurston's writings and films, to which Hurston did not have keys. Then Mason made her document every penny she spent, from "string beans and canned fruit" to "colon medicine (three dollars) and sanitary napkins (sixty five cents)."

Hurston and Mason both felt that Hurston's dual background as a Columbia-trained anthropologist and daughter of the folk South was an advantage in the 1920s culture wars over authenticity. They both loved

the lowbrow, or what Hurston always called "the Negro farthest down." But although she very much wanted Hurston to collect authentic material, Mason was afraid to let any of it out of her own control. She wanted to be sure that it would be understood exactly as she intended. The contract contained a strict secrecy clause enjoining Hurston "not to make known to any other person, except one designated in writing by said first party [Mason], any of said data or information." Mason was especially worried about Hurston's ties to the anthropologists Franz Boas and Melville Herskovits, whom she saw as competitors and untrustworthy Jews. Mason often upbraided Hurston for a lack of discretion and reminded her frequently of the terms of their contract. "You should not rob your books, which must stand as a lasting monument," she insisted.

Mason's distrust destabilized Hurston, who lost confidence in bringing anyone else into the fold, one of the jobs of a Mason protégé. "I am so reluctant," Hurston confided, "to recommend *any*one to you. Often we discuss people and I try to make it clear to you that I am *not* trying to interest *you* in them. I'd want to be *very* sure before I persuaded you to give of your time and energy and blessed spirit and money to worthless people just because I like them. I want you to remember me as worthy of your trust, however imperfect I may prove to be otherwise." Her wariness felt to Mason like foot-dragging. It was added to her flaws. And Mason tightened her many "laws." She became "merciless" to breakers of her "laws," Hurston wrote.

Increasingly, Mason's notebooks were filled with lists of her many disappointments with Harlem. She felt let down and became anxious about running out of time. Interracial collaboration was much more difficult, it turned out, than she had expected. Predictably, perhaps, she began to blame her disappointments on essential differences in racial character.

"Discouraging Things"

It should not be surprising that Mason's desperate dreams of Africa did not come to fruition. What is surprising, perhaps, is how quickly

they crashed. Only a year after throwing herself headlong into Harlem, she was already thoroughly disgruntled. "The whole movement is so different from what I had dreamed it," she complained. By 1929, she was very impatient for the "flaming pathway" or "great bridge" that would make good on her investment. Approaching patronage like a business, she wanted to be able to predict her returns precisely. But she had vastly underestimated the feelings she generated. Instead of trying to understand why her protégés were drawing away, surprised that their "godmother" could be so harsh, she blamed them. Even as they resisted reducing her to a white stereotype, she was too caught up in racialism to do other than fault them racially. Their error, she said, was being too in thrall to white standards and ideals. "I am deeply troubled," she wrote to Locke in early 1929, "about the white psychology of the Negro situation. That supreme and excellent movement we built . . . is quietly dripping its heart's blood out in a dumb environment." By October 1929, a few days before Black Thursday, she was in despair. She told Claude McKay that she was a "better Negro" than most of the Negroes she knew. Her protégés retreated farther.

First Locke revealed that he was disenchanted with her "vision" of the Harlem Museum of African Art. He was lacking in "true" blackness, she responded angrily. "I am a Black God in African art compared to you in the nourishment I give the Negroes, from the root of their primitive ancestry." As far as she was concerned, Locke's failure to stay "true to any ideal" she set for him was yet another of the many "discouraging things that have fallen on me from the Negroes."

Locke and Mason also began to disagree more openly on race itself, the very thing that had drawn them together. Such disagreement was probably inevitable, but Mason had not seen it coming. Locke was an advocate—and an important theorist—of race loyalty. Mason liked and understood that. But he was also an advocate—and an important theorist—of the idea that race was a myth. Mason was a race essentialist. Her belief in racial differences was precious to her. Locke's position seemed some kind of stubborn unpleasantness. Why could he not share

her delight in things she considered authentically Negro? "What am I to do," she lamented, "and how am I to work for Negroes, when the supposedly most mature one, and influential one, is unreliable?"

With enough wealth to control those around her and an alarming intolerance for disagreement, Mason could usually limit challenges to her fixed ideas. But her protégés were very much in the world. Because they were active participants in Harlem's endless debates about identity, their ideas about race underwent constant growth and development. Hers, on the other hand, were preserved in amber.

Locke, moreover, was a cautious man, deliberative and guarded. Mason led with her heart and her instincts, never doubting a "vision" once she had one. Locke led with his intellect, carefully weighing all information before coming to decisions. She found him balanced to the point of irritation. His lack of passion felt to her like a lack of commitment. She wanted protégés who would be swept up in her own sense of urgency. Locke was constitutionally incapable of grand gestures, which, for Mason, were all that mattered. "Truth," for her, was necessarily cataclysmic.

The Depression compounded her difficulties by reducing her resources. By her own account, she lost "half my capital to the Depression." She was hoping "to succeed in my ideal in this matter depressed times or no!" but the deck was looking increasingly stacked against her. She could no longer invest in those who could not—or would not—produce according to her lights. "Alain you know perfectly well that all I want is to have helped to get these fundamental things for the Negro," she wrote. But: "You don't any of you stick to the truth so everything goes to pieces."

She feared that she would not live long enough to convince her protégés of the "flaming pathway" she needed them to build. "The discouragement of all the Negroes . . . weighs heavily on my heart," she wrote to Locke in the summer of 1930. "What is the use of building all these radiant possibilities for a group that seems to have no recognition either of these possibilities or the sum of their effect on the present need and

condition of the world! The flaming call, Alain, to great leadership is sounding, sounding everywhere."

Mason kept Locke on as her chief confidant, her adviser, and her go-between to all her other protégés. But now she promoted Hughes to the "Precious Brown Boy" status that had been Locke's. She put Hughes on a generous monthly stipend and sent him luxurious gifts to free his creativity and support his "great adventures." He sent her gifts of corn and evergreen boughs, long detailed letters, and drafts of his poems and novels, in which Mason discerned the indelible mark of the "Big Indian," a clear sign of success.

Many of Hughes's "adventures" involved Hurston. She was collaborating with Annie Nathan Meyer and Fannie Hurst, but Hughes was her kindred soul. "Langston, Langston, this is going to be big," she wrote of their collaborations. They shared confidences, money, folklore, publishing plans, travel expenses, and plans for the "real Negro art theater" that they hoped to realize with Mason's help. Mason was not comfortable with their plans or their exclusion of Locke. Hughes and Hurston wanted to replace the minstrel tradition and Broadway's commercial black musicals with their own folk forms, drawn from "the Negro Farthest Down." But Locke, "born in Philadelphia, educated at Harvard and Oxford . . . had never known the common run of Negroes," Hurston argued. His rarefied sensibilities were not to be trusted. Heady with success, Hughes and Hurston thought they could turn Mason's triangles to their own advantage.

Their strategy backfired. Throughout the Christmas holidays of 1929, there were dramatic fights and even more dramatic reconciliations. "I love you," Hughes wrote. "I need you very much. I cannot bear to hurt you. . . . You have made me dream greater dreams than I have ever dreamed before. . . . I cannot stand to disappoint you." Mason generally gloried in hyperbolic paeans to her beneficence. In the past, such apologies had succeeded. But now Hughes made a publishing decision that undid all his protestations of devotion.

In July 1930, he published "Afro-American Fragment," one of the

poems for which he is now best known. Its subject is estrangement from even an imagined Africa. Even he could probably not have calculated the profound effect it would have on Mason.

So long,
So far away
Is Africa.
Not even memories alive
Save those that history books create,
Save those that songs
Beat back into the blood—
Beat out of the blood with words sad-sung
In strange un-Negro tongue—
So long,
So far away
Is Africa.

The speaker both pines for and distances himself from an imaginary Africa—in the name of a racial alternative even less defined. It is a poem even more ambivalent about race, Africa, and the value of essences than Cullen's "Heritage." Mason did not believe in such ambivalence. Nor could she abide open questions about Africa's value. The last thing she wanted to see was any of her godchildren wavering on the value—for them—of Africa.

The poem could hardly have come at a worse time. Mason was still supporting Hughes and had installed him and Hurston in Westfield, New Jersey, to work uninterrupted on their collaborative folk play, now called *Mule Bone*. She was disappointed in Locke and still spending a lot of money on a museum project in which she now had no faith. There were conflicts over accounts all summer. By the end of 1930, Mason was still sending checks, and Hughes—her "Alamari"—was still sending her "psychic expression[s]" of his "inner vision." But Mason was not happy.

Then Hughes broke another "law." In February 1931, Mason was chastising him for having taken a "sorrowful misguided way" and "wander[ing] in a miasma of untruth." By March, she had concluded that "the call of the African drum is stilled." She was done with him.

Hughes never understood in what way he had transgressed, but the breach left him feeling "violently and physically ill . . . as if I was going to die." His biographers disagree on what occurred. Arnold Rampersad believes that the problem was "a result of Godmother's displeasure over his unwillingness to return to work" after completing *Not Without Laughter*. There is no evidence, however, that she had such concerns; often, in fact, she advised her protégés to rest and rejuvenate. Faith Berry claims that "the facts . . . reveal that it was not what he did not write that displeased her, but what he did write," which caused the rupture: "his political poems were a contributing factor." Mason had a short fuse, it is true, with regard to what she considered literary propaganda. But political poetry was not against her "laws." Neither not writing nor writing the wrong thing would cause her to give up on the man she considered her spiritual "child."

The cause was an escalating conflict between Hughes and Hurston over their play *Mule Bone*, exacerbated by Mason's increasingly frantic hold on her African "vision." What might have been a classic tangle between coauthors snared Mason in her own psychological machinations, stranding her between the two "godchildren" from whom she now expected vindication for a philosophy she had clung to throughout her life, against the grain of public opinion. Mason was too dogged to change her visions. And she saw no one else who might carry them out.

It is hard to imagine a more ironic wrench thrown into the works than *Mule Bone* turned out to be. Set in Eatonville, the play tells a relatively simple story about two boys fighting over a girl: a tale of triangles and the violence they can engender. Hurston gave a copy of the play to Van Vechten. From him it found its way through a number of hands until it reached theater founder Rowena Jelliffe and the Gilpin Players of Cleveland, who planned to stage it. By chance, Hughes ran into Jelliffe when he happened to be in Cleveland on a family visit. His shock that Jel-

liffe had a copy and planned a production was matched by Jelliffe's sur-prise that he was a coauthor. Hurston was summoned to Cleveland. She had no more idea of how the play had found its way to Cleveland than Hughes did, so she resented the accusations of backhandedness that met her on arrival. Insults were exchanged. Things got out of hand. Hughes and Hurston both turned to Mason for support.

The *Mule Bone* conflict is considered "the most notorious literary quarrel in African-American cultural history." As unfortunate as it was, yet more unfortunate secrets lurked behind it. Under especially strin-gent orders from Mason, Hurston was working clandestinely, at the time, on a project that Mason called her "last hope." Designed, as the idea of a Harlem Museum of African Art had been, to showcase Afri-ca's powerful restorative forces, Hurston's secret project involved high stakes. Locke had let the museum project drop, and Hughes's novel had not accomplished Mason's goals. If any of her projects was now to suc-ceed, that success was in the hands of the protégé whose impulsiveness Mason trusted least. She did not want Hurston distracted by Hughes, who she now claimed made her "earth path even harder." To protect her investment in Hurston she turned against Hughes. Caught up in the usual jostling for Mason's favor, Hurston and Locke did not fully grasp what was occurring. Even they could not have predicted the emotional 180s that Mason could turn. So Locke fed the grudge and threw gaso-line on the fire, calling Hughes "shameful" and "mean," accusing him of "willful egotism" and "megalomania," and predicting his "big fall." "It does seem," he wrote to Mason, "as if all the young Negroes had completely lost their heads." Locke misperceived Mason's about-face as personal. This was a fundamental error in his judgment. Insofar as she had imagined Hughes as her perfect black "child," rejecting Hughes began to mean rejecting the race. Without realizing it, every word that Hurston and Locke spoke against Hughes worked also to damn their race to its most generous patron. And for his part, the rupture devastated Hughes, causing an emotional wound that never healed. He was left with "shattered" health and lifelong bitterness. Even years afterward, his agony shows clearly in his autobiography:

I cannot write here about that last half-hour in the bright drawing-room high above Park Avenue one morning, because when I think about it, even now, something happens in the pit of my stomach that makes me ill. That beautiful room, that had been so full of light and help and understanding for me, suddenly became like a trap closing in, faster and faster, the room darker and darker, until the light went out with a sudden crash in the dark.

Locke was largely oblivious to the growing dangers. But Hurston began to sense them. She had long resented Locke's lack of insight into others' emotions, as well as the cool indifference with which he wielded his considerable cultural capital in Harlem. Never as impressed with his learning, degrees, or demeanor as he was, Hurston occasionally (and privately) called him pretentious, "abstifically a fraud," and "a malicious, spiteful little snot." Publicly, though, she was now saddled with him. With Mason so fiercely taking her side, and at such a cost, Hurston could not risk any sniping about Locke. She had to pretend that the new arrangement, which locked Hughes out, was fine. She did her best to be cordial. But the situation was destined to worsen.

Letters from "The Friends"

For Mason, the break with Hughes, not the stock market crash, would always be "*the* tragedy" of 1930. She was so unseated—"he has knocked her to pieces," Katherine wrote—that she had to leave New York. First Katherine and Cornelia took her away to Dublin, New Hampshire, where they retreated to "Glimpsewood," Rufus Osgood Mason's old gray house among the birch trees, which "in its early days had a reputation for things psychic." From there they went to Gay Head, the windswept rocky tip of Martha's Vineyard, and then to Germantown, Pennsylvania, where they holed up "in the little Katherine's Room in School House Lane."

In those three remote locations, Mason turned to the dead for reassurance. She wanted to be told that letting go of Langston had been right.

A group of spirits, whom she, Katherine, and Cornelia called "The Friends," were asked to weigh in on her handling of the "tragedy." Over a period of months, from late summer to early fall, the three women gathered in spare, drafty sitting rooms to take dictation—through a form of automatic writing—from the dead. "The Friends" were WCS, David (a child), Stella King, H. (Herbert), D.D. (for "Dear Dearest" or Rufus Osgood Mason), and Natalie (Curtis). Long-limbed, melancholy Katherine was grieving for her son Garrison, who had recently died. He was adjusting well, "The Friends" wrote, to life on "our side." A few letters from "The Friends" addressed whether Cornelia, a large-boned, strong-faced lesbian, should marry. (After much consideration, they finally determined not.) Most of the letters, though, were about Hughes and, more generally, Harlem's failure to come through with a world "cure." They are largely paeans to Mason's great sacrifices for blacks: "All honor and glory to you dear Lady Charlotte," "The Friends" wrote; "you dear Lady Charlotte are so valiant it is difficult for us to do more than stand in admiration of your courage." They advised her to move on from her hopes for Hughes. "A readjustment of outlook on all the dusky ones is going to be necessary and a letting go," they counseled. It will be "the hardest task of your flaming career—the task of letting go," but "the risk of your creation in the Negro field was magnificent."

"The Friends" offered detailed recommendations of what was to be done with each protégé. Hughes, they advised, could no longer be helped. "We see little hope ahead for L. [Langston]," they dictated. "You have lived finely—done well—in all regard toward him. So do not have regret. . . . Langston Hughes the blind one is slowly beating out his brains on the wall of his own conceit. He will have flashes of success but the foundations you so carefully worked over[,] planned and built from him are rotting away from misuse." Other protégés who had broken "laws" were dispensed with in just a few words. "Louise [Thompson]," they wrote, "is one to be wiped off the slate of Godmother's existence— simply in few words."

Those letters, "dictated" to Mason, make clear for the first time what Hughes strained so hard to understand. Without knowing it, he had broken Mason's "law" against "egotism." "This egotism," Mason wrote, "sprang up like a mushroom growth overnight and covered our relationship like barnacles on a ship." To our ears, that might seem a peculiar charge. But Mason meant something quite different from what we mean by "egotism" today. Her notion of creative genius entailed a willingness to use one's subconscious, instinctual, subliminal, or child self to channel the collective, creative forces of nature that "civilization has often forgotten or ignored." Those forces, she believed, were available only to the artist who was open to "powerful auto-suggestion" and "the instinctive following of certain fundamental laws of structure and harmony." Fighting egotism meant opening oneself to channeling such outside forces. A principle of the creative process, it was also fundamental to interracial collaboration. "Truly," she wrote, "we must obliterate self if we would receive the clear stream of God's truth from one another, and this humility of soul is as needful between races as it is between individual men." She considered herself a model of self-obliteration. Hughes was not. Without the *Mule Bone* dispute, even such a failure might have been forgiven. But now "The Friends" were certain that there was no going back; the link to Hughes could not be repaired.

Fortunately, "there is still Hope from some sources," they felt. "Zora is blundering but may find her way. . . . Her work which is *YOUR* work has real value." They never mentioned Alain Locke. Evidently Mason did not feel she needed the "other side's" counsel regarding him. Mason turned to the spirit world for advice after the break with Hughes not only because of personal desolation; she also feared that their failure to release their divinity to each other—Hughes's failure, she would have said—might call into question the larger racial project. His "egotism" might block the race's "subliminal self" and thereby the possibility of saving the planet from itself, a goal she still believed was in her grasp.

As Mason was in New Hampshire, trying to exorcise Hughes, he was trying to get her out of his system also, not altogether dissimilarly. He began to write stories about her almost obsessively, violating over

and over again the "law" of silence and secrecy. In one, he presented her general attitudes through two white people, Anne and Michael, "who went in for Negroes . . . [but] as much as they loved Negroes, Negroes didn't seem to love Michael and Anne." Other Hughes characters, such as Dora Ellsworth in "The Blues I'm Playing," identified Mason through her favorite sayings, her Park Avenue furniture, and her summer home in exclusive, rustic Northeast Harbor, Maine. Dora Ellsworth, wearing Mason's usual "gown of black velvet, and a collar of pearls," is a childless widow who takes up a black protégé and fashions herself as an instant expert. "Poor dear lady, she had no children of her own. Her husband was dead. . . . She was very rich, and it gave her pleasure to share her richness with beauty. Except that she was sometimes confused as to where beauty lay." Hughes even depicted Dora Ellsworth reading to her protégé in bed—just as Mason had done with Katherine. Another story, "Rejuvenation Through Joy," gathered up Mason's theories about silence, "vibrations," and even chairs (sitting too long in them was dangerous, she believed) to put them into the mouth of a charlatan, a send-up of Dr. Mason, who is visited by "smart neurasthenics from Park Avenue." Hughes not only lifted the veil on a very private woman; he called her out publicly in a poem about her dominance and control:

Poet to Patron

What right has anyone to say
That I
Must throw out pieces of my heart
For pay?

For bread that helps to make
My heart beat true,
I must sell myself
To you?

Reducing their relationship to poems for cash, Hughes well knew, was the most insulting thing he could have done. The poem was designed to strike back. It was part of many efforts to seize back some control, his equivalent of her appeal to "The Friends."

"Last Hope"

In the fall of 1930, Mason returned to New York, convinced that Hurston was her last and only hope of building her "magic bridge" from Africa to America and, in so doing, curing the modern world. Arthritis had plagued her for years, making it necessary for her to dictate most of her letters to Cornelia or Katherine. Her hearing was almost gone. And her sight was fading. She took a large suite of rooms at the Barclay Hotel from which she oversaw her staff's reopening of her Park Avenue apartment—airing furniture, unpacking trunks, and cleaning all twelve rooms to meticulous standards. All the while, she was steeling herself to tolerate no more dithering from her remaining protégés. Now—or never—she would bring the spirit of Africa to New York. She thought she might have one "big thing" yet left in her if Hurston would just fall into line.

That meant she now had all her eggs in one basket again, just what she had wanted to avoid. This time, everything was wrapped up in a project variously called *Barracoon* and *Kossula*, a book on which Hurston had been laboring for years, without much success. *Barracoon* was a biography of Kossula, also known as Cudjo Lewis, the last surviving slave brought to America in 1859, snatched as a child from a West African town in Benin and sold into slavery on the *Clotilda*, America's last slave ship. That live connection to both Africa and slavery made him a jewel to Mason; he was "the only man on earth who has in his heart the memory of his African home." She believed that "without fail, that life of Kossula must burn to ashes the white blood that tramps leadening the Negro race in America." She saw the chance for another endeavor like *The Indians' Book*. Hurston had interviewed Kossula at his home

in Plateau, Alabama, on a number of trips to the South. With Mason's support and with film equipment provided by her, she had also taken short silent films of him on his slanted porch, smoking his pipe, chopping wood, and gesturing as if storytelling. Those were believed to be the only existing films of him, and Mason stashed them in her safe-deposit box. Convinced that "the future of the Negro in America" was hanging in the balance, she was determined "to succeed in my ideal" of telling Kossula's story through Hurston.

But the manuscript was a mess. Kossula remembered only snippets about Africa. What he did remember—polygamy, leopard killing, murders, and wars—was not the "flaming" material Mason imagined burning off the layers of modern civilization. He recalled almost nothing of slavery and even less of the Middle Passage. *Barracoon* was uneven and sometimes unformed. Hurston needed more material, better material, more interviews. And she knew it. Kossula's story had been a thorn in her side going back to 1927, when she had published an article on him and had been accused of plagiarizing from material in a 1914 book, *Historic Sketches of the South*. Even in a good publishing market—which the Depression certainly was not—the Kossula biography might have been a difficult sell. Both Boni & Liveright and Viking rejected the manuscript. If Mason hadn't been laying on the pressure, Hurston would have dropped the whole business.

Mason pushed hard for revisions. "I am being urged to do things as quickly as possible and so at present I am working furiously," Hurston told Franz Boas, but she was finding it "very hard to get materials in any shape at all." Meanwhile, Mason pressed Locke to use his connections to persuade a credible publisher to take the book. By January 1931, Hurston had a second draft of the manuscript. She began working with the legendary editor Harry Block on a third version, which they hoped to send to Harper. That was the moment when the *Mule Bone* furor erupted. "If any of us breathe one word about it, the glory of what you have done, and the help that you are going to be to your people is going to be divided," Mason warned. Only Mason, Locke, and now Harry Block were in on the *Kossula* secret.

Throughout February and March, Hurston continued "working furiously," trying to complete an acceptable revision of *Kossula* and also finish her folklore collection, *Mules and Men*. "Do not despair of me, Godmother," she wrote in April. "I shall come through this time." But by June, the manuscript was still homeless. "I am at the end with this. I must get out," Mason complained to Locke. "Convince [the publishers] that this is a best seller," she begged him. "Break the stone heads of these publishers & throw them into the debris heap!" Locke failed to do so.

Hurston was just then hitting her stride, ready to transfer her energies to scholarship and theater, and may not have understood what her book's failure meant to Mason, just as Hughes had not foreseen the effects of forswearing his allegiance to Africa. She deposited the manuscript and film footage in Mason's bank box and tried to draw the now profoundly depressed Mason into another theater production. Mason, unused to losing control, dispatched Locke to monitor Hurston. Despondently, she drafted her last will and testament. It left nothing to any of her black protégés and she never mentioned it.

Hurston's new play made ample use of the wealth of material on black spiritual practices—conjure especially—that she had collected in the South from 1928 on, under Mason's contract. That was precisely the material Mason did not want used. "Remember," she admonished Hurston, "your solemn promises made when getting conjure. Perfectly willing to have you write it but not put it on the stage. You are as white as white can be when you break this faith." But Hurston was eager for stage success. She saw her revue, *The Great Day*, as a way to get away from "the oleomargarine era in Negro writing . . . everything butterish about it except butter." And she was eager to escape the vexations of the *Kossula* project. For once she held her ground against Mason's various objections. "Very worried," Mason repeated to Locke, "about her having Conjure in program as she gave her word to people down South she would not do this. May ruin her career. I have never broken a primitive law: they are mine to obey."

The Great Day: A Program of Negro Folklore, with a Choral and Dramatic Cast was a musical portraying a day in the life of a black Florida

railroad workers' camp. Hurston described it as "a Negro concert of the most intensely black type." Using the railroad camp as a folk setting, the play featured work songs, a sermon, lullabies, spirituals, children's games, jook scenes, a Bahamian fire dance, signifying contests, and, in later renditions, a one-act play about slavery entitled *The Fiery Chariot*. This sort of folk drama was risky, with white producers relying on similar materials to keep alive minstrel traditions with their "happy-go-lucky, singing, shuffling, banjo-picking" blacks. The African elements that Hurston incorporated into her revue included an African folk dance celebrating spring, a drum dance, a ring song, and a buzzard imitation. In the program notes, Hurston, aware of her potential audience, described these elements as "primitive and exciting."

Hurston assembled an enormous cast of fifty-two performers and tallied up her expenses for transportation, costumes, theater rental, and publicity. "I am on fire about my people," she wrote to Mason, promising that her concert would make the "Negro Farthest Down" come alive and help her people "return to their gods." Then she asked for money. "If ever I needed you Godmother, I need you now," she pleaded. Mason lent Hurston more than $500, then drew up a second contract, imposing the condition that Alain Locke act as adviser to *The Great Day*, "arrange and write the program notes," and come onstage halfway through the performance to explain its significance and show the audience where it made a "bridge" to Africa. She insisted, again, that the conjure material be cut.

All fall and winter, "Locke made periodic trips to New York . . . to consult with Hurston, attend rehearsals, oversee logistical matters, and keep Mason abreast of all that came to pass." He reported to Mason that he had laid down the law about the conjure material: "I wrote it freshly on her kitchen table. She leaning over me as I did it—and with the explanations, she saw its logic and I believe adopted it. . . . So I think and believe all is again on the right path toward the goal of our hopes and plans." But "Zora was awfully hurt at his high handed manner," Mason admitted. And not all was as it seemed. Hurston refused to show Locke her final program. She did cut out the conjure ceremony as directed by

Mason, and this entailed an expensive reprinting of the program. It was too late, however, to pull the mentions of conjure from some of the pre-publicity for the concert which promised to let the audience in on the secrets of voodoo with a conjure ceremony that had "never before been publicly performed" and that was "authentic in every detail, and filled with weird, impressive rites."

On Sunday, January 10, 1932, Charlotte Osgood Mason invited nearly four dozen of her friends to meet her at the John Golden Theatre to see the production. She was "depressed," she told Alain Locke. She didn't see "where Truth in the Negro world is ever going to be found, much less sustained." Inside the theater, moving through the narrow lobby into the elegant Spanish-style auditorium, patrons were urged to forget, for a few hours, the grimness they'd traveled through to get there: shuttered businesses, unemployed workers, breadlines, newly homeless families warming themselves in the vestibules of vacated offices. Heavy velvet and thick upholstery muffled sounds from the outside world. The stage promised escape to a southern swamp, complete with trees hung thickly with Spanish moss. The cast members were dressed either as southern sawmill laborers or as African fire dancers in feathered capes, loincloths, ankle bells, and elaborate headdresses, and with bare brown feet.

The evening was clear and unseasonably warm. The winter rain had ended, leaving the city smelling fresh. The prepublicity for Hurston's show had promised "original and unusual songs as yet untouched . . . fresh and without the artificial polish of . . . Harlem or Broadway." Mason had sent announcements to everyone on her extensive personal mailing list, recommending the "unusual Negro performance which should be most interesting as it is the first time we have had real Negro folklore presented to us in this way and by a real Negro woman." In their evening dress, Mason and her guests arrived at the plain-looking theater entrance on West 58th Street. A tuxedoed Alain Locke rushed anxiously behind the curtains for one last, hurried consultation with Hurston. The rest of Mason's guests took their time finding their places in the theater's ornate green-and-gold auditorium, arranging their wraps and gloves

over velvet seats, and opening their folded programs to an introduction by Alain Locke promising "the true elements of the Negro heart and soul" and an acknowledgment of Charlotte Mason's "spiritual and material" help in "salvaging some of the surprising portions of the original primitive life of the Negro" (one of the only public acknowledgments Mason ever allowed). In her seat, Mason composed herself to send the right "vibrations" for Hurston's success. Her expression was characteristically implacable. But inside she was miserable.

Backstage, Hurston's stomach was in knots. Unlike her patron, Hurston had an anxious disposition and a tendency to expect the worst. The stakes for *her* were unusually high that evening. If *The Great Day* succeeded, it would realize years of striving to bring authentic black theater to audiences previously exposed only to white-produced, white-directed plays that had "squeezed all the Negro-ness out of every thing." She could move on from failed projects and difficult publishers to a life as a producer. If *The Great Day* failed, on the other hand, she'd be stuck with an angry cast and an angrier patron. Keeping a fifty-two-member cast in line had been like herding cats under the best of conditions, and tonight they were tense and cold. To add to those pressures, reviewers were there from all the important black and white New York newspapers: *The New York Times*, *The Sun*, *The Herald Tribune*, the *New York Evening Post*, and the *Amsterdam News*. Seated expectantly, they shared the buzzing auditorium with one of the more extraordinary cross sections of New York ever assembled. How strange and disappointing it must have been for Hurston to look out at the audience that night and not see Langston Hughes. After years of complaining about the "awfully bad colored shows [that] are being put on Broadway every week or so," Hughes missed the one show he would truly have enjoyed.

Mason had provided, as she kept pointedly reminding Hurston, a "good part of the audience" that night. She paid $113.50 of the evening's $261.00 ticket sales. She had purchased mostly expensive orchestra seats to put her stamp on the evening's complex social rankings, placing her guests throughout the auditorium. Prior to the concert she had distributed tickets to Locke and five of his own guests, to Paul and Leila

Chapin, to Quick family cousins, to Miguel Covarrubias, to members of the English Speaking Union, and to others. For herself, Cornelia Chapin, Katherine Garrison Chapin Biddle, and Francis Biddle, she had reserved a group of seats in the second row, on the left aisle. Also seated in front was Carl Van Vechten, detested by Mason but adored by Hurston. "Please let me see you in a close-up seat," Hurston had written to him that morning. Mason could not have been happy to see him there. Hurston's friends, such as Fannie Hurst, Annie Nathan Meyer, Mary White Ovington, Nancy Cunard (with whom Hurston had just begun a lively correspondence and whom Mason also detested), the modern composer George Antheil, Josephine Cogdell Schuyler, and George Schuyler, would all have received special invitations. Once she was seated, however, with her heavy coat draped across her shoulders, her cane placed under her chair, and the Chapins placed carefully around her, Mason was as likely to be approached as a queen would be.

In the wings, Alain Locke was fidgeting in his "faultless tails," eager to remind Hurston of Mason's laws. Hurston, already in costume in a striped Seminole dress, had no time for him. The curtain went up. The revue commenced. The audience was entranced and enthusiastic.

Mason and Locke had planned for Locke to come out and explain to the audience the meaning of what they had seen. Otherwise, Mason feared, the production would just be cheap amusement. But in a surprise move, Hurston took the stage in the middle of the show. She did her own explaining. "Godmother had meant for me to call Dr. Locke to the stage," she admitted later. "I had seemed to ignore Dr. Locke."

Hurston considered *The Great Day* a great success—"the concert achieved its purpose," she said—and so did the reviewers. But Mason judged it a "failure." She had already sacrificed her cherished relationship with Hughes to pave Hurston's "flaming pathway." Now she was out of patience. Hurston, sensing disaster, tried hard to bail water. "About the concert. Godmother, I am sorry that my thickness has distressed you so. . . . I am afraid that I am hopelessly crude, Godmother darling. Please don't let my clumsiness disturb you too keenly." But Hurston must have known that she had gone too far, because even as

she apologized, she also trespassed further, making warm mentions of the now-banished Hughes. She reported that she and Hughes were reconciled and that he'd been visiting with her brother in Florida. In another letter she told Mason that she and Hughes had had a "polite and rather cordial" phone call and that he had sent his regards to her but was too busy to write." I have "not heard from Alain," she added nervously. "Hope he is not angry about anything."

She could not have been surprised when, in early April, she was summoned for a major dressing-down by Locke. He chastised her for her housing, the costs of her heat and hot water, her lack of gainful employment, the order of the pieces in her book *Negro Folk-Tales from the Gulf States*, her health and medications, her debts, and—most important—her creative work. "I understand that both you and Alain feel that I have lost my grip on things," she noted glumly to Mason.

Mason offered Hurston one last chance. She was to go back south to Eatonville, concentrate only on *Barracoon*, and stop "robbing" her books for theater projects. Mason drew up a new and even stricter contract: Hurston was to use "none of the other data or material" she had collected under her original 1927 contract and especially none of "the Conjure materials and rituals." Mason sent money south to her but not the encouraging, loving letters she had written before *The Great Day*.

But Florida was freedom. Instead of returning to Kossula's story, Hurston revived *The Great Day*, performing it throughout the South. She cut Locke's preface. After briefly chasing Mason in letters, she gave up. The last exchanges between Hurston and Mason all concerned Kossula. "I am very much distressed" about Kossula, Mason wrote to Hurston in May 1932, asking her to make another trip to Plateau to see about him. Hurston promised to do so, then went back to her play. In a private aside to a friend, she expressed her frustration that the "Park Avenue dragon" was still attempting to tell her what to do.

Kossula and the "Park Avenue Dragon"

Throughout the early 1930s, Mason sent monthly checks to Cudjo Lewis, but she worried that Lewis's grandchildren were siphoning the funds. "I have sent his money regularly every month by registered mail," she noted plaintively. She wanted someone—Hurston or Locke perhaps—to check on the situation. But no one did. That told her where her influence now stood.

Mason's and Lewis's worlds could hardly have been more different. At 399 Park, Mason had a professional maid on her staff, an Irishwoman named Mary Beggans; anything she desired was delivered to her home; and a driver waited on call downstairs. In addition to her staff, Cornelia and Katherine read to Mason and brought her books and magazines; they helped her with her correspondence and kept her up-to-date on current affairs, and when Mason hosted luncheons and teas, they put out her good crystal, arranged the sandwiches and tea, and kept the conversation flowing. Used to having others do her bidding, Mason had never worked at a paid job in her life and never, in fact, had a Social Security number. Lewis, on the other hand, had worked every day of his life, helping found the community also known as Africa Town, then helping it prosper and raising a family there. At nearly a hundred years of age, gnarled but spry, he still split his own firewood and worked as a sexton at the local Baptist church. His windowless wooden cabin was a far cry from 399 Park. Its walls were decorated with newspaper clippings, framed pictures, pots and pans, and hat pegs; an oversize fireplace took up one wall, and a slanted front porch off the kitchen sloped down into a packed-earth yard.

But Mason saw a kindred spirit. She retained her imagination and her powerful ability to identify with others. And although she romanticized Lewis, she was not entirely off base in feeling that they were similar. Both were fiercely independent, able to reinvent themselves multiple times. Both were stubborn. Both had traveled far from what their upbringings had predicted. From afar, Mason could once again become the

Cudjo Lewis at his Alabama home.

Godmother she longed to be. To Mason, Lewis's letters, which he wrote on the rough blue-lined notebook paper elementary students use, were gratifyingly thankful:

> You have don more for me then any one elce in this world. Since I ben in this country no one has thought enough of me to look out for my well fair as you has. . . . Dear Godmother, I want to see you with the eye before I die. If it not for you I die of starve but you send me the money. I want to see you with the eye before I die so I want come to New York for one day. Miss Zora she good to me but I want to see you and thank you and tell you much love.

They never met. In 1933, Charlotte Mason broke her hip. For the next thirteen years, she was the sole occupant of a large wing on New York Hospital's sixteenth floor, overlooking the East River. Her room's windows gave her the view she had "always yearned for, great distances, vast stretches," but a street view might have been even better. Mason enjoyed nature, but she *craved* people. She lived for the moments when she could see into someone's soul and divine just how his or her life should be lived. Even when her hip healed, she would not hear of returning home. She liked being waited on, and she liked a high perch. She discovered that she could preside just fine from her hospital bed in a corner room decorated with heavy furniture, European paintings, and antiques brought over from Park Avenue. In relative comfort there, wearing her usual lace collars and propped against a pile of white pillows, she offered an initially steady, then dwindling, stream of visitors her dictates, prophecies, and wisdom. Even confined to a hospital bed, she kept faith with her own visions and mission. She was immobilized but not incapacitated, and she still trusted her power to effect planetary change. She surrounded herself with the memorabilia of an active life: newspapers, magazines, photographs, and correspondence.

As she lay propped in her bed in New York Hospital—tiny, white-haired, arthritic, immobilized, deaf, and nearly blind but still able to "raise the fires of hell" with scathing criticisms of those she felt had gone astray from her "vision" for them—she still cared passionately about black arts and Africa's message for America. She sent letters to Lewis until his death in 1935. And she never relinquished her hold on Hurston's films of him. She continued corresponding from time to time with Locke, and she regaled her hospital guests—white family members and friends—with stories about black Harlem, the one topic she still cared to discuss.

Alone of all her Harlem protégés, Locke stayed in touch throughout the 1930s and 1940s, though he had been told as early as 1936 that his visits upset her, and after then they tapered off almost to nothing. By letter, he provided the detailed accounting of minutiae that Mason always demanded of her godchildren, dutifully reporting to her about

the treadmill of his university work, his health, his travels, politics, literature, local gossip, the mental illness of his assistants, his classes and lectures, the war, his views of Katherine's poetry (increasingly successful in the 1940s), and, with remarkable frequency, news of Langston Hughes. Locke and Mason saw each other every year or two, but only briefly. In 1942, Mason told Locke that she wanted to die and felt she could no longer be useful. Mason's last two letters to Locke, written in 1943 and 1945, are modest and tender, entirely free of the fierceness that had been such a part of her character. "I am very changed dear boy," she wrote. "My memory is not what it used to be nor the power to use my imagination which was so remarkable. I hope I can be of some help to you and we can have an interesting visit together. I hope you will not be too disappointed in your old Godmother."

Ironically, though neither he nor she ever knew it, Locke was not just Mason's last *black* friend; he was her last friend in the world. As her death approached in the mid-1940s, her domineering ways and lack of sympathy had—at long last—alienated even the loyal sisters Cornelia and Katherine. Her closest relative was Ethel, the stepdaughter whom she had raised from childhood after her husband's death in 1903 but from whom she was now thoroughly estranged. ("She was only awful about poor Ethel—but *so* awful," Katherine wrote to Francis after a 1945 hospital visit.) In March, Cornelia reported to Katherine that Mason was stone deaf, in pain, and raving but that "with her strong heart she will drag on I fear." She had already "dragged on" far longer than anyone had expected, enduring well into her nineties in spite of myriad ailments.

At 9 p.m. on a blustery, wet Monday night, April 15, 1946, Charlotte Louise Van der Veer Quick Osgood Mason, the "angel" and the "dragon" of the Harlem Renaissance, finally died of natural causes, a few weeks shy of her ninety-third birthday. Manhattan's oldest and most prestigious hospital was, at last, free to release her rooms to other patients.

No one but the hospital staff was with her at her death. She had not seen either Hughes or Hurston since before entering the hospital in 1933. Katherine was en route to Nuremberg to join her husband, Francis, once

a Mason intimate and now a presiding judge at the war tribunal. Cornelia was in Europe. Locke was not summoned.

On the day after her death, *The New York Times* carried obituaries of many people far less prominent than Charlotte Mason. The big story that day was the death of Commodore Guido Frederick Forster, who had survived attacks by Japanese suicide bombers, only to die in Summit, New Jersey, after a long illness. Langston Hughes had once described Mason accurately as "a friend of presidents and bankers, distinguished scientists, famous singers, and writers of world renown." Yet her death went unreported. That silence must have come at Mason's own insistence. Only after her death would her niece Marianne Quick, who signed her death certificate, have dared to list her aunt Charlotte as a "housewife." Alive, Mason would never have allowed such a label to stand.

In the weeks before her death, lawyers from the prestigious New York firm of Milbank, Tweed, Hope & Webb were bustled into and out of her rooms and assigned various financial and legal matters. But she never had them add any bequests to black artists; nor did she soften toward those she had once believed were the heart of her grand designs. Her will left a roughly million-dollar estate chiefly to Katherine and Cornelia. Nothing went to black schools such as Hampton. Nothing to the NAACP or the Urban League. Nothing to any of the "godchildren"— Alain Locke, Miguel Covarrubias, Aaron and Alta Douglas, Arthur Huff Fauset, the sculptor Richmond Barthé, Hall Johnson, Claude McKay, Langston Hughes, or Zora Neale Hurston. Even at the end, she could not relent.

Within a few weeks of Mason's death, Katherine came to see her in a new light. She wrote to her husband, Francis, about "Mason's bad effect her influence had had on Cornelia." By July of that year she was "slowly destroying much" of "3 suitcases full of my letters to Godmother" unable to bear "the mass of sentimental *tripe*" she had written about Mason. Both she and her son, Randolph, blamed Mason for Randolph's troubles finding his bearing.

Locke never knew any of that. Katherine's about-face was shared only with family. Cornelia and Katherine, who dealt with all of Mason's

personal effects, picked out a number of African art objects as if they'd been "godmother's gift" to Locke at her death. That "rare selection of things from our racial heritage," he wrote to Katherine, had touched him deeply. It was Locke's final, if ironic, triumph over all the other protégés who had once vied for Mason's favors. By then, however, only he still cared.

Mason could forbid obituaries, but she could not keep herself out of the fiction of the Harlem Renaissance. In place of the obituaries she did not allow, that fiction became her legacy. She was depicted so often in the literature of the period that, as David Levering Lewis put it in his history of the Harlem Renaissance, she seemed "almost a composite of some of the characters in Renaissance fiction." She was painfully easy to caricature.

Miss Anne as an Upper East Side matron;
Covarrubias may have used Charlotte Osgood Mason
as a model for the woman on the right.

Hurston did not caricature Mason, but she did embed her in her masterpiece, *Their Eyes Were Watching God*. Hurston's greatest novel comes to a verdict similar to Hughes's character's conclusion that "everybody knows no good come out o' white and colored love." The novel reconfigures the ancient form of the quest romance as a young black woman's search for intimacy and an ideal listener. In this framed tale, we witness both Janie's search and her choice of whom to tell that story to. As it turns out, ideal listeners are few and far between. Hurston's protagonist finds only one ideal listener worth speaking to, a young black woman very much like herself, from the same small town, who has lived through the very same experiences. Rather than explode Hurston's trope of "feather-bed resistance," showing exceptional white audiences for whom the veil can safely be lowered, the novel does the reverse: it leaves them out of the conversation. Written after her friendship with Mason had gone cold, *Their Eyes Were Watching God* dramatizes the impossibility of any real intimacy across racial difference—let alone the chasm that was 399 Park Avenue.

Rewards and Costs: Publishing, Performance, and Modern Rebellion

Nancy Cunard with Negro *anthology.*

Imitation of Life:
Fannie Hurst's "Sensation in Harlem"

Although it's a "white" novel, Imitation of Life *is certainly a part of the African American canon.*

—Henry Louis Gates, Jr.

Imitation of Life may be, as Gates ruefully notes, the most notable white-authored "black novel" ever written. "Since its initial publication, *Imitation of Life* . . . has occupied a singular position in American

Fannie Hurst at her desk.

culture, haunting it more persistently perhaps than any twentieth-century popular text about race other than *Gone with the Wind*." A representation of interracial friendship produced by a white Jewish author who was once the most famous—and highly paid—writer in the country, the novel had a remarkable shelf life, beyond any of Fannie Hurst's other novels, even in her heyday. The relationship between the novel's main characters, Bea and Delilah, has influenced generations of ideas about friendships between white and black women. And Fannie Hurst's connection with Zora Neale Hurston, including their collaboration on *Imitation of Life*, remains one of the most famous interracial friendships in American history.

Yet Fannie Hurst's Harlem story is a fundamentally unhappy one, her vision of black life at least as pernicious as it was salutary. Harlem embraced Hurst at a difficult time. She repaid that embrace in peculiar—but very telling—ways.

Harlem gave extraordinary latitude to its interested whites. Carl Van Vechten was given entrée to black-only clubs, invited to judge drag balls, and allowed by many to use the forbidden "N-word." Mary White Ovington was acknowledged as a—and sometimes *the*—founder of the NAACP, the nation's most important black civil rights organization. Josephine Cogdell Schuyler was encouraged to pass as a black advice columnist, and white torch singer Libby Holman was celebrated for her Broadway impersonation of a black prostitute. Ernestine Rose was roundly praised for making Harlem's public library the most important black cultural institution in the country. Although white, Annie Nathan Meyer was credited with having an important "Negro" voice. Dictatorial patron Charlotte Mason was adored and, when adoration became impossible, obeyed (until she was finally ignored). Even with a deaf ear for others' feelings and a propensity for embarrassing publicity, Nancy Cunard was widely admired for her loyalty to her black lover and her dedication to the *Negro* anthology.

But latitude had its limits. And Fannie Hurst, as much a "Negrotarian" as New York ever produced, exceeded them.

Though wildly successful with white readers, Hurst's blockbuster

1933 novel struck Sterling Brown, Langston Hughes, and other blacks as a betrayal of the friendship they'd shown her. The novel's black characters—Hurst's *only* black characters in her eighteen novels—recycle stubborn racial stereotypes. Like so many paper cutouts, they embody what the Harlem Renaissance struggled to stamp out. They are childlike. They emulate whites and denigrate blacks. They lack dignity. They are foolish. They are impractical but warm, quick to laugh and slow to anger. The novel was a "sensation in Harlem" partly because in it the best-known writer in America paid attention to black lives. But by 1933, many white writers had already beaten Hurst to that punch. *Imitation of Life* was "a sensation in Harlem" mostly because it was so much *not* what a very expectant Harlem had hoped for from Hurst.

Fannie Hurst was born in 1889 in Hamilton, Ohio, and raised in St. Louis in a "quiet house of evenly drawn window shades, impeccable cleanliness, geometrically placed conventional furniture, middle-class respectability." The only child of upper-middle-class, assimilated Jewish parents, she grew up hoping to be nothing like them. Her mild-mannered father was withdrawn. Her mother was actively engaged with others, but also "temperamental" and dramatic, demanding a center stage that Fannie wanted for herself. Fannie considered her mother small-minded and shallow. She wished for parents with hobbies and fascinating friends. "We did not know anybody who was anybody," she complained. For both parents, household minutiae, and their daughter especially, were their all. Her father read the newspaper—husbands always read the newspaper—but did not discuss national affairs. "Intellectual curiosity was languid at our house." The Hursts were especially protective—a younger sister had died of diphtheria at the age of four—but not demonstrative. By her own description, Fannie was a "rather spoiled, overweight brat of a child, living snug as a bug in the middle-class middle-western so-called security of a pre-first world-war era." She took her boredom as an affront.

She was headstrong from day one about her eventual escape from the "somnolent world" in which she was raised. A "wet-blanket of conservatism," she judged it. From childhood on, she was hard at work be-

coming fascinating. She was determined to make herself broad-minded, intellectual, socially engaged, and unconventional—everything she believed that her parents were not. One of her greatest strengths was her phenomenal willpower. As an adult, Fannie lost a great deal of weight and allowed herself to become almost as famous for her dieting as she was for her writing. Having a fashionable figure so was important to her that to maintain it she managed to subsist for decades on a diet of no more than six hundred calories a day: an orange and black coffee for breakfast, a half head of lettuce and light dressing for lunch, and a dinner of boiled or broiled meat or fish with vegetables. Very few people could sustain such a regimen, but Fannie was built without a reverse gear. She moved only forward.

Her schooling, like her childhood home, was unremarkable for a woman of her class and time. It included English (at which she excelled), history, and French and a smattering of math and chemistry (at which she did not excel). Extracurricular activities included the usual activities that aspiring middle-class parents hoped would elevate their daughters: piano lessons, dancing, and tennis. Like most young girls, Fannie kept detailed diaries, complete with illustrations. And, like many a "girl reader" born to a house without books, she haunted the public library. Her parents let her read whatever she wanted. She devoured novels, gobbling up fiction well above her years. Looking back, she said that she had always been a "word lapidary" in love with the "colors" of words. From early on, she'd determined to be a writer of note. She practiced with poems and stories, her own school assignments, and even the school assignments of her classmates. Relatives, neighbors, and teachers obligingly regarded her as a "decidedly outstanding" young woman with remarkable self-possession. She needed her classmates to "regard me as the most interesting girl in the school. I wanted to share me . . . to exhibit me."

Hurst's signature literary style was a blend of sentimental realism and progressive social commentary. Dismissed by some critics as mawkish, overwrought, and labored, her stories were so popular that at the height of her career, they regularly garnered $5,000 and her films anywhere

from $35,000 to $100,000, equivalent to more than $50,000 per story and up to $1 million per novel, with film rights, in today's currency.

Hurst's greatest talent may have been what her biographer Brooke Kroeger called her "talent for success." Once she visualized herself as a writer, her self-confidence never wavered. After graduating from Washington University in 1909, she left St. Louis and moved to New York City, against the objections of her parents, and shared an apartment with a girlfriend, to launch her writing career. "Even then nothing was allowed to disturb her during hours she set aside for work, and she worked seven or eight hours a day," the roommate remembered. She composed on a typewriter at breakneck speed and "never rewrote." When editors asked for revisions, she refused.

In a matter of months, however, she was setting her own terms. Nor did she mind when her willfulness became legendary. She happily divulged all the details of her writing process, sharing any information that interviewers cared to ask about. Ultimately, she refused even to alter her writing or touring schedule to respond to her parents' deaths. Both "highly self-conscious" and "high-handed," she could not imagine that others might not find her single-mindedness attractive. She had been born, she once admitted, a "pig for success," competing even with her dead sister for approval and attention.

Fortunately, Hurst had appealing qualities as well: adventurousness, bursts of generosity, a wicked sense of humor, bluntness, and a deep sense of fair play and justice. In most cases she faced her own weaknesses squarely. She could be very charming.

Being seen as ethnic did not suit her. In childhood, she followed her family's suit and ignored being Jewish. "I would have given anything," she reported in her autobiography, not to be acknowledged as Jewish. In New York, however, she discovered that there was an audience for ethnicity and that being Jewish could be an advantage, a source of colorful stories about immigrant lives. She loved to visit the "sweatshops and tenements of the Lower East Side" to gather background for her portraits of "shopgirls, immigrants, mistresses, and romantic and aspiring dreamers." She took her notepad into night court to collect stories and

also took a series of short-term jobs at a settlement house, as a waitress, in a sweatshop, as a salesgirl at R. H. Macy, and as a factory worker in the interest of gathering material. Heavily plotted and sometimes melodramatic, her work depicted socially marginalized characters struggling against stiff odds. Often, in stories that ranged from "Sob Sister" to *Back Street*, she wrote of women trying desperately to follow the social script of femininity but winding up abandoned and impoverished. Readers identified with Hurst's fury over social double standards. Critics were not as impressed.

Fannie saw few role models for combining domestic and professional goals. So in 1915, she secretly married pianist Jacques Danielson, maintaining her own name and a separate residence—dating her own husband, in effect—in order to keep their relationship "fresh" (and later to help her manage her multiyear affair with the Arctic explorer Vilhjalmur Stefansson). The arrangement also accommodated her writing schedule, as she typically wrote in the morning and then went out in the afternoons and evenings. When the secret got out in 1920, with a front-page *New York Times* story, Hurst made use of that also. Seizing the limelight she'd been given, she inveighed against the "antediluvian custom" of sexism and double standards. She was delighted when the press coined the phrase "a Fannie Hurst marriage" for any unconventional domestic arrangement. She was involved in progressive social causes, including public health, labor, sex education, reproductive rights, marriage reform, and feminism from the early 1900s on. After 1920, she was able to parlay her double celebrity—as writer and rebel—into a career almost as notable for public speaking as it was for popular writing. She was thus in constant demand for writing assignments, radio commentary, lectures, and magazine pieces. The exposure ensured a constant stream of press notices—focused as much on her hats, clothing, and weight as anything else—all of which she pasted into scrapbooks. As her success solidified and her marriage settled down, she became even more interested in the kinds of social issues her family had always ignored. She was a member of the Heterodoxy Club, which brought her into the sphere of feminists such as Charlotte Perkins Gilman, Crystal Eastman, Janet Flanner, and

Susan Glaspell. With them, she signed the Lucy Stone League's charter protest against married women having to take their husband's names. She marched for suffrage with her friend Annie Nathan Meyer's sister Maud Nathan, among others, and was delighted to accept the Suffrage League's invitation to lecture on polygamy and marriage, in spite of knowing little about the latter and nothing at all about the former. More than anything else, Hurst thrilled to her growing reputation as one of the country's most important "friends of the Negro," a public stance even more outré than feminism.

In fact, Fannie Hurst came relatively late to the cause. It was not until the mid-1920s, having first gone to Harlem with Carl Van Vechten, that she began to take a serious interest in what she called "black matters." Although she acted as a judge for a number of Harlem's important literary contests, into the mid-1920s she was still dismissing the importance of race as "something I don't particularly think about one way or the other." She did, however, as she remarked in one interview, think that some blacks were "lovable characters."

In 1926, she joined the board of the National Health Circle for Colored People (NHCCP). The NHCCP partnered with nurses' organizations to push for more public health services for blacks, especially in the South, and "to create and stimulate among the colored people, health consciousness and responsibility for their own health problems." Like so many white-led social welfare organizations at the time, it took for granted that blacks needed white instruction in hygiene and personal responsibility, rather than equitably distributed social resources. In 1927, she lent her name to the organization's fund-raising appeal, urging donors to give generously to a "languid . . . happy friendly race." In 1928, she composed the NHCPP's Christmas Appeal letter. "The Southern Negro," she wrote, "knows pitifully little about keeping his body or his child's body a fit place to dwell." Among the organization's donors was Cornelia Chapin, acting on Charlotte Osgood Mason's behalf.

After 1928, Hurst's name increasingly appeared on the board lists of organizations such as the NAACP and the Urban League. Her involvement was largely nominal, however. Impatient with the routine work of

political organizing and the tedium and anonymity of grassroots work, she preferred judging literary contests, giving talks, penning appeals, and mentoring individuals: tasks that made use of her name and reputation. She rarely attended the board meetings for which she lent her large apartment. Instead, she left instructions with her staff. Her caveat for organizational participation was that fellow members accept "that I was not in a position, owing to countless obligations, . . . to give either time or money." It is hard to imagine that the apartment she lent was a particularly congenial place for committee meetings. It had twenty-foot ceilings, dark woods, oversize medieval art (Catholic Madonnas and crosses), red brocade curtains, calla lilies (Hurst's signature flower), and numerous portraits of herself; it was a stylized shrine to a highly constructed image, as much a stage set as a home.

Fannie Hurst's New York apartment.

It was into that space and that image that Hurst tried to shoehorn Zora Neale Hurston, another outsize personality with a carefully constructed image to maintain. Hurston caught Hurst's attention at the dinner for the 1926 *Opportunity* awards, which Hurst judged. Throwing a red scarf around her shoulders and yelling out the title of her award-

winning play, *Color Struck*, Hurston was clearly the most flamboyant person in the room. Hurst was unused to such competition, and it is to her credit that she gravitated toward the woman who upstaged her. Fannie Hurst was by then the highest-paid writer in the United States, with many novels and hundreds of stories already in print. She was also probably the most influential and widely known white person to interest herself in black New York. Hurston, by contrast, was a recent arrival to New York, struggling to make ends meet. She had appealed for support to both Arthur A. Schomburg and the hairdressing entrepreneur Annie Pope Malone (the Madam C. J. Walker of the Midwest) but both had turned her down. Annie Nathan Meyer had already taken an interest in helping her get into Barnard but lacked sufficient funds to cover all of Hurston's expenses; she encouraged her friend Fannie Hurst to help out as well.

Knowing Hurst proved an enormous advantage to Hurston, then Barnard's only black student. "Your friendship was a tremendous help to me at a critical time. It made both faculty and students *see* me when I needed seeing," Hurston wrote to her. Hurston suddenly had two very well-known Jewish women friends, both of them well-established writers. "I love it! . . . To actually talk and eat with some of the big names that you have admired at a distance," Hurston told a friend. Her unabashed delight contributed to Hurst's ongoing self-crafting. So Hurst helped out enthusiastically, enlarging Hurston's social contacts, introducing her to Stefansson, writer Irvin Cobb, Paramount Pictures cofounder Jesse Lasky, actress Margaret Anglin, and others. It was timely assistance, since Hurston was down to her last "11 cents." And Barnard, which catered to upper-class women, was requiring her to pay for a gym outfit, a bathing suit, a golf outfit, and a tennis racket. Far worse, some of her Barnard professors were assigning "C" grades to her examinations before she'd even sat for them. She was feeling, she said, like a "Negro Extra."

Hurst was entranced with Hurston. She believed she saw an essential, primitive blackness in her. "She sang with the plangency and tears of her people and then on with equal lustiness to hip-shuddering and finger-

snapping jazz," Hurst wrote approvingly. She was as "uninhibited as a child." To Hurst, Hurston was a humble native genius, close to the soil, a delightful "girl" with the "strong racial characteristics" of humor, humility, and wit. She saw in Hurston a "sophisticated negro mind that has retained many characteristics of the old-fashion and humble type." She praised her "talent," her "individuality." Mostly, she delighted in what she called Hurston's "most refreshing unself-consciousness of race." Hurst hired Hurston as a chauffeur and personal secretary—"the world's worst secretary." Hurston was to run errands and answer letters and the telephone. "Her shorthand was short on legibility, her typing hit-or-miss, mostly the latter, her filing, a game of find-the-thimble. Her mind ran ahead of my thoughts and she would interject with an impatient suggestion or clarification of what I wanted to say. If dictation bored her, she would interrupt, stretch wide her arms and yawn: 'Let's get out the car, I'll drive you up to the Harlem bad-lands or down to the wharves where men go down to the sea in ships.'" Fortunately, Hurst loved to visit out-of-the-way places and Hurston loved to drive. Invariably, Hurst took the backseat.

On one of their driving trips, Hurston took Hurst to see her home-town, Eatonville, Florida. Eatonville was the nation's first incorporated black town, Hurston's folklore source, and her emotional touchstone. To her it was a utopian world where blacks lived near whites "without a single instance of enmity"; where people lived a "simple" life of "open kindnesses, anger, hate, love, [and] envy"; where you "got what your strengths could bring you." But Hurst saw "squalor" instead of the splendor dear to Hurston's heart. She looked pityingly on what Hurston claimed as the "deserted home" of Hurston's family, "a dilapidated two-room shack." The building, in fact, had never housed the family. But Hurst never found out that Hurston had never lived in such a shack. On the contrary, the family home in Eatonville was a gracious eight-room property on five acres, a "roomy house" on a nice "piece of ground with two big Chinaberry trees shading the front gate and Cape jasmine bushes with hundreds of blooms on either side of the walks . . . plenty

of orange, grapefruit, tangerine, guavas and other fruits" in the yard. Hurston clearly understood, and provided, what Hurst expected to see.

Hurst was at a difficult point in her career. Commercially successful almost beyond imagining, she was nevertheless becoming increasingly discontent. She longed, as she put it, to be a "darling of the critics," but she was becoming their whipping girl instead. In fact, she had become their model of "how not to write." Hurst had no talent for breaking her own patterns. But now she needed a drastic alteration of her own formula, a book that others would see as entirely new and different.

It was on one of their car trips, just at this juncture, in June 1931, that Hurston—who was also collaborating with Annie Nathan Meyer and under increasing pressure from Charlotte Osgood Mason—furnished Hurst with the material for *Imitation of Life*. Hurst told Hurston that they were motoring toward Vermont to look at property and visit her literary agent, Elisabeth Marbury, who had just taken Hurston on board as well. Marbury was a powerhouse, and Hurston would naturally have been eager to solidify the new relationship with a social visit. Hurston's contract with Mason had ended that March, freeing up her publication plans but also leaving her without the regular financial support she'd grown accustomed to. She had two manuscripts under revision but no acceptances and Franz Boas looking over one shoulder, Mason glaring over the other. With fewer and fewer outlets for black literature available after the stock market crash, good relations with both Hurst and Marbury could make all the difference.

But Fannie Hurst had her own agenda. She had been making secret plans to leave her husband for Stefansson. Hurston provided cover. As they drove north, Hurst suddenly pressured her to drive into Canada, where Stefansson was lecturing; she promised to show Hurston Niagara Falls.

Hurst and Stefansson eventually scuttled their plans, and Hurst remained in her marriage to Danielson. But the trip to Canada was not a loss for her. All along the way, *Imitation of Life* took shape in lengthy conversations in the car. Hurston had always been fascinated with the

inner lives of workingwomen, Hurst's favorite subject. Mapping out the interior life of Hurst's new characters came naturally to Hurston. In her rear seat, Hurst scribbled hurriedly in a small notebook. At night, alone in her hotel room (Hurston stayed in rooming houses that accepted blacks or else she slept in the car), Hurst added to her notes. Hurst returned to New York with the core of the novel that would ensure her legacy for decades to come. Hurston, on the other hand, returned to New York to find that Mason and Locke were furious with her and banishing her to the South.

Imitation of Life was an important experiment for Hurst, designed to prove to the modernists who ignored her and the critics who derided her that sentimentality, a deeply female literary form, *could* address the "hard" social issues. She had a lot riding on the novel. But she needed Hurston's help. She wrote a series of letters, begging Hurston to return to New York and review her draft. Hurston was in Florida working hard on her folk opera and trying to keep that fact from Mason, who wanted her to work on *Barracoon*. Hurst desperately wanted her advice on the manuscript, but Hurston dodged her, sick of being anyone's "pet Negro."

Hurst finished the novel, her only black story, on her own. It shows. Set just beyond the bustling Atlantic City boardwalk, *Imitation of Life* tells two unhappy stories of passing: white Bea Pullman (née Chipley)'s brief passing for a man and black Peola Johnson's lifelong passing for white. Bea's passing costs her dearly, but it is excused because of the disadvantages imposed on women in a world of sexual double standards, a frequent theme of Hurst's. But Peola's passing, although occasioned by a similar desire to escape the racial double standard, is neither excused nor forgiven in the novel. Peola's unhappiness is depicted as her own fault, the consequence of her sinful efforts to pass.

Bea grows up in a claustrophobic, middle-class household not unlike Hurst's own. She lives close enough to hear but not see the exciting Atlantic City boardwalk, a none-too-subtle symbol of bourgeois restraints on women. The Chipleys' world consists of "monotonous . . . minutiae of detail . . . automatic processes of locomotion and eating and sleeping" stuffed into a "little household . . . all cluttered like that, with littleness."

Fannie Hurst.

Mrs. Chipley's early death obliges Bea to begin looking after her "exacting" father and the family's boarder, Benjamin Pullman.

The men of the household, father and boarder, decide that Bea should marry Pullman, an unattractive, older pickle and maple syrup salesman. Bea resolves on going through with the sweet-and-sour marriage for the sake of "security!" and enters into a loveless union in which sex is "a clinical sort of something, apparently, that a girl had to give a man." That "let down" is followed, in quick succession, by pregnancy, with its "perfectly terrible spells of morning nausea"; her father's debilitating stroke; her husband's sudden death in a train wreck; and the premature birth of her daughter, Jessie.

To try to keep her family afloat, Bea uses her dead husband's "B. Pullman" business cards and passes for a businessman. As "B. Pullman," she does well, even better than her late husband. But it is not enough. She

must be father, mother, and daughter, must "report back, every hour or less, to the house on Arctic Avenue that contained her father and child." So she drifts "across the railroad tracks to the shanty district" to wander among the "what nots" who do domestic work and find domestic help. There she encounters Delilah, "the enormously buxom figure of a woman with a round black moon face that shone above an Alps of a bosom" and hires her on the spot. Delilah brings along her "three-month-old-chile" Peola, an infant as light-colored as Delilah is dark: "the purfectest white nigger baby dat God ever dropped down in de lap of a black woman from Virginie," as Delilah describes her.

Once established as a force of order in Bea Pullman's kitchen, presiding "like a vast black sun over the troubled waters of the domestic scene," Delilah, the wondrous "what not," can turn to ensuring the success of Bea's growing waffle house and coffee shop business. Bea's "walkin' trade-mark," Delilah lets Bea market her as a "mammy to the world," selling southern nostalgia to enervated northern city dwellers. Embodying the qualities of nurture and care that made whites such as southern writer Julia Peterkin label the "Mammy" a "credit" to her black race, Delilah helps Bea create a "rest cure" of comfort tucked into American modernity. Hurst's "mammy," finished without the benefit of Hurston's keen eye, is a figure indistinguishable from the one that the Daughters of the Confederacy had hoped to honor, in 1923, in Atlanta, an image of the comfort and care sought by anxious whites, afraid of change. Black journalist Chandler Owen, among others, argued that it was high time for the nation to "let go" of its love of black mammies. "Let it fade away," Chandler wrote. "Let it be buried. . . . We favor erecting a monument to the New Negro." But Hurst, writing ten years later, did not "let go." On the contrary, she used the "Old Negro" to create a memorable New Woman.

Before long, thanks to Delilah, the thoroughly modern Bea is (like Hurst) wildly successful. But she has only an "imitation of life," since she rules over a business rather than a home. Being a New Woman, apparently, has its drawbacks. Female happiness has "passed her by, all

right, without leaving her the leisure to more than fleetingly compre-
hend it." She has "built a colossus, when all she had ever wanted was a
homelife behind Swiss curtains of her own hemming, with a man." But
because she is that "comparatively rare bird, woman in big business,"
she is stuck with the "success of her success."

Delilah tries to save the modern woman from herself. She urges Bea
to get herself some "man lovin'" before it's too late. Delilah's insist-
ence on Bea's right to sexual satisfaction is the novel's strongest feminist
statement, but because Hurst puts it largely in Delilah's voice, it does not
get very far. Bea is never quite sure what she wants. And Delilah is pre-
occupied with her daughter, who's grown from a sulky, self-pitying tod-
dler into a dissembler and liar, passing for white to win popularity and
approval. Delilah is as horrified as if she'd never heard of passing. "Dar
ain't no passing," she insists, "ain't no way to dye black white. . . . Black
wimmin who pass, pass into damnation." Delilah contends that Peola's
sin is rooted in her birth, coursing through the "blue-white blood" she
inherited from her "pap." That blood, Delilah maintains, like "wild
white horses" in her veins, has doomed her daughter. Endorsing rather
than challenging Delilah's view, the novel ensures that Peola's trans-
gressions meet with misery. Blacks cannot and must not impersonate
whites, the novel's narrative logic insists.

That narrative logic may have been a more serious betrayal of Hurst's
Harlem friendships than even her depiction of Delilah. The nonsense of
"blood talk" was precisely what so much Harlem Renaissance literature
devoted itself to exposing. James Weldon Johnson's 1917 *Autobiography
of an Ex–Colored Man* showed the ease with which blacks could learn
codes of white behavior. George Schuyler's 1925 *Black No More* showed
how ridiculous society would become if "blood talk" was taken to the
logical extremes of its hysterical fractional categories. Delilah's belief
that blood would inevitably "out" in surefire racial telltales such as a
bluish tinge to the fingernails was parodied as so much "silly rot" in
Nella Larsen's 1929 *Passing*, which Van Vechten would certainly have
pressed upon Hurst. The Rhinelander case was one example of the hor-

rors of taking such "nonsense" seriously and the Scottsboro case was another. But Hurst's Delilah, modeled so obviously on Aunt Jemima, is an Old Negro, and an insistence on old-fashioned, outworn white ideas of blackness. She is a minstrel figure with an "easily-hinged large mouth, packed with the white laughter of her stunning allotment of hound-clean teeth; the jug color of her skin . . . the terrific unassailable quality of her high spirits," and with malapropisms, and mispronunciations. She is subservient and "unctuous," always ready to soothe Bea's daughter with her "black crocodile-like hand." She wants nothing but resignation for her daughter: "Make her contented wid her lot," she moans. Peola recoils from her mother. And, given what Hurst has made her, it is easy to see why: "The wide expanse of her face slashingly wet, the whites of her eyes seeming to pour rivulets down her face like rain against a window pane, her splayed lips dripping eaves of more tears," Delilah is described. Delilah dies on the floor, kissing her mistress's ankles. Delilah, Sterling Brown noted with disgust, "is straight out of Southern fiction. . . . Resignation to injustice is her creed." She is, he went on to point out, "now infantile, now mature, now cataloguing folk-beliefs of the Southern Negro, and now cracking contemporary witticisms."

White readers loved the novel. "Of course they had reasons," Brown noted drily.

Even for a community habitually polite to its white supporters—"We are a polite people," Hurston always said—Delilah was too much. All the more so because she was popular with whites. "I have heard dialect all my life, but I have yet to hear such a line as 'She am an angel,'" Sterling Brown noted. She is the "old stereotype of the contented Mammy, and the tragic mulatto; and the ancient ideas about the mixture of the races."

Langston Hughes was friends with Hurst. But he could not hold back. He made an example of Hurst's novel in his *Limitations of Life*, one of four satiric skits he wrote for the Harlem Suitcase Theatre lampooning white imitations of blacks. Reversing the racial roles and using variations of the names of the lead actresses in Stahl's 1934 blockbuster movie made from the novel, Hughes had blond Audette rub Mammy

Weavers's feet, promise never to leave her, and gaze at her mistress "like a faithful dog": "I *never* gets tired doin' for you," Audette intoned.

Hurst's use of the passing story, so central to Harlem Renaissance thinking about identity, was viewed as the trespass that Carl Van Vechten's *Nigger Heaven*, Libby Holman's blackface "Moanin' Low," and even most of the white plays about black life were not. Objecting to Hurst's novel, "the 'passing' episodes are . . . unbelievable. . . . [Peola] never quite gets a grasp of the whole problem," Brown wrote. Hurst thought Brown should have been more grateful for the attention she gave to blacks. "I cannot imagine what in the world I have to be grateful for," Brown replied.

Racial passing was serious business in the 1920s and 1930s, when mainstream newspapers, taking for granted that it was unethical, advised white readers about how to detect black blood. In the public imagination, the passer was a moral criminal, trying to impersonate what she or he was not and, at the same time, betraying his or her true nature. But in the hands of black writers such as Charles Chesnutt, James Weldon Johnson, Walter White, Jessie Fauset, and Nella Larsen, passing was a moral victory. For them, the moral force of passing indicted society's unfair lines, not the passer who crossed them. For Harlemites, "there was no story more compelling than the story of a black person who passes for white." Indeed, the passing story provided an occasion in black fiction for whites to be comically portrayed—they are either duped by passers or panicked needlessly about them—and for blacks to be heroes. A victim of racism, the passer is *forced* across the color line, in black fiction, by discrimination and prejudice, which his or her passing reveals. Black fiction also used passing to question the idea that race is a biological essence or identity in the blood. As Paul Gilroy put it, passing puts "rooted identity . . . that most precious commodity . . . in grave jeopardy."

Hurst's narrative logic, however, got every piece of that crucial political formula wrong. She punished Peola for what society had done to her. She failed to treat Peola's passing as a reasonable response to prejudice, let alone an act of valor. She made Peola a villain, rather than

a victim, charging her with the responsibility for her mother's collapse. Nor did Hurst understand the genre's "moment of regret" that always turned society's preference for whiteness upside down. Hurst's Peola prefers white society. She experiences no longing for blackness, no wish for a return, none of the "wild desire" to go home that drives Nella Larsen's passing character almost to madness. Peola never looks back, never misses blackness, never finds a single thing from her black life for which she longs or even feels nostalgic. A cruel daughter who breaks her mother's heart, Peola is pure perpetrator.

Peola's lack of feeling for blackness betrays her author's attitudes. Though known for her sentimental writing, Hurst was remarkably unsentimental. She saw no particular value to racial identity unless it provided story material. Because the story of passing is, at its core, a tale of racial longing (for the black identity left behind), Hurst's story falls flat. *Imitation of Life* cannot imagine racial longing. In place of a black erotics of identity, it shores up Delilah's old-fashioned view that we must be as "Lordagawd" made us. A lifelong self-fashioner, Hurst drew the line at black self-creation, perhaps because she could not imagine racial longing of any type. Her novel was a special disappointment to a community deeply invested in the rich emotional potential of racial identity and deeply invested, as well, in expectations of its Negrotarians.

Many Harlemites joined the fracas over *Imitation of Life* in 1933 and 1934 when the first film version of the novel appeared. But Hurston kept her peace. Although she supported Hurst in private letters, she refrained from saying a word in public. Hurston must have seen, and perhaps hoped that others would not notice, that Delilah was only half Aunt Jemima. Hurst's Delilah was also half Hurston, or rather half what Hurst *perceived* to be Hurston's racial nature. She was painfully aware of the traits Hurst prized in her: "childlike manner . . . no great profundities but dancing perceptions . . . sense of humor," and delightful "fund of folklore." The lack of "indignation" and "insensibility" to racial slights, which Hurst imagined she saw in Hurston, were precisely the materials out of which Delilah was created. She was a "margarine Negro,"

as Hurston called white-authored black caricatures, a figure built in Hurst's image of Hurston, an insult at every level and, perhaps, Hurst's retaliation for Hurston's refusal to help.

Yet, Hurst evidently did not expect a black backlash. She was "stunned when she found her best-selling novel *Imitation of Life* the subject of fierce debate and parody" and "horrified by the sharp criticism" in *Opportunity*. Her novel probably had a profound effect on how the major writers of the Harlem Renaissance viewed friendship with whites and the possibilities of interracial intimacy. But there were few, if any, other direct consequences for Hurst, insulated by her own status, to face. She continued to count both Hughes and Hurston as lifelong friends, staying in touch with Hurston well into the 1940s, though it would always be Hurston's "Dear Miss Hurst" to Hurst's "Dear Zora." She continued to be invited onto the advisory boards of black organizations. She remained a regular attendee of Harlem's storied interracial parties, cabarets, and literary salons. To her great delight, she was promoted to national spokesperson for race, credited with having an inside view of blacks. Such venerable publications as *The New York Times* asked her to tell readers all about "the other, and unknown, Harlem," handing her a podium that some whites, such as Nancy Cunard, in her essay "Harlem Reviewed," would have to struggle to construct. Nothing that followed the novel forced Hurst to take responsibility for its racial slights.

Just after *Imitation of Life* appeared, Hurston wrote an essay entitled "You Don't Know Us Negroes," perhaps her most forceful statement about how much white writers get wrong when they try to write about blacks. Their writings, she argued, "made out they were holding a looking-glass to the Negro [but] had everything in them except Negroness." Without naming Hurst, Hurston's essay addressed every flaw of Hurst's novel, from its minstrel-ridden use of dialect and malapropisms to its treatment of Peola. "If a villain is needed" in a white novel, Hurston noted, white writers just "go catch a mulatto . . . yaller niggers being all and always wrong." Those "margarine Negroes," Hurston went on, are found especially in "popular magazines": Fannie Hurst's

primary outlet. Hurston listed the white writers she called "earnest seek-ers": DuBose Heyward, Julia Peterkin, T. S. Stribling, and Paul Green. Fannie Hurst was not included. It was high time, Hurston argued, for white writers to *earn* the privilege of writing about blacks. "Go hard or go home," she concluded angrily. Intended for *The American Mercury*, the essay was pulled at the last minute and never published. Possibly, Hurst never saw it.

Hurston tried again, and Hurst certainly saw Hurston's essay "The Pet Negro System," published in 1943. Written as a mock sermon, the essay takes a mock document called *The Book of Dixie* as its text:

> And every white man shall be allowed to pet himself a Ne-gro. Yea, he shall take a black man unto himself to pet and to cherish and this same Negro shall be perfect in his sight. Nor shall hatred among the races of men, nor conditions of strife in the walled cities, cause his pride and pleasure in his own Negro to wane.

The "Pet Negro," Hurston explained, "is someone whom a particular white person or persons wants to have and to do all the things forbid-den to other Negroes"; by pointing to his or her pet, the white person decries outside criticism. Even if she's a troublemaker and difficult—as pets often are—talking back to him and refusing to do all he asks, he's only too happy to heap rewards on her, privileges foreclosed to all other blacks. Again, Hurston did not name Fannie Hurst. She did not need to. All of Harlem had known of her friendship with Hurst.

And Hurst certainly would have been familiar with Hurston's mas-terpiece, *Their Eyes Were Watching God*, published in 1937, with its suggestion that trying to speak across the racial divide, or develop any meaningful friendships with whites, is as much a waste of time as "let-ting the moon shine" down your throat.

Hurst's repeated insistence on "un-selfconsciousness" about race ap-plied only to blacks. She did not believe it did—or should—apply to her.

Her demand for "color blindness" was a one-way street, what Patricia Williams calls a "false luxury" that pretends that what matters a great deal does not matter at all. *Feeling* little for either whiteness or blackness, Hurst allowed herself to be intellectually fascinated with blackness while whiteness went unexamined. *That* kind of unself-consciousness about race is fundamental to what George Lipsitz calls the "possessive investment in whiteness": the privilege of not seeing oneself, if white, as raced, and the idea that one's own whiteness is a neutral default, nothing more than the way things are. Music and literary critic Baz Dreisinger, one of the few academics to write about "reverse" racial passing, suggests that we can differentiate "admirable" white identifications with blackness from "onerous" ones by the presence or absence of a self-critical distance. Hurst's own background might have given her the distance Dreisinger describes. As a Jew, she was not considered entirely white. The closer she came to blackness, however, the whiter she became. Had she taken more note of that phenomenon, as well as taking professional advantage of it, her story of identities crossed and recrossed would have been richer.

Whereas Lillian Wood, Josephine Cogdell Schuyler, Annie Nathan Meyer, and Charlotte Osgood Mason all confounded available ideas of race and identity, whether meaning to or not, Fannie Hurst, by and large, affirmed the status quo. The fact that Hurst could so easily avoid any consequences for that failure makes what other white women—from Lillian Wood to Nancy Cunard—willingly incurred for their transgressions all the more remarkable. Hurst's failure of even her own liberal ideals serves as a painful reminder of how unpredictable—even to herself—Miss Anne's involvement could be.

Chapter 8

Nancy Cunard:
"I Speak as If I Were a Negro Myself"

Maybe I was African one time.

—Nancy Cunard

I longed for an American white friend with feelings such as mine—but alas, nary a one.

—Nancy Cunard

On a mild, cloudy Monday, May 2, 1932, Nancy Cunard returned to Harlem from a weekend in Boston, surprised to discover that William Randolph Hearst's tabloid, the *New York Daily Mirror*, was stirring up a media frenzy with claims that "Steamship Heiress Nancy Cunard" and actor Paul Robeson were holed up at Harlem's all-black Hotel Grampion. By dint of constant re-creation that few others would have dared, British Nancy Cunard had transformed herself from a "popular society girl" into an internationally known militant—simultaneously a modern icon of style and a model for rebels and radicals. Although only thirty-six years old, she had already endured (and sometimes enjoyed) nearly twenty years of minute tabloid attention from the British papers, which reported gleefully on all of her comings and goings as well as her hats, suits, jewelry, and makeup: "a mauve tulle scarf tied across her eyebrows, with floating ends, under a big gray felt hat, which looked,

*Nancy Cunard liked this photo of herself from the 1920s and kept it
with her in her scrapbook.*

oh, so Spanish!" The *Daily Mirror*'s tale of an affair with the hand-
some, dynamic Robeson—himself an icon of Harlem's "New Negro"
masculinity—was just the sort of overagitated reporting Nancy loved
to hate (and paste into her enormous black scrapbooks). Except for one
thing. Almost every detail of the *Daily Mirror*'s story was wrong.

Nancy Cunard was not new to Harlem. She was there for the sec-
ond time and well on her way to becoming one of the most important
and influential white women in Harlem—possibly *the* most influential.

She was tired of being just a famous flapper. Now she was angling for acceptance by blacks. It was no time to have her political and aesthetic contributions trivialized or misreported.

Robeson's white lover was not Nancy but another Englishwoman named Yolande Jackson. And Nancy's black lover was not Robeson but the elusive black jazz musician Henry Crowder, who had accompanied her from Paris to Harlem the year before but this time had stayed behind. Robeson and Nancy hardly knew each other. And Nancy was in New York for business, not pleasure: fighting for the release of the nine black "Scottsboro Boys" and also collecting material for a comprehensive anthology of black life eventually published as *Negro: An Anthology*. She also had written an insider's account of Harlem, which was about to be published; that made it all the more infuriating—and ironic—to be portrayed as one of the cabaret-hopping, naive white tourists whom her forthcoming article was preparing to blast.

One of the few things the newspaper story got right was the fact that Nancy and Robeson were staying at the same hotel, hardly surprising given that the Grampion was the only first-rate hotel in Harlem that admitted black guests. Nancy learned that Robeson was also at the Grampion by reading the *Daily Mirror*'s account. Had she known he was there, she would have sought him out and demanded to know why he was ignoring her repeated requests for a contribution to her anthology. She hated being ignored.

Nancy tolerated (relished, some said), a great deal of frivolous press attention. In spite of her painfully thin, boyish body and reputation for coldness—"one of those women who have the temperament of a man," Aldous Huxley said—she delighted in becoming one of the most notorious sex symbols of the early twentieth century. She accepted "blather and ballyhoo" as part of the bargain of being the rebellious only daughter of eccentric Sir Bache Cunard and his wealthy American wife, Maud. But she was a stickler for accuracy. At pains to be taken seriously as a woman writer, she was especially hard on careless journalists. Just before midnight on May 1, she caught wind of the *Mirror*'s impending story and in her clipped, percussive style marched straight to a cable

office, at 11:45 p.m. sending the editor, James Whittaker, a telegram that read, "Racket my dear Sir, pure racket, heiress and Robeson stuff. Immediately correct these. Call Monday one o'clock give you true statement. Nancy Cunard." She now considered the matter closed. But Whittaker either did not receive Nancy's telegram or—more likely—chose to ignore it. Nancy Cunard stories sold copies. The column ran in his morning edition.

Whittaker knew—as Nancy surely also did—that stories about single white women in Harlem would make good copy, especially in 1932, with the Depression deepening. However much other social taboos might be loosening, those against interracial sex remained entrenched. If a reporter could pair a "New Woman" with a "New Negro"—and Nancy and Robeson, respectively, exemplified those categories—so much the better. It was easy to play on the public's conviction that Harlem was a haven of forbidden pleasures where wealthy white women appeared unaccompanied for one unspeakable reason. That sold papers. Newspapers from Haverhill, Massachusetts, to Duluth, Minnesota, carried Whittaker's account under headlines such as "Lady Cunard's Search for Color in New York's Negro Quarter." A hastily produced Movietone newsreel depicting "Lady Nancy Cunard" entering a "Harlem Negro hotel" also helped keep the tale alive. The British press eagerly picked up the story under such headlines as "Auntie Nancy's Cabin Down Among the Black Gentlemen of Harlem."

Nancy and Robeson both demanded retractions of what Nancy called the "outrageous lies, fantastic inventions and gross libels." Robeson's demand was printed; Nancy's was not. Nancy wrote to Robeson that she knew "nothing *at all* of this amazing link up of yourself and myself in the press." She lamented: "The sex motive is always used. . . . The Hearst publications *invent* black lovers for white women." She called a press conference for noon at the Hotel Grampion and wrote up a statement to read to the dozens of reporters attending. "Press Gentlemen, how do you get this way?" it began. She spent the morning pacing, preparing, and strategizing, wondering why the papers could not be sane about race.

Nancy Cunard at her 1932 press conference with
John Banting and Taylor Gordon.

At noon, dressed for her showdown, she strode into the hotel's dining room, escorted by her friend the white English artist John Banting. She was a striking figure, "very slim with skin as white as bleached almonds, the bluest eyes one has ever seen and very fair hair," and her unusual beauty combined "delicacy and steel," as one of her admirers put it. Her "crystalline quality" made some people think she was "cold to the core." But her problem was really the opposite: she cared too deeply about too many things, usually choosing things that others—other wealthy whites, at least—cared very little about. On that occasion, what she cared about was being misrepresented.

Like many highly sensitive people, Nancy liked to appear impervious. She had dressed with unusual care, adopting an understated version of the look that had become her signature. Her hair was wound under

a multicolored crisscrossed turban, and she wore a tightly fitted red leather jacket; a dark, narrow, midlength skirt; colored hose; and black, pointed, high-heeled Mary Janes: militarism and girlishness combined. Usually she covered her arms from wrists to elbows in dozens of African ivory bangles. They were her trademark style—her "barbaric bracelets," her friend the photographer Cecil Beaton called them. That day she sported just a bangle or two on each of her thin, white wrists, barely visible under her leather cuffs. The press had often noted her heavy hand with eyeliner. That day, she rimmed her eyes very lightly in kohl. She wore simple black earrings that hardly reached below her earlobes.

The lean and nervous Banting, wearing a light-colored three-piece suit, white tie, and two-tone shoes, escorted Nancy into the garishly decorated hotel dining room. He felt "half sick with horror" as they faced a roomful of reporters, notebooks at the ready. "I need not have been [afraid]," he soon realized, "for she stood up to the barrage smilingly in her bright armour of belief and her quick wit . . . expertly batting off the more stupid and destructive questions fired at her." Fending off both honorifics and inquiries about Robeson—"it is NOT 'the Hon[.] Nancy,' it is Nancy Cunard"; "I met him once in Paris, in 1926,"—Nancy patiently explained that she'd been "disinherited" and that she had business in New York's black neighborhood. She proudly told the reporters that her American ancestors had come out against slavery as early as 1680. Then she deftly steered the conference away from her private affairs and into the politics of race in America. She asked the assembled reporters to contribute to the Communist Party's Scottsboro Defense Fund and demanded that they encourage their readers to weigh in on the question of why Americans are so "uneasy of the Negro Race." The best answers would be reprinted in her upcoming *Negro* anthology, she promised.

Nancy was a single British woman trying to tell American newspapermen what to do. She did not get what she asked for. Rather than report that she was spearheading the British campaign to free the Scottsboro Boys or that her literary and political efforts had earned her many important friends in Harlem and the status of a Harlem insider, the newspa-

pers continued their ridiculous Robeson story. It fitted perfectly with the "taxonomic fever" of the times: a cautionary tale for those who tried to step across race lines. Letters piled up at the Hotel Grampion's reception desk. But they were almost all hate mail, of an unusually vicious sort.

As she later put it, "race-hysteria exploded." By May 4, the beleaguered hotel staff found themselves with more than five hundred letters addressed to Nancy Cunard. These arrived from all across the nation: some typed, some handwritten, some scrawled with thick pencils, some merely unstamped envelopes weighted with slugs for which Nancy would have to pay postage. The letters insulted her, threatened her, and offered—in a variety of ways—to save her from herself. The letters called her "insane or downright degenerate," "depraved miserable degenerated insane," "a dirty low-down betraying piece of mucus," and "a disgrace to the white race." She was warned that she should "give up sleeping with a nigger" or be "burned alive to a stake. . . . Unless you leave America at once you will certainly be put on the spot and bump of[f] quick." Most people would have destroyed these letters. Nancy saved them. She read them aloud to her friends. She published some of them in an essay entitled "The American Moron and the American of Sense—Letters on the Negro," wanting others to see what she considered an "extraordinary" American display.

Such threats were not the worst of it. She kept but did not reprint even more violent and pornographic letters, unsettling testimony to her observation that "any interest manifested by a white person [in blacks] . . . is immediately transformed into a sex scandal." "To stir up as much fury as possible against Negroes and their white friends," she added, "the sex motive is always used." Those "ornate and rococo outbursts . . . unsigned and threatening . . . sex-mad and scatological" combined violent homicidal fantasies with pornographic ones, fellatio and bestiality especially, making painfully clear the extent to which race-crossing was considered both unnatural and exciting. While calling her a "lousy hoor" with "insane uncontrollable passions" and a "nigger lover," the letter writers begged for a meeting: "I am the one whit[e] man who would have my cock sucked by you, you dirty low down bum," a typical one

declared. Many proposed marriage: "I'm *white*, let me take you away and stop all these wagging tongues."

Images of rebellious "New Women" saturated magazine and news-paper ads when a devil-may-care style was needed to sell perfume, clothing, upholstery, or exotic vacations. But the responses to Nancy Cunard's presence in Harlem show that being a New Woman was not fancy-free. Those who crossed race lines, as she did, faced a violent, ugly backlash. Nancy Cunard was the sort of person who always went "too far," carrying everything to extremes. That makes her racial experimentation, and responses to it, especially valuable to us now. She saved the "crazy letters, these frantic eructations," because they demonstrated so vividly the combustible mix of hate, fear, desire, envy, disgust, and longing that powered racism then and still powers it today. They showed just what white women were up against if they forayed into Harlem. The letters demonstrated the way race and sex become linked, and they spotlighted how much she was braving. They raised a question that she never answered: what reward could possibly have been worth such a price?

"The Guilt of Our Immunity": Growing Up an "Exquisite Specimen"

She was of course a born fighter, and once again, a good hater.
—Charles Burkhart

In 1940, a Trinidadian poet named Alfred M. Cruickshank published a poem that asked why Nancy Cunard would forsake her privileges and status to throw in her lot with blacks. "What was it, Madam, made you to enlist / In our sad cause your all of heart and soul?" his poem "To Miss Nancy Cunard" asked. Nancy's response, published a few months later, is telling. "My friend," she wrote,

As hostesses, muses, and models, white women made their mark.
Fania Marinoff, modeling.

PRIMARY SCHOOL FOR FREEDMEN, IN CHARGE OF Mrs. GREEN, AT VICKSBURG, MISSISSIPPI.—[See Page 398.]

In black communities,
the Yankee schoolmarm was often revered.

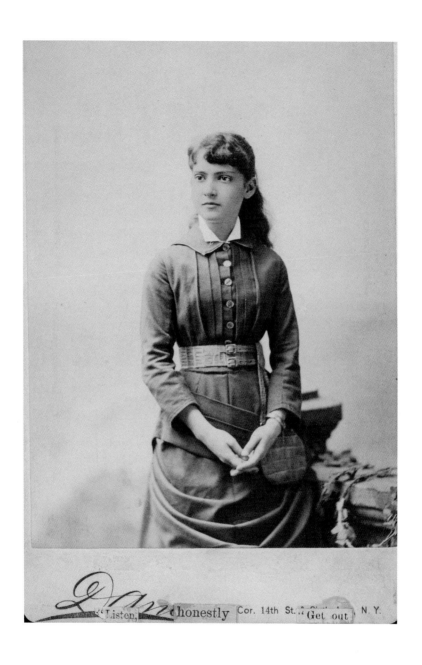

Annie Nathan Meyer as a young woman.
Someone, Annie presumably,
pasted "Listen, honestly, Get out" onto
this portrait of proper womanhood.

Charlotte Osgood Mason ensconced with
Cornelia Chapin (standing) and Katherine Chapin Biddle.

Such blatantly racist postcards were common, and some interracial friends, like Charlotte Osgood Mason and Langston Hughes, collected and exchanged them avidly. Hughes kept his collection until his death.

Mason wrote, "Happy Easter to our dear Langston. 'G—' [for Godmother]." Usually Mason's correspondence was dictated to one of the Chapin sisters, but this brief greeting is in her own hand.

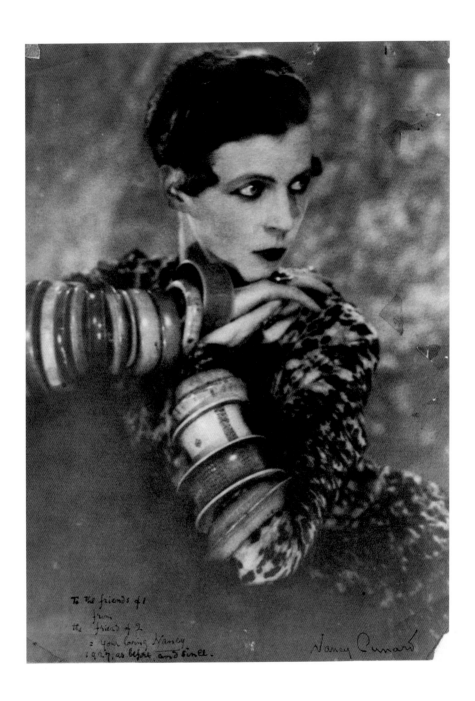

Nancy Cunard with her African bangles, by Man Ray.

Cover for *Henry Music*; Nancy's bangled arms
cross Henry Crowder's shoulders.

By mid-decade the suntanning craze had swept across the globe.

Our lives are wars—You ask
 "Why love the slave,
The 'noble savage' in the
 planter's grave,
And us descendants in a
 hostile clime?"
Cell of the conscious sphere,
 I, nature and men,
Answer you: "Brother—
 instinct, knowledge, and then,
Maybe I was an African one
 time."

That was Nancy's central notion: that one could not only identify with others but also be—or become—them.

For most of our history, when identity has been central to political struggles, the demand has been to acknowledge others' religious, ethnic, race, gender, sexual, or other identities and respect their intrinsic value. Rights claims have insisted on such recognition. Appeals to identification—to leaving behind "our own" identities to take on those of others—on the other hand, tend to inhabit the literary and artistic, rather than political, realms. The arts teach us to identify with others, to sympathize. For Nancy Cunard, identification was not just a means but a goal. Her notion was that identity itself, not just our regard for others' identities, should be fundamentally reshaped and experienced as fluid, voluntary, open, alterable. That politics of identification was an idea born of privilege—the social mobility that comes with wealth—but what made Nancy Cunard so interesting was how heedless she was of leaving that privilege behind.

The idea of becoming others was nothing that anyone in her family would have propagated or even countenanced. Indeed, it was an idea that nothing in her background or her childhood could have foretold. But from a very early age, for no reason that she could explain, she was

convinced that "maybe I was an African one time." When she was six years old, she wrote, her thoughts first "began to be drawn towards . . . 'the Dark Continent.'" She had "extraordinary dreams about black Africa,"

> with Africans dancing and drumming around me, and I one of them, though still white, knowing mysteriously enough, how to dance in their own manner. Everything was full of movement in these dreams; it was that which enabled me to escape in the end, going further, even further! And all of it was a mixture of apprehension that sometimes turned into joy, and even rapture.

It is hard to imagine a more unlikely setting for these dreams than Nancy's childhood home in Leicestershire, England: Nevill Holt. A photograph taken there in 1902 is shot across a wide expanse of gravel driveway to the estate's massive gray stone entrance. A crenellated roof is visible over the doorway, as are small arched stained-glass windows and bell pulls used to summon the servants. The shadows are long, and the front door, two stories high, fades back into darkness. Standing in a small sunlit portion of the doorway is six-year-old Nancy, wearing black laced boots, a white skirt, a dark jacket, a white blouse, and a large white hat. The photo captures no one but her—no groundskeeper, governess, or housemaid. She gazes out from the doorway as if she were the only person in that colossal, shadowed world.

Nancy's father, Bache Cunard, was a squarely built social conservative, a direct descendant of Benjamin Franklin and the grandson of the founder of the Cunard shipping line, a business in which he evinced no interest at all, preferring to live an English gentleman's life of sports and hunting. It surprised nearly everyone when, at the mature age of forty-three, he suddenly married a wealthy twenty-three-year-old Californian named Maud Alice Burke, a lovely young woman who was passionate mostly about socializing and the arts. Maud's family settled the marriage for a $2 million dowry (equivalent to roughly $83 million in

today's currency), a not uncommon arrangement during the "heyday of Anglo-American society marriage."

The house to which Bache took Maud was "darkly paneled and full of armor, old swords, hunting prints and trophies and stuffed heads" and Maud hated it only slightly less than she hated the country life that it represented. The "incompatibility of the couple's tastes and ways" became "local lore." Maud considered motherhood "a low thing—the lowest." But Nancy, their only child, was born, nonetheless, at Nevill Holt, on March 10, 1896, less than a year from the date of her parents' marriage. It was an indifferent start.

There was nothing homey about Nevill Holt. Behind an iron gate and stone piers bearing a bull's head and crown—the Nevill arms— the estate oversaw 13,000 acres of fields and rolling hills. It was a great mass of crenellated stone towers and battlements, occupying more square footage than the New York Public Library and without

Nancy Cunard's photograph of her childhood home, Nevill Holt.
The estate was so vast that servants had to get around by bicycle.
In spite of cutting all ties to her family, Nancy kept this photo of
Nevill Holt with her until her death.

as much warmth. With roughly forty servants at work at any given time—gardeners, coachmen, grooms, maids, cooks, nurses, and governesses—it was more a small village than a family house, with grounds so vast that staff used bicycles to move about. The furnishings were museum-quality in every sense: "men in armour in the [Great] Hall . . . four types of tournament armour still in use in the reign of Henry VIII." Nevill Holt's stone and timbered interior was impossible to heat adequately, and even though Nancy's bedroom was freezing cold, her "odious" governess, Miss Scarth, insisted that she take a cold bath daily, summer or winter. Nancy's mother hosted frequent, extended house parties. During those, Nevill Holt was more like a very large resort hotel than anything else. Between parties, the enormous staff catered to the three Cunards so completely that they never had any great need of one another. Often they did not see each other for days. "It seems fantastic," Nancy later wrote, "to think of the scale of our existence then, with its numerous servants, gardeners, horses, and motor cars."

Nevill Holt was not only massive, cold, and dreary; it was also isolated. "Not allowed a step out of the grounds alone," Nancy "had almost no contact with the land-people," she complained. She "longed for friends of her own age." Her parents were unusually ill suited to child rearing. Mostly, they ignored her. "Like most Edwardian society parents, Maud was content to leave her offspring in the care of nurses, tutors and governesses." Nancy grew up "a strange, solitary child," one friend remembers. "Somehow I felt—and was—entirely detached from both [parents]. She was, she wrote, a "sullen-hearted" child. Between her absent parents and her remote, isolated mansion, "my capacity for happiness was starved," she concluded.

Nancy was trained in music, French, and literature and exposed to many of the successful writers of her day at her mother's parties: "the nearest thing to a Salon that London has," according to the British press. Maud (later known as Emerald) Cunard counted many brilliant, influential men among her friends and lovers, including George Moore, W. Somerset Maugham, W. B. Yeats, Ford Madox Ford, T. S. Eliot,

Lenin, George Bernard Shaw, James Joyce, and Thomas Beecham. Her circle did also include some women—Violet Manners, the Duchess of Rutland; Pansy Cotton; Lady Randolph Churchill (the former Jennie Jerome); and later Wallis Simpson and Diana Mitford Mosley—but no one who could model for Nancy the kind of life she was seeking.

For years, however, that seemed not to matter. Nancy grew into one of the "fashionable beauties" of her time and seemed to accept that she would take her place in society. She happily teased the press, flirting with her growing image as a trendsetter. The papers predicted that she would stay "sweet, fresh, baby . . . dollish . . . and full of fun." "Her hobby in life will probably be dogs," one reported. Undergoing the traditional coming-out rituals of her class—"one ball succeeded another"—she performed ably as "[an] exquisite specimen of English girlhood." She did a bit of private chafing, complaining that it was all "silly" men and "vapid conversation." Nevertheless, in 1916 she made a traditional marriage to a socially suitable young man. Sydney Fairbairn was athletic, unliterary, good-looking, and pleasant. Twenty pounds heavier at her wedding than she would ever be again, Nancy presented herself as a "goldy bride" and a contented young woman.

It did not last. Fairbairn was every bit the mismatch for Nancy that her father had been for her mother. Nancy "went through with it all," she later explained, as the only way "to get away" from "Her Ladyship," as she always called her mother. But after twenty miserable months—which taught Nancy to give up ever trying to do what was expected of her—she determined to go her own way and to make, or find, a community that made more sense to her than the one she'd grown up in.

Her greatest asset was her extraordinary ability to empathize and identify with others. She often told a proud story about strolling in the Nevill Holt grounds with the writer George Moore, her mother's lover and Nancy's dear friend, and encountering a number of tramps: "generally dirty, slouchy men with stubbly chins and anger in their eyes." She "wanted to run away and be a vagabond," she told Moore. The story was a perfect combination of noble feelings and outrageous behavior. It was the sort of thing she would use to build her growing reputation.

A rail-thin, determined Nancy Cunard with her reflection.

Her ability to feel and understand the pain of others helped her step into other worlds. Once she was there, her unusually high tolerance for discomfort—her own as well as that of others—kept her from becoming easily discouraged. She often failed to notice disapproval. That too, gave her a unique social footing, allowing her to take great risks but also setting her up for large failures. The question was what she would do with that combination of traits and proclivities.

Nancy had been writing poetry since her childhood, and her first published poem, "Soldiers Fallen in Battle," set the stage for what would follow. Appearing in 1916, the year of her marriage, the poem asked who would speak for the voiceless:

These die obscure and leave no heritage
For them no lamps are lit, no prayers said,
And all men soon forget that they are dead,
And their dumb names unwrit on memory's page.

The answer, for her, was clear. *She* would write their "dumb names" into public consciousness. Once she swerved from her class and its activities, the privileges and comforts she'd been born to quickly became intolerable. Gritting her teeth through every ball and dinner, she now felt keenly "the guilt of our immunity" from the sufferings of poverty and the war. How was it possible, she wrote in another early poem, "Remorse," to have been so

wasteful, wanton, foolish, bold
. . . All through the hectic days and summer skies . . .
I sit ashamed and silent in this room.

She did not want to "live while others die for us." Her world now became repellent to her, and she needed—desperately—to escape. "Were I not myself so irreducibly myself I should be very happy," she told one friend. She now saw the struggles for freedom and "equality of races . . . of sexes . . . of classes" as "the three things that mattered" in the world. She needed to feel connected to them. "How hidden and remote one is from the obscure vortex of England's revolutionary troubles, coal strikes, etc.," she wrote in her diary. "So much newspaper talk does it seem to me, and yet—is it going to be always so?" Surely there was a way to live a more meaningful life?

Nancy moved to Paris in 1920, taking a small apartment on the corner of quai d'Orléans and rue Le Regrattier on the Île Saint-Louis, just down the street from her friend Iris Tree and around the corner from a small café frequented by expatriate Americans. There were a number of salons on the tiny island, as well as Three Mountain Press, from which she would later buy her gigantic Belgian Mathieu printing press. In Paris, she

quickly became central to a growing circle of modernists and surrealists. She "knew everybody, was known by everybody," Janet Flanner remembered. The British writer Harold Acton claimed that she had inspired and probably slept with "half the poets and novelists of the twenties." Among her many lovers were the artists and writers Ezra Pound, T. S. Eliot, Michael Arlen, Robert McAlmon, Louis Aragon, Richard Aldington, Tristan Tzara, Wyndham Lewis, and Aldous Huxley, all key modernists. The intellectual circle she assembled was a who's who of the avant-garde, including the writers Bryher (Annie Winifred Ellerman), Sybille Bedford, Ernest Hemingway, Janet Flanner, Solita Solano, Havelock Ellis, Djuna Barnes, and John Dos Passos; the artists Man Ray and his model Kiki de Montparnasse, Marcel Duchamp, Constantin Brancusi, Cecil Beaton, the surrealist André Breton, the photographer Berenice Abbott, and George Antheil; writer-activists such as Kay Boyle; and powerful collectors and tastemakers such as Peggy Guggenheim. Nancy's poetry was published by Leonard and Virginia Woolf. Her slick-haired, cigarette-smoking, dark-eyed image began to appear everywhere, and her lean, elegant, and carefully exotic look—embodying the decade's new freedoms—became synonymous with rebellious style. Before she knew it, Nancy Cunard had become "legendary":

> She was photographed, armored from wrist to shoulder in her African bracelets, by Cecil Beaton and Man Ray; and her sapphire-blue eyes, darkly rimmed with kohl, were often to be seen gazing mesmerically from the pages of glossy magazines. Inevitably, but hardly ever successfully, she was imitated, so that scores of lesser leopards slank along the corridors of expensive hotels, helmeted in cloche hats or turbans, their hair cut short, dyed gold, and arranged in two strands (which Nancy herself called "beavers") curving over the cheekbones like twin scimitars.

A "toast of the twenties," the papers called her.

If becoming a "toast" and a "legend" had been her goal, Nancy could

have celebrated. Instead she found herself increasingly dissatisfied. The modernists she'd so admired now struck her as mock rebels, claiming to eschew conventionality while clinging to comfort and tradition. "Their manners, exalting high-mindedness and ostensibly rebelling against class, were hypocritical. They continued to enjoy the world of high society and the things it could afford."

Losing faith in the modernists soured Nancy on the twenties altogether. "Why the smarming over 'The Twenties,'" she would later sneer. "To hell with those days! They weren't so super-magnificent . . . [not] in the least amazing."

As she had done in her childhood, she once again turned her gaze toward Africa. Like Charlotte Mason, she had already accumulated a remarkable collection of African art: sculptures, shields, beading, masks, bottles, paintings, carved horns and tusks, music boxes, rugs, and, most famously, ivory bracelets in all shapes and sizes, which she wore "elbow deep." She tallied the bracelet collection alone at 486 pieces, probably the largest such collection in the world. The objects helped keep alive the connection she had felt to Africa going back to her childhood dreams of "the sand, the dunes, the huge spaces, mirages, heat and parchedness." But she did not want to just love, collect, and appreciate things; she wanted the "vital life-theme" of human "contact." That meant knowing blacks, being accepted by them, becoming a part of their world. She did not want to flounce in and out, merely skimming the surface as a cultural tourist, though primitivism had made such tourism fashionable. In 1915, she glimpsed what "contact" might look like when her modern friends introduced her to jazz. They heard "tom-toms beating in the equatorial night" when they went to see the bands. But Nancy heard something else. And she saw the possibility of being "one of them, though still white."

"One of Them, Though Still White"

*Nancy had a very advanced formulation of equity, ethics, and morals.
It was as exceptional as it was different.*

—Hilaire Hiler

If it is not easy to document what Nancy Cunard was seeking, it is easier, since she was very vocal on this score, to document just what she wanted to avoid and subvert. Chiefly, she hated any and all cultural scripts. She detested traditions. Believing that "common sense" was "NON-SENSE (in the true meaning of this word: a thing without *reason*, of no sense)," she tended to feel that she was on the right track when the majority found her incomprehensible.

Loneliness can challenge rebels, lure them back into the fold. Nancy Cunard had the advantage there. Aristocratic isolation had already inured her to loneliness. Her high tolerance for isolation made her unusually brave. She could use it to dispense with all but the most stalwart companions. That let her venture farther out on limbs than most people would have found comfortable. Isolation may have been a source of unhappiness for her, but it was also a kind of ballast. "One should learn how to live entirely alone from childhood," she once wrote to a friend.

Nancy felt strong inducements to broadcast her interest in blackness, her "blacklove" as some would have called it. Broadcasting her views was not only Nancy's way but also part of her conviction that she could turn publicity—good or bad—to her own purposes. Public pronouncements enabled a final break from the society of her parents. That demonstrated her fitness for entering black society. As far as she was concerned, since identity was declarative and associative, having little—if anything—to do with birth or family, announcing her affiliation with blacks and declaring herself to be "one of them, though still white" made it so. To her, it made perfect sense that in spite of every

imaginable difference in cultural and national background, she could "speak as if I were a Negro myself."

Harlemites did not necessarily see things that way. Few ideas are as riven by contradiction and confusion as American ideas of race. Nancy's conviction that whites could, and should, volunteer for blackness underscored many of those contradictions. It highlighted the tension within Harlem, between seeing race as a social construction to be debunked and treasuring it as a deep essence. Nancy's idea of volunteering for blackness was mixed with her own agendas, both flattering and offensive, appealing and alarming.

Race-crossing did not work the same way for white men and white women. White men were encouraged to cross races to offset the supposedly soul-crushing effects of industrialized economic modernity. For them, the spiritual power of primitive blackness was thought to be restorative, a force that could regenerate their souls, restore their creativity, and charge their sexuality. Taken in small doses, blackness would strengthen, not threaten, their essential identity as white men. Not so for white women. In 1926, the French art dealer Paul Guillaume proclaimed that "the spirit of modern man—or of modern woman— needs to be nourished by the civilization of the Negro." But Guillaume, one of primitivism's most influential proponents, was decidedly in the minority in his inclusion of women. White women's sexuality was not widely seen as needing a powerful charge. And women's souls were seen not only as undamaged by industrial and economic modernity but as impervious to its negative effects, insulated and protected by the home and domestic sphere over which they were expected to preside. Unlike white men, who were urged to take medicinal doses of black culture, white women were cautioned that overexposure to blackness would ineluctably alter their nature. A white woman who overexposed herself to blackness, by duration or degree of intimacy, risked becoming black by association, developing "Black skin" and forfeiting white status: "darkening your complexion," as one angry letter writer put it to Nancy Cunard.

Nancy with a mask from Sierra Leone.

A white woman who had "gone Negro" (as the U.S. State Department described Nancy) not only became less white but also became less female, untethered from both racial and gender norms and adrift without a social category at just the moment when identity categories reached the apex of their cultural importance. An infusion that was promoted as curative for white men was prohibited as a pollutant for white women. Hence, opting into Harlem was, for white women, a far more consequential decision than it could have been for any of their white male counterparts or peers. It was, as one black French friend of Nancy's wrote her, a bold move: "White men have contributed their support, which is all well and good, but when a white woman, or Lady, I should say, of your caliber condescends to engage in the bitter, exhaustive and ostensibly impossible struggle, than that's a phenomenon. . . . I think you are the most marvelous woman in the world." It was, as Nancy's first biographer put it, "a sign of insanity to have a black lover and advertise the fact."

Race-crossing was especially a minefield for Nancy Cunard. Described by one of her friends as "incapable of restraint or discretion," she had an almost preternatural energy. If she had been a car, she would have had one speed: ninety miles per hour. "I find life quite impossible,"

she once declared, "as I cannot enjoy a thing without carrying it to all extremes." Whatever she pursued, she chased with her whole being, unable to stop in midstream, reassess, pull back, change course, or even note the passing landscape. She had neither interest in nor skill at the arts of compromise. Her attempts to opt into blackness helped advance the racial politics of the Harlem Renaissance because she seemed to put into practice what many were then theorizing about the mutability, flexibility, or "free play," as we say now, of identity. But at the same time, her celebrity, and her stubbornness, threatened to topple some of those very advances and goals.

Many white women in Harlem went to great lengths to avoid exactly the sort of press attention that Nancy Cunard encouraged. Josephine Cogdell Schuyler, for example, claimed to be "colored" on her marriage certificate and did much of her best writing under various pen names. Mary White Ovington and Annie Nathan Meyer honed carefully crafted matronly roles to keep the scandal-mongering press at bay. Lillian Wood never bothered to correct the misimpression that she was black. Charlotte Osgood Mason was fanatical about not being mentioned in public. But Nancy Cunard wanted nothing of evasions or caution. A determined New Woman, she crafted a persona in which her posture of brave border crossing and "extreme" sensuality (in reality, she was reputed to experience little pleasure in sex) were crucial components, and no amount of political pressure could induce her to tamp those down.

Privacy never mattered to her. Harlemites, however, placed a high value on discretion. Nancy Cunard failed to grasp, and therefore to respect, that value. Nor did she ever accept the idea that one should tread carefully so as to protect the larger community and its goals. She had, as one black friend remembered, "an unfortunate faculty for producing reams of scandalous publicity." Nancy "liked to shock." She seemed, moreover, unaware that shock was a weapon more easily wielded by the privileged than the powerless. To some, she seemed to have more to gain from Harlem than she could offer it. The black journalist Henry Lee Moon put his skepticism this way, wondering if she was

just another white woman sated with the decadence of Anglo-Saxon society, rebelling against its restrictive code, seeking new fields to explore, searching for color, she was not to be taken seriously. I must confess that I shared with Harlem the quite general impression most effectively expressed by a slight upward twist of the lip and a vague shrug of the shoulder.

Certainly her idea that identity was desire and that you could choose new identities and adopt those of others was something that would not necessarily appeal to those she was trying hardest to court: Harlem's blacks could ill afford any appearance that *they* wanted to be white. All that made Nancy Cunard a difficult ally for those with whom she most wanted to align herself. She made her friends in Harlem uncomfortable. "Nancy's back, we're in trouble," they would say. "Hold onto your hats, kids, Nancy's back!"

Fortunately, Nancy also had an extraordinary work ethic. And if there was one thing that many Harlem intellectuals understood and valued, it was hard work. None of them, including the privileged and patrician Du Bois, had been handed or inherited success. Zora Neale Hurston had launched herself up from rural Florida, without clothes or cash, arriving in Harlem with little but faith in her own talent and a willingness to work; her jobs included being a secretary and selling fried chicken. Langston Hughes had worked as a busboy, an assistant cook, a launderer, and a seaman. Countée Cullen, considered by many to be the finest poet of the Harlem Renaissance, had been abandoned by his mother, taken in by relatives, and forced to make his own way. To them and others, Nancy's willingness to roll up her sleeves and escape her own advantages was endearing. Her delight in discomforting other whites afforded a guilty pleasure that Harlemites could watch with glee. Langston Hughes, who had a keen sense of the joys of discomforting others, adored Nancy Cunard and remembered her as "one of my favorite folks in the world!" One of Nancy's "coloured

friends in Harlem" remembered that "all of them loved Nancy and all deplored her."

Between her intransigent personality and her complex ideas of identity, Nancy Cunard—by accident or design—became a kind of cultural litmus test for how far the racial politics of the 1920s and 1930s could be pushed. No other white woman in Harlem had the potential to contribute as much to Harlem's racial experiments. On the other hand, no other white woman had the potential to do as much harm.

"Does Anyone *Know* Any Negroes?"

Among all of us in the avant-garde in Paris, Nancy was by far the most advanced. She was doing something about the central issue of our time, the Negro people.

—Walter Lowenfels

Dorothy Peterson once asked [Salvador] Dali if he knew anything about Negroes. "Everything!" Dali answered. "I've met Nancy Cunard."

—Langston Hughes

By the mid-1920s, Paris and Harlem presented the greatest possibilities of interracial "contact." Paris was so much in thrall to its own "black craze," fueled in part by the arrival of international superstar Josephine Baker, that some were calling it the "European version of the Harlem Renaissance."

> Black was the color of designer high fashion for women: black stockings, black dresses, black hats, black blouses. Consistent with the latest mode, women's hair was dyed black, bobbed, and carefully kinked. Dark-skinned men became even more popular as companions, as French women asserted that "dark-complexioned men understand women so much better."

One French *Vanity Fair* reporter wrote that he could not take his eyes off the "tom-toms" in Montmartre's jazz and the white ladies "swaying luxuriously in the long arms of dark cowboys." In 1925, Nancy went to one of Josephine Baker's first French performances and wrote a glowing review in the French *Vogue*, praising Baker's "astounding . . . wild-fire syncopation."

But admiring black performers and frequenting their clubs went only so far. Nancy was learning that nightclub "encounters between black and white women did not lead to enduring friendships." As enticing as interracial contact now looked, it was not as easy to achieve as someone so accustomed to getting her way might have imagined.

Her interracial breakthrough occurred, ironically enough, only when she traveled out of France to Italy in the late summer of 1928. With her lover Louis Aragon, her friends Janet Flanner and Solita Solano, and her cousins Edward and Victor Cunard, she traveled to Venice, as she had been doing for many summers. They went to balls, barge parties, and carnivals; dressed in "glittering" costumes; danced until dawn at some of the "sinister new night-bars." It was, she later said, a "hell of a time . . . gay and mad, fantastic and ominous . . . spectacular." She almost forgot that she was discontented. One rainy night, she and Edward took a gondola to the oldest hotel in Venice, the Hotel Luna, to eat dinner and dance. The Luna was featuring an American jazz band, Eddie South's Alabamians: "coloured musicians . . . so different to all I had ever known that they seemed as strange to me as beings from another planet . . . the charm, beauty and elegance of these people . . . their art, their manners, the way they talked. . . . *Enchanting* people." "A new element had come into my life, suddenly," she later said. She immediately took to Henry Crowder, a piano player with "great good looks . . . partly Red Indian," who was older than Nancy and whom she found "thoughtful" and "serious-minded."

Henry Crowder's background could not have been more different from Nancy's. The child of Georgia Baptists, Crowder came from a large family (twelve children) in which both parents worked: his father as a factory worker and carpenter and as a church deacon, his mother as

a cleaning woman. Before becoming a professional musician, Crowder had been a postal worker, a dishwasher, a handyman, a chauffeur, and a tailor. When Nancy met Henry, he was married and had a young son. Henry had been trained all his life "to hate white people," and the last thing he needed was a white woman. Nancy had the opposite response. She felt that she'd been looking for Henry all her life. "My feeling for things African had begun years ago with sculpture, and something of these anonymous old statues had now, it seemed, materialized in the personality of a man partly of that race," she wrote.

A romance developed almost overnight, and its intensity surprised them both. Nancy had a reputation for being difficult and mercurial with her lovers. But with Henry she was "the sweetest woman I have ever known," he said.

He followed her back to Paris and from there to her country house in Réanville, where he composed music and helped her launch her small press, The Hours. Henry, Nancy wrote, did "billing and circulars and parcels . . . and he drove the car too; he was indispensable." The Hours was one of the most successful small presses, in large part because Nancy and Henry worked so hard—as many as eighteen hours a day, hunched over a massive two-hundred-year-old Belgian machine in semidarkness, setting type by hand, their fingers coated in printer's ink, their shoulders, neck, back, and knees aching.

Many of Nancy's friends were supportive of her affair with Henry, if a bit baffled, but some took it for granted that he was a "caprice" or "sexual drug." "He has," Richard Aldington said, "the poise, the sense of life of the blacks, which we whites are losing."

Nancy's account of "the first Negro I had ever known," on the other hand, describes finding a "born teacher" in Henry, who

> introduced me to the astonishing complexities and agonies of the Negroes in the United States. He became my teacher in all the many questions of color that exist in America and was the primary cause of the compilation, later, of my large *Negro Anthology*. But at this time I merely listened with

growing indignation to what he had to tell: of the race riots and lynchings, the segregation in colleges and public places, the discrimination that was customary in all aspects of life.

Nancy's friends were "astounded and revolted" by what they learned, through Henry, about American racism. "They had not realised its existence," Nancy wrote. She refused to be revolted. She felt that she must *do* something about what she had learned. She could not sit in a dining room, *tsk-tsk*ing about the world, while others paid for her advantages.

Sometimes the least sentimental people seem to respond most powerfully to the suffering of others. Nancy was often described as calculating, and many of her lovers complained about her lack of proper feminine feeling. But when it came to her embrace of blackness, her emotions were on the surface. "Her vast anger at [racial] injustice embraced the universe," Solita Solano remembered. "There was no place left in her for the working of any other emotional pattern. . . . It was her mania, her madness."

Their life in Nancy's Normandy farmhouse, sixty miles from Paris, was productive. They ran their press out of an unheated stable without having to bother with the "conventions and long-established rules" that governed other printers. They were relieved to be away from the troubles of Nancy's Paris friends, who were drinking and using drugs to excess and sometimes suicidal. The Hours produced beautiful small books and, because it had almost no overhead, could give its authors—George Moore, Laura Riding, Robert Graves, Samuel Beckett, and Ezra Pound, among others—more than three times the usual royalties. But life in Réanville was almost as isolated as life at Nevill Holt had been. Henry was folding neatly into Nancy's world, but aside from a brief friendship with the wife of one of Henry Crowder's former bandmates, she was not folding into his. And if they were pleasantly protected, they were also cut off. Nancy, Henry remarked, was "at a loose end."

Other troubles presented themselves, and in the seclusion of Réanville the contrast between Nancy's and Henry's personalities became glaring. Nancy was bossy, impulsive, and filled with energy. She was

also physically ill, and she exacerbated her illness by not eating. "A snack now and then, but seldom a regular meal; she looked famished and quenched her hunger with harsh white wine and gusty talk." Henry was cautious, deliberative, diffident, inexpressive, and prone to crabbiness. He resented what he believed to be Nancy's wealth, complaining bitterly about being dependent on her while also expecting her to support him. He felt entitled to more than his weekly salary and could not believe that Nancy was as cash-strapped as she claimed. He became reckless: smashed the car, embroiled them both in a difficult legal settlement, demanded that Nancy buy him another car, then groused about having to share it with her. As the world moved toward an economic depression and what profits The Hours earned had to be poured back into the press, their situation worsened. The work of running the press became ever less romantic as "the back-breaking as well as wrist-breaking" tasks wore on. Nancy loved printing—"everything about the craft seemed to me most interesting"—but neither she nor Henry had a head for business. Both of them tired of distribution, correspondence, and bookkeeping, which all "greatly added to the work of the 'firm.'" Nancy's bed was "always littered with papers . . . correspondence, proof-reading and accounts. . . . Work never seemed to stop."

In 1930, The Hours moved to Paris, where Nancy took a long lease on a shop on rue Guénégaud, a steep side street around the corner from the surrealists' main gallery on the Left Bank, and she and Henry took rooms at separate, but nearby, hotels. Back in the city, Nancy increased her pace to a fever pitch. "The shop," a friend remembered, "had an hysterical atmosphere. Nancy could never rest. . . . The clock did not exist for her; in town she dashed in and out of taxis clutching an attaché case crammed with letters, manifestoes, estimates, circulars and her latest African bangle, and she was always several hours late for any appointment." Unsure of her next move, she became reckless as well. According to a later account by Henry Crowder, she initiated affairs with two other black men, one white woman, and a young white man roughly half her age named Raymond Michelet. "It was an absurd life," Michelet recalled. "She lunched with one, passed the afternoon with the

other, dined with the first, and spent the night with the second. In each, she went to the limit."

Nancy and Henry stayed together on and off until 1935, in spite of all their troubles. Her attitude toward monogamy humiliated him and left him bitter, although he had been married when they met and remained married throughout their affair. In later years he would claim that Nancy had taken advantage of her race and class privileges first to seduce him and subsequently to bully him into accepting their "peculiar association." For her part, Nancy never had an unkind word to say about Crowder and always credited him with opening blackness for her. "Henry made me," she said.

The more demanding and difficult Henry became, the more Nancy tried to honor and placate him. She now embarked on an ambitious project designed to highlight what she insisted were his latent skills as a natural composer. She arranged for him to set poems by some of her most successful and prominent friends—Richard Aldington, Walter Lowenfels, Harold Acton, and Samuel Beckett—to music. She would contribute a poem as well, she promised. To devote more time to the project, she turned the press over to an associate, Wyn Henderson, and she and Henry drove off—"very fast"—to southern France in Henry's blue sports car, "The Bullet," renting a tiny cottage and a small upright piano that had to be brought in with an oxcart. There they completed the volume, *Henry Music*, in one intense month of nonstop work, and Nancy arranged for Man Ray to do the cover: a photomontage of her African art collection and a photo of Henry, with Nancy's bangle-draped arms covering his shoulders like exaggerated epaulets. Man Ray's cover opened out to reveal an array of African art and instruments, above which floated Henry's face. The message that Nancy intended was clear: Henry was the modern embodiment of all that was best in the African legacy, all that Nancy loved most. The book was printed in a small, elegant edition of 150 copies. On Nancy's copy Henry inscribed "To describe requires one with more linguistic capabilities than I possess. She is the one rare exquisite person existent. I love her I adore her. She is

everything to me. I wish her happiness and eternal life." Once the project was over, however, Henry returned to his discontent. Nancy was "at a loose end" again.

The truth is that Nancy Cunard and Henry Crowder were ill suited to each other. Without the attraction of racial difference, which was a powerful pull for both of them, they would probably never have come together at all. Nancy was explosive, impulsive, and conflict-driven. Henry was controlled, reserved, and profoundly averse to conflict. As she put it, he was "a most wary and prudent man . . . who often said: 'Opinion reserved!' Whereas to me, nothing—nor opinion nor emotion nor love nor hate—could be 'reserved' for one instant." Both sought advantages from crossing race lines. Nancy almost certainly gave Henry too much credit for introducing "a whole world to me . . . and two continents: Afro-America and Africa" (considering that she had introduced Henry to African arts and culture, not the other way around). And Henry, just as certainly, gave Nancy too little credit for paving his way and making him comfortable in a "whole world" to which, otherwise, he would have had little access.

Henry disappointed Nancy politically most of all. He had no interest in politics, did not keep up with what was happening in the United States, and showed no eagerness to do so, even when pushed by Nancy. Instead of relying on Henry, she had to undertake her own self-education. Learning everything there was to know about blackness was no easy task. But she created a rigorous course of self-study, modeled on her experience as a lifelong autodidact. She subscribed to all major—and many minor—black American periodicals and had them shipped to her in France. She ordered—and sometimes borrowed—every book by black writers she could locate. Found at her death were folders of black poetry, culled from many sources and carefully retyped and filed. All were poems of militancy and protest, including Claude McKay's famous call to arms "If We Must Die," Will Sexton's "The New Negro," Paul Laurence Dunbar's "We Wear the Mask," and others.

Shortly after meeting Henry, Nancy wrote a poem that built on that file. She called it her "battle hymn" and dedicated it to Henry. Published in various places under the titles "1930" and "Equatorial Way," it speaks in the voice of a black man who "says a fierce farewell" to America and threatens to "tear the Crackers limb from limb" as "vengeance . . . for the days I've slaved." He heads for "an Africa that should be his":

Go-ing . . . Go-ing . . .
. . .
I dont mean your redneck-farms,
I dont mean your Jim-Crow trains,
I mean Gaboon—
I dont mean your cotton lands,
Ole-stuff coons in Dixie bands,
I've said Gaboon—

. . .
Last advice to the crackers:
Bake your own white meat —
Last advice to the lynchers:
Hang your brother by the feet.

Imagining this point of view helped Nancy feel "the agonies of the Negroes." That others might see her assumption of the man's voice as presumptuous, even offensive, did not occur to her. To her, it made perfect sense that she could be the vessel through which "the Negro speaks." The poem was the opening composition of *Henry Music*. Under various titles she republished it as often, and in as many places, as she could.

Around that time, Nancy also had a series of photographs taken by the British photographer Barbara Ker-Seymer. Though more famous photos of Nancy exist, taken by her friends Cecil Beaton and Man Ray, none of them is more interesting than the Ker-Seymer series. Ker-Seymer's photographs are solarized, or printed in reverse, so that Nancy appears black and everything around her white. Some of the photographs depict

Nancy Cunard solarized by Barbara Ker-Seymer.

Nancy with dozens of strands of beads wound about her long, thin neck, as if she were being lynched or strangled. In the photos, Nancy becomes not just an exotic object, a New Woman, an iconic flapper, or an icon of modernism. She becomes a "white negress," whose agonized expressions and constrained postures signal a "bonding" with her black targets of identification.

Through her "battle hymn" and the photo series, Nancy was developing the politics of racial identification that would guide the rest of her life and that she had been moving toward since, as a six-year-old, she had dreamed of Africa. She had never believed that race was

in the blood or biologically determined. She did not need to locate—or invent—remote black ancestors to claim a black identity. "As for wishing for some of it [blood] to be Coloured, no; that's beyond me. That, somehow, I have NOT got in me—not the American part of it. But the AFRICAN part, ah, that is my ego, my soul." Affiliation or affinity, not blood or lineage, Nancy felt, enabled her to "speak as if I were a Negro myself." She was black, or partly black, she believed, because she felt herself to be so. What seemed so complicated to other people was, for Nancy, straightforward. "I like them [blacks] because I seem to understand them," she declared. For those who truly care about others, Nancy wrote, "the tragedies of suffering humanity become as their own." Feeling as strongly as she did about Africa meant, to Nancy, that she was part African and that giving expression to the realities of black life was her mission or calling. Volunteering for blackness seemed to her a necessary act, not an arrogant or appropriative one.

Contemporary critics have been quick to dismiss Nancy's view as a refusal "to acknowledge her race and class privilege" and an attempt "to escape the privileged claustrophobia of her background through an identification with black diasporic and African cultures." For that, Nancy would have probably had a ready answer. Her identification with blacks did not fail to acknowledge her privileges, she might have pointed out, but rather *cost* her those privileges. Once it became clear which side she was on—and she made sure that no one could be left guessing—she did not have to escape from her claustrophobic background; rather, that world firmly closed its doors to her. She welcomed that exile, moreover, actively courting it. Announcing her affiliative identity, she might have countered, had changed her identity as a white woman and made her something else.

Nancy's challenge to available ideas of identity and race was more complex than it might seem. She was, in effect, throwing down a high-stakes gauntlet: if you did not believe that race was permanently in the blood, immutable and fixed, then on what grounds, she asked, could she be denied the right to "speak as if I were a Negro" and be "one of them,

though still white"? If identity was not affiliative and voluntary, an act of desire and choice, then what, exactly, was it? Was there an alternative to affiliation that did not fall back, ultimately, on the old, worn-out ideas of essence and blood?

Nancy Cunard did not take the idea of voluntary identity lightly. It was not sufficient, she believed, to passively announce one's identification with the Other. A person had to invite conflict and rage, had to risk being thrown out of white society for her choice. That risk taking and publicity, she believed, made a voluntary switch more than just imaginary; it put the volunteer in the shoes, to some extent at least, of those with whom she identified.

Given Nancy's goals, a break with her family was inevitable. According to Nancy, her mother, Lady Cunard, knew of her affair with Henry Crowder as early as 1928 but pretended ignorance as long as she could. Finally, on a cold December day in 1930, at her home in Grosvenor Square, one of her lunch guests, Margot Asquith, Countess of Oxford, leaned forward confidentially across the vast dining table. "What is it now?" she asked Maud. "Drink, drugs, or niggers?" Confronted with public knowledge that Nancy had been living openly with Henry for the past two years, Lady Cunard flew into hysterics: "the hysteria caused by a difference of pigmentation," Nancy called it. She attempted to have Nancy and Henry, then in London, arrested. She tried to have Henry deported from England to America. She enlisted friends to intercede with Nancy and beg her to leave Crowder. Finally she made it known that Nancy would be disinherited if she did not toe the line.

Nancy had no intention of toeing the line. Her first response was to make the breach as public as she could. On the basis of her mother's response to Margot Asquith, which Nancy learned of almost immediately, she wrote an ironic essay intended to skewer all white people who believed that "friendships between whites and Negroes are inconceivable." "Does Anyone *Know* Any Negroes?" rehearsed the whole episode, named all the principals, and quoted her mother at some length, sputtering foolishly: "Does anyone *know* any Negroes? I never heard of that.

You mean in Paris then? No, but who *receives* them . . . what sort of Negroes, what do they *do?* You mean to say they *go to people's houses?* . . . It isn't *possible.* . . . If it were true I should never speak to her again." Maud is portrayed as a racist and a fool, an unsophisticated bumpkin. Nancy prepared the essay for publication in *The Crisis*, where it would attract attention. Strangely, the essay had little impact on its intended audience; apparently it was read by very few whites and none at all in England.

Nancy was spoiling for a fight. She was determined that her break with her family and her new identity both be noticed. In early 1931, she republished her "battle hymn" on "The Poet's Page" of *The Crisis* alongside other poems by white women about race, including "A White Girl's Prayer" by Edna Margaret Johnson and "To a Pickaninny" by Edna Harriet Barrett. She also threw her support to a film that the press had described as "the most repulsive conception of our age" and that the growing European fascist parties were singling out as an example of modern decadence. *L'Age d'Or*, by the surrealists Luis Buñuel and Salvador Dalí, offered a number of vignettes that included a woman fellating a statue's toe, priests copulating with prostitutes, defecation, and infanticide. The film was banned in France after French fascists attacked screenings. Nancy succeeded in arranging a one-night London screening of a smuggled copy. As she well knew, her mother's British friends at the time encompassed all the key players of the growing British Union of Fascists, including Oswald Mosley—"The Leader"—and his future wife, the former Diana Mitford, who was just then preparing to leave her husband, Bryan Guinness. It would have been impossible for Nancy's mother or any of her circle to be unaware that Nancy's screening was aimed at them. For Nancy it was a relief to be able to dissociate herself publicly from her mother's right-wing leanings.

Feminists in the 1960s coined the phrase "The personal is political." Nancy Cunard, from the 1920s on, lived by a reverse formulation that said, "The political is personal." In spite of a deeply loyal nature that could—and did—forgive many personal slights from her friends, she could not bear reactionary politics in those she knew. "She was demo-

cratic [about people] to the point of insipidity," one friend remembered, unless they revealed reactionary politics. "If ever she disliked or hated anyone, the cause was political." She never, for example, got over how someone "so hyper-sensitive," so gifted, and so "very human [a] kind of person" as Ezra Pound could have become a fascist. "Totally baffling," she said.

As the "smarming twenties" tumbled into the thirties, Nancy, still "at a loose end," continued trying to get her bearings. Running a press, even one as illustrious as The Hours, having affairs, and scheduling scandalous screenings were not getting her the "contact" she wanted. She was restless and itchy, sure of herself but unsure of where to go. She knew that she wanted "to work on behalf of the colored race." Now she needed a cause. A good fight.

"Scottsboro and Other Scottsboros"

I intend to devote my life to . . . the Colored Race.

—Nancy Cunard

The Scottsboro case had an electric effect on Nancy Cunard. She was stunned by the "collective lunacy" of the "lynch machinery," which seemed intent on sending the Scottsboro Boys to their deaths for crimes that had never occurred. She published a poem called "Rape," which she dedicated "To Haywood Patterson in jail, framed up on the vicious 'rape' lie, twice condemned to death, despite conclusive and maximum proof of his innocence—and to the 8 other innocent Scottsboro boys." Like Josephine Cogdell Schuyler in "Deep Dixie" and Annie Nathan Meyer in her play *Black Souls*, Nancy was looking at the underside of the myth of the black rapist—the unspeakable and usually unspoken truth that some white women desire black men. In "Rape," a desolate farmer's wife, on a restless rainy day, tries to seduce one of her husband's black workers and is rejected by him. Humiliated and furious—as angry

with herself as with him—she charges him with rape. She used exactly the language with which the Klan threatened Nancy in 1932—"Your number's up"—to spread her deadly lies: "And they cotched him in the swamps / And what the hounds left they hung on a tree." Sympathetic at first toward the wife's boredom and sense of entrapment, "Rape" ultimately places her within a southern history where "'the lady of the house' was honoured" as "nobody's nigger" is lynched. That was the history uppermost in Nancy's mind as the Scottsboro Boys were tried over and over again, and convicted every time. The charges against the defendants were ridiculous, but, as Nancy Cunard put it, "not unparalleled." She was filled with "the indignation, the fury, the disgust, the contempt, the longing to fight."

By 1931, Nancy's politics had increasingly become aligned with the Communist critique of class relations, capitalism, and race, though she never became a Communist. She appreciated the way in which the Party drew attention not only to the Scottsboro Boys and their plight but also to the tens of thousands of unemployed Americans then hopping freight cars in search of work, sometimes crowding into the cars so thickly that, as one former hobo recalled, "it looked like blackbirds." She especially appreciated the way the Communist Party, unlike the NAACP, stressed militancy over manners, insisting that racism made the usual social niceties irrelevant and even immoral. At the heart of the fight between the NAACP and the Communist Party's legal wing, the International Labor Defense (ILD), was a fundamental disagreement about what social rules did—and did not—apply when whites were called upon to confront the violence and race hatred within their own ranks. At stake as well was a strategic question about how militant a stand blacks could take in fighting for their rights—the very question that was then splitting the new and old guards of the Harlem Renaissance.

Nancy had experienced a lifetime of social niceties inside the gray stone walls of Nevill Holt. Without a very high degree of civility, certainly, her mismatched parents could never have stayed together. Good manners and emotional reserve, rather than frankness or intimacy, were her parents' highest values. Nancy came to associate civility with hy-

pocrisy and militant outspokenness with authenticity. She set particular store by militancy. "It is only by fighting," she wrote, "that anything of major issue is obtained." Fighters, she declared, "are pure in spirit." She also set great store by honesty and distrusted anything that smacked to her of window dressing. "The facts please," she would say to her friends, "without any hooly-gooly." One friend remembered her as an "extremist in words," who "never hesitated to express herself with the utmost frankness about *anything*." That is not to say that Nancy Cunard was unmannered. In fact, she had impeccable, "delightful manners" and always recoiled sharply from any crudeness of speech or behavior in others; this attitude was an asset in black society.

The NAACP at first was tepid in its response to the Scottsboro arrests and trials. That was not merely caution "to avoid antagonizing Southern prejudice," as the journalist Hollace Ransdell surmised. Mary White Ovington and other NAACP officials wanted to make certain that there was nothing to the rape charge at all—no sexual contact between parties—before leaping into the case. With its credibility and connections resting on respectability and reputation, the NAACP felt justified in being selective. Nancy Cunard and others were outraged. It was clear to her that the charge of rape was nothing more than "terrorisation of the Negroes."

The NAACP had stood up to years of criticism that it was an organization founded and run by outsiders, such as Mary White Ovington. In turn, its leadership was very sensitive to what it saw as outsiders using the black community for their own agendas and interests. Ovington kept mostly quiet on that score, but Walter White and William Pickens both accused the Communist Party of using the case to recruit members and of being "pig-headed" about the complexities of race. Some black papers also doubted that the Communist Party "would make saving the boys' lives its top priority," seemingly clearing the way for the NAACP to take leadership of the case. But the NAACP gave the defendants confusing advice and failed to elicit their mothers' support—a crucial error that turned the case over to the Party and its ILD.

Ovington and others at the NAACP, moreover, underestimated

the attention the Scottsboro case would receive. To them, the case was not unique. As early as 1906, Ovington had written about the "ghastly truth that any unscrupulous white woman has the life of any Negro, no matter how virtuous he may be, in her hand." The power that Bates and Price were wielding was horrific but not new. Instead, she worried about "the nasty propaganda potential of any event with white women and black men."

Nancy Cunard and Mary White Ovington squared off on the Scottsboro case chiefly over their views of the need for caution (Cunard couldn't abide it). Whereas Nancy sometimes traded on her singularity to get her own way (she knew that black male comrades such as Walter White and W. E. B. Du Bois would certainly not try to tell a British heiress how to behave), Ovington courted respectability, which she aligned with being as invisible as possible. From her perspective, the less attention she drew to herself, the more she could build a life that otherwise would have been unthinkable for a woman of her background.

In 1929, the Communist Party made "the struggle for Negro rights" one of its central priorities and sent many whites into black communities, Harlem especially, as organizers. To encourage black recruits and rout out organizational racism "branch and root," interracial socializing was encouraged. White Communists found guilty of "white chauvinism" were publicly tried in open hearings intended to shame them into "the greatest degree of fraternization." Party organizers offered dancing classes to white male organizers so that they would not be ashamed to ask their black female comrades to dance. If Nancy had any pity for the humiliated white organizers, she must have felt even more keenly her own superiority to those slow-learning whites. She supported the Party's insistence that foot-draggers change immediately and absolutely. "The Communists," she wrote admiringly, "are the most militant defenders and organizers that the Negro race has ever had." She credited the Party with "putting a new spirit into the Negro masses" and teaching them to "fight."

During the Great Depression the Communist Party gained ground in Harlem. Its advocacy of militant political protest made it stand out in

its approach to local issues. "Throughout the 1920s, Harlem political leaders, even those renowned for their militancy, rarely employed strategies of confrontation and mass protest to achieve their goals." Langston Hughes, activist and Hampton Institute teacher Louise Thompson, and a few others felt that the Communists were an alternative to the Negrotarians. (Thompson married Party lawyer William L. Patterson after a brief, disastrous marriage to Wallace Thurman.) But its centralized authority, lack of flexibility, and attacks on well-respected blacks, such as W. E. B. Du Bois, alienated many in Harlem. Its highly unusual interracial policies created considerable controversy. Numerous black men who became associated with the Communist Party in the 1930s—such as Theodore Bassett, William Fitzgerald, Abner Berry, and James W. Ford—had white girlfriends or wives. The weekly *Amsterdam News* accused the Party of using white women as "Union Square blondes and brunettes" to seduce "Harlem swains" into communism. According to Claude McKay, a group of black Communist women, led by Party member Grace Campbell, felt strongly enough about it, in the 1930s, to ask that the Party take a stand against this "insult to Negro womanhood." McKay noted that it was not a subject blacks were generally willing to "air." Campbell's group was a particularly "bitter lot," he said. Nancy did not see what all the fuss was about.

It is possible that the Party's interracial program, called "black-white unity," resonated with Nancy's thinking. At the heart of much of Harlem's cultural politics—from Marcus Garvey's back-to-Africa movement to the "Don't buy where you can't work" boycott initiative—appeals to "race loyalty" were meant to galvanize support by capitalizing on feelings of loyalty and shared oppression. It was an effective appeal, with many successes to its credit. But it did not include whites, even Nancy Cunard, except as bystanders and observers. She called race loyalty "the wrong kind of pride; a race pride which stopped at that . . . race conscious in the wrong way." The Party stressed worker solidarity, not race pride. And it formulated an active critique of the ideology underlying race loyalty as divisive and mystifying. The Party attacked the "timidity" of the NAACP and the Urban League, going so far as to

call them "agents of the capitalist class," in the context of the simmering debate over appeals to identity politics. The question of what role whites could and should play in Harlem and in black political struggles more broadly was embedded in those debates. The less one cleaved to an idea of race loyalty—in any of its permutations—the less of a problem it was to have whites in Harlem or in leadership roles in Harlem politics. A principled opposition to the concept of race loyalty helped obviate questions of appropriation, theft, or inappropriate behavior by whites. Though she stopped short of becoming a Communist—Party discipline was out of the question for her—Nancy sympathized wholeheartedly with the Party's racial ideology, its attack on "Negro bourgeois leaders" as "white man's niggers," its challenge to the politics of identity, and its welcome of white activists.

The Scottsboro case brought more white women into black politics: writers such as Annie Nathan Meyer, Muriel Rukeyser, and Hollace Ransdell, as well as activists, Communist and other. That meant that the question of the role white women could play, and the possible damage that their mere presence could pose, was on the table, albeit sometimes in ways that only insiders would have been aware of. Nancy was keenly aware of the myriad ways in which the increased presence of white women provoked debate.

She took the position of honorary treasurer of the British Scottsboro Defense Fund: marching and organizing, circulating petitions and fly-ers, making banners, sponsoring fund-raisers, and encouraging her friends to write poems about the case that could be used in the cause. She also contributed her own money, when she had any, sometimes sending cash to the defendants and their families and encouraging her friends to do likewise. She was determined to make the Scottsboro case more visible in Europe.

One July Fourth, she threw a fund-raiser that drew enormous public-ity as "one of the most spectacular and curious parties that can ever have been held in this country." Capitalizing on the 1920s suntanning craze, with all the Negrophilia it implied, Nancy threw a sun-ray bathing and dancing party, taking over a swimming pool and a dance floor inside one

of London's best hotels. There she created an imaginary resort, where blacks and whites mingled to bathe, dance, talk, and get to know one another. London's *Daily Mail* described the party as "tropically hot" and "exotic," noting breathlessly that "Negroes of all shades of colour were dancing with white women." One London paper imagined that Nancy's behavior must mean that she "hate[s] so many white people." The suntan party drew attention from as far away as Pittsburgh, Canada, South Africa, Ceylon (now Sri Lanka), and Jamaica. One Jamaican paper noted with approval that "Miss Cunard's attitude towards the Negro race has estranged her from her mother, and has robbed her of many friends, while it has gained her new ones."

Nancy did make new friends through the Scottsboro case, realizing some of her ambition both to find "an American white friend with feelings such as mine" and to establish "contact" with blacks. She was in touch with some of the fellow travelers who were also working on the case. In her papers is a warm letter from Josephine Cogdell Schuyler, certainly someone with feelings "such as" Nancy's. (Unfortunately, like many on the left who watched his rightward swing with alarm, Nancy came to see George Schuyler as a political "scoundrel," making further friendship with his loyal wife impossible.) She corresponded with many of the defendants themselves and also with their mothers. Haywood Patterson, who was treated particularly harshly by the Alabama courts, wrote to Nancy about his "unbearable" conditions, his determination "to keep bearing on," and her "comforting" letters to him. He also urged Nancy, who was notoriously heedless of her own health, to take care of herself and get enough rest, something that even Nancy's best friends dared not suggest to her. Through the Scottsboro case Nancy befriended a number of other prisoners, including one James Threadgill, a "Negro lifer" to whom she wrote and sent books for two decades. "Dearest," Threadgill wrote in 1954, "this I hope will find you feeling well and doing just fine." Again she demonstrated her ability to identify with those who were very different from her. "I'm not really thinking of anything else but them [the Scottsboro Boys] all the time," she wrote to a friend.

Six days after the Scottsboro Boys were arrested and the day after all

nine were indicted, Nancy decided to travel to the United States. She also decided to create a document that would tell the truth about race and drafted plans for a massive book to record and celebrate everything that "is Negro and is descended from Negroes." It would be, she said, "the first time such a book has been compiled." She was "possessed," she later wrote, by "a new idea" of what to do and how to live.

Nancy's first trip to Harlem, in July 1931, scheduled to coincide with the death sentences issued to the Scottsboro Boys, was evidently quite a disappointment. She had determined that Henry should accompany her and be her guide, but he was just coming back to Europe from a trip to the United States himself and returned with her only grumblingly. They were not getting along well, and he foresaw more difficulties ahead for him in New York:

> Imagine, a Negro man sailing to New York in the company of a wealthy white woman. . . . Me, of all people, a great big black man, running around New York with a white woman. I must have been crazy. . . . To make matters worse Nancy was the kind who would want to go everywhere and see everything.

Nonetheless, he booked them passage and they endured a "disagreeable" crossing together.

Their first hotel was infested with bedbugs, and they had to gather up their things and move after two nights, taking up residence at the Grampion Hotel instead. Nancy saw the American Depression firsthand, with people out of work, beggars on the street, and storefronts shuttered and abandoned. The year 1931 had already been the hottest ever on record. In July, when Nancy and Henry arrived, the city was gripped by a blistering heat wave. "Nancy was always complaining about the heat," Henry recalled.

Henry also complained. He was not interested in Nancy's causes, did not want to meet with Scottsboro organizers, was constantly wary that

his wife would find out he was back in the country. "He would not even join her in demonstrations or go to Scottsboro protest meetings." He was sick of Nancy's longing for Michelet—which intensified as soon as she landed in New York—and her heavy drinking. He was drinking heavily himself.

Nancy did indeed want to "go everywhere and see everything." Henry refused to leave Harlem, certain that they would encounter "a lot of trouble" if they ventured downtown. Nancy persuaded him to go see Marc Connelly's hit play *The Green Pastures* on 47th Street, however. Featuring an all-black cast with "hundreds of black performers," the play recycled many familiar stereotypes: "fantasies . . . [of] black innocence . . . child-like and credulous." "Bunk," George Schuyler called it. Nancy was appalled at how whites like Connelly were representing and taking over black culture. Yet in her distaste for Connelly she revealed not dissimilar notions:

> Notice how many of the whites are unreal in America; they are *dim*. But the Negro is very real; he is *there*. And the ofays know it. That's why they come to Harlem—out of curiosity and jealousy and don't-know-why. This desire to get close to the other race has often nothing honest about it.

Had she arrived just a few months later on this trip or just a few months earlier on her next, she could have seen Zora Neale Hurston's *The Great Day* or Annie Nathan Meyer's *Black Souls*, either of which would have suited her more than Connelly's depiction of "happy Negroes at a fish fry."

Nancy saw a clear distinction between her view of racial differences and those of Connelly or the white tourists, who filled her with "utter disgust," or Carl Van Vechten—"the spirit of vulgarity" itself, she said. To her, there were a right and a wrong "kind of race-consciousness." Hers was the right kind, she believed, backed by a commitment to full social equality.

Nancy did not meet many of the Scottsboro activists in New York; by the time she arrived, the executions had been stayed on appeal to the Alabama supreme court. Some of the black activists, especially, were wary of her. "They regarded her as irreparably damaged by her background." She wanted to go south, to Alabama, but Crowder would not hear of it. She did meet as many of the key intellectuals of the Harlem Renaissance as she could, including NAACP officials Walter White, W. E. B. Du Bois, and William Pickens. She also struck up friendships with Alain Locke and Langston Hughes. She toured Harlem. And she collected contributors to her planned anthology, then called *Color*. There were occasional hoots from passing motorists—"Can't you get yourself a white man?"—but mostly Nancy and Henry were left alone. She was saddened (as was George Schuyler) by the many skin-whitening and hair-straightening parlors in Harlem, the amount of garbage in the streets, and the way that New York's grand avenues narrowed into shabbiness as they came north. But she was thrilled with "the atmosphere" and "tempo" she found in "the capital of the Negro world." She loved the "superb quality" of dancing in Harlem, the "magnificent and elaborate costumes" of Harlem's famous drag queens, and the "immense soundwaves and rhythmical under-surges" of Harlem's revivalist church services. The real Harlem, she asserted, is "*hard* and *strong*; its noise, heat, cold cries and colours are so . . . it is restlessness, desire, brooding . . . gorgeous roughness."

According to Henry, Nancy was not as well received in Harlem as she would have liked. "She was white, they were black; they could not forget the difference," he said. Nancy would not have wanted them to forget it, since that difference—for her—was the root of the cross-racial appeal. But if Henry was right and Nancy had hoped for greater acceptance than she received, she was laying the groundwork for a place in black culture, even on that not entirely satisfactory first foray.

"Black Man and White Ladyship"

She pursued her own path, with no regard for her happiness.
 —Raymond Mortimer

Her Negrophilism was passionately serious.
 —William Plomer

Through the rest of 1931, like most progressives, Nancy monitored the progress of the Scottsboro case, which had become not only an international cause célèbre but also a referendum on social courage and political strategy. The case, and the wrangling for control of it, forced supporters to ask just how far they would go and what risks they were willing to take.

Nancy Cunard picked up the gauntlet in her own way. In December, she self-published one of the stranger essays in the annals of modern literature, "Black Man and White Ladyship," a vitriolic no-holds-barred attack on her mother. As Anne Chisholm noted, "Nancy attacked her mother at every vulnerable point." One friend who knew both Nancy and her mother at the time wrote that Nancy's pamphlet created "an explosion such as has never been known" in the Cunards' social circles. "Your Ladyship," Nancy wrote, "you cannot kill or deport a person from England for being a Negro and mixing with white people. You may take a ticket to the cracker southern states of the U.S.A. and assist at some of the choicer lynchings which are often announced in advance." The second half of the essay was a minilecture on 244 years of the American slave trade, the practice of lynching, and an argument for Africa's superiority to industrialized, militarized, urbanized modernity.

Nancy had the pamphlet printed privately and distributed to her—and her mother's—friends and acquaintances on both sides of the Atlantic. She republished it a year later in *New Review*, ensuring that it would be as widely read as the previous "Does Anyone *Know* Any Negroes?" had not been. She knew the effect it would have. "I trust we shall never

meet again," Nancy wrote of her mother. She was right. Nancy and her mother never spoke to or saw each other again.

Many were shocked by how Nancy's pamphlet had crossed the line from private to public. Black writer Claude McKay, one of the most important voices of the "New Negro" literature, said that she was "taking a Negro stick to beat the Cunard mother" with. Most commentators have found the pamphlet inexplicable. Nancy Cunard's first biographer says that "there can seldom if ever have been a more savage public attack by a daughter against her mother." Some have made it the linchpin of arguments that everything she ever did was part of an oedipal struggle with her mother.

Of course, Nancy Cunard never cared about the line between the public and the private and prided herself on blurring it. Her essay was, in part, a demonstration of that. But it is really in the context of Scottsboro, with which she was then obsessed, that the essay makes sense. Indeed, it is written only *as if* it were an open letter to her mother. I think it is a response to Scottsboro written to and for black readers. "Black Man and White Ladyship" opens with Nancy's declaration that she has a "very close friend" who is a Negro and also "a great many other Negro friends in France, England, and America." Though the first statement was certainly true, the second is more dubious. What Nancy had then was the *desire* for "a great many other Negro friends," and the essay addresses them. It demonstrates what she is willing to risk, and to lose, on their behalf and for their company. Its repudiation of her mother is a disavowal of whiteness, similar to the ways that Edna Margaret Johnson, Lillian Wood, and Annie Nathan Meyer also disavowed whiteness by publicly decrying it as monstrous. Because "Black Man and White Ladyship" went too far out on a limb to allow Nancy to ever return to her family, it said, "I am no longer one of them; I am one of you (now), and you must take me in." Read in that way, "Black Man and White Ladyship," is less a letter to her mother than Nancy's plea to be adopted by Harlem.

Nancy was, of course, using her racial politics as a stick. And she never saw what others viewed as wrong with that, as long as her politics were sincere. Her willingness to do battle at any time, on any front, and

regardless of personal cost, she felt, was proof of her commitment. The essay's failure—almost no one saw anything of value in it—seemed genuinely surprising to her. She was often unable to anticipate how others would see her. Not especially valuing the cachet that came with being a Cunard, she was baffled by the venom with which others responded to her willingness to throw away her privileges, wealth, and status. She could not understand that people experienced her lack of interest in what they coveted as a slap in the face. Black educator and NAACP field secretary William Pickens observed rightly that "most girls would sell their souls for what Nancy's mother was trying to make Nancy accept and which the girl absolutely refused."

As satisfying as it might have been to take an inevitable break with her mother into her own hands, "Black Man and White Ladyship" was still a symbolic gesture. Nancy had resolved to effect a wider sphere than the "dreary and decadent" social circle that clustered in her mother's parlors.

Then, in the winter of 1932, Ruby Bates recanted. There had been, she now admitted, no rape. To Nancy, back in Europe, Ruby became an exemplar, a woman of "very great courage" whom she credited with achieving "the first great crack in the old Southern structure of white supremacy." Ruby's new testimony, she believed, was "piercing the whole of the rotten Southern fabric of lies and race hatred, holding it up to the entire world, tearing it inside out." There was the fighting spirit that Nancy so admired.

In truth, Ruby had never intended to recant. She had done so when a letter she'd written to her boyfriend, Earl Streetman, made its way into the hands of the lawyers: "Dearest Earl," she had written, "those Negroes did not touch me or those white boys. i hope you will believe me the law don't. I know it was wrong to let those Negroes die on account of me." She said that she had made her original charges out of fear—so that she would not have to "lay out a sentence in jail." She recanted, in part at least, out of fear that she'd lose her boyfriend otherwise. She did eventually join the fight to free the Scottsboro Boys, even traveling with some of their mothers on ILD-sponsored tours that gave her the oppor-

tunity to visit places such as New York City and the White House, ride
at the front of parades, and speak to huge audiences.

Scottsboro Boys' mothers with Ruby Bates.

But Nancy re-created Ruby Bates as a fearless fighter in her own im-
age. Through Ruby's story, she saw how historical forces had influenced
the script that both accusers had been handed: "The girls were not indi-
viduals with alleged wrongs, but had been transformed into part of the
lynch machinery." And she imagined Ruby standing up to all of it, saying
"No" to race, class, and gender and to the way society intertwined them.
In re-creating Ruby as a heroic warrior, Nancy also adopted a feminist
perspective on the women—as both agents and victims—that very few
others evinced. Even the IDL lawyers who defended Bates and Price
also demonized them as liars and whores. Shut out of white womanhood
by class, both Price and Bates had been given the unexpected oppor-
tunity to purchase social status through a racist lie. In truth, Cunard
was ignoring certain truths about Ruby. She overlooked what it meant

for barely working-class women to try to scrabble their way upward. And she overlooked the powerful incentives for such women to turn on those considered beneath them. Had Ruby Bates, in fact, voluntarily attempted to back out of the nation's racial bargain and expose it for what it was—as Nancy credited her with doing—she would indeed have been quite a heroine. Even as she recanted, however, she kept a racist outlook, consistently referring to blacks as lower and less valuable than whites. Bates wanted to do right, she insisted. But she did not want to go down in history as a "nigger lover," the insult slung so freely at Nancy.

As the activist and writer Mary Heaton Vorse put it in her essay "How Scottsboro Happened," "There is one precious superiority which every white person has in the South. No matter how low he has fallen, how degraded he may be, he still can feel above the 'niggers.'" Not even blacks were impervious to the force of the epithet "nigger lover," sometimes having less regard for whites who loved blacks than for other whites. Henry Crowder, at one point, said about Nancy Cunard that in loving blacks, "instead of raising the lowest of the black race to her level by associating with them she lowers himself to their level," suggesting that even he saw Nancy's love for blacks—for him—as crazy or unnatural, perverse or degraded. So it is not surprising that very few white women were willing to be called "nigger lovers." Nancy Cunard was willing. And the Ruby Bates she reinvented as a model for herself, an "American white friend with feelings such as mine," was willing as well. When the appeal was filed for the Scottsboro Boys, Nancy decided to return to Harlem again.

If the Ruby Bates she had reimagined was the image in Nancy's mind as she planned and executed her second trip to Harlem, met with contributors to the anthology now called *Negro*, and faced an explosion of racial hatred, it may well have helped her weather the storm of controversy that her visit evoked. She was ready to show the American public what a "nigger lover" really looked like.

"I Love Everything That Has
Come Out of Africa"

Some books are undeservedly forgotten.

—W. H. Auden

On Nancy's second trip to the United States, in the spring of 1932, she was determined to meet more people and go more places than she had been able to do in 1931 with the nervous Henry in tow. This time she traveled with her friend John Banting and other friends she had met in New York and Boston.

After the media uproar in early May, there was a feeling of resentment in Harlem about all the bad publicity, and Nancy was persuaded to retreat to the country, where she could concentrate all her energies on *Negro*, which had by then become a mountain of unorganized and mostly unedited contributions. In July, she took a trip to the West Indies with a black man from Boston, A. A. Colebrooke, and the press had a field day with that trip as well, insisting that Colebrooke had left his wife for Nancy. But Nancy was determined not to lose her focus on *Negro*, and she mostly ignored the coverage. She visited Cuba and Jamaica, met with both Nicolás Guillén and Marcus Garvey (who adored her), and by August was ready to return to Michelet, Paris, and the job of shaping *Negro*.

Only an impassioned outsider such as Nancy would have imagined that it would be possible to create one "entirely documentary" record of everything that "is Negro and descended from Negro." And probably only Nancy Cunard would have determined that the record could be written by both whites and blacks. As she envisioned it, *Negro* would cover all corners of the diaspora, all forms of cultural expression, and every possible discipline of scholarly thought on black culture and history. It would contain artwork, literature, bibliographies, travel guides, "documents, letters, photographs . . . articles, essays . . . documentary facts . . . Spirituals, Jazz, Blues . . . African tribal music . . . Reproduc-

tions of African Art . . . Accounts of lynchings, persecution and race prejudice . . . [as well as] outspoken criticism and it would be as inclusive as possible." Clearly Nancy imagined herself as a cultural ambassador, representing black American culture to Europe and the world:

> The vast subject so well known in the United States of America was little known in England, where one point of view was even "Why make such a book—aren't Negroes just like ourselves?" While I could see what was meant by this intellectual and scientific point of view, I could assure whoever it was who asked the question that if Negroes be like us their lives are mighty different!

It did not concern her that she had never been to Africa or its colonies and had been able to make only short and relatively superficial visits to the United States.

The agenda was absurdly ambitious—both unreasoned and unreasonable, as Michelet later said. "I am terrified by the size of the book, the effort it will be to get everything in," Nancy confessed to one friend in an unusually unguarded moment. But *Negro* achieved it, and more, when it finally appeared in 1934. The book weighed in at 855 pages, 385 illustrations, and well over 200 entries by 150 contributors, including Theodore Dreiser, William Carlos Williams, Zora Neale Hurston, Josephine Cogdell Schuyler (under the name Heba Jannath), Langston Hughes, W. E. B. Du Bois, Walter White, Countée Cullen, and many others. An extra-large-format book weighing eight pounds, it was one of the most expensive books ever published. Nancy fussed over its every detail, from endpapers to typesetting. No publisher would touch the book, so (like Annie Nathan Meyer) she had it printed at her own expense. "The publishing company I am going to in London, though visibly very interested in my book would not think of putting up one penny towards its production. . . . They say the subject would not make it worth their while." The book was originally budgeted at about £350, but its costs rose to more than four times her estimates. Fortunately,

she'd just won a libel suit in the British courts over the press's misrepresentation of her second visit to Harlem. The proceeds from the case just covered the printing bill. "Did I tell you who, really, paid for it? The British press!! Out of the £1250 I got off them for three libels on myself and the Negro race at the time I was in N.Y. Not bad? Even that does not cover the cost; it has cost between £1400 and £1500 to produce the edition of 1,000." Even with that, she nearly could not get the book printed. To her friend Arthur Schomburg, she confessed that "getting the book through the press was incredible. The board of Directors of the printers and I almost came to blows over their cretinous refusal to print one or two small things." At the last minute they absolutely refused to print a contribution called "The Negress at the Brothel" that Nancy had to have printed elsewhere on matching paper and hand-sewn into the book with page numbers I, II, III. The price of the book, not surprisingly, was high. Nancy was mortified. "It is my grief that our book has to be so dear," she told Schomburg, unable to meet the many requests she received for free copies.

Very little remains of Nancy's enormous archival record of *Negro*— her notes and drafts, her correspondence, her editing of the hundreds of contributions, or her accounts. When she returned to Réanville after the war, she found that her farmhouse had been subjected to "monumental pillage" and that everything there was now a shambles.

> The collapse of everything save the roof. No doors, no windows, no furniture left. Books, books, books, flung higgle-piggle all over the bathroom floor . . . a sort of mattress of books, thick and deep. . . . Five years of destruction . . . the bath torn away from its fittings . . . two stone heads . . . broken in two. . . . Sticking out of some debris was my father's first letter, torn out of a family album . . . my lovely blue landscape by Tanguy . . . shot full of bullet holes . . . a bayonet thrust through a part of the portrait Eugene MacCown had done of me in Paris in 1923 . . . traces of beads were left, mere fragments in the passage under the straw . . . of the en-

> tire collection of African and other primitive sculpture not
> one single piece remained, and most of the African ivory
> bracelets had vanished . . . outside under a tree all mashed
> and earth-trodden, I found a drawing by Wyndham Lewis.

Fortunately, a very little bit of her voluminous correspondence does survive in the archives of a few contributors, including Arthur Schomburg, Langston Hughes, and Sterling Brown. Nancy's long correspondence with Claude McKay, the poetic architect of "New Negro" militancy, is especially interesting for what it reveals about the difficulties she faced and the strategies she developed as she put herself forward as black culture's white ambassador. In his first letter to her, written from Morocco on December 1, 1931, McKay singled Nancy out from other whites in a way that must have been especially gratifying to her. "I feel very excited about your book," he wrote. "We poor Negroes are literally smothered under the reams of stale, hackneyed, repetitious stuff done by our friends . . . but it is unimaginable that you could be handicapped or allow yourself to be by the social-racial reactions that hamper us sometimes." No sooner had he paid her that high compliment, however, than he grouped her intended volume under the category of "white literature on blacks," altogether ignoring that these were the boundaries Nancy expected *Negro* to smash. That a volume edited by a white woman could have anything other than a white perspective simply did not occur to McKay. That her volume would be anything other than blackness itself, pure and unmediated, would never have occurred to Nancy Cunard.

As it turned out, she and McKay were speaking past each other and failing to communicate on other levels as well. She was very disappointed to find out, a little later on, that McKay expected to be paid for his contribution to the volume. It was so clear to her that *Negro* could not possibly pay for itself (there wasn't even enough money to cover its expenses) and that, moreover, it was a labor of love that she was surprised to see the question of remuneration raised. McKay, for his part, was enraged. Some other contributors shared McKay's view. Sterling Brown expressed his disappointment in just the racial terms that Nancy

believed no longer could apply to her: "You'se a rich white lady and I'se jes' a po' black boy," he wrote to her ironically, "so I sho' would 'preciate it if you'd pay me jes' a little sumpthin." Brown's recent criticisms of Fannie Hurst suggested a parallel between the two women that could have only appalled Nancy.

Negro opens with a poem that cannily, and to insiders only, announces Nancy's feeling about her role. The poem is Langston Hughes's well-known "I, Too" and the lines "I, too sing America. / I am the darker brother" could have been uttered as easily by Nancy, an answer to her critics through Hughes's voice. They form another version of her saying, "Maybe I was African one time" and "I speak as if I were a Negro myself."

Like any anthology, *Negro* is a mixed bag. William Carlos Williams's paean to the attractiveness of black maids, for example, is something of an embarrassment, as is Nancy's attack on Du Bois, whom she calls "bourgeois" and insufficiently militant. But there are many exceptional pieces as well, including some of the best writing Zora Neale Hurston ever did and William Pickens's chilling essays on lynching, placed up front by Nancy. Unlike other black anthologies of the time, *Negro* was global, with hundreds of pages on African history and art, and articles from and about blackness in the West Indies, Latin America, Europe, and the Caribbean. Scholars of modernism today struggle to connect avant-garde aesthetic experimentation to African-American realism in the 1920s and '30s. Cunard's anthology made a strong case for a reconfigured notion of modernism—transatlantic as well as transracial. She placed contributions from realists such as Theodore Dreiser, Josephine Herbst, Pauli Murray, Michael Gold, and George Schuyler next to works by highly innovative modernists such Louis Zukofsky, Langston Hughes, and Samuel Beckett (who translated eighteen pieces for the volume). Cunard combined history, literature, art history, sociology, literary criticism, and reminiscences with historical documents—including Lincoln's Emancipation Proclamation—essays, stories, poems, glossaries, newspaper

excerpts, and speeches, as well as works commissioned for the volume (the bulk of its contributions), such as Josephine Cogdell Schuyler's essay on race in America, "America's Changing Color Line." She divided the volume into sections on countries, "Negro stars," music, poetry, sculpture, and ethnology, and, extending the "Poet's Page" practice of publishing whites writing about blackness, she devoted a section to "Poetry by Whites on Negro Themes," in which she participated.

There were disappointingly few reviews, but *Negro* garnered Nancy Cunard long-awaited accolades from blacks, many of whom told her that she was unlike any other white woman they'd ever known. Alain Locke, already established as the leading anthologist of the Harlem Renaissance, told her that *Negro* was "the finest anthology in every sense of the word ever compiled on the Negro." He said, "almost enviously," that she had surpassed him. "All of us are grateful. . . . You will have endless vindications in the years to come." She saved those letters of praise (as well as the hate mail she'd once received) and kept them with her until her death. The large binder that holds them begins with a letter from Henry Crowder, to whom the volume itself was dedicated:

> What a spectacle of tireless energy. What devotion to your task. . . . Nothing short of the greatest love for the poor oppressed blacks could have prompted you to tackle and go through with the book in the manner that you have. . . . You have had splendid vision, and you have created the masterpiece with marvelous technical skill.—The gratitude of the Negro race is yours. . . . Nancy you have done well. You have made the name Cunard stand for more than ships. . . . Your deep sympathy for the Negro breathes through the pages.

Josephine Cogdell Schuyler loved the book. "My dear, it is so beautiful, it is absolutely the prettiest, handsomest, most provocative

book I've ever seen. . . . I think you have done a brave, courageous and splendid thing!" She had been reading it through from cover to cover until her husband, George, had come home, she told Nancy, and had snatched it out of her hands. She couldn't wait to get it back. Her friend Taylor Gordon confessed that "a lot of [black] people thought you were just here on a BALL" but that *Negro* had proved them wrong. Arthur Schomburg echoed Gordon, saying that Nancy had "made good" and "come through the rye with flying colors." She had gone, he wrote, from being a "transient tourist" of black culture to the rare white person who can correct other whites: "merciless in her castigation of those white types who have not changed in their visions and perspective of life."

Such praise had not come easily. And in spite of what an extraordinary achievement it was, Nancy Cunard never rested on the success of *Negro*. The day it appeared, she was not celebrating; she was continuing her commitment to the oppressed by donning a man's coat, aviator's helmet, and scarves to march with London's hunger strikers.

"Reputations Are Simply Hell"

Reputations are simply hell and there's nothing—or little enough—to be done about changing them.

—Nancy Cunard

By the time she died in 1965, Nancy Cunard bore little resemblance to the mythic flapper she'd been in her youth. She was frail, cantankerous, in terrible pain, and nearly destitute. At the very end, desperately ill, she dodged doctors and friends and collapsed alone in the street.

She never succeeded in erasing the taint of sexual lunacy from her embrace of black politics and culture. Almost every aspect of her life has been pathologized and chalked up to selfishness, neurosis, attention grabbing, or worse. Her racial politics come in for even more condemnation now than they did in her own day, when her dedication—if nothing else—won her respect.

Women, interestingly enough, have been particularly hard on Nancy Cunard. Susan Gubar, for example, pronounced her a "self-loathing . . . vamp who used her social status" and her wealth for the "appropriation of a culture very much not her own." Ann Douglas dismisses Nancy's political life by collapsing it into the blows "she struck at her mother." Lois Gordon considers Nancy's lifelong "identification with those who were unempowered or unjustly punished" as a response to being "whacked on her hands" when she was a child. Even Anne Chisholm, whose view of Nancy is generally quite balanced, fails to challenge the perception that she was an "erotic boa constrictor."

It did not help matters much that she ultimately did go insane, meeting a premature death as a raving alcoholic in a public hospital ward. For some observers, her death proved that she had been crazy to do what she did and that everything she had attempted was doomed.

But in between her escape from Nevill Holt and her death, Nancy Cunard neither wasted away nor raved. In fact, she had a long and distinguished career as a journalist, the only white woman to be a full-time reporter for the Associated Negro Press, the black community's answer to the segregated Associated Press. She traveled to Moscow. She was in the Spanish Civil War, driving an ambulance and writing dispatches. She wrote books about British sophisticate and writer Norman Douglas and about George Moore; an epic antiwar poem that she was still working on at her death; unfinished books on African ivories; and a large work—seemingly never published—on the slave trade that was to begin with the slave raids in Africa by the British in 1767 and continue through "some matters of the contemporary scene" in America and that she was hoping would be made into a movie. The direction she'd found in the 1920s and '30s remained the course she steered until her death.

Janet Flanner believed that Nancy had "the best mind of any Anglo-Saxon woman in Europe." Yet she is known principally for her affairs and outrageous behavior. One wonders why so little of that other life is known, why she was so famous for some things and unknown for others. Did she have to come to such a sad end? Could things have been dif-

ferent for her? What if the community she chose had been free to fully welcome her? It is impossible to say. Perhaps she would have eventually imploded regardless of the place she found for herself in the world, destroyed by either her own intensity or her alcoholism or both. "She had to extract from each moment all there was to have," Raymond Michelet remembered. "Nancy burned like a flame."

Clearly Nancy Cunard was too contradictory to live a normal, contented life. William Carlos Williams remembered her as a woman of "passionate inconstancy." "Baffling contradictions," another friend said. Michael Arlen, one of Nancy's closest friends, who devoted his novel *The Green Hat* to trying to pin down Nancy's character, described her, finally, as outside all categories: "some invention, ghastly or not, of her own. . . . She didn't fit in anywhere. . . . You felt she had outlawed herself. . . . You felt she was tremendously indifferent to whether she was outlawed or not." There was nowhere she really belonged. She was a modernist who walked away from modernism. She could have been a New Woman but, like Josephine Cogdell Schuyler, found Village bohemia altogether too tame. The 1920s bored her. She wanted to be part of black culture, but black people did not always want her.

Nancy Cunard was a play of contrasts that might have been considered noble in a man but were unacceptable in a woman. She was, for example, extravagant and austere, passionate but unromantic, mercurial but steadfast (even dogged), grim and witty, loyal and unforgiving, unconventional but fastidious, politically committed but an anarchist, and an icon of the 1920s who thought the 1920s were a waste. Nancy was happy as a celebrity but believed she could escape caricature. She was a pioneer of what we now call the "free play of identity," but it is precisely that free play for which she is most often caricatured today.

Nancy embodied contradictions. But it was fundamental to her character to be always doing, doing, doing, trying to hurl herself past conflicts and contradictions in a frenzy of activity. Sometimes, in her haste, she made the complexity she refused to acknowledge that much more apparent. Then she was at her most discomforting to others. Convinced

that she could shed her background as an act of solidarity and will, she made colossal missteps. Once a young black man tried to pay Nancy for a "small kindness" and she replied, "I am your mother. There is no payment due." In such moments she was both the villain and the victim of her own story.

Epilogue:
"Love and Consequences"

Being black for a while will make me a better white.

—Janis Joplin

"You never dream of asking a woman 'what sort of woman are you?' so long as she keeps to the laws made by men," a literary character modeled on Nancy Cunard points out. Miss Anne found out the truth of that quickly. Refusing to follow the rules, she risked her womanhood, discovering that society proffers or withholds it at will. But Miss Anne could not help it; she led with her passions. She was committed to fair play. But she was also self-interested. Her rule breaking was designed, in part, to help her fashion a more exciting life. This makes her a messy role model for the act of identifying with others.

Miss Anne did not have role models. No one was doing the things she tried to do. Even today, her combination of qualities is frowned upon. Women who are politically impassioned—Emma Goldman, Eleanor Roosevelt, Hillary Clinton—are lightning rods for criticism and are caricatured as masculine and unnatural. It is still considered unseemly, evidently, for a woman to take too much pleasure in her politics. And the pleasure of identifying with others has always been suspect.

Miss Anne's pleasures and politics raised hard questions: When does empathy become appropriation? Is speaking for others unethical? Is it possible? What is the line between sacrificing for others and exercising one's own privilege and social mobility? When is imitation flattery, and when is it theft? Failing to conform to any of the social scripts of gender, race, or class, she raised those questions in especially awkward and uncomfortable ways. To some, that just made her "crazy."

A few years ago, I was invited to give a talk at the New York Public Library on the women in this book. It was an early spring day, and the audience was filled with historians, biographers, archivists, novelists, poets, and literary critics. The lecture hall was marble and oak, lit by massive wrought-iron chandeliers, and I remember thinking that this was the architecture of clarity and knowledge, of answers and certainty. My talk that day focused on Nancy Cunard. A little nervously—since the audience was unusually august and the room was austere—I described Nancy Cunard's involvement with Scottsboro, her writings, her ideas about race. I talked about how difficult it was to come to terms with someone who had tried so hard to make a contribution but had been so vexing in many of her assumptions and behaviors, her postures and personae. How do we judge, I asked, someone who in spite of the "penalty she had to pay for her interest in the Negro" remains, for so many, a "modern white aristocrat"? What can we make of someone who saw herself as a champion of black people even as she used them to her own advantage?

At the end of my talk, an eminent historian and senior colleague rose. He squared his black oxfords on the dark oak floor, swayed for a moment in his gray suit, and then shouted—shouted—at me, "I knew Nancy Cunard, and she was crazy, I tell you!" He turned slightly purple. "She was crazy! I knew her, I tell you, and she was crazy!"

It took me a few days to calm down enough to do the math. It was not impossible that my eminent historian had met Nancy Cunard. But given her death in 1965 and his age, he could not have been more than six years old when she died. In the weeks that followed, I wondered if I should be writing about Nancy Cunard at all if she could still deprive eminent historians of their manners and good sense. But perhaps that is exactly the point. If Nancy Cunard, with all of her flaws and failures, can still be a source of agitation and outrage, then surely—given the ramifications of what she was after—she merits a second look.

Miss Anne, after all, has descendants among us. In 2008, for example, Riverhead Books published a book called *Love and Consequences: A Memoir of Hope and Survival*. It was a story of growing up biracial in the Los Angeles gang the Bloods, written by Margaret B. Jones. Mi-

chiko Kakutani called it "humane and deeply affecting" and praised its "amazing job of conjuring" South-Central and the "bonds of love and loyalty" that thread through the violence of gang life there. Rebecca Walker, Alice Walker's daughter, praised it as a "must-read" book that could deepen our understanding of race.

The problem was that Margaret Jones was actually Margaret Seltzer, raised in well-off Sherman Oaks, never in a gang, and not biracial. She "fabricated" the entire story. Asked to explain why she did it, Seltzer said that she had been moved to concoct the story out of her love for black students she'd met in her high school. She believed that she could give "a voice to people who people don't listen to."

Margaret Seltzer's response is redolent of Edna Margaret Johnson's "A White Girl's Prayer" to become "yellow . . . bronze . . . or black." Her belief that she could speak *for* blacks evokes Nancy Cunard's "I speak as if I were a Negro myself." Like Miss Anne, Seltzer mixed selfish motives with noble ideals.

Learning of Margaret Seltzer's fraud just before *Love and Consequences* appeared, the publishers quickly recalled the book and canceled Seltzer's book tour. It is hard to blame them. The false-memoir phenomenon has been agonizing for publishers and unnerving for writers. One wonders what Seltzer was thinking and whether, in some small way, she was channeling Miss Anne's desires. Her questions, after all, are Miss Anne's questions (though taken to dangerous extremes), as pressing now as they were almost a hundred years ago: Can we alter our identities at will, and, if so, how? What, if anything, do we owe those with whom we are categorized? Does freedom mean escaping our social categories or inhabiting those that don't seem to belong to us?

In a recent essay on the sudden rise of wiggers and the contemporary youth culture of cross-racial fascination, race theorist David Roediger reminds us not to romanticize white-to-black identification. A "tremendous attraction toward nonwhite cultures," he notes, can lead toward "hideous reassertions of whiteness" as easily as it can lead to antiracism. Cross-racial identification, he argues, is often a mess. But "messiness," he also avers, is precisely what demands our analytical attention.

Miss Anne was as messy as it gets. But she was not always thought of as "crazy." In fact, many in Harlem were firmly convinced that she was onto something. Harlem Renaissance novelist Rudolph Fisher, for example, amazed by the way whites were "actually playing Negro" in the 1920s, wondered if the impersonation might change them, tuning them in to a black "wave-length . . . [helping them] learn . . . to speak our language . . . at last." He saw that possibility in Miss Anne's efforts. In 1927, white poet Lucia Trent, born in the former slave state of Virginia in 1897 and the daughter of a college professor, published a poem called "A White Woman Speaks" in *Opportunity*. About an innocent black man lynched by a mob, her poem preceded Scottsboro by four years.

A White Woman Speaks

So the law's agents left you to the throng;
You, whom the Court found innocent of wrong;
You, who could only stare and only sob;
They gave you over to that bawling mob,
Who shot at you like bullies from the back,
Because—poor devil—yes, your skin was black!

I do not pity you, my friend, who go
To sudden solitude of those who know
Only the ancient silences of death,
Who hear no more the feet of rain, the breath
Of low waves folding on the April seas,
But, O! deep in my heart I pity these
Poor human blunderers who have to-night
Made me, God knows, ashamed of being white!

As Fisher hypothesized, Trent spoke as a white woman in an attempt to change her own whiteness. One sign of that change is her phrase "my friend." That seems innocuous now. But white women in 1927 rarely

claimed black men as friends, whether the men were victims of racist violence or novelists such as Rudolph Fisher. Her imaginary friendship helped her rewrite social norms. Identifying with a black man, Trent wrote, also made her "ashamed of being white." That shame is the flip side of the poem's pleasure in friendship. Pleasure and shame are both, the poem suggests, how we learn to listen to others. Trent's pleasure and shame, Edna Margaret Johnson's, and Nancy Cunard's are neither crazy nor outside the civic realm where social struggles are waged. Both emotions are crucial—if messy—aspects of meaningful social change. Miss Anne always understood that.

The racial divides that Miss Anne crossed could not have been changed—and still cannot be—by individual identifications alone, however much those cross-racial indentifications might strain against our norms. But such identifications do have "political edges" with the power to point to and help push along the systemic and structural changes we seek. And Miss Anne always understood that as well.

Acknowledgments

It is a great pleasure to thank those who aided this book.

Initial institutional support was provided by the University of Southern California, and I am especially grateful to the Department of English, Dean Beth Meyerowitz, and my USC research assistants: Carolyn Dunn, Ruth Blandon, Lucia Hodgson, and, particularly, Jennifer Stoever-Ackerman. Northeastern University provided much-appreciated research and subvention support. Help with research and proofreading came from an excellent team of research assistants: Allison Rodriguez, Lauren Kuryloski, Tabitha Clark, and, particularly, Brent Griffin, Aleks Galus, and Hania Musiol, who began working on the project even before I arrived in Boston. Department staff members Jean Duddy, Melissa Daigle, and Linda Collins were always helpful. The staff and faculty who helped to found the Northeastern University Humanities Center—Kumarini Silva, Hilary Poriss, Amílcar Antonio Barreto, Jen Sopchochkai, Allison Rodriguez, and Nakeisha Cody—eased the transition from Los Angeles to Boston, as did Deans Bruce Ronkin, Uta Poiger, and, especially, James Stellar. I benefited from the encouragement and friendship of Northeastern president Joseph E. Aoun and Zeina Aoun.

Foundations and libraries provided the release time from teaching and access to archival resources without which this book could not have been written. I thank the Beinecke Rare Book and Manuscript Library at Yale University and the Harry Ransom Center at the University of Texas, Austin. I especially thank the Guggenheim Foundation, for the miraculous gift of time free from other obligations. Two residential centers provided invaluable camaraderie and time: the Cullman Center for Scholars and Writers of the New York Public Library and the

W. E. B. Du Bois Institute for African and African American Research; both are special places. At the Cullman Center, I would especially like to thank the staff and my colleagues Sharon Cameron and Farah Jasmine Griffin. At the Du Bois Institute, I owe special debts of gratitude to Vera Grant, Krishna Lewis, Tom Wolejko, Donald Yacovone, and Abby Wolf; to Karla F. C. Holloway for bonding over Fannie Hurst; and, most especially, to Henry Louis Gates, Jr., who gives back to other scholars like no one else in academia.

The archives listed under Manuscript Sources were all generous with time and resources. Some librarians went out of their way to help me track difficult sources and obscure illustrations, and I would especially like to thank Melissa Barton, Nancy Kuhl, and the staff at the Beinecke Library; Alice Birney at the Library of Congress; Jennie Cole and the staff at the American Jewish Archives; Nicolette Dobrowski at Syracuse; JoEllen El Bashir at the Moorland-Spingarn Research Center; Andrea Felder at the New York Public Library; Marlayna Gates at Yale University; Lois Conley, Yves Hyacinth, and Tricia Reinhart at Northeastern; Donald Glassman and the staff at the Barnard College Archives; William LeFevre at the Reuther Library; Diana Lachatenere, Mary Yearwood, Steven Fullwood, the late André Elizée, Colin Palmer, and the staff at the Schomburg Center for Research in Black Culture; David Smith and the staff at the New York Public Library; Thomas Staley, Richard Watson, Richard Workman, and the staff at the Harry Ransom Center; and Anne Woodrum and the staff at Brandeis. Genealogist extraordinaire Chris McKay of the Schomburg Center oriented me to census research and accompanied me to the municipal archives; her skills are remarkable and her enthusiasm is infectious.

Among the many other individuals who provided support and encouragement, I would like to thank Carol Bemis, Dorothy and Leo Braudy, Wini Breines, Amy Cherry, Erin Cramer, Stewart and Kathie Dalzell, Laurie and John Deer, Jeffrey Elmer, Laura Frader, Judy Glass, Laura Green, Kathryn Hayes, Selma Holo, Elsa Jacobson, Emily Kaplan, Coppelia Kahn, Ann Kogen, Lori Lefkovitz, Jane Marcus, Roxanne Davis May, Gabriela Redwine, Dinky Romilly, Susanne Salem Schatz, Doris Shairman,

Adam Shatz, Andrea Sutton, David Kaplan Taylor, Tracy Vancura, Laura Wexler, Louise Yelin, and Rafia Zafar. Three friends passed away before I could thank them, but I want to remember here John Glass, Liz Maguire, and Hazel Rowley, who was always a ready sounding board for my work. In Boston and New York, I encountered a community of biographers and cultural historians notable for their generosity and good spirits, and I am especially thankful to know Debby Applegate, Paul Fisher, Gretchen Gerzina, Charlotte Gordon, Martha Hodes, Megan Marshall, Sue Quinn, Judith Tick, Diane McWhorter, Suzanne Wasserman, and all the women of the Women Writing Women's Lives Seminar. Special gratitude is due to Rachel Berger, Jo Chaffee, Jessica Douglas, Ryan Hollohan, Gail Reid, Dan Ryan, Peter Tighe, Pete Viteretti, Diane Weisenberg, and, most especially, Mo Sila, who keeps the faith.

Interviewees were unfailingly gracious. For giving their time and answering my many questions, I thank: Carolyn Ashkar, Knoxville College; Sarah Bhagwandin, Granbury and Austin, Texas; Frances Biddle, Wellfleet, Massachusetts, and Bryn Mawr, Pennsylvania; Steven Biddle, Wellfleet, Massachusetts, and Quakertown, Pennsylvania; Alfred Bredenberg; the late Schuyler Chapin, New York; Lady Bee Coleman, Evanston, Illinois; Phoebe Eaton, Pennsylvania; the late Odessa Franklin, White Pine, Tennessee; Violet Franklin, White Pine, Tennessee; Joanne Rhome Herring, Soldotna, Alaska; Lisa Illia, Las Vegas, Nevada; the Reverend William James, New York City; Britt Juliff, College Station, Texas; the late Walter Juliff, College Station, Texas; Diane Locke, Granbury, Texas; Cody Martin, Granbury, Texas; Barbara Mason, Morristown, Tennessee; Clara Osborne, Morristown, Tennessee; Toby and Barbara Pearson, Morristown, Tennessee; Shalmah Prince; Mary Saltarelli, Granbury, Texas; and Claudia Southern, Granbury, Texas. Special thanks are also owed to Robert Bell of the Cunard estate; Lisa Illia of the Garth estate; and especially to Britt Juliff for so generously sharing photographs, documents, and memories of Josephine Cogdell Schuyler. My debt to Frances and Stephen Biddle for sharing their Charlotte Osgood Mason materials is immense; their friendship was a great gift of this book.

Many Harlem Renaissance scholars were also gracious about answering my questions. I especially thank Emily Bernard, Todd Decker, Jeffrey Ferguson, Clive Fisher, George Hutchinson, Bruce Kellner, Michelle Patterson, Arnold Rampersad, Kathryn Talalay, and Carolyn Wedin.

I benefited from the opportunity to share work-in-progress with undergraduate and graduate classes at Northeastern University and with audiences at the American Literature Association, the American Studies Association, the W. E. B. Du Bois Institute for African and African American Research, Harvard University, the Massachusetts Historical Society, the Modernist Studies Association, the New York Public Library, Northwestern University, the Schomburg Center for Research in Black Culture, Stanford University, the University of Colorado at Boulder, Vanderbilt University, and the Women Writing Women's Lives Seminar, New York City.

Profound gratitude goes to those who read portions of the manuscript or the proposal in draft: Joseph Allen Boone, Alice Echols, Lynn Enterline, Karla Holloway, Amy Kaplan, Clair Kaplan, Bernard and Rosalyn Kaplan (great readers who taught me to value books and ideas), Elaine McArdle, Marilyn Neimark, Carla Peterson, Necee Regis, Ramón Saldivar, Alisa Solomon, Tracy Vancura, and Suzanna Danuta Walters (who brings joyful irreverence and political commitment). My writing group was instrumental in helping me give narrative shape to a mountain of material, and I thank Carol Bundy, Kathleen Dalton, Carol Oja, and, especially, Susan Ware—who read the entire manuscript and many of the chapters more than once; I was fortunate to have her discerning eye and support.

The HarperCollins editorial and production teams are stellar. Their commitment to books and the importance of cultural history runs deep. My appreciation goes to Lynn Anderson, Leigh Burmesch, Rebecca Welbourn, Diane Burrowes, Emily Cunningham, Debbie Mercer, Kaitlin Mischner, the meticulous Susan Gamer, and indexer-extraordinaire Nancy Wolff. Special thanks go to my fabulous publicist, Jane Beirn, and to Maya Ziv (my Wemberly). The permissions work for the illus-

trations, as well as obtaining high-resolution copies, was handled with professionalism and good humor by the wondrous Neil Giordano, who never said no.

I am especially fortunate in my agent, Brettne Bloom, and my editor, Gail Winston, great readers and astute critics. Both believed in this project from the first, and I treasure their friendship and suggestions. They were exceptionally generous with their time, loyalty, and feedback; both were sensitive to the difficulties of group biography and insightful about strategies for drawing together a group of women who resisted definition. They read many drafts and pushed this to be a better book. I could not ask for a better agent or a better editor.

I am one lucky writer.

My greatest debt is to my husband, Steve Larsen, the most eclectic reader I know and the most generous partner I could imagine for a writer. From building bookcases to mulling over titles to reading and commenting on every chapter (in almost every draft), Steve's keen eye, Norwegian understatement, and steadfast encouragement have been invaluable. His respect for my work, belief in this book, and willingness to make space for Miss Anne made all the difference. This book is dedicated to him.

Credits

Grateful acknowledgment is made for permission to reprint the following:

Insert A

Life magazine cover, July 15, 1926. "Everything is Hot-tentotsy now": Illustrated by L. T. Holton. Courtesy of the Granger Collection, New York.

Photograph of a Harlem nightclub: "Dickie Wells, Harlem." Photograph by Russell Aikins. Originally published in *Fortune*, March 1936.

Walter White, June 1942: Photograph by Gordon Parks. Library of Congress, Prints and Photographs Division, Farm Security Administration/Office of War Information Collection.

Carl Van Vechten, self-portrait, 1934: Courtesy of the Van Vechten Trust and the James Weldon Johnson Collection, Beinecke Rare Book and Manuscript Library, Yale University.

Detail from a tourist map of Harlem: "Manhattan, first city in America." Published by S. M. Stanley Co., 1933. Courtesy of the Map Division, New York Public Library, Astor, Lenox and Tilden Foundations.

Libby Holman in "Moanin' Low": Publicity still, Libby Holman and Clifton Webb, singing "Moanin' Low" from *The Little Show*, circa 1929. From the Libby Holman Collection, Howard Gotlieb Archival Research Center, Boston University.

Langston Hughes: Schomburg Center for Research in Black Culture, Photographs and Prints Division, Portrait Collection, New York Public Library, Astor, Lenox and Tilden Foundations.

Zora Neale Hurston: Photographer unknown. Library of Congress, Prints and Photographs Division.

Alain Locke: Photographer unknown. Courtesy of Moorland-Spingarn Research Center, Manuscript Division, Howard University.

Josephine Cogdell Schuyler as a young woman: Schomburg Center for Research in Black Culture, Manuscripts, Archives, and Rare Books Division, Philippa Schuyler Papers, New York Public Library, Astor, Lenox and Tilden Foundations.

Josephine Cogdell's painting of her father: Courtesy of Walter Juliff. Painting in private collection.

John Garth, *Adam and Eve*: Painting courtesy of Lisa Illia, daughter of John Garth. Painting in private collection.

Excerpt from Josephine Cogdell Schuyler's scrapbook. Courtesy of George S. Schuyler Papers, Special Collections Research Center, Syracuse University Library.

Insert B

Fania Marinoff: Photographer unknown. Courtesy of the Van Vechten Trust and the Carl Van Vechten Papers, James Weldon Johnson Collection, Beinecke Rare Book and Manuscript Library, Yale University.

Yankee Schoolmarm: "Primary school for Freedmen, in charge of Mrs. Green, at Vicksburg, Mississippi." Wood engraving. Originally printed in *Harper's Weekly*, June 23, 1886, p.d.

Annie Nathan Meyer as a young woman: Courtesy of Barnard College Archives.

Studio portrait of Charlotte Osgood Mason with Cornelia Chapin and Katherine Chapin Biddle: Collection of Mrs. Edmund Randolph Biddle and Stephen G. Biddle, Quakertown, Pennsylvania. Courtesy of Mrs. Edmund Randolph Biddle and Stephen G. Biddle.

1920s postcard "A Darkey's Prayer": Langston Hughes Papers, Yale Collection of American Literature, Beinecke Rare Book and Manuscript Library.

1920s mammy postcard: Langston Hughes Papers, Yale Collection of American Literature, Beinecke Rare Book and Manuscript Library.

Verso of mammy postcard, with handwritten note addressed to Langston Hughes from Charlotte Osgood Mason: Langston Hughes Papers, Yale Collection of American Literature, Beinecke Rare Book and Manuscript Library.

Nancy Cunard, 1926: Photographed by Man Ray. © Artists Rights Society/ The Man Ray Trust.

Cover of *Henry Music*, published by Hours Press, 1930: Courtesy of the Harry Ransom Center Book Collection, University of Texas at Austin.

Life magazine, suntanning-craze cover, "The Girl Who Gave Him the Cold Shoulder": Illustrated by John Held, Jr. Cover of *Life* magazine, circa 1923. Cabinet of American Illustration, Library of Congress, Prints and Photographs Division.

In-Text Illustrations

"A White Girl's Prayer," by Edna Margaret Johnson in "The Poet's Page," from *The Crisis: A Record of the Darker Races*. February 1931: Reprinted courtesy of the Crisis Publishing Co., Inc., the publisher of the magazine of the National Association for the Advancement of Colored People.

Fania Marinoff in Harlem: Photographed by Carl Van Vechten. Courtesy of the Van Vechten Trust and the James Weldon Johnson Collection, Beinecke Rare Book and Manuscript Library, Yale University.

"Harlem After Dark," cartoon: Courtesy of the George S. Schuyler Papers, Special Collections Research Center, Syracuse University Library.

Amy Spingarn: Amy Spingarn at Troutbeck, Amenia, New York, date unknown. Photographer unknown.

Opportunity awards dinner invitation, May 1, 1925: Illustrated by Winold Reiss. Courtesy of the Reiss Partnership/Reiss Archives.

"A Night-Club Map of Harlem," ink drawing: illustrated by E. Simms Campbell.

Harlem street scene: intersection of Lenox Avenue and West 135th Street, circa 1920s–'30s. Photographer unknown. Corbis Images.

Newspaper composograph of Alice Jones Rhinelander at her 1925 trial, originally published in the *New York Evening Graphic*: Composite photograph by Harry Grogin and Emile A. Gavreau.

Etta Duryea, circa 1910: Photographed by Elmer Chickering. Courtesy of the Boston Public Library, Print Department.

Etta Duryea and Jack Johnson, circa 1910: Photographed by Elmer Chickering. Library of Congress, Prints and Photographs Division.

Miguel Covarrubias cartoon, caricature of Carl Van Vechten, Fania Marinoff, and Taylor Gordon: Ink wash and ink brush over graphite underdrawing by Miguel Covarrubias. © María Elena Rico Covarrubias.

Libby Holman and Gerald Cook, circa 1940s: Photographed by Marcus Blechman. Hedgerow Theater Collection, Howard Gotlieb Archival Research Center, Boston University.

Harlem street scene, 422–424 Lenox Avenue: Photographed by Berenice Abbott for the Federal Art Project, June 1938. Photography Collection, Miriam and Ira D. Wallach Division of Art, Prints and Photographs, New York Public Library, Astor, Lenox and Tilden Foundations.

Blanche Knopf in drag: Photographed by Nickolas Muray. Courtesy of George Eastman House, International Museum of Photography and Film, © Nickolas Muray Photo Archives.

Libby Holman, date unknown: Photograph by Marcus Blechman. Hedgerow Theater Collection, Howard Gotlieb Archival Research Center, Boston University.

Close-up of the program from the NAACP benefit gala at the Forrest Theatre, Sunday, December 8, 1929: Programs & Playbills Collection, Manuscripts, Archives & Rare Books Division, NAACP Papers, Library of Congress.

Mary White Ovington, circa 1890–1900: Photographed by Charles J. Dampf Studios. Library of Congress, Prints and Photographs Division.

Helen Lee Worthing and Dr. Nelson, December 1929: International Newsreel. Photographer unknown.

Nancy Cunard, dancing with unidentified man: Date and photographer unknown.

Lillian Wood and the Morristown College faculty: Courtesy of Knoxville College Library Archives.

The Franklin sisters: Author's photograph. Used by permission of Lady Bee Coleman and Violet Franklin (Odessa Franklin, deceased).

Morristown College memorial bust: author's photograph.

Morristown College for sale: author's photograph.

The Schuyler family at home, circa 1944–1945: Schomburg Center for Research in Black Culture, Prints and Photographs Division, New York Public Library, Astor, Lenox and Tilden Foundations.

The Cogdell family home in Granbury, Texas: Date and photographer unknown. Schomburg Center for Research in Black Culture, Manuscripts, Archives, and Rare Books Division, Philippa Schuyler Papers, New York Public Library, Astor, Lenox and Tilden Foundations.

Josephine Cogdell and the family cook: Date and photographer unknown. Photograph courtesy of Cody Martin.

Josephine Cogdell as a pinup girl: Schomburg Center for Research in Black Culture, Manuscripts, Archives, and Rare Books Division, Philippa Schuyler Papers, New York Public Library, Astor, Lenox and Tilden Foundations.

John Garth, self-portrait: date unknown.

Josephine Cogdell as an artist's model: Schomburg Center for Research in Black Culture, Manuscripts, Archives, and Rare Books Division, Philippa Schuyler Papers, New York Public Library, Astor, Lenox and Tilden Foundations.

Josephine Cogdell Schuyler: Photographer and date unknown. The George S. Schuyler Papers, Special Collections Research Center, Syracuse University Library.

Josephine Cogdell Schuyler on a Harlem rooftop: Photographer unknown. Courtesy of the Juliff family.

Ernestine Rose, circa 1898: Photographer unknown. Courtesy of the Hampton Library in Bridgehampton, New York.

The Schuylers at home, reading: Photograph by Joe Covello, date unknown. Courtesy of Black Star Publishing Co., and the Photographs and Prints Division, Schomburg Center for Research in Black Culture, Philippa Schuyler Papers, New York Public Library, Astor, Lenox and Tilden Foundations.

Josephine Cogdell Schuyler's scrapbook: Philippa Schuyler Collection, Special Collections Research Center, Syracuse University Library.

Credits

Josephine Cogdell Schuyler, 1948: Photographed by Carl Van Vechten. Courtesy of the Van Vechten Trust and the James Weldon Johnson Collection, Beinecke Rare Book and Manuscript Library, Yale University.

Cover of *Opportunity*, January 1925: Illustrated by Winold Reiss. Courtesy of the Reiss Partnership/Reiss Archives.

Detail of program for Annie Nathan Meyer's *Black Souls*: Courtesy of the Barnard College Archives.

Annie Nathan Meyer, circa 1932: Photographer unknown. Courtesy of the Barnard College Archives.

Program for *Black Souls*: Courtesy of the Barnard College Archives.

Charlotte Osgood Mason: Photographer unknown. Langston Hughes Papers, Collection of American Literature, Beinecke Rare Book and Manuscript Library, Yale University.

Charlotte Osgood Mason: Collection of Mrs. Edmund Randolph Biddle and Stephen G. Biddle, Quakertown, Pennsylvania. Courtesy of Mrs. Edmund Randolph Biddle and Stephen G. Biddle.

Cudjo Lewis: Courtesy of the Doy Leale McCall Rare Book and Manuscript Library, McCall Library, University of South Alabama.

Miguel Covarrubias cartoon: Ink wash and ink brush over graphite underdrawing by Miguel Covarrubias. © María Elena Rico Covarrubias.

Nancy Cunard, holding *Negro*: Date and photographer unknown. Nancy Cunard Collection, Harry Ransom Center, the University of Texas at Austin.

Fannie Hurst at her desk: Date and photographer unknown. The New York Public Library for the Performing Arts, Billy Rose Theatre Division, Astor, Lenox and Tilden Foundations.

Fannie Hurst's apartment: Date and photographer unknown. Robert D. Farber University Archives & Special Collections, Brandeis University, and the Department of Special Collections, Manuscript Division, Washington University Libraries, Washington University in St. Louis.

Fannie Hurst, circa 1931: Photographer unknown. Library of Congress, Prints and Photographs Division.

Nancy Cunard, [1920–1924]: Photographer unknown. Nancy Cunard Collection, Harry Ransom Center, the University of Texas at Austin.

Nancy Cunard in Harlem, with John Banting and Taylor Gordon, 1932: Photographer unknown. © Hulton-Deutsch Collection/Corbis.

Nevill Holt, from Nancy Cunard's scrapbooks: Nancy Cunard Collection, Harry Ransom Center, the University of Texas at Austin.

Nancy Cunard, 1925: Photographed by Curtis Moffat. © Victoria & Albert Museum, London.

Nancy Cunard, with a mask from Sierra Leone: Nancy Cunard Collection, Harry Ransom Center, the University of Texas at Austin.

Credits

Nancy Cunard: Solarized photograph by Barbara Ker-Seymer. Photography Collection, Literary File, Harry Ransom Center, the University of Texas at Austin.

Ruby Bates and the Scottsboro mothers, with Richard Moore, 1934: Photographer unknown. © AP/Wide World.

Notes

Principal Archives and Abbreviations

AJA Jacob Rader Marcus Center of the American Jewish Archives, Cincinnati, Ohio .

Barnard Barnard College Archives, New York, New York

Beinecke Beinecke Rare Book and Manuscript Library, Yale University, New Haven, Connecticut

Brandeis Robert D. Farber University Archives and Special Collections Department, Brandeis University, Waltham, Massachusetts

Georgetown Special Collections Research Center, Georgetown University Library, Washington, D.C.

HRC Harry Ransom Center, University of Texas, Austin

LOC Manuscript Division, Library of Congress, Washington, D.C.

MSRC Moorland-Spingarn Research Center, Howard University, Washington, D.C.

Quakertown Collection of Mrs. Edmund Randolph Biddle and Stephen G. Biddle, Quakertown, Pennsylvania

Reuther Walter P. Reuther Library, Wayne State University, Detroit, Michigan

Schomburg Schomburg Center for Research in Black Culture, New York Public Library, Astor, Lenox and Tilden Foundations

Syracuse Special Collections Research Center, Syracuse University Library, Syracuse, New York

Introduction: In Search of Miss Anne

xvii "There were many white faces": Watson, *The Harlem Renaissance*, 95.

xvii "You know it won't be easy to explain": Van Vechten, *Nigger Heaven*, 204.

xviii "midwife": The term "midwife" appears in many different sources. See, e.g., Quarles, *The Negro in the Making of America*, 233; Harris and Molesworth, *Alain L. Locke*, 40, 107, 179, 182, 253, 381.

xviii described with the same few sentences: One example is an often-told but apocryphal story in which Mason is said to have "her brown godchildren perched on a stool before her throne-like ancestral chair" when she didn't have them up and about the apartment, dancing like "primitives." Rampersad, *The Life of Langston Hughes*, vol. 1, 157. Robert Hemenway, who related this story in his earlier biography of Hurston, suggests that his source for it was Louise Thompson Patterson—but Patterson both detested Mason (and with good reason, as Mason detested her as well) and appears never to have been in Mason's

Park Avenue apartment when both Hughes and Hurston were present. See Hemenway, *Zora Neale Hurston*, 107. David Levering Lewis, Steven Watson, and others have repeated this story, as did I in *Zora Neale Hurston: A Life in Letters*, 48. See Lewis, *When Harlem Was in Vogue*, 151, and Watson, *The Harlem Renaissance*, 144.

xix Historians and critics: Mumford, *Interzones*; Gubar, *Racechanges*, 152, 156; Douglas, *Terrible Honesty*, 101, 373; Dreisinger, *Near Black*.

xx These biographies typically dispense with their time in Harlem: See, e.g., Chisholm, *Nancy Cunard*, and Gordon, *Nancy Cunard*.

xx for white *women*: Racial "crossover" remains a largely male prerogative according to Roediger and others. See Roediger, *Colored White*, 235–6. On gender and racial crossover, see also Wald, *Crossing the Line*, and McDowell, "Pecs and Reps," in Stecopolous and Uebal, eds., *Race and the Subject of Masculinities*. On the appeal to white women of midcentury racial crossover, see Breines, *Young, White, and Miserable*.

xxi "race spirit" of the Harlem Renaissance: Alain Locke, "Foreword," in *The New Negro*, xxvii. This collection, an expansion of the special edition of *The Survey Graphic* published the previous year, is often considered the "definitive text" of the Harlem Renaissance. In his introduction to the 1992 edition of this much-reprinted text, Arnold Rampersad discusses the "energy and joy" that came from "subversive" race politics in the 1920s. Rampersad, "Introduction," xxiii.

xxi "New Negroes" . . . "return fighting": Du Bois, "Returning Soldiers," 13.

xxi "far outnumbered" . . . "fighting back": McKay, "If We Must Die." "If We Must Die" was reprinted in *The Messenger* in September 1919 and in McKay's *Harlem Shadows* in 1922. See also Van Notten, *Wallace Thurman's Harlem Renaissance*, 33.

xxi "The New Negro has arrived": W. A. Domingo, "If We Must Die," first published in *The Messenger*, reprinted in Wilson, ed., *The Messenger Reader*, 336. On the derivation of "The New Negro," see especially Gates, "The Trope of a New Negro," and Gates and Jarrett, eds., *The New Negro*.

xxi "the mainspring of Negro life": Locke, "The New Negro," in Locke, ed., *The New Negro*, 11.

xxi Negrotarians: This is Hurston's term, widely circulated throughout the Harlem Renaissance.

xxi antilynching activists: See especially Hall, *Revolt Against Chivalry*; Gilmore, *Defying Dixie*; Brown, *Eradicating This Evil*.

xxi "Negrotarians . . . came in almost": Lewis, *When Harlem Was in Vogue*, 98. See, e.g., Ascoli, *Julius Rosenwald*, and Mjagkij, "A Peculiar Alliance."

xxii "I have found": Ovington, *Black and White*, 1.

xxiii But no photos of the dinners survive: I am grateful to the archivists at the Schomburg Center for Research in Black Culture for assisting my long search for such a photo.

xxiii "for many of the contestants": Holbrook, "The Opportunity Dinner," 177.

xxiv It was "a novel sight": "A Negro Renaissance," 16.

xxiv The dinner was free: Charles S. Johnson, to Alain Locke, "2nd letter" [undated], Alain Locke Papers, Moorland-Spingarn Research Center, Howard University, Washington, D.C. (hereafter abbreviated MSRC), as cited in Hutchinson, *The Harlem Renaissance in Black and White*, 392.

xxv "colored people always": Moryck, "A Point of View," 246.

xxv "a new race differently endowed": Edna Worthley Underwood, responding to Charles Johnson's invitation to be a contest judge. Lewis, *When Harlem Was in Vogue*, 115. These attitudes did not die out after the twenties and thirties. They persisted into the 1950s, in writings such as Norman Mailer's notorious essay "The White Negro," and they persist today in some aspects of "Wigger" culture.

xxv "a band of justice-loving white women": Gelhorn, "But of Course—No Social Equality," 14.

xxvi race is a social construction: On whiteness, see, e.g., Jacobson, *Whiteness of a Different Color*; Painter, *The History of White People*; Frankenberg, *Displacing Whiteness*; Frankenberg, *White Women, Race Matters*; Roediger, *Colored White*; Lipsitz, *The Possessive Investment in Whiteness*.

xxvii "I did what I wanted to": Ovington, *Black and White*, 50.

xxvii Negrophobia and Negrophilia: In his introduction to Mezz Mezzrow's memoir of cross-racial passing, from white to black, Bernard Wolfe notes that Negrophilia and Negrophobia may be related "dialectically" as they are "polar opposites." Mezzrow and Wolfe, *Really the Blues*, 403.

xxviii "racism is ordinary": Holland, *The Erotic Life of Racism*, 3. Excellent treatments of the everyday life of racism include: Bonilla-Silva, *Racism Without Racists*; Davis, *Women, Race & Class*; Morrison, *Playing in the Dark*; Shipler, *A Country of Strangers*; Terkel, *Race*; Williams, *Seeing a Color-Blind Future* and *The Alchemy of Race and Rights*. Many of the best illuminations of everyday racism and its workings are found in literature, from slave narratives to *Invisible Man*, *Beloved*, and beyond. The literature of the Harlem Renaissance—both white and black—offers many depictions of how saturated everyday American life has been with racism.

xxviii "especially happy": Als, "Queen Jane, Approximately," 55.

xxviii the Harlem Renaissance as interracial: Hutchinson, *The Harlem Renaissance in Black and White*. See also Bernard, *Remember Me to Harlem*.

xxxi Miss Anne's love of blackness: My thinking here has been broadly influenced by "affect studies" and especially the study of how so-called private emotions and feelings, seemingly inchoate longings and desires, can be understood as a form of political resistance and political critique, a form of resistance to the status quo that does not always rise to the level of legitimate political protest and that therefore has often flown beneath the radar of political and historical analysis. On affect as political, see, e.g., Sedgwick, *Touching Feeling*; Ahmed, *The Cultural Politics of Emotion*; Clough, *The Affective Turn*; Protevi, *Political Affect*; Staiger,

Notes

Cvetkovich, and Reynolds, eds., *Political Emotions*; Gregg and Seigworth, eds., *The Affect Theory Reader*.

Chapter 1: Black and White Identity Politics

3 "The black-white relationship": Huggins, *Harlem Renaissance*, 84–85.

4 "the color line": According to Brent Edwards, W. E. B. Du Bois first used this phrase in 1900. It gained social currency in 1903 when he stated that "the problem of the twentieth century is the problem of the color-line." See Edwards, *The Practice of Diaspora*, and Du Bois, *The Souls of Black Folk*.

4 "race traitor": This term has recently been reclaimed by the "New Abolitionists." See Ignatiev and Garvey, eds., *Race Traitor*, and Segrest, *Memoir of a Race Traitor*.

4 "General Purchasing Agents": Marchand, *Advertising the American Dream*, 169.

4 "the scandal of the decade": Lewis and Ardizzone, *Love on Trial*, xi.

5 Jones and Rhinelander met in 1921: Leonard suffered from a fragile constitution, stuttering, and stammering. His father sent him to The Orchards, a Connecticut institute for nervous and mental disorders, where he befriended Carl.

5 his trust fund: Smith-Pryor, *Property Rites*.

6 "into a long line of women": Thaggert, "Racial Etiquette" in Nella Larsen, *Passing*, ed. Kaplan, 511.

6 "persecute, ridicule and strip naked": Du Bois, "Rhinelander," 112–13.

6 *The New York Times* alone: Madigan, "Miscegenation and 'The Dicta of Race and Class,'" in Larsen, *Passing*, 389.

6 the spectators struggling: "Rhinelander Admits Pursuit," 1.

6 "enslaved" . . . "there is not a mother": "Rhinelander's Suit," 4.

7 a lump sum: Smith-Pryor, *Property Rites*, 248.

7 Alice's victory was pyrrhic: Smith-Pryor, *Property Rites*, 234.

8 dozens of black homes: The most famous such case, involving the family of Ossian Sweet in Detroit, Michigan, is expertly recounted in Boyle, *Arc of Justice*.

8 "instrument of social discipline . . . spectacularized": Apel, *Imagery of Lynching*, 44, 50.

8 "We want and need": Pencak, *For God and Country*, 8.

9 Newspapers treated her life . . . "'hate me'": *New York World*, September 13, 1912; *The New York Times*, September 12, 1912; *Chicago Examiner*, September 12, 1912; *The New York Times*, September 14, 1912; *Cleveland Gazette*, September 21, 1912; *The Chicago Defender*, September 21, 1912; *Broad Ax* [Chicago], September 21, 1912.

9 "not of temporary madness": Ward, *Unforgivable Blackness*, 294.

9 "crossing the color line": Hahn, "Crossing the Color Line."

9 Others estimated twenty thousand: The novelist Jessie Fauset, as quoted in Vincent, "There are 20,000 PPassing," A1.

9 One put the number as unrealistically high: "75,000 Pass in Philadelphia Every Day."

10 Sociologist Charles S. Johnson: Johnson, editorial, *Opportunity*, 3, no. 34 (October 1925): 291.

10 "when . . . a Caucasian [is] not": "When Is a Caucasian Not a Caucasian?," 478.

10 relatives lynched: "Careful Lyncher! He May Be Your Brother."

10 "pure white" wives revealed as "colored": "Blonde Girl Was 'Passing.'"

10 Editorials suggested: Remove "the prime [economic] incentive"; in Baldwin, *From Negro to Caucasian*, 4.

10 "telltales": Nella Larsen, *Passing*.

10 In the hands of white writers: See Twain, *Pudd'nhead Wilson*.

10 "one-drop rule," which held: From 1910 on, various states enacted laws based on this notion.

11 The "one-drop rule": Gotanda, "A Critique of 'Our Constitution Is Color Blind,'" cited in Lopez, *White by Law*, 27.

11 That forced every American to choose: See, e.g., Sollors, *Neither Black nor White, Yet Both*.

11 Since greater numbers of people: "New 'one drop of blood' rules in the early twentieth century, meant to make it more difficult for mixed-race individuals to pass as white, in some cases actually created more possibilities for individuals by making it harder to prove that a grandparent was African." Gross, *What Blood Won't Tell*, 13.

11 "race pride" and "racial solidarity": Locke, *Race Contacts and Interracial Relations*, ed. Stewart, 96–97.

11 "opposition to race mixture": Smith-Pryor, *Property Rites*, 33.

11 Garvey's insistence on "the racial purity": "Essays on Race Purity by Marcus Garvey," in *The Marcus Garvey and UNIA Papers*, ed. Hill, cited in Pascoe, *What Comes Naturally*, 183.

12 discouraged interracial marriages: According to Catherine R. Squires, most black newspapers hewed closely to the NAACP's view in this regard. "Black newspapers spoke out against antimiscegenation law, but this did not translate into wholehearted support for interracial marriage or intimacy." Squires, *Dispatches from the Color Line*, 40.

12 "traitor": Du Bois, "A Lunatic or a Traitor," 8–9.

12 "superstitions": George Schuyler, *Black and Conservative*. Schuyler also used "supestitution" to combine "superstition" and "institution."

12 for "men and women": Pascoe, *What Comes Naturally*, 174.

12 "*Voluntary* Negroes": Among others, George Schuyler used the phrase "*voluntary* Negro" to refer to someone "almost white" who elects to be black. See George Schuyler, "At the Darktown Charity Ball." The jazz musician Mezz Mezzrow also referred to himself as a "*voluntary* Negro"—a telling white mis-

understanding of the meaning of the term. Mezzrow was a white musician who often passed for black in Harlem during the 1920s and 1930s. The "secret" to sloughing off whiteness, Mezzrow wrote, is to "live close to the Negro, see through his eyes, laugh and cry with him, soak up his spirit." He was pleased to say that after spending "my life fighting to get back to the source . . . I became a Negro." Mezzrow and Wolfe, *Really the Blues*, 371, 372, 208. See also Wald, "Mezz Mezzrow and the Voluntary Negro Blues," in *Race and the Subject of Masculinities*, eds. Stecopoulos and Uebel, republished in Wald, *Crossing the Line*.

12 socialize interracially: Mrs. Sherwood Anderson, Adele Astaire, Tallulah Bankhead, Ethel Barrymore, Pearl Buck, Ina Claire, Joan Crawford, Mrs. E. E. Cummings, Mabel Dodge, Muriel Draper, Jeanne Eagels, Zelda Fitzgerald, Peggy Guggenheim, Libby Holman, Blanche Knopf, Beatrice Lillie, Fania Marinoff, Edna St. Vincent Millay, Marilyn Miller, Lady Mountbatten, Princess Violette Murat, Dorothy Parker, Julia Peterkin, Marjorie Kinnan Rawlings, Helena Rubenstein, Irita Van Doren, Emily Vanderbilt, Gertrude Vanderbilt Whitney, Rebecca West, and Elinor Wylie and others.

12 support or organize black communities: Jane Addams, Ethel Barrymore, Louise Bryant, Freda Diamond, Crystal Eastman, Helen Worden Erskine, Hallie Flanagan, Dorothy Fields, Martha Gruening, Peggy Guggenheim, Blanche Knopf, Mrs. Henry Goddard Leach, Leslie Lew, Annie Nathan Meyer, Harriet Monroe, Belle Moskowitz, Margaret Naumberg, Mary White Ovington, Sylvia Pankurst, Julia Peterkin, Idella Purnell, Ernestine Rose, Amy Spingarn, Irita Van Doren, Amy Vanderbilt, Lillian Wald, Virginia Welles, and others.

12 represent blacks in literature and the arts: Pearl Buck, Freda Diamond, Helen Worden Erskine, Hallie Flanagan, Dorothy Fields, Dorothy Heyward, Fannie Hurst, Blanche Knopf, Edna St. Vincent Millay, Mary White Ovington, Dorothy Parker, Anne Pennington, Julia Peterkin, Marjorie Kinnan Rawlings, Amy Spingarn, Gertrude Stein, Florine Stettheimer, Rebecca West, and others.

12 be intimate with black men: Lucille Cameron, Mabel Dodge, Etta Duryea, Bella Fauset, Uta Hagen, Yolande Jackson, Margery Latimer, Nina McKinney, Margaret Naumberg, Jane Newton, Irene Paneau, Clara Rockmore, Helen Rosen, Merrill Work, Helen Lee Worthing, Ellen Wright, and others.

12 pass as black: Irene Paneau, Lillian E. Wood, Helen Lee Worthing, and others.

13 "implacable Negrophobia": White, *Flight*, 72.

13 "crossover": Roediger's term for whites who seek to cross into black culture. See his *Colored White*, 212–40.

14 "I was only an American Negro": Hughes, *The Big Sea*, 325.

14 "I Was African": Nancy Cunard to Alfred M. Cruickshank, "The People," February 15, 1941, clipping, Box 27, Folder 5, Harry Ransom Center, University of Texas, Austin (hereafter abbreviated HRC).

14 "usable past": Brooks, "On Creating a Usable Past," 337–41.

14 On the one hand, Africa represented: See Levine, *Black Culture and Black Consciousness*, 4.

14 "tom-toms" . . . "song": Hughes, "Danse Africaine" and "Afro-American Fragment," in *The Collected Poems of Langston Hughes*, ed. Rampersad, 28, 129.

14 "There is little evidence": Locke, "The Legacy of the Ancestral Arts," in *The New Negro*, ed. Locke.

14 "hokum . . . just plain American": George Schuyler, "The Negro Art Hokum," 662.

15 "I want to see": from Bennett, "Heritage," 371:

I want to see the slim palm-trees,
Pulling at the clouds
With little pointed fingers . . .

I want to see lithe Negro girls,
Etched dark against the sky
While sunset lingers.
. . .
I want to hear the chanting
Around a heathen fire
Of a strange black race.
. . .
I want to feel the surging
Of my sad people's soul
Hidden by a minstrel-smile.

16 "So I lie, who find no peace": Cullen, *Color*. "Heritage" was dedicated to Cullen's companion Harold Jackman, with whom Cullen decamped to France two months after his celebrated wedding to Yolande Du Bois, the daughter of W. E. B. Du Bois. More than a thousand guests attended the gala wedding.

16 "It has attracted the African": Locke, "The New Negro," 6.

17 "revaluation": Locke, "The New Negro," 15.

17 The nation's folklore craze: See especially Filene, *Romancing the Folk*.

17 natural people: On the nineteenth-century roots of "romantic racialism" especially, see Frederickson, *The Black Image in the White Mind*.

17 "friends of the Negro": Used sincerely during Reconstruction and into the early 1900s by writers ranging from Charles Chesnutt on the one hand to Grover Cleveland on the other, the phrase "friend of the Negro" was in common use throughout the Harlem Renaissance, often with a slightly ironic tone, or a weary sense of resignation. During Reconstruction, the Republican Party called itself the "friend of the Negro." See Chesnutt, "The Disenfranchisement of the Negro," and "Friend of the Negro," 1. Zora Neale Hurston also used this phrase in her *Dust Tracks on a Road*.

18 "The white people are pushing themselves": Owen, "The Black and Tan Cabaret," 97.

18 "promoted poetry": Huggins, *Harlem Renaissance*, 9.

Notes

18 "the final measure of the greatness": Johnson, preface to *The Book of American Negro Poetry*, 9; Johnson, "Race Prejudice and the Negro Artist," quoted in Lewis, *When Harlem Was in Vogue*, 193.

19 white writers: With the exception of Charlotte Osgood Mason, who simply claimed legal and spiritual authorship of every word her black protégés turned out, all of the white women whose stories are uncovered here tried their hand at black literature. Cunard's greatest success in interracial collaboration was as a publisher and editor of black literature. Mary White Ovington wrote constantly, and in almost every genre. Josephine Cogdell Schuyler never stopped writing, even when she felt she could no longer write under her own name. Annie Nathan Meyer's play *Black Souls*, partly cowritten with Hurston, was one of the most successful pieces she ever wrote; it was certainly the most controversial. Fannie Hurst's *Imitation of Life* remains, to this day, the literary work for which Hurst is best known. The white educator Lillian E. Wood used black fiction to slip out of the white world and be known as a black writer.

19 "wealth of novel": These statements come from the multi-month symposium "The Negro in Art: How Shall He Be Portrayed," for which Van Vechten helped pen the questions.

19 "a sort of Mecca": Van Vechten, *Nigger Heaven*, 49.

19 "Glossary of Negro words": "'Arnchy': a person who puts on airs. 'Bolito': a gambling game highly popular in contemporary Harlem. The winning numbers each day are derived from the New York Clearing House bank exchanges and balances as they are published in the newspapers, the seventh and eighth digits, reading from the right, of the exchanges, and the seventh of the balances. In bolito one wagers on two figures only. 'Bulldiker': lesbian. 'Creeper': a man who invades another's marital rights. 'Dicties': swells, in the slang sense of the word. 'High yellow': mulatto or lighter. 'Jigchaser': a white person who seeks the company of Negroes. 'Miss Annie': a white girl. 'Ofay': a white person (pig Latin for 'foe'). 'Pink-chaser': a Negro who seeks the company of whites."

19 "a primitive birthright": Van Vechten, *Nigger Heaven*, 89.

19 "To say that Carl Van Vechten": Hughes, *The Big Sea*, 272.

19 The novel's title: Van Vechten blamed this on a lack of a sense of humor in the black community. "Irony is not anything that most Negroes understand," he claimed. George S. Schuyler, "Reminiscences," Columbia Oral History Project, 1960.

20 Du Bois spoke for many: Countée Cullen, for example, did not speak to Van Vechten for more than a dozen years after the publication of *Nigger Heaven*.

20 "exceptionally bad manners": Bernard, *Carl Van Vechten and the Harlem Renaissance*, 126.

20 "cheap melodrama . . . "affront" . . . "blow in the face.": Du Bois, "Books," 31–32.

20 And *The Pittsburgh Courier*: Lewis, *When Harlem Was in Vogue*, 181.

20 "rich" life: Verdelle, foreword to Peterkin, *Scarlet Sister Mary*, xxviii.

20 "I have lived among the Negroes": Julia Peterkin to H. L. Mencken in 1921. Quoted in Verdelle, foreword to Peterkin, *Scarlet Sister Mary*, xxvii.

20 "uncanny insight": Brown, "The New Secession—A Review," 147–48. See also Brown, "Our Literary Audience," 42–46, 61.

20 When Peterkin's *Scarlet Sister Mary*: Hutchinson, *The Harlem Renaissance in Black and White*, 202. My discussion of Peterkin's status draws in part on Hutchinson's account; see 199–203.

21 New Negro stalwart: Locke, review of *Scarlet Sister Mary*. See also Hutchinson, *The Harlem Renaissance in Black and White*, 203.

21 "Tell me, frankly": Harold Jackman, letter to Claude McKay (April 22, 1928), James Weldon Johnson Collection, Beinecke Rare Book and Manuscript Library, Yale University, New Haven, Conn. (hereafter abbreviated Beinecke). Quoted in Wintz, *Black Culture and the Harlem Renaissance*, 183.

21 "Damn it, man": Sherwood Anderson to H. L. Mencken, June 25, 1922, H. L. Mencken Collection, New York Public Library, Astor, Lenox and Tilden Foundations, quoted in Lewis, *When Harlem Was in Vogue*, 99.

22 "Negro theater . . . must come": Gregory, "The Drama of Negro Life," in *The New Negro*, 159.

22 "silly songs and leg shows": Du Bois, "The New Negro Theater."

22 had value as an authentic "Negro drama": Krasner, *A Beautiful Pageant*, 208.

22 "held out as inspiration": Hutchinson, *The Harlem Renaissance in Black and White*, 189.

22 "acclaimed by critics": Krasner, *A Beautiful Pageant*, 213. Alain Locke put it in market terms in 1927, arguing that "if the expectations of the Negro drama as a fruitful phase of American drama are to be realized, the field . . . must be a freeman's estate, with that reciprocity and universality of spirit which truly great art requires. . . . Vital as the Negro actor and dramatist are to this development, theirs is [*sic*] and can be no monopoly of the field." Locke, "Introduction," in *Plays of Negro Life*, ed. Locke and Gregory, 3–4.

22 "an ideal means": Scott, "Negroes as Actors in Serious Plays," 20; Spence, "A Criticism of the Negro Drama," 192–93, both cited in Hutchinson, *The Harlem Renaissance in Black and White*, 190.

22 "About us . . . By us . . . For us": Krasner, *A Beautiful Pageant*, 214.

22 But he also called O'Neill a "genius": Pfister, *Staging Depth*, 121, 135. Locke, "Introduction," in *Plays of Negro Life*, ed. Locke and Gregory, 1.

22 Theophilus Lewis: Krasner, *A Beautiful Pageant*, 208.

23 "the crying need": Julia Peterkin, response to symposium, "The Negro in Art: How Shall He Be Portrayed?," 238–39.

23 "It makes me sick": Zora Neale Hurston to Langston Hughes, September 20, 1928, in Kaplan, *Zora Neale Hurston*, 126. All Hurston letters are from this collection unless otherwise indicated.

23 "take all the life": Zora Neale Hurston to Charlotte Osgood Mason, in Kaplan, *Zora Neale Hurston*, 224.

24 "Negroes are practically never rude": Hughes, *The Big Sea*, 225.

24 "the homeliest woman" . . . "primitive people": Fisher, *The Walls of Jericho*, 59ff.

25 "Jewish girl who": Thurman, *Infants of the Spring*, 97.

25 "the ex-wife of a noted": Thurman, *Infants of the Spring*, 178–79.

26 "people who went in for Negroes": Hughes, "Slave on the Block," in *The Ways of White Folks*, 19–20.

26 "surly, black despot": Johnson, *Autobiography*, 89.

26 "insane white shameless wench": Toomer, *Cane*, 3.

26 "Hair—braided chestnut": Toomer, "Portrait in Georgia," 81. Claude McKay's "The Barrier," published at almost the same time, carries the same message:

> *I MUST not gaze at them although*
> *Your eyes are dawning day;*
> *I must not watch you as you go*
> *Your sun-illumined way;*
> *. . .*
> *I must not see upon your face*
> *Love's softly glowing spark;*
> *For there's the barrier of race,*
> *You're fair and I am dark.*

McKay, *Harlem Shadows* (New York: Harcourt, 1922) (Joel Spingarn was a founder of Harcourt). Probably the best-known of such portrayals would come later in Ralph Ellison's *Invisible Man* and Richard Wright's *Native Son*. One of the earliest images in Ellison's novel is of the adolescent narrator, thrown onto a small stage for a battle royal, suddenly faced with "a magnificent blonde—stark naked." Nothing could be more terrifying than this stripper's presence. The narrator knows that to look at her, even by mistake, is to risk lynching from the white male audience: "my teeth chattered, my skin turned to goose flesh, my knees knocked." As he matures, white women pose less of an immediate danger to him but they invariably figure as foolish characters with misplaced, stereotypical interest in black men. They want him to release their latent sexuality with "brutal" and "savage" force: "Look at me just like that; just like you want to tear me apart. . . . I feel so free with you. You've no idea. . . . You're not like other men." Ellison, *Invisible Man*.

27 "We know so *little* about each other": Wright, *Native Son*.

27 "the sincerity of my [interracial] friendship": Ovington, *Black and White*, 134.

27 "oughta stay outa Harlem": Thurman, *Infants of the Spring*, 137.

Notes

Chapter 2: An Erotics of Race

29 "Harlem seemed a cultural enclave": Huggins, *Harlem Renaissance*, 89, 11.

29 "What a crowd!": Quoted in Ottley, *The Negro in New York*, 174.

29 "real kick": "New York Life," 26.

29 "New York's Playground": Shaw, *Nightlife*, 73. I have not been able to locate any guidebooks to Harlem written for blacks. Most of that information—where to eat, where to hear good music, and so on—was conveyed by the hundreds of newspapers catering to black readers.

29 "place of exotic gaiety": Morand, *New York*, 270, 274, 268.

30 "Negro vogue": Hughes, *The Big Sea*, 228.

30 "the great Mecca": Johnson, "Harlem: The Culture Capital," in *The New Negro*, ed. Locke, 301.

30 "surpasses Broadway": "Black Belt's Night Life," 1, 12.

30 "Here is the Montmartre": James, *All About New York*, 248–49.

31 "the symbol of liberty": Quoted in Anderson, *This Was Harlem*, 61.

32 "a rare and intriguing moment": Huggins, *Harlem Renaissance*, 3.

32 "a large scale laboratory experiment": Johnson, *Black Manhattan*, xvii, 281 .

32 The "Negro renaissance": Thurman, *Infants of the Spring*, 115.

32 "in droves": Hughes, *The Big Sea*, 224.

32 "It is the zest": Cunard, "Harlem Reviewed," in *Negro*, ed. Cunard, 69.

32 "White America has": Johnson, "The Dilemma of the Negro Author," 479.

32 "cheap trip": Huggins, *Harlem Renaissance*, 90.

33 "At almost every Harlem upper-crust dance": Hughes, *The Big Sea*, 227–28.

34 Libby Holman made Connie's Inn: Machlin, *Libby*, 68–70.

34 "crowded with people": Thurman, *Infants of the Spring*, 109–13.

35 "great party giver": Hughes, *The Big Sea*, 244.

35 town house: Bundles, *On Her Own Ground*, 171–72.

35 "Negro poets and Negro number bankers": Hughes, *The Big Sea*, 244.

35 "a season's whim": Fisher, "The Caucasian Storms Harlem," 395–96, 398.

36 "Ordinary Negroes": Hughes, *The Big Sea*, 225.

36 "a most disgusting thing": Williams, "Writer Scores Best Girls," section 2, 1.

36 "The majority of Harlem Negroes": "The Slumming Hostess," 4.

36 "few white people ever see": Thurman, "Harlem Facets," *The World Tomorrow*, November 1927. Reprinted in *The Collected Writings of Wallace Thurman*, eds. Singh and Scott, 35, 37. Miguel Covarrubias was one of the leading artists of the Harlem Renaissance. His cartoons and drawings appeared often; he illustrated many Harlem Renaissance books.

36 "write some poetry, or something": Nella Larsen to Dorothy Peterson, Thursday the 21st [1927], James Weldon Johnson Collection, Beinecke.

36 "Here in the world's greatest city": "The Slumming Hostess," 4.

37 "America's most democratic institution": Owen, "The Black and Tan Cabaret," 97–98.

38 "Midtown office": Kellner, *Kiss Me Again*, 187. Kellner's chapter on Marinoff in this group biography remains the only sustained biography of Fania Marinoff to this day.

38 "*so* Negro that they were reported": Hughes, *The Big Sea*, 251.

38 They leaned heavily on the advice: See Van Vechten, *Splendid Drunken Twenties*; Kaplan, *Zora Neale Hurston*; Hutchinson, *In Search of Nella Larsen*; Davis, *Nella Larsen*; Hughes and Van Vechten, *Remember Me to Harlem*, ed. Bernard; and Hutchinson, *The Harlem Renaissance in Black and White*.

40 In spite of her extraordinary talent: *Passing* was dedicated to Carl Van Vechten and Fania Marinoff, in testament to the crucial—not frivolous—function their interracial parties served.

40 $500: Walter White to the New York Women's Committee, memorandum, November 9, 1929, Papers of the NAACP, Part 11: Special Subject Files, 1912–1939, Series A: Africa; Through Garvey, Marcus [Benefits]. Inflation conversion per the Consumer Price Index, Bureau of Labor Statistics, http://data.bls.gov/search/query/results?q=inflation+converter.

41 *Shuffle Along*: *Shuffle Along*, a musical comedy with an all-black cast, is sometimes credited with kicking off the Harlem Renaissance. Interest in the production was so strong that "the street on which it was playing had to be designated for one-way traffic only." Kellner, *The Harlem Renaissance*, 323. The midnight show took place on October 17, 1921, early in the Harlem Renaissance. Decker, "The NAACP 'Follies' of 1929," unpublished paper, delivered at the American Musicological Society, Seattle, Washington, November 2004. I am grateful to Professor Decker for generously sharing this unpublished work in progress with me.

41 "extravaganza," the "biggest benefit": Walter White to Bill Robinson, October 7, 1929, Papers of the NAACP, Part 11, Series A, Reel 8, frame 438. Microfiche. Harvard University.

42 "childlike . . . comic": Huggins, *Harlem Renaissance*, 251, 248.

42 Although black newspapers: David Krasner provides the example of a 1915 editorial from the *Baltimore Afro-American* urging an end to blackface. See Krasner, *A Beautiful Pageant*. It is important, Krasner reminds us, not to ignore the fact that "blackface appealed to black audiences at least to some degree," 279.

42 "standard material for stage comedy": Huggins, *Harlem Renaissance*, 268.

42 The man or woman in blackface was a "surrogate": Huggins, *Harlem Renaissance*, 255. Critic Eric Lott hypothesizes that blackface performances lent themselves particularly well to "symbolic crossings" of meaning, allowing derogation

to morph into homage and create a both-and hybrid of contradictory feelings he calls "derisive celebration." Lott, *Love and Theft*, 29.

42 Blackface could still be found: On blackface in "high culture" such as ballet, see Oja, *Making Music Modern*, 337.

42 runaway hit: NAACP Papers, Program; Machlin, *Libby*, 59–60.

42 "We would want by all means": Walter White to Libby Holman, November 8, 1929, NAACP Papers. The only advertised performers not to appear were ballroom dancers Fredi Washington and Al Moore and composer George Gershwin, who forgot which theater had been rented for the benefit and looked, in vain, for ads in white newspapers. White had decided that advertising in mainstream papers was a waste of time, presumably since whites likely to attend subscribed to the black papers. Gershwin telegraphed White the next morning to apologize, saying that he "felt terrible about not appearing." December 9, 1929, telegram. NAACP papers.

42 "fantastic motley of ugliness and beauty": Larsen, "Moving Mosaic or the NAACP Dance, 1929," Program. Larsen repeats this passage, virtually verbatim, in *Passing*.

42 "mother": caption, Ovington photo, program brochure, NAACP papers.

42 Alfred and Blanche Knopf also: Van Vechten, *Splendid Drunken Twenties*, 268.

43 checked off: Only some of their names, and sometimes mistyped—for example, Charlotte Osgood *Nathan*—appear on the final patron rosters, which were evidently assembled at the last minute and in great haste; others appear on draft copies. NAACP Papers.

43 "afraid to purchase orchestra seats": Duberman, *Paul Robeson*, 125.

43 "extremely difficult, if not impossible": This interraciality makes the benefit, Decker argues, equal in cultural significance to "Marian Anderson's 1939 Easter Sunday concert at the Lincoln Memorial," also organized by White. Decker, "NAACP 'Follies' of 1929," 11.

43 "The Aframerican": Johnson, "The Dilemma of the Negro Author," 477, 480.

44 Those were the very stereotypes: "The Slumming Hostess," 4.

44 "My sweet man": Machlin, *Libby*, 61.

44 "well pleased": "NAACP Sponsors First Sunday Night Benefit at Downtown Theatre," 5.

44 "onerous ownership": Dreisinger, *Near Black*, 148.

44 "ready-mades": See Butler, *Gender Trouble*.

44 "a birthright": Van Vechten, *Nigger Heaven*, 89–90.

44 one of the most taboo issues: Interestingly, the NAACP, and White, had often been accused of playing things too safely. Nancy Cunard was a particularly vociferous critic of the NAACP. See her "A Reactionary Negro Organization," in *Negro*, ed. Cunard.

45 someone who had chosen: Johnson, *Autobiography*, 105.

46 "I am possessed by a strange longing": Johnson, *Autobiography*, 153.

46 "not going to be a Negro" . . . "forehead": Johnson, *Autobiography*, 141, 139.

46 "supremely happy": Johnson, *Autobiography*, 153.

46 "a coward": Johnson, *Autobiography*, 153.

46 "strange longing": Johnson, *Autobiography*, 153.

47 "gay, grotesque, and a little weird": Larsen, *Quicksand*, 53–54.

47 "brown laughing": Larsen, *Quicksand*, 87, 86.

47 "wild desire . . . to hear them laugh": Larsen, *Passing*, ed. Kaplan, 7, 51.

47 "a refusal to pass": Mills, " 'Passing': The Ethics of Pretending," 48.

47 The longing to "come back": Larsen, *Passing*, 38.

47 "A good many colored folks": Booker T. Washington, quoted in Johnson, "Crossing the Color Line," 528.

48 They wanted to qualify: On the difficulty of labeling such cross-identifications as either pure appropriations or pure forms of resistance to the status quo, see Kobena Mercer's reconsideration of Robert Mapplethorpe's photographs of black men, " 'Skin Head Sex Thing.' "

48 paradoxical persistence . . . "hidden longing": Fauset, "The Sleeper Wakes," reprinted in *The Sleeper Wakes*, ed. Knopf, 23. In an essay that precedes Fauset's story by quite a few years, George Schuyler imagines two gossips chatting at a charity ball about "white women who were passing for Negroes" and haunting the clubs and cabarets. It's a problem, the gossips agree. But not as much as it seems. Those passing white women, it turns out, are actually black. And "once they decide to admit the possession of the magic drop, however, all is well." Schuyler, "At the Darktown Charity Ball," 377.

49 "creative impulse throbbing": Mason to Locke, May 1, 1932, Alain Locke Papers, MSRC.

49 "I am Africa": Hawkins, "I Am Africa," 232.

49 "speak as if I were a Negro myself": Nancy Cunard to Mrs. Davies, March 20 [1931], Nancy Cunard Papers, HRC.

49 "rooted identity . . . that most precious commodity": Gilroy, *Against Race*, 105.

49 well-heeled: Although her family's wealth was paltry in comparison with the Cunards', the Ovington Brothers Department Store on Fulton Street in Brooklyn was nonetheless a high-end establishment, nearly as well known at the time as Macy's, and it provided a very comfortable lifestyle for Ovington's family.

50 "To live on in an eternal round": Mary White Ovington to Corrine [Bacon], July 4 [n.y.], Mary White Ovington Papers, Walter P. Reuther Library, Wayne State University, Detroit (hereafter abbreviated Reuther).

50 "Do stand by me if you can": Mary White Ovington to Louise Ketcham Ovington, n.d., Mary White Ovington Papers, Reuther.

50 Hyperconscious of the "need for caution": Wedin, *Inheritors of the Spirit*, 99.

51 she founded: Debate continues over whether Ovington is "the" founder or one of the few founders.

51 Yet the press: This account draws on Wedin, *Inheritors of the Spirit*, 96–99.

52 "one of the five": Bogle, *Bright Boulevards, Bold Dreams*, 56.

52 badly beaten by an intruder: "Burglar Hits Actress," 20; "Film Beauty, Patient of Race Physician, Brutally Attacked by 'Mystery Assailant,' " 13.

52 "We didn't intend": "Prominent Physician Weds Movie Star," 2.

52 "We all have the blood": "Actress Returns to California Doctor," 2.

53 Worthing and Nelson challenged Hollywood: "Carry Mixed Marriage," 3.

53 "losing game": Quotes are from an article published posthumously in *Ebony* in February 1952 and said to be Worthing's autobiography, written shortly before her suicide. The entire article can be read at http://illkeepyouposted.typepad. com/ill_keep_you_posted/2008/07/i-first-heard-of-helen-lee-worthing-one- of-the-it-girls-of-the-silent-screen-era-in-the-book-bright-boulevards-bold- dre.html, under the title "Helen Lee Worthing: A Tragedy in Glorious Black and White," in three installments.

53 Worthing began to receive: "Helen Lee Worthing," part three.

53 "gradually withdrew from society": "Carry Mixed Marriage," 3.

53 isolating herself: "Follies Beauty Will Always Remember Kindness and Love of Colored Hubby," 2.

53 Two years into the marriage: "Helen Lee Worthing."

53 By November 1932, she was confined: "Faces Insanity Complaint: Helen Lee Worthing Held in County Hospital at Los Angeles," 22.

53 A few years later she reappeared: "Helen Lee Worthing on Comeback Trail," 3.

53 "Worthing's decline and her banishment": Bogle, *Bright Boulevards, Bold Dreams*, 59.

53 "it was a sign of insanity": Chisholm, *Nancy Cunard*, 319.

53 "white women who voluntarily married": Mumford, *Interzones*, 13.

54 interracial sex had a " 'cosmic' significance": Rogers, *Sex and Race*, quoted in Pascoe, *What Comes Naturally*, 190.

54 "the white wives of Harlem": McKay, *Harlem*, 233.

54 "white Delilahs": Wells, quoted in "An Anti-Lynching Crusade," 421–22, cited in Hodes, *White Women, Black Men*, 191.

55 "riding the rails" . . . "Bates and Price must have": Gilmore, *Defying Dixie*, 120.

55 "was a mirror": Carter, *Scottsboro*, xi.

55 "By the spring of 1932": Gilmore, *Defying Dixie*, 128.

55 "tectonic shifts": Gilmore, *Defying Dixie*, 124.

55 Artists and writers came out: Among the many protesters were Theodore Dreiser, Sherwood Anderson, Sinclair Lewis, Franz Boas, Ezra Pound, John Dos

Passos, Edna St. Vincent Millay, George Bernard Shaw, Malcolm Cowley, Heywood Broun, Waldo Frank, Floyd Dell, Mike Gold, Mary Heaton Vorse, Albert Einstein, Thomas Mann, H. G. Wells, Maxim Gorki, Aldous Huxley, Bertrand Russell, Arthur Symons, Rebecca West, Virginia Woolf, Norman Douglas, Lincoln Steffens, Bronislaw Malinowski, Leo Tolstoy, and André Gide.

56 "women of the ASWPL": Apel, *Imagery of Lynching*, 62.

Chapter 3: *Let My People Go*: Lillian E. Wood Passes for Black

59 "The crusade of the New England schoolma'am": Du Bois, *The Souls of Black Folk*, reprinted in *Writings*, 380.

59 "Nothing at all": Shockley, *Afro-American Women Writers*, xiv. Shockley describes a number of Afro-American women writers about whom "nothing at all could be found" in the biographical record.

60 "imagined community": Anderson, *Imagined Communities*.

60 In 1925: In fact, the novel was published by the African Methodist Episcopal Book Concern with no publication date. Bibliographers have assigned it various dates, including 1922 and 1923. In an unpublished autobiography, Wood gives two dates for the novel: 1914, which is impossible on the basis of internal evidence, and 1925. She wrote her unpublished autobiography at the end of her life, in 1953, and acknowledges that many of her dates may be wrong. Nevertheless, both internal evidence from the novel's story—which draws heavily on contemporary history—and the confirmation of former students of Wood's suggest that 1925 is the most probable date for the novel's publication. No archives of the AME Book Concern, originally based in Philadelphia, survive. Nor have I been able to locate either book advertisements or book reviews. The book refers to historical events into the early 1920s and seems unaware of some after 1925. In her memoirs, Wood also indicates that she began taking creative writing courses in the teens. It is most likely, then, that she began the novel around 1914, completed it in the early 1920s, and published it, as she claims, in 1925.

61 Until now: Shockley, *Afro-American Women Writers*; Roses and Randolph, *Harlem Renaissance and Beyond*, 349; Rush, et al., *Black American Writers Past and Present*, 781; Fairbanks and Engeldinger, *Black American Fiction*, 299: Margolies and Bakish, *Afro-American Fiction*; Ammons, *Conflicting Stories*, 21; Tate, *Domestic Allegories of Political Desire*, 237; Lovell, *Black Song*, 522; Rado, ed., *Rereading Modernism*, 126; Davis and West, ed., *Women Writers in the United States*, 219; Davidson, Wagner-Martin, and Ammons, *The Oxford Companion to Women's Writing in the United States*, 375; Ansón, *La Negritud*, 255; Wallace, *Black Macho*, 222; Matthews, *Black American Writers*; Adams, *The White Negro*, 165; Williams, *American Black Women*. I discovered that Wood was white in the mid-1990s after being asked to edit *Let My People Go* for the Schomburg Series of African American Women Writers, 1910–1940. I am grateful to Henry Louis Gates, Jr., for initially drawing my attention to Wood. Thanks to my discovery that Lillian E. Wood was a white writer, we were able to pull her from the series. Another misidentified writer, however, Emma Dunham Kelley-Hawkins,

the author of the novels *Megda* and *Four Girls at Cottage City*, did make it into the series, only to be pulled after many years when her white identity was revealed. It is widely agreed that Kelley-Hawkins, who was often on the syllabi of African-American literature courses, would have received very little attention as a white writer. She was most interesting as a black writer who seemed to write only about whites. In the Kelley-Hawkins case, misidentification stemmed from an ambiguous, dark photograph and an old case of bibliographical error. On the Emma Dunham Kelley-Hawkins case, see Jackson, "Mistaken Identity," D1; Jackson, "Identifying Emma Dunham Kelley," 728–41.

61 "a more in-depth study": Roses and Randolph, *Harlem Renaissance and Beyond*, 349.

61 "nothing at all" could be found: Shockley, *Afro-American Women Writers*, xiv.

61 Wood's biography appears: Shockley, *Afro-American Women Writers*, 392.

61 That history begins: Hodes, *White Women, Black Men*; DeRamus, *Forbidden Fruit*.

62 "dared to know" . . . "American history": Du Bois, *Black Reconstruction in America*, 708. Du Bois, *The Souls of Black Folk*, 380, 432.

62 "shut out": McPherson, *The Abolitionist Legacy*, 172.

62 "Ostracized by white society": Small, "The Yankee Schoolmarm," 385.

62 "Schoolmarms, not native black": Small, "The Yankee Schoolmarm," 386.

62 Teaching in a black school: Butchart, *Northern Schools, Southern Blacks, and Reconstruction*, 185–86.

63 Most had never seen large numbers: "My own rearing had been in a quiet New England town, and I hardly think I had ever seen a hundred colored people when I went South on this mission." Rice, "A Yankee Teacher," 152.

63 "All the men looked just alike": Rice, "A Yankee Teacher."

63 "condescending" . . . "antagonism" . . . "feelings": Frederickson, "'Each One Is Dependent on the Other,'" in *Visible Women*, ed. Hewitt and Lebstock, 310, 316.

63 served to challenge racist claims: Jonsberg, "Yankee Schoolmarms in the South," 77. "Preconceived opinions" is from the diary of a teacher, Elizabeth Botume, *First Days Amongst the Contraband*, published in 1893. These teachers, as Jonsberg notes, also write of their desire to escape the "drudgery" of marriage.

63 "By the 1940s and 1950s": Blum, "'The Contact of Living Souls,'" 91, 94.

63 independent households: Hoffman, "Inquiring After the Schoolmarm," 108.

64 In an inadequate frame building: Wells, *A School for Freedom*, 1–2. I am deeply grateful to Wells's mother, Mrs. Mary Coleman, for providing me her daughter's excellent history (one of the most comprehensive and reliable accounts of the college available), helping me gain insight into the early days of Morristown, and taking me on a personal tour of the abandoned campus, which her vivid memories brought back to life.

64 "graves and graves" . . . "south to teach": Wells, *A School for Freedom*, 1.

64 often hostile and "occasionally violent": Wells, *A School for Freedom*, 1.

64 "a gold watch . . . shop in town": Stearns, *A Highway in the Wilderness*, 8, 13, 20, 28, 35, 36, 40.

65 "white society": Small, "The Yankee Schoolmarm," 385.

65 "come from another planet": Small, "The Yankee Schoolmarm," 385.

65 "earthquake-like . . . strain": Stearns, *A Highway in the Wilderness*, 36.

65 "persistently stereotyped": Small, "The Yankee Schoolmarm," 381, 383, 402.

65 already maligned as "meddlesome": In *The Mind of the South*, W. J. Cash called her both "meddlesome" and "a dangerous fool." Jones, *Soldiers of Light and Love*, 6.

65 To a resentful South: Cavanagh, "Spinsters, Schoolmarms, and Queers," 421–40; Oram, " 'Embittered, Sexless or Homosexual,' " in *Not a Passing Phase*, ed. Lesbian History Group, 99–118. The culture that placed a high premium on maternity gave would-be teachers a double message: teaching was seen both "as a poor substitute for marriage and family" and "as the only career compatible with mothering." Hoffman, "Inquiring After the Schoolmarm," 107.

66 The more unnatural: Hoffman, "Inquiring After the Schoolmarm," 107.

66 "New understandings are arrived at": Frederickson, " 'Each One is Dependent,' " in Hewitt and Lebstock, eds., *Visible Women*, 316.

66 "positive memories": Blum, " 'The Contact of Living Souls,' " 98, 93.

66 "It's a hard thing": Wood, *Let My People Go*, 20.

66 "call" . . . "to live for": Jones, *Soldiers of Light and Love*, 41, 40, 42.

67 Lillian, whose legal name was Elizabeth: This seems the most reliable date, but her death certificate lists her birth year as 1865, probably a typographical error. The 1880 census, for example, in which she appears as "Elizabeth," gives her age as twelve.

67 two older sisters: Lillian had two other sisters who did not survive: May, born in 1857, and Jane, born in 1859. Both appear in the 1860 census but not the 1870 census and are never listed with the family again.

67 Lillian loved a local farmer: Wood refers to a failed love affair in her autobiography. The Franklin sisters, who lived with Wood in the 1940s, confirmed this romance and added that it was with a local farmer. Interview with Lady Bee, Odessa, and Violet Franklin, White Pine, Tennessee, November 2007. The Franklin sisters lived with Lillian Wood for two years in the mid-1940s. I am enormously grateful to the Franklin sisters for sharing with me their home, memories, family photographs, documents, and inscribed copy of *Let My People Go*.

67 a decent wage: The most highly skilled workers could make a very good salary indeed, but most milliners failed to achieve even a living wage. However, millinery work was especially friendly to Irish workers and the Wood sisters were half Irish on their mother's side, half British on their father's. By 1916, 86,000 women across the nation were employed in the millinery trade. Only dressmaking and

housekeeping employed more women. One contemporary historian described it as "a trade than which none seems more attractive because of its artistic requirements and its handicraft-stage, its demand for creative skill and its high remuneration for the best work." See Perry and Kingsbury, *Millinery as a Profession for Women*.

67 "disaster again overtook us": Wood, "Memoirs."

68 At that point, Lillian received: Lillian's early life story is reconstructed, in part, from available census, birth, and death records, and from her unpublished memoirs, written in the final year of her life and not always reliable, especially regarding dates. I have also been able to piece together her early story from census records, her death certificate, and other national and genealogical records. I am profoundly grateful to Chris MacKay of the Schomburg Center for Research in Black Culture for her help in tracing Wood.

68 At that time it was highly unusual: McPherson, *The Abolitionist Legacy*, 181.

68 "God then designed": Wood, "Memoirs." Unless otherwise noted, throughout the rest of this chapter, all direct quotes from Wood are from her unpublished "Memoirs." I would like to express my thanks to Marlayna Gates, librarian at Yale University, for helping me track down Wood's unpublished autobiography.

68 "By about 1900 it was possible . . . descend into blackness": Williamson, *The Crucible of Race*, 327, 467.

69 Hampton Institute: See Anderson, *The Education of Blacks*, 35.

69 "refrain from participating": Anderson, *The Education of Blacks*, 38. Industrialists and white educators such as Charles W. Dabney, president of the University of Tennessee, approved. "'The place for the Negro in the immediate future is upon the farms and in the simpler trades,'" Dabney maintained. Bryan and Wells, "Morristown College," 67.

69 "Southern white opposition": Butchart, *Northern School, Southern Blacks, and Reconstruction*, 182.

69 Morristown was without any public hospital: Hammond, "A Historical Analysis," 96.

69 Classes were crowded: Hammond, "A Historical Analysis," 81.

69 "to care for the boys and girls": Witten, "The History of Morristown Normal," 7.

70 "shunned": Hammond, "A Historical Analysis," 57.

70 "Taunts and threats were part": Wells, *A School for Freedom*, xii.

70 "Nigger Hill": *The Christian Educator*, May 1913, 16; Hammond, "A Historical Analysis," 57.

70 "Our friends among the white people": Hill, "Retrospection and Prophecy."

70 "did not necessarily think": Gilmore, *Gender and Jim Crow*, 45.

70 "I found to my surprise": Witten, "The History of Morristown Normal," 8.

70 "lived in [the] New Jersey Home": Witten, "The History of Morristown Normal," 8. Witten gives Hepler's first name as Amanda.

70 At Morristown, Lillian attempted: Author's interview with Toby and Barbara Pearson, Morristown, Tennessee, September and November 2007.

70 Even Alain Locke: Harris and Molesworth, *Alain L. Locke*; Stewart, ed., *Race Contacts and Interracial Relations*.

70 student exchange program: Even into the 1920s few such programs existed.

71 She was rumored: Author's interview with Toby and Barbara Pearson, Morristown. On the Yankee schoolmarm as an erotic, "physically attractive" figure, complicating the sexual boundaries of southern culture, see Baker, *Turning South Again*, 45–60.

71 Fulton was a former slave: Fulton's mother was also sold, for $1,800, as were his sister, for $2,500, an uncle, for $1,900, and an aunt, for $1,300. Fulton was six at the time and remembered the sale and his terror that he would lose his mother vividly. *The Christian Educator*, October–November 1895, 135, cited in Hammond, "A Historical Analysis," 51.

71 "the ugliest furniture": Author's interview with Clara Osborne, Rose Center, Morristown, November 2007.

71 "nearly all the race's ordeals": Shockley, *Afro-American Women Writers*, 392.

72 With the explosive growth: The black press mushroomed in the early 1920s from roughly two hundred to roughly five hundred newspapers. Vincent, *Voices of a Black Nation*, 23.

72 "believes the old threadbare lie": Wells-Barnett, *The Red Record*, 7.

72 "If Southern white men": Wells-Barnett, *The Red Record*, 7.

72 " 'Tie the wretch' ": Quoted in Giddings, *Ida*, 212.

73 The threat of lynching: As Isabel Wilkerson has noted, then—as now—"scholars widely disagreed over the role of lynchings in sparking a particular wave of migration." As Wilkerson notes, however, this violence often "planted the seeds of a departure that may have taken months to actually pull off." Wilkerson, *The Warmth of Other Suns*, 533. On the "threat of violence" and the Great Migration, see also Griffin, *"Who Set You Flowin'?,"* 1–47, and Goldsby, *A Spectacular Secret.*

73 "hurried to the lynching": Pfeifer, *Rough Justice*, 34.

73 "If we must die": McKay, "If We Must Die," 21.

74 "The nation's callous disregard": Goldsby, *A Spectacular Secret*, 19–20.

74 "the recent horrible lynchings": Du Bois, "Postscript," 203.

74 "The Negro women of the South": Hall, *Revolt Against Chivalry*, 93, ellipses and brackets in original.

74 "There must be good people": McPherson, *The Abolitionist Legacy*, 364–65.

75 "true friend of the Negro": Frederickson, *The Black Image in the White Mind*, 102.

75 "a slow process": Hall, *Revolt Against Chivalry*, 223.

75 "The hour has come": Mary B. Talbert to Mary White Ovington, October 21, 1922. NAACP Papers, Part 7: The Anti-Lynching Campaign, 1912–1955, Series B: Anti-Lynching Legislative and Publicity Files, 1916–1955, Library of Congress, Washington, D.C. (hereafter abbreviated LOC).

75 "most white women simply": Gilmore, *Gender and Jim Crow*, xix–xx.

75 "Lynch law" . . . "our people": Wood, *Let My People Go*, 131–32.

76 Feeling for "his sisters suffering wrongs": Wood, *Let My People Go*, 19.

76 "She took a chance": Author's interview with Clara Osborne and Barbara Mason, Rose Center, Morristown, Tennessee, November 10–11, 2007.

76 "the new black woman": Shockley, *Afro-American Women Writers*, 393.

76 modest print run: One of Wood's former students who lived with her in the 1940s, believes that only 500 copies of the novel were printed. Author's interview with Odessa and Violet Franklin and Lady Bee Coleman, White Pine, Tennessee, November 10–11, 2007.

77 "tremendous impact": Author's interview with the Franklins and Coleman, November 10–11, 2007.

77 "What she believed in": Author's interview with the Franklins and Coleman, November 10–11, 2007.

78 "like Negroes . . . best friend": Wood, *Let My People Go*, 25–26.

78 "friend[s] of the Negro": Wood, *Let My People Go*, 65.

78 "A crowd of white women": Wood, *Let My People Go*, 48–49.

79 "the rights of men": Wood, *Let My People Go*, 37.

79 Wood published: The AME Book Concern maintains no archives. Author's interview with Reverend William James, former Morristown College trustee, June 10, 2007, New York City; phone interviews, AME church officials, 1997 and 2007.

79 In African-American literature: On the role of "authenticating machinery" in rendering black storytelling credible, see Stepto, *From Behind the Veil*.

79 roll their eyes: Wood, *Let My People Go*, 59.

80 "remarkable women": Stearns, *A Highway in the Wilderness*, 42.

80 Lillian Wood died of a heart attack: Certificate of death, Lillian E. Wood, State of Tennessee, Certificate 55-2733, December 7, 1955. "Race: White. Birth Date: June 17, 1865. Age in Years: 90. Length of Stay in This Place: 48 Years. Cause of Death: Coronary Thrombosis." She was buried in Mount Sterling, Ohio.

80 extraordinary antilynching exhibit: Sponsored by more than 183 black and white patrons, many of whom had come to know one another through parties such as those given by Fania Marinoff and Mabel Dodge, Spingarn's show included just under four dozen works of sculpture, painting, drawing, and lithographs by, among others, Peggy Bacon, George Bellows, Reginald Marsh, Paul Cadmus, Thomas Hart Benton, Isamu Noguchi, and George Biddle (brother-in-law of Charlotte Osgood Mason's protégée Katherine Garrison Chapin Biddle, who was also working on antilynching artworks). Even today, such an exhibition would be contro-

versial. James Allen's recent coffee-table book of lynching photographs, *Without Sanctuary*, generated controversy centered on the claim that large numbers of such graphic pictures had never before been publicly displayed. According to her husband Joel's biographer, Amy Spingarn "assumed the forefront" of the work to mount the exhibition and find support for its brief tour to cities along the East Coast. Ross, *J. E. Spingarn and the Rise of the NAACP*, 154. Recent scholarship on this exhibition, however, never mentions Spingarn's name; credit for the exhibition is given to Walter White, whose signature, as executive secretary of the NAACP, was attached to most of the correspondence that went out to participating artists. See, e.g., the following detailed accounts of the exhibition: Vendryes, "Hanging on Their Walls," in *Race Consciousness*, ed. Fossett and Tucker; and Apel, *Imagery of Lynching*. Currently there is no biography of Amy Spingarn (and even Wikipedia has no entry for her). Many of the best histories of the NAACP, in fact, contain listings only for Amy Spingarn's husband and brother—both of whom were vitally important to the organization—but none for her. See, e.g., Kellogg, *A History of the NAACP*, vol. 1; Sullivan, *Lift Every Voice*; and Zangrando, *The NAACP Crusade*. Amy Spingarn's charcoal sketches of friends such as Zora Neale Hurston, though apparently never exhibited, capture the private personalities of many black celebrities; they add to the official visual record of the Harlem Renaissance left by such men as Carl Van Vechten and Nickolas Muray, but are rarely reproduced. The Spingarns have sometimes been listed, erroneously, as "African American," even in the indexes to some prestigious manuscript collections.

80 A few of its records and archives: Author's interview with Carolyn Ashkar, librarian, Knoxville College, November 12, 2007.

Chapter 4: Josephine Cogdell Schuyler: "The Fall of a Fair Confederate"

83 "Most of America is crazy": Jannath [Josephine Cogdell Schuyler], "America's Changing Color Line," in *Negro*, ed. Cunard.

83 "My purpose?": Anonymous [Josephine Cogdell Schuyler], "The Fall of a Fair Confederate," 536.

83 "Sad Are Beautiful Revenges": Josephine Cogdell Schuyler, diary, Box 8, Folder 5, Josephine Schuyler Papers, Schuyler Family Papers, Schomburg Center for Research in Black Culture, New York Public Library, Astor, Lenox and Tilden Foundations (hereafter abbreviated Schomburg).

84 "was being abducted": Josephine Cogdell Schuyler, manuscript fragment of "From Texas to Harlem with Love," chap. 16, 342, Philippa Schuyler Unprocessed Papers, Schuyler Family Papers, Schomburg.

84 "I have dropped": Josephine Cogdell Schuyler, fragment of "From Texas to Harlem with Love," 13, Schuyler Family Papers, Unprocessed, MG63, Josephine Schuyler Collection, Schomburg.

84 "dramatic": Josephine Cogdell Schuyler, diary, n.p., Josephine Schuyler Papers, Schuyler Family Papers, Schomburg.

84 "cast my lot": Anonymous [Josephine Cogdell Schuyler], "The Fall of a Fair Confederate," 536.

84 The taboo against interracial intimacy: According to historian Peggy Pascoe, the racial categories built into both miscegenation laws and marriage license forms exerted profound pressures on cultural ideas of racial identity. Pascoe, *Doing What Comes Naturally.* See also Lemire, *"Miscegenation."* Lemire argues that the domains of marriage and sexuality are most resistant to changes in biological notions of racial identity; anti-miscegenation and anti-interracial advocates, she shows, were canny about taking advantage of that recalcitrance.

85 "marry an intellectual": *The Chicago Defender*, February 19, 1921, 7.

85 "second degree criminal assault": "Poughkeepsie Has Marital Upset."

85 Beatrice Taylor . . . Helen Croute: "Marriage to Colored Man Cause of Persecution," 1; "Persecuted for Wedding Race Husband," A1.

85 The Jack Johnson case: *Pittsburgh Courier*, October 19, 1929, 4.

85 "never argued": "Intermarriage," Editorial, *New York Amsterdam News*, February 15, 1928, 20.

86 "overeager to marry": Miller, "The Marriage Bar."

86 "uncharitable attitude": "Mixed Marriages," A10.

86 Almost as many blacks as whites: Kornweibel, *No Crystal Stair*, 113.

86 "some worthy black woman": *The Chicago Defender*, October 26, 1912, 1.

86 "vogue": Hughes, *The Big Sea*, 228.

86 "difference in attitude": Jannath, "America's Changing Color Line," in *Negro*, ed. Cunard, 88.

86 "love between a white woman": Berliner, *Ambivalent Desire*, 69. Berliner was writing specifically about Paris, but his description applies to New York City as well.

86 "outcasts": "Mixed Marriages," A10.

86 "My family is incapable": Anonymous [Josephine Cogdell Schuyler], "The Fall of a Fair Confederate," 536.

87 "the most recognizable name": Ferguson, *The Sage of Sugar Hill*, 125.

87 "the first interracial celebrity marriage": Ferguson, *The Sage of Sugar Hill*, 18.

87 "America's Strangest Family": "Meet the George Schuylers," 22–26.

88 "It is incredible": George Schuyler, "When Black Weds White," 15. Eventually at least some members of Josephine's family were aware of her life in Harlem. Indeed, some family members corresponded with Philippa when she was a young woman. Josephine Cogdell to "Dearest Lucy," n.d. [1940s–'50s], courtesy of Walter and Britt Juliff, in private collection.

88 "general terms 'Negro'": George Schuyler, "The Caucasian Problem," in *What the Negro Wants*, ed. Logan, 285.

88 "race is a superstition [*sic*]": George Schuyler, *Black and Conservative*, 352. It is uncertain whether this is a typographical error or Schuyler's play on the word "institution."

88 "break down race prejudice": Anonymous [Josephine Cogdell Schuyler], "The Fall of a Fair Confederate," 536.

89 "interracial celebrity marriage": Peplow, *George S. Schuyler*, 117, n. 24.

89 best correspondents: Van Vechten, *Splendid Drunken Twenties*, ed. Kellner. Early on in this project, Bruce Kellner was generous with his time and candid view of Marinoff.

90 In Van Vechten's careful system: Some years ago, the Beinecke Library decided to dispense with those designations (though a record of them is kept by the archivists), a loss to scholars of the era. Scholars do still turn to Van Vechten's system, rather than available biographical data, because its indications of racial background are often more reliable than standard biographical sources, census data, or even the self-designations of authors. Indeed, so meticulous was Van Vechten that he even marked Jean Toomer throughout as "was N now W" in deference to Toomer's eventual refusal to be published as a "black" or "Negro" writer. Van Vechten's "N now W" reflects the absence, at this time, of any biracial designation but the much-detested term "mulatto."

90 "tell the sheep from the goats": Larsen, *Passing*, ed. Kaplan, 55.

90 "Us Darkies": Josephine Cogdell Schuyler to Carl Van Vechten, June 1, 1959, Carl Van Vechten Correspondence, James Weldon Johnson Collection, Beinecke.

91 "My White Fortress": Tanne, "To a Dark Poem," 50.

91 "The white woman was almost": Jannath, "America's Changing Color Line," 87.

91 "I beat the walls for wild release": Tanne, "Barrier," 79.

91 Josephine Cogdell was born: Her marriage certificate lists her age as twenty-eight, though she would have been thirty-one, barely younger than George. Her 1936 and 1967 passports both list her birth date as June 23, 1900. Her death certificate lists her birth year as 1900, rather than 1897, suggesting that George may not have known her true age. The Cogdell family Bible verifies 1897 as her birth year. I am grateful to the Juliff family for sharing this with me and allowing me to photograph the Bible's Family Record page.

91 "savage": Anonymous [Josephine Cogdell Schuyler], "Fall of a Fair Confederate," 531.

92 "It was understood . . . Her name": Author's interview, local historian, Granbury, Texas, December 15, 2007. For obvious reasons, I leave these interviewees anonymous.

92 "little or no middle class": Anonymous [Josephine Cogdell Schuyler], "The Fall of a Fair Confederate," 530.

92 Her father, Daniel Calhoun: Some historians use Daniel Crandell Cogdell.

92 First National Bank: The handsome Italianate stone building he had built for his bank still stands, adjacent to Granbury's courthouse on the town square.

92 "around a million acres": Josephine Cogdell Schuyler, manuscript fragment of "From Texas to Harlem with Love," chap. 16, 342, Philippa Schuyler Unprocessed Papers, Schuyler Family Papers, Schomburg.

92 She had tutors: Gaston Cogdell (Josephine's nephew), quoted in Talalay, *Composition in Black and White*. I am grateful to Talalay for sharing her knowledge of the family with me, patiently answering my questions, and attempting, once again, to discover the location of Josephine's lost manuscript "From Texas to Harlem with Love."

92 "super-energy . . . Feudal Ruler": Heba Jannath [Josephine Cogdell], undated diary [1923–1924], Box 8, Folder 17, n.p., Schuyler Family Papers, Schomburg.

93 "We lived on a scale": When that house burned down in 1907, D. C. Cogdell had it replaced with a fourteen-room version on an even grander scale, designed by Wyatt Hedrick and built to top anything else in the county. The new house, which is still standing and was recently for sale, is a 7,000-square-foot Craftsman-style masterpiece. The house stayed in the Cogdell family until the early 1960s, when it was sold to Dr. Little, the town physician. He kept it until John and Pam Ragland bought it and turned it into the Iron Horse Inn, a bed-and-breakfast. They sold the inn to Bob and Judy Atkinson, who loved the home and its history. Judy so loved the home and its original features, she told me, that she planned to remove a few of the built-ins and take them as "keepsakes" when they left. The current owners, Don and Diana McBride, are restoring the home's history and guarding its integrity.

93 "writers weren't held in high esteem": Author's interview with Walter Juliff (Josephine's nephew), College Station, Texas, December 18, 2007.

93 Behind the house were quarters: This early history of Granbury and the Cogdell houses draws on a number of documents, including Ewell, *Hood Country History*, first published in 1895 and reprinted as part of Hightower, ed., *Hood County History in Picture and Story*; Saltarelli, " 'Bright and Shining Facts for All the People' "; Saltarelli, "Civic Pioneer Builds the 'Ultimate' Cottage,' "; Cogdell House handouts provided by Judy Atkinson and the Iron Horse Inn; and author's interview with Mary Saltarelli, Diane Lock, and Claudia Southern, local historians, Granbury, Texas, December 15, 2007.

93 "How I loathe it all": Heba Jannath [Josephine Cogdell], undated diary [1923–1924], Box 8, Folder 17, n.p., Schuyler Family Papers, Schomburg.

93 "silly notion": Heba Jannath [Josephine Cogdell], *The Last Born*, unpublished novel ms., 5, Schomburg.

94 D.C. proposed to Lucy: Josephine Cogdell Schuyler, manuscript fragment of "From Texas to Harlem with Love," chap. 16, 342, Philippa Schuyler Unprocessed Papers, Schuyler Family Papers, Schomburg.

94 "savagely selfish": Houston, quoted in Talalay, *Composition in Black and White*, 34.

94 "determined, dogged . . . attention": Josephine Cogdell, undated diary, Box 8, Folder 15, n.p., Schuyler Family Papers, Schomburg.

94 "pigmy and a giant": Josephine Cogdell, undated diary, Box 8, Folder 15, n.p., Schuyler Family Papers, Schomburg.

94 "any man's slave": Heba Jannath [Josephine Cogdell], *The Last Born*, 9.

94 "They were fiery, temperamental": Talalay, *Composition in Black and White*, 33.

94 "'godless family'": Gaston Cogdell, quoted in Talalay, *Composition in Black and White*, 33, ellipses in original.

94 "superbly unmoral": Heba Jannath [Josephine Cogdell], *Southwest*, unpublished novel manuscript, Schomburg, 618.

94 With all the high moral standards: Josephine Cogdell, diary, "High School Notebook," Box 8, Folder 19, Schuyler Family Papers, Schomburg.

94 "absolutely unfitted": Josephine Cogdell, untitled novel fragment, 380, Schomburg.

95 "murdered, quarreled, raped": Talalay, *Composition in Black and White*, 34.

95 "'She tried to have'": Gaston Cogdell, Jr., quoted in Talalay, *Composition in Black and White*, 36.

95 Elinor Glyn's scandalous novel: Cunard sneaked Glyn's novel—her first—into her bedroom and "thrilled" for a week to its scandalous story of sexual freedom—"exactly what I wanted to know about!"—when she was only eleven years old. Cunard, *GM*, 57, 56.

95 "'liable to do most anything'": Susie Mae Cogdell and Gaston Cogdell, both interviewed by Talalay, 34.

95 "all the iconoclasts": Josephine Cogdell Schuyler, manuscript fragment of "From Texas to Harlem with Love," chap. 16, 342. Philippa Schuyler Unprocessed Papers, Schuyler Family Papers, Schomburg.

96 "doomed": Anonymous [Josephine Cogdell Schuyler], "The Fall of a Fair Confederate," 528. Other black friends included Dolf, Daisey's cook and Aniky's brother; "Uncle Bob," butcher and half brother to a former Granbury mayor; Little Varney, the iceman; Ivory; Uncle Varney, an ex-slave; and Lou-Vanilla, mistress of a Granbury leading citizen.

96 "the activities of the Negroes": Anonymous [Josephine Cogdell Schuyler], "17 Years of Mixed Marriage," 62.

96 "I preferred sitting": Anonymous [Josephine Cogdell Schuyler], "The Fall of a Fair Confederate," 528–29.

96 "My mother, watching us hang around": Anonymous [Josephine Cogdell Schuyler], "17 Years of Mixed Marriage," 62.

97 "thoroughgoing Negrophobe": Anonymous [Josephine Cogdell Schuyler], "The Fall of a Fair Confederate," 528.

97 "among these black people": Heba Jannath [Josephine Cogdell], *Southwest*, 841.

98 "Any mention of the Negro": Anonymous [Josephine Cogdell Schuyler], "17 Years of Mixed Marriage," 63.

98 "no color line in his love life": Anonymous [Josephine Cogdell Schuyler], "17 Years of Mixed Marriage," 62.

98 "Interracial love": Josephine Cogdell Schuyler, "An Interracial Marriage," 274; Anonymous [Josephine Cogdell Schuyler] "17 Years of Mixed Marriage," 62.

98 For her daughter's fourth birthday: Talalay, *Composition in Black and White*, 94.

Josephine also kept letters from family members for decades. Letters from her father, going back almost forty years, were among her papers when she died.

98 "romantic era": Josephine to Lucy, n.d., courtesy of Walter and Britt Juliff.

99 "I was a thoroughgoing Negrophobe": Anonymous [Josephine Cogdell Schuyler], "The Fall of a Fair Confederate," 528.

99 "I became a Negrophile": Anonymous [Josephine Cogdell Schuyler], "The Fall of a Fair Confederate," 531.

99 "From Texas to Harlem with Love": Years after Josephine's death, George was still trying to get the novel published. Ronald Hobbs to George S. Schuyler, February 16, 1972, Schomburg. Hobbs was the nation's first black literary agent.

99 "it is possible": Britt, "Women in the New South," in Calverton and Schmalhausen, eds., *Woman's Coming of Age*, xi–xx, cited in Freedman, "The New Woman," 376.

99 "flaming joviality . . . crude": Heba Jannath [Josephine Cogdell], *The Last Born*, 165, 172.

99 "humiliate wifehood": Heba Jannath [Josephine Cogdell], *Southwest*, 598. One of those affairs, with an older Jewish banker, may have resulted in a bequest that helped her travel to California and New York, as her unpublished autobiographical novels suggest.

100 Quickly becoming pregnant: Later she would have at least one more abortion.

100 "very strange affair": Josephine Cogdell Schuyler, diary, undated, Box 8, Folder 11, n.p. Josephine's most detailed descriptions of this marriage are in her two unpublished autobiographical novels, *The Last Born* and *Southwest*.

100 "be a rebel": Heba Jannath [Josephine Cogdell], *The Last Born*, 206.

100 "Taking orders from people": Josephine Cogdell Schuyler, diary, undated [1927], Box 8, Folder 11, n.p.

100 "second Paris": *Alta Californian*, August 7, 1853. Quoted in Levin, *Bohemia in America*, 70.

100 "More open than Eastern cities": Cherny, "Patterns of Toleration and Discrimination," 139–40.

100 Guidebooks to San Francisco: See Levin, *Bohemia in America*, 307, 311.

100 "dynamite the baked": Hapgood, quoted in Stansell, *American Moderns*, 2.

100 As one guidebook put it: Reimer, *Bohemia*, quoted in Levin, 295.

100 The San Francisco bohemians: Dearborn, *Queen of Bohemia*, 179.

101 "male authority and female subservience": Kitty Cannell, quoted in Dearborn, *Queen of Bohemia*, 234.

101 "San Francisco supported a milieu": Stansell, *American Moderns*, 4.

102 "She could be seen": Stansell, *American Moderns*, 28.

102 "helping to shape": Rudnick and Heller, *1915: The Cultural Moment*, 71.

102 "We intend simply": "The New Woman."

102 In California, she cut it: George Schuyler described his wife as "blonde" in his

autobiography, perhaps to highlight her lightness as a white woman, perhaps because he preferred blonde women, perhaps because he could not recall his wife's hair color, though he dedicated the autobiography to her. Josephine was not a blonde but a brunette. At some point after marrying George, and possibly in deference to his preferences, she began to bleach her hair blonde. She also darkened her complexion. To date, published references to Josephine all repeat George's error. George Schuyler, *Black and Conservative*, 163.

103 "I know I'm not beautiful" . . . "And it always surprises": Josephine Cogdell, journal, 1927, Box 8, Schuyler Family Papers, Schomburg.

103 In California, Josephine was taken: In the United States, many raw-foodists trace their origins to Dr. St. Louis Estes, a former dentist, the founder of the Raw Food Eaters' Health Club and the author of an influential though controversial book, *Raw Food and Health* (still in print), which came out in 1927. Estes toured the country, offering himself as evidence of the benefits of a raw-food diet. "In middle age he was crippled, given up to die. 'Right food' cured him. Once he was bald. 'Right food' grew his hair again. By changing food he twice changed the color of his hair," *Time* magazine reported in 1934. "'A diet of natural food, that is, milk and raw fruits and vegetables, will cure baldness and bad teeth, rheumatism, weak eyes and ugly dispositions, and above all raw food will keep one slim and energetic.' Thirteen years ago, Dr. Estes . . . cured himself of paralysis . . . by eating raw food."

104 "All cooked food": Jannath, "Death and Diet [II]," 107.

104 "California was flaming": Anonymous [Josephine Cogdell Schuyler], "The Fall of a Fair Confederate," 530.

104 "an insular, irrelevant": Quoted in Dearborn, *Queen of Bohemia*, 177.

104 "Socialism has always drawn": Josephine Cogdell, journal, 1920, Box 8, Folder 3, Schuyler Family Papers, Schomburg.

104 "Like all intelligent": Josephine Cogdell Schuyler, "An Interracial Marriage," 274.

104 "A colored woman": Anonymous [Josephine Cogdell Schuyler], "The Fall of a Fair Confederate," 529.

105 "shame and guilt": Anonymous [Josephine Cogdell Schuyler], "The Fall of a Fair Confederate," 530.

105 "white chickens pecking": Anonymous [Josephine Cogdell Schuyler], "The Fall of a Fair Confederate," 531.

105 "exalted opinion": Anonymous [Josephine Cogdell Schuyler], "The Fall of a Fair Confederate," 530.

105 "began a novel": Anonymous [Josephine Cogdell Schuyler], "The Fall of a Fair Confederate," 531.

105 "a point of . . . classes and studios": Anonymous [Josephine Cogdell Schuyler], "17 Years of Mixed Marriage," 62.

105 It published her somewhat garbled: Cogdell, "Truth in Art in America," 634–35; Cogdell, "My Sorrow Song," 388; Cogdell, "Irony," 366; Cogdell, "Spring," 178;

Cogdell, "Those Inimitable Avatars," 302. I am grateful to Hania Musiol for helping me locate and obtain copies of these early race writings by Josephine Cogdell.

105 "A swift metamorphosis": Anonymous [Josephine Cogdell Schuyler], "The Fall of a Fair Confederate," 531.

106 "Everyone was madly in love with him": According to his daughter Lisa, that effect continued up until his death in 1971. Even as an old man, Garth was surrounded by a phalanx of adoring women wherever he appeared. Author's interview with Lisa Illia, February 18, 2011.

107 With her allowance: It is possible the banker "Paxton" gave her money.

107 "melancholy [that] had": Josephine Cogdell, undated diary, Box 8, Folder 9, Schuyler Family Papers, Schomburg.

107 Josephine sometimes had to pawn: In 1923, she pawned a diamond ring at Treister's Jewelers for which she reported receiving $975, a small fortune at the time.

108 "Nonsense": Josephine Cogdell Schuyler, undated diary [1920s], Box 8, Folder 5, Schuyler Family Papers, Schomburg.

108 "it's good enough" . . . "the same": Josephine Cogdell Schuyler, undated diary, July [1927], Box 8, Folder 11, Schuyler Family Papers, Schomburg.

108 She would also look: Author's interview with Lisa Illia, February 18, 2011.

110 "Socialists, Trade Unionists": Barnet, *All-Night Party*, 143.

110 In Greenwich Village: Josephine Cogdell Schuyler, undated diary [1927], Box 8, Folder 24, Schuyler Family Papers, Schomburg.

110 "large airy room" . . . "Village Yankees": Josephine Cogdell Schuyler, undated diary [1927], Box 8, Folder 24, Schuyler Family Papers, Schomburg.

111 "participation in suffrage": Stansell, *American Moderns*, 229.

111 "half-way through the door": Stansell, *American Moderns*, 231.

111 "living by one's wits": Levin, *Bohemia in America*, 150.

111 "Female Bohemians had to be": Freedman, "The New Woman," 393.

111 four thousand: DeBoer-Langworthy, *The Modern World of Neith Boyce*, 12.

111 "intellectually sterile": Anonymous [Josephine Cogdell Schuyler], "17 Years of Mixed Marriage," 63.

111 "new world": Johnson, *Along This Way*, 152. In the early years of the twentieth century, "Black Bohemia" was located not in Harlem but in the Tenderloin and San Juan Hill.

112 "In Harlem": Josephine Cogdell Schuyler, undated diary, Box 8, Folder 24, Schuyler Family Papers, Schomburg.

112 "The Fall of a Fair Confederate": Anonymous [Josephine Cogdell Schuyler], "The Fall of a Fair Confederate," 62.

112 "The fact that he was dark": Anonymous [Josephine Cogdell Schuyler], "17 Years of Mixed Marriage."

112 "There is a certain affinity": George Schuyler, *Slaves Today*, 183–84.

112 "Mecca": Anderson, *This Was Harlem*, 61.

113 "Only Negroes *belong* in Harlem": Robeson, *Paul Robeson*, 42, 44.

113 "was a place": Nugent, quoted in Watson, *The Harlem Renaissance*, 144.

113 "Everything about Harlem": Josephine Cogdell, undated diary, Box 8, Folder 9, Schuyler Family Papers, Schomburg.

114 "the intellectual pulse": Lewis, *When Harlem Was in Vogue*, 105.

114 thanks in part to the efforts: George Schuyler, *Black and Conservative*, 124.

114 "The popular idea of Harlem": Anonymous [Josephine Cogdell Schuyler], "The Fall of a Fair Confederate," 535.

114 "Intense political debates": Ransby, *Ella Baker*, 67.

114 "I found the group": Anonymous [Josephine Cogdell Schuyler], "17 Years of Mixed Marriage," 63.

114 "raise questions": quoted in Ransby, *Ella Baker*, 79.

114 "a notorious naysayer": Ferguson, *The Sage of Sugar Hill*, 183.

115 "'fundamental, eternal'": George Schuyler, "The Negro-Art Hokum," 662–63.

115 "*We* are not": George Schuyler, "Views and Reviews," July 3, 1926, 2.

116 "My whole life changed": George Schuyler, *Black and Conservative*, 163.

116 "something of an expert": Ferguson, *The Sage of Sugar Hill*, 143.

116 "How bawdy the music" Quoted in Talalay, *Composition in Black and White*, 19.

117 "the dream is the Superself": Schuyler and Schuyler, *Kingdom of Dreams*, 194.

117 "to help you": Schuyler and Schuyler, *Kingdom of Dreams*, 204.

117 "Altho I trembled with fear": Josephine Cogdell Schuyler, diary [1924?], Box 8, Folder 6, Schuyler Family Papers, Schomburg.

118 "neurotic disease": Schuyler and Schuyler, *Kingdom of Dreams*, 75.

118 "as far back": George Schuyler, *Black and Conservative*, 3–4.

118 "a good table . . . order and discipline": George Schuyler, *Black and Conservative*, 6.

118 "I was always to fight back": George Schuyler, *Black and Conservative*, 18.

119 George Schuyler couldn't get enough: George Schuyler, *Black and Conservative*, 60.

119 He worked as a porter: Peplow, *George S. Schuyler*, 20.

119 "full bosom . . . pretty good": George Schuyler, *Black and Conservative*, 98.

120 "The words 'Negro'": George Schuyler, "The Caucasian Problem," in *What the Negro Wants*, ed. Logan, 298.

120 "fundamental, eternal": George Schuyler, "The Negro Art Hokum," 663.

120 "At best, race is a superstitution": George Schuyler, *Black and Conservative*, 352.

120 "the *only* gentleman": Josephine Cogdell, undated diary, Box 8, Folder 9, Schuyler Family Papers, Schomburg.

120 "disappointed me": Josephine Cogdell, undated diary, Box 8, Folder 9, Schuyler Family Papers, Schomburg.

121 "liberal on the race question": George Schuyler, *Black and Conservative*, 163.

121 "Everything about Harlem thrilled me": Anonymous [Josephine Cogdell Schuyler], "The Fall of a Fair Confederate," 532.

121 "My sentimental views": Anonymous [Josephine Cogdell Schuyler], "The Fall of a Fair Confederate," 532.

121 "loyal . . . tribulations": George Schuyler, "Reminiscences," 159; George Schuyler, "Views and Reviews," February 6, 1926, 3; George Schuyler, "Speaking of History and Monuments," 16.

121 "would have been hard pressed": Ferguson, *The Sage of Sugar Hill*, 150.

122 love letters: E.g., George Schuyler to Josephine Cogdell Schuyler, March 28, 1929, Schomburg Center.

122 "Sex across the color line": Mumford, *Interzones*, xi.

122 "Something marvelous": Josephine Cogdell Schuyler, undated diary [1927], Schuyler Family Papers, Schomburg.

123 "invisible norm": Nell Painter, quoted in Alcoff, "The Unbearable Whiteness of Being."

123 "Even worse than what they": Anonymous [Josephine Cogdell Schuyler], "The Fall of a Fair Confederate," 533.

124 "Temptation": On "Temptation" as Josephine's poem, see Ferguson, *The Sage of Sugar Hill*, 274, n. 30. Although I agree that the poem is hers, Ferguson did not, until a recent phone conversation with me, consider it a satire. That earlier opinion is representative of the low regard many of George's biographers have long had for his wife.

124 "With George": Quoted by Talalay, *Composition in Black and White*, 21.

124 "I felt that what was good": Anonymous [Josephine Cogdell Schuyler], "The Fall of a Fair Confederate," 532.

125 Then, unexpectedly: Josephine Cogdell, undated diary [1927], Schuyler Family Papers, Schomburg.

126 "flabby bankers and brokers": Anonymous [Josephine Cogdell Schuyler], "The Fall of a Fair Confederate," 533.

128 "Experimenting with a Negro lover": Quoted by Talalay, *Composition in Black and White*, 37. Talalay provides no citation for this quote; it cannot be verified from extant original sources.

128 "When Black Weds White": George Schuyler, "When Black Weds White."

129 "I have gained the peace": Anonymous [Josephine Cogdell Schuyler], "The Fall of a Fair Confederate," 536.

129 "The violent American complex": George Schuyler, "When Black Weds White," 12.

129 "there was never a happier bride": Josephine Cogdell Schuyler, "An Interracial Marriage," 275.

129 "The race barrier": Anonymous [Josephine Cogdell Schuyler], "17 Years of Mixed Marriage," 65.

129 "I know up North" . . . "orthodox wife": Josephine Cogdell, undated diary [1927–28], n.p.; Schuyler Family Papers, Josephine Schuyler Collection, Schomburg.

130 "the mudsill upon which": George Schuyler, "Our Greatest Gift to America," in Johnson, ed., *Ebony and Topaz*, 124.

130 "intellectual Slave": Gordon, "Some Disadvantages of Being White," 79.

131 "want to play": Josephine Cogdell Schuyler, untitled fragment, "From Texas to Harlem with Love," 5. Different versions of this narrative appear, with different wording, in various draft versions of "From Texas to Harlem with Love." This version is quoted by Talalay, *Composition in Black and White*, 38. I have not been able to locate Talalay's transcription in extant copies of the manuscript. What follows draws from the diaries and fragments.

132 "inter-racial marriage": Lemire, *"Miscegenation,"* 150, n. 5.

132 "This is by far the easiest": Asbury, "Who Is a Negro?," 6.

133 But for some reason: Certificate and record of marriage, January 6, 1928, Certificate 2639, George S. Schuyler and Josephine Lewis, State of New York, New York Municipal Archives.

133 "a progressive deed": Dreisinger, *Near Black*, 7.

134 "As I stepped down": Josephine Cogdell Schuyler, manuscript fragment of "From Texas to Harlem with Love," chap. 16, edited draft, 9, Philippa Schuyler Unprocessed Papers, Schuyler Family Papers, Schomburg.

134 "You papa, you initiated me so": Josephine Cogdell Schuyler, manuscript fragment of "From Texas to Harlem with Love," chap. 16, edited draft, 5–6, Philippa Schuyler Unprocessed Papers, Schuyler Family Papers, Schomburg.

135 "The future war": Jannath, "America's Changing Color Line," 89.

135 "New Women": George Schuyler, "Emancipated Women and the Negro."

136 "spoiled": Joann Rhome Herring, daughter of Josephine's sister Daisy's oldest son, telephone interview, February 17, 2013.

137 "Taboo": Jannath, "Taboo," 307.

137 "My husband is a Yankee": Josephine Cogdell Schuyler, manuscript fragment of "From Texas to Harlem with Love," chap. 16, 342, Philippa Schuyler Unprocessed Papers, Schuyler Family Papers, Schomburg, 343–44.

137 "You are entering a new life": Josephine Cogdell Schuyler, manuscript fragment of "From Texas to Harlem with Love," chap. 16, 343–44, Philippa Schuyler Unprocessed Papers, Schuyler Family Papers, Schomburg.

138 "Anything that's alive": Jerome [Josephine Cogdell Schuyler], "Love Always Changing," 9.

139 "There are Negroes, of course": George Schuyler, "Our White Folks," 386.

139 "inside information": George Schuyler, "Our White Folks," 387.

139 "Knowing him so intimately": George Schuyler, "Our White Folks," 387.

140 "the moony scions": George Schuyler, "Our White Folks," 385.

140 "Lilliputians": George Schuyler, "Our White Folks," 391.

141 "Copious praise": Ferguson, *The Sage of Sugar Hill*, 126.

141 "the most recognizable name": Ferguson, *The Sage of Sugar Hill*, 125.

141 "particular kind of lie": Nancy Cunard, editorial footnote to Jannath, "America's Changing Color Line," in *Negro*, ed. Cunard, 88.

141 "There is no creature": Dorothea Gardner, "Black Women Strike Back," "National News," *Illustrated Feature Section* (short-lived national newspaper insert), May 19, 1932, 15, clipping in George S. Schuyler Papers, Syracuse University.

142 "dignified, friendly": Anonymous [Josephine Cogdell Schuyler], "17 Years of Mixed Marriage," 63.

142 "the wives of many": Ransby, *Ella Baker*, 81.

142 "irretrievable fall": Quoted in Ferguson, *The Sage of Sugar Hill*, 148.

142 But in his autobiography: George Schuyler, *Black and Conservative*, 124, 213. The single most important cultural institution of the Harlem Renaissance was its public library, with white librarian Ernestine Rose as its head. Extending principles of "localization" and "community self-expression" that she had developed in her work with immigrant groups, Rose encouraged exhibitions of local artists, reading groups on black history and literature, book clubs, symposia, and extensive programs of adult education, especially in African-American literature and African history. She hired the library's first black librarians, including Nella Larsen, and defended her interracial staff to its many detractors. "Before one race meets another on equal grounds, it must know and respect itself," she wrote. "Race knowledge must be stimulated and guided." See Rose, "Serving New York's Black City," 255–58; "Books and the Color Line," 75–76; "Where White and Black Meet," 467–71; "A Librarian in Harlem," 220. While rarely acknowledged in histories of the period, Rose had as much behind-the-scenes impact on Harlem Renaissance culture as Mary White Ovington did on its politics.

142 "Leaving Josephine to send": George Schuyler, *Black and Conservative*, 165–66.

143 "Leaving Josephine behind": George Schuyler, *Black and Conservative*, 167.

144 "animated discourse": Ransby, *Ella Baker*, 79.

145 "fed off their importance": Ferguson, *The Sage of Sugar Hill*, 149.

145 "George and Josie": untitled poem by W. P. Dabney, *Cincinnati Union*, October 16, 1930, n.p., clipping in the George S. Schuyler Papers, Syracuse University.

146 "love must be monogamous": Josephine Cogdell, undated diary, Schuyler Family Papers, Josephine Cogdell Schuyler Collection, Schomburg.

147 The Harlem Hospital: Gill, *Harlem*, 299.

147 "Women and children": Quoted in Ransby, *Ella Baker*, 75.

147 reduced his salary: Williams, *George S. Schuyler*, 47.

148 "Butcher Shop": Gill, *Harlem*, 285.

148 Ella Baker and other women friends: Ransby, *Ella Baker*, 81.

148 "Gargoyles of Color": Tanne [Josephine Cogdell Schuyler], "On Lenox," 338. Lenox Avenue is one of Harlem's main streets.'The poem's speaker is recording first impressions of the excitement of life in Harlem.

148 "Whites sometimes": Jannath, "America's Changing Color Line," in *Negro*, ed. Cunard, 86.

148 "extraordinarily productive": Peplow, *George S. Schuyler*, 26.

148 Many have noted a change: Peplow, *George S. Schuyler*, 48.

148 Often he was in areas: At one point, *The Pittsburgh Courier* even announced that Schuyler was "in the interior of Africa" and unable, owing to the "irregularity of the mail services," to send his usual pieces. *The Pittsburgh Courier*, April 25, 1931, 10; "Schuyler Abroad," *The Pittsburgh Courier*, April 4, 1931, 11–12.

149 "I know or have heard": Jannath, "America's Changing Color Line," in *Negro*, ed. Cunard, 85, 87.

150 If Josephine was right: On the asymmetries of "reverse passing," see Dreisinger, *Near Black*.

150 "bits of scandal": Josephine Cogdell, undated diary, Schuyler Family Papers, Josephine Schuyler Collection, Schomburg.

151 "moonlight" . . . "pure white womanhood": Jannath, "Deep Dixie," 87.

151 "*Damned* Good Story": William Pickens to Heba Jannath, March 4, 1931, Box 3, Folder 6, Schuyler Family Papers, Josephine Cogdell Schuyler Collection, Schomburg.

151 As Tanne, Josephine published: Tanne, "To a Dark Poem," *The Messenger*, March 1928. I base my claim that Laura Tanne is Schuyler on her style; on the fact that Tanne published only in the journals where Josephine Schuyler also published and only as long as Josephine was writing under pseudonyms; and on the fact that an exhaustive search for Laura Tanne, in any state at any time in the nation's records, reveals no one by that name. It is possible but highly unlikely, given George Schuyler's editorship of *The Messenger* at that time, that Tanne was a different woman publishing pseudonymously. However, her themes, as well as her style, were all those that Josephine was also working on.

151 "gross": Tanne, "Now I Know the Truth." Tanne, "The Avenue," 56. Tanne's poetry is occasionally sentimental about interracial love. For example, in one tableau, we see an interracial couple's stroll through snow: "He, brown, and I, pink-white— / Strange flowers of a common vine." Tanne, "The Avenue," 56. But more often, it is biting about the "cold Nordic" world that "lashes" the black man's soul. Tanne, "Barrier," 79. Most of the pseudonyms that I have come to believe were Josephine's are verifiable. I also suspect, but cannot verify, that Helna Issel is her. No such person appears in the U.S. Census or any other searchable

database from that time. Publishing in 1931, in *The Crisis*, during the height of Josephine's publishing years under other names, Issel celebrates loving a black man with the claim that her heart is made "light with the daring price it paid" for love. "There is no good like giving all for this." Issel, "While All May Wonder," 234. Josephine Cogdell published poems in *The Crisis* as Laura Tanne and Heba Jannath in numerous issues, including October 1928, December 1928, September 1929, May 1930, August 1930, September 1930, December 1930, May 1931, and July 1932. It is likely that poems published under the names Laura E. Forrest on May 1931, Helna Issel on July 1931, and Gwyn Clark on October 1931 are hers as well.

152 usually a masculine form: All of the principal satirists of the Harlem Renaissance— Wallace Thurman, Richard Bruce Nugent, Walter White, George Schuyler, Theophilus Lewis, Rudolph Fisher, J. A. Rogers, and others—were men.

152 Hence, anyone paying attention: See "Raggetybag" and "The Circle," published as "Two Poems by a Young Nordic Southerner."

153 "Believe me, I know": Jerome, "Love Always Changing," 9. I am grateful to Hania Musiol for helping me to locate copies of these columns.

153 "money is necessary": Jerome, "Money and Marriage," A7; Jerome, "Wait for the Right Mate," B4.

153 Think of marriage: Jerome, "Men Still Want to Marry," A4.

153 "your first duty": Jerome, "Divorce Better Than Disgust," 6.

153 "mercenary" . . . "calculating": Jerome, "Mrs. Jerome Praises the Modern Girl," B4.

153 "Couples should be pals": Jerome, "Treat Wives as Comrades," B3.

154 "sad are beautiful revenges": Josephine Cogdell Schuyler, diary, Box 8, Folder 5, Josephine Schuyler Papers, Schuyler Family Papers, Schomburg.

154 "Generally speaking": Anonymous [Josephine Cogdell Schuyler], "An Interracial Marriage," 275.

154 "an adventure in bitterness": Tanne, "On Lenox," 338.

154 She continued to call herself: Josephine's 1936 passport is the last one to list her occupation as "writer." Subsequent passports list it as "housewife." Josephine's passports are in her papers at the Schomburg Center for Research in Black Culture, cataloged, ironically enough, with the papers of her daughter and her husband.

155 Reporters were magnetized: See Bennett, "Negro Girl, 2½, Recites Omar and Spells 5-Syllable Words," 18; "Prodigious Crop," 27; "The Shirley Temple of American Negroes," 4; Bracker, "Child Composer, 8, Is Honored," 28; Mitchell, "An Evening with a Gifted Child," 8–31; Talalay, "All-American Newsreel," *Composition in Black and White*, 45–54.

156 "topple America's race barriers": Talalay, *Composition in Black and White*, 103.

156 "What glory she will reflect": George Schuyler to Josephine Cogdell Schuyler, October 20, 1935, Schomburg.

156 "Jody's desire to prove": Talalay, *Composition in Black and White*, 49.

156 "As I look back": Josephine Cogdell Schuyler, scrapbook, November 1936, Philippa Schuyler Papers, Syracuse University.

156 Both parents were followers: Talalay, *Composition in Black and White*, 55.

157 "widows": Josephine Cogdell Schuyler, scrapbook, 1936. Philippa Schuyler Papers, Syracuse University. When Philippa was five and Josephine needed to make a quick trip back to Texas to see her father, who was ailing, she left Philippa not with George but with a white woman friend, Edna Porter, for the duration of the ten-day trip.

157 "somewhat less" than his best: George Schuyler to Josephine Cogdell Schuyler, n.d., Schuyler Family Papers, Schomburg.

157 "Jody was Philippa's whole world": Talalay, *Composition in Black and White*, 59.

157 "obsessive need": Talalay, *Composition in Black and White*, 58.

157 "ruled by Philippa": Kathleen Houston, quoted by Talalay, *Composition in Black and White*, 222.

157 "she has no other influence": Josephine Cogdell Schuyler to George Schuyler, July 8, 1949, Schuyler Family Papers, Schomburg.

158 "greatest literary effort": Peplow, *George S. Schuyler*, 56.

159 "There was something lacking": George S. Schuyler, *Black No More*, 40.

159 "You are indeed": Josephine Cogdell Schuyler to W. E. B. Du Bois, February 19, 1931, W. E. B. Du Bois Papers, Manuscript Division, LOC.

159 "white literature": Van Doren, "Black, Alas, No More!" (review of *Black No More*), *Nation*, February 25, 1931, 218.

159 Josephine rushed to its defense: Josephine Schuyler, "Correspondence," 382.

160 "further right than Barry Goldwater": Talalay, *Composition in Black and White*, 97.

160 "Communist plot": George Schuyler, *Black and Conservative*, 187.

161 "I felt you had long ago": Josephine Cogdell Schuyler to George Schuyler, July 8, 1949, Schuyler Family Papers, Schomburg.

163 Carolyn: Carolyn Mitchell, the wife of one of their friends and later executrix of George's estate. The suicide note is at Schomburg and Syracuse.

Chapter 5: *Black Souls*: Annie Nathan Meyer Writes Black

169 "*Black Souls* is accusing them": Josephine Cogdell Schuyler to Annie Nathan Meyer, "Friday Morning" [1932], Box 13, Folder 1, Annie Nathan Meyer Papers, Jacob Rader Marcus Center, American Jewish Archives, Cincinnati, Ohio (hereafter abbreviated AJA).

170 not "authentic": Meyer, *It's Been Fun*, 268.

171 "felt utterly unworthy": Annie Nathan Meyer, journal entry dated April 6 [1924], Box 13, Folder 1, Annie Nathan Meyer Papers, AJA.

171 "Miss Ovington": Annie Nathan Meyer, journal entry dated May 14 [1924], Box 13, Folder 1, Annie Nathan Meyer Papers, AJA.

172 "Miss Ovington tho't play": Annie Nathan Meyer, journal entry dated June 7 [1924], Box 13, Folder 1, Annie Nathan Meyer Papers, AJA.

172 edit and authenticate: This practice was not altogether uncommon in the Harlem Renaissance. Van Vechten also used it with *Nigger Heaven*, which was read in galleys by James Weldon Johnson and Walter White and then authenticated and fact-checked by Rudolph Fisher. See Kellner, *Carl Van Vechten*, 211.

172 "keys me up": Zora Neale Hurston to Annie Nathan Meyer, May 12, 1925, in Kaplan, *Zora Neale Hurston*, 55, 58.

172 "*I must not let you* be disappointed": Zora Neale Hurston to Annie Nathan Meyer, May 12, 1925, in Kaplan, *Zora Neale Hurston*, 55.

172 "Your grateful . . . gratefully": Zora Neale Hurston to Annie Nathan Meyer, May 12, 1925; July 18, 1925; September 15, 1925; September 28, 1925; November 10, 1925, in Kaplan, *Zora Neale Hurston*, 55, 63, 62, 65, 68.

172 "immensely moving": Zora Neale Hurston to Annie Nathan Meyer, January 15 [1926], in Kaplan, *Zora Neale Hurston*, 78.

172 "I want to be the principal's wife": Zora Neale Hurston to Annie Nathan Meyer [Winter 1925–1926], in Kaplan, *Zora Neale Hurston*, 74.

172 "every one of the literary people": Zora Neale Hurston to Annie Nathan Meyer [Spring 1926?], in Kaplan, *Zora Neale Hurston*, 82.

172 "scouting around": Zora Neale Hurston to Annie Nathan Meyer [winter, 1925–1926], in Kaplan, *Zora Neale Hurston*, 73.

173 "[If] the book is published": Annie Nathan Meyer to Zora Neale Hurston, January 21, 1927, Box 7, Folder 3, Annie Nathan Meyer Papers, AJA.

173 "I hope you will like": Zora Neale Hurston to Annie Nathan Meyer, March 7, 1927, in Kaplan, *Zora Neale Hurston*, 91.

173 "would strike": Zora Neale Hurston to Annie Nathan Meyer, October 7, 1927, in Kaplan, *Zora Neale Hurston*, 108.

173 Meyer was committed: It is not clear whether Hurston and Meyer managed to meet before deciding to drop the project. The failed collaboration seemed to cause no bad feelings. They stayed in touch throughout the next decade, mostly by telephone, and Meyer continued to look for ways to support and endorse Hurston's growing career. Meyer recommended Hurston's first novel, *Jonah's Gourd Vine*, to Lippincott and read the novel in draft. When Hurston published her second book, *Mules & Men*, the collection of folklore and nonfiction by which she is best known today, she dedicated the book to Annie Nathan Meyer: "To My Dear Friend, Mrs. Annie Nathan Meyer, Who Hauled the Mud to Make Me But Loves Me Just The Same." They celebrated with one of Meyer's large, formal, elegant interracial teas on May 10. The party, at the Women's University Club in midtown (Meyer's Park Avenue apartment was much too cluttered for parties), gave the guests a chance to dress up and forget, for a few hours, that they were

in the middle of a depression. Hurston dressed in "a flaming white dress" and looked "like a movie actress." Robert Hemenway, transcript of interview with Bertram Lippincott, 1971, personal library of Robert Hemenway, University of Kansas. I am grateful to Robert Hemenway for providing access to those files.

173 "any manager bold enough": Annie Nathan Meyer, journal entry, June 7 [1924], Box 13, Folder 1, Annie Nathan Meyer Papers, AJA.

174 "To me the most original note": Meyer, *It's Been Fun*, 271.

174 "absolutely true to life": Josephine Cogdell Schuyler to Annie Nathan Meyer, January 4, 1933, Box 6, Folder 2, Annie Nathan Meyer Papers, AJA.

175 "Those policeman made me tell a lie": Gilmore, *Defying Dixie*, 121–22.

175 For white women, especially: Cunard, *Grand Man*, 98; Cunard, "Black Man and White Ladyship," reprinted in Moynagh, 190.

175 "we are two nations": Dos Passos, *The Big Money*, 371.

175 "the lynch machinery": Cunard, "Scottsboro and Other Scottsboros," in *Negro*, ed. Cunard, 252.

175 nine convictions: In May, the U.S. Supreme Court agreed to hear the case, but by November it had ruled only that the case be remanded to the lower courts which upheld the guilty verdicts and death sentences. The Alabama supreme court, in 1934, denied new trials for the Scottsboro Boys, but the U.S. Supreme Court, once again, agreed to hear the case. In 1935, the U.S. Supreme Court ruled that the absence of any blacks on the jury had denied the defendants their right to a fair trial, and the case was, once again, remanded to the Alabama courts, which, nonetheless, found the defendants guilty again. In 1937, the charges were finally dropped against four of the defendants. Of the remaining defendants, one was paroled in 1938, two in 1944, and one in 1946, and one, Haywood Patterson, escaped, was charged with murder after a barroom fight, was convicted of manslaughter, and died in prison. In 1976, Clarence Norris, the only convicted defendant still alive, was pardoned by Governor George Wallace. Norris died in 1989.

175 "our nation . . . emerge": Original program for *Black Souls*, opened Wednesday, March 30, 1932, Annie Nathan Meyer papers, Barnard College Archives, New York (hereafter abbreviated Barnard).

175 When the Provincetown Playhouse: Federal support for theater had not yet begun and would not begin until after 1933, following an appeal from George Biddle, Katherine Garrison Chapin Biddle's brother-in-law, to President Roosevelt. See http://wwcd.org/policy/US/newdeal.html.

176 "stands up & dares": Annie Nathan Meyer, journal entry, May 15, 1891, Box 13, Folder 1 Annie Nathan Meyer Papers, AJA.

176 "narrow, provincial": Nathan, *Once upon a Time and Today*, 50.

176 "we used our solid silver": Meyer, *It's Been Fun*, 67.

176 "imbued . . . with the spirit": Nathan, *Once upon a Time and Today*, 34.

177 "the nobility of Jewry": Meyer, *It's Been Fun*, 11.

177 Augusta Anne Florance: Even in Nathan family documents, "Florance" is sometimes spelled "Florence."

177 "well-to-do and surrounded": Meyer, *It's Been Fun*, 40.

177 "pursuits": Meyer, *It's Been Fun*, 163; Nathan, *Once upon a Time and Today*, 44, 45.

177 "heart-hungry, brain-famished": Meyer, *It's Been Fun*, 188.

177 "Men hate intelligent wives": Meyer, *It's Been Fun*, 157.

177 "stand out": Meyer, *It's Been Fun*, 120.

177 "the fighting Nathan sisters": Birmingham, *The Grandees*, 310.

177 "She did it mostly to spite Maud": Birmingham, *The Grandees*, 316.

177 "attracted a great deal of attention"; "most forceful of the Antis": Meyer, *It's Been Fun*, 205; 206.

178 "During the entire forty-six": Annie Nathan Meyer to Helen Worden, January 13, 1936, Annie Nathan Meyer Papers, AJA.

178 "heart-sick": Annie Nathan Meyer, journal entry, November 10, 1935, quoted in Goldenberg, "Annie Nathan Meyer," 307. Even recently, books that recount Meyer's founding tend to avoid the definite article in describing her. See, for example, Rosalind Rosenberg's careful rhetoric in her *Changing the Subject*, 2.

178 "grudging, grudging": Annie Nathan Meyer, journal entry, November 10, 1935, quoted in Goldenberg, "Annie Nathan Meyer," 309.

178 Jewish activists might become "white": According to many historians of whiteness, Jews were not yet considered fully white by the 1920s. See especially Brodkin, *How Jews Became White Folks*, and Jacobson, *Whiteness of a Different Color*. The history of black and Jewish relations is long, vexed, and also, sometimes, a model of political collaboration. See, e.g., Sundquist, *Strangers in the Land*. While much has been written on the complex history of black-Jewish relations, most of it focuses on the period following World War II, considered a "golden age" of black-Jewish alliance, and little of it specifically on white Jewish women or their work in black communities in the 1920s. Excellent work on that subject in later periods, however, includes Schultz, *Going South*, and Antler, *The Journey Home*.

178 "God! I'd like to be recognized": Annie Nathan Meyer, journal entry, July 2, 1924, in Goldenberg, "Annie Nathan Meyer," 258.

178 To cover the play's costs: Guerita Donnelly to Annie Nathan Meyer, April 8, 1932, Box 6, Folder 1, Annie Nathan Meyer Papers, AJA.

178 By the end of the fourth night: Eleanor Fitzgerald Expense Sheet, April 2, 1932, Box 6, Folder 1, Annie Nathan Meyer Papers, AJA.

179 "happy Negroes at a fish fry": Connelly's stage direction, Part I, Scene II.

179 "As you know," she wrote to Meyer: Josephine Cogdell Schuyler to Annie Nathan Meyer, "Friday Morning" [1932], Box 13, Folder 1, Annie Nathan Meyer Papers, AJA.

180 " 'Miss Verne, I begged you' ": Meyer, *Black Souls*, 58. All citations from the play are from this edition.

181 "I am absolutely certain": Zora Neale Hurston to Annie Nathan Meyer, October 7, 1927, emphasis in original, in Kaplan, *Zora Neale Hurston*, 108.

181 "reluctant to adopt": Perkins and Stephens, *Strange Fruit*, 6, 5. "Very few white women," Hazel Carby has written, "responded to the critiques" of black women who demonstrated their "compromised role . . . in the maintenance of a system of oppression." Carby, " 'On the Threshold of Woman's Era,' " 262–77. According to some historians, a comprehensive attempt to mobilize white women on these lines did not take place until the 1930s, when the Association of Southern Women for the Prevention of Lynching began "publicly accepting the responsibility that black women had been pointing out to them for decades." Perkins and Stephens, *Strange Fruit*, 7. On the difficulty of opting out of dominant ideology through what are sometimes called "negative performatives"—"count me out," "not in my name," or "don't do this on my account"—see especially Butler, *Gender Trouble*, and Parker and Sedgwick, *Performativity and Performance*, 9–10.

181 "about the worst enemies": Quoted in Perkins and Stephens, *Strange Fruit*, 23.

182 "a remarkably courageous and straightforward": Publicity brochure for *Black Souls*, Annie Nathan Meyer Papers, Barnard.

182 "one of the most powerful": James Weldon Johnson, publicity blurb for print edition of *Black Souls*. Two-page flyer of "country-wide enthusiasm" (including statements by George Schuyler and Mary White Ovington), Annie Nathan Meyer Papers, Barnard.

182 "unvarnished truths": Unpublished editorial, Annie Nathan Meyer Papers, Barnard.

182 "Black Souls . . . gives a true picture": Johns, review of *Black Souls*. A few black reviews were critical. The *New York Amsterdam News* felt that McClendon had been underutilized in the play, and *The Crisis* review, which accused the play of being "overladen with propaganda," prompted a long, angry exchange between Meyer and W. E. B. Du Bois, who apologized for the offense and explained that he had not been in town to review it personally. Annie Nathan Meyer, scrapbooks, AJA, and W. E. B. Du Bois to Annie Nathan Meyer, Annie Nathan Meyer Papers, AJA.

182 "The author has such": Promotional blurbs, notes found inside a draft of Meyer's essay, "Spreadhenism Again," Annie Nathan Meyer Papers, AJA.

182 fan letters: Frederich W. Hinnichs to Annie Nathan Meyer, April 18, 1932; Bell Lanafear Lewis to Annie Nathan Meyer, April 8, 1932; Estelle G. Platt to Annie Nathan Meyer, April 11, 1928, all in Box 6, Folder 1, Annie Nathan Meyer Papers, AJA.

182 it was also roundly dismissed: W. A. Vicker, *The American*, March 31, 1932; S.C., *New York Daily Mirror*, March 1932; *The Daily News*, March 31, 1932; *The New York Journal*, March 31, 1932; J.H., *The New York Times*, March 31, 1932; S.R., *The Sun*, March 31, 1932; B.W., *World Telegram*, March 31, 1932; N.S.K., *The Wall Street Journal*, April 6, 1932.

182 "a great deal of earnest talk": Waldorf, *New-York Evening Post*.

182 "The play fails": Barnes, *New York Herald Tribune*.

183 "has no authentic tang": Eaton, "Printed Drama in Review." Eaton's review referred both to the later book version of the play and to its staged production in 1932.

183 "What a pity it is": Arthur Huff Fauset to Annie Nathan Meyer, n.d., n.y., Annie Nathan Meyer Papers, Barnard.

183 "in advance": Josephine Cogdell Schuyler to Annie Nathan Meyer, January 4, 1933, Box 6, Folder 2, Annie Nathan Meyer Papers, AJA.

183 "I always felt": Annie Nathan Meyer to Margaret Christie, August 24 [n.y.], Annie Nathan Meyer Papers, Barnard.

183 "press storm": Eugene O'Neill to Kenneth Macgowan, January 12, 1934, in Bryer, ed., *The Theatre We Worked For*, 207.

183 "more publicity before production": Macgowan, "O'Neill's Play Again," X2.

183 "A romantic scene": Frank, "Tempest in Black and White," 77.

183 "doomed passion": Frank, "Tempest in Black and White," 77.

183 "tragically brief run": Arthur Huff Fauset, unpublished review of *Black Souls*, Annie Nathan Meyer Papers, Barnard.

183 "ever narrowing band": Arthur Huff Fauset, quoted in Annie Nathan Meyer to John Hope, July 14, 1932.

184 "brilliant and peppery": George Schuyler, *Black and Conservative*, 213.

184 "landmark": Arthur Huff Fauset, unpublished review of *Black Souls*, Annie Nathan Meyer Papers, Barnard.

184 "some white educator of colored people": Annie Nathan Meyer to Nicholas Murray Butler, June 4, 1924, Box 1, Folder 6, Annie Nathan Meyer Papers, AJA.

184 "When persons didn't know": Meyer, *It's Been Fun*, 268.

184 "It is the biggest piece of work": Annie Nathan Meyer to Rita Matthias, September 25, 1924, Box 6, Folder 1, Annie Nathan Meyer Papers, AJA.

184 "wonderful letters of appreciation": Annie Nathan Meyer to James Weldon Johnson, July 14, 1932, Box 6, Folder 1, Annie Nathan Meyer Papers, AJA.

184 "the Negroes should raise the money": Promotional materials for *Black Souls*, Annie Nathan Meyer Papers, AJA.

184 "Zora Hurston said I really penetrated": Annie Nathan Meyer to "Miss [Margaret] Christie," August 24 [1943], Annie Nathan Meyer Papers, AJA.

185 "Mammies": Meyer, *It's Been Fun*, 268.

185 "happy-go-lucky": Johnson, "Preface," in *The Book of American Negro Poetry*.

185 "I studied and read": Annie Nathan Meyer to Miss [Margaret] Christie, August 24 [1943], Annie Nathan Meyer Papers, AJA.

185 His relations with white liberals: Davis, "John Hope."

185 "Your visit with my wife": John Hope to Annie Nathan Meyer, October 18, 1924, Box 6, Folder 1, Annie Nathan Meyer Papers, AJA.

185 "returned from Atlanta Ga.": Annie Nathan Meyer, journal entry, May 14 [1924], Annie Nathan Meyer Papers, AJA.

186 "I was not writing": Meyer, *It's Been Fun*, 4.

186 "This [*Black Souls*]": Meyer, *It's Been Fun*, 268.

186 "the first play": Annie Nathan Meyer to Grace Nail Johnson, August 7, 1931, James Weldon Johnson, MSS Johnson, Series II, Box 33, Folder 152, Beinecke Rare Book and Manuscript Library, Yale University, New Haven, Conn. (hereafter abbreviated Beinecke).

186 "deserted lighthouse": Meyer, *It's Been Fun*, 260–61.

186 "presented in societies": Meyer, *It's Been Fun*, 270.

186 "distinct genre of American drama": Perkins and Stephens, *Strange Fruit*, 4.

187 Very few antilynching plays: Ovington's biographer does not even call *The Awakening* an antilynching play; she calls it an "NAACP recruitment play." Wedin, *Inheritors of the Spirit*, 182.

187 The black plays in this tradition: See Johnson, *A Sunday Morning in the South*; Miller, *Nails and Thorns*; and Livingston, *For Unborn Children*. See also Howell, *The Forfeit*, the first white-authored play in the tradition, and also Link, *Lawd Does You Undastahn*. Perkins and Stephens provide an excellent overview of the tradition.

187 "find out for yourself": Advertising brochure for *Black Souls*, Annie Nathan Meyer Papers, AJA.

188 "I have great faith": Annie Nathan Meyer to James Weldon Johnson, June 17, 1934, JWJ MSS Johnson, Series II, Box 33, Folder 152, Beinecke.

188 By mid-July: Her contract specified 112 5-by-7½-inch pages, printed in Bodoni—a very modern typeface—on Flemish Book White Dove paper. It also specified stitched bindings, a red-and-black paper cover, and a green cloth cover.

188 town house neighborhood: See Gross, *740 Park*.

189 "rehearsed devotedly": Meyer, *It's Been Fun*, 270.

189 "Here is realism": Ovington, scrapbook, Box 22, Folder 3, Annie Nathan Meyer Papers, AJA.

189 "*Black Souls* is so unusual": George Schuyler, "Views and Reviews," December 2, 1933.

189 In his yearly retrospective: Once they'd read what Locke had written about Annie, however, Mason and Hurston may both have felt relieved that he'd ignored them. He called *Black Souls* "a propaganda piece, of good intentions and laudable sympathy, but decidedly weak in dramatic conception and execution." Locke, "Black Truth and Black Beauty," 14. Predictably, Meyer was incensed. Next to her scrapbook copy of Locke's review she wrote: "Zora Hurston told me Locke always sneered at people who didn't kowtow to him. Mary White Ovington

and George Schuyler confirm this." Annie Nathan Meyer, scrapbook, Box 22, Folder 3, Annie Nathan Meyer Papers, AJA. Fortunately, *Opportunity* quickly assigned a second review of *Black Souls* to theater critic Montgomery Gregory. His opinion could hardly have been more different from Locke's. Calling Meyer a "pioneer" (her favorite word), Gregory praised the play as "an important social document and a dramatic tour-de-force. . . . It is impossible," he went on, "to do justice to 'Black Souls' in a review." Gregory, *Opportunity*, May 1933, 155–56.

189 Gloss Edwards: Annie Nathan Meyer to Gloss Edwards, July [1946], Box 6, Folder 2, Annie Nathan Meyer Papers, AJA.

190 What she needed to be "happy": Annie Nathan Meyer to Margaret Christie, November 3, 1943, Annie Nathan Meyer Papers, Barnard.

190 "Negro student": Meyer, "Negro Student Problems," 145–46.

190 used her platform: Given her lifelong dedication, Rosenberg's assertion that Meyer "abhorred politics" is surprising. Rosenberg, *Changing the Subject*, 52.

190 "broad-minded white women": Annie Nathan Meyer, journal entry, April 6 [1924].

191 "The more I think of it": Annie Nathan Meyer to Frank Shay [producer, Barnstormers' Theatre, Provincetown, Mass.], May 6, 1926, carbon, Box 1, Folder 7, Annie Nathan Meyer Papers, AJA.

191 two-part profile: Taylor, "The Doctor, the Lady, and Columbia University."

191 "Annie's names, married and maiden": Kendall, *"Peculiar Institutions,"* 81.

192 At one point she even developed: Clifford Mitchell, *Los Angeles News Dispatch*, November 18, 1932; Annie Nathan Meyer scrapbooks, Box 22, Folder 3, Annie Nathan Meyer Papers, AJA.

192 "worth living for": Annie Nathan Meyer, journal entry dated April 6 [1924], Box 13, Folder 1, Annie Nathan Meyer Papers, AJA.

192 "I was always more of a pioneer": Annie Nathan Meyer to Emma Bugbee, *New York Herald Tribune*, October 6, 1939.

192 "It is of no more use": Meyer, *It's Been Fun*, 3.

Chapter 6: Charlotte Osgood Mason: "Mother of the Primitives"

193 "Mother of the Primitives": Zora Neale Hurston to Charlotte Osgood Mason, March 10, 1931, Zora Neale Hurston to Cornelia Chapin, February 29, 1932; Zora Neale Hurston to Charlotte Osgood Mason, September 28, 1932, all in Kaplan, *Zora Neale Hurston*, 212, 244, 273.

193 "I am eternally black": Charlotte Osgood Mason to Alain Locke, December 10, 1927, Alain Locke Papers, Moorland-Spingarn Research Center, Howard University, Washington, D.C. (MSRC).

193 "I am a Black God": Charlotte Osgood Mason to Alain Locke, April 1, 1928, draft 2, Alain Locke Papers, MSRC.

193 "Mrs. Mason . . . is one of the mysteries": Hemenway, *Zora Neale Hurston*, 104.

193 "I saw Langston": Harold Jackman to Countée Cullen, January 3, 1929, Countée Cullen Papers, Amistad Research Center, Tulane University, quoted in Rampersad, *The Life of Langston Hughes*, Vol. 1, 157.

194 There was her failed stint: Zora Neale Hurston to Charlotte Osgood Mason, September 25, 1931, in Kaplan, *Zora Neale Hurston*, 228–29.

195 "Harlem is an all-white": McKay, *A Long Way from Home*, 133, 49.

195 "no dollars": Langston Hughes to Carl Van Vechten, May 8, 1929, in Hughes and Van Vechten, *Remember Me to Harlem*, ed. Bernard, 64.

195 "I never expect": Hurston, *Dust Tracks*, 155.

195 The most powerful publishers: Carl Van Vechten's daybook, Wednesday, November 5, 1924, in Van Vechten, *Splendid Drunken Twenties*, ed. Kellner, 60.

195 Van Vechten recommended: For a few years knowing blacks was his passion: he ticked off the date he met each one with a carefully noted "met" after their names, with all the scrupulousness of a collector.

195 "bright pink, pale purple": Van Vechten, *Splendid Drunken Twenties*, 213.

195 "the midtown branch": Kellner, *Carl Van Vechten*, 162.

195 "I stir Blanche & Alfred": Van Vechten, *Splendid Drunken Twenties*, 241.

196 Van Vechten's "Negrophilia": On Van Vechten's love of blackness, see especially Bernard, *Carl Van Vechten*, 13.

196 "passion for blackness": Bernard, *Carl Van Vechten*, 1.

196 "not worth knowing": Williams, *Seeing a Color-Blind Future*, 74.

196 "Every porter in the country": Van Vechten, *Splendid Drunken Twenties*, 200; Kellner, *Carl Van Vechten*, 214; see also Hughes, *The Big Sea*.

196 He thrilled to being: Bernard, *Carl Van Vechten*, 217.

196 Although blacks were anxious: Kellner, *Carl Van Vechten*, 200.

196 In 1929, when Essie Robeson: Carl Van Vechten to Alfred Knopf, June 25, 1929, Box 728, Folder 9, Knopf Papers, HRC.

196 "frightful anger": Carl Van Vechten, daybook entry, Thursday, December 19, 1929, in Van Vechten, *Splendid Drunken Twenties*, 269.

197 Park Avenue, by the time: Trager, *Park Avenue*, 105.

197 "sedate gentility": Ferber, *A Kind of Magic*, 91.

197 Apartments such as Mason's: www.dollartimes.com/calculators/inflation.htm.

198 "one of the two dearest": Alain Locke to Charlotte Osgood Mason, July 26, 1932, Alain Locke Papers, MSRC.

198 "true conceptual mother": Zora Neale Hurston to Charlotte Osgood Mason, May 10, 1931, in Kaplan, *Zora Neale Hurston*, 218.

198 "It was all very wonderful": Hughes, *The Big Sea*, 312ff.; 315.

198 "shadowy" . . . cash: Kellner, ed., *Harlem Renaissance*, 237; Lewis, *When Harlem Was in Vogue*, 151, 154, 155.

198 "The purse strings": Kellner, "Refined Racism," in *The Harlem Renaissance Re-Examined*, ed. Kramer, 96.

199 "So little is known today": Kellner, *The Harlem Renaissance*, 237. See also Stewart, "A Biography of Alain Locke," 323, unpublished; Lewis, *When Harlem Was in Vogue*, 151.

200 "The Angel in the House": Woolf, "The Professions of Women." From *The Death of the Moth*. Reprinted in Barrett, ed. *Virginia Woolf*, 59.

200 There was railroad and industrial: Sarah Joris Rapalje was born on June 9, 1625, in Albany, New York. See also census records, Franklin Township, 1860, Schedule 1, p. 85: census records, Borough of Princeton, 1870, Schedule 1, p. 64; census records Somerville, Somerset County, New Jersey, 1880, Schedule I, p. 5 (for Charlotte's brother, Peter); census records, Borough of Princeton, 1880, Schedule I, p. 26; census records, Borough of Manhattan, 1920, District 1, Sheet 16A, 6901 (Charlotte is listed as living with her maid Mary Beggans), with the Chapins on West 51st Street in 1920—she frequently stayed elsewhere while her apartment at 399 Park Avenue was being packed, readied after a trip, or worked on; census records, Borough of Manhattan, 1930, District 21574, p. 5643 (she is not listed at 399 Park Avenue in the 1930 census even though she was living there at the time; most likely she was out when the census taker came by or, even more likely, refused to answer his questions).

200 As was common: Quick, *A Genealogy of the Quick Family*.

200 Her great-great-grandfather: Charlotte Mason's 1927 "Alain Locke" notebook, April 19, 1927, Alain Locke Papers, MSRC.

200 "old doctrine": Howe, "Introduction," in *Woman's Work in America*, ed., Meyer, 1.

200 "More dangerous": Meyer, "Editor's Preface," in *Woman's Work in America*, iv.

201 roughly six hundred: The census counted 610 families in 1870. Students who boarded with families were not part of the count. United States Census, Borough of Princeton, June 27, 1870, 68.

201 They lived in a neighborhood: United States Census, Borough of Princeton, June 27, 1870, 64.

201 "a suitable school": Peterson, "As Princeton Changes a Black Community Fears for Future," B2. "The top religious leaders in the Confederacy" were all Princeton students. Twenty-two Southern senators were educated at Princeton before the war. Maynard, in *Princeton Alumni Weekly*.

202 "Indeed, as many Princetonians died": Maynard, in *Princeton Alumni Weekly* 111.

202 She was left mostly on her own: All around her, the college students were gearing up for leading the nation, the civic mission that was central to their education, while young women like herself were being raised to become wives and mothers, "angels in the house." Kemeny, *Princeton in the Nation's Service*, 10–11 and passim.

203 Members of the Chapin family: Author's interviews with Schuyler Chapin, Frances Biddle, and Stephen Biddle.

203 One day, at the height: "James C. Johnson," *Princeton Press*, Saturday, May 16, 1896. Hageman's history identifies the woman as Theodosia Prevost, probably an error.

203 Johnson paid Provost back: Hageman, *History of Princeton*, 269.

203 According to one family member: His first wife, Marianne Goodwin, died of pneumonia in 1880.

203 Such addictions were fairly common: Author's interview with Phoebe Eaton, Mason's step-granddaughter, May 2, 2005. I am deeply grateful to the Biddles, Steve and Frances, for accompanying me on this interview.

204 In New York, he was the darling: On how the Civil War changed national understandings of death, grief, mourning, and the afterlife, see Faust, *This Republic of Suffering*.

204 "born sensitive": Mason, *Hypnotism and Suggestion*, 10. In her husband's view, "sensitives" were to be found not only among many different people and sometimes even "very young children" but also among "animals, especially horses and dogs." Mason, *Telepathy and the Subliminal Self*, 302–3; 283.

204 "divine energy": Mason, *Hypnotism and Suggestion*, 288.

204 Dr. Mason could now devote: Mason's particular specialty was hypnosis. He claimed, through hypnotic therapy, to have cured an extraordinary array of ailments in children and adults. He boasted of such pediatric successes as relieving a five-year-old girl of persistent nightmares about a black man; giving strength and courage to a seven-year-old "cry baby"; and curing a number of adolescent epileptics of all seizures and symptoms. His adult success stories were even more varied. They included a male homosexual who reversed his preference for men; a chronic masturbator and smoker who gave up "self abuse" altogether and also cut back on his smoking; a young mother whose breast milk would not come in; a hypochondriac; a paranoid with persecution hallucinations; various melancholics, drunks, addicts, neurasthenics, and patients with paralysis, stage fright, hallucinations, and insanity. See also Mason, *Telepathy and the Subliminal Self*; Mason, *Hypnotism and Suggestion*; Mason, "Duplex Personality"; Mason, "Alternating Personalities"; Mason, "Educational Uses of Hypnotism"; Mason, "Educational Uses of Hypnotism"; Mason, "Forms of Suggestion Useful in the Treatment of Inebriety"; Mason, "The Influence of Hypnotic Suggestion upon Physiological Processes"; Mason, "The Genesis of Genius"; Mason, "Some Cases Treated by Hypnosis and Suggestion"; Mason, "The Educational and Therapeutic Value of Hypnotism"; Mason, "What Is Genius?"; Mason, "Professor Fiske and the New Thought"; Mason, "Is It Wise for the Regular Practising Physician to Spend Time to Investigate Psychic Therapeutics?"; Mason, "Typical Cases of Clairvoyance"; "Dr. Mason on Telepathy"; Mason, "Some Facts Concerning Hypnotism"; Mason, "Drink"; Mason, "A Life of Pasteur"; Mason, "Concerning Supernormal Perception"; Mason, "William Blake: Artist, Poet, Visionary"; Mason, "Value of Psychical Research"; Mason, "Character"; Mason, "Telepathy"; Mason, "Life After Death"; Mason, "Hypnotism: The Attitude of Physicians Toward It from Mesmer to Charcot." See also his newspaper series, cited in the bibliography.

205 Among the cases he claimed to have cured: Mason, *Hypnotism and Suggestion*.

205 If the "ego": Mason, *Telepathy and the Subliminal Self*, 143; Mason, *Hypnotism and Suggestion*, 290.

205 "the most important work": Mason, quoting William E. Gladstone on the overall efforts of the Society for Psychical Research, *Hypnotism and Suggestion*, 305.

205 In a series of newspaper stories: The series, entitled "In the Field of Psychology: Reports of the Scouts Who Have Been Exploring," was published in *The New York Times* on October 22, 1893; November 5, 1893 November 12, 1893; November 19, 1893; and December 3, 1893.

205 "Our western civilization": Mason, *Telepathy and the Subliminal Self*, 255.

205 "materialistic, hard, mechanical": Mason, *Telepathy and the Subliminal Self*, v.

205 "standing apart and singing": Mason, *Hypnotism and Suggestion*, 272.

205 His wife agreed: Spiritualism's American origins, in the spring of 1848, were tailor-made for divided opinion. On March 31, in Hydesville, New York, Catherine and Margaretta Fox, Methodist adolescents, reported a rapping noise with which they could—they said—communicate by finger clicks and knocks. They claimed to be in touch with the spirit of one Charles B. Rosna, a murdered peddler buried in their farmhouse basement. Igniting a national craze for all forms of communicating with the dead, from automatic writing with planchettes and Ouija boards to séances and mediums, the Fox sisters gave rise to hundreds of self-declared mediums in the Finger Lakes region of New York alone, thousands of national spiritualist societies, and perhaps millions of adherents to spiritualism by the 1850s—in short, a "full-scale cultural fad." P. T. Barnum even exhibited the sisters in his New York museum, adding to their renown. In 1888, however, the Foxes exposed their own psychic powers as an elaborate hoax, produced by making popping noises with their toes:

> *My sister Katie was the first to observe that by swishing her fingers she could produce certain noises with her knuckles and joints, and that the same effect could be made with the toes. Finding that we could make raps with our feet—first with one foot and then with both—we practiced until we could do this easily when the room was dark. . . . A great many people when they hear the rapping imagine at once that the spirits are touching them. It is a very common delusion.*

Some followers were devastated by the confessions of fraud, so much so that many refused to believe them, clinging tenaciously to the consolation that communicating with the dead had given them. The November 23, 1904, discovery of a man's headless skeleton buried in the wet earth beneath a hidden inner foundation of the girls' Hydesville home, along with recanted confessions by one of the sisters, bolstered their original story. For others, the body meant little. "What of it?" *The New York Times* asked. "It [the body] would only show that they were shrewd enough to exploit a local mystery to their own profit and the ludicrousness fooling, first, a few credulous rustics, and later a few hundred or thousand equally credulous urbanites." Only those with "peculiarly constructed minds," the *Times* maintained, would see corroboration in the body's discov-

ery. The *Times*, along with other national papers, inveighed against spiritualist "ghost-hunting" as nothing but "tricks" played by those "chiefly concerned with living without working." Some contemporary clergy warned that spiritualism was an "incursion . . . [of] unclean and fallen spirits" and that "tampering with demons" would induce "degeneration." For many, the spiritualists belonged in the same category as quacks, confidence men, and charlatans like John R. Brinkley, who promised sexual vitality to the thousands of unwitting patients who allowed him to surgically implant goat testicles into their scrotums, many dying under his hands. Others associated spiritualism with "black magic," "devil worship," and "witchcraft" and viewed believers as being under the sway of "mania," "superstition," "chicanery," "epidemic delusion," or worse.

The sisters remained, even long after their deaths, exemplars of the peculiarly American battles between faith and facts, tradition and rebellion. Thousands of followers remained loyal to them, in spite of everything. For believers, the Fox sisters' strange saga was proof that society hounded nonconformists, an attitude that drew many to the spiritualists' side: Mary Todd Lincoln, James Fennimore Cooper, Horace Greeley, abolitionists and feminists such as Isaac and Amy Post, William Lloyd Garrison, Frederick Douglass, Susan B. Anthony, Sojourner Truth, and others who were open-minded to unorthodox beliefs.

American and British scientists and professionals seeking to dissociate spiritualism from its discredited popular variant banded together to form the Society for Psychical Research. The organization attracted such members as William James (the president of the society from 1894 to 1895), the British physicist Oliver Lodge, and the philosopher Henri Bergson. Making spiritualism respectable was, nevertheless, an uphill battle. It called for unimpeachable scientific spokesmen. It also needed advocates of unimpugnable integrity. Rufus Osgood Mason presided over the establishment of the society's New York chapter, wrote two books on hypnotism and telepathy, published half a dozen essays on "related phenomena" in medical journals, and produced a running column on the paranormal for *The New York Times*, passionately defending in his pages what the paper's own editorialists were simultaneously decrying in theirs.

206 "heal . . . spirit": Mason, "The Passing of a Prophet," 875.

206 "every little mingapoop": Mason to Locke, April 17, 1932, Collection of Mrs. Edmund Randolph Biddle and Stephen G. Biddle, Quakertown, Pa. (hereafter abbreviated Quakertown); Mason to Miguel Covarrubias, August 25, 1930, Quakertown.

206 "flaming pathway": Mason to Locke, May 1, 1932, Alain Locke Papers, MSRC.

206 "magic bridge": Mason to Locke, May 1, 1932, Alain Locke Papers, MSRC.

206 "As the fire burned in me": Charlotte Osgood Mason to Alain Locke, May 1, 1932, Alain Locke Papers, MSRC.

206 He died at home: Certificate of death, Rufus Osgood Mason, May 11, 1903, State of New York, Certificate 14751.

207 Social healers offered orientalism: On the latter, especially, but also on the

broader mass interest in cures, see Brock, *Charlatan*; Holbrook, *The Golden Age of Quackery*; Hoberman, *Testosterone Dreams*; Boyle, *The Road to Wellville*.

208 "the primitive element": Mason to Locke, June 19, 1927, James Weldon Johnson, MSS 26, Box 111, Folder 2079, emphasis in original. "Anglo Saxon culture sucks the life blood out of the soul of art that is being born in this civilization," she also noted. Charlotte Osgood Mason, February 20, 1927 [second entry], Alain Locke Notebook, Alain Locke Papers, MSRC.

208 "the most delectable": James, *Washington Square*, 23.

208 liberal family: Her father, George, spent time at Brook Farm and married Anna Shaw, whose brother Robert led the all-black 54th Regiment from Massachusetts during the war.

208 "sincere, intense aversion": Patterson, *Natalie Curtis Burlin*, 21. I am grateful to Michelle Patterson for sharing her biography with me in manuscript.

208 Robert Gould Shaw: Shaw's self-sacrifice and his family's insistence that he be buried with his black troops achieved for him an iconic status as a martyr for racial justice almost unmatched in American history (this status continued throughout the Harlem Renaissance and endures today in films such as *Glory*). He is enthroned as a white crusader for racial justice alongside John Brown and William Lloyd Garrison, for example, in Paul Laurence Dunbar's poem "Robert Gould Shaw" and Benjamin Brawley's poem "My Hero." See Bundy, *The Nature of Sacrifice*.

208 Anna's sister, Josephine: See Waugh, *Unsentimental Reformer* and Bundy, *The Nature of Sacrifice*.

208 "The sphere of the family": Curtis, *Orations and Addresses*, 230.

208 "moral courage": Curtis, "Life of a Gifted Woman," 17.

208 "whose sex forbade them": Oliver Wendell Holmes, "Memorial Day: An Address Delivered May 30, 1884, at Keene, N.H., before John Sedgwick Post No. 4, Grand Army of the Republic," anthologized in *The Essential Holmes*, ed. Posner, 80.

209 "I want to have": Natalie Curtis to Elizabeth Day, June 29, 1890, Natalie Curtis Papers, Danbury, Conn., quoted in Patterson, *Natalie Curtis Burlin*, 43.

209 "warm interest": Patterson, *Natalie Curtis Burlin*, 104.

209 "restless and rebellious women": Babcock and Parezo, eds., *Daughters of the Desert*, 1.

209 "'living ruins'": Patterson, *Natalie Curtis Burlin*, 84.

209 "sunset hour": Jean Toomer's *Cane*, one of the most important works of the Harlem Renaissance, echoed that sense that "the sun is setting on a song-lit race of slaves, [but] it has not set." "Song of the Son," in Toomer, *Cane*.

209 "the direct utterance"; "age": Curtis, *The Indians' Book*, xxi, xxix.

209 "I resented": Natalie Curtis Burlin to George Foster Peabody, October 16, 1921, quoted in Bredenberg, "Natalie Curtis Burlin." Bredenburg is a relative of Na-

talie Curtis Burlin and maintains a website and some of her archive. I am grateful for the information he provided me in our interview of June 14, 2008, which confirmed that there are no letters between Curtis and Mason contained in the archives he maintains.

209 "the Southwest was quite literally overrun": Lavender, *Scientists and Storytellers*, 21. Boas's endorsement of fieldwork and support for women ethnographers was radical. His students sought to prove that gender, like race, was culturally constructed. They wanted "to explode assumptions about women's natural capabilities by illustrating the ways in which women defied such classifications once cultural restrictions were removed."

210 "staged authenticity" . . . "artist-demonstrators": Weigle and Babcock, eds., *The Great Southwest*, 157. Weigle and Babcock are quoting here from Harvey House promotional and tourist materials. In addition to selling specially designed jewelry, beadwork, and small weavings for tourists, the Fred Harvey Company amassed the nation's finest collection of high-end artifacts, ensuring that wealthy collectors such as William Randolph Hearst would have to work through the company and its official-sounding "Indian Department" to acquire goods and making itself the key power broker to the new museums just then seeking to build their collections. Collecting was quickly becoming a race against time, and the Harvey House enterprise consolidated its control by employing most of the nation's foremost anthropologists and ethnologists, paying them to collect and also to write copy: catalogs of the Harvey House collections and books, brochures, and printed material that could both legitimize the Harvey House collections and serve as travel information.

210 Mason and Curtis disdained: Curtis, "New Art in the West," 17.

210 he invited Natalie to sing: Dalton, *Theodore Roosevelt*, 314.

210 "closed completely that door to the [other] white man": Charlotte Osgood Mason to Alain Locke, August 16, 1927, Alain Locke Papers, MSRC. Hurston, fascinated with the same phenomenon, later called it "feather bed resistance" and made the strategy a bedrock of her folklore collections and her own life strategies as well.

210 "speaks with the straight tongue": Curtis, *The Indians' Book*, xxiii. Some of their competitors, however, were far more skeptical. Mabel Dodge, resentful of other New Yorkers moving into a Southwest she hoped to claim for herself alone, described Curtis (she did not mention Mason) as blind to her own condescension. "I think she never knew the Indians laughed kindly at her way of singing Indian music," she said, oblivious, perhaps, of the possibility—if she was right—that she, too, might have been the target of some "kindly" derision. Luhan, *Edge of Taos Desert*, Vol. 4, 70.

211 "monotonous barbaric chanting": Curtis, "An American Indian Composer," 626.

211 "a new way of packaging racism": Krasner, *A Beautiful Pageant*, 59.

211 "What a problem": Natalie Curtis to Aleš Hrdlička, March 30, 1916, quoted in Patterson, *Natalie Curtis Burlin*, 193.

211 "Do we tend to become": Curtis, *The Indians' Book*, 584.

212 Max Eastman as Katherine's private tutor: Max Eastman to Mrs. O. Mason, May 5, 1911, Box 4, Folder 33, Francis Biddle Papers, Special Collections Research Center, Georgetown University Library, Washington, D.C. (hereafter abbreviated Georgetown). Among other books he suggested in 1911, he stressed the need for Katherine to read Thorstein Veblen's *The Theory of the Leisure Class*.

212 A matching third ring: I am grateful to Frances and Steve Biddle for this and other information shared during many conversations in Wellfleet, Mass., and Bryn Mawr, Pa.

212 "there is never quite paper enough": Katherine Garrison Chapin to Francis Biddle, July 24, 1917, Box 1, Folder 2, Katherine Garrison Chapin Biddle Papers.

212 Katherine's descendants have told me: I am grateful to Schuyler Chapin, Frances Biddle, and Stephen Biddle for their time and candor.

213 "to keep extant": Natalie Curtis to Dr. H. B. Frissell, May 7, 1911, quoted in Patterson, *Natalie Curtis Burlin*, 201.

213 "the country's promise": Curtis, "The Winning of an Indian Reservation," 330.

213 Hampton Institute: Mason, as a Hampton donor, presumably approved its vocational model.

213 "Great Happiness" . . . "not in the Social Register": Natalie Curtis to "Aunt Natalie," May 27, 1917; A. Curtis to G. Curtis, August 18, 1917, quoted in Patterson, *Natalie Curtis Burlin*, 279, 282.

214 "Don't, in your interest": Natalie Curtis to "Friends," July 13, 1921, quoted in Patterson, *Natalie Curtis Burlin*, 319.

214 "a kind of bible": Patterson, *Natalie Curtis Burlin*, 232.

214 According to most sources: Rampersad, *The Life of Langston Hughes*, vol. 1; Harris and Molesworth, *Alain L. Locke*; Huggins, *Harlem Renaissance*.

215 "I want," she wrote: Charlotte Osgood Mason, "Fauset Notes," October 9, 1927, Alain Locke Papers, MSRC.

215 "privilege . . . to build": Charlotte Osgood Mason, "Committee African Art" notes, March 17, 1927, Alain Locke Papers, MSRC; Charlotte Osgood Mason, "Locke" notes, Alain Locke Papers, MSRC.

215 "father": Huggins, *Harlem Renaissance*, 57.

215 "the presentation of African Art": Mason to Locke, Mason notebook, "A.L., Letters to Him," April 1, 1928, Alain Locke Papers, MSRC.

215 Locke's lecture: Harris and Molesworth, *Alain L. Locke*, 220, 223.

215 "Nothing is more galvanizing": Locke, *The Critical Temper of Alain Locke*, ed. Stewart, 409, quoted in Harris and Molesworth, *Alain Locke*, 222.

216 "we must believe": Locke, "A Note on African Art."

216 including Mason: A 2012–2013 exhibition at New York's Metropolitan Museum of Art, "African Art, New York, and the Avant-Garde," featuring the Blondiau-Theatre Arts Collection, among two others, did not mention Charlotte Mason's

name. In place of a formal exhibition catalog, the magazine *Tribal Art* devoted a special issue to the exhibition. *Tribal Art*, Special Issue 3, "African Art, New York, and the Avant-Garde," 2012.

216 "natural, primitive, life-affirming": North, *The Dialect of Modernism*, 27.

216 "African art": Huggins, *Harlem Renaissance*, 79; see also Locke, "The Legacy of Ancestral Arts," in *The New Negro*, ed. Locke.

217 how the relationships *felt*: See the note on "affect studies," page 359, note xxxi.

217 Those feelings blossomed: Mason notebook, Alain Locke Papers, MSRC.

217 "tremendous rapport": Charlotte Osgood Mason, March 6, 1927, Alain Locke notes, Alain Locke notebook, Alain Locke Papers, MSPC.

217 "a relationship in which": Harris and Molesworth, *Alain Locke*, 240, 237.

217 Both owned important pieces: Locke's catalog lists her fetish totem masks, Bundu secret society mask and headdress, and his ceremonial fetish-figure dance mask. Exhibition catalog, "The Negro in Art Week, November 16–23."

218 "I used to dream": Charlotte Osgood Mason, "A" notes, March 18, 1927, Alain Locke Papers, MSRC.

218 "the dreams I had 47 years": Mason to Locke, May 1, 1932, Alain Locke Papers, MSRC.

218 "happy in her heart": Mason, "Steamer Letter to Alain Locke" (draft), June 29, 1927, Alain Locke Papers, MSRC.

218 What if "undeveloped Negroes": Mason, "Committee African Art" notes, March 17, 1927, Alain Locke Papers, MSRC.

218 "weakening white civilization": Mason, "Committee African Art," notes, March 17, 1927, Alain Locke Papers, MSRC, 44.

218 "we have trampled": Mason, memorandum, July 5, 1931, Alain Locke Papers, MSRC.

218 "white Negroes": Mason, memorandum, June 19, 1927, Alain Locke Papers, MSRC.

218 "perfect contempt": Mason, "Al" notes, February 20, 1927, and "Mr. Locke" notes, March 1, 1927, Alain Locke Papers, MSRC.

219 "You know I believe deeply": Mason to Locke, August 25, 1929, Alain Locke Papers, MSRC.

219 "for a large measure": Harris and Molesworth, *Alain Locke*, 241.

219 "godfather": Wintz and Finkelman, eds., *Encyclopedia of the Harlem Renaissance*, Vol. 1, 578.

220 "I believe we can transfigure": Mason, undated notes, notebook labeled "Letters to Alain Locke, From February 16," Alain Locke Papers, MSRC.

220 "A Primitive light": Mason, "Steamer Letter to Alain Locke," June 29, 1927. Alain Locke Papers, MSRC.

220 "This is unbelievable": Mason to Locke, December 10, 1927, Alain Locke Papers, MSRC.

220 "sophisticated intellectual": Hemenway, *Zora Neale Hurston*, 104.

220 "little evidence": Locke, "The Legacy of the Ancestral Arts," in *The New Negro*, ed. Locke, 254.

221 "They are absolutely no use": Charlotte Osgood Mason, "Memos. Negro-Art," April 19, 1927, Alain Locke notes, Alain Locke notebook, Alain Locke Papers, MSRC.

222 individual writers: Hughes dedicated his autobiography to Amy Spingarn and her husband, Joel. One of her dearest friends, he praised the "quiet way" she always did things. Rampersad, *The Life of Langston Hughes*, vol. 1, 122. In her autobiography, *Dust Tracks on a Road*, Zora Neale Hurston inserted a cryptic acknowledgment of Spingarn's assistance: "I am indebted to Amy Spingarn in a most profound manner. She knows what I mean by that." Hurston, *Dust Tracks*, 228.

222 "the salvation of your people": Mason to Hughes, September 9, 1928, MSS 26, Box 111, Folder 2079, James Weldon Johnson Collection, Beinecke.

222 "I had loved very much": Hughes, *The Big Sea*, 327.

222 "flaming pathway": Mason to Locke, June 5, 1927, MSS 26, Box 111, Folder 2079, James Weldon Johnson Collection, Beinecke.

222 "You are a golden star": Mason to Hughes, September 9, 1928, Langston Hughes Papers, James Weldon Johnson Collection, Beinecke.

222 "We don't bore one another": Hughes, notes, "Personal Papers," Langston Hughes Papers, James Weldon Johnson Collection, Beinecke.

223 "silent Indian chief": Mason to Hughes, June 5, 1927, MSS 26, Box 111, Folder 2079, James Weldon Johnson Collection, Beinecke.

223 "In the primitive world": Hughes, *The Big Sea*, 311. According to Rampersad, this foreword was later cut. See Rampersad, *The Life of Langston Hughes*, vol. 1, 170.

223 "Laugh if you will": Hurston, *Dust Tracks*, 128, 129.

224 Hurston called Mason: Hurston to Mason [December 1927], 111; May 18, 1930, 187–89; March 9, 1931, 211–12; April 18, 1931, 217–18; May 10, 1931, 218–19, in Kaplan, *Zora Neale Hurston*.

224 She had a remarkable command: Indeed, her psychic hold was so strong that to this day some people who knew her well are still nervous about talking of her. "When I interviewed Langston Hughes (only a few weeks before his death)," Nathan Huggins wrote, "he was still quite upset by the memory of his experience with this lady patron; he still honored his trust not to divulge her name." Huggins, *Harlem Renaissance*, 315. Hughes died in 1967. When I interviewed a member of the Chapin family, Schuyler Chapin, in 2005, he was still uncomfortable talking about Mason and repeatedly mentioned her unusual personal powers. An extremely cosmopolitan man and New York City's "culture czar" for a dozen years, general manager of the Metropolitan Opera, and former Columbia University dean of the arts, Chapin was still shaking his head decades later about

how intimidating he had found Mason and how impossible it seemed to him to so much as disagree with her. Author's interview with Schuyler Chapin, New York, October 13, 2005.

224 She could be generous: "Godmother could be as tender as mother-love when she felt you had been right spiritually," Zora Neale Hurston said. Hurston, *Dust Tracks*, 129.

224 One of her laws: Mason to Hughes, July 26, 1927, MSS 26, Series 1, Box 111, James Weldon Johnson Collection, Beinecke; Charlotte Osgood Mason to Alain Locke, June 17, 1928, Alain Locke Papers, MSRC. Mason's notions about what should be left to silence baffled many of her protégés. All things financial, domestic, nutritional, and digestive were to be recorded in painstaking detail: every penny spent, every piece of linen purchased, every calorie consumed, each bodily waste emitted. She kept voluminous journals and housekeeping records (no longer extant) and encouraged all of her protégés and godchildren to do the same. Indeed, she blamed her inability to write in later years—most of her extant letters are dictated to Cornelia and Katherine—on excessive writing in her youth: "Having written so incessantly all my life, the neuritis in my arm has become so paralyzing that I cannot use it now even to write short letters." Draft of a letter to her cousin Will, n.d., Quakertown. In her lifetime, she published only one short essay, about the death of her husband, "The Passing of a Prophet."

225 "Our engagement": Katherine Garrison Chapin, "Secret Diary," August 13, 1918, Quakertown.

225 "delicious" . . . "a great happiness to us both": Katherine Garrison Chapin, "Secret Diary," Quakertown, 1919.

226 "The Negro, in spite": Hurston, *Mules and Men*, 4–5. The "feather-bed resistance" passage repeats, almost verbatim, in Hurston's "You Don't Know Us Negroes."

226 "goes to Whiteland": Hurston to Hughes, April 12, 1928, in Kaplan, *Zora Neale Hurston*, 115–16.

227 But such collecting: See Stewart, *On Longing*; Elsner and Cardinal, eds., *The Cultures of Collecting*.

227 They were hence: Locke and Hughes were both better at the "present company excepted" game than Hurston. She bashed other whites with gusto in Mason's company, as Mason encouraged her to do. But she too often failed to notice that most of them were Jews, whom Mason—along with much of the rest of the nation—did not consider fully white. Frequently impulsive and overeager, Hurston often failed to give Mason the reassurance of her racial exceptionalism that Mason craved:

> *About a month ago I wrote a short criticism of "Negro workaday songs" to Godmother in which I said that white people could not be trusted to collect the lore of others, and that the Indians were right. I was quoting Godmother's words, but somehow she felt that I included her in that category. I hurriedly explained to her*

and she said she was satisfied. I was so sure we understood each other that I didn't say present company excepted.

Hurston to Hughes, July 10, 1928, in Kaplan, *Zora Neale Hurston*, 121.

227 "dry & long winded writing" . . . "instrument to do it with": Mason notebook "A.L., 1929," Mason to Locke, September 27, 1929, Alain Locke Papers, MSRC; Mason to Hurston, August 21, 1929, Quakertown; Mason notebook "A.L., 1929," MSRC; Mason to Locke, May 4, 1928, MSRC; Mason to Locke, January 26, 1929, MSRC; Mason to Locke, January 26, 1929, MSRC; Mason to Locke, February 10, 1929, MSRC.

228 "Things do not live": Mason to Locke, Alain Locke Papers, MSRC.

228 "Such a pity your tongue": Mason to Locke, May 21, 1930, Alain Locke Papers, MSRC.

228 "sometimes a whip": Matthias, "Unknown Great Ones." The essay does not mention Mason—"the godmother"—by name.

228 "I see all my terrible weakness": Hurston to Mason, April 18, 1931, in Kaplan, *Zora Neale Hurston*, 217–18.

228 Mason's legal "agent": Contract between Zora Neale Hurston and Charlotte Osgood Mason, Alain Locke Papers, MSRC.

228 Mason made her document: Kaplan, *Zora Neale Hurston*, 48.

229 "the Negro farthest down": Hurston, *Dust Tracks*, 129.

229 "not to make known": Contract, Hurston and Mason, Alain Locke Papers. MSRC; dated December 1, 1927, and updated to 1932.

229 "You should not rob": Mason to Hurston, January 18, 1932, Alain Locke Papers, MSRC.

229 "I am so reluctant": Hurston to Mason, September 25, 1931, in Kaplan, *Zora Neale Hurston*, 227–28.

229 "merciless": Hurston, *Dust Tracks*, 129.

230 "The whole movement": Mason to Locke, April 11, 1928, Mason's notebook, "A.L.: Letters to Him," Alain Locke Papers, MSRC.

230 "I am deeply troubled": Mason to Locke, January 26, 1929, Alain Locke Papers, MSRC.

230 "better Negro": Mason to Claude McKay, October 19, 1929, "Drafts of Letters," Alain Locke Papers, MSRC.

230 "I am a Black God": Mason to Locke, April 1, 1928, draft 2, Alain Locke Papers, MSRC.

230 "true to any ideal": Mason to Locke, January 6 and 12, 1930, Alain Locke Papers, MSRC.

230 "discouraging things": Mason to Locke, August 8, 1930, Alain Locke Papers, MSRC.

231 "What am I to do": Mason notebook "A.L., Letters to Him," Mason to Locke, October 30, 1928, Alain Locke Papers, MSRC. Remarkably, Locke's most recent

biographers write that there were only "rare times when she [Mason] scolded Locke." See Harris and Molesworth, *Alain L. Locke*, 237.

231 "half my capital": Mason to Locke, February 28, 1932, Alain Locke Papers, MSRC. Beliefs that "the crash of Wall Street . . . barely rattled the exquisite china at 399 Park Avenue and touched Mrs. Mason's godchildren not at all" and that "the stock market crash apparently had little immediate effect on Mason" are probably based on Harlem's myths about Mason. Rampersad, *The Life of Langston Hughes*, vol. 1, 174; Harris and Molesworth, *Alain L. Locke*, 244.

231 "to succeed in my ideal": Mason to Locke, December 6, 1931, Alain Locke Papers, MSRC.

231 "Alain you know perfectly well": Mason to Locke, January 25, 1931, Mason's notebook "Alain. 1931. Memorandum and Letters," Alain Locke Papers, MSRC.

231 "The discouragement of all": Mason to Locke, July 11, 1930, Alain Locke Papers, MSRC.

232 "great adventures": Mason to Hughes, December 1, 1927, Langston Hughes Papers, James Weldon Johnson Collection, Beinecke.

232 "Big Indian": Mason to Hughes, June 29, 1928, Langston Hughes Papers, James Weldon Johnson Collection, Beinecke.

232 "Langston, Langston": Hurston to Hughes, March 8, 1928, in Kaplan, *Zora Neale Hurston*, 114.

232 "real Negro art theater": Hurston to Hughes, April 12, 1928, in Kaplan, *Zora Neale Huston*, 116.

232 "born in Philadelphia": Hurston, "Concert," 806.

232 "I love you": Hughes to Mason, February 23, 1929, James Weldon Johnson Collection, Beinecke.

233 "So long": Hughes, "Afro-American Fragment," 235.

234 "sorrowful misguided way" . . . "drum is stilled": Mason to Hughes, June 6, 1930; July 10, 1930; October 30, 1930; December 25, 1930; February 12, 1931; March 1, 1931, James Weldon Johnson Collection, Beinecke.

234 "violently and physically ill": Hughes, *The Big Sea*, 327, 326.

234 "a result of Godmother's displeasure": Rampersad, *The Life of Langston Hughes*, vol. 1, 185.

234 "the facts . . . reveal": Berry, *Langston Hughes*, 106.

235 "the most notorious literary quarrel": Bass and Gates, eds., *Mule Bone*, 5.

235 Locke had let the museum project drop: According to Jeffrey Ferguson, "the museum continued haphazardly until 1928, when organizational problems ended it. The permanent collection is installed in the 135th St. Branch of the New York Public Library." Ferguson, "The Newest Negro."

235 "earth path even harder": Undated letters from "The Friends," Katherine Garrison Chapin Biddle Papers, Biddle Family Letters, Georgetown. All subsequent references to the letters from "The Friends" are from those files.

235 "shameful" . . . "lost their heads": Locke to Mason, May 7, 1932, Alain Locke Papers, MSRC.

235 He was left with "shattered" health: Rampersad, *The Life of Langston Hughes*, vol. 1, 185.

236 "I cannot write here": Hughes, *The Big Sea*, 325.

236 "abstifically a fraud" . . . "malicious": Hurston, "The Chick with One Hen"; Hurston to James Weldon Johnson, February 1938, James Weldon Johnson Collection, Beinecke.

236 "*the* tragedy": Dictated "Langston Hughes" notes, Mason, September 5, 1930, Quakertown.

236 "he has knocked her to pieces": Dictated "Langston Hughes" notes, Mason, September 5, 1930, Quakertown.

237 A group of spirits: Lack of awareness of these letters has led to misunderstandings about this break and its chronology. Rampersad accurately dates the rupture to spring 1930 but does not note that both of them attempted reconciliation up to a final break in the winter of 1930–31. Faith Berry dates the rupture to the later period but fails to note that it began months earlier, in the spring of 1930. Hughes himself was elusive about the exact date of his break with Mason, and, no doubt, each came to a sense of finality at different times between the spring of 1930 and early winter of 1931, by which time it was apparent that all attempts at reconciliation had failed.

238 "This egotism": Mason, "Langston Hughes" notes, September 2, 1930, Quakertown.

238 "powerful" . . . "harmony": Mason, "Genius and Primitive Man," 1905 or 1906, unpublished essay. Quakertown and Bryn Mawr. A note in Katherine Chapin Biddle's handwriting appended to the front of this manuscript reads, "This was written by Godmother in 1905 and 1906. Held by Harpers for a year then material stolen—Col. Harvey came out with it[.] End [of book] is the benediction of the Indians Book." See also Eliot, "Tradition and the Individual Talent," in *The Sacred Wood*.

238 "Truly": Mason, "Genius and Primitive Man," 154.

239 "who went in for Negroes": Hughes, "Slave on the Block," in Hughes, *The Ways of White Folks*, 19–20.

239 "Poor dear lady": Hughes, *The Ways of White Folks*, 99.

239 "smart neurasthenics" . . . "Patron": Hughes, "Rejuvenation Through Joy," in Hughes, *The Ways of White Folks*, 99. Hughes, "Poet to Patron."

240 "the only man on earth": Zora Neale Hurston, *Barracoon*, unpublished book manuscript, 14, Alain Locke Papers, MSRC. Mason met Hurston, in fact, precisely as Hurston was just publishing her first major essay on Kossula, "Cudjo's Own Story of the Last African Slaver," in October 1927. Hurston, "Cudjo's Own Story." As it turned out, much of the article was plagiarized from Emma Langdon Roche's book *Historic Sketches of the Old South*, which Mason certainly did

not know. Robert Hemenway provides an excellent account of this odd case of plagiarism, Hurston's only such case, as far as we know. See his *Zora Neale Hurston*. Hurston's link to Kossula was probably the reason that Mason had been so eager to bring her into her fold. To Mason, Kossula was now the foundation of the "magic bridge" she still wanted to build between Africa and America. "I was sent by a woman of tremendous understanding of primitive peoples to get this story," she wrote in *Barracoon*. I am indebted to JoEllen ElBashir for helping me obtain this copy of the manuscript.

240 "without fail, that life": Mason to Locke, June 7, 1931, Alain Locke Papers, MSRC.

241 "the future of the Negro": Mason to Locke, June 7, 1931, Alain Locke Papers, MSRC.

241 "to succeed in my ideal": Mason to Alain Locke, December 6, 1931, Alain Locke Papers, MSRC.

241 material in a 1914 book: Roche, *Historic Sketches of the South*. Roche spells Lewis's name "Kazoola" and his ship's name "*Clotilde*," a spelling Hurston sometimes adopted as well. Hurston, "Cudjo's Own Story," 648–63.

241 "I am being urged": Hurston to Franz Boas, April 16, 1930, and June 9 [1930], in Kaplan, *Zora Neale Hurston*, 187.

242 "Do not despair of me": Hurston to Mason, April 7, 1931, in Kaplan, *Zora Neale Hurston*, 216–17.

242 "I am at the end": Mason to Locke, January 25, 1931, Mason's notebook, "Alain. 1931. Memorandum and Letters," Alain Locke Papers, MSRC.

242 "Convince [the publishers]": Mason to Locke, June 7, 1931, Alain Locke Papers, MSRC.

242 "Remember": Mason to Hurston, draft, January 17, 1932, Alain Locke Papers, MSRC.

242 "the oleomargarine era": Hurston, "You Don't Know Us Negroes."

242 "Very worried": Mason to Locke, in notes, January 10, 1932, Alain Locke Papers, MSRC.

243 "a Negro concert": Hurston to Mason, September 25, 1931, in Kaplan, *Zora Neale Hurston*, 228.

243 "happy-go-lucky": Krasner, *A Beautiful Pageant*, 207.

243 "primitive and exciting": Hurston, "The Fire Dance" program, Orlando, Florida, 1939, Zora Neale Hurston Collection, George A. Smathers Libraries, University of Florida.

243 "I am on fire": Hurston to Mason, October 15, 1931, in Kaplan, *Zora Neale Hurston*, 235, 233.

243 "Locke made periodic trips": Kraut, *Choreographing the Folk*, 100.

243 "I wrote it freshly": Locke to Mason, December 31, 1931, Alain Locke Papers, MSRC.

243 "Zora was awfully hurt": Mason, "A.L." Notes, January 10, 1932, Alain Locke Papers, MSRC.

244 "never before": Hurston, announcement, "The Great Day," James Weldon Johnson Collection, Beinecke.

244 "where Truth in the Negro world": Mason to Locke, February 1, 1932, Alain Locke Papers, MSRC.

244 "original and unusual songs": Hurston, announcement, "The Great Day," James Weldon Johnson Collection, Beinecke.

244 "unusual Negro performance": Mason, notes, January 5, 1932, Alain Locke Papers, MSRC.

245 "squeezed all the Negro-ness": Hurston to Mason, September 25, 1931, in Kaplan, *Zora Neale Hurston*, 226.

245 "awfully bad colored shows": Hughes to McKay, June 27, 1929, Claude McKay Papers, James Weldon Johnson, Beinecke, as quoted by Rampersad, 172.

246 "faultless tails": Hurston, "Concert," 808.

246 "Godmother had meant": Hurston, "Concert," 808.

246 "the concert achieved its purpose": Hurston, *Dust Tracks*, 141.

246 and so did the reviewers: See Illidge, "'The Great Day' Heartily Received"; "Rare Negro Songs Given"; Ruhl, "Second Nights."

246 But Mason judged it a "failure": Mason to Locke, April 8, 1932, Alain Locke Papers, MSRC.

246 "About the concert": Hurston to Mason, January 21, 1932, in Kaplan, *Zora Neale Hurston*, 242.

247 "polite and rather cordial": Hurston to Mason, March 27, 1932, in Kaplan, *Zora Neale Hurston*, 247.

247 "I understand": Hurston to Mason, April 4, 1932, in Kaplan, *Zora Neale Hurston*, 249.

247 "none of the other data": Contract, Hurston and Mason, Alain Locke Papers, MSRC; dated December 1, 1927, and updated to 1932.

247 "Park Avenue dragon": Hurston to Ruth Benedict, December 4, 1933, in Kaplan, *Zora Neale Hurston*, 284.

248 "I have sent his money": Mason to Hurston, May 22, 1932, Alain Locke Papers, MSRC.

248 luncheons and teas: Mason's teas were elaborate and carefully planned. A spring tea for Hall Johnson, for example, served at a fashionably late hour, included "sandwiches of chicken, tomato, or crabmeat; little cakes with dry icing, orangeade, lemonade, and gingerale ('little lemonade glasses for orangeade—tumblers for gingerale'); two dishes of candy, yellow candles, and decorations of yellow roses and larkspurs in a green bowl."

249 "You have don more": Cudjo Lewis (Kossula) to Mason, March 29, 1929, Alain Locke Papers, MSRC.

250 "always yearned for": Charlotte Osgood Mason to Langston Hughes, July 11, 1929, MSS 26, Box 111, Folder 2084, James Weldon Johnson Collection, Beinecke.

250 "raise the fires of hell": Author's interview with Schuyler Chapin, New York, October 13, 2005.

251 "I am very changed": Mason to Locke, December 11, 1943, Alain Locke Papers, MSRC.

251 "She was only awful": Katherine Garrison Chapin Biddle to Francis Biddle, November 11, 1945, Biddle Family Letters, Katherine Chapin Biddle Papers, Georgetown.

251 "with her strong heart": Cornelia Chapin to Katherine Garrison Chapin Biddle, March 12, 1946, Biddle Family Letters, Katherine Chapin Biddle Papers, Georgetown.

251 At 9 p.m. on a blustery: Certificate of death for Charlotte L. Mason, no. 9082, April 16, 1946, Bureau of Records and Statistics, Department of Health, City of New York.

252 The big story that day: There were stories about more than three dozen men but only a few about women: the "wife of a well-known physician," the "mother of the North Shore Chapter of the American Red Cross," and "the wife of James F. Dewey, former United States Department of Labor Conciliator." Only two women were mentioned for their own accomplishments: Mrs. Jay K. Bowman, "one of the founders of the National Federation of Business and Professional Women's Clubs," and Dr. Katharine Munhall, "one of Buffalo's earliest women physicians."

252 "a friend of presidents": Hughes, *The Big Sea*, 315.

252 "Mason's bad effect": Katherine Chapin to Francis Biddle, May 1946 [date illegible], Katherine Garrison Chapin Biddle Letters, Biddle Family Letters, Georgetown.

252 "slowly destroying much": Katherine Chapin to Francis Biddle, July 4, 1946, Katherine Garrison Chapin Biddle Letters, Biddle Family Letters, Georgetown. Fortunately, some of these did survive. My gratitude, again, goes to Frances Biddle for her generosity, hospitality, and humor.

253 "rare selection of things": Locke to Cornelia Chapin, December 25, 1946, Box 30, Folder 48, Katherine Garrison Chapin Biddle Letters, Biddle Family Letters, Georgetown.

253 "almost a composite": Lewis, *When Harlem Was in Vogue*, 151.

Chapter 7: *Imitation of Life*: Fannie Hurst's "Sensation in Harlem"

257 "Sensation in Harlem": "A Sensation in Harlem," 10.

257 "white" novel: Gates, back cover blurb, Hurst, *Imitation of Life*, ed. Itzkovitz.

257 "initial publication": Itzkovitz, Introduction to Hurst, *Imitation of Life*, xxxix.

258 extraordinary latitude: For examples of this forbearance, see also Hutchinson,

The Harlem Renaissance in Black and White, and Bernard, *Carl Van Vechten and the Harlem Renaissance*.

259 betrayal: Harrison-Kahan, *The White Negress*, 107. Harrison-Kahan does not take the position that Hurst's novel was a "betrayal," though she notes that some people have done so.

259 "quiet house": Hurst, *Anatomy of Me*, 19.

259 "We did not know anybody": Hurst, *Anatomy of Me*, 87.

259 "Intellectual curiosity was languid": Hurst, *Anatomy of Me*, 13.

259 "rather spoiled, overweight": Hurst, *Anatomy of Me*, 6.

259 "pre-first world-war era": Hurst, *Anatomy of Me*, 6.

259 "somnolent world" . . . "wet-blanket": Hurst, *Anatomy of Me*, 6, 10.

259 hard at work: Mrs. Ralph Toensfeldt to Fannie Hurst, n.d. (sent in response to Fannie Hurst's request for reminiscences for her autobiography, *Anatomy of Me*). Fannie Hurst Papers, Robert D. Farber University Archives and Special Collections Department, Brandeis University, Waltham, Mass. (hereafter abbreviated Brandeis).

260 six hundred calories: Fannie Hurst, daily diet notes, 1940s, Fannie Hurst Papers, Brandeis.

260 "word lapidary": Hurst, *Anatomy of Me*, 27.

260 From early on: When she attempted to fulfill the creative writing assignments given to her classmates, for example, in exchange for their doing chemistry and math homework for her, her teacher called her to the office straightaway. Miss Jones "recognized Fannie's style and expressions and as she looked over each story, she wrote on it, 'Written by Fannie Hurst.'" Mrs. Frances Lewis to Fannie Hurst, n.d.; Fannie Hurst Papers, Brandeis.

260 "decidedly outstanding": Mrs. Frances Lewis to Fannie Hurst, n.d. (sent in response to Fannie Hurst's request for reminiscences from home when she was writing her autobiography, *Anatomy of Me*, published in 1958); Fannie Hurst Papers, Brandeis.

260 "regard me as the most interesting": Hurst, *Anatomy of Me*, 48.

261 equivalent to more than: Consumer Price Index Inflation Calendar, Bureau of Labor Statistics, www.bls.gov/data/inflation_calculator.htm. To date, twenty-eight films have been made from her work.

261 "Even then": Mrs. Strauss, "Anecdotes Concerning Miss Hurst's Early Years," Fannie Hurst Papers, Brandeis.

261 "highly self-conscious": "Reminiscence," no author, Fannie Hurst Papers, Brandeis.

261 "pig for success": Fannie Hurst to Joseph Levy, undated letter [1923], Box 151, Folder 2, HRC.

261 competing even with her dead sister: Hurst, *Anatomy of Me*, 7–8.

261 "I would have given anything": Hurst, *Anatomy of Me*, 42.

261 "sweatshops and tenements": Itzkovitz, Introduction to Hurst, *Imitation of Life*, xi.

261 She took her notepad: Kroeger, *Fannie*, 15.

262 "antediluvian custom": "Fannie Hurst Wed," 1.

263 Suffrage League's invitation: Kroeger, *Fannie*, 35, 33.

263 "black matters": Hurst used this phrase to file all those materials having to do with black culture or politics. Her labeled folder is in the Fannie Hurst Papers, HRC.

263 "something I don't particularly think about": Floyd Calvin, "No Racial Likes or Dislikes," in Fannie Hurst's scrapbooks, 1928–1929, HRC.

263 "to create and stimulate": National Health Circle for Colored People brochure, Box 189, Folder 3, Fannie Hurst Papers, HRC.

263 "languid . . . happy friendly race": Kroeger, *Fannie*, 188; 1927 appeal letter for National Health Circle for Colored People, HRC.

263 "The Southern Negro": 1928 Christmas Season Appeal, National Health Circle for Colored People, written and signed by Fannie Hurst, Box 189, Folder 3, HRC.

263 the organization's donors: Chapin's donor address is listed as 399 Park Avenue.

264 "that I was not in a position": Fannie Hurst to William H. Kirkpatrick [chairman, Urban League], November 25, 1941, Box 189, Folder 3, Fannie Hurst Papers, HRC.

265 She had appealed for support: Hurston to Annie Nathan Meyer, November 10, 1925, in Kaplan, *Zora Neale Hurston*, 68.

265 Annie Nathan Meyer had already taken: Hurston to Meyer, November 10, 1925, in Kaplan, *Zora Neale Hurston*, 68.

265 "Your friendship was": Hurston to Hurst, March 16 [1926], in Kaplan, *Zora Neale Hurston*, 85.

265 "I love it!": Hurston to Constance Sheen, February 2, 1926, in Kaplan, *Zora Neale Hurston*, 80.

265 So Hurst helped out: Hurston to Constance Sheen, January 5 [1926], in Kaplan, *Zora Neale Hurston*, 74.

265 And Barnard, which catered: Hurston to Meyer, October 12, 1925, in Kaplan, *Zora Neale Hurston*, 66.

265 Far worse: Hurston to Meyer, January 15 [1926], in Kaplan, *Zora Neale Hurston*, 77–78.

265 "Negro Extra": Hurston to Meyer, January 15 [1926], in Kaplan, *Zora Neale Hurston*, 78.

265 "She sang with the plangency": Hurst, "Zora Hurston," 19.

266 "girl" . . . "characteristics": Hurst to Annie Nathan Meyer, February 14, 1935; Fannie Hurst to Henry Allen Moe, December 1, 1935, Zora Neale Hurston Files, Fannie Hurst Papers, HRC.

266 "most refreshing unself-consciousness": Hurst to Henry Allen Moe, December 1, 1933. John Simon Guggenheim files, John Simon Guggenheim Foundation, New York.

266 "world's worst secretary" . . . " 'sea in ships' ": Hurst, "Zora Hurston," 18, 17.

266 "without a single instance": Hurston, *Dust Tracks*, 6, 46.

266 "dilapidated two-room shack": Hurst, "Zora Hurston," 18.

266 the family home: Hurston, *Dust Tracks*, 10–11.

267 "darling of the critics": Van Gelder, "An Interview with Fannie Hurst," 2. See also Kroeger, *Fannie*, 15.

267 "how not to write": Itzkovitz, Introduction to Hurst, *Imitation of Life*, xiii.

267 It was on one of their car trips: Hurston to Hurst, February 6, 1940, in Kaplan, *Zora Neale Hurston*, 452–53.

268 "monotonous" . . . "exacting": Hurst, *Imitation of Life*, 1, 5, 10.

269 "security!" . . . "nausea": Hurst, *Imitation of Life*, 27, 35, 46, 47.

270 "report back" . . . "Virginie": Hurst, *Imitation of Life*, 74–76.

270 "like a vast black sun": Hurst, *Imitation of Life*, 78.

270 "walkin' trade-mark": Hurst, *Imitation of Life*, 105.

270 "mammy to the world": Hurst, *Imitation of Life*, 86.

270 "rest cure": Hurst, *Imitation of Life*, 145.

270 anxious whites: Chandler Owen protested this proposed monument as racist nostalgia for the "slave days when *black mammies* toiled in the cotton fields, cleaned the houses, cared for the children, nursed them at their bosoms. . . . We don't want any 'mammy' statues anywhere. We want the children of this generation to abhor and forget those days when the white madam had leisure and the black mammy had labor." "Black Mammies," 670.

270 "Let it fade away": Owen, "Black Mammies," 670.

270 "imitation" . . . "success": Hurst, *Imitation of Life*, 107, 263, 124, 112, 157, 180.

271 "man lovin'" . . . "damnation": Hurst, *Imitation of Life*, 181, 118, 247.

271 does not get very far: Many critics see the novel as more feminist than I do. Traci Abbott, for example, argues that Hurst was one of the most "significant feminist critics of her time" in her treatment of "modern sexual identity." Abbott, "Every Woman's Share," 635.

271 Delilah's belief that blood: On such signs, and on fingernails, especially, see Sollors, "The Bluish Tinge in the Half Moon," in *Neither Black Nor White, Yet Both*, 142–61.

272 "easily-hinged large mouth" . . . "tears": Hurst, *Imitation of Life*, 79, 90, 241.

272 "is straight out of Southern fiction": Brown, "*Imitation of Life*," 87–88. Reprinted in Brown, *A Son's Return*, ed. Sanders, 289.

272 "Of course they had reasons": Brown, "*Imitation of Life*," 288.

272 "We are a polite people": Hurston, *Mules & Men*; this same passage—on feather-bed resistance—is repeated verbatim in her "You Don't Know Us Negroes," written for *The American Mercury* and unpublished; "killed" in galleys in 1934.

272 "I have heard" . . . "old stereotype": Brown, *"Imitation of Life,"* 288–89.

272 an example of Hurst's novel: The other white writers Hughes mocked were Julia Peterkin, who won the Pulitzer Prize for her now-forgotten 1928 novel, *Scarlet Sister Mary*—replete with plantation nostalgia, dialect, and "colorful" black women who just couldn't help "fallen into sin" and for whom every "cotton-picking . . . work-day is a holiday"; Eugene O'Neill, whose *Emperor Jones* caused such controversy in New York; and Harriet Beecher Stowe, whose Little Eva and Uncle Tom influenced decades of race relations and racial representations.

272 Reversing the racial roles: Hughes, *Limitations of Life*, in *Black Theatre, USA*, ed. Shine and Hatch, 631–32.

273 "The 'passing' episodes": Brown, *"Imitation of Life,"* 289.

273 "grateful": Hurst, "Letter," 121; Brown, "Letter," 121–2. Jane Caputi discusses this exchange as well in "'Specifying' Fannie Hurst."

273 "there was no story": Bernard, *Carl Van Vechten*, 129.

273 "rooted identity": Gilroy, *Against Race*, 105. By showing race as performance, Maria Sanchez writes, passing "wreaks havoc" on any fixed identity. Sanchez, ed. *Passing*, 2.

274 A cruel daughter: Both film versions lighten this by having Peola regret her choice and the damage it's done to her mother.

274 Because the story of passing: An erotics of identity is central, however, to this form. As critic Biman Basu puts it, in the black story of passing, "racial transgression is itself eroticized. . . . The political economy of passing cannot be separated from its economy of desire." Basu, "Hybrid Embodiment and an Ethics of Masochism," 384.

274 Although she supported Hurst: Hurston's careful attitude toward Hurst has often been misread. Hurst editor Daniel Itzkovitz maintains, for example, that "when the novel came under attack . . . Hurston . . . became one of its staunchest support-ers," Itzkovitz, Introduction to *Imitation of Life*, xxvi–xxvii.

274 Hurst's Delilah was also half Hurston: Hurst's editor Daniel Itzkovitz argues the opposite. "Delilah is of course no Zora Neale Hurston," he wrote. Introduction to *Imitation of Life*, xxvi. Oddly, no critic I am aware of has commented on the Delilah-Hurston connection.

274 "childlike manner": Hurst, "Zora Hurston," 18–20.

275 "stunned when she found": Itzkovitz, Introduction to *Imitation of Life*, vii–viii, xxxii.

275 it would always be: Kroeger, *Fannie*, 178. Hurst made use of this very trope of inequality in *Imitation of Life*: to show Bea's sense of alienation from her hus-band, she has Bea refer to him, even to herself, always as "Mr. Pullman." By way of contrast, Josephine Cogdell Schuyler always addressed her friend Langston Hughes as "Dear Mr. Hughes."

275 "the other, and unknown, Harlem": Hurst, "The Other, and Unknown, Harlem," 96ff.

275 "You Don't Know Us Negroes": Hurston, "You Don't Know Us Negroes." Typeset galleys, Ms. Collection, LOC.

276 "The Pet Negro System": Hurston, "The 'Pet Negro' System."

276 trying to speak across: Hurston, *Their Eyes Were Watching God*.

276 "un-selfconsciousness": Hurst, Introduction, Hurston, *Jonah's Gourd Vine*. Hurst's Introduction is rarely reprinted.

277 "false luxury": Collins, *Seeing a Color Blind Future*, 5. On "color blindness" as "not the opposite of racism" but "another form of racism," see also Carr, *"Color-Blind" Racism*; Dyson, *Race Rules*; and Bonilla-Silva, *Racism Without Racists*.

277 "possessive investment": Lipsitz, *The Possessive Investment in Whiteness*.

277 "admirable" . . . "onerous": Dreisinger, *Near*, 148–49.

277 As a Jew: Hurston's biographer Robert Hemenway has also argued that one of the reasons Fannie Hurst loved Hurston was that Hurston made Hurst seem whiter. Hemenway, *Zora Neale Hurston*.

Chapter 8: Nancy Cunard: "I Speak as If I Were a Negro Myself"

279 "Maybe I was African one time": The epigraph is from a letter from Nancy Cunard to Mrs. Davies, March 20 [1931], Cunard Papers, Harry Ransom Center, Austin, Texas (hereafter abbreviated HRC). Nancy Cunard to Alfred M. Cruickshank, "The People," February 15, 1941, clipping, Box 27, Folder 5, HRC.

279 "I longed for an American white friend": Nancy Cunard to Charles Burkhart. In Ford, ed., *Nancy Cunard*, 328 (hereafter abbreviated *BPIR*).

279 "a mauve tulle scarf": *Sketch*, March 29, 1922, scrapbook 1913–1921, Box 26, Folder 1, HRC.

281 Robeson's white lover: Duberman, *Paul Robeson*, 143.

281 And Nancy's black lover: Cunard, "Does Anyone *Know* Any Negroes?"

281 admitted black guests: More famous hotels, such as the elegant Hotel Teresa, "Harlem's Waldorf-Astoria," did not accept black guests until 1940.

281 "one of those women": Huxley, *Point Counter Point*, 9. Huxley is describing a fictional character based on Nancy Cunard.

281 "blather and ballyhoo": Cunard, *Grand Man*, 99.

282 "Racket my dear Sir": Typed copy of Nancy Cunard's telegram, Nancy Cunard Papers, HRC.

282 A hastily produced Movietone newsreel: Gordon, "'The Green Hat' Comes to Chambers Street," *BPIR*, 134. No known copies of the newsreel survive.

282 The British press: *The Empire News*, Manchester, May 8, 1932, copy retyped by Nancy Cunard, Nancy Cunard papers, HRC.

282 "outrageous lies, fantastic inventions": Cunard, *Grand Man*, 99.

282 "nothing *at all*": Duberman, *Paul Robeson*, 158.

282 "sex motive": Cunard, "The American Moron and the American of Sense," in *Negro*, ed. Cunard, 197. Very few copies of Cunard's original *Negro* are extant and the few that come onto the market sell for upwards of $10,000 in good condition. Even this Greenwood/Negro Universities Press reprint edition is exceedingly rare, and I am enormously grateful to Jane Marcus for making her copy available to me for photocopying. Later, more readily available reprint editions by Ungar Publishing are only partial.

282 "Press Gentlemen": Nancy's typed copy of press release, May 2, 1932, Nancy Cunard Papers, HRC.

283 "very slim": Garnett, "Nancy Cunard," in *BPIR*, 26.

283 "delicacy and steel": Mortimer, "Nancy Cunard," in *BPIR*, 48.

283 "crystalline quality": Acton, "Nancy Cunard: Romantic Rebel," in *BPIR*, 73.

284 "half sick": Banting, "Nancy Cunard," in *BPIR*, 182.

284 Fending off . . . she promised: Whittaker later claimed that Nancy expressed delight in the publicity the press conference would provide for her book, calling it "ripping" good "ballyhoo." Not only was Nancy too angry at press misstatements to consider her hour with the press mere "ballyhoo," but every other account of the press conference stresses the gravitas—not silliness—with which she confronted the press. Nancy Cunard, press statement, May 2, 1932; "Nancy Cunard Stopping at Harlem Hotel" and "Ain't Misbehavin'," 1; Whittaker, "Miss Cunard Asks Aid"; "Nancy Cunard Defends Life with Negroes"; Nancy Cunard's account of "Incidents with the American Press, Spring 1932," all in Nancy Cunard Papers, HRC.

285 "race-hysteria exploded": Cunard, *Grand Man*, 99.

285 weighted with slugs: Marcus, "Bonding and Bondage," in *Borders, Boundaries, and Frames*, ed. Henderson, 63, n. 11.

285 "insane" . . . "quick": Cunard, "The American Moron," in *Negro*, ed. Cunard, 198–99.

285 "extraordinary": Cunard, *Grand Man*, 99.

285 "any interest": Cunard, "The American Moron," in *Negro*, ed. Cunard, 197.

285 "ornate and rococo outbursts": Cunard, *Grand Man*, 99–100.

285 "lousy hoor": Nancy Cunard, Box 17, Folder 12; Box 19, HRC. "This is my third letter that I'm writing you," another letter in this set lamented, "and I can't understand why I do not receive your answer, in my two letter that I wrote to you I asked if you will . . . marry me or not . . . you are just the kind of woman I need."

286 Images of rebellious "New Women": See, e.g., "Chic Safari," Neiman Marcus Advertisement, *The New York Times*, Style section, April 25, 2010, for Nancy's recurring image in popular culture and advertising.

286 "crazy letters": Cunard, *Grand Man*, 99.

286 "The Guilt of Our Immunity": Tree, "We Shall Not Forget," *BPIR*, 22; Nancy Cunard scrapbook, Box 26, HRC. Most of Cunard's scrapbooks are undated, with the exception of her scrapbook of 1913–1921. Other scrapbooks are, by and large, either specific to unnamed time periods or subject-specific, such as her scrapbook of congratulatory correspondence and materials upon the publication of *Negro*.

286 "She was of course a born fighter": *BPIR*, 329.

286 "What was it, Madam": Cruickshank, "To Miss Nancy Cunard," *The People*. Also published in *The Teacher's Herald*, December 1940. Nancy Cunard's scrapbooks, Box 27, Folder 5, HRC.

287 "Our lives are wars": Nancy Cunard, "To Alfred Cruickshank," *The People*, Saturday, February 15, 1940, Box 27, Folder 5, HRC.

287 Rights claims have insisted: On the politics of recognition, see especially Taylor, "The Politics of Recognition," in *Multiculturalism*, ed. Gutman; Fraser and Honneth, *Redistribution or Recognition*; and Appiah, *The Ethics of Identity*.

288 "began to be drawn towards": Cunard, *Grand Man*, 140.

288 $83 million: The Consumer Price Index, on July 31, 2010, provided a conversion factor of 0.041 for 1895; Chisholm provides the figure of $83 million, *Nancy Cunard*, 6.

289 "heyday of Anglo-American society marriage": Scholars date the custom of marrying "socially hungry American wives" in search of "position and esteem" to "impoverished but titled Englishmen" from 1874, with the marriage of Jennie Jerome to Lord Randolph Churchill. See Eliot, *They All Married Well*.

289 "darkly paneled": Chisholm, *Nancy Cunard*, 10.

289 "incompatibility of the couple's tastes": Chisholm, *Nancy Cunard*, 11. Maud may have hoped to lure Bache away from Nevill Holt. But he disliked travel, except for a summer hunting month in Scotland, preferring to stay home near his studio, built at the top of one of the old towers, where he spent hours—sometimes days—happily engaged in elaborate and detailed metalworking. Nancy later remembered him as "thoroughly conservative in his ideas" but "manually an ingenious, gifted man," a side of him that almost no one but Nancy knew.

289 "a low thing—the lowest": Chisholm, *Nancy Cunard*, 12.

289 occupying more square footage: Flanner, "Nancy Cunard," in *BPIR*, 87.

290 "men in armour": Cunard, *G.M.: Memories of George Moore*, 21.

290 "It seems fantastic": Cunard, *G.M.: Memories of George Moore*, 22.

290 "Not allowed a step out": Cunard, *G.M.: Memories of George Moore*, 49.

290 "longed for friends": Fielding, *Those Remarkable Cunards*, 15.

290 "Like most Edwardian society parents": Fielding, *Those Remarkable Cunards*, 15.

290 "a strange, solitary child": Fielding, *Those Remarkable Cunards*, 14.

290 "Somehow I felt": Cunard, *G.M.: Memories of George Moore*, 22.

290 "sullen-hearted": Cunard, "Toulannaise," in Cunard, *Sublunary*.

290 "my capacity for happiness was starved": Nancy Cunard, 1919 diary, Nancy Cunard Papers, HRC.

290 "the nearest thing to a Salon": "The Season in Town," *Sketch*, March 29, 1922, scrapbook 1913–1921, Box 26, Folder 1, Nancy Cunard Papers, HRC.

291 "fashionable beauties": Press clipping, scrapbook 1913–21, Box 26, Folder 1, Nancy Cunard Papers, HRC.

291 "Her hobby in life": Chisholm, *Nancy Cunard*, 35.

291 "goldy bride": Press clippings, scrapbook 1913–21, Box 26, Folder 1, HRC.

291 her mother's lover: Cunard, *GM*, 40. Nancy lived all her life with rumors, which she did little to dissuade, that George Moore was her real father. Moore would never definitively confirm or deny the rumors.

293 "These die obscure": Cunard, "Soldiers Fallen in Battle."

293 "wasteful, wanton, foolish, bold": Cunard, "Wheels," reprinted in *BPIR*, 1916. Lois Gordon reads this as a poem about Nancy's fear of aging. See Gordon, *Nancy Cunard*, 49.

293 "live while others die for us": Cunard, "War," *Outlaws*, 29.

293 "Were I not myself": Nancy Cunard to Solita Solano, LOC, quoted in Gordon, *Nancy Cunard*, 124.

293 "equality of races": Nancy Cunard, notebook, 1956, Nancy Cunard Papers, HRC.

293 "How hidden and remote": Nancy Cunard, diary, 1919, Chisholm, *Nancy Cunard*, 49.

293 There were a number of salons: Hansen, *Expatriate Paris*.

294 "knew everybody": Flanner, "Nancy Cunard," *BPIR*, 88.

294 "half the poets and novelists": *BPIR*, 73.

294 She was photographed, armored: Fielding, *Those Remarkable Cunards*, 74.

294 "toast of the twenties": *The Evening Standard*, quoted in Gordon, *Nancy Cunard*, 371.

295 "Their manners, exalting high-mindedness": Gordon, *Nancy Cunard*, 45. As Nancy's friend Bryher put it, "Those rebels were no more free from the conventions that they fastened upon themselves than a group of old ladies gossiping over their knitting."

295 "Why the smarming": Nancy Cunard, "Memories" notebook, HRC.

295 "To hell with those days!": Walter Lowenfels, "Nancy Cunard," *BPIR*, 91; Cunard, *Grand Man*, 70–71.

295 a remarkable collection: My description of Nancy's collection is drawn from multiple sources, including a report from NAACP field secretary Pickens, "African Art in Cunard's Home," 5. For years Nancy kept elaborate notebooks filled with meticulous notes for a planned (but never published) book on African ivories: carved tusks from Benin, masks from the Congo, Abyssinian women's "aprons,"

call-horns, "pounders," and sculptures, carefully illustrated with Nancy's small, detailed ink drawings. Cunard, notebooks, Box 5, Folder 7, HRC.

295 bracelet collection: Lois Gordon reported the collection at 1,000 pieces. According to Nancy, after her French farmhouse was ransacked by Nazi sympathizers, only 170 of her bracelets remained, some of which she scavenged by scrabbling in the dirt with her hands. See also Cunard, *These Were the Hours*, ed. with a foreword by Ford, 26–27, 203, 198–208.

295 "the sand, the dunes": Cunard, *Grand Man*, 140.

295 "vital life-theme": Nancy Cunard to Arthur Schomburg, n.d., Schomburg Center for Research in Black Culture, New York Public Library, Astor, Lenox and Tilden Foundations (hereafter abbreviated Schomburg). See also Cunard, "Black Man and White Ladyship" in Moynagh, ed., on the importance of human "contact" versus the "*unreal*" socializing of aristocrats.

295 "tom-toms beating": Goffin, "Hot Jazz," in *Negro*, ed. Cunard, 378.

295 "one of them, though still white": Cunard, *Grand Man*, 140.

296 "Nancy had a very advanced": Hiler, "Introductory," *BPIR*, 35.

296 "common sense": Cunard, "Does Anyone *Know* Any Negroes?," 301.

296 "One should learn how to live": Nancy Cunard to Solita Solano, LOC.

297 "speak as if I were a Negro": Cunard to Mrs. Davies, March 20 [1931], HRC.

297 "spirit of modern man": Guillaume, "The Triumph of Ancient Negro Art," 147.

297 Guillaume, one of primitivism's most influential: "Guillaume," Nancy wrote, "has probably the best collection [of African art] in the world—he is also very sympathetic and a good friend of the Negro." Nancy Cunard to Arthur Schomburg, January 19 [between 1928 and 1930], Schomburg Papers, Schomburg.

297 "Black skin": Nancy Cunard, Hate Mail [1932], HRC. See also Dreisinger, *Near Black*; Torgovnick, *Gone Primitive*.

297 "darkening your complexion": Nancy Cunard, Hate Mail [1932], HRC.

298 "gone Negro": Marcus, *Hearts of Darkness*, 139.

298 "White men have contributed": Edgar W. Wiggins to Nancy Cunard, April 9, 1934, HRC.

298 "a sign of insanity": Chisholm, *Nancy Cunard*, 319.

298 "incapable of restraint or discretion": Chisholm, *Nancy Cunard*, xii.

298 "I find life quite impossible": Nancy Cunard, diaries, 1919, HRC.

299 "an unfortunate faculty": Moon, "Review."

299 "liked to shock": Chisholm, *Nancy Cunard*, xii.

300 "just another white woman": Moon, "Review."

300 "Nancy's back, we're in trouble": Macpherson, "Ne Mai," in *BPIR*, 348. Not only Nancy's black friends felt that way. Sybille Bedford, who was white, wrote that "to us she was the friend one loved, whose arrival one often dreaded." Bedford, *Aldous Huxley: A Biography*, 132.

300 abandoned by his mother: In 2008, a niece, Shirley Porter Washington, came forward to dispute the widely disseminated biography of Cullen. According to Washington's self-published book, Cullen was born to a well-educated, elite New Orleans family. *Countée Cullen's Secret Revealed by Miracle Book*. See, however, Molesworth, *And Bid Him Sing*, for a scholarly account of the known facts of Cullen's life.

300 "one of my favorite folks": Hughes to Cunard, June 2, 1954, HRC.

301 "all of them loved Nancy": McPherson, "Ne Mai," *BPIR*, 348.

301 "Among all of us in the avant-garde": Lowenfels, *BPIR*, 91.

301 Dorothy Peterson once asked: Hughes, *The Big Sea*, 252–53.

301 "black craze": Shack, *Harlem in Montmartre*, xvi, 33, 38.

301 "Black was the color": "Paris Beauties Kink Their Hair in Suki Glory," quoted in Shack, *Harlem in Montmartre*, 38.

302 "swaying luxuriously": Bald, "Montparnasse Today," *Vanity Fair*, July 1932, 31, 58, quoted in Shack, *Harlem in Montmartre*, 40.

302 "astounding . . . wild-fire syncopation": Cunard, *Vogue*, 1926, quoted in Ward, "The Electric Body."

302 "encounters between black and white women": Weiss, *Paris Was a Woman*, 23.

302 "glittering" costumes: Cunard, *Grand Man*, 83.

302 "A new element": Cunard, *Grand Man*, 84.

302 "great good looks": Cunard, *Grand Man*, 84, 86.

303 "My feeling for things African": Cunard, *Grand Man*, 86.

303 "the sweetest woman I have ever known": Chisholm, *Nancy Cunard*, 123.

303 "billing and circulars and parcels": Cunard, *Grand Man*, 87.

303 The Hours was one of the most successful small presses: During the time that Nancy was running The Hours, from 1928 to 1931, she published works by George Moore, Norman Douglas, Ezra Pound, Louis Aragon, Robert Graves, Laura Riding, Samuel Beckett, Henry Crowder, and others. According to Hugh Ford, her total of two dozen or so published books "far exceeds the output of any other private press for a comparable period." Ford, "Foreword," in Cunard, *These Were the Hours*, viii.

303 "He has," Richard Aldington said: Chisholm, *Nancy Cunard*, 130.

303 "the first Negro I had ever known": Cunard, "Does Anyone *Know* Any Negroes?," 300–1, quoted in Gordon, *Nancy Cunard*, 152.

303 "introduced me to the astonishing complexities": Cunard, *These Were the Hours*, 26ff.

304 "astounded and revolted": Cunard, "Does Anyone *Know* Any Negroes?," 300.

304 "Her vast anger": Solano, "Nancy Cunard," *BPIR*, 77.

304 the usual royalties: Cunard, *These Were the Hours*, 13–14.

304 brief friendship with the wife: Crowder wrote that she "became quite fond of the drummer [Jerome Bourke]'s wife, an extremely beautiful colored girl who had

travelled from America with us." Crowder, *As Wonderful as All That?*, 68. (This memoir, written at the encouragement and with the assistance of editor Hugo Speck, was not published during Crowder's—or Cunard's—lifetime.)

304 "at a loose end": Crowder, *As Wonderful as All That?*, 120.

305 "A snack now and then": Acton, in *BPIR*, 74.

305 "the back-breaking": Cunard, *These Were the Hours*, 16.

305 "always littered with papers": Cunard, *Grand Man*, 92.

305 "The shop": Acton, in *BPIR*, 74.

305 she initiated affairs: Crowder, *As Wonderful as All That?*

305 "It was an absurd life": Michelet, "Nancy Cunard," excerpt translated by Chisholm, *Nancy Cunard*, 172. Published first in French as Michelet, "Nancy Cunard," in *BPIR*, 127–32.

306 "Henry made me": Nancy Cunard to Charles Burkhart, April 24, 1955, Southern Illinois University, Carbondale. Nancy's copy of *Negro* is at HRC.

307 "a most wary" . . . "Afro-America and Africa": Thorne, "A Share of Nancy," in *BPIR*, 295.

307 a rigorous course of self study: One "childhood diary" from 1910, for example, outlines a study plan of nine books a month, including works by Kingsley, Shelley, Schiller, Goldsmith, Molière, Shakespeare, Dickens, Aeschylus, and Chaucer, as well as the Book of Job, the Book of Esther, and more. Nancy was sixteen at the time.

307 poems of militancy and protest: Her folder of "Negro poetry copies from various sources, 1920s," for example, includes many poems on lynching, Africa, the slave trade, and civil rights. Nancy Cunard scrapbooks, Box 22, Folder 5, HRC.

308 "battle hymn": Cunard, *These Were the Hours*, 149.

308 "tear the Crackers": Cunard, *These Were the Hours*, 149. Published in *The Crisis*, *Henry Music*, and elsewhere.

308 "agonies of the Negroes": Cunard, *These Were the Hours*, 26.

308 "the Negro speaks": Cunard, draft of advertisement for proposed "symposium of poetry," never published, HRC.

309 "white negress": Marcus, "Bonding and Bondage," in *Borders, Boundaries, and Frames*, ed. Henderson, 48. See also Marcus, *Hearts of Darkness*. Marcus's forthcoming left-feminist biography of Nancy Cunard will differ from previous accounts.

310 "As for wishing": Nancy Cunard to Clyde Robinson, September 25, 1961, quoted in Ford, Introduction to Cunard, *Negro*, abridged edition, n. 4, xii.

310 "I like them [blacks]": Quoted in "Girl's Fight for Negroes," *Ceylon Observer*, July 30, 1933, clipping file, HRC.

310 "the tragedies of suffering humanity": Cunard, "Three Negro Poets," 355.

310 "to acknowledge": Winkiel, "Nancy Cunard's *Negro* and the Transnational Politics of Race," 508, 510.

Notes

311 "What is it now?": This story was already famous in its day, and many accounts of it exist, some told by luncheon guests and others by Nancy's friends. See, e.g., Fielding, *Those Remarkable Cunards*, 104, and Lowenfels, "Nancy Cunard," in *BPIR*, 92. Nancy's own account appears in various versions, including in "Black Man and White Ladyship," reprinted in Moynagh, ed. *Essays on Race and Empire*.

311 "the hysteria caused": Cunard, "Black Man and White Ladyship," 182.

311 "friendships between whites": Cunard, "Does Anyone *Know* Any Negroes?," 301.

312 "the most repulsive conception": Spanish newspaper, quoted in Morris, *This Loving Darkness*, 28–29.

312 British Union of Fascists: Both Oswald Mosley and Diana later—to Nancy's great delight—spent time in London's Holloway prison for their fascist activities. When they were to be let out of prison early, Nancy joined with many others to protest their release.

312 "She was democratic": Burkhart, *Herman and Nancy and Ivy*, 17.

313 "so hyper-sensitive" . . . "Totally baffling": Cunard, *These Were the Hours*, 128–29.

313 "I intend to devote my life": as quoted in clipping, "Two First-Class Families," Nancy Cunard clipping file, HRC.

313 "collective lunacy": Cunard, "On Colour Bar," 172.

314 "not unparalleled": Cunard, "Scottsboro and Other Scottsboros," in *Negro*, ed. Cunard, 245.

314 "the indignation, the fury": Nancy Cunard to Hugh Ford, March 1, 1963, fragment (last page missing), HRC.

314 "it looked like blackbirds": Walter Ballard, interview, www.livinghistoryfarm.org/farminginthe30s/movies/ballard_water_07.html.

314 Good manners and emotional reserve: Her father, Bache, assiduously avoided all emotional expressiveness, while her mother got away with speaking her mind in society by developing her own "acute sense of social propriety." Fielding, *Those Remarkable Cunards*, 99.

315 "It is only by fighting": Cunard, "Scottsboro and Other Scottsboros," in *Negro*, ed. Cunard, 269.

315 "The facts please": Thorne, in *BPIR*, 293.

315 "extremist in words": Duff, in *BPIR*, 188.

315 "delightful manners": Harper, "A Few Memories," in *BPIR*, 343.

315 "to avoid antagonizing Southern prejudice": Ransdell, "Report on the Scottsboro, Ala., Case," May 27, 1931, typescript, http://law2.umkc.edu/faculty/projects/ftrials/scottsboro/Scottsbororeport.pdf.

315 "pig-headed": Miller, *Remembering Scottsboro*, 33.

315 "would make saving": "Reds Take Charge of Boys' Defense," *New York Amsterdam News*, January 6, 1932, 1, 3.

316 "the nasty propaganda potential": Wedin, *Inheritors of the Spirit*, 87, 99.

316 "the struggle for Negro rights" . . . dancing classes: Naison, *Communists in Harlem*, 46, 47, 137.

316 "The Communists": Cunard, "Reactionary," in *Negro*, ed. Cunard, 146.

316 "a new spirit": Cunard, "Reactionary," in *Negro*, ed. Cunard, 147.

317 "Throughout the 1920s": Naison, *Communists in Harlem*, 3, 21.

317 The weekly *Amsterdam News*: Matusevich, "'Harlem Globe-Trotters,'" in *The Harlem Renaissance Revisited*, ed. Ogbar, 230; Editorial, *Amsterdam News*, February 9, 1935; see also Naison, *Communists in Harlem*, 136–37.

317 "bitter lot": McKay, *Harlem: Negro Metropolis*, 234.

317 "the wrong kind of pride": Cunard, "Harlem Reviewed," in *Negro*, ed. Cunard, 68, 73.

318 "white man's niggers": Cunard, "Reactionary," 147.

318 "one of the most spectacular and curious parties": F. G. H. Salusbury, "Miss Nancy Cunard's Exotic Party to Champion the 'Martyred Negroes,'" HRC.

318 the 1920s suntanning craze: Mighall, "A History of Tanning." Suntanning was partly a rebellion against the use of parasols, gloves, and white powder (and for many a rebellion against clothes altogether, since sunbathers were often associated with nudism).

319 "tropically hot": *Daily Mail*, clipping marked July 10, 1933, HRC.

319 "hate[s] so many white people": "Girl Who Hates 'So Many White People,'" *The Daily Express*, July 6, 1933, clipping, HRC; reprinted as "Girl's Fight for Negroes," *Ceylon Observer*, July 30, 1933, clipping, HRC.

319 "Miss Cunard's attitude": "Party Given by Miss Cunard at London Hotel," *Daily Gleaner*, July 22, 1933, HRC.

319 "scoundrel": Cunard to Schomburg, March 14 [1935], Schomburg Papers, Schomburg.

319 "unbearable" . . . "comforting": Patterson to Cunard, February 22, 1937, HRC.

319 "Dearest": James Threadgill to Nancy Cunard, September 3, 1954, HRC.

319 "not really thinking of anything else": Quoted in Chisholm, *Nancy Cunard*, 209.

320 "is Negro": Nancy Cunard, circular advertisement for *Color*, HRC.

320 "possessed": Cunard, *Grand Man*, 97.

320 "Imagine, a Negro man": Crowder, *As Wonderful as All That?*, 133.

321 "He would not even join her": Chisholm, *Nancy Cunard*, 212.

321 "fantasies . . . [of] black innocence": George Schuyler, "Views and Reviews," December 2, 1933.

321 "Notice how many": Cunard, "Harlem Reviewed," in *Negro*, ed. Cunard, 69–70.

321 "the spirit of vulgarity": Cunard, "Harlem Reviewed," in *Negro*, ed. Cunard, 73.

322 "They regarded her": Chisholm, *Nancy Cunard*, 203.

322 "Can't you get yourself a white man?": Cunard, "Harlem Reviewed," in *Negro*, ed. Cunard, 67.

322 "the atmosphere" . . . "gorgeous roughness": Cunard, "Harlem Reviewed," in *Negro*, ed. Cunard, 67, 69, 70, 73.

322 "She was white, they were black": Crowder, *As Wonderful as All That?*, 138.

323 "She pursued her own path": Mortimer, "Nancy Cunard," in *BPIR*, 49.

323 "Her Negrophilism": Plomer, "In the Early Thirties," in *BPIR*, 126.

323 "Nancy attacked her mother": Chisholm, *Nancy Cunard*, 184.

323 "an explosion": Brian Howard to his mother, quoted in Chisholm, *Nancy Cunard*, 187.

323 "I trust": Quoted in Gordon, *Nancy Cunard*, 160.

324 never spoke to or saw each other again: Chisholm, *Nancy Cunard*, 188.

324 "taking a Negro stick": McKay, *A Long Way from Home*, 244.

324 "there can seldom if ever": Chisholm, *Nancy Cunard*, 184.

324 oedipal struggle with her mother: See Douglas, *Terrible Honesty*, 274.

325 "most girls would sell their souls": Pickens, "African Art in Cunard Home," 5.

325 "dreary and decadent": Cunard, "Black Man and White Ladyship," in Cunard, *Essays on Race and Empire*, ed. Moynagh, 196.

325 "very great courage" . . . "inside out": Cunard, "Scottsboro and Other Scottsboros," in *Negro*, ed. Cunard, 265.

326 "The girls were not individuals": Cunard, "Scottsboro and Other Scottsboros," in *Negro*, ed. Cunard, 252.

327 "There is one precious superiority": http://asp6new.alexanderstreet.com/wam2/wam2.object.details.aspx?dorpID=1001113023.

328 "Some books are undeservedly forgotten": Auden, *The Dyer's Hand*, 10.

328 retreat to the country: "Lady Cunard's Search for Color."

328 "entirely documentary" . . . "as inclusive as possible": Nancy's original solicitation for *Negro*, then called *Color*, HRC.

329 "The vast subject": Cunard, *Grand Man*, 98.

329 "I am terrified by the size": Cunard to unknown correspondent, letter fragment, September 20, 1932, HRC.

329 "The publishing company": Cunard to Schomburg, April 30 [1934], Schomburg.

330 "Did I tell you": Cunard to Schomburg, April 30 [1934], Schomburg.

330 "getting the book through": Cunard to Schomburg, April 30 [1934], Schomburg.

330 "It is my grief": Cunard to Schomburg, April 30 [1934], Schomburg.

330 "The collapse of everything": Cunard, *These Were the Hours*, 201–5. A slightly different account of this devastation also appears in Cunard, *Grand Man*, 206–7.

331 "I feel very excited": McKay to Cunard, December 1, 1931, HRC.

333 "finest anthology": Alain Locke to Nancy Cunard, April 14, 1934, *Negro* scrap-book, HRC. Marcus also cites this letter in *Hearts of Darkness*, 144.

333 "What a spectacle of tireless energy": Crowder to Cunard, March 3, 1934, pasted into her copy of *Negro*, HRC.

333 Schuyler loved the book: Her letters are in Nancy's *Negro* scrapbook, HRC.

334 man's coat, aviator's helmet: Chisholm, *Nancy Cunard*, 213.

334 "Reputations are simply hell": Nancy Cunard, unpublished manuscript, quoted in Benkovitz, "The Back Like a Weasel's," 27.

335 "self-loathing . . . vamp": Gubar, *Racechanges*, 150, 152.

335 "she struck at her mother": Douglas, *Terrible Honesty*, 276.

335 "identification with those": Gordon, *Nancy Cunard*, 7.

335 "erotic boa constrictor": Chisholm, *Nancy Cunard*, 189.

335 "best mind": quoted in Wineapple, *Genet*, 79.

336 "She had to extract": Chisholm's translation, *Nancy Cunard*, 173.

336 "passionate inconstancy": Williams, "Nancy Cunard," *BPIR*, 56.

336 "Baffling contradictions": Duff, "Nancy Cunard," in *BPIR*, 190.

336 "some invention, ghastly or not": Arlen, *The Green Hat*, 27–28.

Epilogue: "Love and Consequences"

339 "Being black for a while": Roediger, "Guineas, Wiggers, and the Dramas," 661.

339 "You never dream of asking": Arlen, *The Green Hat*, 284. The character speaking is Iris March.

340 "penalty she had to pay": McKay, *A Long Way from Home*, 343.

340 In 2008, for example: Jones, *Love and Consequences*.

341 "humane and deeply affecting": Kakutani, "However Mean the Streets, Have an Exit Strategy."

341 "must-read": Walker, back cover blurb, Jones, *Love and Consequences*.

341 She "fabricated" the entire story: Rich, "Gang Memoir."

341 "a voice to people": Rich, "Gang Memoir."

341 "tremendous attraction": Roediger, "Guineas, Wiggers and the Dramas," 659.

342 "wavelength": Fisher, "The Caucasian Storms Harlem," 398.

342 In 1927, white poet Lucia Trent: United States Passport Applications, 1795–1925; New York Passenger Lists, 1820–1957; 1910 Federal Census; 1920 Federal Census. Trent published two volumes of poetry in her lifetime, *Children of Fire and Shadow* and *Thank You, America*. She was for many years the book reviewer for *The Nation*, praised highly as a poet by Robert Frost and others and known as "the best woman reader of poetry today." "Reception Wednesday Will Honor Two Famous Poets," 6. An excellent sampling of Trent's poetry and essays and

criticism of her writing, though oddly no biography of her life, is available on Cary Nelson's Modern American Poetry Website, www.english.illinois.edu/maps/poets/s_z/trent/trent.htm.

342 "A White Woman Speaks": Trent, "A White Woman Speaks."

343 That shame is the flip side: On the social meanings of shame, see especially Sedgwick and Frank, eds., *Shame and Its Sisters*.

343 "political edges": Roediger, *Colored White*, 231. Not all critics see as much positive "political edge" in this "crossover." A range of views on such contemporary crossover is represented in Tate, ed., *Everything But the Burden*.

Bibliography

Archival materials such as letters, notes, diaries, journals, newspaper clippings; unpublished manuscripts; interviews; and census, birth, death, and marriage records appear in the endnotes and are not repeated here. An overview of manuscript sources follows. To aid readers interested in further research on the women in this book or on such historical and thematic issues as passing, primitivism, spiritualism, and intermarriage, selected texts which are not directly cited in the notes but which proved instrumental to an understanding of the women and their era are included here and marked with the symbol +.

Manuscript Sources

Jacob Rader Marcus Center of the American Jewish Archives: Annie Nathan Meyer Papers

Barnard College Archives: Annie Nathan Meyer Papers

Beinecke Rare Book and Manuscript Library, Yale University: Countée Cullen Collection, Claude McKay Collection, James Weldon Johnson Collection, Dorothy Peterson Collection, Spingarn Collection, Wallace Thurman Collection, clippings file of the James Weldon Johnson Collection, Zora Neale Hurston Papers, Langston Hughes Papers, James Weldon Johnson and Grace Nail Johnson Papers, Mabel Dodge Luhan Papers, Claude McKay Papers, Richard Bruce Nugent Papers, Dorothy Peterson Papers, Aileen Pringle Papers, Carl Van Vechten Papers, Walter White Papers

Robert D. Farber University Archives and Special Collections Department, Brandeis University: Annie Nathan Meyer Papers

Howard Gotlieb Archival Research Center, Boston University: Libby Holman Papers

Rare Book & Manuscript Library, Butler Library, Oral History Collection, Columbia University: George S. Schuyler Oral History

Special Collections Research Center, Georgetown University Library: Biddle Family Papers, Biddle Family Letters, Francis B. Biddle Papers, Katherine Biddle Papers

Harry Ransom Center, University of Texas, Austin: Nancy Cunard Collection, Fannie Hurst Papers, Eugene O'Neill Collection, Alfred A. Knopf Inc. Records

Morristown College Archives, Knoxville College Library: Morristown College catalogs

Manuscript Division, Library of Congress: George Biddle Papers,

Janet Flanner and Solita Solano Papers, National Association for the Advancement of Colored People Records

Moorland-Spingarn Research Center, Howard University: Alain Locke Papers

Manuscripts and Archives, New York Public Library: Carl Van Vechten Papers; Berg Collection of English and American Literature, New York Public Library: Fannie Hurst Papers; Irma and Paul Milstein Division of United States History, Local History, and Genealogy, New York Public Library

Collection of Mrs. Edmund Randolph Biddle and Stephen G. Biddle, Quakertown, Pa.: Cornelia Van Auken Chapin Papers, Katherine Garrison Chapin Biddle Papers, Charlotte Osgood Mason Papers

Walter P. Reuther Library, Wayne State University: Mary White Ovington Papers

Schomburg Center for Research in Black Culture: Mary McLeod Bethune Papers, Claude McKay Papers, William Pickens Papers, Arthur A. Schomburg Papers, Schuyler Family Papers, Philippa Schuyler Papers (unprocessed), subject and proper name clipping files

Arthur and Elizabeth Schlesinger Library on the History of Women in America, Radcliffe Institute for Advanced Study, Harvard University, Cambridge, Mass.: Cornelia Chapin Papers

Special Collections Research Center, Syracuse University Library: Philippa Schuyler Papers, George S. Schuyler Papers

University Archives, Washington University: Fannie Hurst Papers

Abbott, Traci B. "Every Woman's Share: Female Sexuality in Fannie Hurst's *Imitation of Life*." *Women's Studies* 37 (2008): 634–60.

Acton, Harold. "Nancy Cunard: Romantic Rebel." In Ford, ed., *Brave Poet*, 73–75.

+ "Actress Quits Play with Negroes in Cast." *The New York Times*, September 12, 1925: 9.

"Actress Returns to California Doctor," *New York Amsterdam News*, December 25, 1929: 2.

Adams, Bruce Payton. "The White Negro: The Image of the Passable Mulatto Character in Black Novels, 1853–1954." Dissertation, University of Kansas, 1975.

Adams, Don, and Arlene Goldbard. *New Deal Cultural Programs: Experiments in Cultural Democracy.* Online, December 22, 2009. http://wwcd.org/policy/US/newdeal.html.

Ahmed, Sara. *The Cultural Politics of Emotion.* New York: Routledge, 2004.

"Ain't Misbehavin'." *Philadelphia Tribune*, May 5, 1932: 1.

+ Alcoff, Linda Martin. "Who's Afraid of Identity Politics?" In *Reclaiming Identity: Realist Theory and the Predicament of Postmodernism*. Ed. Paula Moya and Michael Hames-Garcia. Los Angeles: University of California Press, 2000, 312–44.

Alcoff, Linda. "The Unbearable Whiteness of Being: How Changing U.S. Demographics Will Upend White People's Sense of Identity, History, and What It Means for the Rest of Us." *The Indypendent*, May 1, 2011. Online. www.indypendent.org/2011/05/01/unbearable-whiteness-being-how-changing-us-demographics-will-upend-white-peoples-sense-identity-history-what-it-means-rest-us.

+ Allen, Frederick Lewis. *Only Yesterday: An Informal History of the 1920s*. New York: Harper, 1931.

Als, Hilton. "Queen Jane, Approximately." *The New Yorker*, May 9, 2011: 54–63.

American Trials: 'The Scottsboro Boys' Trials, 1931–1937, August 19, 2010. www.law.umkc.edu/faculty/projects/trials/scottsboro/scottsbororeport.pdf.

Ammons, Elizabeth. *Conflicting Stories: American Women Writers at the Turn into the Twentieth Century*. New York: Oxford University Press, 1991.

Anderson, Benedict. *Imagined Communities: Reflections on the Origin and Spread of Nationalism*. London, UK: Verso, 1991.

Anderson, James D. *The Education of Blacks in the South, 1860–1935*. Charlotte: University of North Carolina Press, 1988.

Anderson, Jervis. *This Was Harlem: A Cultural Portrait, 1900–1950*. New York: Farrar, 1982.

+ Anderson, Sarah A. "The Place to Go: The 135th Street Branch Library and the Harlem Renaissance." *The Library Quarterly* 73.4 (2003): 383–421.

Anonymous (Josephine Cogdell Schuyler). "The Fall of a Fair Confederate." *Modern Quarterly: A Journal of Radical Opinion* (Winter 1930–1931): 528–36.

———. "Two Poems by a Young Nordic Southerner." *The Messenger*, November 1927: 324.

Ansón, Luis María. *La Negritud*. Madrid: Revista de Occidente, 1971.

"An Anti-Lynching Crusade in America Begun." *Literary Digest*, August 11, 1894: 41–42.

Antler, Joyce. *The Journey Home: How Jewish Women Shaped Modern America*. New York: Schocken, 1998.

Bibliography

Apel, Dora. *Imagery of Lynching: Black Men, White Women, and the Mob.* New Brunswick, N.J.: Rutgers University Press, 2004.

Appiah, Kwame Anthony. *The Ethics of Identity.* Princeton, N.J.: Princeton University Press, 2005.

Arlen, Michael. *The Green Hat: A Romance for a Few People.* New York: Doran, 1924.

Asbury, Herbert. "Who Is a Negro? The Inside Story of Two Million Negroes Who Passed for White." *Negro Digest* 4.12 (October 1946): 3–11.

Ascoli, Peter M. *Julius Rosenwald: The Man Who Built Sears, Roebuck and Advanced the Cause of Black Education in the American South.* Bloomington: Indiana University Press, 2006.

+ Askowith, Dora. *Three Outstanding Women: Mary Fels, Rebekah Kohut, Annie Nathan Meyer.* New York: Bloch, 1941.

"Author George S. Schuyler Dies at 82 in New York." *Jet*, September 29, 1977: 56.

Babcock, Barbara A., and Nancy J. Parezo, eds. *Daughters of the Desert: Women Anthropologists and the Native American Southwest, 1880–1980: An Illustrated Catalogue.* Albuquerque: University of New Mexico Press, 1998.

Baker, Houston A., Jr. *Turning South Again: Re-thinking Modernism/Re-Reading Booker T.* Durham, N.C.: Duke University Press, 2001.

Bald, Wambly. "Montparnasse Today." *Vanity Fair*, July 1932.

+ Baldwin, Kate A. *Beyond the Color Line and the Iron Curtain: Reading Encounters Between Black and Red, 1922–1963.* Durham, N.C.: Duke University Press, 2002.

Baldwin, Louis Fremont. *From Negro to Caucasian, or How the Ethiopian Is Changing His Skin.* San Francisco, Calif.: Pilot, 1929.

Ballard, Walter. Interview. *Wessels Living History Farm, York Nebraska.* www.livinghistoryfarm.org/farminginthe30s/water_07.html.

Banting, John. "Nancy Cunard." In Ford, ed., *Brave Poet*, 179–85.

Barnes, Howard. *New York Herald Tribune*, March 31, 1932.

Barnet, Andrea. *All-Night Party: The Women of Bohemian Greenwich Village and Harlem, 1913–1930.* Chapel Hill, N.C.: Algonquin, 2004.

+ Barnet, Anthony. *Listening for Henry Crowder: A Monograph on His Almost Lost Music with the Poems & Music of Henry-Music.* East Sussex, Eng.: Allardyce, 2007.

Barrett, Michèle, ed. *Virginia Woolf: Women and Writing.* New York: Harcourt Brace Jovanovich, 1979.

Bass, George Houston, and Henry Louis Gates, Jr., eds. *Mule Bone: A Comedy of Negro Life*. New York: Harper, 1991.

Basu, Biman. "Hybrid Embodiment and an Ethics of Masochism: Nella Larsen's *Passing* and Sherley Anne Williams's *Dessa Rose*." *African American Review* 36.3 (2002): 383–401.

+ Bauer, Dale M. *Sex Expression and American Women Writers, 1860–1940*. Chapel Hill: University of North Carolina Press, 2009.

+ Beam, Lura. *He Called Them by the Lightning: A Teacher's Odyssey in the Negro South, 1908–1919*. Indianapolis, Ind.: Bobbs-Merrill, 1967.

+ Bederman, Gail. *Manliness and Civilization: A Cultural History of Gender and Race in the United States, 1880–1917*. Chicago: University of Chicago Press, 1995.

Bedford, Sybille. *Aldous Huxley: A Biography*. New York: Knopf, 1974.

Benkovitz, Miriam. "The Back Like a Weasel's." *Columbia Literary Column* 28.1 (1978): 27.

Bennett, Gwendolyn. "Heritage." *Opportunity: The Journal of Negro Life*, December 1923: 371.

Bennett, Lincoln. "Negro Girl, 2½, Recites Omar and Spells 5-Syllable Words." *New York Herald Tribune*, February 8, 1934: 18.

+ Benston, Kimberly W. *Performing Blackness: Enactments of African-American Modernism*. London, UK: Routledge, 2000.

Berlant, Lauren. *The Female Complaint: The Unfinished Business of Sentimentality in American Culture*. Durham, N.C.: Duke University Press, 2008.

Berliner, Brett A. *Ambivalent Desire: The Exotic Black Other in Jazz-Age France*. Amherst: University of Massachusetts Press, 2002.

Bernard, Emily. *Carl Van Vechten and the Harlem Renaissance: A Portrait in Black and White*. New Haven, Conn.: Yale University Press, 2012.

———, ed. *Remember Me to Harlem: The Letters of Langston Hughes and Carl Van Vechten, 1925–1964*. New York: Knopf, 2001.

+ ———, ed. *Some of My Best Friends: Writings on Interracial Friendships*. New York: Harper, 2004.

Berry, Faith. "Black Poets, White Patrons: The Harlem Renaissance Years of Langston Hughes." *The Crisis* 88.6 (1981): 278–306.

———. *Langston Hughes: Before and Beyond Harlem*. New York: Random House, 1995.

Birmingham, Stephen. *The Grandees: America's Sephardic Elite*. Syracuse, N.Y.: Syracuse University Press, 1997.

"Black Belt's Night Life." *Variety*, October 16, 1929: 1, 12.

+ Black, Cheryl. *The Women of Provincetown, 1915–1922.* Tuscaloosa: University of Alabama Press, 2002.

"Blonde Girl Was 'Passing.'" *Boston Chronicle*, January 23, 1932.

Blum, Edward J. "'The Contact of Living Souls': Interracial Friendship, Faith, and African-American Memories of Slavery and Freedom." *Journal for the Study of Radicalism* 3.1 (2008): 89–110.

———. "Of Saints and Sinners: Religion and the Civil War and Reconstruction Novel." *Journal of Religion and Society* 4 (2002): 1–9.

+ Boas, Franz. *The Mind of Primitive Man.* Rev. ed. New York: Free Press, 1963.

Bogle, Donald. *Bright Boulevards, Bold Dreams: The Story of Black Hollywood.* New York: One World/Ballantine, 2006.

Bonilla-Silva, Eduardo. *Racism Without Racists: Color-Blind Racism and Racial Inequality in Contemporary America.* London, UK: Rowman and Littlefield, 2010.

Boyle, Kevin. *Arc of Justice: A Saga of Race, Civil Rights, and Murder in the Jazz Age.* New York: Henry Holt, 2004.

Boyle, T. C. *The Road to Wellville.* New York: Viking, 1993.

Bracker, Milton. "Child Composer, 8, Is Honored at Fair." *The New York Times*, June 20, 1940: 28.

Braude, Ann. *Radical Spirits: Spiritualism and Women's Rights in Nineteenth-Century America.* New York: Beacon, 1989.

Bredenburg, Alfred. "Natalie Curtis Burlin (1875–1921): A Pioneer in the Study of American Minority Cultures," n.d. Online, June 1, 2008. www.nataliecurtis.org.

Breines, Winifred. *The Trouble Between Us: An Uneasy History of White and Black Women in the Feminist Movement.* New York: Oxford University Press, 2006.

———. *Young, White, and Miserable: Growing Up Female in the Fifties.* Boston, Mass.: Beacon, 1992.

Breyer, Jackson R., ed. *The Theatre We Worked For: The Letters of Eugene O'Neill to Kenneth Macgowan.* New Haven, Conn.: Yale University Press, 1982.

Britt, George. "Women in the New South." In *Woman's Coming of Age: A Symposium.* Ed. V. F. Calverton and Samuel D. Schmalhausen. New York: Liveright, 1931.

Brock, Pope. *Charlatan: America's Most Dangerous Huckster, the Man Who Pursued Him, and the Age of Flimflam*. New York: Crown, 2008.

Brodkin, Karen. *How Jews Became White Folks and What That Says About Race in America*. New Brunswick, N.J.: Rutgers University Press, 1998.

Brooks, Van Wyck. "On Creating a Usable Past." *The Dial*, April 11, 1918: 337–41.

+ Brown, Dorothy M. *Setting a Course: American Women in the 1920s*. Boston, Mass.: Twayne, 1987.

Brown, Mary Jane. *Eradicating This Evil: Women in the American Anti-Lynching Movement*. New York: Garland, 2000.

Brown, Sterling. "Imitation of Life: Once a Pancake." *Opportunity*, March 1935: 87–88.

+ ———. "Negro Character as Seen by White Authors." *The Journal of Negro Education* 2.2 (1933): 179–203.

———. "The New Secession—A Review." *Opportunity*, May 5, 1927: 147–48.

———. "Our Literary Audience." *Opportunity*, February 8, 1930: 42–46.

———. *A Son's Return: Selected Essays of Sterling A. Brown*. Ed. Mark A. Sanders. Boston, Mass.: Northeastern University Press, 1996.

Bryan, Charles F., Jr., and Jovita Wells. "Morristown College: Education for Blacks in the Southern Highlands." *East Tennessee Historical Society's Publications* 51–52 (1981): 61–77.

Bundles, A'Lelia. *On Her Own Ground: The Life and Times of Madam C. J. Walker*. New York: Scribner, 2001.

Bundy, Carol. *The Nature of Sacrifice: A Biography of Charles Russell Lowell, 1835–64*. New York: Farrar, Straus and Giroux: 2005.

"Burglar Hits Actress." *The New York Times*, April 16, 1927: 20.

+ Burke, Virginia M. "Zora Neale Hurston and Fannie Hurst as They Saw Each Other." *CLA Journal* XX.4 (1977): 435–47.

Burkhart, Charles. *Herman and Nancy and Ivy: Three Lives in Art*. London, UK: Gollancz, 1987.

———. "Letters from Nancy." In Ford, ed., *Brave Poet*, 324–31.

Butchart, Ronald E. *Northern Schools, Southern Blacks, and Reconstruction: Freeman's Education, 1862–1875*. Westport, Conn.: Greenwood, 1980.

Butler, Judith. *Gender Trouble: Feminism and the Subversion of Identity*. New York: Routledge, 1990.

Caputi, Jane. "'Specifying' Fannie Hurst: Langston Hughes's 'Limitations of Life,' Zora Neale Hurston's *Their Eyes Were Watching God*, and Toni

Morrison's *The Bluest Eye* as 'Answers' to Hurst's *Imitation of Life*." *Black American Literature Forum* 24.4 (1990): 697–716.

Carby, Hazel V. "'On the Threshold of Woman's Era': Lynching, Empire, and Sexuality in Black Feminist Theory." *Critical Inquiry* 12.1 (1985): 262–77.

"Careful Lyncher! He May Be Your Brother." *Philadelphia Tribune*, January 21, 1932.

Carr, Leslie G. *"Color-Blind" Racism*. Thousand Oaks, Calif.: Sage, 1997.

"Carry Mixed Marriage to Movie Czar." *The Pittsburgh Courier*, December 28, 1929: 3.

Carter, Dan T. *Scottsboro: A Tragedy of the American South*. Rev. ed. Baton Rouge: Louisiana State University Press, 2007.

Cash, W. J. *The Mind of the South*. New York: Knopf, 1941.

Caspary, Vera. *The White Girl*. New York: J. H. Sears, 1929.

Cavanagh, Sheila L. "Spinsters, Schoolmarms, and Queers: Female Teacher Gender and Sexuality in Medicine and Psychoanalytic Theory and History." *Discourse: Studies in the Cultural Politics of Education* 27.4 (2006): 421–40.

+ Chapin, David. *Exploring Other Worlds: Margaret Fox, Elisha Kent Kane, and the Antebellum Culture of Curiosity*. Amherst: University of Massachusetts Press, 2004.

Cherny, Robert W. "Patterns of Toleration and Discrimination in San Francisco: The Civil War to World War I." *California History* 73.2 (1994): 130–41.

Chesnutt, Charles. "The Disenfranchisement of the Negro." *Lewiston Evening Journal*, April 15, 1903: 1.

———. "Friend of the Negro." *Lewiston Evening Journal*, April 15, 1903: 1.

Chic Safari, Neiman Marcus. Advertisement. *The New York Times*, Style section, April 25, 2010.

Chisholm, Anne. *Nancy Cunard*. New York: Knopf, 1979.

+ Clements, William M. "The 'Offshoot' and the 'Root': Natalie Curtis and Black Expressive Culture in Africa and America." *Western Folklore* 54.4 (1995): 277–301.

Clough, Patricia, ed. *The Affective Turn: Theorizing the Social*. Chapel Hill, N.C.: Duke University Press, 2007.

Cogdell, Josephine (*see also* Anonymous; Issel, Helna; Jannath, Heba; Jerome, Julia; Schuyler, Josephine Cogdell; Tanne, Laura). "Irony." *The Messenger* 6 (1924): 366.

————. "My Sorrow Song." *The Messenger* 6 (1924): 388.

————. "Spring." *The Messenger* 7 (1925): 178.

————. "Those Inimitable Avatars—The Negroes and the Jews!" *The Messenger* 7 (1925): 302.

————. "Truth in Art in America." *The Messenger* 5 (1923): 634–36.

+ Colley, Zoe A. "From Mammy to Schoolmarm: Challenging Images of Women as Civil Rights Activists in Nineteenth-Century America." *Gender and History* 18.2 (2006): 417–20.

Collins, Patricia Hill. *Seeing a Color Blind Future: The Paradox of Race.* New York: Farrar, 1997.

Cooley, John. "White Writers and the Harlem Renaissance." *The Harlem Renaissance: Revaluations.* Ed. Amritjit Singh et al. New York: Garland, 1989. 13–22.

+ Cott, Nancy F. *The Grounding of Modern Feminism.* New Haven, Conn.: Yale University Press, 1987.

+ "Cotton Club, Harlem, Bars Colored Couple Accompanied by White Friends Giving Police Orders as the Reason." *New York Age,* July 24, 1927: n.p.

Crowder, Henry, and Hugo Speck. *As Wonderful as All That? Henry Crowder's Memoir of His Love Affair with Nancy Cunard, 1928–1935.* Navarro, Calif.: Wild Trees, 1987.

+ Cruse, Harold. *The Crisis of the Negro Intellectual: A Historical Analysis of the Failure of Black Leadership.* New York: William Morrow, 1984.

Cullen, Countée. "Heritage." *Color.* New York: Harper, 1925.

+ "Cunard Heiress in Harlem to Study Color Problem." *The Chicago Defender,* May 7, 1932.

+ Cunard, Nancy. "American Sailors Are Made to Pay for Insulting Hampton Inst. Envoy." *The Chicago Defender,* April 5, 1941: 4.

+ ————. "At a Refugee Camp." *Manchester Guardian,* February 10, 1939: 6.

————. "Black Man and White Ladyship." *New Review,* April 2, 1932: 30–35. Reprinted in Moynagh, ed.

+ ————. "Black Moors, Fighting for Spanish Fascists, Given Demoralizing Treatment." *Atlanta Daily World,* July 15, 1937: 1, 6.

+ ————. "Claims Moors Deserting Franco: African Fighters in Spanish War Selling Weapons, Is Report." *Atlanta Daily World,* September 27, 1937: 1, 3.

+ ————. "Decade of Exile." *Arena,* February 1950: 4–26.

————. "Does Anyone *Know* Any Negroes?" *The Crisis*, September 19, 1931: 300–1.

+ ————. *Essays on Race and Empire*. Ed. Moynagh.

+ ————. "The Exodus from Spain." *The Manchester Guardian*, February 8, 1939: 39.

+ ————. "Find Most British West Indians Favor U.S. Rule." *The Chicago Defender*, May 31, 1941: 6.

————. Foreword. Cunard ed., *Negro*, iii–iv.

+ ————. "From Afar." *The Bookman: A Review of Books and Life*, November 1924: 261.

————. *GM: Memories of George Moore*. London, UK: Rupert Hart-Davis, 1956.

————. *Grand Man: Memories of Norman Douglas*. London, UK: Secker, 1954.

+ ————. "Haile Selassie Will Retain His Claim to Throne, Legation Says." *Atlanta Daily World*, August 11, 1937: 1.

————. "Harlem Reviewed." In Cunard ed., *Negro*, 67–74.

+ ————. "The Hours Press." *The Book Collector* 13 (1964): 488–96.

+ ————. "I Am Not One for Expression." *The New Statesman*, December 16, 1922: n.p.

+ ————. "In the Fields." *The Living Age*, September 2, 1922: 605.

+ ————. "From the Spanish Border." *The Nation* 163 (1946): 539.

+ ————. "Letter from Paris." In *The Twenties in Vogue*. Ed. Carolyn Hall. New York: Harmony, 1983.

+ ————. "A Message from South-West France." *Our Time*, August 5, 1945: 4–5.

+ ————. "Moors Forced to Fight for Franco." *The Chicago Defender*, October 22, 1932: 24.

+ ————. "The Musée de L'Homme." *The Burlington Magazine for Connoisseurs* 88.516 (1946): 66, 68–71.

+ ————. "Nancy Cunard Tells of the Fall of Teruel." *The Chicago Defender*, February 26, 1938: 24.

————. "Nancy Cunard Writes Inside Story of Selassie's Plea Before League of Nations." *Philadelphia Tribune*, July 16, 1936: 2.

————. *Negro: An Anthology Made by Nancy Cunard, 1931–1933*. Ed. Nancy Cunard. First published London, UK: Wishart, 1934. Reprinted in full, Greenwood, New York: Negro Universities Press, 1969.

+ ————. "News from South America." Review of "News from South America" by G. S. Fraser. *Horizon: A Review of Literature and Art* 20 (1949): 66–69.

+ ————. "A Note on the Musée Labit in Toulouse." *The Burlington Magazine for Connoisseurs* 87.510 (1945): 232–33.

————. "On Colour Bar." *Life and Letters* 32 (1942): 172.

+ ————. *Outlaws*. London, UK: Elkin Mathews, 1921.

+ ————. "Panama Bars Cubans; Call Them 'Reds.' " *The Chicago Defender*, July 12, 1941: 9.

+ ————. "Paris in Rally for Ethiopia." *The Chicago Defender*, December 11, 1935: 24.

————. *Poems of Nancy Cunard: From the Bodleian Library*. Ed. John Lucas. Nottingham, Eng.: Trent, 2005.

+ ————. "Professor Jeze Is Threatened." *The Chicago Defender*, December 21, 1935: 24.

————. "A Reactionary Negro Organization." In Cunard, ed., *Negro*, 142–47.

+ ————. "Reports Vary on Fate of Senegalese Troops." *The Chicago Defender*, June 14, 1941: 1–2.

————. "Scottsboro and Other Scottsboros." In Cunard, ed., *Negro*, 45–69.

————. "Soldiers Fallen in Battle." *Eaton College Chronicle*, June 1916.

+ ————. "The Soldiers Leave the Battlefield Behind." *The Manchester Guardian*, February 9, 1939: 13.

————. *Sublunary*. London, UK: Hodder, 1923.

————. *These Were the Hours: Memories of My Hours Press, Réanville and Paris, 1928–1931*. Carbondale: Southern Illinois University Press, 1969.

————. "Three Negro Poets." *Left Review*, October 3, 1937: 355.

+ ————. "Trasimene." *Saturday Review*, June 2, 1923: n.p.

+ ————. "The Triumph of the Treasures of France." *The Burlington Magazine for Connoisseurs* 87.508 (1945): 168–73.

+ ————. "The Watergate Theatre." *Life and Letters* 65 (1950): 238–41.

+ ————. "Wayland Rudd Thrills Paris as the Star of Film 'Paladin of Humanity.' " *The Chicago Defender*, January 29, 1955: 7.

————. "Wheels." In Ford, ed., *Brave Poet*, 13.

+ ————. "Yes, It Is Spain." *Life and Letters Today*, September 19, 1938: 57–59.

+ Cunard, Nancy, and George Padmore. *The White Man's Duty*. London, UK: W. H. Allen, 1944.

+ Curry, Constance, et al. *Deep in Our Hearts: Nine White Women in the Freedom Movement.* Athens: University of Georgia Press, 2002.

Curtis, George William. *Orations and Addresses of George William Curtis, Vol. I.* New York: Harper, 1894.

Curtis, Natalie Berlin. "Again, the Negro." *Poetry: A Magazine of Verse* 11.3 (1917): 147–51.

+ ———. "An American-Indian Composer." *Harper's Monthly Magazine,* June–November 1903: 626.

+ ———. "American Indian Cradle-Songs." *The Musical Quarterly* 7.4 (1921): 549–58.

+ ———. "Black Singers and Players." *The Musical Quarterly* 5.4 (1919): 499–504.

+ ———. "Hampton's Double Mission." *The Southern Workman* 34.10 (1905): 543–45.

———. *The Indians' Book: An Offering by the American Indians of Indian Lore, Musical and Narrative, to Form a Record of the Songs and Legends of Their Race.* New York: Harper, 1907.

———. "Life of a Gifted Woman: Elizabeth Burrill Curtis." *Springfield Daily Republican,* April 15, 1914: 17.

———. "Mr. Roosevelt and Indian Music: A Personal Reminiscence." *Outlook,* March 5, 1919: 99–400.

+ ———. "Negro Music at Birth." *The Musical Quarterly* 5.1 (1919): 86–9.

———. "New Art in the West." *International Studio,* November 1917: 14–18.

+ ———. "A Plea for Our Native Art." *The Musical Quarterly* 6.2 (1920): 175–78.

+ ———. "Recognition of Negro Music." *The Southern Workman,* January 1920: 6–7.

+ ———. "The Shepard Poet: A Bit of Arizona Life." *The Southern Workman* 33.3 (1904): 145–48.

+ ———. "The Winning of an Indian Reservation: How Theodore Roosevelt and Frank Mead Restored the Mojave-Apaches to Their Own." *Outlook,* June 25, 1919: 327–30.

Dalton, Kathleen. *Theodore Roosevelt: A Strenuous Life.* New York: Knopf, 2002.

+ Dancer, Maurice. "U.S. Bars Entry of Nancy Cunard." *The Chicago Defender,* August 2, 1941: 1–2.

Davidson, Cathy, Linda Wagner-Martin, and Elizabeth Ammons. *The Oxford Companion to Women's Writing in the United States.* New York: Oxford University Press, 1995.

Davis, Angela. *Women, Race & Class*. New York, Random House, 1981.

Davis, Cynthia J., and Kathryn West, eds. *Women Writers in the United States: A Timeline of Literary, Cultural, and Social History*. New York: Oxford University Press, 1996.

Davis, Leroy. "John Hope." *Georgia Encyclopedia*, August 21, 2009. www.georgiaencyclopedia.org/nge/Article.jsp?id=h–855.

Davis, Thadious. *Nella Larsen: Novelist of the Harlem Renaissance: A Woman's Life Unveiled*. Baton Rouge: Louisiana State University Press, 1994.

Dearborn, Mary V. *Queen of Bohemia: The Life of Louise Bryant*. New York: Houghton, 1996.

DeBoer-Langworthy, Carol. *The Modern World of Neith Boyce: Autobiography and Diaries*. Albuquerque: University of New Mexico Press, 2003.

Decker, Todd. "The NAACP 'Follies' of 1929: A Forgotten Interracial Benefit on Broadway." TS. Todd Decker, St. Louis, Mo.

DeRamus, Betty. *Forbidden Fruit: Love Stories from the Underground Railroad*. New York: Atria, 2005.

+ Deutsch, Helen, and Stella Hanau. *The Provincetown: A Story of the Theater*. New York: Farrar and Rinehart, 1931.

+ Dilworth, Leah. *Imagining Indians in the Southwest: Persistent Visions of a Primitive Past*. Washington, DC: Smithsonian Institution Press, 1996.

Diouf, Sylviane. *Dreams of Africa in Alabama: The Slave Ship* Clotilda *and the Story of the Last Africans Brought to America*. New York: Oxford University Press, 2007.

Dos Passos, John. *The Big Money*. New York: Mariner, 2000.

Douglas, Ann. *Terrible Honesty: Mongrel Manhattan in the 1920s*. New York: Farrar, 1995.

"Dr. Mason on Telepathy: His Explanation of Cases of Thought Transference." *The New York Times*, December 13, 1896: 7.

+"Dr. R. Osgood Mason: Obituary." *The New York Times*, May 12, 1903.

Dreisinger, Baz. *Near Black: White-to-Black Passing in American Culture*. Amherst: University of Massachusetts Press, 2008.

Du Bois, W. E. B. *Black Reconstruction in America*. 1935. New York: Atheneum, 1992.

———. "Books." *The Crisis*, December 1926: 31–32

———. "A Lunatic or a Traitor." *The Crisis*, May 28, 1924: 8–9.

———. "The New Negro Theater." *New York Call*, April 1917: n.p.

———. "Postscript." *The Crisis*, August 1927: 203.

———. "Returning Soldiers." *The Crisis*, May 1919: 13.

———. "Rhinelander." *The Crisis*, January 1926: 112–13.

———. *The Souls of Black Folk* (1903). Du Bois, *Writings*, 357–547.

———. *Writings*. 1903. New York: Library of America, 1986.

Duberman, Martin. *Paul Robeson: A Biography*. New York: Ballantine, 1989.

Duff, Charles. "Nancy Cunard: The Enigma of a Personality." In Ford, ed., *Brave Poet*, 186–90.

+ Dumenil, Lynn. *The Modern Temper: American Culture and Society in the 1920s*. New York: Hill and Wang, 1995.

+ Dyer, Richard. *White: Essays on Race and Culture*. New York: Routledge, 1997.

Dyson, Michael Eric. *Race Rules: Navigating the Color Line*. New York: Addison-Wesley, 1996.

Eaton, Walter Prichard. "Printed Drama in Review." *New York Herald Tribune Books*, January 1, 1933.

Edwards, Brent Hayes. *The Practice of Diaspora: Literature, Translation, and the Rise of Black Internationalism*. Cambridge, Mass.: Harvard University Press, 2003.

Eliot, Elizabeth. *They All Married Well*. London, UK: Cassell, 1959.

Eliot, T. S. "Tradition and the Individual Talent." In *The Sacred Wood*. London, UK: Methuen, 1922.

Ellison, Ralph. *Invisible Man* (1947). New York: Vintage, 1995.

Elsner, John, and Roger Cardinal, eds. *The Cultures of Collecting*. Cambridge, Mass.: Harvard University Press, 1994.

Engs, Robert F. "They Gave Them Schools . . . but Why *Only* Schools?" *History of Education Quarterly* 24.4 (1984): 619–25.

Estes, St. Louis A. *Raw Food and Health*. New York: Estes Raw Food and Health Association, 1927.

Ewell, Thomas T. *Hood County History*, first published in 1895; C. L. Hightower, Sr., ed., *Hood County History in Picture and Story, 1978*. Fort Worth, Texas: Historical Publishers and the Junior Woman's Club, Granbury, Texas, 1978.

"Faces Insanity Complaint: Helen Lee Worthing Held in County Hospital at Los Angeles." *The New York Times*, November 29, 1932: 22.

"Fannie Hurst Wed: Hid Secret 5 Years." *The New York Times*, May 4, 1920: 1.

+ Faderman, Lillian. *Odd Girls and Twilight Lovers: A History of Lesbian Life in Twentieth-Century America.* New York: Penguin, 1991.

Fairbanks, Carol, and Eugene A. Engeldinger. *Black American Fiction: A Bibliography.* Metuchen, N.J.: Scarecrow, 1978.

+ Fass, Paula. *The Damned and the Beautiful: American Youth in the 1920s.* Oxford: Oxford University Press, 1977.

Faust, Drew Gilpin. *This Republic of Suffering: Death and the American Civil War.* New York: Knopf, 2008.

+ Favor, Martin. *Authentic Blackness: The Folk in the New Negro Renaissance.* Durham, N.C.: Duke University Press, 1999.

Ferber, Edna. *A Kind of Magic.* New York: Doubleday, 1963.

Ferguson, Jeffrey B. "The Newest Negro: George Schuyler's Intellectual Quest in the Nineteen Twenties and Beyond." Dissertation, Harvard University, 1998.

———. *The Sage of Sugar Hill: George S. Schuyler and the Harlem Renaissance.* New Haven, Conn.: Yale University Press, 2005.

Fielding, Daphne. *Those Remarkable Cunards: Emerald and Nancy.* New York: Atheneum, 1968.

Filene, Benjamin. *Romancing the Folk: Public Memory and American Roots Music.* Chapel Hill: University of North Carolina Press, 2000.

"Film Beauty, Patient of Race Physician, Brutally Attacked by 'Mystery Assailant.'" *The Pittsburgh Courier,* April 27, 1927: 13.

Fisher, Rudolph. "The Caucasian Storms Harlem." *The American Mercury,* August 1927.

———. *The Walls of Jericho.* 1928. Ann Arbor: University of Michigan Press, 1992.

Flanner, Janet. "Nancy Cunard." In Ford, ed., *Brave Poet,* 87–90.

"Follies Beauty Will Always Remember Kindness and Love of Colored Hubby." *The Pittsburgh Courier,* December 30, 1930: 2.

Ford, Hugh. Foreword. *These Were the Hours: Memories of My Hours Press, Réanville and Paris, 1928–1931.* By Nancy Cunard. Carbondale: Southern Illinois University Press, 1969, vii.

———, ed. *Nancy Cunard: Brave Poet, Indomitable Rebel, 1896–1965.* Philadelphia, PA: Chilton, 1968.

Foster, Lenoar. "The Not-So-Invisible Professors: White Faculty at the Black College." *Urban Education* 36 (2001): 611–29.

Frank, Glenda. "Tempest in Black and White: The 1924 Premiere of Eugene O'Neill's *All God's Chillun Got Wings.*" *Resources for American Literary Study* 26.1 (2000): 77.

Frankenberg, Ruth, ed. *Displacing Whiteness: Essays in Social and Cultural Criticism.* Durham, N.C.: Duke University Press, 1997.

————. *White Women, Race Matters: The Social Construction of Whiteness.* Minneapolis: University of Minnesota Press, 1993.

Fraser, Nancy, and Axel Honneth. *Redistribution or Recognition? A Political Philosophical Exchange.* London, UK: Verso, 2003.

Frederickson, George M. *The Black Image in the White Mind: The Debate on Afro-American Character and Destiny, 1817–1914.* Rev. ed. Middletown, Conn.: Wesleyan University Press, 1987.

Frederickson, Mary E. "'Each One Is Dependent on the Other': Southern Church Women, Racial Reform, and the Process of Transformation, 1880–1940." *Visible Women: New Essays on American Activism.* Ed. Nancy A. Hewitt and Suzanne Lebstock. Urbana: University of Illinois Press, 1993.

Freedman, Estelle B. "The New Woman: Changing Views of Woman in the 1920s." *Journal of American History* 61.2 (1974): 372–93.

Fulks Scott, Esther. "Negroes as Actors in Serious Plays." *Opportunity* 1 (1923): 20.

Garnett, David. "Nancy Cunard." In Ford, ed., *Brave Poet*, 26–28.

Gates, Henry Louis, Jr. "A Fragmented Man: George Schuyler and the Claims of Race." *The New York Times Book Review*, September 20, 1992, 42–43.

————. "The Trope of a New Negro and the Reconstruction of the Image of the Black." *Representations* 24 (1988): 129–55.

Gates, Henry Louis, Jr., and Gene Andrew Jarrett, eds. *The New Negro: Readings on Race, Representation and African American Culture, 1892–1938.* Princeton, N.J.: Princeton University Press, 2007.

Gelhorn, Sarah N. "But of Course—No Social Equality." *The Chicago Defender,* June 17, 1922: 14.

Giddings, Paula J. *Ida: A Sword Among Lions: Ida B. Wells and the Campaign Against Lynching.* New York: Harper, 2009.

Gill, Jonathan. *Harlem: The Four Hundred Year History from Dutch Village to Capital of Black America.* New York: Grove, 2011.

Gilmore, Glenda. *Defying Dixie: The Radical Roots of Civil Rights, 1919–1950.* New York: Norton, 2009.

————. *Gender and Jim Crow: Women and the Politics of White Supremacy in North Carolina, 1896–1920*. Chapel Hill: University of North Carolina Press, 1996.

Gilroy, Paul. *Against Race: Imagining Political Culture Beyond the Color Line.* Cambridge, Mass.: Harvard University Press, 2000.

+ Ginsberg, Elaine K., ed. *Passing and the Fictions of Identity.* Durham, N.C.: Duke University Press, 1996.

Goffin, Robert. "Hot Jazz." In Cunard, ed., *Negro*, 378.

Goldenberg, Myrna. "Annie Nathan Meyer: Barnard Godmother and Gotham Gadfly." Dissertation, University of Maryland, 1987.

Goldsby, Jacqueline. *A Spectacular Secret: Lynching in American Life and Literature.* Chicago: University of Chicago Press, 2006.

+ Goodman, James E. *Stories of Scottsboro.* New York: Pantheon, 1994.

Gordon, A. H. "Some Disadvantages of Being White." *The Messenger* 10 (1928): 79.

Gordon, Eugene. " 'The Green Hat' Comes to Chambers Street." In Ford, ed., *Brave Poet*, 134.

Gordon, Lois. *Nancy Cunard: Heiress, Muse, Political Idealist.* New York: Columbia University Press, 2007.

Gordon, Taylor. *Born to Be.* Lincoln: University of Nebraska Press, 1995.

Gotanda, Neil. "A Critique of 'Our Constitution Is Color Blind.' " *Stanford Law Review* 1 (1991): 1–68.

Gregg, Melissa, and Gregory J. Seigworth, eds. *The Affect Theory Reader.* Durham, N.C.: Duke University Press, 2010.

Gregory, Montgomery. "The Drama of Negro Life," *The New Negro*, ed. Locke 159.

————. Review of *Black Souls*, by Annie Nathan Meyer. *Opportunity*, May 1933: 155–56.

Griffin, Farah Jasmine. *"Who Set You Flowin'?" The African-American Migration Narrative.* New York: Oxford University Press, 1995.

Gross, Ariela J. *What Blood Won't Tell: A History of Race on Trial in America.* Cambridge, Mass.: Harvard University Press, 2008.

Gross, Michael. *740 Park: The Story of the World's Richest Apartment Building.* New York: Broadway, 2005.

Gubar, Susan. *Racechanges: White Skin, Black Face in American Culture.* New York: Oxford University Press, 1997.

Guillaume, Paul. "The Triumph of Ancient Negro Art." *Opportunity*, May 1926: 146–47.

Hageman, John Frelinghuysen. *History of Princeton and Its Institutions*. Philadelphia, Pa.: Lippincott, 1979.

Hahn, Emilie. "Crossing the Color Line." *New York World*, July 28, 1929: n.p.

+ Hale, Grace Elizabeth. *Making Whiteness: The Culture of Segregation in the South, 1890–1940*. New York: Vintage, 1999.

Hall, Jacquelyn Dowd. *Revolt Against Chivalry: Jessie Daniel Ames and the Women's Campaign Against Lynching*. New York: Columbia University Press, 1993.

Hamblen County Centennial Celebration. *Historic Hamblen, 1870–1970*. Morristown, Tenn.: Morrison, 1970.

Hammond, Brenda Hines. "A Historical Analysis of Selected Forces and Events Which Influenced the Founding, Growth, and Development of Morristown College, a Historically Black Two-Year College, from 1881 to 1981." Dissertation, George Washington University, 1983.

Hansen, Arlen J. *Expatriate Paris: A Cultural and Literary Guide to Paris of the 1920s*. New York: Avade, 1990.

+ "Harlem Vast Negro City." *Los Angeles Times*, March 1, 1925: 6.

+ "Harlem, the Hooch-Seller's Paradise, by the Evidence." *New York Age*, April 21, 1923: 1.

Harper, Allanah. "A Few Memories of Nancy Cunard." In Ford, ed., *Brave Poet*, 341–44.

Harris, Leonard, and Charles Molesworth. *Alain L. Locke: The Biography of a Philosopher*. Chicago: University of Chicago Press, 2008.

Harrison-Kahan, Lori. *The White Negress: Literature, Minstrelsy, and the Black-Jewish Imaginary*. New Brunswick, N.J.: Rutgers University Press, 2011.

+ Hart, Robert C. "Black-White Literary Relations in the Harlem Renaissance." *American Literature* 44.4 (1973): 612–28.

Hawkins, Walter Everette. "I Am Africa." *The Crisis*, July 1928: 232.

+ "Heiress in Lawsuit." *The Chicago Defender*, December 24, 1932: 1.

+ "Heiress Nancy Cunard, Negro Rights Champion." *Times Herald*, March 18, 1965: B4.

+ "Heiress Sails After Harlem Study." *The Washington Post*, July 7, 1932: 4.

"Helen Lee Worthing on Comeback Trail." *New York Amsterdam News*, August 15, 1936: 3.

+ Heller, Adele, and Lois Rudnick, eds. *1915: The Cultural Moment: The New Politics, the New Woman, the New Psychology, the New Art, and the New Theater in America.* New Brunswick, N.J.: Rutgers University Press, 1991.

Hemenway, Robert. *Zora Neale Hurston: A Literary Biography.* Champaign: University of Illinois Press, 1980.

Hewitt, Nancy A., and Suzanne Lebstock, eds. *Visible Women: New Essays on American Activism.* Urbana: University of Illinois Press, 1993.

Hightower, C. L., Sr., ed. *Hood County History in Picture and Story, 1978.* Fort Worth, Texas: Historical Publishers, 1978.

Hill, Judson. "Retrospection and Prophecy." *Morristown College News,* April 1924.

Hill, Robert. "Essays on Race Purity by Marcus Garvey." *The Marcus Garvey and UNIA Papers.* Vol. 4. Berkeley: University of California Press, 1989.

Hoberman, John. *Testosterone Dreams: Rejuvenation, Aphrodisia, Doping.* Berkeley: University of California Press, 2005.

Hodes, Martha. *Sex, Love, Race: Crossing Boundaries in North American History.* New York: New York University Press, 1999.

———. *White Women, Black Men: Illicit Sex in the 19th-Century South.* New Haven, Conn.: Yale University Press, 1997.

+ Hoffert, Sylvia D. "Yankee Schoolmarms and the Domestication of the South." *Southern Studies: An Interdisciplinary Journal of the South* 24.2 (1985): 188–201.

Hoffman, Nancy. "Inquiring After the Schoolmarm: Problems of Historical Research on Female Teachers." *Women's Studies Quarterly* 22.1–2 (1994): 107.

Holbrook, Francis. "The Opportunity Dinner." *Opportunity* 3 (June 1925): 177.

Holbrook, Stewart. *The Golden Age of Quackery.* New York: Macmillan, 1959.

Holland, Sharon Patricia. *The Erotic Life of Racism.* Durham, N.C.: Duke University Press, 2012.

Holmes, Oliver Wendell. *The Essential Holmes: Selections from Letters, Speeches, Judicial Opinions and Other Writing of Oliver Wendell Holmes.* Ed. Richard A. Posner. Chicago: University of Chicago Press, 1996.

Howell, Corre Crandall. *The Forfeit.* In Perkins and Stephens, eds., *Strange Fruit* 94–98.

Huggins, Nathan Irvin. *Harlem Renaissance.* New York: Oxford University Press, 1971.

Hughes, Langston. "Afro-American Fragment." *The Crisis,* July 1930: 235.

————. *The Collected Poems of Langston Hughes.* Ed. Arnold Rampersad. New York: Vintage, 1995.

————. *The Big Sea: An Autobiography.* New York: Hill, 1940.

————. *Limitations of Life.* In Shine and Hatch, *The Early Period* 224–25.

————. "Mother and Child." In Hughes, *The Ways of White Folks* 189–97.

————."Poet to Patron." *Collected Poems.* Ed. Rampersad.

————. "Rejuvenation Through Joy." In Hughes, *The Ways of White Folks* 69–98.

————. "Slave on the Block." In Hughes, *The Ways of White Folks* 19–31.

+ ————. "These Bad Negroes: A Critique on Critics." *The Pittsburgh Courier,* March 22, 1927.

————. *The Ways of White Folks.* 1933. New York: Vintage, 1990.

Hurst, Fannie. *Anatomy of Me: A Wonderer in Search of Herself, An Autobiography by the Author of "Back Street."* New York: Doubleday, 1958.

————. *Imitation of Life.* Ed. Daniel Itzkovitz. Durham, N.C.: Duke University Press, 2004.

————. Introduction. In *Jonah's Gourd Vine.* By Zora Neale Hurston. Philadelphia, Pa.: Lippincott, 1934.

————. "The Other, and Unknown, Harlem." *The New York Times,* August 4, 1946: 1.

————. "Zora Neale Hurston: A Personality Sketch." *Yale University Library Gazette* 35 (1960): 19.

Hurston, Zora Neale. "Concert." Hurston, *Folklore* 804–8.

————. "Cudjo's Own Story of the Last African Slaver." *Journal of Negro History* 12 (1927): 648–63.

————. *Dust Tracks on a Road.* 1942. New York: Harper, 1995.

————. *Folklore, Memoirs, and Other Writings.* New York: Library of America, 1995.

————. "Glossary of Harlem Slang," published with "Story in Harlem Slang," *The American Mercury* 55 (1942): 84–96.

————. "How It Feels to Be Colored Me." *World Tomorrow,* May 11, 1928.

————. "The Last Slaveship." *The American Mercury,* March 1944: 351–58.

————. *Mules and Men.* Bloomington: Indiana University Press, 1978.

+ ————. "Negro Folk Theatre." Chapel Hill, N.C.: Carolina Dramatic Association, 1939.

————. "The 'Pet Negro' System." *The American Mercury*, May 1943: 593–600.

Hutchinson, George. *The Harlem Renaissance in Black and White*. Cambridge, Mass.: Harvard University Press, 1995.

Huxley, Aldous. *Point Counter Point*. Champaign, Ill.: Dalkey Archive, 2001.

Ignatiev, Noel, and John Garvey, eds. *Race Traitor*. New York: Routledge, 1996.

Illidge, Cora Gary. "'The Great Day' Heartily Received." *New York Amsterdam News*, January 13, 1932: 7.

+ "Inter-Marriage: A Symposium." *The Crisis*, February 1930: 50, 67.

"Intermarriage." Editorial. *New York Amsterdam News*. March 3, 1928: 20.

"An Intermarriage Wave." *New York Amsterdam News*, July 24, 1929: 20.

Issel, Helna (Josephine Cogdell Schuyler?). "While All May Wonder." *The Crisis*, July 1931: 234.

Itzkovitz, Daniel, ed. *Imitation of Life*. Durham, N.C.: Duke University Press, 2004.

Jackson, Holly. "Identifying Emma Dunham Kelley: Rethinking Race and Authorship." *PMLA* 122 (2007): 728–41.

————. "Mistaken Identity." *Boston Globe*, February 20, 2005: D1.

Jacobson, Matthew Frye. *Whiteness of a Different Color: European Immigrants and the Alchemy of Race*. Cambridge, Mass.: Harvard University Press, 1999.

"James C. Johnson." *Princeton Press*, May 16, 1896. n.p.

+ James, Doris. *My Education at Piney Woods School*. New York: Fleming H. Revell, 1938.

James, Henry. *Washington Square*. New York: Harper, 1901.

James, Rian. *All About New York: An Intimate Guide*. New York: John Day, 1931.

Jannath, Heba (Josephine Cogdell Schuyler). "America's Changing Color Line." In Cunard, ed., *Negro*, 83–89.

+————. "Black Man." *The Crisis*, May 1930: 163.

+————. "Death and Diet." *The Messenger*, April 1928: 77–78, 92.

————. "Death and Diet [II]." *The Messenger*, May–June 1928: 107, 118.

————. "Deep Dixie: A Short Story in Verse." *The Crisis*, March 1931: 87–89.

+————. "Harlem—Easter." *The Messenger*, May–June 1928: 109.

+————. "James." *The Messenger*, March 1928: 50.

————. "Taboo." *The Crisis*, September 1930: 307.

Jarrell, Corey. "Helen Lee Worthing: A Tragedy in Glorious Black and White." Online, July 19, 2008; May 17, 2011. http://illkeepyouposted. typepad.com/ill_keep_you_posted/2008/07/i-first-heard-of-helen-lee-worthing-one-of-the-it-girls-of-the-silent-screen-era-in-the-book-bright-boulevards---bold-dre.html.

+ Jenkins, Betty L. "A White Librarian in Black Harlem." *The Library Quarterly* 60.3 (1990): 216–31.

Jerome, Julia (Josephine Cogdell Schuyler). "Divorce Better Than Disgust." *The Pittsburgh Courier*, March 30, 1928: 6.

+ ————. "Learn to Lose Gracefully in Love." *The Pittsburgh Courier*, January 26, 1929: A4.

————. "Love Always Changing Says Julia Jerome: Marriage Fails Because People Won't Admit Fact." *The Pittsburgh Courier*, November 3, 1928: 9.

+ ————. "Love Often Demands Shrewdness." *The Pittsburgh Courier*, January 12, 1929: A5.

+ ————. "Madly in Love with One Another." *The Pittsburgh Courier*, April 20, 1929: A6.

————. "Men Still Want to Marry." *The Pittsburgh Courier*, December 1, 1928: A4.

————. "Money and Marriage." *The Pittsburgh Courier*, June 15, 1929: A7.

————. "Mrs. Jerome Praises the Modern Girl." *The Pittsburgh Courier*, December 8, 1928: B4.

————. "Shall We Protect Young Girls from Love." *The Pittsburgh Courier*, May 23, 1931: 9.

————. "Treat Wives as Comrades: Couples Should Be Pals." *The Pittsburgh Courier*, February 16, 1929: B3.

————. "Wait for the Right Mate." *The Pittsburgh Courier*, November 10, 1928: B4.

+ ————. "Women Prefer Bold Men." *The Pittsburgh Courier*, December 15, 1928: A8.

Johns, Vere. Review of *Black Souls*, by Annie Nathan Meyer. *New York Age*, April 9, 1932.

Johnson, Caleb. "Crossing the Color Line." *Outlook and Independent*, August 26, 1931: 526ff.

Johnson, Charles S. Editorial. *Opportunity* 3.34 (October 1925).

Johnson, Georgia Douglas. *A Sunday Morning in the South*. In Perkins and Stephens, *Strange Fruit*, 103–9.

Johnson, James Weldon. *Along the Way: The Autobiography of James Weldon Johnson*. 1933. New York: Da Capo, 2000.

————. *Autobiography of an Ex–Colored Man*. New York: Penguin, 1990.

————. *Black Manhattan*. New York: Knopf, 1930.

————. "The Dilemma of the Negro Author." *The American Mercury*, December 15, 1928.

————. "Harlem: The Cultural Capital." In Locke, *The New Negro*, 301–11.

————, ed. *The Book of American Negro Poetry*. Rev. ed. New York: Harcourt Brace Jovanovich, 1931.

Jones, Jacqueline. *Soldiers of Light and Love: Northern Teachers and Georgia Blacks, 1865–1873*. Athens: University of Georgia Press, 1992.

Jones, Margaret B. (Margaret Seltzer). *Love and Consequences: A Memoir of Hope and Survival*. New York: Riverhead, 2008.

Jonsberg, Sara Dalmas. "Yankee Schoolmarms in the South: Models or Monsters?" *The English Journal* 91.4 (2002): 75–81.

Kakutani, Michiko. "However Mean the Streets, Have an Exit Strategy." *The New York Times*, February 26, 2008: 1.

Kaplan, Carla. "1926: Fire!!" In *A New History of American Literature and Culture*. Ed. Werner Sollors and Greil Marcus. Cambridge, Mass.: Harvard University Press, 2009, 593–98.

————. "Identity." In *Keywords of American Cultural Studies*. Ed. Bruce Burgett and Glenn Hendler. New York: New York University Press, 2006.

————. "The Lives of Others." *The Nation*, August 13, 2007, 30–35.

————. "Making It New—Constructions of Modernism." In *The Blackwell Companion to American Literature*. Ed. Paul Lauter. New York: Blackwell, 2010, 40–56.

————. "Nella Larsen's Erotics of Race." In Kaplan, ed., *Passing*, ix–xxvii.

————. "On Modernism and Race." *Modernism/Modernity* 4.1 (1997): 157–69.

————, ed. *Passing: A Norton Critical Edition*. New York: Norton, 2007.

————. *Zora Neale Hurston: A Life in Letters*. New York: Doubleday, 2002.

————. "Zora Neale Hurston, Folk Performance, and the 'Margarine Negro.'" In *The Cambridge Companion to the Harlem Renaissance*. Ed. George Hutchinson. Cambridge, Mass.: Cambridge University Press, 2007.

Kelley-Hawkins, Emma Dunham. *Megda* and *Four Girls at Cottage City*. Reprinted in *The Schomburg Series of African-American Women's Writing*. Ed. Henry Louis Gates, Jr. New York: Oxford University Press, 1988.

Kellner, Bruce. *Carl Van Vechten and the Irreverent Decades*. Norman: University of Oklahoma Press, 1968.

————. *The Harlem Renaissance: A Historical Dictionary for the Era*. New York: Methuen, 1987.

————. *Kiss Me Again: An Invitation to a Group of Noble Dames*. New York: Turtle Point, 2002.

————. "Refined Racism: White Patronage in the Harlem Renaissance." In Kramer *Harlem Renaissance Re-Examined* 96–99.

Kellogg, Charles Flint. *NAACP: A History of the National Association for the Advancement of Colored People*, Vol. 1: *1909–1920*. Baltimore, Md.: Johns Hopkins University Press, 1967.

Kemeny, P. C. *Princeton in the Nation's Service: Religious Ideals and Educational Practice, 1868–1928*. New York: Oxford University Press, 1998.

Kendall, Elaine. *"Peculiar Institutions": An Informal History of the Seven Sister Colleges*. New York: Putnam, 1975.

"Klan Slaps Racial Intermarriage: Message Sent to Senators." *The Pittsburgh Courier*, October 19, 1929: 4.

Knopf, Marcy, ed. *The Sleeper Wakes: Harlem Renaissance Stories by Women*. New Brunswick, N.J.: Rutgers University Press, 1993.

+ Koppelman, Susan, ed. *The Stories of Fannie Hurst*. New York: Feminist Press, 2004.

Kornweibel, Theodore, Jr. *No Crystal Stair: Black Life and the Messenger, 1917–1928*. Westport, Conn.: Greenwood, 1975.

Kramer, Victor A., ed. *The Harlem Renaissance Re-Examined*. New York: AMS Press, 1987.

Krasner, David. *A Beautiful Pageant: African American Theatre, Drama, and Performance in the Harlem Renaissance, 1910–1927*. New York: Palgrave MacMillan, 2002.

Kraut, Anthea. *Choreographing the Folk: The Dance Stagings of Zora Neale Hurston*. Minneapolis: University of Minnesota Press, 2008.

Kroeger, Brooke. *Fannie: The Talent for Success of Writer Fannie Hurst*. New York: Times Books, 1999.

————. *Passing: When People Can't Be Who They Are*. New York: PublicAffairs, 2003.

+ "Lady Cunard Defies Color Line as Social Barrier." *The Chicago Defender*, July 16, 1932: 1, 4.

"Lady Cunard's Search for Color." *New York American Weekly*, May 29, 1931.

Larsen, Nella. *Passing: A Norton Critical Edition*. Ed. Carla Kaplan. New York: Norton, 2007.

———. *Quicksand*. 1928. Blacksburg, VA: Wilder, 2010.

Lavender, Catherine J. *Scientists and Storytellers: Feminist Anthropologists and the Construction of the American Southwest*. Albuquerque: University of New Mexico Press, 2006.

Leak, Jeffrey B., ed. *Rac[e]ing to the Right: Selected Essays of George S. Schuyler*. Knoxville: University of Tennessee Press, 2001.

Lemire, Elise. *"Miscegenation": Making Race in America*. Philadelphia: University of Pennsylvania Press, 2002.

Levin, Joanna. *Bohemia in America: 1858–1920*. Stanford, Calif.: Stanford University Press, 2010.

Levine, Lawrence W. *Black Culture and Black Consciousness: Afro-American Folk Thought from Slavery to Freedom*. New York: Oxford University Press, 1977.

+ Lewis, Alfred Allen. *Ladies and Not-So-Gentle Women: Elisabeth Marbury, Anne Morgan, Elsie de Wolfe, Anne Vanderbilt, and Their Times*. New York: Penguin, 2000.

Lewis, David Levering. *When Harlem Was in Vogue*. New York: Oxford University Press, 1979.

Lewis, Earl, and Heidi Ardizzone. *Love on Trial: An American Scandal in Black and White*. New York: Norton, 2001.

+ "Lieutenant Colebrook Disappears; Lady Cunard Deserted." *The Chicago Defender*, August 13, 1932: 1.

Link, Ann Seymour. "Lawd Does You Undastahn." In Perkins and Stephens *Strange Fruit* 191–201.

Lipsitz, George. *The Possessive Investment in Whiteness: How White People Profit from Identity Politics*. Philadelphia, Pa.: Temple University Press, 1998.

Livingston, Myrtle Smith. "For Unborn Children." In Shine and Hatch, *The Early Period* 188–92.

Locke, Alain. "Black Truth and Beauty: A Retrospective Review of the Literature of the Negro for 1932." *Opportunity*, January 1933: 14.

+ ———. "The Concept of Race as Applied to Social Culture." *The Howard Review* 1 (1924): 290–99.

————. *The Critical Temper of Alain Locke: A Selection of His Essays on Art and Culture*. Ed. Jeffrey C. Stewart. New York: Garland, 1983.

————. Introduction. In *Plays of Negro Life: A Source-Book of Native American Drama*. Ed. Alain Locke and Montgomery Gregory (1927). Westport, Conn.: Greenwood, 1970.

————. "The Legacy of the Ancestral Arts." In Locke, *The New Negro*, 254–67.

————, ed. *The New Negro: Voices of the Harlem Renaissance*. 1925. New York: Atheneum, 1992.

————. "The New Negro." In Locke, ed., *The New Negro*, 3–16.

————. "A Note on African Art." *Opportunity*, May 2, 1924: 134–38.

————. *Race Contacts and Interracial Relations: Lectures on the Theory and Practice of Race*. Ed. Jeffrey C. Stewart. Washington, DC: Howard University Press, 1992.

————. Review of *Scarlet Sister Mary* by Julia Peterkin. *Opportunity* 7 (1929): 190–91.

————. "Spiritual Truancy." *New Challenge* 2.2 (Fall 1937): 63–66.

Lopez, Ian F. Hanley. *White by Law: The Legal Construction of Race*. New York: New York University Press, 1997.

Lott, Eric. *Love and Theft: Blackface Minstrelsy and the American Working Class*. New York: Oxford University Press, 1993.

Lovell, John. *Black Song: The Forge and the Flame—The Story of How the African American Spiritual Was Hammered Out*. New York: Macmillan, 1972.

Lowenfels, Walter. "Nancy Cunard." In Ford, ed., *Brave Poet*, 91–95.

Luhan, Mabel Dodge. *Edge of Taos Desert: An Escape to Reality*. Vol. 4. *Intimate Memories* (1937). Albuquerque: University of New Mexico Press, 1987.

Macgowan, Kenneth. "O'Neill's Play Again." *The New York Times*, August 31, 1924: X2.

Machlin, Milt. *Libby: The Murder Case That Shocked the Nation*. New York: Tower, 1980.

Macpherson, Kenneth. "Ne Mai." In Ford, ed., *Brave Poet*, 345–49.

Madigan, Mark J. "Miscegenation and 'The Dicta of Race and Class': The Rhinelander Case and Nella Larsen's *Passing*." In Kaplan, ed., *Passing*, 387–92.

Mailer, Norman. "The White Negro." *Dissent* 4.3 (1957): 276–93.

Major, Clarence. *From Juba to Jive: A Dictionary of African-American Slang*. New York: Puffin, 1994.

+ Manring, M. M. *Slave in a Box: The Strange Career of Aunt Jemima*. Charlottesville: University of Virginia Press, 1998.

Marchand, Roland. *Advertising the American Dream: Making Way for Modernity, 1920–1940*. Berkeley: University of California Press, 1985.

Marcus, Jane. "Bonding and Bondage: Nancy Cunard and the Making of the Negro Anthology." *Borders, Boundaries, and Frames: Cultural Criticism and Cultural Studies*. Ed. Mae Henderson. New York: Routledge, 1995: 33–63.

———. *Hearts of Darkness: White Women Write Race*. New Brunswick, N.J.: Rutgers University Press, 2004.

+ ———. "Navy Blues: A Séance." *Literary Imagination* 10.2 (2008): 185–97.

Margolies, Edward, and David Bakish. *Afro-American Fiction, 1853–1976*. Detroit, Mich.: Gale, 1979.

"Marriage to Colored Man Cause of Persecution." *New York Amsterdam News*, May 20, 1925: 1.

Mason, Charlotte Osgood. "The Passing of a Prophet: A True Narrative of Death and Life." *North American Review* 185 (1907): 869–79.

Mason, R. (Rufus) Osgood. "Alternating Personalities: Their Origin and Medico-Legal Aspect." *The Journal of the American Medical Association* 27 (1896): 1082–85.

Mason, Charlotte Osgood. "Character: Dr. A. T. Schofield's Book on Heredity and Environment." *The New York Times*, October 25, 1902: BR19.

———. "Concerning Supernormal Perception." *The New York Times*, July 27, 1902: SM10.

———. "Drink." *The New York Times*, November 19, 1899: 23.

———. "Duplex Personality—Its Relation to Hypnotism and Lucidity." *Journal of Nervous and Mental Disease* 20 (1895): 420–23.

———. "The Educational and Therapeutic Value of Hypnotism, and the Relation of Suggestion to Psychical Research." *The Coming Age* 3.2 (February 1900): 100–118.

———. "Educational Uses of Hypnotism." *The North American Review* 163.479 (1896): 448–55.

———. "Educational Uses of Hypnotism." *Pediatrics* 3.3 (1897): 97–105.

———. "Forms of Suggestion Useful in the Treatment of Inebriety." *Quarterly Journal of Inebriety* 29 (1897): 219–25.

———. "The Genesis of Genius." *Mind* 4.6 (September 1899): 321–34.

———. *Hypnotism and Suggestion in Therapeutics Education, and Reform*. New York: Henry Holt, 1901.

———. "Hypnotism: The Attitude of Physicians Toward It from Mesmer to Charcot." *The New York Times*, April 25, 1903: BR17.

———. "In the Field of Psychology: Reports of the Scouts Who Have Been Exploring." *The New York Times*, October 29, 1893: 20; November 5, 1893: 18; November 12, 1893: 20; November 19, 1893: 20; December 3, 1893: 20.

———. "The Influence of Hypnotic Suggestion upon Physiological Processes." *The Journal of the American Medical Association* 30 (1898): 846–48.

———. "Is It Wise for the Regular Practising Physician to Spend Time to Investigate Psychic Therapeutics?" *Medical Record*, September 27, 1902: 3–7.

———. "Life After Death: The Late F. W. H. Meyer's Posthumous Work on the Survival of Human Personality." *The New York Times*, March 28, 1903: BR1.

———. "A Life of Pasteur: The Manner of Man He Was, and the Results He Accomplished." *The New York Times*, February 22, 1902: BR1.

———. "Professor Fiske and the New Thought." *The Arena*, April 1901.

———. "Some Facts Concerning Hypnotism." *The New York Times*, June 26, 1898: 16.

———. "Some Cases Treated by Hypnosis and Suggestion." *New York Medical Journal* 69 (1899): 37–41.

———. *Telepathy and the Subliminal Self: Recent Investigations Regarding Hypnotism, Automatism, Dreams, Phantasms, and Related Phenomena.* New York: Henry Holt, 1897.

———. "Telepathy: Can Telepathy Explain? By Minot J. Savage." *The New York Times*, January 31, 1903: BR14.

———. "Typical Cases of Clairvoyance." *The New York Times*, December 6, 1896: 13.

———. "Value of Psychical Research." *The New York Times*, March 17, 1902: 8.

———. "What Is Genius?" *Metaphysical Magazine* 9.3 (March 1899): 129–41.

———. "William Blake: Artist, Poet, Visionary—Facts, Books, and Opinions Concerning Him." *The New York Times*, August 23, 1902: BR6.

Matthews, Geraldine. *Black American Writers, 1773–1949: A Bibliography and Union List.* Boston, Mass.: G. K. Hall, 1975.

Matthias, Blanche Coates. "Unknown Great Ones." *The Woman Athletic*, June 1923.

Matusevich, Maxim. "Harlem Globe-Trotters: Black Sojourners in Stalin's Soviet Union." In *The Harlem Renaissance Revisited.* Ed. Jeffrey Ogbanna

Green Ogbar. Baltimore, Md.: Johns Hopkins University Press, 2010: 211–44.

+ Maxwell, William J. *New Negro, Old Left: African-American Writing and Communism Between the Wars*. New York: Columbia University Press, 1999.

Maynard, W. Barksdale. *Princeton Alumni Weekly* 111 (March 2011): 9, 23. Online. http://paw.princeton.edu/issues/2011/03/23/pages/4092/index.xml?page=2&.

+ Mayo, Katherine. "The Yankee Schoolmarm." *Outlook*, March 3, 1920: 379–81.

McDowell, Deborah E. "Pecs and Reps: Muscling in on Race and the Subject of Masculinities." In Stecopoulos and Uebel, eds., *Race and the Subject* 361–85.

+ McIntosh, Peggy. "White Privilege: Unpacking the Invisible Knapsack." *Peace and Freedom*, July 1989, n.p.

McKay, Claude. "The Barrier." McKay, *Harlem Shadows* 13.

———. *Harlem: Negro Metropolis*. New York: Harcourt Brace Jovanovich, 1940.

———. *Harlem Shadows*. New York: Harcourt Brace Jovanovich, 1922.

———. *Home to Harlem*. Boston, Mass.: Northeastern University Press, 1928.

———. "If We Must Die." *The Liberator*, July 1919: 21.

———. *A Long Way from Home: An Autobiography* (1937). New York: Mariner, 1970.

McPherson, James M. *The Abolitionist Legacy: From Reconstruction to the NAACP*. Princeton, N.J.: Princeton University Press, 1975.

+ McSpadden, Holly. "Transgressive Reading: Nancy Cunard and *Negro*." In *Essays on Transgressive Readings: Reading over the Lines*. Ed. Georgia Johnston. New York: Edwin Mellen, 1997.

"Meet the George Schuylers: America's Strangest Family." *Our World*, April 6, 1951: 22–6.

+ Meier, August. *Negro Thought in America, 1880–1915: Racial Ideologies in the Age of Booker T. Washington*. Ann Arbor: University of Michigan Press, 1968.

Mercer, Kobena. "'Skin Head Sex Thing': Racial Difference and the Homoerotic Imaginary." In *How Do I Look: Queer Film and Video*. Ed. Bad Object-Choices. Seattle, Wash.: Seattle Bay, 1991.

Meyer, Annie Nathan. *Barnard Beginnings*. Boston, Mass.: Houghton Mifflin, 1935.

————. *Black Souls*. New Bedford, Mass.: Reynolds, 1932.

+ ————. *The Dominant Sex*. New York: Broadway, 1911.

+ ————. *The Dreamer*. New York: Broadway, 1912.

+ ————. *Helen Brent, M.D.: A Social Study*. New York: Cassell, 1892.

————. *It's Been Fun: An Autobiography*. New York: Henry Schuman, 1951.

————. "Negro Student Problems." *Opportunity*, May 1933: 145–46.

+ ————. *The New Way*. New York: Samuel French, 1925.

+ ————. *Robert Annys: Poor Priest--A Tale of the Great Uprising*. New York: Macmillan, 1901.

————. "To Emma Bugbee." *New York Herald Tribune*, October 6, 1939.

+ ————. "Women's Assumption of Sex Superiority." *North American Review*, January 1904. n.p.

+ ————, ed. *Women's Work in America*. New York: Henry Holt, 1891.

Mezzrow, Mezz, and Bernard Wolfe. *Really the Blues* (1946) New York: Barnes and Noble, 2009.

Mighall, Robert. "A History of Tanning." *The Sunday Times*, April 25, 2008. Online. www.timesonline.co.uk/tol/life_style/health/article3814579.ece.

Miller, James A. *Remembering Scottsboro: The Legacy of an Infamous Trial*. Princeton, N.J.: Princeton University Press, 2009.

Miller, Kelly. "The Marriage Bar." *New York Amsterdam News*, January 22, 1930: 20.

Miller, May. "Nails and Thorns." In Perkins and Stephens, *Strange Fruit* 177–88.

Mills, Claudia. " 'Passing': The Ethics of Pretending to Be What You Are Not." *Social Theory and Practice* 25.1 (1999): 29–51.

Mitchell, Joseph. "An Evening with a Gifted Child." *The New Yorker*, August 31, 1940: 8–31.

"Mixed Marriages." *The Chicago Defender*, February 13, 1926: A10.

Mjagkij, Nina. "A Peculiar Alliance: Julius Rosenwald, the YMCA, and African Americans, 1910–1933." *American Jewish Archives Journal* 44.2 (1992): 585–60.

Molesworth, Charles. *And Bid Him Sing: A Biography of Countée Cullen*. Chicago: University of Chicago Press, 2012.

Molesworth, Charles, and Leonard Harris. *Alain L. Locke: The Biography of a Philosopher*. Chicago: University of Chicago Press, 2008.

Molesworth, Charles, ed. *The Works of Alain Locke*. New York: Oxford University Press, 2012.

+ "Mom of Late Piano Genius Hangs Herself." *Jet* 36.7 (1969): 30.

Moon, Henry Lee. " 'Negro' Arrives at Last." Review of Cunard, ed., *Negro. New York Amsterdam News*, April 7, 1934: 9.

+ Moore, George. *Letters to Lady Cunard 1895–1933*. London, UK: Rupert Hart-Davis, 1957.

Morand, Paul. *New York*. New York: Henry Holt, 1930.

+ Morresi, Renata. "Black Man and White Ladyship (1931): A Manifesto." *Recharting the Black Atlantic: Modern Cultures, Local Communities, Global Connections*. Eds. Annalisa Oboz and Anna Scacchi. New York: Routledge, 2008.

+ ———. "Negotiating Identity: Nancy Cunard's Otherness." In *Resisting Alterities: Wilson Harris and Other Avatars of Otherness*. Ed. Marco Fazzini. New York: Rodopi, 2004: 147–58.

+ ———. "Two Examples of Women's "Hidden" Cultural (Net)work: Nancy Cunard's Opinion and Life and Letters To-Day." *Networking Women: Subjects, Places, Links Europe-America*. Ed. Marina Camboni. Rome: Edizioni di Storia e Letterature, 2004.

Morris, C. B. *This Loving Darkness: The Cinema and Spanish Writers, 1920–1946*. New York: Oxford University Press, 1980.

Morrison, Toni. *Playing in the Dark: Whiteness and the Literary Imagination*. New York: Vintage, 1992.

+ Morristown College. "History of Morristown College." *Morristown College Bulletin* 98.1 (1972).

+ Morristown Normal and Industrial College. "Annual Catalogue 1912–1913."

+ ———. "Annual Catalogue 1933–1934."

+ ———. "Annual Catalogue 1947–1948."

+ ———. "Annual Catalogue 1949–1950."

Mortimer, Raymond. "Nancy Cunard." In Ford, ed., *Brave Poet*, 48–49.

Moryck, Brenda. "A Point of View: An Opportunity Dinner Reaction." *Opportunity*, August 1925.

+ Moynagh, Maureen. "Cunard's Lines: Political Tourism and Its Texts." *New Formations: A Journal of Culture/Theory/Politics* 34 (1998): 70–90.

———, ed. *Essays on Race and Empire*. Ontario, Can.: Broadview, 2002.

+ "Mrs. Josephine Schuyler: Obituary." *Variety*, May 7, 1969.

Mumford, Kevin J. *Interzones: Black/White Sex Districts in Chicago and New York in the Early Twentieth Century*. New York: Columbia University Press, 1997.

+ Murray, Gail S., ed. *Throwing Off the Cloak of Privilege: White Southern Women Activists in the Civil Rights Era*. Gainesville: University Press of Florida, 2004.

Musiol, Hanna. " 'Objects of Emancipation': The Political Dreams of Modernism." Dissertation, Northeastern University, 2011.

"NAACP Sponsors First Sunday Night Benefit at Downtown Theatre." *Amsterdam News*, December 11, 1929: 5.

+ Nadell, Martha Jane. *Enter the New Negroes: Images of Race in American Culture*. Cambridge, Mass.: Harvard University Press, 2004.

+ "Nancy Cunard and Escort Quit Cuba for West Indies." *The Chicago Defender*, July 30, 1932: 2.

+ "Nancy Cunard Gets Welcome in Jamaica." *The Chicago Defender*, August 6, 1932: 13.

+ "Nancy Cunard Guest at Colored Hotel in Harlem." *Daily News*, May 2, 1932: 1, 3, 8.

"Nancy Cunard Pays Tribute to Famous Dutch Anthropologist." *New York Age*, August 4, 1934: 3.

+ "Nancy Cunard Reaches Havana." *The Washington Post*, July 10, 1932: 10.

"Nancy Cunard Stopping at Harlem Hotel." *Philadelphia Tribune*, May 5, 1932: 1.

+ "Nancy Cunard Tells Her Story; Disowned for Colored Friend." *Daily News*, May 3, 1932: 1, 10.

+ "Nancy Cunard Writes Book on Race Issues." *The Chicago Defender*, February 24, 1934: 22.

+ "Nancy's Escort Will Not Let Her Be Photographed." *The Chicago Defender*, July 23, 1932: 4.

Naison, Mark. *Communists in Harlem During the Depression*. Urbana: University of Illinois Press, 1983.

+ "Natalie Curtis Burlin." *The Southern Workman* L.12 (1921): 528a–29a.

+ "Natalie Curtis Dies Abroad." *The New York Times*, October 29, 1921: 12.

Nathan, Maud. *Once upon a Time and Today*. New York: Putnam, 1933.

"The Negro in Art: How Shall He Be Portrayed?" *The Crisis* 1929. Reprinted in Jarrett and Gates, eds., *New Negro*, 190–204.

"A Negro Renaissance." *New York Amsterdam News*, May 13, 1925: 16.

Nelson, Cary, and Bartholomew Brinkman, eds. *Modern American Poetry*. Online. www.english.illinois.edu/maps.

"The New Woman." December 19, 2010. www.library.csi.cuny.edu/dept/history/lavender/386/newwoman.

"New York Life." *Life*, May 17, 1929: 26.

+ Nicholson, Virginia. *Among the Bohemians: Experiments in Living, 1900–1939*. New York: HarperCollins, 2002.

Norris, Clarence, and Sybil D. Washington. *The Last of the Scottsboro Boys: An Autobiography*. New York: Putnam, 1979.

North, Michael. *The Dialect of Modernism: Race, Language and Twentieth-Century Literature*. New York: Oxford University Press, 1994.

O'Neill, Eugene. *The Emperor Jones*. New York: Random House, 1920.

Oja, Carol. *Making Music Modern: New York in the 1920s*. New York: Oxford University Press, 2000.

"*Opportunity*'s Second Annual Contest for Negro Writers Offers 1,000 Prize." *Opportunity* 3 (1925): 308–9.

Oram, Aliso. "'Embittered, Sexless, or Homosexual': Attacks on Spinster Teachers, 1918–1939." *Not a Passing Phase: Reclaiming Lesbians in History, 1840–1985*. Ed. Lesbian History Group. London, UK: Women's Press, 1989.

+ Osborne, Willie P., Clara L. Osborne, and Luie Hargraves, eds. "Contributions of Blacks to Hamblen County 1796–1996." Morristown: Tenn.: Progressive Business Association and MCF Discover Tennessee, 1995.

+ Osofsky, Gilbert. *Harlem: The Making of a Ghetto. Negro New York, 1890–1930*. Chicago, Ill.: Ivan R. Dee, 1996.

Ottley, Roi. *The Negro in New York: An Informal Social History, 1625–1940*. New York: Praeger, 1969.

Ovington, Mary White. *Black and White Sat Down Together: The Reminiscences of an NAACP Founder*. New York: Feminist Press, 1996.

+ ———. *Half a Man: The Status of the Negro in New York*. New York: Longmans, Green, 1911.

———. *The Shadow*. New York: Harcourt Brace Jovanovich, 1920.

+ ———. *The Walls Come Tumbling Down*. New York: Harcourt Brace Jovanovich, 1947.

Owen, Chandler. "The Black and Tan Cabaret: America's Most Democratic Institution." *The Messenger*, February 1925: 97–98.

———. "Black Mammies." *The Messenger*, March 1923: 670.

Painter, Nell Irvin. *The History of White People*. New York: Norton, 2010.

"Paris Beauties Kink Their Hair in Suki Glory." *The Chicago Defender*, October 14, 1922.

Parker, Andrew, and Eve Kosofsky Sedgwick, eds. *Performativity and Performance*. New York: Routledge, 1995.

Pascoe, Peggy. *What Comes Naturally: Miscegenation Law and the Making of Race in America*. New York: Oxford University Press, 2009.

Patterson, Michelle Wick. *Natalie Curtis Burlin: A Life in Native and African American Music*. Lincoln: University of Nebraska Press, 2010.

Pencak, William. *For God and Country: The American Legion, 1919–1941*. Boston, Mass.: Northeastern University Press, 1989.

Peplow, Michael W. *George S. Schuyler*. Boston, Mass.: Hall, 1980.

Perkins, Kathy A., and Judith L. Stephens, eds. *Strange Fruit: Plays on Lynching by American Women*. Bloomington: Indiana University Press, 1998.

Perry, Lorinda, and Susan Myra Kingsbury. *Millinery as a Profession for Women: Studies in Economic Relations of Women*. Vol. 5. New York: Longmans, Green, 1916.

"Persecuted for Wedding Race Husband." *Baltimore Afro-American*, May 23, 1925: A1.

Peterkin, Julia. *Bright Skin*. Indianapolis, Ind.: Bobbs-Merrill, 1932.

———. *Scarlet Sister Mary*. 1928. Athens: Georgia University Press, 1998.

Peterson, Iver. "As Princeton Changes a Black Community Fears for Future." *The New York Times*, September 3, 2001: B2.

Pfeifer, Michael J. *Rough Justice: Lynching and American Society, 1874–1947*. Urbana: University of Illinois Press, 2006.

+ Pfeiffer, Kathleen. *Race Passing and American Individualism*. Amherst: University of Massachusetts Press, 2003.

Pfister, Joel. *Staging Depth: Eugene O'Neill and the Politics of Psychological Discourse*. Chapel Hill: University of North Carolina Press, 1995.

Pickens, William. "African Art in Cunard's Home." *The Afro-American*, October 1, 1938: 13.

Pierson, Don. "Does It Pay to 'Pass'?" *Chicago Whip*, August 20, 1927.

"Poughkeepsie Has Marital Upset: Marriage of White Girl and Colored Man Forces Judge to Resign." *New York Amsterdam News*, March 3, 1926: 3.

"Prodigious Crop." *Time*, August 26, 1935: 27.

"Prominent Physician Weds Movie Star." *The Pittsburgh Courier*, July 27, 1927: 2.

Protevi, John. *Political Affect: Connecting the Social and the Somatic.* Minneapolis: University of Minnesota Press, 2009.

Quarles, Benjamin. *The Negro in the Making of America.* 3rd ed. New York: Macmillan, 1996.

Quick, Arthur Craig. *A Genealogy of the Quick Family in America (1615–1942), 317 Years.* South Haven, Mich.: Arthur C. Quick, 1942. http://perso.heritagequestonline.com/hqoweb/library/do/books/results/image/print?urn=urn.

Rado, Lisa, ed. *Rereading Modernism: New Directions in Feminist Criticism.* New York: Garland, 1994.

Rampersad, Arnold. *The Life of Langston Hughes: I, Too, Sing America.* Vol. I. *1902–1941.* New York: Oxford University Press, 2002.

Ransby, Barbara. *Ella Baker and the Black Freedom Movement: A Radical Democratic Vision.* Chapel Hill: University of North Carolina Press, 2003.

Ransdell, Hollace. "Report on the Scottsboro, Alabama, Case," May 27, 1931. TS. In *Famous American Trials: 'The Scottsboro Boys' Trials, 1931–1937.* Online, August 19, 2010. www.law.umkc.edu/faculty/projects/trials/scottsboro/scottsbororeport.pdf.

"Rare Negro Songs Given: Zora Hurston's Compilation of Four Years Heard at Golden Theatre." *The New York Times,* January 11, 1932: 29.

+ Ravitz, Abe C. *Imitations of Life: Fannie Hurst's Gaslight Sonatas.* Carbondale: Southern Illinois University Press, 1997.

"Reception Wednesday Will Honor Two Famous Poets." *The Evening Independent,* September 13, 1941: 6.

"Reds Take Charge of Boys' Defense." *New York Amsterdam News.* January 6, 1932: 1, 3.

+ Reed, Touré. *Not Alms but Opportunity: The Urban League and the Politics of Racial Uplift, 1910–1950.* Chapel Hill: University of North Carolina Press, 2008.

Reimer, William. *Bohemia: The East Side Cafes of New York.* New York: Caterer, 1903.

"Rhinelander Admits Pursuit." *The Boston Globe,* November 18, 1925: 1.

"Rhinelander's Suit." *Opportunity,* January 1926.

Rice, Elizabeth G. "A Yankee Teacher in the South: An Experience in the Early Days of Reconstruction." *Century Magazine,* May 1901: 151–54.

Rich, Motoko. "Gang Memoir, Turning Page, Is Pure Fiction." *The New York Times,* March 4, 2008: 1.

+ "Robeson Sued for Divorce." *The Chicago Defender,* July 2, 1932: 1, 3.

Roche, Emma Langdon. *Historic Sketches of the South*. 1914. New York: Knickerbocker, 2010.

Roediger, David R. *Colored White: Transcending the Racial Past*. Berkeley: University of California Press, 2002.

———. "Guineas, Wiggers, and the Dramas of Racialized Culture." *American Literary History* 7.4 (1995): 654–68.

———. *Towards the Abolition of Whiteness*. London, UK: Verso, 1994.

Rogers, J. A. *Sex and Race*. St. Petersburg, Fla.: Rogers, 1967.

+ Romano, Renee C. *Race Mixing: Black-White Marriage in Postwar America*. Cambridge, Mass.: Harvard University Press, 2003.

+ Rose, Ernestine. *Bridging the Gulf: Work with the Russian Jews and Other Newcomers*. New York: Immigrant Publication Society, 1917.

+ ———. "Harlem Experiment." *Journal of Adult Education* 8 (1936): 352–53.

+ ———. "Harlem, New York: Racial Development and Cooperation—A Record of Two Experiments." *Journal of Adult Education* 5 (1933): 53–55.

+ ———. "A Librarian in Harlem." *Opportunity* 1 (1923): 206–7, 220.

+ ———. *The Public Library in American Life*. New York: Columbia University Press, 1954.

+ ———. "Serving New York's Black City." *Library Journal* 46 (1921): 255–58.

+ ———. "Where White and Black Meet." *The Southern Workman* 51 (1922): 467–71.

+ ———. "Work with Negroes Round Table." *Bulletin of the American Library Association* 16.4 (1922): 362–66.

+ Rosenberg, Rosalind. *Beyond Separate Spheres: Intellectual Roots of Modern Feminism*. New Haven, Conn.: Yale University Press, 1982.

———. *Changing the Subject: How the Women of Columbia Shaped the Way We Think About Sex and Politics*. New York: Columbia University Press, 2004.

Roses, Lorraine Elena, and Ruth Elizabeth Randolph. *Harlem Renaissance and Beyond: Literary Biographies of 100 Black Women Writers, 1900–1945*. Boston, Mass.: G. K. Hall, 1990.

Ross, Barbara Joyce. *J. E. Spingarn and the Rise of the NAACP, 1911–1939*. New York: Atheneum, 1972.

+ Rothman, Hal K. *Devil's Bargains: Tourism in the Twentieth-Century American West*. Wichita: University Press of Kansas, 1998.

Rudnick, Lois Palken. *Mabel Dodge Luhan: New Woman, New Worlds*. Albuquerque: University of New Mexico Press, 1984.

Rudnick, Lois, and Adele Heller. *1915: The Cultural Moment: The New Politics, The New Woman, the New Psychology, the New Art, and the New Theater in America*. New Brunswick, N.J.: Rutgers University Press, 1991.

Ruhl, Arthur. "Second Nights." *New York Herald Tribune*, January 17, 1932.

Rush, Theresa Gunnels, et al. *Black American Writers Past and Present: A Biographical and Bibliographical Dictionary*. Vol. 2. Metuchen, N.J.: Scarecrow, 1975.

Sanchez, Maria, and Linda Schlossberg, eds. *Passing: Identity and Interpretation in Sexuality, Race, and Religion*. New York: New York University Press, 2001.

+ Scharf, Lois, and Joan M. Jensen. *Decades of Discontent: The Women's Movement, 1920–1940*. Boston, Mass.: Northeastern University Press, 1987.

Schultz, Debra L. *Going South: Jewish Women in the Civil Rights Movement*. New York: NYU Press, 2001.

"Schuyler Abroad," *The Pittsburgh Courier*, April 4, 1931: 11–12.

+ Schuyler, George S. "At the Coffee House." *The Messenger*, June 1925: 236–37.

———. "At the Darktown Charity Ball." *The Messenger*, December 1924: 377–38.

+ ———. "Black America Begins to Doubt." *The American Mercury* 25 (1932): 423–30.

———. *Black and Conservative: An Autobiography*. New Rochelle, N.Y.: Arlington, 1966.

+ ———. *Black Empire* (1936–1938). Boston, Mass.: Northeastern University Press, 1991.

+ ———. "Black Paradise Lost." *Opportunity* 13 (1935): 113–16.

———. "The Caucasian Problem." In Leak, ed. *Rac[e]ing to the Right* 37–50.

+ ———. "Do Negroes Want to Be White?" *The American Mercury* 82 (1956): 55–60.

+ ———. "The Education of White Folks." *Interracial Review*, July 1943.

———. "Emancipated Women and the Negro." *Modern Quarterly* 5.3 (1929): 361–63.

+ ———. *Ethiopian Stories*. Ed. and comp. Robert A. Hill. Boston, Mass.: Northeastern University Press, 1994.

+ ———. "Flowers of Sin: Part I" *New York Amsterdam News*, June 22, 1935: 6A.

+ ————. "Flowers of Sin: Part II" *New York Amsterdam News*, July 6, 1935: 2A.

+ ————. "Flowers of Sin: Part III" *New York Amsterdam News*, July 13, 1935: A2–A3.

————. "The Negro and Nordic Civilization." *The Messenger*, May 1925: 198–201, 207.

————. "The Negro-Art Hokum." *Nation*, June 16, 1926: 662–63.

————. "Our Greatest Gift to America." *Ebony and Topaʐ: A Collectanea*. Ed. Charles S. Johnson. New York: Ayer, 1927 122–24.

————. "Our White Folks." *The American Mercury*, December 1927: 385–92.

+ ————. "Racial Intermarriage in the United States: One of the Most Interesting Phenomena in Our National Life." *The American Parade* 1 (1928): 54–61.

————. *Slaves Today: A Story of Liberia*. College Park, Maryland: McGrath, 1969.

+ ————. "Some Southern Snapshots." *New Masses*, December 1926: 15–17.

————. "Speaking of Monuments and History." *The Pittsburgh Courier*, April 24, 1926: 16.

+ ————. "A Treatise on Mulattoes." *The Crisis*, 1937: 308–9.

————. "Views and Reviews." *The Pittsburgh Courier*, February 6, 1926: 3.

————. "Views and Reviews." *The Pittsburgh Courier*, July 18, 1931: 10.

————. "Views and Reviews." *The Pittsburgh Courier*, December 2, 1933: 10.

+ ————. "Views and Reviews." *The Pittsburgh Courier*, January 27, 1934: 10.

+ ————. "Views and Reviews." *The Pittsburgh Courier*, May 19, 1934: 10.

+ ————. "Views and Reviews." *The Pittsburgh Courier*, October 20, 1934: 10.

+ ————. "Views and Reviews." *The Pittsburgh Courier*, June 8, 1935: 12.

————. "When Black Weds White." *Modern Quarterly* 8 (1934): 11–17.

Schuyler, Josephine Cogdell (*see also* Anonymous; Cogdell, Josephine; Issel, Helna; Jannath, Heba; Jerome, Julia; and Tanne, Laura). "Correspondence." *The Nation*, April 8, 1931: 382.

————. "An Interracial Marriage." *The American Mercury*, March 1946: 273–77.

+ ————. *Philippa: The Beautiful American—The Traveled History of a Troubadour*. New York: Philippa Schuyler Memorial Foundation, 1969.

+ ————. "Race, Diet and Intelligence." *The Crisis*, May 1969: 207–10.

————. "17 Years of Mixed Marriage." (condensed reprint of "An Interracial Marriage"). *The Negro Digest*, July 1946: 61–65.

+ ———. "The Slaughter of the Innocents." *The Crisis*, October 1934: 295–96.

Schuyler, Josephine, and Philippa Duke Schuyler. *Kingdom of Dreams*. New York: Award, 1966.

+ Scott, Anne Firor. *The Southern Lady: From Pedestal to Politics 1830–1930*. Chicago: University of Chicago Press, 1970.

Scott, Esther Fulks. "Negroes as Actors in Serious Plays." *Opportunity* 1 (1923): 20.

Sedgwick, Eve Kosofsky. *Touching Feeling: Affect, Pedagogy, Performativity*. Durham, N.C.: Duke University Press, 2003.

Sedgwick, Eve Kosofsky, and Adam Frank, eds., *Shame and Its Sisters: A Silvan Tomkins Reader*. Durham, N.C.: Duke University Press, 1995.

Segrest, Mab. *Memoir of a Race Traitor*. Cambridge, Mass.: South End, 1994.

"A Sensation in Harlem." *New York Amsterdam News*, January 26, 1935: 10.

"75,000 Pass in Philadelphia Every Day." *Afro-American*, December 19, 1931.

Shack, William A. *Harlem in Montmartre: A Paris Jazz Story Between the Great Wars*. Los Angeles: University of California Press, 2001.

+ Shapiro, Lily J. "Patronage as a Peculiar Institution: Charlotte Osgood Mason and the Harlem Renaissance." Dissertation, Harvard College, 1993.

Shaw, Charles G. *Nightlife: Vanity Fair's Intimate Guide to New York After Dark*. New York: Day, 1931.

+ "She Is Pet of London." *The Washington Post*, June 28, 1915: 10.

Shine, Ted, and James V. Hatch, eds. *Black Theater USA: Plays by African Americans, The Early Period, 1847–1938*. Rev. and expanded ed. New York: Free Press, 1996.

———. *Black Theatre, USA: Plays by African Americans: The Recent Period, 1935–Today*. New York: Free Press, 1996.

"The Shirley Temple of American Negroes." *Look*, November 7, 1939: 4.

Shipler, David K. A Country of Strangers: Blacks and Whites in America. New York: Vintage, 1998.

Shockley, Ann Allen. *Afro-American Women Writers, 1746–1933: An Anthology and Critical Guide*. New York: Meridian, 1989.

Showalter, Elaine. *These Modern Women: Autobiographical Essays from the Twenties*. New York: Feminist Press, 1979.

Singh, Amritjit, and Daniel M. Scott, III, eds. *The Collected Writings of Wallace Thurman: A Harlem Renaissance Reader*. New Brunswick, N.J.: Rutgers University Press, 2003.

Bibliography

Sinnette, Elinor Des Verney. *Arthur Alfonso Schomburg: Black Bibliophile and Collector*. New York: New York Public Library, and Detroit, Mich.: Wayne State University Press, 1989.

"The Slumming Hostess." *New York Age*, November 6, 1926: 4.

Small, Sandra E. "The Yankee Schoolmarm in Freedmen's Schools: An Analysis of Attitudes." *Journal of Southern History* 45.3 (1979): 381–402.

Smitherman, Geneva. *Black Talk: Words and Phrases from the Hood to the Amen Corner*. Rev. ed. New York: Houghton Mifflin, 2000.

Smith-Pryor, Elizabeth. *Property Rights: The Rhinelander Trial, Passing, and the Protection of Whiteness*. Chapel Hill: University of North Carolina Press, 2009.

+ Smith-Rosenberg, Carroll. *Disorderly Conduct: Visions of Gender in Victorian America*. New York: Oxford University Press, 1985.

Sollors, Werner. *Interracialism: Black-White Intermarriage in American History, Literature, and Law*. Oxford: Oxford University Press, 2000.

+ ———. *Neither Black nor White, Yet Both: Thematic Explorations of Interracial Literature*. New York: Oxford University Press, 1997, 142–61.

+ Solomon, Mark. *The Cry Was Unity: Communists and African Americans, 1917–1936*. Jackson: University Press of Mississippi, 1998.

+ Speck, Ernest B. "Henry Crowder: Nancy Cunard's 'Tree.'" *Lost Generation Journal* 6.1 (1976): 6–8.

Spence, Eulalie. "A Criticism of the Negro Drama as It Relates to the Negro Dramatist and Artist." *Opportunity* 6 (1928): 192–93.

Squires, Catherine R. *Dispatches from the Color Line: The Press and Multiracial America*. Albany: State University of New York Press, 2007.

+ Staggs, Sam. *Born to Be Hurt: The Untold Story of* Imitation of Life. New York: St. Martin's, 2009.

Staiger, Janet, Ann Cvetkovich, and Ann Reynolds, eds. *Political Emotions: New Agendas in Communication*. New York: Routledge, 2010.

Stalling, Taylor, et al., eds. *Whiteness: A Wayward Construction*. Laguna Beach, Calif.: Laguna Art Museum and Fellows of Contemporary Art, 2003.

Stansell, Christine. *American Moderns: Bohemian New York and the Creation of a New Century*. New York: Holt, 2000.

Stearns, A. [Almira] H. *A Highway in the Wilderness*. Chattanooga, Tenn.: MacGowan, 1898.

Stecopoulos, Harry, and Michael Uebel, eds. *Race and the Subject of Masculinities*. Durham, N.C.: Duke University Press, 1997.

Stepto, Robert E. *From Behind the Veil: A Study of Afro-American Narrative.* Urbana: University of Illinois Press, 1979.

Stewart, Jeffrey C. "Race Prejudice and the Negro Artist." *Harper's,* November 1928: 157.

Stewart, Jeffrey Conrad. "A Biography of Alain Locke: Philosopher of the Harlem Renaissance, 1886–1930." Dissertation, Yale University, 1997.

+ Stewart, John W. "Benevolent Economies: An Exploration of Literary Patronage During the Harlem Renaissance." Dissertation, University of Southern Mississippi, 2003.

Stewart, Susan. *On Longing: Narratives of the Miniature, the Gigantic, the Souvenir, the Collection.* Durham, N.C.: Duke University Press, 1993.

+ Story, Ralph D. "Patronage and the Harlem Renaissance: You Get What You Pay For." *College Language Association Journal* 32.2 (1989): 284–95.

+ Sullivan, Patricia. *Days of Hope: Race and Democracy in the New Deal Era.* Chapel Hill: University of North Carolina Press, 1996.

———. *Lift Every Voice: The NAACP and the Makings of the Civil Rights Movement.* New York: New Press, 2010.

Sundquist, Eric J. *Strangers in the Land: Blacks, Jews, Post-Holocaust America.* Cambridge, Mass.: Harvard University Press, 2009.

Sweeney, Carole. "One of Them, but White: The Disappearance of *Negro: An Anthology* (1934)." *Women: A Cultural Review* 16.1 (2005): 93–107.

Talalay, Kathryn. *Composition in Black and White: The Tragic Saga of Harlem's Biracial Prodigy.* New York: Oxford University Press, 1995.

Tanne, Laura (Josephine Cogdell Schuyler). "The Avenue." *The Messenger,* March 1928: 56.

———. "Barrier." *The Messenger,* April 1928: 50.

———. "Now I Know the Truth." *The Crisis,* February 1930: 45–46.

———. "On Lenox." *The Crisis,* October 1928: 338.

———. "To a Dark Poem." *The Messenger,* March 1928: 50.

Tate, Claudia. *Domestic Allegories of Political Desire: The Black Heroine's Text at the Turn of the Century.* New York: Oxford University Press, 1992.

Tate, Greg, ed. *Everything But the Burden: What White People Are Taking from Black Culture.* New York: Harlem Moon, 2003.

Taylor, Charles. "The Politics of Recognition." In *Multiculturalism: Examining the Politics of Recognition.* Ed. Amy Gutman. Princeton, N.J.: Princeton University Press, 1994, 25–74.

Taylor, Robert Lewis. "The Doctor, the Lady, and Columbia University." *The New Yorker*, October 23, 1943: 27–32.

Terkel, Studs. Race: How Blacks and Whites Think and Feel About the American Obsession. New York: New Press, 1992.

Thaggert, Miriam. "Racial Etiquette: Nella Larsen's *Passing* and the Rhinelander Case." In Kaplan, ed. *Passing*, 507–32.

+ Thomas, H. Nigel. "Patronage and the Writing of Langston Hughes's *Not Without Laughter*: A Paradoxical Case." *College Language Association Journal* 92.1 (1988): 48–70.

Thorne, Anthony. "A Share of Nancy." In Ford, ed., *Brave Poet*, 293–311.

Thurman, Wallace. *Infants of the Spring*. 1932. Boston, Mass.: Northeastern University Press, 1992.

Tibbets, Celeste. "Ernestine Rose and the Origins of the Schomburg Center." *Schomburg Center Occasional Papers Series* 2. New York: Schomburg Center for Research in Black Culture, n.d., 1–41.

Toomer, Jean. *Cane* (1923). New York: Boni and Liveright, 1975.

———. "Portrait in Georgia." *Modern Review*, January 1923: 81.

Torgovnick, Marianna. *Gone Primitive: Savage Intellects, Modern Lives*. Chicago: University of Chicago Press, 1990.

Trager, James. *Park Avenue: Street of Dreams*. New York: Atheneum, 1990.

Tree, Iris. "We Shall Not Forget." In Ford, ed., *Brave Poet*, 18–25.

+ Trent, Lucia, and Ralph Cheyney. *Thank You, America!* New York: Suttonhouse, 1937.

+ Trent, Lucia. *Children of Fire and Shadow*. Chicago, Ill.: Packard, 1929.

———. "A White Woman Speaks." *Opportunity* 5 (June 1927): 174.

Twain, Mark. *Pudd'nhead Wilson* (1894). London, UK: Penguin, 1969.

+ Underwood, Sara A. *Automatic or Spirit Writing, with Other Psychic Experiences*. Chicago, Ill.: Thomas G. Newman, 1896.

Van Doren, Dorothy. "Black, Alas, No More!" *The Nation*, February 25, 1931: 218.

Van Gelder, Robert. "An Interview with Fannie Hurst." *The New York Times Book Review*, January 25, 1942: 2.

Van Notten, Eleanore. *Wallace Thurman's Harlem Renaissance*. Atlanta, Ga.: Rodopi 1994.

Van Vechten, Carl. *Nigger Heaven* (1926), Urbana: University of Illinois Press, 2000.

————. *The Splendid Drunken Twenties: Selections from the Daybooks, 1922–1930.* Ed. Bruce Kellner. New Haven, Conn.: Yale University Press, 1987.

+ Vanderbilt, Cornelius, Jr. *Park Avenue.* New York: Macaulay, 1930.

Vendryes, Margaret Rose. "Hanging on Their Walls: 'An Art Commentary on Lynching.' The Forgotten 1935 Exhibition." *Race Consciousness: African-American Studies for the New Century.* Ed. Judith Jackson Fossett and Jeffrey A. Tucker. New York: New York University Press, 1997.

Verdelle, A. J. Foreword. *Scarlet Sister Mary.* By Julia Peterkin. Athens: University of Georgia Press, 1998.

Vincent, Florence Smith. "There Are 20,000 Passing." *The Pittsburgh Courier,* May 11, 1929: 1.

Vincent, Theodore G., and Robert Crisman, eds. *Voices of a Black Nation: Political Journalism in the Harlem Renaissance.* San Francisco, Calif.: Ramparts, 1973.

Wald, Gayle. *Crossing the Line: Racial Passing in Twentieth-Century U.S. Literature and Culture.* Durham, N.C.: Duke University Press, 2000.

————. "Mezz Mezzrow and the Voluntary Negro Blues." Stecopoulos and Uebel, eds., *Race and the Subject* 116–37.

Waldorf, Wilella. *New York Evening Post,* March 31, 1932.

Wallace, Michele. *Black Macho and the Myth of the Superwoman.* London, UK: Verso, 1990.

+ Wallace-Sanders, Kimberly. *Mammy: A Century of Race, Gender, and Southern Memory.* Ann Arbor: University of Michigan Press, 2008.

Ward, Geoffrey C. *Unforgivable Blackness: The Rise and Fall of Jack Johnson.* New York: Knopf, 2004.

Ward, Philip M. "The Electric Body: Nancy Cunard Sees Josephine Baker." 2003. Online, January 31, 2010. www.pemward.co.uk/page_115473499796.html.

+ Ware, Caroline F. *Greenwich Village, 1920–1930: A Comment on American Civilization in the Post-War Years.* Berkeley: University of California Press, 1963.

Ware, Susan. *Holding Their Own: American Women in the 1930s.* New York: Twayne, 1982.

————, ed., *Notable American Women: A Biographical Dictionary—Completing the Twentieth Century.* Cambridge, Mass.: Belknap, 2004.

Ware, Vron, and Les Black. *Out of Whiteness: Color, Politics, and Culture.* Chicago: University of Chicago Press, 2002.

+ Warnat, Winifred I. "The Role of White Faculty on the Black College Campus." *The Journal of Negro Education* 45.3 (1976): 334–38.

Washington, Shirley Porter. *Countée Cullen's Secret Revealed by Miracle: A Biography of His Childhood in New Orleans.* Bloomington, Ind.: AuthorHouse, 2008.

Watson, Steven. *The Harlem Renaissance: Hub of African-American Culture, 1920–1930.* New York: Pantheon, 1995.

Waugh, Joan. *Unsentimental Reformer: The Life of Josephine Shaw Lowell.* Cambridge, Mass.: Harvard University Press, 1998.

+ "Wave of Intermarriage Strikes Nordic Purists." *New York Amsterdam News,* July 24, 1929: 1.

Wedin, Carolyn. *Inheritors of the Spirit: Mary White Ovington and the Founding of the NAACP.* New York: Wiley, 1998.

Weigle, Marta, and Barbara Babcock, eds. *The Great Southwest of the Fred Harvey Company and the Santa Fe Railway.* Phoenix, Ariz.: Heard, 1996.

+ Weigle, Marta. "From Desert to Disney World: The Santa Fe Railway and the Fred Harvey Company Display the Indian Southwest." *Journal of Anthropological Research* 45.1 (1989): 115–37.

Weis, Andrea. *Paris Was a Woman: Portraits from the Left Bank.* San Francisco, Calif.: Harper, 1995.

Wells, Jovita, ed. *A School for Freedom: Morristown College and Five Generations of Education for Blacks, 1868–1985.* Morristown, Tenn.: Morristown College, 1986.

+ Wells-Barnett, Ida B. [Ida B. Wells]. *On Lynchings.* New York: Humanity, 2002.

———. *The Red Record: Tabulated Statistics and Alleged Causes of Lynching in the United States.* Stockbridge, Mass.: Hard, 2006.

+ Wetzsteon, Ross. *Republic of Dreams. Greenwich Village: The American Bohemia, 1910–1960.* New York: Simon and Schuster, 2003.

"When Is a Caucasian Not a Caucasian?" *Independent,* March 2, 1911: 478–79.

White, Walter. *Flight* (1926). Baton Rouge: Louisiana State University Press, 1998.

———. *A Man Called White: The Autobiography of Walter White.* Athens: University of Georgia Press, 1995.

+ ———. *Rope and Faggot: A Biography of Judge Lynch.* South Bend, Ind.: University of Notre Dame Press, 2001.

+ "Whites Urge Eviction of Lieut. Colebrook's Family." *The Chicago Defender,* December 10, 1932: 2.

Whittaker, James. "Miss Cunard Asks Aid for 9 Doomed Negroes." *Daily Mirror,* May 2, 1932.

Wilkerson, Isabel. *The Warmth of Other Suns: The Epic Story of America's Great Migration*. New York: Random House, 2010.

Williams, Ora. *American Black Women in the Arts and Social Sciences*. 3rd ed. Metuchen, N.J.: Scarecrow, 1994.

Williams, Oscar R. *George S. Schuyler: Portrait of a Black Conservative*. Knoxville: University of Tennessee Press, 2007.

Williams, Patricia J. *The Alchemy of Race and Rights: Diary of a Law Professor*. Cambridge, Mass.: Harvard University Press, 1991.

————. *Seeing a Color-Blind Future*. New York: Farrar, Straus and Giroux, 1997.

Williams, Susan Miller. *A Devil and a Good Woman, Too: The Lives of Julia Peterkin*. Athens: University of Georgia Press, 1997.

Williams, Susan, and Barbara Ellen Smith. "Conflict and Community-Building in the Appalachian South." *Across Races and Nations: Building New Communities in the U.S. South*. Center for Research on Women, Southern Regional Council, n.p., n.d.

Williams, Terrence E. "Writer Scores Best Girls Who Entertain 'Nordics.' " *The Pittsburgh Courier*, October 1, 1927.

Williamson, Joel. *The Crucible of Race: Black-White Relations in the American South Since Emancipation*. New York: Oxford University Press, 1984.

+ Wilson, Sondra Kathryn, ed. *The Crisis Reader: Stories, Poetry, and Essays from the N.A.A.C.P.'s* Crisis *Magazine*. New York: Modern Library, 1999.

+ ————, ed. *The Messenger Reader: Stories, Poetry, and Essays from* The Messenger *Magazine*. New York: Modern Library, 2000.

+ ————, ed. *The Opportunity Reader: Stories, Poetry, and Essays from the Urban League's* Opportunity *Magazine*. New York: Modern Library, 1999.

Wineapple, Brenda. *Genet: A Biography of Janet Flanner*. New York: Ticknor and Fields, 1989.

Winkiel, Laura. "Nancy Cunard's *Negro* and the Transnational Politics of Race." *Modernism/Modernity* 13.3 (2006): 507–30.

+ Winsor, Mary. "The White Woman's Burden." *The Nation* 112.2902 (February 16, 1921): 257–58.

Witten, Edythe Steward. "The History of Morristown Normal and Industrial College." Master's thesis. Tennessee Agricultural and Industrial State College, 1943.

Wood, Lillian. *Let My People Go*. Philadelphia, PA: AME, n.d.

Woolf, Virginia. "Professions for Women." In Michelle Barrett, ed. *Virginia Woolf: Women and Writing*. New York: Harcourt Brace Jovanovich, 1979.

Wright, Richard. *Native Son* (1940). New York: Harper, 1998.

+ "The Yankee Schoolmarm: A Kentucky Eulogy of the New-England School Teacher." *The New York Times*, July 7, 1890: 6.

Zangrando, Robert L. *The NAACP Crusade Against Lynching, 1909–1950*. Philadelphia, Pa.: Temple University Press, 1980.

Index

Note: Page numbers in *italics* refer to illustrations.

About the Author

CARLA KAPLAN is an award-winning professor and writer who holds the Stanton W. and Elisabeth K. Davis Distinguished Professorship in American Literature at Northeastern University, and she has also taught at the University of Southern California and Yale University. Kaplan is the author of *The Erotics of Talk* and *Zora Neale Hurston: A Life in Letters*, as well as the editor of *Dark Symphony and Other Works* by Elizabeth Laura Adams, *Every Tongue Got to Confess* by Zora Neale Hurston, and *Passing* by Nella Larsen. A recipient of a Guggenheim and many other fellowships, Kaplan has been a fellow in residence at the Cullman Center for Scholars and Writers, the Schomburg Center for Research in Black Culture, and the W. E. B. Du Bois Institute, among other research centers.